Herbert Bayer, Graphic Designer

Visual Cultures and German Contexts

Series Editors

Deborah Ascher Barnstone (University of Technology Sydney, Australia)
Thomas O. Haakenson (California College of the Arts, USA)

Visual Cultures and German Contexts publishes innovative research into visual culture in Germany, Switzerland, and Austria, as well as in diasporic linguistic and cultural communities outside of these geographic, historical, and political borders.

The series invites scholarship by academics, curators, architects, artists, and designers across all media forms and time periods. It engages with traditional methods in visual culture analysis as well as inventive interdisciplinary approaches. It seeks to encourage a dialogue amongst scholars in traditional disciplines with those pursuing innovative interdisciplinary and intermedial research. Of particular interest are provocative perspectives on archival materials, original scholarship on emerging and established creative visual fields, investigations into time-based forms of aesthetic expression, and new readings of history through the lens of visual culture. The series offers a much-needed venue for expanding how we engage with the field of Visual Culture in general.

Proposals for monographs, edited volumes, and outstanding research studies are welcome, by established as well as emerging writers from a wide range of comparative, theoretical, and methodological perspectives.

Advisory Board

Donna West Brett, University of Sydney, Australia
Charlotte Klonk, Humboldt Universität Berlin, Germany
Nina Lübbren, Anglia Ruskin University, UK
Maria Makela, California College of the Arts, USA
Patrizia C. McBride, Cornell University, USA
Rick McCormick, University of Minnesota, USA
Elizabeth Otto, University at Buffalo SUNY, USA
Kathryn Starkey, Stanford University, USA
Annette F. Timm, University of Calgary, Canada
James A. van Dyke, University of Missouri, USA

Titles in the Series

Art and Resistance in Germany, edited by Deborah Ascher Barnstone and Elizabeth Otto
Bauhaus Bodies: Gender, Sexuality, and Body Culture in Modernism's Legendary Art School, edited by Elizabeth Otto and Patrick Rössler
Berlin Contemporary: Architecture and Politics after 1990, by Julia Walker
Photofascism: Photography, Film, and Exhibition Culture in 1930s Germany and Italy, by Vanessa Rocco
Single People and Mass Housing in Germany, 1850–1930: (No) Home Away from Home, by Erin Eckhold Sassin

Herbert Bayer, Graphic Designer

From the Bauhaus to Berlin, 1921–1938

Patrick Rössler

BLOOMSBURY VISUAL ARTS
LONDON • NEW YORK • OXFORD • NEW DELHI • SYDNEY

BLOOMSBURY VISUAL ARTS
Bloomsbury Publishing Plc
50 Bedford Square, London, WC1B 3DP, UK
1385 Broadway, New York, NY 10018, USA
29 Earlsfort Terrace, Dublin 2, Ireland

BLOOMSBURY, BLOOMSBURY VISUAL ARTS and the Diana logo
are trademarks of Bloomsbury Publishing Plc

First published in Great Britain 2023

This manuscript is adapted from a dissertation submitted in 2022 to the Faculty of
Architecture, Civil Engineering and Urban Planning of the Brandenburg University of
Technology (BTU) Cottbus-Senftenberg in partial fulfillment of the requirements for a
doctoral degree.

Cover design: Tjaša Krivec
Cover image: Herbert Bayer, Yva (Else Neuländer-Simon),
Studio portrait, c. 1935. Photograph.

A catalogue record for this book is available from the British Library.

A catalog record for this book is available from the Library of Congress.

ISBN: HB: 978-1-3502-2967-9
 ePDF: 978-1-3502-2968-6
 eBook: 978-1-3502-2969-3

Series: Visual Cultures and German Contexts

Typeset by Integra Software Services Pvt. Ltd.
Printed and bound in Great Britain

To find out more about our authors and books visit www.bloomsbury.com
and sign up for our newsletters.

Contents

List of Illustrations vi

A Short Bayer Timeline xvii

Introduction: Herbert Bayer's Lost Decade 1

Part One Formative Experiences—How an Apprentice from Linz
 Became a Junior Master at the Bauhaus

1 Youth: Family, Friends, and Companions 15

2 Irene Hecht and Herbert Bayer: A Fateful Relationship 27

3 Intimate Friendships: Bayer's Work and Life at the Bauhaus 39

4 Sturm und Drang: Life in Berlin 53

5 Ise Gropius and the Summer of 1932 67

Part Two A Commercial Artist in Nazi Germany

6 Working for Dorland Advertising Agency in Berlin 83

7 Designs for Propaganda 93

8 Good Life in Berlin 117

9 Loyal Bauhaus Circles 133

Part Three The Path to Emigration

10 The Last Person Left Behind in Berlin 147

11 Trial Run: The London Gallery Exhibition 155

12 Dress Rehearsal: Summer Excursion to the United States 161

13 A Well-Considered Departure 169

Part Four A New Life: Bayer in the Land of Opportunity

14 Bayer's New Start in the United States: The Bauhaus at MoMA 189

15 Difficult Beginnings: Bayer's First Eight Years in the United States 197

Epilogue: Bayer in Berlin, or: A Life in an Echo Chamber 215

Notes 232

Bibliography 285

Index 303

Illustrations

Plates

1 Herbert Bayer, Inflationary money for Thuringia, Weimar 1923. Rotary printing; Private collection. © Estate of Herbert Bayer/Artists Rights Society (ARS), New York/VG Bild Kunst, Bonn

2 Herbert Bayer, Tourist flyer for the city of Dessau, 1926. Offset printing, folded; Private collection. © Estate of Herbert Bayer/Artists Rights Society (ARS), New York/VG Bild Kunst, Bonn

3 Herbert Bayer, Advertising brochure for the Bauhaus, 1927. Offset printing; Private collection. © Estate of Herbert Bayer/Artists Rights Society (ARS), New York/VG Bild Kunst, Bonn

4 Herbert Bayer, Advertising card for his Berlin studio, 1928. Offset printing; Archiv der Moderne Weimar. © Estate of Herbert Bayer/Artists Rights Society (ARS), New York/VG Bild Kunst, Bonn

5 Herbert Bayer, Book cover for Otto Beyer Publishers, Berlin, 1931. Offset printing; Private collection. © Estate of Herbert Bayer/Artists Rights Society (ARS), New York/VG Bild Kunst, Bonn

6 Herbert Bayer, Catalogue for the Section Allemande exhibition, Paris, 1930. Letterpress with embossed plastic cover; Private collection. © Estate of Herbert Bayer/Artists Rights Society (ARS), New York/VG Bild Kunst, Bonn

7 Herbert Bayer, Travel poster for Teutoburger Wald region, 1931. Offset printing; Lentos Kunstmuseum Linz, Herbert Bayer Collection. © Estate of Herbert Bayer/Artists Rights Society (ARS), New York/VG Bild Kunst, Bonn

8 Herbert Bayer, Advertising brochure for Gropius Adler car, 1932. Letterpress, folded; Private collection. © Estate of Herbert Bayer/Artists Rights Society (ARS), New York/VG Bild Kunst, Bonn

9 Herbert Bayer, Type specimen for *bayer-Type*, Cover of folder, c. 1936. Offset printing; Private collection. © Estate of Herbert Bayer/Artists Rights Society (ARS), New York/VG Bild Kunst, Bonn

10 Herbert Bayer, Type specimen for *Normande* typeface, brochure cover, 1933. Offset printing; Private collection. © Estate of Herbert Bayer/Artists Rights Society (ARS), New York/VG Bild Kunst, Bonn

11 Herbert Bayer, Catalogue for the German pavilion at the Chicago World Fair, cover, 1933. Offset printing on glassine paper; Private collection. © Estate of Herbert Bayer/Artists Rights Society (ARS), New York/VG Bild Kunst, Bonn

12 Herbert Bayer, Catalogue for the exhibition *Die Kamera*, cover, 1933. Offset printing; Private collection. © Estate of Herbert Bayer/Artists Rights Society (ARS), New York/VG Bild Kunst, Bonn

13 Herbert Bayer, Booklet for the exhibition *Deutsches Volk, deutsche Arbeit,* cover, 1934. Offset printing; Private collection. © Estate of Herbert Bayer/Artists Rights Society (ARS), New York/VG Bild Kunst, Bonn

14 Herbert Bayer, Key visual for the exhibition *Das Wunder des Lebens,* 1935. Collage, photograph, and gouache; The Wolfsonian-FIU, Florida, Herbert Bayer collection. © Estate of Herbert Bayer/Artists Rights Society (ARS), New York/VG Bild Kunst, Bonn

15 Herbert Bayer, Book cover for Union Deutsche Verlagsgesellschaft, Stuttgart, 1935. Offset printing; Private collection. © Estate of Herbert Bayer/Artists Rights Society (ARS), New York/VG Bild Kunst, Bonn

16 Herbert Bayer, Page from *Das Wunder des Lebens* booklet, 1935. Offset printing; Private collection. © Estate of Herbert Bayer/Artists Rights Society (ARS), New York/VG Bild Kunst, Bonn

17 Herbert Bayer, Booklet for *Deutschland* exhibition, cover, 1936. Offset printing; Private collection. © Estate of Herbert Bayer/Artists Rights Society (ARS), New York/VG Bild Kunst, Bonn

18 Herbert Bayer, Cover for *die neue linie* magazine, October 1934 issue. Offset printing; Private collection. © Estate of Herbert Bayer/Artists Rights Society (ARS), New York/VG Bild Kunst, Bonn

19 Herbert Bayer, Cover for *die neue linie* magazine, February 1936, winter Olympics issue. Offset printing; Private collection. © Estate of Herbert Bayer/Artists Rights Society (ARS), New York/VG Bild Kunst, Bonn

20 Herbert Bayer, Program flyer for the opening of the Dietrich-Eckart arena, 1936. Offset printing, folded; Private collection. © Estate of Herbert Bayer/Artists Rights Society (ARS), New York/VG Bild Kunst, Bonn

21 Herbert Bayer, Program flyer for the German radio exhibition, 1936, cover and rear panel with photomontage. Offset printing; Private collection. © Estate of Herbert Bayer/Artists Rights Society (ARS), New York/VG Bild Kunst, Bonn

22 Herbert Bayer, Small poster for clean workspaces, *Joy of Work* campaign, 1935. Offset printing; Private Collection. © Estate of Herbert Bayer/Artists Rights Society (ARS), New York/VG Bild Kunst, Bonn

23 Herbert Bayer, Front and rear cover for ADEFA almanac, 1936. Offset printing; Lentos Kunstmuseum Linz, Herbert Bayer Collection. © Estate of Herbert Bayer/Artists Rights Society (ARS), New York/VG Bild Kunst, Bonn

24 Herbert Bayer, ADEFA poster with Aryan slogan, 1936/37. Letterpress; Lentos Kunstmuseum Linz, Herbert Bayer Collection. © Estate of Herbert Bayer/Artists Rights Society (ARS), New York/VG Bild Kunst, Bonn

25 Herbert Bayer, poster for the ball of the International Film Convention, Berlin 1935. Letterpress; Lentos Kunstmuseum Linz, Herbert Bayer Collection. © Estate of Herbert Bayer/Artists Rights Society (ARS), New York/VG Bild Kunst, Bonn

26 Herbert Bayer, Cover for *Gebrauchsgraphik* magazine, October 1938. Offset printing; Private collection. © Estate of Herbert Bayer/Artists Rights Society (ARS), New York/VG Bild Kunst, Bonn

27 Herbert Bayer, Cover for *die neue linie* magazine, January 1938, Italy issue. Offset printing; Private collection. © Estate of Herbert Bayer/Artists Rights Society (ARS), New York/VG Bild Kunst, Bonn

28 Herbert Bayer, Book cover for Faber & Faber, London, 1934. Offset printing; Private collection. © Estate of Herbert Bayer/Artists Rights Society (ARS), New York/VG Bild Kunst, Bonn

29 Herbert Bayer, Invitation card for his one-man show at the London Gallery, 1937. Letterpress; Private collection. © Estate of Herbert Bayer/Artists Rights Society (ARS), New York/VG Bild Kunst, Bonn

30 Herbert Bayer, Cover for *Harper's Bazaar* magazine, August 1940, College fashions issue. Offset printing; Private collection. © Estate of Herbert Bayer/Artists Rights Society (ARS), New York/VG Bild Kunst, Bonn

31 Herbert Bayer, Cover for a General Electric Company brochure, 1942. Offset printing with cellophane wrapper; Private collection. © Estate of Herbert Bayer/Artists Rights Society (ARS), New York/VG Bild Kunst, Bonn

32 Herbert Bayer, Greeting card for the year 1942, referring to his *Lonely Metropolitan* photomontage. Letterpress; Private collection. © Estate of Herbert Bayer/Artists Rights Society (ARS), New York/VG Bild Kunst, Bonn

Figures

0.1 Herbert Bayer, *Der einsame Großstädter (The Lonely Metropolitan)*, 1932. Photomontage, gelatin silver print; Denver Art Museum, Herbert Bayer Collection and Archive. © Estate of Herbert Bayer/Artists Rights Society (ARS), New York/VG Bild Kunst, Bonn 2

0.2 Herbert Bayer, *Der Muster-Bauhäusler (Model Bauhaus Man)*,
1923. Watercolor, ink, and gouache; Harvard Art Museums/Busch-
Reisinger Museum. © Estate of Herbert Bayer/Artists Rights Society
(ARS), New York/VG Bild Kunst, Bonn 3

0.3 Herbert Bayer's core network of friends, 1930s; Projekt Bewegte
Netze/Andreas Wolter. © own graph 9

0.4 Herbert Bayer, Bauhaus stationery, c. 1928. Letterpress, in all-
lowercase writing; Private collection. © Estate of Herbert Bayer/
Artists Rights Society (ARS), New York/VG Bild Kunst, Bonn 10

1.1 Atelier Arnold Hirnschrodt, Ried/Inn: The family of Rosa and
Maximilian Bayer, together with their children Theo, Max, Herbert,
and Helene (from left), 1910. Photograph; Denver Public Library,
Herbert Bayer Collection 16

1.2 Photographer unknown, Herbert Bayer with guitar during his
Wandervogel period, c. 1916. Photograph; Denver Public Library,
Herbert Bayer Collection 17

1.3 Lisel Kron, Herbert Bayer during his Bauhaus application days, 1921.
Photograph; Denver Public Library, Herbert Bayer Collection 19

1.4 Herbert Bayer, *Stadt* (*The City*), 1922. Woodcut, the artist's first
published work; in *Freideutsche Jugend* 8, no. 2 (February); Private
collection. © Estate of Herbert Bayer/Artists Rights Society (ARS),
New York/VG Bild Kunst, Bonn 21

2.1 Photographer unknown, Irene Bayer-Hecht while going into rehab
at Leysin (Switzerland), March 1926. Photograph; Denver Public
Library, Herbert Bayer Collection 28

2.2 Photographer unknown, Herbert Bayer and Sepp Maltan after hiking
in Italy, Berchtesgaden, 1924. Photograph; Denver Public Library,
Herbert Bayer Collection 30

2.3 Photographer unknown, Wedding image of Herbert Bayer and Irene
Gropius with best men Xanti Schawinsky (left) and Andreas Hecht
(right), Helene Nonne and Joost Schmidt in the back, November
1925. Photograph; Bayer family estate Meinhardt/Hinterberger, Linz 32

2.4 Ise Gropius: Herbert Bayer and Irene Bayer-Hecht at the Elbe beach
in Dessau, 1927. Photograph; Denver Public Library, Herbert Bayer
Collection 33

2.5 Irene Bayer-Hecht: Sketch of a metal ashtray, September 1926. Pencil
on paper; Private collection 37

3.1 Herbert Bayer, Poster for Bauhaus dance, 1923. Photo reproduction
of a collage; Private collection. © Estate of Herbert Bayer/Artists
Rights Society (ARS), New York/VG Bild Kunst, Bonn 39

3.2 Photographer unknown, Xanti Schawinsky, Herbert Bayer, and
 Walter Gropius, Berlin, 1930. Photograph; Denver Public Library,
 Herbert Bayer Collection 40
3.3 Herbert Bayer, Catalogue for Marcel Breuer's aluminum furniture
 designs, c. 1933. Cover, French edition, offset printing; Private
 collection. © Estate of Herbert Bayer/Artists Rights Society (ARS),
 New York/VG Bild Kunst, Bonn 42
3.4a/b Irene Bayer-Hecht: Herbert Bayer designing the *Dessau* prospectus,
 Bauhaus Dessau, 1926. Photograph; Private collection 44
3.5 Bauhaus advertising workshop: Poster design for an instruction week
 in advertising at the Bauhaus, October 1927. Photo reproduction of a
 poster; Private collection. 44
3.6 Herbert Bayer, Sheet for the loose-leaf catalogue of Bauhaus
 workshop products, c. 1927. Letterpress; Denver Art Museum,
 Herbert Bayer Collection and Archive. © Estate of Herbert Bayer/
 Artists Rights Society (ARS), New York/VG Bild Kunst, Bonn 46
3.7 Herbert Bayer, *Bauhaus* magazine No. 1, 1928. Cover, offset printing;
 Denver Art Museum, Herbert Bayer Collection and Archive. ©
 Estate of Herbert Bayer/Artists Right Society (ARS), New York/VG
 Bild Kunst, Bonn 49
3.8 Herbert Bayer, "Elementare Buchtechnik" room installations at
 Pressa 1928, Sketch from his answer to Arthur Cohen's questionnaire
 #4, 1982. Pen on paper; Denver Public Library, Herbert Bayer
 Collection. © Estate of Herbert Bayer/Artists Rights Society (ARS),
 New York/VG Bild Kunst, Bonn 51
4.1 Photographer unknown, Three friends at the beach in Southern
 France (Herbert Bayer, Marcel Breuer, Xanti Schawinsky), summer
 1928. Photograph; Denver Public Library, Herbert Bayer Collection 54
4.2 Herbert Bayer, magazine article on the Pont Transbordeur in
 Marseille in *Das illustrierte Blatt*, No. 49 (December 8, 1928). Offset
 printing; Private collection 55
4.3 Magazine page from German *Vogue* under the art direction of
 Herbert Bayer (July 1929). Offset printing; Private collection 57
4.4 Unknown photographer, Work at Studio Dorland (Mehmet F. Agha
 and Herbert Bayer in the back), 1929. Photograph; Denver Public
 Library, Herbert Bayer Collection 58

4.5 Herbert Bayer, Irene Bayer-Hecht breastfeeding her daughter Julia,
 1929. Photograph; Denver Public Library, Herbert Bayer Collection.
 © Estate of Herbert Bayer/Artists Rights Society (ARS), New York/
 VG Bild Kunst, Bonn 60

4.6 Herbert Bayer, Sketch on the field of vision in exhibition design,
 published in the *Section Allemande* catalogue, 1930. Offset printing;
 Private collection. © Estate of Herbert Bayer/Artists Rights Society
 (ARS), New York/VG Bild Kunst, Bonn 64

4.7 Walter Christeller, View of the German Union of Building Trades
 hall at the Deutscher Werkbund's German Building Exhibition,
 Berlin, 1931. Photograph; The Wolfsonian-FIU, Florida, Herbert
 Bayer collection 65

4.8 Unknown designer, Invitation card for the Herbert Bayer exhibition,
 Bauhaus Dessau, May 1932. Letterpress; Private collection©
 Copyright holder unknown (artist) 66

5.1 Dr. Weller, *Sisters* (Ise Gropius, addressed just as "the wife of
 Professor Walter Gropius" without mentioning her name, and actress
 Ellen Frank); in *Scherls Magazin*, no. 5 (May 1929). Rotogravure;
 Private collection 69

5.2 Unknown photographer, Ise Gropius, Xanti Schawinsky, and Herbert
 Bayer in Ascona, summer 1930. Photograph; Denver Public Library,
 Herbert Bayer Collection 70

5.3 Josef Albers, Herbert Bayer and daughter Julia in Ascona, summer 1930.
 Photograph; Denver Public Library, Herbert Bayer Collection. © ARS 71

5.4 Herbert Bayer, Ise Gropius hiking near Marmolata, Italy, c. 1933.
 Photograph; Denver Public Library, Herbert Bayer Collection. ©
 Estate of Herbert Bayer/Artists Rights Society (ARS), New York/VG
 Bild Kunst, Bonn 72

5.5 Herbert Bayer, *Selbstporträt (Self-portrait)*, 1932. Photomontage,
 gelatin silver print; Denver Art Museum, Herbert Bayer Collection
 and Archive. © Estate of Herbert Bayer /Artists Rights Society (ARS),
 New York/VG Bild Kunst, Bonn 76

5.6 Unknown photographer, Nude (Ise Gropius) with shadow, c. 1932.
 Photograph; Bauhaus-Archiv Berlin, Estate of Walter Gropius 80

6.1 Herbert Bayer, Advertisement for Dorland agency, c. 1934.
 Photograph; Private collection. © Estate of Herbert Bayer/Artists
 Rights Society (ARS), New York/VG Bild Kunst, Bonn 85

6.2 Herbert Bayer, magazine *Dorland* No. 1 (only issue), cover, 1933.
 Letterpress; Private collection. © Estate of Herbert Bayer/Artists
 Rights Society (ARS), New York/VG Bild Kunst, Bonn 86
6.3 Herbert Bayer, Advertisement for Dorland's Chlorodont campaign,
 1938. Offset printing; Private collection. © Estate of Herbert Bayer /
 Artists Rights Society (ARS), New York/VG Bild Kunst, Bonn 88
6.4 Unknown photographer, Magazine billboard for *die neue linie*,
 c. 1932. Photograph; Private collection 89
7.1 Herbert Bayer, Photographer's stamp with his personal mark
 "– – Y – –", 1930s. Ink on paper; Private collection. © Estate of Herbert
 Bayer/Artists Rights Society (ARS), New York/VG Bild Kunst, Bonn 94
7.2 Herbert Bayer, Declaration on the Determination of Fees by the
 Reich Chamber of Fine Arts for the Financial Year 1937; Denver
 Public Library, Herbert Bayer Collection 96
7.3 Herbert Bayer, Page from *Deutsches Volk, deutsche Arbeit* booklet,
 1934. Offset printing; Private collection. © Estate of Herbert Bayer/
 Artists Rights Society (ARS), New York/VG Bild Kunst, Bonn 100
7.4 Georg Pahl, Demographic display from the exhibition *Das Wunder
 des Lebens,* 1935; Bundesarchiv Berlin, Image No. 102-16748 101
7.5a/b Herbert Bayer, Spreads from *Deutschland* booklet, 1936. Offset
 printing; Private collection. © Estate of Herbert Bayer/Artists Rights
 Society (ARS), New York/VG Bild Kunst, Bonn 104
7.6 Photographer unknown, Installation shot from *Freut Euch des Lebens*
 exhibition, 1936. Photograph; Private collection, reproduced from
 Zdenek Rossmann, *Písmo a fotografie,* 1938, pp. 92–93 106
7.7 Herbert Bayer, Title spread from *Der Arbeiter und die bildende Kunst*
 booklet, 1936. Offset printing; Private collection. © Estate of Herbert
 Bayer/Artists Rights Society (ARS), New York/VG Bild Kunst, Bonn 107
7.8 Herbert Bayer, Four photomontages for Joy of Work campaign,
 1935. Reproductions; Private collection, reproduced from *Die Form*
 magazine, No. 7, 1935, p. 191. © Estate of Herbert Bayer/Artists
 Rights Society (ARS), New York/VG Bild Kunst, Bonn 108
7.9 Herbert Bayer, Retouched 1936/1937 ADEFA poster, 1967.
 Reproduction; Private collection, reproduced from *herbert bayer—
 painter, designer, architect*, p. 49. © Estate of Herbert Bayer/Artists
 Rights Society (ARS), New York/VG Bild Kunst, Bonn 111
8.1 Herbert Bayer and his daughter Julia, Baltic coast, summer 1933. Still
 from a private movie; Denver Public Library, Herbert Bayer Collection 118

8.2 Herbert Bayer, advertisement for Venus artificial silk, c. 1937; Private collection. © Estate of Herbert Bayer/Artists Rights Society (ARS), New York/VG Bild Kunst, Bonn 121

8.3 Photographer unknown, Willy B. Klar, Walter Matthess, Hans Ritter, and Herbert Bayer in Obergurgl, Tyrol, 1930s. Photograph; Denver Public Library, Herbert Bayer Collection 122

8.4 Hein Gorny, Herbert Bayer skiing downhill, 1930s. Photograph; Denver Public Library, Herbert Bayer Collection. © Collection Regard/Marc Barbey, Berlin 123

8.5 Photographer unknown, Willy B. Klar and Herbert Bayer on a sailing trip, c. 1937. Photograph; Denver Public Library, Herbert Bayer Collection 124

8.6 Photographer unknown, Beauty queen Friedl Körner on a vacation trip to Salzkammergut with Herbert Bayer, Austria, 1937. Photograph; Denver Public Library, Herbert Bayer Collection 125

8.7 Photographer unknown, Herbert Bayer, "Vips" Wittig, and Willy B. Klar hiking in the Giant Mountains, Czechoslovakia, May 1937. Photograph; Denver Public Library, Herbert Bayer Collection 126

8.8 Herbert Bayer, *Gute Nacht, Marie (Good night, Mary)*, 1932. Photomontage, gelatin silver print; Denver Art Museum, Herbert Bayer Collection and Archive. © Estate of Herbert Bayer/Artists Rights Society (ARS), New York/VG Bild Kunst, Bonn 128

8.9 Photographer unknown, Ninette, inscribed in French: "To love … is first to make a pact with pain." January 1935. Photograph; Denver Public Library, Herbert Bayer Collection 129

9.1 Photographer unknown, Marcel Breuer and Herbert Bayer visiting an archeological site in Greece, summer 1934. Photograph; Denver Public Library, Herbert Bayer Collection 134

9.2 Photographer unknown, Xanti Schawinsky and his wife Irene von Debschitz, undated. Photograph; Denver Public Library, Herbert Bayer Collection 137

9.3 Photographer unknown, Herbert Bayer, Lady "Peter" Norton, Xanti Schawinsky, and Sir Clifford Norton, Obergurgl, Tyrol, c. 1937. Photograph; Denver Public Library, Herbert Bayer Collection 141

9.4 Herbert Bayer, Book cover for H. Girsberger Publishers, Zurich, 1931. Offset printing; Private collection. © Estate of Herbert Bayer/ Artists Rights Society (ARS), New York/VG Bild Kunst, Bonn 142

10.1 Photographer unknown, Willy B. Klar (left), Walther Matthess
 (front), and Herbert Bayer (right) with the Dorland staff, 1930s.
 Photograph; Denver Public Library, Herbert Bayer Collection 148

10.2 Herbert Bayer, Stationery for Dr. Hittel company (Blendax
 toothpaste), 1933. Letterpress; Private collection. © Estate of Herbert
 Bayer/Artists Rights Society (ARS), New York/VG Bild Kunst, Bonn 150

10.3 Photographer unknown, Herbert Bayer at his desk, Dorland agency,
 1933. Photograph; Denver Public Library, Herbert Bayer Collection 153

10.4 Photographer unknown, Herbert Bayer sick in bed, 1938.
 Photograph; Denver Public Library, Herbert Bayer Collection 154

11.1 Herbert Bayer, Catalogue for his one-man show at the London Gallery,
 cover, 1937. Letterpress; Private collection. © Estate of Herbert Bayer/
 Artists Rights Society (ARS), New York/VG Bild Kunst, Bonn 156

11.2 Atelier Binder, Herbert Bayer, Studio portrait, c. 1935. Photograph;
 Denver Public Library, Herbert Bayer Collection 157

11.3 Photographer unknown, View of Bayer's one-man show at the
 London Gallery, 1937. Photograph; Denver Public Library, Herbert
 Bayer Collection 159

11.4 Photographer unknown, View of Bayer's one-man show at the
 London Gallery, 1937. Photograph; Denver Public Library, Herbert
 Bayer Collection 159

12.1 Photographer unknown, Herbert Bayer and Marcel Breuer, 1936.
 Photograph; Denver Public Library, Herbert Bayer Collection 162

12.2 Photographer unknown, Summer vacation on Planting Island—
 Xanti Schawinsky, Herbert Bayer, Marcel Breuer, and Walter Gropius
 (from left), Mary Cook (front), 1937. Photograph; Denver Public
 Library, Herbert Bayer Collection 165

12.3 Photographer unknown, Herbert Bayer in Northport, Long Island,
 September 1937. Photograph; Denver Public Library, Herbert Bayer
 Collection 166

12.4 Herbert Bayer, Greeting card for the year 1938, recto and verso.
 Letterpress; Denver Art Museum, Herbert Bayer Collection and
 Archive. © Estate of Herbert Bayer/Artists Rights Society (ARS),
 New York/VG Bild Kunst, Bonn 167

13.1 Photographer unknown, Herbert Bayer, Irene Bayer-Hecht, and their
 daughter Julia, 1937. Photograph; Denver Public Library, Herbert
 Bayer Collection 170

13.2 Herbert Bayer, Advertising brochure for Prym snap fastener
company, 1936. Verso and recto, rotogravure; Private collection.
© Estate of Herbert Bayer/Artists Rights Society (ARS), New York/
VG Bild Kunst, Bonn 171

13.3a/b Herbert Bayer, Soles of hob-nailed hiking boots, 1936. Photograph
and montage for *die neue linie* cover, August 1938; Denver Public
Library, Herbert Bayer Collection. © Estate of Herbert Bayer/Artists
Rights Society (ARS), New York/VG Bild Kunst, Bonn 171

13.4 Photographer unknown, Xanti Schawinsky and Herbert Bayer,
Obergurgl, 1930s. Photograph; Denver Public Library, Herbert Bayer
Collection 175

13.5a/b Photographer unknown, Passport photos for Herbert Bayer, 1937/38.
7 Photographs and tax clearance certificate to obtain a passport,
August 1938; Denver Public Library, Herbert Bayer Collection 177

13.6 Photographer unknown, Herbert Bayer on board of the *Bremen*
vessel, August 1938. Photograph; Denver Public Library, Herbert
Bayer Collection 179

13.7 Photographer unknown, Herbert Bayer with his convertible in Bad
Pyrmont, c. 1933. Photograph; Denver Public Library, Herbert Bayer
Collection 181

14.1 Photographer unknown, Herbert Bayer with fellow travelers, New
York harbor, August 1938. Photograph; Denver Public Library,
Herbert Bayer Collection 190

14.2 Herbert Bayer, *The Bulletin of the Museum of Modern Art*—Bauhaus
Exhibition, cover, 1938. Offset printing; Private collection. ©
Estate of Herbert /Artists Rights Society (ARS), New York/VG Bild
Kunst, Bonn 191

14.3 Herbert Bayer, Sketch for the book jacket for the Bauhaus exhibition
catalogue, 1938. Photograph; Denver Public Library, Herbert Bayer
Collection. © Estate of Herbert Bayer /Artists Rights Society (ARS),
New York/VG Bild Kunst, Bonn 193

14.4 Soichi Sunami, View of Bayer's display of Schlemmer's Triadic Ballet
at the Bauhaus 1919–1928 exhibition, New York, 1938. Photograph;
Denver Public Library, Herbert Bayer Collection 194

15.1 Photographer unknown, Herbert Bayer, Walter and Ise Gropius
working on the Bauhaus 1919–1928 exhibition at MoMA, New York,
1938. Photograph; Denver Public Library, Herbert Bayer Collection 199

15.2 Photographer unknown, Joella and Herbert Bayer, USA, 1940s.
 Photograph; Denver Public Library, Herbert Bayer Collection 201

15.3 Fred Hamilton, Alexander Calder and Herbert Bayer in Locust
 Valley on Long Island, New York, summer 1940. Photograph; Denver
 Public Library, Herbert Bayer Collection 206

15.4 Photographer unknown, View of Bayer's displays at the Road to
 Victory exhibition, MoMA, New York, 1942. Photograph; Denver
 Public Library, Herbert Bayer Collection 207

15.5 Gordon Coster, Herbert Bayer leaving the *Modern Art in Advertising*
 exhibition, Chicago, 1945. Photograph; Denver Public Library,
 Herbert Bayer Collection 210

15.6 Title page of the *Modern Art in Advertising* exhibition catalogue,
 signed by artists and contributors, Chicago, 1945. Offset printing
 and ink; Private collection. © Estate of Herbert Bayer /Artists Rights
 Society (ARS), New York/VG Bild Kunst, Bonn 211

15.7 Photographer unknown, Herbert Bayer at work in his studio, Aspen,
 Colorado, c. 1946. Photograph; Denver Public Library, Herbert Bayer
 Collection 212

15.8 Photographer unknown, Herbert Bayer at work in New York, 1942.
 Photograph; Denver Public Library, Herbert Bayer Collection 214

16.1 Photographer unknown, Herbert Bayer taking pictures on his
 vacation at the Danube, summer 1934. Photograph; Denver Public
 Library, Herbert Bayer Collection 216

16.2 Ise Gropius, Group portrait of Xanti Schawinsky, Herbert Bayer,
 and Walter Gropius, Christmas 1933. Photograph; Bauhaus-Archiv
 Berlin, Estate of Walter Gropius. © Bauhaus-Archiv Berlin 218

16.3 Herbert Bayer, Book jacket for Wittenborn and Schultz Publishers,
 New York, 1946. Offset printing; Private collection. © Estate of
 Herbert Bayer/Artists Rights Society (ARS), New York/VG Bild
 Kunst, Bonn 220

16.4 Herbert Bayer, Book cover for Reinhold Publishers, New York, 1967.
 Offset printing; Private collection. © Estate of Herbert Bayer/Artists
 Rights Society (ARS), New York/VG Bild Kunst, Bonn 223

16.5 Hein Gorny, Herbert Bayer on his skiing vacation, 1935. Photograph;
 Denver Public Library, Herbert Bayer Collection. © Collection
 Regard/Marc Barbey, Berlin 230

A Short Bayer Timeline

1900 **April 5**: Birth of Herbert Bayer in Haag am Hausruck, Upper Austria

1917/18 Serves for 18 months in the Austrian Army; death of Bayer's father Maximilian

1920/21 Apprenticeship with architect Emmanuel Margold, Darmstadt Artists's Colony, where he first encounters the Bauhaus manifesto

1921 **October**: Walks to the Bauhaus in Weimar to enroll, meets director Walter Gropius (1883–1969), and Josef Albers (1888–1976), Marcel Breuer (1902–1981), and Xanti Schawinsky (1904–1979), who become his lifelong friends

1922 Joins the mural painting workshop led by Wassily Kandinsky (1866–1944)

1922/23 Love affair with Bauhaus student Lore Leudesdorff (1902–1986)

1923 **April 1**: László Moholy-Nagy (1895–1946) appointed to the Bauhaus and quickly becomes Bayer's mentor

 April/May: Irene Hecht (1898–1991) applies to the Bauhaus but is rejected by the Master's Council

 July: First encounter with Irene Hecht, Bayer is immediately smitten

 Summer: Bayer organizes advertising department for the Bauhaus exhibition and designs inflationary money for the State Bank of Thuringia

 August 13: Leaves Weimar for a year of travel as a journeyman through Italy with fellow student Sepp Maltan (1902–1975)

 August 15: Bauhaus show opens with catalogue cover designed by Bayer

 October: Marriage of Walter Gropius and Ilse Frank (1897–1983), thereafter known as Ise

1924 **Summer**: Bayer helps out in Maltan's workshop in Berchtesgaden, Bavaria

 October: Returns to Weimar and the Bauhaus

 December: Irene Hecht returns from Paris to Weimar and moves into Bayer's apartment

1925 **February 3**: Passes journeyman's exam in Weimar

 March 31: Bauhaus suspends teaching in Weimar, moves to Dessau and resumes classes in fall 1925 (facilities under construction through December 1926)

April: Bayer signs a three-year contract with the city of Dessau to head the newly founded advertising workshop as a junior master (*Jungmeister*) at the Bauhaus

November 11: marriage to Irene Hecht, with Xanti Schawinsky serving as best man

1926 Bayer designs stationery and printed matter for the Bauhaus, promotes New Typography and all-lowercase lettering

December: The Bayers move with other *Jungmeister* into the Prellerhaus, the newly opened studio wing of Gropius's newly completed Bauhaus building

1927 **October**: Bayer organizes a week-long advertising workshop at the Bauhaus, together with Johannes "Werbwart" Weidenmüller (1881–1936)

1928 **April**: Having fulfilled his Bauhaus contract, Bayer leaves Dessau, coinciding with the exodus of Gropius, Moholy-Nagy, Breuer, and Schawinsky

Summer: Mediterranean travels with Breuer and Schawinsky

Fall: The Bayers move to Berlin, taking separate apartments; freelance career in Berlin begins

1929 **January 29**: Bayer's first international one-man show opens at the Povolozky Gallery in Paris, organized on-site by Irene Bayer-Hecht

Spring: Bayer is contracted by Mehmed F. Agha for Condé Nast, redesigns the short-lived German *Vogue*, which runs for five more issues before closure

July 12: Birth of Julia "Muci" Bayer (1929–1963)

1930 **January**: Bayer agrees to head Studio Dorland, the independent creative department of the ad agency Dorland GmbH Germany; takes freelance commissions as well (until 1938)

March: Lifestyle magazine *die neue linie* runs the first of Bayer's 26 covers (until 1938)

May 14 to July 13: German Werkbund exhibit in Paris (*Section Allemande*); Bayer designs two showrooms and creates poster and catalogue

Summer: Family holiday in Ascona; begins an affair with Ise Gropius that continues intermittently for about three years

October 9: Death of Bayer's mother Rosa (b. Simmer) at the age of 60 in Linz, Austria

1931 **March 2–16**: First prize at *Foreign Advertising Photography* exhibition in New York for his 1928 Bauhaus magazine cover

May–August: Designs the hall of the German Building Unions (together with Gropius and Moholy) for the *Deutsche Bauausstellung* in Berlin

1932 Creates a series of photomontages, including *Selbstporträt* (Self-Portrait) and *Der einsame Großstädter* (The Lonely Metropolitan)

May 15 to 24: One-man show of fine art and graphic design at the Bauhaus

Summer: Ise Gropius tells Walter Gropius about her affair with Bayer

1933 **January 30**: Hitler becomes chancellor of Germany

March: Two-week ski holiday with Ise Gropius in Davos, Switzerland

Spring: Breuer, concerned by the Nazi rise to power, moves to Hungary; Bayer handles some of his affairs in Germany

June: Irene Bayer-Hecht begins a prolonged absence from Berlin (mostly in Czechoslovakia); the couple's daughter, Muci, remains in Bayer's care until summer 1934

August: Bayer's last tryst with Ise Gropius (in the Italian Dolomites)

November: Josef and Anni Albers move to Black Mountain, North Carolina, the first members of Bayer's circle to leave for the United States

Christmas: Muci Bayer's parents, otherwise estranged, celebrate together in Berlin for their child's sake

New Year's Eve: Bayer joins Walter and Ise Gropius, Breuer, and Schawinsky for a ski tour in Czechoslovakia

1934 **April-June**: Designs the poster, catalogue, and a small booklet for propaganda exhibition *Deutsches Volk, deutsche Arbeit* (German People, German Work) in Berlin

Summer: Travels with Breuer in the Balkans and Greece

October: Walter and Ise Gropius leave Berlin for London

1935 **March–May**: Designs poster, booklet, and publicity for propaganda exhibition *Das Wunder des Lebens* (The Wonder of Life) in Berlin

1936 Designs ad campaign and annual report for the ADEFA (German-Aryan textile manufacturers)

July–August: Print publications and publicity for propaganda exhibition *Deutschland* in conjunction with the Olympic Games in Berlin

Fall: Begins affair with Inez Heinsen (until spring 1937)

October: Xanti Schawinsky emigrates to the United States with his wife, Irene von Debschitz, to teach at Black Mountain College, invited by Albers

1937 **March 17**: Walter and Ise Gropius arrive in New York and move to Cambridge, MA; Gropius takes up post at Harvard's Graduate School of Design (GSD).

April 7: Bayer's solo exhibition at London Gallery of Lady "Peter" Norton opens

Spring: Moholy, based in London since 1935, leaves for United States to become director of the New Bauhaus in Chicago

Summer: The inner Bauhaus circle, including the visiting Bayer, convenes for a retreat on Planting Island, Marion at the invitation of the Gropiuses

Fall: Breuer follows Gropius to GSD and becomes his partner in architectural practice

1938 **Spring**: Bayer finishes gathering materials for the Bauhaus show at the Museum of Modern Art (MoMA)

August 15: Sets sail for New York on the *Bremen*, arriving August 22, 1938

November: Trade magazine *Gebrauchsgraphik* publishes Bayer's last cover design in Germany

November 30: Irene Bayer-Hecht and Muci leave Europe on the *Washington* among the last Jews getting safely out of Germany; Bayer is unable to meet their ship when it docks in New York on December 9

December 7–January 30, 1939: Exhibition *Bauhaus 1919–1928* on view at MoMA, installed by Bayer

1939 **February**: Mental breakdown, hospitalized in New York; intensification of his relationship with Joella Haweis Levy (1907–1996), at the time still married to gallery owner Julien Levy

December: *PM*, American trade magazine for the advertising industry, runs a thirty-two-page cover story on Bayer

1942 **May–October**: US Propaganda exhibition *Road to Victory*, designed by Bayer and curated by Edward Steichen, on view at MoMA

1944 **July 27**: Granted US citizenship

August 22: Divorce from Irene Bayer-Hecht

December 2: Marriage to Joella Haweis Levy

1945 Designs *Modern Art in Advertising* exhibition, organized by the Container Corporation of America at the Art Institute of Chicago; Bayer meets company founder and his future patron Walter Paepcke (1896–1960)

1946 **November 24**: László Moholy-Nagy dies of leukemia in Chicago, aged 51

1947 Alexander Dorner's *The Way Beyond "Art": The Work of Herbert Bayer* published as part of a MoMA book series, the first Bayer monograph; accompanying exhibition travels to ten venues in the United States

1963 **October 6**: Death of Julia "Muci" Bayer (aneurysm) at the age of 34 in Santa Monica, CA

1985 **September 30**: Death of Herbert Bayer, 85, in Santa Barbara, CA

1991 Death of Irene Bayer-Hecht, 93, in Santa Monica, CA

2004 **February 18**: Death of Joella Bayer, 96, in Montecito, CA

Introduction: Herbert Bayer's Lost Decade

When Herbert Bayer died on September 30, 1985, he was remembered mainly for his groundbreaking work at the Bauhaus. First as a student in Weimar, then as the junior master for advertising in Dessau, he witnessed a movement that shaped the spirit of Modernism. Until he left the art school in 1928, his own graphic design contributed to that movement substantially, helping to forge the Bauhaus as a cradle of functionalism. In 1938, when he finally and definitively turned his back on Nazi Germany, it was only after a long period of oscillation; he was suspended between poles of adaptation and rebellion for a considerably longer time than many of his closer Bauhaus friends and colleagues. This book is focused on these ten years of Bayer's work as a graphic designer in the German capital of Berlin, and it will give insight into the multilayered process of how a well-received and acknowledged commercial artist tried to walk the thin line between professional creativity and alignment to the Nazi regime, between moral sincerity and being in league with the devil.

Born on April 5, 1900, Bayer was quite literally a child of the new century. Given the turbulent decades through which he lived, the paradoxes that marked his life were not exceptional. Rather, they mirrored the contradictions of his day and, as such, embodied almost prototypically his generation's transition from the traditions of the past to new and often painful beginnings. Bayer came from a small village in Austria, celebrated his greatest successes in Berlin and New York, witnessed the rise of Nazism from the German capital, and finally settled in the Rockies near Aspen, Colorado. Once established in the United States, Bayer found acceptance as a prominent representative of the Bauhaus, whose memory he proudly preserved until old age, and enjoyed recognition as one of corporate America's finest designers.

It was there, in the snowscape of his new homeland, that he finally overcame a condition that had burdened him for many years: that of the "lonely metropolitan," to quote the title of his memorable photomontage, *Der einsame Großstädter*, 1932 (see Fig. 0.1). His eyes look out desperately from a block of flats in Berlin, or likewise from a pair of helpless hands. Although drawn to the professional and private opportunities offered by the big city, he remained deeply attached to life in nature, particularly to hiking and skiing, which he missed greatly whenever work bound him to the city for longer periods. Many astute observers of design have noted Bayer's multifaceted oeuvre, his "Total Design" approach, and his innovations as an artist. Herbert Bayer's complex personality, however, has until now remained in the background. Apart from a few key dates, little biographic detail is widely known. This book's chief goal

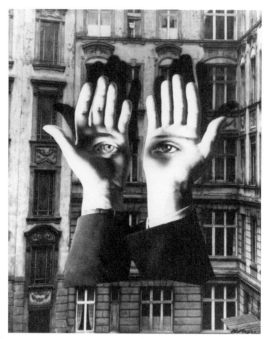

Figure 0.1 Herbert Bayer, *Der einsame Großstädter (The Lonely Metropolitan)*, 1932. Photomontage, gelatin silver print; Denver Art Museum, Herbert Bayer Collection and Archive. © Estate of Herbert Bayer/Artists Rights Society (ARS), New York/VG Bild Kunst, Bonn.

is to offer insight into the ups and downs of his private life, the better to contribute to understanding the restless and at times almost manic artist who tapped into so many forms of creative expression.

Herbert Bayer used the term Total Design to cover the broad scope of his creative activities.[1] His range was indeed dazzlingly broad, from painting, photography, sculpture, and architecture to environmental, landscape, and exhibition design, with stops along the way in textiles and ceramics. But it was above all as a graphic designer that he secured his place in art history. A lifelong champion of the *Gesamtkunstwerk* (Total Work of Art), Bayer came to embrace his holistic approach during his training at the Bauhaus in Weimar and consolidated it during his years as a so-called Junior Master (*Jungmeister*) in Dessau. His socialization at the legendary art school was the formative experience of his life, and he would remain deeply attached to the people and concepts he encountered there.

Bayer's 1923 watercolor *Der Muster-Bauhäusler (The Model Bauhaus Man*, see Fig. 0.2), halfway between a spoof and a self-portrait, provides an early and ironic allegory of the all-round artist: a faceless manikin dressed in elegant evening wear, a large question mark hovering between head and halo, bearing a standard on which a heart is impaled.[2] In some respects, Bayer himself embodied an "ideal" *Bauhäusler*, being sociable and humorous while at the same time advocating the unity of art and life throughout his life.[3]

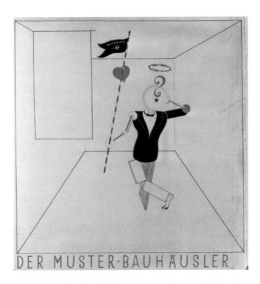

Figure 0.2 Herbert Bayer, *Der Muster-Bauhäusler (Model Bauhaus Man)*, 1923. Watercolor, ink, and gouache; Harvard Art Museums/Busch-Reisinger Museum. © Estate of Herbert Bayer/Artists Rights Society (ARS), New York/VG Bild Kunst, Bonn.

As a multitalented artist and designer, Bayer often found himself in the position of mediator among the spheres of the arts, communication, and business.[4] He always considered painting to be the core of his oeuvre and placed the highest importance on his independent fine-art work.[5] From today's perspective, however, he left his most important mark on commercial design; he himself claimed credit for bringing the term "visual communication" to the advertising branch.[6] Soon after enrolling at the Bauhaus, he designed print publicity for the school's first major exhibition, mounted in fall 1923. The emergency banknotes he developed during that same year's devastating inflation showed him embracing the New Typography—the 1920s movement towards functional, asymmetric graphic design using sans-serif typefaces—early and vigorously. Indeed, he remains known as one of its most highly esteemed practitioners.[7] It was Bayer who, among others, attempted to revolutionize German type culture by introducing an all-lowercase style; even if it never caught on outside of a small circle of devotees, it was nonetheless a striking design philosophy with far-reaching implications. Groundbreaking contributions to the development of typeface design and the implementation of DIN standards are a lasting Bayer legacy.[8]

While other scholars have examined Bayer's achievements as a Bauhaus graphic designer, his subsequent years in Berlin have received considerably less attention.[9] This ten-year phase of his career began when he left the Dessau faculty in mid-1928 to freelance in the metropolis. It lasted until the summer of 1938, when he set sail for the United States. That this decade coincided with the most notorious epoch in German history is one reason why it is widely neglected in Bayer studies so far. It was a time rife with personal contradictions for him. Branded a "degenerate artist" by the National-Socialist regime on the one hand, on the other he became a sought-after figure in

advertising circles. Indeed, by 1935, he was probably the most influential German commercial artist of his day, enjoying international acclaim and experimenting with a visual language that was twenty years ahead of his time. Bayer's successful second career in the United States built on this interwar reputation, and it ultimately allowed him to realize his total design concept in his new home of Aspen, Colorado, particularly at the Aspen Institute. For the rest of his life, however, Bayer prudently kept the work he had done in Hitler's Germany in the back of the drawer.

When Bayer landed in America in late summer 1938, he had experienced six years of Nazi rule.[10] I focus the present study on the transitory decade leading up to his departure, not only because it was a phase that substantially shaped his design work— including the Total Design philosophy he brought to fruition at Aspen—but also because of the care he took to obscure it from his personal biography. Quite apart from its interest to art and design historians, the self-inflicted lacuna of 1933–1938 in Bayer's biography is itself sociologically and historiographically relevant. An examination of Bayer's years in Nazi Germany provides insight not only into his own career but also into the living and working conditions under totalitarianism in general. Altogether, my intent in this book is to present previously overlooked biographical dimensions in order to enhance the existing interpretations of Bayer's oeuvre and spur further analysis.

As documents long buried in Bayer's personal estate confirm, his departure from the so-called Third Reich was far less a desperate escape into exile than a carefully planned exit, with a comparatively soft landing. Exploring Bayer's lost Berlin decade, we see an artist deftly adapting his avant-garde sensibilities to appeal to a considerably broader audience; we also see how those in power accepted, even appreciated, these skills—if only for a time. As we shall see, in the mid-1930s, Bayer was one of the best-paid and most sought-after commercial artists in Germany.[11] At the same time, Bayer was married to someone the Nazi Government classified as a "half-Jew," which seems to have impacted his life and work at some points, and also economically.[12]

The term "inner emigration"—often applied to German intellectuals who remained in Nazi Germany—is hardly the correct framework for describing Bayer's situation within the totalitarian state.[13] Even if his private journals show a man plagued by self-doubt, both oppressed and depressed by the political conditions, he did not refuse commissions. According to cultural historian Jost Hermand, a state of inner exile from Nazi society prevailed in cases where, "despite all forced adaptation—critical or even resisting attitudes became apparent."[14] The mere fact that Bayer expressed anti-Nazi attitudes in private does not place him in this category. In the 1930s, Bayer's path corresponded more closely to what Hermand calls a type of "market economy producer attitude … that—in addition to its deliberate efforts to distract attention— corresponds, as always, primarily to the success-seeking and profit-oriented attitudes of the managerial classes that try to adapt to every regime."[15] Nor does his experience fit the definition of inner emigration put forward by historian Michael Philipp. Using a socio-historical perspective, Philipp distinguishes *resistance* from *cooperation*, among other things, by the absence (or presence) of "acceptance or promotion by Nazi institutions."[16] Bayer's lauded work on state propaganda projects from 1934 to 1938 suffices to exclude him from the category of *resistance*. To his credit, Bayer never

claimed membership of the club of inner émigrés, although Arthur A. Cohen quietly floated the concept in his authorized Bayer monograph of 1984 (see p. 224).[17]

Of course, Bayer's experiences during this period were hardly unique. Scholars of architecture and design will recognize similar motifs in the lives of a whole group of ex-Bauhäusler, from Walter Gropius and Ludwig Mies van der Rohe, to Marcel Breuer, Josef Albers, and László Moholy-Nagy.[18] All of these figures ultimately had the tremendous luxury of voting with their feet: leaving Nazi Germany for America at a time when US-immigration quotas were drastically restricted. Peter Hahn, former director of the Bauhaus-Archiv Berlin, concluded of the immigrant Bauhäusler that

> one can hardly speak of exile in the strict sense of the word in any of these cases, any more than one can of political resistance to the new regime in Germany, let alone anti-fascist struggle. Those concerned went mainly [to America] for professional reasons and because they believed that they would have better opportunities to put their artistic creed into practice outside Germany.[19]

It is not always easy to distinguish the fate of exile from related concepts such as flight, emigration, migration, or simply departure. The traditional distinction between *exile* (through a forced departure due to expatriation, banishment, or persecution) and *emigration* (based on an active and voluntary decision to leave) is of course not always easy to apply in practice.[20] Individual situations are usually more complex, and the quality of volition can indeed be gradual rather than dichotomous. Even a cursory glance at the rich and ever-deepening literature on exile theory is enough to make clear that Bayer's move to America was emigration, not exile.[21] In no way was his story connected to active political resistance; nor did he experience religious or political persecution.[22] The term "exile" fails to describe the relatively comfortable fresh start he undertook in late 1938, just as the term "inner emigration" cannot be applied to professional activities he undertook in Germany after Hitler's rise to power.[23] Without neglecting that the Jewish descent of his first wife and his daughter may have played a role in his decision, the present study recognizes Bayer's relocation to the US for what it was: emigration. Furthermore, his career differs substantially, even from those of his closest associates, precisely because he remained longer in Berlin, where he was enjoying a good deal of success. He himself was quite down-to-earth in describing his motives: "I had stayed longer than others as I was not molested in my work, and my work with industry was non-political, and because I did not think that the political madness of the regime could last, but finally after the annexation of Austria I left."[24]

This book will outline Bayer's long path to emigration; it starts with his formative years at the Bauhaus and then puts a particular emphasis on the time when he worked as a graphic designer in Berlin, and for which he claimed this period of non-political work for the industry. It will present certain examples where this characterization seems doubtful, and it will add impressions from his private life to give more (and maybe better) explanations for his perseverance under a political regime he deeply detested. It concludes with an observation of Bayer's first steps in the United States, when memories of life in Nazi Germany were still vivid, and with a review of the narratives he and his biographers have developed for his Berlin period during his lifetime.

Sources and Documents

Bayer's Berlin decade coincided with his role as studio manager at the prominent advertising agency Dorland GmbH Berlin, itself an affiliate of the prestigious international Dorland agency. The sources I consulted include original documents, correspondence, and other archival materials; Bayer's memoirs and diaries; various published manuscripts; and a wide range of sources in the research literature. I was particularly fortunate in being able to consult a wealth of unpublished personal documents, some of them previously unavailable or simply unstudied. These include Bayer's diaries spanning a fifty-year period from 1922 to 1972, housed in the Herbert Bayer Collection at Denver Public Library, as well as the trove of letters held there from Bayer's first wife Irene Bayer-Hecht and from his Berlin friends Jorge Fulda, Willy B. Klar, and many others. The transcripts of interviews that Ruth Bowman and Arthur Cohen conducted with Bayer for the California Oral History Project also provided fascinating insight into Bayer's lost decade—not just for what they included but for what they glossed over. Among the better-known archives I consulted are the Marcel Breuer Papers housed in the Smithsonian Institution's Archives of American Art, which contain the many letters Bayer wrote to his close friend, and Bayer's letters to Walter and Ise Gropius, which are preserved in the Bauhaus-Archiv's Gropius estate and the Smithsonian's Archives of American Art. Equally valuable are the letters in both archives that the Gropiuses wrote to each other.[25]

The exhibition projects that periodically brought Bayer's work back into the public eye were, of course, key to my research, as they served Bayer to shape his own biographical narrative during his lifetime.[26] In addition to the 1938 show at the Museum of Modern Art (MoMA) in New York, there was the 1968 Bauhaus touring exhibition that he planned himself and the two-part presentation (in 1982 and 1986) of the donation he made in his lifetime to the Bauhaus-Archiv.[27] These exhibitions of his work, like their accompanying publications, touched fleetingly, if at all, on the Berlin years 1928–1938.

Only recently has a more differentiated reappraisal of his works from the 1930s become possible.[28] This is thanks to new access to the Dorland Archive[29] and to Bayer's estate, which entered the archives of the Denver Art Museum after his widow Joella Bayer died in 2004 at the age of 96, was administered there for years and is now held in the Denver Public Library.[30] Following the retrospective at the Lentos Kunstmuseum Linz in 2009, the Bauhaus-Archiv invited me to curate a major exhibition of Bayer's graphic design work of the 1930s in 2013. To accompany this first comprehensive overview of its kind, I prepared a preliminary catalogue, *Herbert Bayer: Die Berliner Jahre: Werbegraphik 1928–1938*, as well as a short biography, *Der einsame Großstädter: Herbert Bayer eine Kurzbiographie*, together with the American Bayer scholar Gwen Chanzit.[31]

This book builds on both books, consolidates the relevant material, and presents it for the first time to an English-speaking audience. By homing in on Bayer's interwar activities, I was able to build on significant recent scholarly analysis of his work in Nazi Germany.[32] In the process I hope to correct some false impressions, relating to the Gropius circle more broadly, that have arisen in mainstream sources.

For example, Jana Revedin's 2019 novel *Jeder nennt mich hier Frau Bauhaus* (*Everyone here calls me Frau Bauhaus*) takes a number of historical liberties, one of them quite pernicious. Of course in fiction, anything goes—a stillbirth here, a misplaced professional label there, an impossible 1929 Atlantic crossing, and so on; the plotline of a lesbian affair between Ise Gropius and Irene Bayer-Hecht is almost amusing considering the deep loathing they, in fact, felt for each other. The author of course provides the obligatory disclaimer that her characters are "nothing more than figures resembling living people." But even historical fiction comes with responsibilities. The novel introduces one very dangerous falsehood: that Ise Gropius was Jewish. While this undoubtedly adds drama to a novel set on the threshold of the Nazi era, it is profoundly cavalier to play with facts. There are no records linking either Ise Frank's mother or father to Judaism, and there is little to suggest that such a link exists.[33] As readers of the present volume encounter passages from the Gropius correspondence touching on "the Jewish question," I urge them to suspend the idea of a "Jewish Ise Gropius" and examine her choice of words, phrasing, and tone as dispassionately as possible.

The 2019 biographical account of Walter Gropius by distinguished British writer and cultural historian Fiona MacCarthy provides a different sort of cautionary tale: that of the language barrier separating mainstream Anglo-American writing from German sources and scholarship. Rich as it is in psychological insight and speculation, MacCarthy neglects to consult primary sources and instead leans heavily on secondary sources in English, including Ise Gropius's own carefully curated translations from the Gropius correspondences. Claiming inaccurately to present altogether original material from hitherto untapped sources, the biography, in fact, ignores the work of contemporary German scholars entirely. Before further misunderstandings make their way into the Gropius bloodstream, I feel strongly that scholars who can bridge this language barrier have the responsibility to do so on behalf of those who cannot. Thankfully, serious Anglo-American scholars of the Bauhaus will continue to draw on the rich primary and secondary sources in both languages.

Networks in Movement

I based my book on three essential propositions, all of them building on the observation that Bayer's personal communication networks were established at the Bauhaus, fostered in his Berlin years, and activated to assist his emigration.[34] (1) While working as a commercial artist in the last years of the Weimar Republic, Bayer was engaged in spreading an essentially *modern visual language*; this was key to the global rise of both commercial graphic design and the new professional category of the ad man that went with it. (2) After 1933 Bayer continued to offer his sophisticated design services in Berlin for several years. The presence of his modern-design sensibility in the German media landscape helped foster the *illusion of intellectual diversity* in Hitler's Germany.[35] This explains why Bayer's ultimate decision to leave Nazi Germany cannot be understood as the logical outcome of some state of "internal emigration." Rather, a particular constellation of psychological, personal, and social factors led him to the United States. (3) His emigration to the United States, though it came rather late,

was facilitated and supported by his *network of friends, colleagues, and patrons*. And even if the move was accompanied by personal difficulties, those networks nonetheless offered him comparatively comfortable conditions for making a new start.[36]

The chapters that follow address these propositions from a number of different perspectives, in largely chronological order. Readers expecting a thorough art-historical analysis of Bayer's works from the 1930s may be disappointed, as I discuss individual pieces only in passing, and when doing so, limit my focus to his advertising graphics and magazine covers because my intent in this book is more biographical. This study was undertaken within the framework of a large-scale research project funded by the German Research Foundation (Deutsche Forschungsgemeinschaft or DFG) between 2013 and 2016. Under the heading "Networks in Movement" (*Bewegte Netze*), the project compiled the first complete listing of all Bauhaus students, faculty, staff, and associated people in a fully accessible public database.[37] From this data set, my colleagues and I identified a total of six specific communication networks; these groupings of like-minded teachers and students, friends and lovers, patrons and employers proved an interesting way of tracing the transition of the Bauhaus from an institutional entity to a looser community based on individual interactions as students and staff came and went, and the school was ultimately dissolved in 1933.[38] The circle around Herbert Bayer represents one of these six major networks.[39]

The present study periodically returns to this theme of Bayer's personal network (see Fig. 0.3). While still at the Bauhaus, Bayer met Irene Hecht, the woman who became his first wife and bore their daughter Julia, nicknamed Muci.[40] Here too he struck up his lasting friendships with Xanti Schawinsky and Marcel Breuer and attracted the attention of the first director of the Bauhaus, Walter Gropius and his wife Ise.[41] These relationships, all of them Bauhaus-born, remained significant throughout Bayer's life. His professional and private life were irrevocably intertwined, as illustrated by his connections to the Bauhaus masters László Moholy-Nagy and Josef Albers, Lady Norton (aka Peter Norton, owner of the London Gallery), MoMA curator John McAndrews, magazine editor Bruno E. Werner, and the textile/fashion influencer Willy B. Klar. Bayer also continued to keep in touch with his family in Austria, contact that became increasingly important to him during the Nazi dictatorship, after his move to the United States, and in wartime.

This book's biographical focus makes it possible to examine, in Part I, Bayer's living and working circumstances at the Bauhaus and in Berlin after he joined the Dorland agency. In Parts II and III, it also shines as bright a light as is possible on Bayer's state of mind during the Nazi period. It is hard to say whether or not the indulgences of his bachelor lifestyle in this decade were in some way a response to the permanent tension Bayer felt at the time as he oscillated between the two poles of personal aversion and professional success. Inwardly, Bayer rejected the surrounding social conditions of the state, which he perceived as oppressive and inhuman; outwardly, however, he seemed to enjoy his role as Germany's most innovative advertising designer. For a man whose self-declared "advertising purgatory" included work that was strongly associated with state propaganda (Chapters 6 and 7), one can only wonder what his after-work outbursts of almost manic hedonism actually signified (Chapter 8).

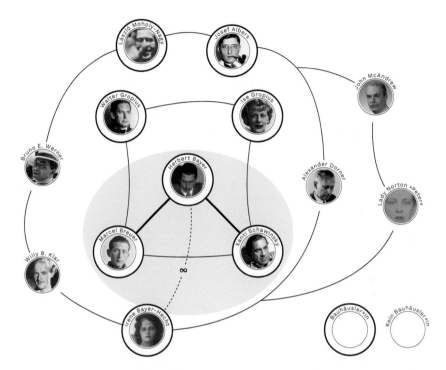

Figure 0.3 Herbert Bayer's core network of friends, 1930s; Projekt Bewegte Netze/Andreas Wolter. © own graph.

The route out of Nazi Germany that Bayer finally took was linked closely to the destinies of people in his private circle, not only from the Bauhaus era: his "network of compatriots" proved to be an important factor for emigration, as it was in many cases.[42] Part IV of this book describes Bayer's activity organizing the 1938 Bauhaus exhibition at MoMA, a plum commission that paved the way for a new start in the United States. Bayer's subsequent reinvention of himself, aided by his early champions and interlocutors, allowed for the insertion in his own lifetime of various biographical legends and misrepresentations that, in my opinion after a careful review of the archival material, are long overdue for revision.

A Note on the Quoted Material

As most of the documents from the interwar period were written in German, I opted to quote these sources only in translation for the sake of comprehension and brevity. The translations are my own, with input from this book's copy editor, Miranda Robbins. Readers interested in consulting the original German will often find corresponding passages printed either in the 2013 catalogue or the companion biography of 2014.[43]

Figure 0.4 Herbert Bayer, Bauhaus stationery, c. 1928. Letterpress, in all-lowercase writing; Private collection. © Estate of Herbert Bayer/Artists Rights Society (ARS), New York/VG Bild Kunst, Bonn.

For concision, throughout the book I give only short citations of each source. Full publication information is available in the bibliography.

A related note on punctuation: to minimize irritation, I have opted for the most part to introduce "normal" capitalization practices in place of the radical all-lowercase writing style that Bayer and a few of his friends pursued, with varying degrees of zeal, in the post-Bauhaus period (see Fig. 0.4). (See Chapter 3 for more on this innovation and Bayer's attachment to it.) In his later years, Bayer wrote and spoke mostly English, which explains the unique tone and often quaint diction of the remarks he made in what he called his "occasional diaries" and interviews. Bayer and his close friends were, of course, not native English speakers, yet despite their somewhat awkward choice of words, they tended to write in the language of their adopted home. Bayer's charming English is reproduced here verbatim. In a few—rare—cases, I have silently corrected obvious orthographic errors, particularly in the spelling of names.

Acknowledgments

This book would not have been possible without the invaluable help of many people and institutions. First of all, I would like to thank Annemarie Jaeggi, the director of the Bauhaus-Archiv/Museum für Gestaltung, Berlin, for supporting this research project and the associated exhibition held in 2013, and especially for allowing this publication

to draw on the Bayer holdings of the archive to such a large extent. The same applies to my research at the Denver Art Museum, the second major archival location of Bayer's estate, which has provided the opportunity to take note of many hitherto unknown documents relating to his biography. I am also indebted to the Denver Art Museum for its kind permission to reproduce Bayer's works from their collection. The former chief curator, Gwen Chanzit, provided invaluable help in allowing me to view this rich source of material several times under optimal research conditions, and she graciously contributed an account of Bayer's American years to the German-language biography of 2014. The staff at both locations were extremely helpful, allowing me with great patience and support to undertake my intensive investigations: namely Klaus Weber, Astrid Bähr, Wencke Clausnitzer-Paschold, and Sabine Hartmann at the Bauhaus-Archiv in Berlin; Renee Miller and Lea Norcross at the Denver Art Museum; and their respective team members. More recently, Abby Hoverstock, Senior Archivist at the Denver Public Library, took over responsibility for the Herbert Bayer papers, and I much appreciated her straightforward approach and uncomplicated assistance.

I am deeply indebted to my colleague and friend Magdalena Droste (of Berlin and Cottbus) for laying the foundation for the analysis of the artist's life and work with her catalogue and exhibition of the first major Bayer retrospective at the Bauhaus Archive in 1982. The present study would not have come to life without her groundbreaking analyses, publications, and commentaries. Our many conversations helped considerably to refine my views—not least her description of her encounter with Herbert Bayer in his later years. It was an honor to lead our DFG project "Networks in Movement" together with her. That project's coordinator Anke Blümm (in Weimar) invested tremendous time and effort into tracing back the biographies of the many Bauhaus students. Thanks to her and our colleagues Jens Weber and Andreas Wolter (mediaarchitecture.de), the "Bauhaus People" database is now publicly available to all researchers. I owe special thanks to Sylvia Claus and the whole Faculty for Architecture, Civil Engineering and Urban Planning at the Brandenburg University of Technology (BTU) Cottbus-Senftenberg for their willingness to welcome this unusually and heavily sociological project into the discipline of art history. This manuscript is based on a dissertation submitted in 2022 to the Faculty of Architecture, Civil Engineering and Urban Planning of the BTU Cottbus-Senftenberg in partial fulfillment of the requirements for a doctoral degree.

I would also like to thank my colleague and friend Elizabeth Otto (Buffalo, NY), probably the most knowledgeable Bauhaus expert in the United States, who enriched this manuscript substantially with her unparalleled talent for translating complex thoughts into profound argument. She convinced me to present the research on Herbert Bayer's German years to an English-speaking audience, and her transatlantic perspective on art and life in the 1920s and 1930s contributed to my own understanding of the course of events. This book owes its final shape in large part to the meticulous and rigorous editorial work of both her and Miranda Robbins in Berlin, whose close reading of my prose turned my awkward English into an elegant narrative. I owe her a huge debt of gratitude for asking perceptive questions about Bayer's complex biography and challenging me to sharpen my assessments.

I found further discussion partners and supporters in the many other institutions that care for the Bauhaus legacy and preserve Bayer's holdings, especially Sylvia Ziegner (Stiftung Bauhaus Dessau), Ulrike Bestgen (Klassik Stiftung Weimar), and Elisabeth Nowak-Thaller (Lentos Kunstmuseum Linz), who helped me establish contact with Bayer's relatives, Petra Meinhart and Veronika Hinterberger (Linz). Both of them kindly provided relevant documents from the family estate for which I express special thanks. An unforgettable conversation with Ati Gropius Johansen shortly before she died allowed me to confirm some of the personal facts that I had discovered in the sources; I am still grateful for the generous gift of this encounter, which involved great effort on her part. In addition, I extend thanks to the many people not mentioned here by name who helped me realize this project at the many stages of its journey.

My special thanks go to Jonathan Levy Bayer who generously gave the permission to reproduce works by his stepfather in this volume. The Aspen Institute contributed substantially to ensuring this volume's publication; Lissa Ballinger provided vital support. An anonymous benefactor very generously made this volume's extensive color plate section possible. Finally, I am also profoundly grateful to my academic home, the University of Erfurt, for providing me with a framework for pursuing this research with the necessary intensity outside the core of my regular research and teaching duties.

This book is dedicated to my parents: to my mother, who was unfortunately unable to witness its publication, and my father, who, through his tireless efforts on behalf of our family, has given me the freedom to complete this project. Displaced from two countries as a war refugee, he experienced as a child the period described in this volume. Without my wife Kerstin and my daughter Nina, the two great inspirations in my life, none of these lines would have ever been written. Together with Julia and Hannah, they tolerate my weaknesses and motivate me even in difficult times.

Part One

Formative Experiences—How an Apprentice from Linz Became a Junior Master at the Bauhaus

1

Youth: Family, Friends, and Companions

Herbert Bayer was the second son of Maximilian Bayer, a tax official originally from the German town of Passau, and Rosa Simmer, the daughter of an innkeeper from Upper Austria. Throughout his life, his older brother Theo remained a supportive presence, especially during the 1930s and 1940s. His relationship with two younger siblings, Helene ("Heli") and Max, though intimate, was not as close (see Fig. 1.1). The proud father often took his children with him on work trips through the Austrian countryside as he visited the farmers of his tax district on their remote homesteads. According to Bayer, his lifelong love of his native Austria and of the mountains stems from these formative impressions of nature. His passion for winter sports, especially skiing, was awakened early and often took the form of extensive ski tours through the mountains. On his mother's side, he liked to remember the family inn at the edge of a dark forest, the sisters who would break into song, and the telling of gruesome tales that had their origins in the seventeenth-century Peasants' Wars.

In the 1967 monograph of his work that Bayer initiated, he related a few anecdotes about his early childhood in Haag am Hausruck, a village in the Salzkammergut region near Linz in Upper Austria. He fondly recalled his favorite place to play, the garden of the local courthouse. There he could talk through a window to the inmates in the district prison. One of these once appeared with his paint box and greatly impressed young Herbert by producing a watercolor before his eyes—an experience he never forgot:

> For obvious reasons, he painted a fortress on a hill, with high walls and towers and a few small windows placed very high up. Having no water at hand, he wet the brush in his mouth. I later tried without success to repeat the olive-green coloring which he produced with his chewing tobacco-tinted saliva. This is my first clear recollection of image-making with paint and brush.[1]

For his thirty-ninth birthday, his brother Max sent him the transcribed text of a poem in local dialect that the nine-year-old Herbert had recited in the family circle some thirty years earlier. What was meant as a friendly greeting from home, however, was also an apt summary in verse of one of Bayer's own core conflicts:

> *Um koa Geld derfst nöt suacha, du suchtast umasonst,*
> *dracht nur dei Schicksal, oft woast schon wos s'is*
> *Und jetzt geh in Gottsnam und schau no amal zruck.*

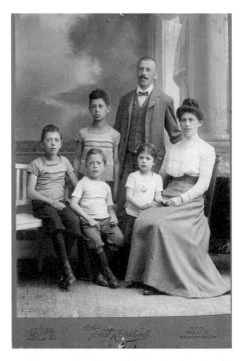

Figure 1.1 Atelier Arnold Hirnschrodt, Ried/Inn: The family of Rosa and Maximilian Bayer, together with their children Theo, Max, Herbert, and Helene (from left), 1910. Photograph; Denver Public Library, Herbert Bayer Collection.

(Not for any money in the world you should search, [if you do] you search in vain / just carry your destiny, often you already know what it is / and now go in the name of God and look back once more.)[2] Throughout his life, Bayer would find it difficult to follow the simple folk wisdom he had written down as a child; instead, he was always in search of personal and professional fortune while at the same time looking back on a past that he romanticized, nestled in the landscape of his Austrian homeland.

By the time the family moved to the provincial capital of Linz in 1912 (after stays in the towns of Windischgarten and Ried), the adolescent Herbert was already hiking with gusto throughout the Salzkammergut region. He found comrades when he joined the Wandervogel, a youth organization founded at the turn of the century as an extension of the reformist movements of the day.[3] The hiking and camping excursions of the Wandervogel were suffused with German poetry and song, and ideals of self-reliance, adventure, and romantic notions of freedom (see Fig. 1.2). Their mountain and camping excursions not only satisfied the schoolboy's interest in poetry in the rural dialect but also fostered his musical talent—activities he continued until his emigration in 1938: "The guitar was my constant companion, and we hiked to distant places to write down old songs."[4] In addition, he sketched landscapes, trees, and houses, and received top grades at school in freehand drawing. He began to paint as well. Quite

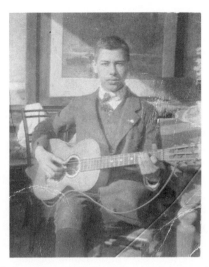

Figure 1.2 Photographer unknown, Herbert Bayer with guitar during his Wandervogel period, c. 1916. Photograph; Denver Public Library, Herbert Bayer Collection.

early, he produced several portraits of members of a particular family he befriended, the Schiefermayers, who received him like a son whenever he and his Wandervogel friends visited them in the town of Eferding.[5]

The art historian Elisabeth Nowak-Thaller has described in detail Bayer's personal and creative development in Austria.[6] Within the family, it was primarily his mother who recognized and promoted his drawing talent. Even as a small boy, Bayer copied works of art from books as well as the magazine *Über Land und Meer* (*Over Land and Sea*). The artists' association März, founded in Linz in 1913, probably also influenced him with its regular exhibitions.[7] Later, in 1929, he was to have his own solo exhibition with the group and design the cover for its 1931 yearbook. The budding young artist's dream of studying at the Vienna Academy of Art was shattered, however, when his father died of tuberculosis in 1917. The sight of Maximilian Bayer on his deathbed, blood pouring from his mouth, would haunt him for the rest of his life, as would the diffuse feeling of guilt over never being able to repay his parents for the sacrifices they had made on behalf of their children.[8]

Then, in 1916, the young man went to work. Bayer's first job was for the Upper Austrian Railway Directorate, followed by eighteen months of military service as a one-year volunteer in 1917. He arrived at the Italian front just as the war ended, then returned home to Linz and served there in uniform for some time, primarily disarming renegade Slavic soldiers.[9] The Great War broke up the once-mighty Austro-Hungarian Empire, and left deep scars on what remained, ushering in a period of great political instability and uncertainty. Having narrowly escaped the worst trauma of war, Bayer passed the final few months of his service drawing his comrades in the barracks. His military service thus served as a productive time to develop his drawing skills and eventually to show them off to his fellow soldiers.[10]

The first station in his long career as a designer came in the arts-and-crafts workshops of the local architect Georg Schmidhammer from Linz in October 1919, after receiving his formal school-leaving certificate in 1918. Here Bayer became familiar not only with the names of Gustav Klimt and Egon Schiele but also with the early activities of the Deutscher Werkbund. Here, too, he was introduced to the principles of the Gesamtkunstwerk—the total work of art—in the sense that the Wiener Werkstätten employed it.[11] The young intern created a wide range of designs including membership cards for the local football club, ex libris plates, textile patterns, emergency banknotes (to make up for the lack of small coins in the town of Lembach im Mühlkreis in Upper Austria), and much more. The multitalented Bayer would, over time, hone the diverse skills that he developed in these early designs, examples of which are still preserved in his estate in Denver.[12]

Schmidhammer's atelier provided a glimpse of how a studio operated and would later serve as a model when Bayer set up his own business some ten years later. Linz may not have been a metropolis, but it offered Bayer his first chances to exhibit his work to the public: a selection of watercolors in the Landesmuseum early in the summer of 1919, as part of the inaugural exhibition of a local artists' association Der Ring. His designs met with positive reception in the local press.[13]

Bayer sensed that Linz offered only limited opportunities and soon set off on his first extensive period of time abroad. After half a year at a local painting school run by Matthias May, an artist from Cologne—where he was given free tuition as a "half-orphan"—he arrived in Darmstadt in March 1921. Bayer selected this city not only for the forward-looking community of Jugendstil masters to be found there, but also because he had an uncle in Darmstadt with whom he could lodge.[14] Initially he did contract work for the studio of Emanuel Josef Margold, an Austrian architect and member of the Darmstadt Artists's Colony, located on the city's tallest hill, the Mathildenhöhe. He later recalled,

> I arrived there in Lederhosen and set to work among the Art Nouveau buildings in the wake of the "art decorative" artists, who had gathered there at the invitation of the art-minded Prince of Hessen before World War I. ... As a working-apprentice in Margold's small office, I was initiated into the design of packages, something entirely new at the time, and in the design of interiors, mosaics, and graphics of a decorative expressionist style.[15]

Margold, who was quite prominent as a member of the Wiener Werkstätte, had developed a corporate design for the successful Hermann Bahlsen cookie factory in Hannover between 1914 and 1917, including decorative cookie tins, fabric samples, print advertising, shop window decorations, and even entire shop fittings.[16] Bayer assisted on these projects and worked in other areas as well.[17] According to the job reference provided by Margold's studio, Bayer was responsible for "the artistic development of commissions in the field of commercial art as well as for the design of textiles and wallpaper."[18]

Despite being some 300 kilometers away, the distance from the Darmstadt Artists's Colony in Hessen to the Weimar Bauhaus in Thuringia was conceptually

much closer. At the Bauhaus as on the Mathildenhöhe, the ideal was to combine art and craftsmanship in the service of modern, forward-looking forms of building and living. Bayer later recalled the weekly meetings with his friends in Darmstadt, where they not only discussed Bauhaus master Wassily Kandinsky's influential essay "Concerning the Spiritual in Art" but also the famous 1919 Bauhaus manifesto—emblazoned with Lyonel Feininger's woodcut *Die Kathedrale* (*The Cathedral*).[19] In his 1967 monograph Bayer recounted a tall tale—which he attributed to Margold—detailing the Bauhaus admissions criteria: "[T]he applicant is locked up in a dark room. Thunder and lightning are let loose to get him into a state of agitation. His being admitted depends on how well he expresses this experience by drawing or painting."[20] While it had little in common with reality, the anecdote conveys a sense of the powerful myths that surrounded the institution in its early years. The twenty-one-year-old country boy felt magically attracted by these legends, which, in the fall of 1921, prompted him to "leave Darmstadt for Weimar at once, a move which was to give my life a decided direction. I did not give much thought to the problem of supporting myself."[21]

Although the certificate Margold issued for him attested that Bayer had worked with him until March 1, 1922, he had visited Weimar already in the fall of 1921 and was received by founding director Walter Gropius (see Fig. 1.3). It seems that, on the basis of his previous experience, Bayer was permitted to enroll immediately.[22] He began life as a Bauhäusler under slightly different circumstances from the rest of his cohort. For example, instead of taking the full *Vorkurs*—the famous preliminary course, taught by Paul Klee and Johannes Itten—he was only required to audit their lectures.[23] In March 1922 he joined the wall painting workshop of Kandinsky, whose essay had impressed

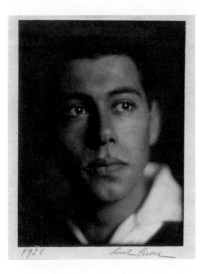

Figure 1.3 Lisel Kron, Herbert Bayer during his Bauhaus application days, 1921. Photograph; Denver Public Library, Herbert Bayer Collection.

him so deeply in Darmstadt; later he described this choice as a stopgap solution, as the Bauhaus did not yet have a workshop for printing and typography.[24] This changed with the appointment of the Hungarian Constructivist László Moholy-Nagy in 1923, who ultimately played a far more formative role in Bayer's creative development than the much older Kandinsky. As for Gropius, years later Bayer recounted in his diaries the impression he made on him at the time: "I never was a student of Gropius, only attended one lecture of his at the Bauhaus, and it didn't mean anything to me."[25] While Bayer would always admire Gropius as a mentor, he never considered himself to have been his pupil artistically. Rather, by the time preparations got underway for the important 1923 Bauhaus exhibition, Bayer had found the field that would occupy him decisively for his eight years at the Bauhaus: the development of type, typography, and layouts, primarily for advertising purposes—in short, what today is called graphic design.

Magdalena Droste and Ute Brüning have already examined Bayer's work at the Bauhaus in detail.[26] In this chapter I will add some biographical information in order to shed light on how his experiences shaped his future approach to art and life. The recollections of an early friend at the Bauhaus, Rudolf (Rudi) Baschant, suggest how formative the friendships Bayer formed at this time were for his life. As Baschant still recalled vividly years later, it was he who welcomed both Herbert Bayer and Josef (Sepp) Maltan—who arrived in Weimar wearing Bavarian Lederhosen—to the Bauhaus and looked after them. After World War II, Bayer repaid this kindness by sending his old friend care packages from the United States. Without them, according to the private accounts of both, the Baschants would not have survived the hunger and hardship that followed the total defeat of Nazi Germany.[27]

Further details come into focus from the diary that Bayer kept from the start of his time at the Bauhaus.[28] It documents the emotional upwellings of a twenty-two-year-old seized with enthusiasm for the Expressionist style and still infused with the romanticism of his days hiking through the mountains. Through its pages we hear the voice of a young man in a foreign world, far from the Austrian idyll of his sheltered youth. It shows him vacillating between an intense longing for home and a great fascination—but also revulsion—with Berlin, the pulsing, seething capital of the Weimar Republic, which he started to visit at this time. His first stay in the metropolis yielded impressions of "dirt, prostitutes, perversity" and a keen homesickness for the mountains—painful enough, apparently, to trigger fantasies of suicide.

We also read in the fall of 1922 of emotional upheaval caused by an unrequited passion for a woman at the Bauhaus.[29] Her identity is not certain, but the affection was apparently not mutual. Bayer soon recorded in his diary his regret about his naiveté ("I foolishly did not see it clearly"), and he self-diagnosed the melancholy and restlessness that would accompany him throughout his life and stand in the way of his happiness for a long time. He writes, "Long for rest and work / when I am restless and not in / smooth paths. ... and find nowhere the satisfaction, / the balance, can create nothing."[30] This formative experience of rejection ensured that, for fear of injury, he would be reluctant to surrender to another person emotionally again. He would reflect on this as late as in 1971:

So many years ago it became clear to me that one must not become completely and absolutely dependent on another human being. This does not mean that one should

not let oneself go completely in one's devotion and love. But the dependence must remain under control, one must not want to rely completely on the other person and give up one's own will too much.[31]

Even in those early days, he had already decided that a certain amount of selfishness would be inevitable—and that he would always seek, and find, his footing in his work. Even when personal crises considerably hampered his creativity, he would throw himself into applied work, which was usually in great demand. As if to illustrate this point, the twenty-two-year-old Bayer saw his first work published at about the same time; his woodcut *Stadt (The City)*, was printed in the monthly magazine *Freideutsche Jugend (Free-German Youth)* in 1922.[32] The simple motif already anticipated his transition from Expressionistic-decorative style to objective design (see Fig. 1.4).

With his considerable skill set, preparations for the 1923 Bauhaus exhibition soon offered Bayer an even more prominent stage. Now, as a graphic designer and poster artist, he had a welcome opportunity to test the principles of a "new," functional typography in practice.[33] In preparation for the show the Bauhaus established its advertising department, with Kandinsky as the official director.[34] Bayer, however, was the de-facto organizer of the nineteen participating students.[35]

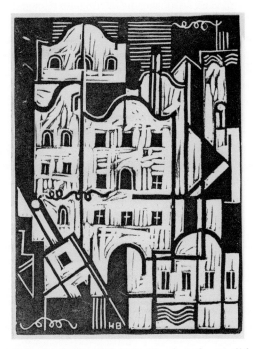

Figure 1.4 Herbert Bayer, *Stadt (The City)*, 1922. Woodcut, the artist's first published work; in *Freideutsche Jugend* 8, no. 2 (February); Private collection. © Estate of Herbert Bayer/ Artists Rights Society (ARS), New York/VG Bild Kunst, Bonn.

The opportunity coincided with Bayer's most important typographical student project: the design of emergency money for the state of Thuringia. German hyperinflation was just then reaching its staggering peak, and the state government turned to the nearby Bauhaus to draft new banknotes. In retrospect, it is rather remarkable that Gropius and Moholy would have entrusted this important project to such a young graphic designer. It could well have been the most prestigious commission ever assigned to the politically controversial institution, which had struggled since its founding for recognition and legitimacy from the local government. One can only surmise that their choice of Bayer was partly due to his previous experience with designing banknotes in Linz, and partly due to the tremendous general workload involved in organizing the school's first major exhibition.[36] Unexpectedly, the state government agreed to Bayer's designs. When the banknotes were issued on August 10, 1923, he suddenly found his work distributed in the millions (see Plate 1).[37] Inflationary money of this sort often included denominations in the millions, even, in the case of Thuringia, up to and including a 5-trillion mark note; it all quickly became worthless with the ever-worsening financial crisis. Bayer's astonishingly clean and simple designs, which were unique at the time, are still considered to be the first high-profile manifestation of the New Typography in Germany.[38]

Theoretically linked to Constructivism, the New Typography movement found its way to the Bauhaus primarily through Moholy's teaching.[39] The presence in Weimar of Theo van Doesburg, an active ambassador of the De Stijl movement, was also a factor, particularly through his work organizing the International Congress of Constructivists and Dadaists, which took place in Weimar in September 1922. Although Gropius ultimately chose not to offer van Doesburg a position on the Bauhaus faculty, the Dutch modernist held independent evening lectures near the school in the spring of 1922, and these drew many Bauhäusler. There is no evidence that Bayer himself attended van Doesburg's course on De Stijl, but his fellow Bauhaus students Werner Graeff, Otto Umbehr, and Andor Weininger, all like Bayer born between 1899 and 1901, were present.[40] It is possible that Bayer just could not afford it. Of the Bauhaus's tuition and fees, he later he claimed that he "attended for free, because I didn't have anything to pay with"; he lived extremely modestly in one of the Bauhaus's one-room "Prellerhaus" studios.[41] But other Bauhäusler were also extremely poor, and some were apparently able to attend van Doesberg's evenings free of charge.[42]

Considering he was merely a student, it is hardly surprising that Bayer was not an official participant at van Doesberg's International Congress of Constructivists and Dadaists in 1922, but he would likely have attended one of its public events, as the audience consisted mainly of Bauhaus students.[43] In any case, the congress marked El Lissitzky's first visit to the Bauhaus, and Bayer was able to meet him on the occasion.[44] Bayer would later name two pioneering works of Lissitzky's typography as significant influences on his work: the children's tale *About Two Squares* of 1922 and *For the Voice*, an edition of poems by Vladimir Mayakovsky, published in Berlin in 1923.[45]

Bayer's turn to Constructivist design principles was spurred by a number of influences, not least Kandinsky's own intensive involvement with De Stijl at the time. This was reflected in the master's 1926 Bauhaus book *Punkt und Linie zu Fläche* (*Point and Line to Plane*), for which Bayer designed the jacket. There was also Bayer's close friendship with Marcel Breuer, a fellow Bauhäusler and near contemporary, who

worked in the carpenter's workshop and whose Constructivist chair designs became popular among the avant-garde.[46] Bauhaus master Moholy-Nagy, a mentor of both Bayer and Breuer, designed printed matter only occasionally, with a few notable exceptions, such as his covers and spreads for the school's book series. Nonetheless, he always remained the intellectual leading spirit of Bauhaus typography, while Bayer focused on concrete implementation, first in his own work and then with his students once he became a junior master.[47] As Bayer put it ironically in one of his later English-language interviews: "[Moholy] was a great talker. He gave the impression that he would be a charlatan. We always called him 'the art journalist.' ... They could talk a great deal but they couldn't make great art."[48]

Moholy-Nagy's written theories help to illuminate the typographical approach that Bayer quickly adopted. In the one-page text on "The New Typography" that he contributed to the 1923 Bauhaus exhibition catalogue, he emphasized the importance of typography in the communication process and called for maximum clarity of expression.[49] The sober, objective spirit of the age, he wrote, was also to be reflected in unambiguous, unembellished design of printed matter, which first and foremost had to serve optimal legibility. The form of presentation, he added, had to be consistently subordinated to the goal of communication—his implicit reference to the apt statement attributed to Louis Sullivan, according to which "form follows function". It was therefore preferable to use a sans-serif typeface (in changing type sizes, running vertically as well as horizontally) in addition to clear page layouts with plenty of white space; asymmetrical typesetting (instead of the classic orientation along a central axis); and bars, dots, arrows, and other geometric elements to structure the message.

Bayer's near contemporary Jan Tschichold, soon a major protagonist of the New Typography, first grasped its innovative potential in 1923 when he visited the Bauhaus exhibition in Weimar.[50] Bayer described working with Tschichold two years later while the latter was guest-editing the ground-breaking *elementare typographie*, a twenty-four-page special insert to the October 1925 issue of the trade journal *Typographische Mitteilungen*; Bayer helped him assemble the visual material.[51] It was because of this collaboration that the issue drew chiefly on illustrations from the Bauhaus, including Bayer's 1923 emergency banknote designs as well as drafts of his advertising work.[52]

Bayer participated intensively in the preparations for the 1923 Bauhaus exhibition in Weimar, including producing and designing such printed matter as the catalogue cover, two motifs for a set of postcards connected to the exhibition, and designs for advertisements and posters.[53] Considering the universally acknowledged significance of this exhibition, it is somewhat ironic that Bayer himself never actually attended it. Indeed, by the time the show opened on August 15, 1923, he had already left Weimar on his journey to Italy. Bayer's only recently discovered travel diary, however, makes clear that he left Weimar for his year abroad on August 13, 1923—just two days before the opening, which had already been postponed several times that year. Bayer, who had presumably been planning his trip for some time, thus missed a key event in early Bauhaus history.

On August 14, after visiting the passport office in Berlin, Bayer left by train via Salzburg for Berchtesgaden in the Bavarian Alps.[54] There he met his Bauhaus comrade Sepp Maltan, and the two continued by train as far as the Brenner Pass. On August 20, they began their hike through the Dolomites into Italy, eventually reaching Rome some weeks later.[55] In a total of six densely annotated notebooks, the diary records the

overwhelming impressions of his year-long journey, which led him all the way to the Sicilian city of Palermo.[56]

"Following the traditional 'urge to go south' and an inborn wanderlust, I traveled through Italy and Sicily, working as a house painter, sketching, and painting. It was a venture which left a more lasting imprint than my later travels," Bayer later wrote.[57] His stated reason for the journey was the need to gain a journeyman's experience, for at the age of twenty-three, he did not yet feel ready to begin a job or teach other students.[58] He had considered himself intellectually overwhelmed as a student. Even later in life, he sought to avoid public speaking due to his deep shyness, which he mentioned in his diary as early as 1922.[59]

His travels could well also have been an attempt to gain some distance from the unhappy early love affair mentioned in his diary. More details are hidden in an extraordinary source: a 1970 *roman-à-clef* by a certain "Kai Steffen," pseudonym for the Bauhaus student Lore Leudesdorff.[60] Here the author's alter ego experiences an almost three-year liaison from 1921 on with a fellow student from the wall-painting workshop. "Bruno" the Austrian is easily recognizable as Bayer:

> When she closed her eyes, she saw Bruno's face, very close, above her. His green eyes and black lashes, full lips and sparkling teeth. She dreamed her face into his hands. She dreamed her body nestled against his. She dreamed of being one with him. All feelings in her body and soul were focused only on him. Bruno! … Those were three wonderful years at the Bauhaus—studying, the Bauhaus air, Bruno. We were completely there for each other.[61]

Whatever relationship the two enjoyed in the realm of non-fiction was destroyed by Bayer's interest in another woman—his future wife Irene Hecht, whom he met just prior to deciding to leave on his trip (see Chapter 2).

Bayer and Maltan were virtually penniless when they began their Italian journey. They lived extremely modestly, sleeping in haystacks and occasionally earning a little money as house painters. Arriving in Naples on foot from Rome, Bayer was so impressed by the eruption of Mount Vesuvius that he broke through a fence to see the spectacle at closer range.[62] The pair proceeded to Sicily and spent four months touring the island, sketching prolifically.[63] As Nowak-Thaller writes:

> Here Bayer once again drew magnificent architectural cycles …, meticulously executed in pencil and charcoal, chalk and ink, or as watercolors. These are travel sketches inspired by the new teachers Kandinsky, Klee, and Itten but largely free, which take up the atmospheric moods of the landscapes and their architectural features in increasingly abstract form.[64]

Bayer's predilection for the classical formal repertoire also stems from this extensive stay among the historical sites and landscapes, the impressions of which he recorded in the expressive-romantic style typical of the time.

Thanks to the generosity of a German baron—a distant acquaintance of Maltan's—the travelers were able to return from Italy to Berchtesgaden by car and train. There, in the summer of 1924, Bayer assisted in Maltan's painter's workshop before being

drawn back to Weimar.[65] He turned down an opportunity to return to Linz as an exhibition designer.[66] Years later, he fondly recalled this carefree stage in his biography: "I remember Sepp Maltan, my life as a housepainter among the peasants—a wonderful youthful time."[67]

On October 29, 1924, after more than a year away, Bayer described hearing the sounds of Thuringian dialect once more in his ears and experiencing "the dull Weimar weather at the Bauhaus," where Gropius had promised him a position as a junior master (*Jungmeister*).[68] A prerequisite for this junior faculty slot was the successful completion of the journeyman's examination, evidently something of a bureaucratic formality. He passed this on February 3, 1925 by decorating the walls of a theater-restaurant in Weimar.

According to Schawinsky's recollections, decorating local watering holes was a sought-after (if only occasional) source of supplementary income for the Bauhäusler.[69] The Weimar Handwerkskammer (Chamber of Crafts) duly certified that Bayer had passed the exam for the painter's trade.[70] Though he was indeed amply qualified as a wall painter, not least through the experience of working in Sepp Maltan's workshop in the summer of 1924, the field was, of course, only marginally related to the genuine expertise he had already acquired at the Bauhaus, namely in advertising design.

It was, in fact, only with the school's move from Weimar to Dessau in April 1925 that Bayer at last could take up his promised appointment as a junior master. He signed a three-year contract with the city of Dessau in April 1925. After a transitional phase for the institution of half a year, filled with administrative preparations, curriculum adjustments, planning the new buildings, relocating furnishings, and some farewell festivities, the school officially opened in provisional buildings in Dessau on October 14, 1925, just in time for the start of the fall semester.[71] It would take almost three semesters before the faculty could move its entire operations into Gropius's famous Bauhaus building inaugurated in December 1926.[72]

Bayer's countless design works succeeded in making Constructivist typography virtually synonymous with the Bauhaus. For this reason, it is still sometimes referred to as "bauhaus typography."[73] Interestingly, however, Bayer's work was not present in the Bauhaus issue of the magazine *Junge Menschen*, which appeared in November 1924, designed by the junior masters grouped around Josef Albers and Marcel Breuer. As the issue received its impetus from the 1923 Bauhaus exhibition, it is likely that the planning process had already been completed before Bayer's return.[74] Certainly, much had happened throughout Germany during his absence. Significantly, the New Typography had gained considerable momentum.[75] In Bochum, for example, Max Burchartz (who had previously attended van Doesburg's course in Weimar) and Johannes Canis opened their full-service advertising agency werbe-bau in November 1924. Burchartz's publication *Gestaltung der Reklame* (Information Sheet No. 1 on Advertising Design) caused a sensation among designers and typographers.[76] For his part, Moholy had also just published his first commercial cover design for a book in the Constructivist style.[77] Bayer had been an early adopter of the New Typography. Now, his return to Germany and assumption of a teaching role in the Dessau Bauhaus situated him as a leader in the midst of this suddenly burgeoning movement, in exactly the right place at the right time.

Irene Hecht and Herbert Bayer:
A Fateful Relationship

Some account of Herbert Bayer's troubled marriage to his first wife, Irene (née Hecht), and the ensuing responsibility for their child, Julia ("Muci"), born in 1929, is essential to understanding his artistic development. Their relationship crystallized the complicated attitude toward women that marked in particular the first half of his life.[1] Only later in the United States, with his second wife, Joella Haweis Bayer, at his side, did he experience a certain balance. Yet from his first encounter with Irene Hecht in 1923 at the Weimar Bauhaus until his new start in the United States in 1938, their bond shaped Bayer's existence profoundly. For nearly two decades, Herbert Bayer's seemingly endless sequences of ups and downs, passion and adultery, desire and rejection burdened both partners and later their daughter, and it often led to mental and physical exhaustion for all parties concerned. As her letters profess, Bayer-Hecht remained emotionally bound to Bayer throughout her life.[2] "In my long life I have loved only two people with all my heart, Herbert and Julie," she wrote to her former brother-in-law Theo Bayer shortly before her death in 1991.[3]

Irene Bayer-Hecht remains a marginal figure in the history of Bauhaus modernism. Though she was inclined toward the visual arts and had some training in photography and forms of reproduction like lithography, she never enrolled at the Bauhaus, hardly ever sat in on classes there, and—significantly—never perceived herself a Bauhäusler.[4] Nonetheless, her marriage to Bayer brought her into close contact with the inner circle around Walter Gropius, something she regarded with decidedly mixed feelings.[5] She harbored strong reservations about Bayer's close friendships with his colleagues, particularly, for reasons I will discuss later, his mentor Gropius and his wife Ise, and she explicitly described Bayer's former teacher László Moholy-Nagy as her husband's "enemy."[6] Still, she enjoyed the company of certain junior masters at the Bauhaus, including Joost Schmidt, Marcel Breuer, and especially Xanti Schawinsky, with whom Hecht also maintained a cordial relationship in the 1920s and 1930s, and who hosted her and her daughter upon their arrival in New York in late 1939.[7] For the most part, however, she consistently styled herself a Bauhaus outsider.

Irene Angelica Hecht was born on October 28, 1898 in Chicago (Cook County, Illinois).[8] She was of Jewish descent, "half Jewish," something she mentioned in two of her letters to Bayer from 1925 and that Bayer himself recalled in a later interview.[9] Her family moved to Europe, and Hecht was raised in the city of Arad in Transylvania. Here they spoke Hungarian, as the region was part of Austria-Hungary until 1918,

when it became part of the newly unified Romania. After secondary school, Hecht moved to Berlin in 1921 to attend the Academy of Arts in Charlottenburg (today part of the Universität der Künste).[10] Around this time, her father and other family members returned to the United States. She retained her American citizenship but stayed on in Europe.

Hecht arrived in Weimar by the spring of 1923 (and not that fall, as has often been asserted, for the Bauhaus exhibition).[11] She stayed first with a Hungarian compatriot, Bauhaus student Farkas Molnár, and later moved to a hotel, the Chemnitius.[12] Bauhaus records show that she applied in April 1923 for trial admission to the winter 1923/24 *Vorkurs* but was rejected. Her dossier left the masters unimpressed; only Josef Hartwig, master craftsman in sculpture at the time, spoke out in her favor, though even he considered her "very scatterbrained"; Paul Klee and Gropius were summarily opposed. "Weak," noted Gropius tersely, "wants to work with enamel—out of the question for us."[13] On May 8, 1923, the school's secretary returned Hecht's portfolio to her Weimar hotel. No explanation accompanied the rejection.[14] For a young woman far from home and just setting out in life, it could only have been an embittering blow, but Hecht stayed on in town nonetheless.

Herbert Bayer's first meeting with the attractive American (see Fig. 2.1) took place in 1923, probably in mid-July, a time that coincided with the preparatory phase for the big Bauhaus exhibition.[15] Hecht appears in Lore Leudesdorff's autobiographical novel as a distinct rival, an overbearing woman with a Hungarian accent who steals "Bruno" away on her very first day at the Bauhaus. "Suddenly there was a woman standing beside me. Not a young girl. Older than me. Substantial, but not stout. Everything about her

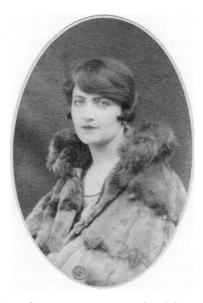

Figure 2.1 Photographer unknown, Irene Bayer-Hecht while going into rehab at Leysin (Switzerland), March 1926. Photograph; Denver Public Library, Herbert Bayer Collection.

was substantial. Vivacious. Uncomplicated. … She would take him. You could tell she was used to taking what she wanted. And he would let himself be taken."[16]

Indeed, it appears that the chemistry between Bayer and Hecht was intense from the very beginning. Bayer received numerous fervent love letters from his admirer during his Italian journey, which began that August.[17] On October 9 she wrote to him from Berlin in a passionate, unmistakably Expressionist style: "I love you—you—you you you / you I hate—when I get my hands on you I will tear you to pieces until your blood runs from my hands, runs with lust from my feet, because I must feel it in my eyes, must have you …. I dreamed of you, but it was nothing decent. Dying / loving / killing / hating / loving / loving / Irene."[18] She apparently broke with another admirer at the time in order to devote herself completely to Bayer.[19] Even this first letter, which mentions "madness and longing with pain," seems to foresee tragedy.[20]

The next month, from Leipzig, where she was attending the Hochschule für Grafik und Buchkunst (Leipzig Academy for Graphic and Book Arts), Hecht began a letter to her lover with the passionate words "Il mio, I'm waiting" and warned him against returning to a German state shaken by hyperinflation and an economic crisis: "You must not return here, for it is a living hell. No work, no bread, no sun! … Would you move with me to America? I have connections." She proposed that they join her family there, an idea that, unbeknownst to either of them, anticipated their future urgent need to emigrate under difficult conditions in the 1930s.[21] In a letter written shortly before Christmas, she announced that she would be leaving Leipzig for Paris; apparently her father's support of twenty-five US dollars per month was not enough for her to live on; she needed a job. Her father was demanding that his twenty-four-year-old daughter— after her long years of education—at last "stick to one thing and use it as a profession." In the same letter, Hecht expressed doubts about her future with Bayer: "I don't know whether we will ever see each other again, whether we will still love each other."[22]

The letters that followed nonetheless show her clinging to her absent lover. In January 1924 she described her imminent departure for Paris, where she hoped to find work as a lithographer. And she admonished Bayer: "You must remain with me, as a hope, a last faith … No man has ever found his way back to me …. You are the first man I wish to be with after six months."[23] The same letter includes the emergence of a key motif in their first years as a couple: pregnancy. "Life is stirring within me, and my unborn children are crying for light. Where is he, my son? He should become a Messiah of the joyful, a man of light. Our sad love has no realization, and we are denied the opportunity to see the most beautiful."[24] In response to one of his love letters that same month, she provoked him: "Don't you remember that I am lazy, indolent, passionate, I like to flirt, I like to dance, also with other men, my skin is yellow and my hair is short …. Better not be faithful to me, love a beautiful brown girl there [in Italy], and then write me if I am still the woman."[25] A few paragraphs later found her musing again in concrete terms about their future as a couple, however, announcing on the one hand that she wanted to find work for Bayer in Paris while on the other declaring that she was prepared to join him if he found a "place to rest." "You could hold on to me / 1—2—3—50 years / If you wanted / I am so modest / I only want love— / But I must have that." She even had a pragmatic suggestion for his professional future: "Why don't you try big billboard companies?"[26]

Hecht soon realized that supporting herself in Paris was difficult, particularly finding a job. Various biographical accounts present this as a glamorous time in her life. The well-traveled young woman, who spoke English, German, French, and Hungarian, audited lectures at the Sorbonne and the École des Beaux-Arts,[27] maintained intensive contact with Hungarian artists,[28] met Pablo Picasso and Fernand Léger,[29] and gained access to literary circles.[30] But her everyday life may have been far less spectacular than these isolated episodes suggest. At first she stayed with the sons of some of her father's friends.[31] The only practical training she received in Paris was as a milliner; once she found a job, she earned about 600 francs a month—just enough to cover life's basic needs, but still more than what many bohemians lived on.[32]

By mid-1924, Hecht had still not managed to set aside enough money to visit her lover, who had, in the meantime, returned to Berchtesgaden after his travels and was planning to set up a house-painting business there with his hiking companion Sepp Maltan (see Fig. 2.2). She now found herself in a dilemma. She yearned to join him, but leaving Paris risked precipitating a break with her father and cutting herself off from her family's support, including her allowance. Moreover, she continued to express skepticism about the relationship, after almost a year without a single personal encounter with him:

> If I take the step, there is no going back, and I know you are not the kind of man who stays at a woman's side for long. I know that my kisses are seductive, but that's not enough, is it? Help me! I die of longing for a night with you. … I want to love you in the open field where I feel the smell of the earth in my pores, and there I want to receive my child from you. For that is the goal of my life.[33]

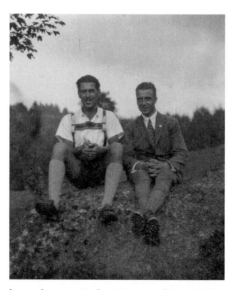

Figure 2.2 Photographer unknown, Herbert Bayer and Sepp Maltan after hiking in Italy, Berchtesgaden, 1924. Photograph; Denver Public Library, Herbert Bayer Collection.

Both motifs—her wish to bear children and her foreboding about Bayer's unreliability as a long-term partner—would have a decisive influence on their later relationship. They also combined with Hecht's deep conviction that she would find fulfillment in marriage and motherhood, a traditional role that was rather at odds with the idea of the emancipated woman prevalent in avant-garde circles at the time.[34]

It was not until December 11, 1924 that Hecht and Bayer finally saw each other again.[35] Their meeting place turned out to be Weimar, where they had first met almost a year-and-a-half earlier. She had no great desire to return to the Bauhaus.[36] Indeed, she had already experienced the first of an almost endless series of illnesses, and her financial reserves were depleted.[37] But Bayer had just been invited back to prepare for his post as a junior master. The Weimar registry of residents lists his date of return as December 8, 1924. Nothing is recorded about the couple's first reunion in Weimar, but it must have been overwhelming for both of them.[38] They agreed to marry quickly, even though the decision was probably in large part Hecht's. Their civil marriage would take place within a year, on November 11, 1925, in Dessau, midway through Bayer's second semester as a junior master.

At that time, tensions between the school and the conservative state government in Thuringia were escalating. Gropius and his team would soon begin drawing up the first plans to move to Dessau in the neighboring state of Saxony-Anhalt. This began in April 1925, a few weeks after Bayer successfully completed the journeyman's exam that officially qualified him to join the junior teaching staff (after all contracts of the Bauhaus and its faculty with the state of Thuringia had ended by March 31, 1925). Bayer, hired by the city of Dessau in April for a three-year period, spent the summer preparing his classes in the newly founded advertising workshop.

The wedding photograph shows the couple flanked by Hecht's twenty-two-year-old brother Andreas ("Bondi") Hecht, who had arrived from Leipzig, and the twenty-one-year-old Alexander ("Xanti", or "Xandi") Schawinsky, then still a student at the Bauhaus and now Bayer's best man and best friend (see Fig. 2.3).[39] The second row shows Joost "Schmidtchen" Schmidt, who later succeeded Bayer as head of the advertising department at the Dessau Bauhaus, along with his wife Helene Nonné-Schmidt, also a Bauhaus student, whom he had married in the same year. ("Schmidt was a person I liked very much," Bayer later recalled. "He got drunk very easily, and that always made him the soul of the party. But as an artist, he never really came through."[40]) As a whole, the photo shows a playfully staged and slightly ironic scene. The choice of wedding date was perhaps no coincidence; "11.11" traditionally marks the beginning of the lighthearted carnival season in Germany. The photograph's prominent frame, which presents the bridal couple as a kind of picture within the picture, anticipates an element that Bayer later liked to use in his work (see Plate 18). The gramophone, banjo, and other musical accessories add further layers of informality to the celebration, and in the background an easel with sketches and one of Bayer's advertising designs leaves no doubt that this is a Bauhaus marriage.

Half a year before this happy date, Irene Hecht's wedding preparations had been overshadowed by a serious medical crisis. On April 23 she had an operation in Leipzig—"neither dangerous nor painful," as she reported to Bayer. A week later, however, she reported that her condition had deteriorated.[41] From Bayer-Hecht's later

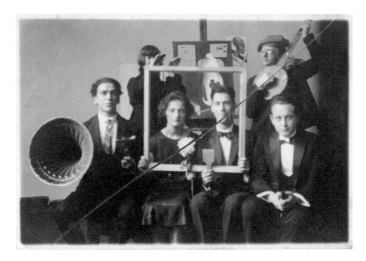

Figure 2.3 Photographer unknown, Wedding image of Herbert Bayer and Irene Gropius with best men Xanti Schawinsky (left) and Andreas Hecht (right), Helene Nonne and Joost Schmidt in the back, November 1925. Photograph; Bayer family estate Meinhardt/Hinterberger, Linz.

letters of February 1926 we can deduce that the procedure was, in fact, an abortion.[42] Presumably Bayer was not yet ready to start a family, and the letters strongly suggest that he agreed to move up the wedding in return for a termination of the pregnancy.[43] There is no doubt that his fiancée suffered considerable physical and mental health consequences as a result. It took another three years before their child, Julia, was born.

Superficially, however, the Hecht–Bayer constellation was in many ways typical for a romantic partnership at the Bauhaus: the husband, an aspiring junior master with talent and excellent professional prospects; the wife, interested in art and willing to support her husband's progress. Yet finances at the Bauhaus were always precarious enough that Bayer constantly sought commissions from the business world to supplement his income. He was overburdened with work and far from wealthy. Indeed, the couple lived in almost perpetually precarious circumstances, never able to afford a carefree life. According to his contract with the city of Dessau, Bayer's very modest teacher's salary was based on the national civil servants' pay scale, which in 1927 came to 191.67 reichsmarks per month[44]—the equivalent of about \$760 in 2022 currency.[45] These financial difficulties may seem surprising considering the singular importance of Bayer's work in establishing the visual identity of the Bauhaus—intensive design contributions that succeeded in turning Constructivist typography into a Bauhaus trademark—but he was a young man at the time. Due largely to her poor health, Bayer-Hecht found herself unable to contribute much to the couple's finances which made her almost entirely dependent on her husband. This was a continual source of discomfort to her.[46] There are, however, no documented instances of Bayer ever proving

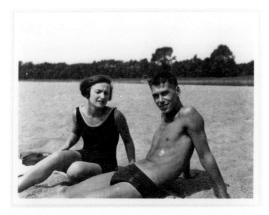

Figure 2.4 Ise Gropius: Herbert Bayer and Irene Bayer-Hecht at the Elbe beach in Dessau, 1927. Photograph; Denver Public Library, Herbert Bayer Collection.

unwilling to share his small income with her. Also, there is no record of Hecht's family contributing to the household after her marriage.

The couple experienced serious marital tension almost immediately. While Irene Bayer-Hecht often stressed in her letters that she loved her husband and was prepared to put her own life on hold for their common partnership, she complained bitterly and repeatedly that she found no real place at his side. The dazzling junior master was in many ways deeply self-absorbed (see Fig. 2.4). In addition to his copious teaching and design responsibilities, he had artistic aspirations to pursue. Then there were the unique attractions of the Bauhaus environment itself—the lighthearted male and female friendships blossoming around him and a playful atmosphere that was doubtless easier to face than the psychological anguish of his lonely wife. Irene Wallbrecht, a student of Bayer's at the advertising workshop, later reported that "he is extremely businesslike with the female students, reserved and critical, teaching more by example and exactness than by talking. He is ambitious, incredibly hardworking, and I think he fears being distracted by adventure" while, at the same time, legend has it that each of the 30 students from the textile workshop had woven a shirt only for Bayer.[47]

Bayer-Hecht perhaps also continued to sense his inner reluctance to commit to the relationship, a hesitation about personal attachment that may have had its roots in his first unhappy experiences in love. That winter she again became seriously ill, affecting her lungs and inner organs, and she needed to spend two months at a sanatorium in Leysin in French-speaking Switzerland, not far from Montreux. On February 9, 1926, just three months into her marriage, she arrived—alone—in the small village, completely exhausted and wracked with pain.[48] Bedridden, but able to enjoy a view of Mont Blanc, she sought to shorten the long days by writing exhaustive letters to her husband. Again, her writings reflect fundamental uncertainty about the couple's future while also showing Bayer-Hecht's deep compassion for her beloved, who was paying for her expenses at the Swiss retreat.

In my life I was only happy for minutes and hours, and those were only when close to you. That is why I am grateful to you in spite of everything I have had to suffer physically and emotionally. You were always good to me and have endured me like a martyr, but I don't thank you for that, because I don't like martyrs. Now we both have time to reflect.[49]

A four-page letter of February 13 shows Bayer-Hecht struggling with her own role as a wife and the everyday tasks she claimed she was not prepared to perform, while crystallizing in impressive metaphors and strong language the complications that already hounded the newlyweds,

I know the slightest movement of your heart, and I know that I didn't fulfill your most secret wishes. I didn't bring you any peace, no compensation, not even erotically. My hair is not curly! ... In this, our duet, only you are really important. ... I love you. In a way that absorbs my being and life, endlessly, without fulfillment, fruitless and sad, but far away from you, magically clear and safe, unwavering and everlasting. After that I see nothing. ... Believe me I have suffered much, but I love you even more for being my only dearest."[50]

This admission that she was unable to cope with her role as wife should not be interpreted as a declaration of her wish to emancipate herself, however. The dominant role of her husband was never something she questioned, and indeed, she wrote of it being the only thing that mattered in the partnership. Much as the modern reader would like to find evidence of an ironic subtext here, Bayer-Hecht intended nothing of the sort; she truly loved and admired her husband but appears to have despaired of ever finding her place beside his strong personality.

Bayer's infidelity was a recurring theme. "I want something that I don't have to share with any other woman. Your body doesn't belong to me—your soul sometimes."[51] The good-looking young teacher—rather a well-dressed, fashionable "beau" and less the anti-bourgeois bohemian as many other Bauhäusler[52]—was permanently surrounded by pretty students.[53] Apparently he even flattered his admirers with flowers and photos in addition to his physical attentions. In her view, these "idealistic" (i.e., naive) German girls did not even allow themselves to be "paid" appropriately for their services. In her letters, Bayer-Hecht laments that she, as his wife suffering from illness, has become erotically unattractive to him after only a short period of marriage. Indeed, the role of the betrayed lover was nothing new to her. As early as February 1925—well before their marriage—she had described receiving anonymous letters from his mistresses.[54]

Despite these discomforts, from her Swiss sanatorium she continued to express interest in Bayer's work. She praised his new stationery design and asked him to send her more of the same, Bauhaus brochures with photos, and "if you have any success, exhibitions or in the newspapers, please write me. I am so happy about it."[55] The Bauhaus environment, however, had no appeal for her. "Now the Bauhaus! Believe me, forget about it. It has fulfilled its task; now it repeats itself, becomes dogmatic," she wrote, anticipating what many other observers would later conclude.[56] "It's just

good enough for you to use it now for a few years as you conquer the world for yourself, ... or to earn money, if you want."[57]

Bayer, in contrast, wholeheartedly embraced the unapologetically modernist attitude to life—and art—to be found at the Bauhaus. Indeed, perhaps more than any other artist, he embodied the 1923 Bauhaus mission statement: "Art and technology, a new unity." After a transitional semester with little teaching or workshop activity, the institution's move to Dessau was at last complete by the end of 1925. As head of the newly established advertising workshop there, he could depend on the school as a source of income, something Bayer-Hecht grudgingly accepted. "It would be a lie to say that I long for Dessau, but in the end you are there, and so it does mean something to me."[58]

In retrospect, it is possible that Bayer-Hecht suffered from so-called post-abortion syndrome, an adverse mental health condition that can often last for years. According to current findings, the psychological and emotional after-effects of abortion are especially likely to occur when the patient's decision to terminate a pregnancy is made under external pressure, and when social support for the decision is low—factors that both seem to have applied in her situation.[59] She repeatedly stated that she had a "sick mind" and lamented the state of "her nerves." From Switzerland, for example, she told Bayer that her recovery would be faster "if my nerves were in order, but they have also found great psychological disorder in me. We have both sinned heavily against our lives, but it was out of ignorance. The future must be different."[60] It is entirely plausible that Bayer-Hecht's fluctuating emotional state and the constant ups and downs that marked her partnership with Bayer for the next decade and beyond originate in the mental anguish resulting from that early psychological and physical trauma. Her summary of this difficult period, written in March 1926, reads like an extended apology:

> I have to admit it: I loved very selfishly. I wanted to have you all to myself. For many months, my brain was clouded ... I find myself, along with other women, when I see them, ugly, stupid, unlovable. I know now and always did that this is stupid and unimportant, but I suffered a lot when I was already broken and made small ... Therefore the need to hear a compliment from time to time, no matter how stupid it is. Never in these sad months did the thought occur to me that anything could send you away from me except for the fact that I am not enough for you. I am so humble and know my worthlessness in this world to the point that no other thought came to me ... With us there was only you, who constantly sacrificed everything. I am very ashamed. Forgive me.[61]

The same letter also discloses an official all-clear: "Thanks to fate ... my worst fears are over. I'm having my period. This has been a bad month for me."[62] Her doctors had ultimately identified an inflammation of the ovaries as the basis of her ongoing health problems; "my ovaries. They must be strange little things that they never rest."[63] This, combined with other aftereffects of her earlier pregnancy, was the cause of her ill health affecting her lungs and nerves, and causing her to be underweight.[64]

In his own letters, Bayer evidently complained to her of his Bauhaus workload, and she unsuccessfully suggested that he take time off, "Schmidtchen and Moholy should

replace you."[65] She worried he was burning the candle at both ends and perhaps even showing symptoms of tuberculosis,

> I'm afraid that all this tiredness and everything is also in your lungs ... It would be a sin to sacrifice and waste your beautiful young years with the thought of a false ambition. ... You think you absolutely have to do something. Always! Take your time! Don't let yourself be influenced by this inappropriate pace, which only holds emptiness. What's behind it? Only *les âmes tourmentés* [tortured souls].[66]

Later she arranged to have her husband's blood values analyzed in Leipzig, and the results indeed showed an increase in white blood cells. She recommended that he do sports and take a break in the mountains, suggesting a six-month stay in the Alps with his old friend Sepp Maltan. "Perhaps you could get away from the Bauhaus for a few months ... All the damned small-time, civil-service stuff that any stuck-up fool can do should just go up in smoke."[67]

As for Bayer, even if he had no pronounced appetite for "normal" married life, it appears that he too may have developed the desire for a child sometime around the turn of the year 1925–1926. He had grown up in a large family and thoughts of children often accompany a man at the time of marriage. In April 1926, after Bayer-Hecht left the sanatorium, the couple met at Lake Como, and she moved with Bayer back to Dessau, despite her lack of love for the city. But already by mid-July of 1926, they were in the throes of another separation. Bayer-Hecht wrote: "My dear husband, I have thought about our last conversation and your advice. I think you are absolutely right when you think we should remain separated for some time for health reasons."[68] She returned to Leipzig, site of her earlier studies, where her brother still lived, but soon left for another sanatorium. Early September found her recovering in Friedrichsbrunn in the eastern Harz mountains, where she yearned—in vain, as it turned out—for a visit from her husband.

One of her letters from this period stands out for its enclosure of one of her own designs, a large-format sketch of a metal ashtray with a round base (see Fig. 2.5). She sent it together with her request that Bayer ask his Bauhaus colleague Walter Haas, responsible for commercial matters as successor to the school's legal adviser, Emil Lange, "what he thinks about this. Under no circumstances show it to anyone from the metal workshop."[69] The request is intriguing providing, as it does, further evidence of Bayer-Hecht's distrust of the creative people at the Bauhaus, and of Moholy in particular, who was still head of the metal workshop at the time. The sketch also shows Bayer-Hecht quietly trying her hand at developing products for the Bauhaus. That the drawing itself is preserved together with her letter suggests that her husband never shared the design, however, or at most, that it was returned to him with no accompanying notes. As his letters to her are lost, we are of course unable to know the precise extent to which he encouraged her design ambitions, but his support for his wife's creative work appears to have been lukewarm at best.

In Leipzig, Bayer-Hecht returned to the Academy for Graphic and Book Arts where she took evening classes in photography and reproduction techniques with the intention of learning skills to support her husband. It was only a brief introduction to

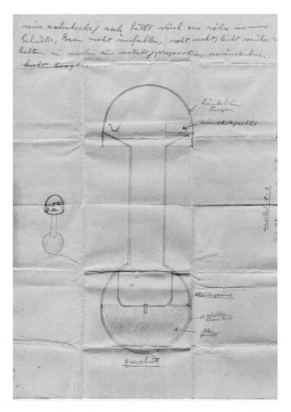

Figure 2.5 Irene Bayer-Hecht: Sketch of a metal ashtray, September 1926. Pencil on paper; Private collection.

reproductive technologies and artwork production consisting of a few evening sessions. The photographer Lucia Moholy had taken a similar course there the previous year, and it was perhaps at her suggestion that Bayer-Hecht enrolled, for the two women were on friendly terms. Certainly, the prospect of helping Bayer complete his graphic design tasks would have appealed to Bayer-Hecht.[70] She made a large number of plates and prints for him.[71] Before one of her visits to Dessau she asked him to give her more to do: "If you have something to photograph, get the machine in time and develop plates, cassettes, etc.; I could copy everything here."[72]

Although Bayer-Hecht was never officially enrolled at the Bauhaus and did not study photography there, her name does appear as no. 34 in the register of Dessau Bauhaus students alongside the names of others who moved from Weimar.[73] She audited individual lectures and courses, for example with the photographer Walter Peterhans in Dessau.[74] Later, she would recall that her photographic contributions to her husband's projects also marked a positive moment in the relationship.[75] On the one hand, she lived independently in Leipzig; as she noted, "I stand alone and have to cope with my life alone."[76] On the other hand, she tried to maintain the marriage, even

from a distance. To overcome this unsatisfying situation, Bayer-Hecht went to Berlin on Bayer's behalf in October 1926 to explore their options for moving there together. Among others, she contacted Johannes "Werbwart" Weidenmüller, an advertising specialist famous for his idiosyncratic theories, who was probably already known to the Bayers from guest lectures he had given at the Bauhaus (see p. 43). Summarizing her conversations in a letter, she wrote, "All spoke very pessimistically about the possibilities of your finding work in advertising, and in any case they advised against starting something here until you have many connections."[77]

This trip to Berlin shows that her husband was already contemplating leaving the Bauhaus by autumn 1926. Bayer-Hecht suggested that he would need to come to Berlin himself for at least a few days to speak with the relevant people in person, but at the same time she anticipated an improvement in the couple's situation in Dessau with the opening of the new Bauhaus building. Her thoughts were probably particularly influenced by the fact that the new building offered a studio in the Prellerhaus that the couple could move into by the end of 1926.[78] In November, however, she became pregnant for the second time and had another abortion, this time primarily for medical reasons.[79] The doctor she consulted was probably the physician Friedrich Popitz, an adherent of the anthroposophy movement and spouse of a former Bauhaus student and graphic artist, Irmgard "Söre" Sörensen, who may have made the contact. This connection to Sörensen-Popitz[80] would later be important for Bayer, as she worked for a major Leipzig publisher and likely facilitated his commissions for the covers of the magazine *die neue linie*.

In fall 1927 the relationship underwent yet another change when the couple moved into a flat in Dessau together, accompanied by two cats. Apparently both had decided to adopt a relaxed attitude, taking their cue from the then novel concept of the "companionate marriage" that was gaining currency at the time in progressive circles.[81] The pair may have come across the popular 1927 book by this title, written by the American social reformers Ben B. Lindsey and Wainwright Evans and published in German translation in 1928. It promoted the concept of a "trial marriage" in which young couples—still unmarried and childless—granted each other greater freedoms, including birth control, in order to foster a bond of friendship.[82] While Bayer evidently saw this as something closer to what would later be called "free love," Bayer-Hecht's own assessment of the union suggests a certain resignation, "We will try to live well together," she wrote him in December 1927. "Now I can calmly say: as a companion. No loved one, no great feelings, but perhaps a good friend whom one likes; is that allowed? Are you now satisfied with me? Have I understood you correctly?"[83]

Less than five years into the relationship, all that remained of the dazzling prince with whom Hecht had fallen in love in Weimar was the workaholic junior master at the Bauhaus, who—from her point of view, in a manner that was typically male—used his good looks and impressive talent to attract a changing cast of female admirers. When the time came, Hecht was happy about Bayer's decision to leave the Bauhaus for Berlin. Although she accompanied her husband to the German capital in the fall of 1928, that moment is also widely seen as the definitive start of their separation. They moved into separate apartments and never attempted to live together again.[84]

3

Intimate Friendships: Bayer's Work and Life at the Bauhaus

Even in its Weimar period, the Bauhaus nurtured a community among its members. Although they coalesced in different circles, this community nonetheless conveyed a strong team spirit to the outside world, as shown by the many well-publicized Bauhaus events and festivities (see Fig. 3.1).[1] Herbert Bayer, too, shared in this pioneering Bauhaus spirit. Later, in Dessau, outside of his marriage to Irene Bayer-Hecht, his social life was almost entirely focused on the institution's teachers and students; apparently, there was little regular contact with the rest of the Dessau population.[2] For Bayer, first as a student and later as a junior master, the Bauhaus formed a basis not only for his professional career but also for the friendships and networks that sustained him for years to come. The school's impact on both his private life and creative development was significant. Furthermore, the social and professional Bauhaus crucible in which Bayer's personality was forged informed many of the positions he later took as a designer, including—and perhaps especially—after the Nazis' assumption of power

Figure 3.1 Herbert Bayer, Poster for Bauhaus dance, 1923. Photo reproduction of a collage; Private collection. © Estate of Herbert Bayer/Artists Rights Society (ARS), New York/VG Bild Kunst, Bonn.

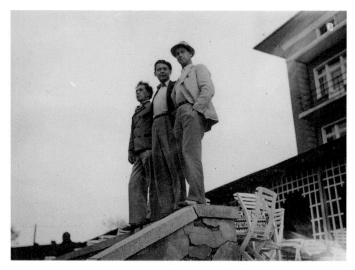

Figure 3.2 Photographer unknown, Xanti Schawinsky, Herbert Bayer, and Walter Gropius, Berlin, 1930. Photograph; Denver Public Library, Herbert Bayer Collection.

in 1933. Intriguingly, a closer look at his network of private, sometimes intimate, relationships with his mentors and companions helps explain how Bayer's work and personality came to be marked by an almost tragic ambivalence in the years leading up to the Second World War.

The core circle that accompanied Bayer even after his emigration from Germany consisted of the former Bauhaus students, Marcel Breuer and Xanti Schawinsky; his teacher László Moholy-Nagy, whom he regarded throughout his life as an underestimated Bauhaus master[3]; his mentor Walter Gropius, who first discovered Bayer's talent and provided a constant source of fatherly friendship; and Ise Gropius, Walter Gropius's wife, who would play a crucial role in Bayer's life during Germany's transition from the Weimar Republic to the Third Reich (see Fig. 3.2). Much scholarly attention has already been given to the life of Walter Gropius.[4] The charismatic founding director of the Bauhaus was, even after his retirement as "Mr. Bauhaus," the key figure in a stable network of former Bauhaus students and teachers.[5] He had spent years in the military as a young man, and the experience shaped his leadership style profoundly. Not only did he dominate the external image of the school during his almost ten-year term as director, he also led it in a deeply authoritarian manner.[6] As Bayer later recalled, "Gropius ... looked like an officer that had just come from the war."[7] Unsurprisingly, he aroused fascination among students and younger colleagues in particular.

Bayer must have struck the director early on as a particularly talented student.[8] "He admired my work, it seems from the very beginning on. He believed in my talent, and he always said, 'you are the most talented of all the people that we have here.'"[9] The art historian Rolf Sachsse has described the young man as having something of a Midas touch particularly for projects involving print and publicity because he "understood how to reduce given formal complexes to the simplest of basic principles

and to process them autonomously."[10] This made him a natural for promotion by Gropius, and it was he who appointed him to the Dessau teaching staff as a junior master in 1925.[11] At the same time, Gropius similarly promoted Marcel Breuer, just as he had previously hired Josef Albers in 1923 and Gunta Stölzl in 1924, although she was awarded the title only in 1927. Bayer's skills gave him clear prospects for contributing to the external presentation of the Bauhaus.[12] Nevertheless, Bayer's relationship with Gropius remained rather formal until their Bauhaus days were behind them. Bayer later recalled, "I didn't have any closer relationship to him until he left the Bauhaus. ... At the Bauhaus he was the Director."[13] A steady friendship between the two men developed subsequently through numerous professional and private activities. These included holidays together near the Swiss town of Ascona and ski trips in the mountains. Bayer later remembered weekend excursions, including picnics, in Gropius's automobile, his Adler prototype (see Plate 8). He emphasized the significance of the friendship that they developed as peers, and stated: "we were just friends, we saw each other all the time."[14] Even as the friendship grew closer, Gropius remained an authority figure for Bayer throughout his life; this hierarchy survived until Gropius's death, as impressively demonstrated in later episodes involving Ise Gropius.[15] Once this cohort collectively left the Bauhaus for Berlin in 1928, Walter and Ise Gropius lived very close to both Marcel Breuer and Bayer, and the circle often gathered for meals.[16]

Perhaps the most important member of this group for Bayer was Marcel Breuer, who was Bayer's junior by two years and his best pal. Breuer came from a Jewish-Hungarian family and was known as Lajko to his friends; he had enrolled in the Bauhaus in 1920—a year before Bayer—and turned to furniture design early on.[17] In 1921, Breuer and Gunta Stölzl (future Bauhaus master and his girlfriend at the time) collaborated on a "Romantic Armchair," later renamed the African Chair, as an expression of their affection for each other.[18] In the years that followed, Breuer's enthusiasm for Constructivism and functional design led him to tubular steel furniture, which soon became his trademark. Like Bayer, he was prominently involved in preparing the 1923 Bauhaus exhibition. After Bayer had left for Italy in August of that same year, Breuer quit his position as a paid journeyman at the Bauhaus to spend several months in Paris. Until Bayer left for the United States, Breuer was probably the person with whom he shared his most intimate thoughts. Commenting ironically on their friendship in 1935, Bayer stated, "I'm here for your love, you won't at any rate find anything better."[19]

The many parallels in the two friends' Bauhaus trajectories have been described in detail elsewhere.[20] They were simultaneously appointed to their posts as junior masters in Dessau. In 1926, soon after Bayer's marriage to Irene Hecht, Breuer married the Bauhaus student Martha Erps, a member of the weaving studio. After the Breuers divorced in 1934, contact between the two friends intensified again. In contrast to the position of Gropius and other, older Bauhaus members, both men shared a common focus on their own performance as individuals. As Magdalena Droste has explained, the two belonged to a new generation less inclined to hand over authorship of their creations to an abstract collective construct called "the Bauhaus." Both signed their designs early on, as a symbol of their conviction in their own talent and the significance of their work.[21] Breuer attached great importance to his work as an architect and did not

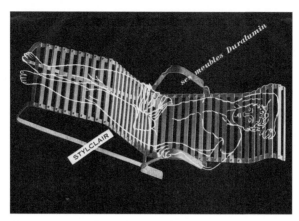

Figure 3.3 Herbert Bayer, Catalogue for Marcel Breuer's aluminum furniture designs, c. 1933. Cover, French edition, offset printing; Private collection. © Estate of Herbert Bayer/ Artists Rights Society (ARS), New York/VG Bild Kunst, Bonn.

like being reduced to his tubular steel furniture; later he even wanted his chairs removed from the 1938 Bauhaus retrospective at MoMA, asserting—as Bayer later quoted him— "I never learned anything at the Bauhaus; I don't want to have been there."[22]

Working as they did in different fields, the comrades were not in direct competition with each other. Indeed, they often cooperated closely, for example, when Bayer designed stationery and advertising material for Breuer's furniture series (see Fig. 3.3), or in 1927 when Breuer planned his unrealized *Bambos* houses on the Dessau campus for six of the junior masters, including Bayer and himself.[23] The two were also paired by the fact that Breuer, like Bayer, terminated his contract with the Bauhaus when Gropius did. When Xanti Schawinsky left the Bauhaus soon afterward, in the fall of 1929, the last member of a trio of sworn friends had departed Dessau. As the photographer and *bon vivant* from the Bauhaus orbit Jorge Fulda later wrote to Bayer, including a mention of the threesome's mentor, "it is nice to see that the friendship between you, Xanti, Pius [Gropius], and Breuer, forged in the classical era in Weimar, holds you together thick as thieves."[24] Schawinsky later described how they had all lived in the Dessau Prellerhaus, the studio wing of the new Bauhaus building, where the famous single balconies proved to be "ideal communication places," from which,

> contact with neighbors could be established by shouting, without having to visit each other. If [Josef] Albers wanted to present a new joke, he only had to call out the names of the floor's inhabitants—Lajko, Herbert, Xanti [Breuer, Bayer, Schawinsky]—and they would "meet" on the small balconies. From there they could also look into each other's studios through the large glass walls, unless the curtains were closed. The "transparency" was part of everyday life and was a thoroughly positive experience.[25]

Schawinsky, born in Basel four years after Bayer, was the child of Polish-Jewish parents and the youngest member of the trio. He enrolled at the Bauhaus in the

spring of 1924, after first visiting the school in the summer of 1923 to see the Weimar exhibition.[26] Bayer was still on his travel year during Schawinsky's first semester, so the two could not have met until the winter of 1924 at the earliest. A very intensive friendship must have formed quickly between the two, because Schawinsky stood as best man at Bayer's wedding less than a year later, in November 1925.[27]

Schawinsky was very interested in Oskar Schlemmer's stage workshop and followed it intensively for years, even acting as Schlemmer's teaching assistant in Dessau. From 1927 on, he simultaneously pursued commercial graphics and, when Schlemmer departed the Bauhaus in 1929, he, too, left Dessau for Magdeburg, where he headed the graphics department for the city's office of construction.[28] As saxophonist in the Bauhaus band, Schawinsky was a fixture at all Bauhaus celebrations. Bayer wasn't the only one to appreciate his humor and cheerfulness, which often made him the life and soul of the party. Schawinsky was also a permanent member of the "Ascona Circle" that often accompanied the Gropiuses during their vacations on Lago Maggiore from 1930 on.

Bayer's friendship with Schawinsky was unique in that they became close when the latter was still Bayer's student. Schawinsky, too, drew on his Bauhaus training in advertising as the basis for his future livelihood. In his final project before he left Dessau, a Bauhaus commission, Schawinsky was one of a group of students who designed the Junkers stand at the *Gas und Wasser* exhibition in Berlin in 1929. It was a groundbreaking design, but a long-lasting dispute with Joost Schmidt and others over the authorship of the installation ensued. Decades later, Schawinsky made a point of stating on the record that he had "never been a member of the advertising department."[29]

It was among this circle of friends and the wider Bauhaus context that Bayer developed his identity as a graphic designer, a profession for which there was not yet a term in German. When Bayer headed the advertising workshop, its equipment was limited to a machine for manual typesetting and one sans-serif typeface (Breite Grotesk by Schelter & Giesecke) in various sizes and cuts, plus a few wooden letters for poster design, while the available presses consisted of a platen press and a roller proof-press for posters. This naturally restricted creative opportunities. It also created additional work, as when, in order to produce a typographical photo, the photograph and the lettering had to be combined in two different steps.[30]

A famous photographic portrait of Bayer, one that he later used repeatedly, was taken by Irene Bayer-Hecht in 1926. Initially unpublished in its original state, it shows him at his desk, drafting the artwork for an advertising folder for the city of Dessau (see Plate 2), using text and image elements in a grid. This photograph, of which there are at least two versions (see Fig. 3.4a/b), is a visual representation of the new profession of the graphic designer—not only drawing but also controlling all steps in a project's implementation.[31] It is thus a key image from a time in which there were not yet any visual prototypes for illustrating the profession. Years later, Bayer would recognize the portrait's iconographic potential.[32]

In October 1927 Bayer arranged for the Bauhaus to host the second instruction week in advertising ("Werbeunterrichtliche Woche"), a session led by Johannes "Werbwart" Weidenmüller on behalf of the Verband deutscher Reklamefachleute (VdR, the Association of German Advertising Experts) (see Fig. 3.5).[33] In addition to

Figure 3.4a/b Irene Bayer-Hecht: Herbert Bayer designing the *Dessau* prospectus, Bauhaus Dessau, 1926. Photograph; Private collection.

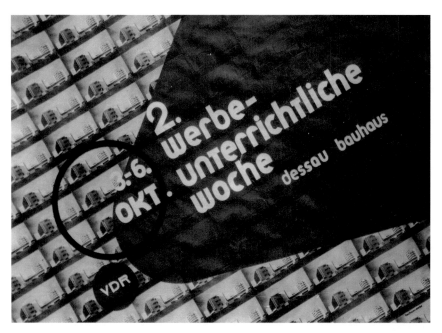

Figure 3.5 Bauhaus advertising workshop: Poster design for an instruction week in advertising at the Bauhaus, October 1927. Photo reproduction of a poster; Private collection.

Gropius and Moholy-Nagy, the Bauhaus participants at the session included Bayer, Albers, and Joost Schmidt. The fact that the school subsequently gave its workshop for publicity (Reklamewerkstatt) a new name—the workshop for typography and advertising (Werkstatt für Typographie und Werbung)—attests to the event's impact on the institution.[34] Bayer's subsequent work developing the workshop's curriculum accordingly reflected the content of the week-long course. He later summed up the curriculum that he developed, "Treatment of advertising at a glance, differentiation of advertising media; 'elementary' and 'attention-grabbing' design. Drawing and the currently most important, 'advertising-compatible use' of photography and film … In the fourth semester the 'construction and preparation of the advertising plan' was added as well as the 'purpose- and time-bound' work on commissions."[35]

Bayer was also progressive in his interest in considering advertising research through social science, as demonstrated by course offerings on the "Systematics of Advertising" and the "Effects of Awareness."[36] Among the latter, he listed "eye-catching attention," interest in "penetrating the subconscious," "memory as remembrance," "pleasing and aesthetic pleasure," and finally "persuading and convincing."[37] The terms are prescient for later-stage models of advertising impact research. With his curriculum, Bayer introduced a new subject to the Bauhaus, one that corresponded with what was being taught contemporaneously at other institutions such as the Folkwangschule Essen and the Kunstakademie Düsseldorf (Düsseldorf Art Academy).[38] It is intriguing that he later recalled employing very little theory in his teaching, favoring a "learning-by-doing" approach with students working on commissions.[39]

Of all the figures associated with the New Typography, Bayer was the most outspoken proponent of its most radical innovation: all-lowercase lettering. The approach, which Moholy had already suggested in his 1925 newspaper article "Bauhaus and Typography," was easy to recognize—an unparalleled symbol of the era's belief in efficiency.[40] Around that time, Bayer had written to the standardization pioneer Walter Porstmann inquiring about the idea of introducing a uniform font (an *Einheitsschrift*) that avoided capital letters entirely.[41] Though setting type exclusively in lowercase was unusual—and sometimes even dysfunctional, particularly for the German language, which capitalizes all nouns—Bayer and its other adherents endorsed it vigorously: "we write everything in small letters, because it saves us time." This was sometimes printed on Bauhaus stationery, along with a more discursive credo:

1. this spelling is recommended by all innovators of writing as our future typeface. see the book *sprache und schrift* by dr. porstmann, verlag des vereins deutscher ingenieure [publishing company of the association of german engineers], berlin 1920.
2. our writing does not lose anything by using lowercase, but becomes easier to read, easier to learn, much more economical.
3. why use two characters, e.g. A and a, for one sound, a? one sound one character. why use two alphabets for one word? why double the number of characters when half of them suffice?[42]

This introduction of uniquely lowercase lettering is arguably the most controversial aspect of Bauhaus typography. Indeed, it is one of the few examples of an innovation

originating in Bauhaus communication that was unable to gain traction.[43] Even if the inner Bauhaus circle—largely the same group that would move to Berlin together in the late 1920s—maintained the practice in their private correspondence for years, and Bayer hewed to it for life, the idea fell flat with the broader public.[44]

From today's perspective, the overall significance of the Bauhaus print material that bore the mark of the broader New-Typography movement—materials that were designed, in many cases, by Bayer—can hardly be overestimated in terms of how the institution was perceived. After early efforts to create a Bauhaus corporate design (see Fig. 3.6), not only was the advertising for the institution's products rendered in a loosely defined "Bauhaus style," so too were the print media designed by the school for its clients.[45] Commercial commissions represented a lucrative opportunity to generate income for the Bauhaus, although Bayer later clarified that, "little was produced that was actually used."[46] A small group of students who saw their future more in graphic design than in architecture or the other applied arts found their way to the school's new advertising workshop. As Bayer recalled, it never drew more than eight to ten students at a time.

THEATERSTUHL mit Klappsitz.
Sitz, Rücken- und Armlehne aus schwarz mattiertem Holz.

B2

Sitzbreite ca. 550 mm
Gummi-Anschläge.

Figure 3.6 Herbert Bayer, Sheet for the loose-leaf catalogue of Bauhaus workshop products, c. 1927. Letterpress; Denver Art Museum, Herbert Bayer Collection and Archive. © Estate of Herbert Bayer/Artists Rights Society (ARS), New York/VG Bild Kunst, Bonn.

Perhaps it is telling that Bayer never regarded his teaching at the Bauhaus as an intellectual achievement. "I was young and not particularly aware of the currents and trends in the art world of the time," he wrote, stressing that his work there "was based more on instinct than on reflection."[47] The advertising workshop was dominated by practical work on internal and external commissions, which were appreciated as study projects and gladly undertaken collectively. As he summarized, "students learned by participating in the productions, by self-experience."[48] It was only after Joost Schmidt took over the workshop in 1928 that didactic exercises were introduced.[49] Schmidt also taught the theoretical principles of typography, something Bayer had not done.[50]

Several recent comprehensive publications on Bauhaus typography and graphic design showcase the important commissions produced by Bayer and his students.[51] The works ranged from the aforementioned Dessau prospectus (see Plate 2) to some product brochures for the Fagus company.[52] Other examples are the poster for a Kandinsky exhibition at the Anhaltischer Kunstverein (Anhalt Art Association) in Dessau and the advertising material created for the exhibition *Neue Baukunst* (New Building Arts), commissioned by the Vereinigung für junge Kunst (Association for Young Art) in Oldenburg, which have been lost but are documented in correspondence.[53] This indicates how respect for the Bauhaus advertising workshop had grown outside the school, but above all, there is the printed matter for the Bauhaus itself, which slowly and steadily contributed, one small step at a time, to the institution's overall corporate image.[54] In addition to innumerable drafts for house letterhead, product catalogues, and announcements of festivals, lectures, and curricula, this was especially true of Bayer's recruitment booklet for prospective students from 1927, which included a forty-page section with local ads that was essentially co-designed by students of the advertising workshop under the junior master's supervision (see Plate 3).[55] Here ideas of Bauhaus typography were incorporated into a more comprehensive approach to printed matter.

The cover, adorned with Irene Bayer-Hecht's snapshot of the iconic Prellerhaus balconies of the new building in Dessau, is a particularly good illustration of the central role Bayer accorded to melding photography and typesetting in his new approach to layout[56]: "It was a logical leap from typography to photography."[57] In recounting his trajectory as a designer, Bayer emphasized that he had no formal training in photography and Moholy-Nagy had not instructed him informally; he was, however, inspired by Moholy to simply carry a small camera with him and press the button.[58] His wife, too, continued to take photographs on his behalf; she developed and enlarged his photographs and was also involved in producing advertising photographs during Bayer's Bauhaus period. The couple playfully illustrated this in the sheet they contributed to the March 1928 portfolio *9 years of bauhaus*, a collective farewell gift to Gropius. The Bayers' sheet consists of ninety-six individual images from a film strip: Herbert Bayer's portrait mounted on cardboard, accompanied by one tiny photograph of Irene Bayer-Hecht as a "signature." Presumably it was she who had operated the camera.[59] In contrast to this playful experiment, Bayer's later studio works, especially his series of photomontages around the Lonely Metropolitan (see Fig. 0.1), were carefully executed productions. When he left Europe, his involvement in art photography came to an end.[60]

By the time Gropius received his farewell portfolio, the Bayers were already decamping from the Prellerhaus for Berlin. Unable to meet Walter Gropius in person, Herbert Bayer had written him on January 12, 1928, timing his letter to arrive before the Bauhaus's first budget meeting of the year. His contract with the city of Dessau was set to end on March 31, 1928, and he had reached a decision:

> I would like to leave the Bauhaus and have the firm intention of handing in my resignation on April 1, '28, effective October 1, '28. I am informing you now so my salary can be freed up for other uses. I am leaving because I have a strong desire to work, which is not possible here to the desired extent. I am not satisfied with my work and my achievements at the Bauhaus because the pressure on me makes it impossible to fully use my skills. I also want a more natural life in general. The unfavorable living conditions contribute to this decision. And yet I am sorry to leave the Bauhaus. I hope that you will take this decision in the right way and will not hold it against me.[61]

Although Bayer only announced his intention to resign in the future, already that same day, leading Bauhaus figures such as Oskar Schlemmer felt that Bayer, in thus informing Gropius, had "formally resigned."[62] As nothing more official has survived in the records, Bayer presumably realized that nothing more formal was required; his contract was set to expire anyway.

On April 1, 1928, after renewed quarrels with local politicians, Walter Gropius resigned from his post as Bauhaus director, ending almost ten years at the institution's helm.[63] When the Masters' Council convened on the afternoon of January 17, 1928, Moholy-Nagy declared that he, like Gropius, would also be departing. The council agreed for the time being to keep the imminent resignations of the junior masters Marcel Breuer and Herbert Bayer quiet.[64] As Bayer remembered it, their plan was to announce staff cutbacks and the departures at the same time.[65] Bayer later explained that he and Breuer had decided to go to Berlin together. He felt that, at age twenty-seven, he was too young to continue teaching without acquiring more work experience, "The teacher shouldn't be learning in a school and then just turn around and teach things that he learned. He should go out in the world and gain some experience and maturity before he becomes a teacher. ... We thought, well, there are all those theories of the Bauhaus, we should now translate them into practice."[66]

To lay the groundwork for this post-Bauhaus career, Bayer had prepared a complete redesign of the in-house journal *Bauhaus*. The school had launched the publication, with Gropius and Moholy as the official editors, in the winter of 1926/27 to coincide with the opening of the new Gropius-designed Bauhaus building. In the first year Oskar Schlemmer and Hannes Meyer had each taken responsibility for compiling an issue (on theater and architecture, respectively), and now, with the first number of 1928, it was Bayer's turn, with photography and advertising. Though still quite new, the quarterly was already circulating to approximately 3,000 readers, including much of Europe's avant-garde, making it an optimal way to showcase Bayer's talents. His issue appeared on February 15, 1928, a month after he gave notice of his resignation as a junior master at the Bauhaus.

Radically modifying the magazine's tabloid dimensions to reflect the newly introduced DIN standards (A4) and giving it a new stapled saddle binding, Bayer also overhauled the interior from format to typeface and the design of the spreads.[67] Whereas the earlier volume had been published in newspaper style, letterfold plus folded in half, each page visually packed, Bayer's layouts were decidedly more balanced. By far the most noticeable change was the issue's striking cover, which soon made a name for its designer (see Fig. 3.7).[68] Bayer's innovative three-dimensional still life combined a folded back issue of *Bauhaus* from 1927 with some of the commercial artist's tools and geometric objects—sphere, cone, and cube—to create a complex arrangement of shapes and shadows, a clever staging of the symbolic elements associated with Bauhaus teaching.[69] The innovative nature of this cover would earn him major international recognition: three years later, in 1931, it won Bayer first prize at the *Foreign Advertising Photography* exhibition at the Art Center in New York City, beating submissions by the likes of Man Ray, André Kertesz, Germaine Krull, Paul Schuitema, Piet Zwart, and even his former teacher, Moholy-Nagy.[70]

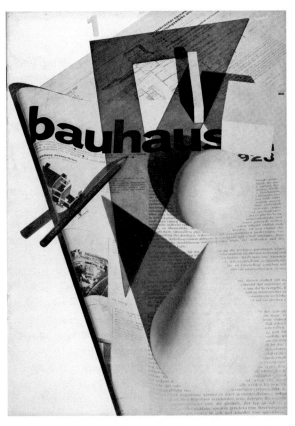

Figure 3.7 Herbert Bayer, *Bauhaus* magazine No. 1, 1928. Cover, offset printing; Denver Art Museum, Herbert Bayer Collection and Archive. © Estate of Herbert Bayer/Artists Rights Society (ARS), New York/VG Bild Kunst, Bonn.

In preparation for publishing his *Bauhaus* cover, Bayer worked up three potential versions of it. The first may have been deemed too confusing for commercial use, as the old issue which appeared in the photograph still had the year 1927 clearly visible on its own cover. Nonetheless, Bayer used reproductions of this version for books and catalogues.[71] This alternate version was also the first to circulate in the international trade press; it was published in the anthology *Modern Photography* in fall 1931 as a special issue of *The Studio*. This was Charles Holmes's influential magazine, which promoted fine and decorative arts since 1893 and was published in both London and New York. In *Modern Photography*, the full-page reproduction of Bayer's magazine cover was entitled only *Composition,* without reference to its function. And along these lines, the editor's caption interpreted this picture not as a functional journal cover, but as a work of art; he wrote that, "the overlapping shadows and the geometrical objects are disposed in a manner recalling the composition of abstract paintings."[72] Bayer's second version of the cover, which was originally printed in an advertising leaflet, replaced the irritating "1927" with "1928," and added a prominent "1" to clarify that this was indeed the first number of the new volume.[73] For the final version that ran on the cover, Bayer supplied a more discreet number in light gray instead of using the eye-catching numerals of the previous two versions.

Inside this February 1928 number of *bauhaus*, the journal chiefly showcased photography and advertising projects, a suitable sendoff for Bayer, Moholy, and Breuer. The overall theme likely drew its impetus from the special "advertising week" workshop led by Johannes "Werbwart" Weidenmüller in Dessau the previous autumn. The issue opened with a short introduction by Weidenmüller, followed by Moholy's manifesto-like piece "fotografie ist lichtgestaltung" (Photography is Creation with Light), which was illustrated with his photograms and three photographs credited to "Bayer-Hecht." Next came an essay by Bayer, "Typografie und Werbesachengestaltung" (Typography and the Design of Advertising Material), in which he laid out guidelines for the sort of typographic work he planned to do in the future. Breuer was also present in the issue—not only in the double page showing his designs for the Bambos houses in Dessau but also in a full-page ad for his tubular steel furniture on the inside back cover, which was presumably designed by Bayer, just as the first prospectus for Breuer's furniture.[74]

A few days after this *bauhaus* issue was published, the national trade journal *Wirtschaftlichkeit* (*Economic Efficiency*) ran a four-page article by Bayer on advertising photography. It featured illustrations of four of his works, including a self-portrait as part of his New Year's greeting card 1927–1928, and it was clearly another part of his efforts to promote himself in professional circles. Bayer used an ambitious phrase to characterize his work: *photographisch naturwahre Überrealitäten*, or roughly, "hyper-realities that are photographically true to nature."[75] Rather suddenly, Bayer had a substantial presence in international avant-garde and trade journals with a programmatic claim that would characterize his graphic design over the next decade.

That spring, still while preparing his departure from the Bauhaus, Bayer also made his first independent forays into exhibition design.[76] For *Pressa,* the groundbreaking *International Press Exhibition* that opened in Cologne on May 12, 1928, probably with Moholy-Nagy's encouragement, he planned a room on book design within a section on

Figure 3.8 Herbert Bayer, "Elementare Buchtechnik" room installations at *Pressa* 1928, Sketch from his answer to Arthur Cohen's questionnaire #4, 1982. Pen on paper; Denver Public Library, Herbert Bayer Collection. © Estate of Herbert Bayer/Artists Rights Society (ARS), New York/VG Bild Kunst, Bonn.

contemporary European book art, titled, "Elementare Buchtechnik" (elementary book technology).[77] Remembered now as a landmark in the history of exhibition design, *Pressa* showcased many leading figures of the international avant-garde, including El Lissitzky, who developed a striking photomontage display for the Soviet pavilion. According to Bayer's later recollections, his room on "Buchtechnik" showcased the sort of typography then being practiced at the Bauhaus by Moholy, Bayer, Schlemmer, and Joost Schmidt. Photographs of this part of the *Pressa* exhibition have not survived but, as Bayer later sketched it, the presentation was clear and simple, in pure white, with vertical wall panels constructed of wooden slats, on which the exhibits—book covers and interior layouts—were framed and mounted under glass, then hung diagonally (see Fig. 3.8).[78] It also appears that Bayer designed a *Pressa* exhibition stand for the Berlin Central Housing Welfare Company, though he never included it in later work lists.[79] For his part, Moholy's text in the exhibition's companion volume, repeating the title of Bayer's section, called for a fundamental change in book production, stressing functionality and describing the role of newly available photographic and reproduction techniques.[80]

In sum, by spring of 1928 Bayer and many of the key people in his personal and professional life were planning their departures from Dessau. As Moholy-Nagy and Breuer would also turn their backs on the Bauhaus, the institution was on the cusp of a real generational shift. Once in Berlin, Bayer chose to share an apartment with Xanti Schawinsky, who later recalled: "The close friendship with Herbert Bayer soon had the effect that we shared an apartment and studio. Breuer, whose wife went on a trip around the world, also moved near us."[81] The Berlin chapter of Bayer's life had begun.

Sturm und Drang: Life in Berlin

Despite his intention to leave Dessau in spring, Bayer continued to have some teaching responsibilities at the Bauhaus until May 1928. School records from the start of the summer semester in April document the newly restructured faculty, with Joost Schmidt as the head of the Sculpture and Advertising Workshop, while also noting that "advertising is supervised to 3/5 by Herr Bayer." According to this source, Bayer's official departure from the Bauhaus, together with Breuer's, took place on May 18.[1] The precise date of Bayer's actual move to Berlin cannot be reconstructed from the sources, however, but it was most likely in the late summer of 1928.

Before, his summer was dominated by an almost three-month-long break from work—and marriage—during which he, Marcel Breuer, and Xanti Schawinsky took their bicycle tour in Italy and the South of France (see Fig. 4.1).[2] Bayer and Schawinsky first traveled by train to Zurich, continuing by bicycle to Ascona, where they visited friends (including Ise Gropius's sister Hertha Frank and her daughter Ati, whom the Gropiuses later adopted). After two more weeks of cycling, they reached Genoa, met Breuer, and continued via Monte Carlo and Provence to Marseille, before taking the ferry to Corsica. Occasionally, Irene Bayer-Hecht joined the group on the road, as documented by several photographs, some of them taken by herself.[3] In his memoirs Schawinsky recalled several episodes from this trip, including the triad's constant search for romantic flings, and described one such encounter:

> in a piazetta above the bay we chat up a slim blonde. she stops and smiles, she likes us, she likes herbert best of all. she is polish. mademoiselle polska. herbert makes a date with her for the evening, we take pictures of her and of us dueling over her. herbert has won. then to the casino ... roulette, *rouge et noir.* ...

> they've lost half of their holiday money in no time, none of their losses recovered, finally stopped before it's all gone, you should see how fast it goes, what a mess, that evening lajko [Breuer] goes back inside [the casino], herbert has his rendezvous with the pretty polish woman ...

> in the morning hours herbert arrives; we wake up. well? it was a big flop. she brought her mother with her, and she ordered the most expensive champagne, a bottle that cost as much as a whole bicycle! so they were dancing; what's the big deal? she must get a percentage from the bar; it was a real flop. now i'm broke; you have to help me out until i get the money wired. what a mess, what a pigsty! we console him and laugh our heads off. *come better times!*[4]

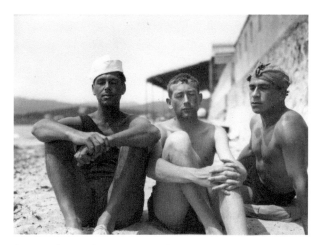

Figure 4.1 Photographer unknown, Three friends at the beach in Southern France (Herbert Bayer, Marcel Breuer, Xanti Schawinsky), summer 1928. Photograph; Denver Public Library, Herbert Bayer Collection.

Instead of the romantic sketchbooks that had accompanied his earlier trip to Italy, Bayer now brought along a cheap bellows camera. (He recalled it as "light in weight to travel with" and later bought a Rolleiflex and a Contax.[5]) In Marseille, he photographed the Pont Transbordeur, the city's landmark suspension ferry—a "fantasy of wire and air," as he described it in a three-page article that he was able to sell to *Das illustrierte Blatt* in Frankfurt after the end of his journey (see Fig. 4.2).[6] Two months later, the same popular magazine published eight more of his photographs, headlined "From my Visual Notebook" and featuring unusual perspectives and striking light-and-dark contrasts.[7] The photos marked a rare foray for Bayer into pure photography without a graphic design component; his summer of experimentation later bore fruit when more of his photos were selected for inclusion, presumably with Moholy's blessing, in the 1929 Werkbund exhibition *Film und Foto* (*FiFo*, see p. 62).

Knowing the benefits that his connection to the Bauhaus would bring to his new career, once he was back at work in the Metropolis, Bayer was savvy about referring to Dessau when he could. One of the first business cards he designed for himself cleverly emphasizes both his association with and his separation from the school (see Plate 4). The first version was printed in February 1928—well before his move to Berlin—to announce his membership in the Association of German Advertising Experts (Verband deutscher Reklamefachleute, VdR); it playfully sets off the sans-serif *d* in *dessau* against its mirror image, the *b* in the name *bayer*. The design also employs a largely empty right-hand column to draw attention to his VdR membership, with the association's logo at the lower right, and a hint that the card is part of a comprehensive VdR register for the advertising branch. What at first appears to be an infelicitous typo in the word *werbeindustrie*—here spelled *werbindustrie*—actually refers to the terminology promoted by "Werbwart" Weidenmüller, who still exerted a strong

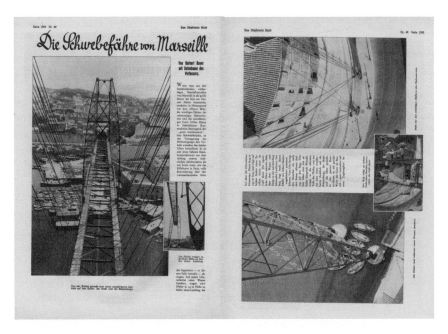

Figure 4.2 Herbert Bayer, magazine article on the Pont Transbordeur in Marseille in *Das illustrierte Blatt*, no. 49 (December 8, 1928). Offset printing; Private collection.

influence on Bayer's approach to advertising. The accompanying statement, running in small red type over the portrait photo, stresses the importance of functionality in advertising design and announces its author's plans to implement the Bauhaus idea in commercial design. It then lists Bayer's range of expertise, "I use all appropriate means of representation of typography, photography, painting, and drawing, for trademarks, stationery, advertisements, brochures, posters, advertising structures, and other advertising materials."

In the fall of 1928, Bayer modified the card to reflect his move to Berlin; the second version includes a conspicuous X over the words *dessau, bauhaus* at the top of the card and the addition of middle lines running his new address and telephone number—Hardenbergstraße 24 in Berlin's chic Western district of Charlottenburg, which he abbreviates as "chlbg" in the text.[8] The 1930 official directory of the city of Berlin lists Bayer for the first time as citizen, declaring a *Reklameatelier* (advertising studio) at this very location.[9]

As it turns out, Bayer's first steps into freelance work led him straight back to magazine design. The idea of establishing a German edition of *Vogue*, with its focus on society and upmarket fashion, probably came from Francis F. Wurzburg, the German-born vice president of Condé-Nast, who envisioned a mix of independent (German) editorial content running alongside stories, fashion spreads, and cover illustrations drawn from the international edition. The publishing house had already successfully launched international editions in England (1916) and France (1920), and was eager

to insert the magazine into yet another prosperous market.[10] The first issue of *Deutsche Vogue* appeared in Berlin in April 1928 and was circulating at 35,000 by the fall.[11]

At that time, Condé-Nast's sole advertising partner for all of *Vogue*'s international editions was the Dorland advertising agency, one of the first global players in the field. Founded in 1883 in Atlantic City by the ad man John M. Dorland, it had opened its London office in 1905, rolling out a series of sometimes steady, sometimes temporary outposts in Berlin, Paris, Brussels, Rome, Zurich, and Saint Petersburg by the dawn of the First World War. By 1920, the London branch had grown to more than 100 employees; a fully independent Paris branch was established in 1924, and by the 1930s Dorland had become one of the five largest ad companies in the world. Dorland's Berlin bureau, after wartime hostilities necessitated a pause in operations, was officially reestablished in 1928 and duly entered into the commercial register at the local district court as a limited liability company—Dorland GmbH Berlin—on March 30, 1928. Walter S. Maas, chief of Dorland's Paris office, was listed as sole shareholder. Mehemed F. Agha, *Vogue*'s pioneering creative director, held power of attorney and essentially ran the Berlin branch until spring 1929, the year he left Europe for New York.[12]

In early 1929, Condé Montrose Nast himself had come to Berlin together with *Vanity Fair* editor Frank Crowninshield who recounted that he and Nast secured Agha as art director not only for all of *Vogue* but also for *Vanity Fair* and other flagship titles in the Condé-Nast empire in New York while "sitting at the death-bed of the German edition of *Vogue*."[13] Agha therefore probably conducted his first interview with Bayer for replacing him as a graphic designer until the end of 1928 at the earliest, already knowing that he would hire the former Bauhaus master for a magazine that was about to cease to exist.[14] Bayer recalled this encounter as follows:

> When I came to Berlin, I started to work free-lance, and I showed my work also at the newly opened office of *Vogue* and the art director, Agha. ... Agha saw it and said, "well, we want you and we like you here," and I said, "yes, that's fine I can do that," and so I was art director of *Vogue*—because he wanted to go back to Paris and I was to replace him, which happened then.[15]

A glance at the magazine reveals that from its launch in April 1928 through the May 1929 number, German *Vogue* maintained a rather conventional look, with few signs of striking out toward the New Typography. It is only with the June 1929 issue that we see evidence of a full design relaunch—and, with it, the fingerprints of Herbert Bayer: sans-serif fonts, asymmetrical typesetting, and the abandonment of frames and ornamentation in favor of white areas and full-page photographs (see Fig. 4.3).[16] In 1981, Bayer mentioned creating the page layouts for the magazine.[17] While one searches in vain for his name inside, we must of course remember that this was not a time when the names of art directors appeared on mastheads alongside those of the editors.

By the time of its makeover, however, German *Vogue* was indeed already on its death-bed. The highly unprofitable edition ended with the October 1929 issue.[18] Although Bayer's major relaunch must have taken several weeks to prepare, he appears to have designed only five issues of the magazine over a period of less than six months. Interestingly, by 1935, he was already hinting that he had enjoyed a somewhat longer

DIE
GROSSE
SAISON
VON DEAUVILLE

Figure 4.3 Magazine page from German *Vogue* under the art direction of Herbert Bayer (July 1929). Offset printing; Private collection.

career at *Vogue*. That year, when Walter Gropius sent out a questionnaire to former Bauhäusler to inquire into how their professional lives were unfolding, Bayer noted that he had served "1928–1930 artistic director of the society magazine *Vogue*"—a two-year association that conveniently papered over some of the typical gaps in the résumé of an up-and-coming freelancer.[19]

Though their professional collaboration was short-lived, Agha himself must have benefitted from seeing Bayer working at close hand. Bayer's approach to design would have made Agha infinitely better acquainted with the principles of the New Typography.[20] Soon he was presenting the new style to the broader American public, not only as design director of many mainstream American magazines, but also as a theorist. His article "What Makes a Magazine 'Modern'?" in the October 1930 issue of *Advertising Arts* introduced the community of US advertising professionals to German periodicals from the Bauhaus environment.[21] A year later, Agha served on the jury of the aforementioned *Foreign Advertising Photography* exhibition in New York, for which Bayer won the top prize.

The shuttering of German *Vogue* in the fall of 1929 had already been preceded by the sale of Dorland GmbH Berlin to Condé-Nast that March.[22] But the ownership did not last long. The combination of the magazine's closure and the Stock Market Crash of October 25, 1929 prompted Condé-Nast to liquidate the Dorland office. This presented an opportunity in November 1929 for Walter Matthess, previously head of advertising for German *Vogue* at Dorland; he expressed interest in taking over the ad agency completely and spinning it off from the rest of the international consortium. On January 13, 1930, he bought the company from Condé-Nast and began courting Bayer to serve as its creative motor in a separate "Studio Dorland."[23] The ad man, as historian Alexander Schug has put it,

knew that the future of the Dorland [Berlin GmbH] could only be secured with this renowned designer [Herbert Bayer]. However Matthess could no longer afford such a highly paid and well-known graphic designer as an employee in the middle of the world economic crisis … Matthess decided to run the commercial business of Dorland GmbH, while Bayer was to take over the "dorland studio" as artistic director. The "dorland studio" … became financially independent and was therefore managed by Bayer on his own responsibility.[24]

Bayer was happy with the agency's newly independent status. He later put it thus:

It then happened that *Vogue* eventually closed in Berlin and Dorland then said, "well, why don't you come and make an arrangement. You do all the work for us, but you are free for yourself, but just call it "Studio Dorland." And I wanted that, I wanted an impersonal signature, and certain things which I did personally, I always said "Bayer-Dorland."[25]

Perhaps not surprisingly, Bayer's tendency to embroider his employment history persisted in the politically and economically uncertain years that followed—especially when he was planning his emigration to the United States. The short biography that ran at the back of the important catalogue to the 1938 Bauhaus retrospective that he co-curated at the Museum of Modern Art in New York stated that he had served as "Director of Dorland advertising agency" from 1928 to 1938 (see p. 191).[26] This statement is, of course, grossly misleading, as he only ran a graphic design studio *affiliated* with the Dorland agency—no more, no less (see Fig. 4.4).

In March 1930, Bayer received a prestigious commission under his own name: to design covers for the new monthly magazine *die neue linie* (*The New Line*). Founded by the Leipzig publishers Otto and Arndt Beyer, the fashion magazine was a highly

Figure 4.4 Unknown photographer, Work at Studio Dorland (Mehmet F. Agha and Herbert Bayer in the back), 1929. Photograph; Denver Public Library, Herbert Bayer Collection.

visible project. We know from Ise Gropius's diary that the Beyers were already in touch with the Bauhaus in 1927, initially within the context of the *Pressa* exhibition. Ise Gropius noted, "Herr Beyer from the Beyer publishing house is here to discuss with gr[opius] a project he has in mind for the Cologne press exhibition. Since the publishing house produces books on housing economics, he wants to make a generous propaganda effort by building a modern house for the exhibition."[27] Two years later, in the spring of 1929, the publishers were ready to give a thorough relaunch to their flagship magazine *Frauen-Mode*, with an eye toward making headway in the field of elite society magazines. This was the same market occupied, if only briefly, by German *Vogue*, alongside the segment's undisputed leader, *Die Dame* (*The Lady*), published by Ullstein Verlag. Shortly after Bayer gave *Deutsche Vogue* its new look in June 1929, the publishers of *Frauen-Mode* announced that their magazine would be appearing under a new name: *die neue linie*.[28]

Frauen-Mode's August 1929 issue already contained a preview of the type of illustration that would grace the cover of its successor: a stunning photomontage by Moholy that departed fundamentally from the magazine's old Art Deco look. It thus appears that a number of design decisions were already introduced that summer, even before *die neue linie* first rolled off the presses in September. The changes were presumably introduced by the former Bauhaus student Irmgard Sörensen-Popitz, simply "Söre" in her published work. Söre had studied with Jan Tschichold in Leipzig, and in Weimar in 1924–1925 under Moholy and others; she went on to become an art director at the Beyer Verlag in Leipzig and to marry the physician Friedrich Popitz.[29] She must have approached her former Bauhaus teacher Moholy about designing the magazine, because the credit printed in September's inaugural issue clearly states: "Cover picture and typographical design by Prof. Moholy-Nagy, Berlin."[30] Though his name was not mentioned in further issues, Moholy's design concept continued with only minor adjustments until the magazine ceased publication in 1943.

With its generous design, cropped and often full-format photographs, elegant sans-serif typeface, and an asymmetrical double-page layout, *die neue linie* certainly represented the prime example of Modernism tamed for the mass market.[31] Not only did Moholy's basic layout shape the magazine for years to come, it also influenced the appearance of other fashion magazines in the United States and around the world.[32]

Despite Bayer's own personal connection to both Söre Popitz and Dr. Friedrich Popitz,[33] he could not have accepted the assignment of art directing *die neue linie* even if it had been offered to him; he was officially working for a direct competitor at the time. Shortly after *Deutsche Vogue* was discontinued, however, the editor-in-chief of *die neue linie*, Bruno E. Werner, commissioned Bayer to design covers.[34] For ten years this lucrative project brought Bayer's unique style to newsstands in Germany and abroad. Bayer later recalled, "it was Werner who engaged me and Moholy-Nagy to design covers."[35] He would stay in close contact with Werner for some time, not least because their daughters later attended the same school.[36]

Indeed, between July 1929 and 1932, Bayer's private life was deeply shaped by a new presence, that of his young daughter, Julia "Muci" Bayer.[37] Though he and his wife were separated, they must have had another erotic encounter sometime around November 1928, for the child they longed for was born on July 12, 1929 (see Fig. 4.5).

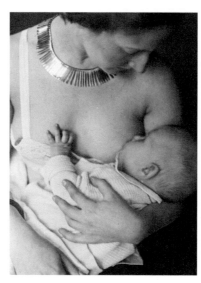

Figure 4.5 Herbert Bayer, Irene Bayer-Hecht breastfeeding her daughter Julia, 1929. Photograph; Denver Public Library, Herbert Bayer Collection. © Estate of Herbert Bayer/ Artists Rights Society (ARS), New York/VG Bild Kunst, Bonn.

Both parents adored her.[38] Schawinsky, Bayer's best man at the wedding, was named godfather.[39] Although Bayer-Hecht later lamented that this was the period in which she lost her inner resilience, the new family strove to develop a sense of togetherness.[40] They regularly spent time as a trio, but the child's mother suffered from the fact that they did not share a home.[41] Certainly, their unconventional marriage lends irony to the fact that Bayer soon accepted a commission to illustrate the cover of Zoë Wassilko-Serecki's popular 1931 family guide *Eltern wie sie sein sollen* (*How Parents Should Be*), for which he produced one of his signature photomontages (see Plate 5). It is noteworthy that Bayer did not use snapshots of himself or his daughter for this photomontage, something he did often in other projects. His own approach to family life, particularly his refusal to remain loyal to his wife, was indeed far from the principles described in the book.

Despite their separation, Irene Bayer-Hecht nonetheless continued to support her husband's efforts to present his work to the public. She showed particular dedication in helping with his first international solo exhibition, which opened on January 29, 1929 at Galerie Povolozky in Paris.[42] The publisher Jacques Povolozky and his wife Elena Povolozky, herself a painter, had long been active in the Left Bank's gallery and publishing scene and were advocates for avant-garde artists.[43] Bayer, now somewhat established as a commercial designer, hoped that the show would bring him recognition for his work as an artist. Twenty-seven pieces were included, mostly paintings from his final days at the Bauhaus. The slim exhibition pamphlet had a foreword by the Belgian literary critic, poet, and magazine publisher Paul Dermée, who praised Bayer for his fusion of different styles and contemporary expressivity: "Herbert Bayer is Cubist or Constructivist or Surrealist, depending on various criteria," he wrote. "Yes, he is all that and much more: he is a young painter for today."[44]

Given the importance of this exhibition for him, it is somewhat surprising that Bayer never visited this show or even designed the accompanying pamphlet. Presumably it is because he did not speak French that he left the organizational tasks to his wife, who after all had spent most of 1924 in Paris. Moreover, in his first days as a Dorland employee, he certainly had neither the time nor the leisure to travel.

Bayer-Hecht's letters from Paris describe her intensive involvement in the exhibition preparations and the difficulties she experienced. She was, in fact, pregnant and ought perhaps to have been minding her continually delicate health. On January 27, she told him, "I feel growing, with the small being in me. Now it is already entering its fourth month," before going on to complain about the locals' incompetence and the considerable strain that the high costs put on the family's small budget. "The people in Paris [at the gallery] are very nice and kind, but I don't know how they would have managed on their own. But since I threw my weight into it, everything is done. Unfortunately it is costing much more than we anticipated."[45] Another letter lists expenses, describing how she scrimped and saved on her accommodation and food in order to afford frames for the show and reproductions in the pamphlet. "I know, my dear, how little you have," she wrote her husband, "and I don't want anything for myself."[46] Two days before the opening, she again lamented having to do everything on her own, "even with the posters I had to go to shops and coffee houses. It is unclear to me how anything would have been done if one of us hadn't come."[47]

Despite these difficulties, Bayer-Hecht could happily report to her husband that his show was a "great success" with "many people there"[48]—despite the fact that she had not "bought" the critics, which was apparently fairly standard practice on the Paris art scene at the time.[49] The gallery's reputation secured a visit from Christian Zervos, editor of the well-respected *Cahiers d'Art*, who saw the show on February 9 and included a short mention of Bayer in a subsequent issue. He wrote of, "A young artist exhibiting for the first time in Paris, whom I first met on my visit to the Bauhaus in Dessau, where he taught typography."[50] Bayer saved the clipping in his own press archive. The same issue also contained a six-page portfolio of Moholy's photographic experiments.[51] Although Bayer-Hecht voiced disappointment that Paris's most important poster designer of the time, A. M. Cassandre, was ill and could not visit the exhibition, she concluded that she had nonetheless "learned a lot from this thing. I also learned a lot about advertising."[52]

At her request, Bayer had also sent her a letter of recommendation for *Vu*, France's top popular illustrated weekly, which had just been founded the year before as a showcase for the work of modern photographers. On February 11, she approached the editorial office, presumably to explore sales opportunities for photographs. It does not appear she had much success, either for herself or for her husband; only issue no. 97 (January 22, 1930) carries an image with the credit line "Herbert Bayer." It is a photograph of a person lying on the beach, possibly a self-portrait.

The year 1929 also saw a second solo show for Bayer, this one in his hometown of Linz. The regional artists' association, März, which Bayer had joined as a teen, noted in its circular of November 1928 that it was planning "an exhibition of paintings and prints by our guest Herbert Bayer, Berlin, who was born in Upper Austria."[53] Bayer's poster design announced a two-week run, from May 18 to June 2, but no information remains about the scope of the works on view.[54] Bayer may have arranged the exhibition

as an opportunity to visit relatives, particularly his mother, who passed away after what was described as a long illness in October 1930.

In the fall of 1929, he and Schawinsky went to the atrium of the former Kunstgewerbemuseum in Berlin to catch *Film und Foto (FiFo)*, the Deutscher Werkbund's landmark traveling exhibition that Moholy had co-curated, and which included Bayer's own work.[55] There was also a display of "fashion photography and advertising from the magazine *Vogue*" initiated by the magazine's soon-to-be-closed German office.[56] Bayer had missed *FiFo*'s first station in Stuttgart early that summer, where Moholy had installed his legendary Room No. 1 ("Wohin geht die fotografische Entwicklung"—In what direction is photographic development heading?), which outlined his views on the history of photography.[57] In total, twenty-six of Bayer's photographs were displayed, nearly all of them taken during the previous summer's bicycle tour, in addition to an unspecified number of "photomontages and advertising printed matter," as the catalogue put it.[58] Irene Bayer-Hecht was also included—listed separately as "Irene Bayer" among the participating photographers—with five of her own works.

In conjunction with *FiFo*, a special issue of *Kunstblatt*—the most established German magazine for contemporary art—appeared in May 1929, to which the editor Paul Westheim contributed the three-page article, "Herbert Bayer: Photographer and Painter." This, too, featured his photographs and watercolors from the South of France and was the first discussion of Bayer as an artist to appear in the German art press. Coming as it did in an issue devoted to the avant-garde, moreover, it optimally positioned Bayer's pictures alongside works by André Kertesz, Germaine Krull, Helmar Lerski, Albert Renger-Patzsch, Ewald Hoinkis, Aenne Biermann, Sasha Stone, and others. Thus it signaled recognition from the art establishment for a young artist who had not yet turned thirty. Westheim's piece admiringly described Bayer as a "Realist and Surrealist," who documents the reality of the everyday in his photographs, while his paintings "reach out beyond what can be mechanically grasped by an apparatus or the retina."[59]

As a freelancer, it was essential for Bayer to gain visibility in avant-garde circles and to build a prominent profile as an artist. He had launched the process deftly with his "farewell" issue of *Bauhaus* magazine and the above-mentioned exhibitions. Meanwhile, in advertising circles, he found major recognition when the VdR's widely distributed trade magazine *Die Reklame* ran a four-page article on "Bauhaus Advertising" in its January 1929 issue. "Bauhaus style strives to be the purest expression of its time," wrote the author, Karl Theodor Haanen, "and the demands of our times—swept around on the flywheel of the machine and shaken by social hardships and struggles—are clarity, simplicity, straight lines, and above all, purposefulness."[60] As essential elements of this approach, Haanen describes lowercase letters, photomontage, and text–image combinations. And, rather than including any of the classic examples from the early phase of New Typography (by Schlemmer, Moholy, or Schmidt), the essay's eight illustrations exclusively featured works by Bayer: his *Bauhaus* cover from February 1928, various invitations to Bauhaus events, his brochure for Breuer's tubular steel furniture, the illustration of an exhibition stand, and his VdR calling card with his portrait. Haanen concludes his article with an ardent call for the "strong forces" from Dessau to change the world and promote innovation in graphic design. On the whole it was a skillful act of promoting Bayer as a leading innovator, using the Bauhaus banner to announce Bayer's own interests and abilities.[61]

In addition to his membership in the VdR, Bayer had a connection, albeit a more tenuous one, to the Ring neuer Werbegestalter (Ring of New Advertising Designers) led by Kurt Schwitters. This circle included Max Burchartz, Walter Dexel, Willi Baumeister, Jan Tschichold, and Friedrich Vordemberge-Gildewart, among others. Bayer's relationships with the Ring were not particularly close. He knew Schwitters and had seen his Merzbau in Hannover, but the connection was so nebulous that he later did not recall ever being involved in the association or visiting its exhibition.[62] Actually, Bayer had been a guest at several of the Ring's exhibitions and had made works available, for example, to the Berlin exhibition *Neue Typografie*, which was on view from April 20 to May 20, 1929 in the atrium of the former Kunstgewerbemuseum. The invitation leaflet lists Bayer as a participating artist, and with nine pieces included— printed matter from his Bauhaus period—he was not only present but prominent in the show, more so than the "true" members of the Ring.[63]

Indeed, these members had initially shown some reluctance toward collaborating with the Bauhaus, concerned that a formal association would cause disadvantages for the movement as a whole. Despite this, according to a July 1928 Ring newsletter, the association's doors were largely open: "Anyone who is at the Bauhaus and designs in a modern way from the inside out can become a member."[64] It is therefore not surprising that Bayer applied for membership immediately upon leaving the Bauhaus. Schwitters had already proposed him as a possible member in the summer of 1928.[65] The necessary members' vote was never cast, however; at least it is not documented in any of the newsletters.[66]

During this period, Bayer's work appeared in another prominent venue when Moholy included several of his designs in his now famed introductory segment of the *Neue Typografie* exhibition, a room devoted to the question "Wohin geht die typographische Entwicklung?" (In what direction is typographic development heading?) An obvious counterpart to the same question of photography that Moholy posed to title his hall at *FiFo*, the typography show also travelled to a variety of locations in Germany.[67] Bayer was thus present in both graphic design and photography at the two major manifestations of the German design avant-garde of the late 1920s, *FiFo* and *Neue Typografie*. Surprisingly, however, he was not included in what was doubtless the most significant publication on the New Typography in the interwar period, the 1930 volume *Gefesselter Blick* (*The Captivated Gaze*), published by the Rasch brothers, both of whom were in the Ring orbit.[68] Perhaps Bayer had by then lost his reputation as one of the movement's pioneers, at least in avant-garde circles. Paradoxically this could have been due to his own commercial success, though his increasing willingness to depart from strict New Typography principles was likely a factor as well.

Bayer played a major role in designing the German pavilion, known as the *Section Allemande*, at the 1930 salon of the Société des Artistes Décorateurs, held in Paris from May 14 to July 30, 1930. It was an impressive showcase of the Bauhaus avant-garde centered on Gropius, Moholy, Breuer, and Bayer. Commissioned by the Deutscher Werkbund, the team developed an ultra-modern spatial experience for the exhibition, including two rooms that Bayer designed. In Halls Four and Five he placed standard furniture on a wall, arranged architectural photographs according to his idea of an "extended viewing space," and equipped a large-format glass cabinet with everyday objects, from ceramics to silverware and other household goods.[69] Bayer later recalled

that the exhibition was a signal event for the Gropius circle because it was their first opportunity to convey a vocabulary of modern exhibition design, including the emphasis on a controlled lighting, a thoughtful denotation and connotation of the presented objects, a sophisticated dramaturgy from the opening to the closure of the suggested path, surprising changes in the observer's perspectives, and a structure that organizes its spaces in a particular rhythm.[70]

In his capacity as advertising designer, moreover, Bayer created both the *Section Allemande* poster and the accompanying catalogue, both of which were received with great enthusiasm by the Parisian trade press and beyond.[71] His poster, with its intersecting visual layers and geometric spherical shape, follows the best tradition of functional Bauhaus typography, while the insertion of a small human figure at the center serves as a symbol of nature and indicates scale and proportion.[72] The accompanying bilingual booklet provided the French audience with basic information on the Bauhaus and was also intended to give the German-speaking public some orientation within the foreign-language exhibition (see Plate 6).[73] With its transparent plastic cover, thumb index, and various foldout panels, it set design standards. Siegfried Giedion hailed it in 1930 as a "minor typographical masterpiece."[74] In her analysis of the publication, architectural historian Wallis Miller has pointed out that it independently constructs ways of seeing and understanding the show, thus becoming more than a mere appendage to the exhibition.[75] Bayer himself also always regarded the Paris poster and catalogue as highlights in his career as a commercial artist. Perhaps most essentially, the catalogue included his iconic section-perspective of a photo installation observed by a beholder with a giant eye, a true "eyeball hominid," to use the phrase of Ellen Lupton—which would guide Bayer's ideas on exhibition design throughout his life (see Fig. 4.6).[76]

With these many achievements—exhibitions, publications, and critical praise, not to mention a steady job as a prominent graphic designer—under his belt, even traditional advertisers started to become interested in the young head of Studio

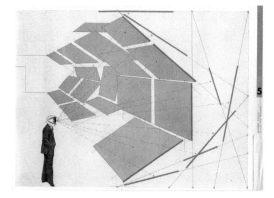

Figure 4.6 Herbert Bayer, Sketch on the field of vision in exhibition design, published in the *Section Allemande* catalogue, 1930. Offset printing; Private collection. Estate of Herbert Bayer/Artists Rights Society (ARS), New York/VG Bild Kunst, Bonn.

Dorland. New clients came calling, including those eager to promote tourism to a broad public. For a client in North-Rhine Westphalia, for example, Bayer designed an entire advertising campaign of printed matter touting the scenic Teutoburg Forest and its surroundings. Launched sometime around 1928, the project included an exhibit in Berlin's famous Wertheim department store.[77] For the main poster motif, Bayer used himself as a model, shown in three-quarter view from the back, his gaze sweeping the distance (see Plate 7).

In 1931 Bayer, Gropius, and Moholy collaborated on a spectacular 850-square-meter hall at the Deutscher Werkbund's *Deutsche Bauausstellung Berlin* (German Building Exhibition), held from May 9 to August 2, 1931. The commission involved furnishing a vast series of displays for the German Union of Building Trades. For this purpose Bayer, the most active of the three collaborators, developed innovative concepts for information design that were far ahead of their time (see Fig. 4.7). The hall, which is extremely well documented by Gropius's surviving floor plan and a set of almost eighty photographs, combined the language of the New Vision with the spatial experience that Herbert Bayer would later dub Total Design.[78] In its content, the exhibit was suffused with the left-wing language of Germany's trade unions. As its introductory panel declared, "the free German trade unions want to bring the lifestyle of the workers to the highest possible level and to ensure that they have a permanent and humane share in the achievements of culture." This was supposed to be realized by, among other things, "socializing the entire building and housing industry." After the war, Bayer and his advocates would highlight such statements to imply that he harbored anti-fascist sympathies at the time.[79]

The same year, 1931, brought Bayer what he might well have considered the highest professional accolade: an eighteen-page portfolio devoted to his work in the May 1931 issue of *Gebrauchsgraphik (International Advertising Art)*, the bilingual leading national and international commercial-art trade journal of its time.[80] In the accompanying text,

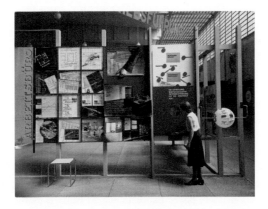

Figure 4.7 Walter Christeller, View of the German Union of Building Trades hall at the Deutscher Werkbund's German Building Exhibition, Berlin, 1931. Photograph; The Wolfsonian-FIU, Florida, Herbert Bayer collection.

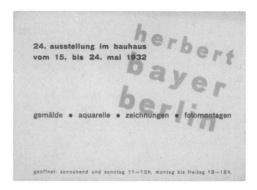

Figure 4.8 Unknown designer, Invitation card for the Herbert Bayer exhibition, Bauhaus Dessau, May 1932. Letterpress; Private collection. © Copyright holder unknown (artist).

the journal's editor, Hermann Karl Frenzel, praised Bayer's achievements since leaving the Bauhaus. They represented, he wrote, "a systematic transfer of this very interesting experimental laboratory for applied art to the practical world. Most of the suggestions for the new typography and the new typographic image design using photography have their origin in the works of the Bauhaus Dessau, and the works of Bayer show some of the most interesting results of these experiments."[81] The portfolio generously reproduced Bayer's posters and brochures, ten spreads from the *Section Allemande* catalogue, magazine covers, exhibition construction, photographs, and works of fine art. For the first time, Bayer's achievements in multiple media were presented to a broad public.

The next year, Bayer followed up with a solo show at, of all places, the Dessau Bauhaus. The twenty-fourth Bauhaus exhibition, which ran for only a few days, from May 18 to 24, 1932, gave Bayer an opportunity to display the full range of his work as an artist—"paintings, watercolors, drawings, photomontages" according to the invitation postcard (see Fig. 4.8). Surprisingly, and for reasons that are not clear, none of his commercial design work was on view, though this would certainly have been of great interest to the students in the advertising workshop. In the political turmoil of the period, it was one of the last events before the Dessau Bauhaus was dissolved in September 1932. Unfortunately, most details about the show have been lost; the Bauhaus log simply confirms that the opening was held on May 19, and that within the six days, visitors from Amsterdam, Cleveland, and Salzbrunn signed in.[82] No documentation has survived in the form of catalogue, poster, or photographs; nor is anything known about any possible accompanying events, for example, whether Bayer was present at the opening or gave a lecture, or whether his Bauhaus-era friends used the show as an occasion to pay one last visit to the art school before the Nazis came to power in January 1933. The moment when the Nazi movement started to change Germany for worse, Herbert Bayer had established himself as the country's leading pioneer of modern graphic design in Germany.

Ise Gropius and the Summer of 1932

Herbert Bayer's May 1932 exhibition at the Dessau Bauhaus was held at a time of intense political turmoil, with the Nazi party winning a landslide victory in the July 1932 Reichstag elections. Bayer's private life was in tumult that spring as well, which explains why he was unable to devote much attention to the show.[1] Irene Bayer-Hecht had left Berlin with three-year-old Muci for a stay in the Swiss resort of Ascona, hoping that her husband would soon join them. Xanti Schawinsky and Walter Matthess of the Dorland Agency (for whom she had arranged an apartment) were already waiting there at the beginning of April, when mother and daughter arrived in stormy Ticino. Bayer's own trip was planned for June.[2]

Soon after their arrival, Muci, then almost three years old, was entrusted to a children's sanatorium on the recommendation of a pediatrician, while her mother took up quarters in a small room with a balcony. The two were frequently together, but the circumstances underlined the extent of the child's strong bonds to her father. According to her mother, Muci ate and slept poorly, continually talked about and clamored for her father, while his messages to her tended to provoke emotional confusion.[3] As for the marriage, it seems to have been as fraught as ever; Irene arranged separate sleeping quarters for Bayer in the event of his visit. And yet her emotional dependence on him remained unbroken: "I can hardly bear to be so far away from you. With me, I believe, it is also not just the habit of being pleasant, but something you could perhaps call love."[4] During the first weeks of her stay she was intensively occupied with the idea of buying land in or around Ascona in order to build a house together with friends. Two different plots were under consideration, but as the necessary financial means had to come from Bayer—who was still consolidating his position as creative head of the independent studio Dorland Berlin—he had the last word on the matter.[5] Without being able to consult Bayer's (lost) answers to his wife's letters, it is impossible to judge how serious the thoughts of moving to Switzerland really were.

What is evident is that Bayer-Hecht was deeply pessimistic about their prospects as a family in Germany. This is evident in her remarkably clear-eyed assessment in the turbulent political year of 1932: "In my opinion, it would be the right thing to move to Paris now. Believe me, my dear, Berlin is finished, Germany in general … Here one expects inflation in Germany in the near future, censorship, and a state of war … I am of course aware that [this] will mean the end of Dorland."[6] She thought she might get a jump start in the French capital through the help of an old contact from the Bauhaus days, Ré Richter, the future Ré Soupault.[7] In 1929, Richter's work as a fashion

journalist under the pseudonym Renate Green had taken her to Paris, where she was now a fixture in avant-garde and fashion circles. Bayer-Hecht, convinced that there was "nothing to be earned" for her husband in Ascona either, was also exploring the idea of opening a beauty salon based on a new treatment apparatus produced by the German Hormona Society Berlin; this project also soon foundered.[8]

The costly stay in the Swiss resort town and Muci's stay at the pediatric facility were financed entirely by Bayer, who sent a monthly allowance of 200–300 Reichsmarks. His wife was well aware that this meant scrimping and saving at Herbert's end, and she repeatedly assured him that she was doing all that she could to save money, living almost at a subsistence level.[9] She was evidently uncomfortable and even resentful about being so dependent on him. The letters from May show her toying with the idea of taking suitors. "The temptation is absurdly high," she declared on May 3. "Too many rich people who do not know where to put their time and money." As the month went on, these hints grew darker: "The men are like hungry wolves, and unfortunately my moral resistance is very low at the moment," came the remark of May 5. Even more explicitly, she wrote: "Perhaps I will find a rich lover, then everything would be fine," she declared on May 22, before stating: "It would be easier for me to prostitute myself here. Because it can hardly be called anything but that if a stranger who is indifferent to me pays for me."[10] There is no evidence that Irene ever actually sought out rich "admirers," but her barbs could only have been intended to wound the reader.

Meanwhile Bayer, still in Berlin, was standing on the brink of another biographical break. By the late spring of 1932, he and Ise Gropius were almost two years into an extramarital affair, yet, remarkably, up to this point, the protagonists managed during their lifetimes to keep their relationship hidden from the broader public.[11] Early that year, however, they had at last reached the decision to tell Walter Gropius, and the summer marked a watershed moment for them all. It ended with Bayer losing the woman he truly loved and for whom he would always long, even while she and her husband remained part of his inner circle of friends for the rest of his life.

Ise Gropius (née Ilse Frank) was nearly fourteen years younger than Gropius, whom she had wed after a whirlwind romance in October 1923. Gropius's assiduous courtship at this time led her not only to break off her engagement to a distant cousin, Hermann Frank, but also to take a new name for herself—Ise, instead of Ilse—at his urging (see Fig. 5.1).[12] Herbert Bayer, by contrast, was three years younger than her and thus a near contemporary. Even her Bauhaus nickname—"Pia," so clearly a counterpart to her husband's "Pius"—showed the degree to which her personal identity was inextricably bound to his. It did not perhaps bode well for Bayer's prospects as a lover that even he called her Pia.

A first almost prophetic indication of the tragic role Ise Gropius would play in the Bayer-Hecht marriage is evident as early as March 1926. "Frau Gropius wrote to me," reported the newly married Irene Bayer-Hecht to her husband from her sanatorium in Leysin. "Why? She is clever and double-faced. Everything she does has a purpose. She wants something, either from you or from me. Time will reveal what it is."[13] It is likely that the two women first met in the summer of 1925, about six months after Bayer's return to Weimar. Ise Gropius recorded her first encounter with Irene Hecht in

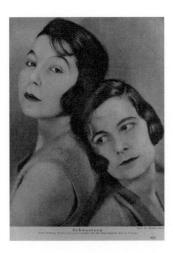

Figure 5.1 Dr. Weller, *Sisters* (Ise Gropius, addressed just as "the wife of Professor Walter Gropius" without mentioning her name, and actress Ellen Frank); in *Scherls Magazin*, no. 5 (May 1929). Rotogravure; Private collection.

her diary: "In the afternoon Miss Hecht. Lively, clever and spirited, but somehow one is not quite sure about her. She will certainly feel at ease and develop well in the local atmosphere."[14] Some two weeks later, she referred to the (not yet married) couple as "the Bayers" when mentioning them as guests at the Gropius home that evening. "Mrs. Bayer is very lively and entertaining," remarked Ise Gropius before adding: "In social conversations one can always rely on the Jews; they get the river flowing and keep it going by virtue of their intellect."[15]

It is unclear whether Bayer-Hecht knew or suspected that she and Ise Gropius had fateful experiences in common. In his painstakingly researched biography of Gropius, Reginald Isaacs noted that Ilse Frank, still unmarried, had already had a brush with pregnancy in 1923, which she later described as a false alarm, but was probably a pregnancy that she opted to terminate.[16] Then, after a long stay in a sanatorium in the summer of 1924, she underwent an appendectomy in August 1925, in the course of which, "due to the incompetence of the doctor, I lost my baby at an early stage and never became pregnant again, to our deepest regret."[17] Whatever caused Ise Gropius's inability to bear children, Bayer-Hecht, too, had experienced great hardship in connection with pregnancy—to the point that Bayer himself might have grasped the parallel.

According to Isaacs, the liaison between Ise Gropius and Bayer had begun early in the summer of 1930, again in Ascona, where friends from the Bauhaus days had gathered on vacation. By this point, they were both firmly ensconced in a circle of Bauhaus friends. Xanti Schawinsky later stressed the extent to which "the inner circle of former Bauhaus members stuck close together" not just when on holiday, but also in Berlin: "Gropius and his wife, Breuer and [his wife] Marta, Moholy, Bayer … The real center of the gatherings was the Gropius apartment, where the cuisine was excellent

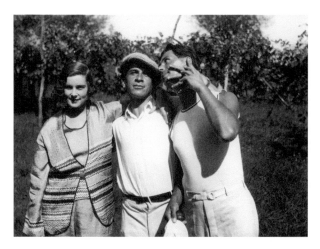

Figure 5.2 Unknown photographer, Ise Gropius, Xanti Schawinsky, and Herbert Bayer in Ascona, summer 1930. Photograph; Denver Public Library, Herbert Bayer Collection.

(a praise to Pia!).”[18] The group sometimes vacationed together, in particular at the retreats at Monte Vérita, near Ascona (see Fig. 5.2). There, in 1930, as Isaacs writes,

> Most frequently it would be Ise and a companion who would complete the climb for the view of the lake and valley, then descend to the town at sunset …

> But for Ise and one old friend [H.B.], Bauhaus camaraderie had become a love affair. On many occasions, they had been very much alone while climbing the hills above Lake Maggiore, and sometimes in Casa Hauser. It was inevitable that they would be drawn together. Far from being casual, their love was serious, painful, and ecstatic.[19]

It should be mentioned that not only Walter Gropius but also Bayer-Hecht, together with one-year-old Muci, were present in Ascona that summer and may well have sensed that an affair was beginning. On the surface, everything seemed normal; Josef Albers, for instance, took photographs of Bayer playing with his young daughter which Albers scholar Brenda Danilowitz later described as embodying the “sheer fun, the joy of being a parent, the unclouded optimistic mood” (see Fig. 5.3).[20]

Much later, when Isaacs asked her about the beginnings of the liaison, Ise Gropius told him that “she had felt very little uneasiness” about it, “accepting the pleasure it brought her as her due. For the [first] seven years of marriage, she had felt herself to be overly protected, ‘too much under Gropius’s wing,’ and now she felt she ‘had to get into the arena again to test her power of attraction for men.’”[21] There is some evidence that the initiative came from Ise. Ati Gropius Johansen, her adopted daughter and biological niece, later also described Ise as the driving force behind this extramarital relationship.[22]

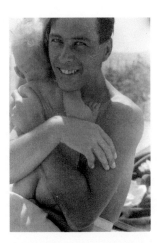

Figure 5.3 Josef Albers, Herbert Bayer and daughter Julia in Ascona, summer 1930. Photograph; Denver Public Library, Herbert Bayer Collection. © ARS.

The fall of 1930 coincided with the death of Bayer's mother, Rosa, on October 9 at the age of 60 in Linz. According to the death notice signed by all the Bayer children on behalf of the family, there had been a long period of suffering leading up to her death. Although Bayer later told Ruth Bowman he had felt close to his mother, and that she "had a great understanding for me and my nature and my inclinations towards art,"[23] there is remarkably no trace of her in his estate: no letters or mementos, and not even a passing mention or complaint from her daughter-in-law in her extensive correspondence with her husband. The cause of this lacuna—whether other preoccupations prevented material from accumulating in his archive or a cherished trove was later lost or deliberately removed—may never be known.

Neither the demands of parenthood nor the recent loss of a parent seem to have hindered the affair between Bayer and Ise Gropius, which only intensified in 1931. Walter Gropius was tied up with numerous obligations and constant travel, while his wife, having married rather young, was apparently eager to pursue new experiences. Late that summer, while Ise Gropius was once again vacationing in Ascona—this time without her husband, who had stayed at home and had no idea that Bayer was coming as well—her husband was prompted to write his first indignant letter. "I am *shocked* that you and ___ [H. B.] are driving to Milan alone; you shouldn't do that," he wrote to her on September 11, 1931. "My feelings for you are just as tender as on the first day. These are not just words … Please stay 100% mine."[24] Walter Gropius's plea seems to have been unsuccessful, but the details are not entirely clear, as Bayer's first surviving letter to Ise Gropius dates to the year 1932. In it, he suggests that both of them were at last aware of how urgently the situation needed to be clarified. At this point, the constellation between them must have shifted: "I'm back in the snow and sun again and think how nice it would be if you could be here too. Even if everything has changed, we could at least ski together. Oh the world could be so beautiful sometimes."[25] The meaning of Bayer's "everything is different" is unfortunately not clear, but in any case

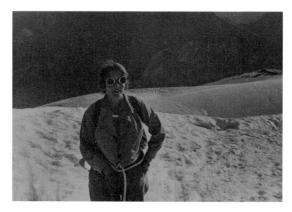

Figure 5.4 Herbert Bayer, Ise Gropius hiking near Marmolata, Italy, c. 1933. Photograph; Denver Public Library, Herbert Bayer Collection. © Estate of Herbert Bayer/Artists Rights Society (ARS) New York/VG Bild Kunst, Bonn.

a sense of reality appeared to be encroaching on the couple. Bayer's great respect for his mentor is evident in his request that his beloved tell her husband that he had written to her: "Tell Pius about the letter, we have not seen each other for so long. It is actually inhuman." He also acknowledged that "Irene tried to make Christmas Eve a very pleasant time. Good food and Muci's great joy made everything bearable. I've only been away for a few days, but I already have such a longing to see Muci."[26]

Finally, at the end of March 1932, Walter Gropius travelled to Barcelona for a meeting of architects from the CIAM (Congrès Internationaux d'Architecture Moderne) circle. His wife told him she would be going alone on a ski holiday—supposedly to unwind and enjoy the solitude (see Fig. 5.4). Bayer was in fact waiting for her. Apparently the lovers decided during this reunion that it was time for her to inform her husband of the affair, which, as Isaacs writes, "she could not ... conceal from him any longer. But it was difficult for Ise to declare herself, and three months went by before she did. So discreet had the lovers been and so trusting was Gropius that he was surprised."[27]

As for Bayer-Hecht, it is impossible to say whether the couple told her at the same time. Certainly, the torment she experienced in the winter of 1931–1932 suggests that she sensed something; perhaps she did not know the identity of the person in question—for her name is never mentioned in the correspondence of 1932—but the scenario of her husband devoting his attention to another woman was, of course, nothing new.

Walter Gropius, for his part, was completely taken aback when he learned of his rival's identity, though he allegedly recognized the parallel with his own biography. He himself had twice courted married women (Alma Mahler and Lily Hildebrandt, respectively), winning them from older rivals. Gustav Mahler and Hans Hildebrandt had not been mentors, however, whereas he had made a special protégé of Bayer since the latter's student days. When meeting in Weimar, Gropius confronted Bayer immediately, demanding an end to the affair: "If you insist on going on," he threatened,

"I will fight."[28] This is probably the event that, in late May 1932—precisely when Bayer's solo exhibition was on at the Bauhaus Dessau—triggered a letter from Bayer to his wife that had a particularly disturbing effect on her.

The contents of that letter have been lost, but in her response on June 4, Bayer-Hecht painted a picture of the "weeks and months of torture" she had experienced in early 1932.[29] Only a few days earlier she had seemed almost resigned to her fate: "Make it pleasant for yourself and be happy, otherwise this winter's torture will have been in vain, and my departure as well. Now you finally have what you wanted. You are quite free, and I don't make any rules for you."[30] Another letter, of June 13, describes violent outbursts of emotion caused by yet another missive from her husband, also lost. It must have marked a dramatic departure from his previous messages. "It was probably unavoidable that I cried over your last letter … You remain yourself, even if some new conflict has come into your life between your two letters. … I don't matter if you love someone else. I'm happy in other ways and for other reasons."[31]

Apparently, after his conversation with Walter Gropius in Weimar, Bayer left the city in a hurry. Soon after he reported to Ise Gropius:

> I live as in a dream that mixes together the most beautiful and the saddest things. But everything I see in between, everything, I always relate to you. You are everywhere, and I only see you. … My dear, I know now that I can't close myself off to you and that my love for you will remain with me for the rest of my life despite everything. … You know that we want to do everything we can to avoid destroying your marriage. … Even the nonsensical idea keeps coming back to me: if only there were a way to live out our feelings, and then you could go back to Pius. But I'm afraid life would be too short for that. Pius was infinitely concerned and generous and noble and everything that a human being could ever be. He prevented me from being ashamed in front of him. It is so difficult that I cause him such grief.[32]

The lines contain everything that Bayer-Hecht had been missing from her husband for so many years: intensity of feeling and expressions of desire, longing, and respect. There's rich irony in the fact that Weimar—the very place where he had first met and fallen in love with his wife in the summer of 1923—was now only connected in Bayer's mind with thoughts of his unattainable lover. His feelings for Ise Gropius were clearly very strong. However, his loyalty to Walter Gropius was even stronger. This was the man who had first discovered and nurtured his talents, and who had consistently showed so much fatherly interest in his work. Seen against this background, it is understandable why Bayer, who had just turned thirty, must have felt the anguish over the situation. Obviously he was torn between two women who loved him in different ways but with equal intensity and steadiness, one of whom had borne him a child, the other who held out the promise of a life of passion and fulfillment. He was also in many ways betraying his father figure.

In a series of letters to his wife, Walter Gropius reported on his inner conflict and the sudden strain on the intimate relationship with his former student.[33] Gropius took Bayer's comprehension as a sign of growing understanding and renewed friendship. Around the same time Bayer also apparently admonished Ise Gropius, noting that

Walter Gropius "expects us to make an effort." Logically enough, Bayer concluded that his lover would "probably remain a distant ideal, not within reach."[34] In order to forget his erotic frustrations, he declared himself ready to throw himself into his work. So far, he wrote to her, "I have been able to do that under all circumstances."[35] But with these thoughts, too, he seemed unable to resist seeing Ise Gropius as a distant ideal compared to the reality of his marriage; "I could work very well by your side. And in recent years, I have worked badly."[36] Yet the next day found him expressing a kind of loyalty to his wife: "I would like to stay together with Irene, but I cannot decide that alone. I almost believe that she has recently gained a clearer view of our situation, which will certainly help us."[37]

After the two men talked again at the beginning of July in Berlin, Walter Gropius was feeling optimistic about finding a way to resolve the exhausting ménage à trois.[38] On July 22, in the midst of his trip to Ascona, Bayer paid a spontaneous visit to Gropius in Frankfurt. In their meeting, Bayer appears to have actively sought out the open and productive discussion that his lover had encouraged him to pursue. Ise Gropius had hoped the two men could "give lasting permanence to the male companionship you established there."[39] A detailed report of their conversation, which lasted about ten hours, is recorded in the letter Walter Gropius sent to his wife that very night.[40] As Gropius put it, "It was certainly a rare human situation and we were both very conscious of it," but he believed in reaching a real breakthrough and "growing understanding."[41] He claimed the conversation had allowed Bayer to unburden himself of his feelings of guilt, and that the older man had offered him the opportunity to expand their friendship, assuring him of his trust. "Of course," the letter continued, "his unknown future with Irene awaits him":

> We talked about this in great detail, and he told me many things about Irene that I didn't know. So he seems to be quite sure of her love and has the impression that she will now face him calmly and without a fight. … He emphasized again and again that he gained a lot from her, and that she was a good comrade to him. I think it would be right if he spoke openly with her … I think it's possible that complete openness on Herbert's part will shape her attitude decisively. It would of course lift her self-confidence, which has suffered through Herbert and all of us. … To Herbert I offered to use my influence on Irene, if ever he thought it useful, so that I might contribute toward clarifying and easing things.[42]

This paragraph crucially bears witness to the fact that Bayer, in all the intensity of the constellation, was nonetheless thinking of his wife and valued his relationship with her and with his child. In fact, Gropius's notion that he could himself in some way have exerted a positive influence on her showed a complete misunderstanding of her attitude toward her husband's mentor; her distrust of and loathing for Gropius remained undiluted.

Ise Gropius had strong reservations of her own to express. Responding to her husband's letter on July 25, she wrote:

> I would not be very happy if Irene were to be fully informed, because I cannot tell you how unsympathetic it would be for me to suddenly entrust this whole matter,

which has up until now been handled with the greatest possible tact, to someone who is as unreliable, uncontrollable, and insecure as she is. I understand your view that she has a right to know what's going on, but I still feel wary of being at her mercy like this.[43]

Today we do not know whether Ise Gropius ever shared these concerns directly with Bayer—just as we do not know precisely *what* Bayer-Hecht actually knew about what was going on around her at the time.

After the marathon ten-hour talk with Gropius in Frankfurt, Bayer drove on via Stuttgart to Ticino, probably arriving in Ascona in the last week of July, where his wife and daughter were waiting. Apparently he did not stay long. In a letter to Ise Gropius, probably written shortly after his arrival, he professed that he was thinking of her day and night. "With Irene I'm unhappy and wonder why I didn't know this right away. But I don't want to throw in the towel."[44] The contrast between these lackluster feelings for his wife and his undiluted passion for his lover could not have been greater. He did, however, express a new hesitation about committing his intimate thoughts to paper, unsure of whether Walter Gropius would see his letter. "But remember that I love you infinitely, the longer it lasts, the more surely I see it again now—for what is Ascona without you?"[45] Ise Gropius did, in fact, inform her husband of this letter, along with briefing him on Bayer's ongoing doubts about his marriage. "On the question of whether [their] future together is self-delusion," she wrote Gropius, "I don't know what advice to give him. It will be a gloomy business if he spends the winter alone in Berlin again. If Irene comes to Berlin, I hope that she will handle it wisely and stay in the background for the time being."[46]

Isaacs's cursory remarks on how subsequent events unfolded suggest that the situation had hardly been clarified. Having made the revelation to her husband in Berlin that June, Ise Gropius hastily went to stay with her sister Hertha Frank in the Bavarian Alps. Bayer learned of her whereabouts after what appears to have been an all-too-brief stop in Ticino. He visited her there, probably on his way back to Berlin.[47]

As for Bayer-Hecht, the deeply humiliating constellation did not prevent her from communicating her usual ardor. Even in July she wrote: "Dearest, I would like to embrace you, not only because you are so kind and good to me, but also because I am a woman full of longings and dreams, and despite everything you were my most beautiful dream."[48] Signing off, she declared in ironic self-awareness, "I will always remain your old loving idiot, Irene."[49] In her last letter from Ascona, on July 12, she included a sentence that summed up the whole sad business more aptly than perhaps any other: "We are both poor weak people and dream of being in love with gods."[50]

Bayer himself was torn between the presumably hopeless pursuit of Ise Gropius and his sense of family duty. His usual pursuits did not succeed in distracting him, and although he later described 1932 as *the* year in which he separated from his wife, he was still unsure at the time about what path to follow. He captured this longtime melancholy in his self-portrait, *Der einsame Großstädter* (*The Lonely Metropolitan*, see Fig. 1.1) of the same year. Although this key work has been reproduced in virtually

every Bayer monograph to date, it has surprisingly rarely been analyzed with the artist's personal biography in mind.[51] Already in 1947, curator Alexander Dorner described it as Bayer's conceptually strongest photomontage.[52] Mastering a language clearly inspired by both Dada and Surrealism, the image seems self-explanatory at first glance; it draws the viewer's attention alternately to the hands or face to illustrate how different layers of reality quite literally overlap.[53] But it also represents more than just ironic commentary on the noise and bustle of city life.[54] It is no coincidence that Bayer's own eyes are looking out from the palms of his own hands, rising up in an almost supplicant gesture before the background of an anonymous Berlin tenement. It is as much a self-portrait as the equally striking photomontage from the same 1932 series, *Humanly Impossible (Self-portrait) (Menschen unmöglich [Selbst-Porträt])*, in which Bayer literally tears out a piece of his own body (see Fig. 5.5). Could this excised flesh of his flesh have stood for Ise Gropius who he was expected to give up? Or for his wife and child, a kind of Adam's rib? Considering the psychological and emotional tumult Bayer was experiencing in the year 1932, both works seem aptly to mirror a bleak and anguished mental state. Certainly there is more to them than the mere visual gag that some have interpreted.[55]

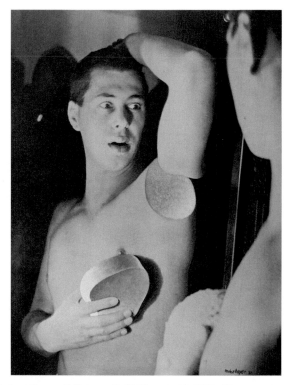

Figure 5.5 Herbert Bayer, *Selbstporträt (Self-portrait)*, 1932. Photomontage, gelatin silver print; Denver Art Museum, Herbert Bayer Collection and Archive. © Estate of Herbert Bayer Artists Rights Society (ARS) New York/VG Bild Kunst, Bonn.

Various entries in his diary from the autumn and winter of that year confirm him grappling intensely with his own thoughts,

—I still can't figure out if I will be able to carry out the decision to separate. ... I know how lonely Irene will be, and I would like to spare her all this.[56]

—My daily visit to Irene and Muci is always a painful joy and almost exhausting. Who says goodbye every day without suffering?[57]

—I'm in a very weak condition, and my nerves are a little bit sick. With every thought of Irene, Muci, and all the other things that are gone now, tears come. And I cry often. But don't let on about it! Don't get soft toward others ... I hate Pia sometimes. But I don't want to think unfairly, I understand the difficulty and work she must do to make her own marriage happy. When she is back [in Berlin], it will be a more difficult and energy-sapping time than it is now.[58]

Right at this time, Walter Gropius decided to move with his wife into a house in Wiesbaden, far from Berlin, where they could live at the expense of his current main client, the Adler Automobile Works in Frankfurt (see Plate 8). He did not, however, press Ise into making a clear choice between himself and Bayer, although this had initially been his goal. As Isaacs writes, "he no longer felt that the love of his wife and his friend was a transitory one that would disappear by itself."[59] Bayer described the situation in an undated diary entry from 1933 that vividly illustrates the importance he attached to his relationship with Walter Gropius:

I live, working late into the night but only on current commissions, because my brain is too busy with other thoughts: with the separation from Irene, with Muci and her future, with money worries; the difficulties between Pia and Pius; the dead silence between Pius and me. I suffer from general unwillingness to work and anything else; sleep badly, dream oppressively, wake up in a poor state and am a taciturn stranger all day long. ... Then a letter arrives from Pius; he extends his hand and asks for openness. I call him; then we meet. And I'm happy—I myself am amazed; I can be absolutely free with him. I thank the forces that helped to repair this damaged bridge between us. And yet I am a person who has forgotten how to laugh.[60]

In the period that followed, the passion between Ise Gropius and Herbert Bayer would periodically flare up.[61] Among their trysts was a two-week stay in the mountains of Arosa in March 1933, a trip that Walter Gropius permitted.[62] Even though the betrayed husband tolerated the escapade, it did not live up to the lovers' expectations. As Ise Gropius openly reported, all started pretty well: "What I enjoy is simply the carefree and serene feeling of skiing, Herbert's love and devotion to me, and the knowledge that none of this is happening against you."[63] But Bayer injured his knee after a few days and was in a bad mood and must have been having doubts. Bayer spent his days mostly asleep, she wrote Gropius, while she looked after the household in their alpine hut just like a "farmer's wife." Bayer used the long evenings in the shelter to recount various romantic conquests he had had with other women over the past six

months. "Those that I wanted to know about and those that I would much rather not have known about," she wrote to her husband. She continued,

> He started a thing with a married woman who suddenly fell in love with him and now he doesn't know what to do with her. He and Lajko [Breuer] complain about not being able to talk to all these women and girls, that they're just good for bed, and of course [the women] feel offended sooner or later. Internally, Herbert has also committed himself too much to me, and so every other relationship fails, because every woman immediately grasps that he is only half there.[64]

Apparently, a letter from Walter Gropius (now lost) soon introduced a severe disturbance into the couple's intimacy. Ise Gropius's response of March 9, 1933 suggests that her husband was now considerably annoyed and believed that Bayer's behavior did not show sufficient respect for the marriage. She described the letter's devastating effects on Bayer: "shock," "strong palpitations," and "outbreaks of sweat."[65]

After this "a kind of mildew"[66] settled over the retreat, and even the arrival of a letter from the married woman Bayer had been courting on the side—which had apparently been a source of hilarity to both him and Ise—could not dispel the silence between the two parties. On March 16, she confided to her husband, "the illusion of a togetherness with me, even if only temporary, is destroyed for him."[67] This is also reflected in the submissive, almost servile letter of reply that Bayer wrote to his mentor Walter Gropius, also on March 9. "I hesitated for a very long time with the decision to come here, partly for reasons connected with Irene, but above all because I feared that the cold fact of Pia and me being together would again painfully interfere with your life," he wrote. He continued,

> Today, after your letter, I would have even more the desire to see you here, because without exaggeration, you really are missing. … I wish you were here, not only because it's what is needed but because I want to be here with you … Probably my innate reticence makes communication more difficult. Besides, I actually find it more difficult to express myself to you, out of the old veneration that I felt for you as your junior … It weighs on me terribly that I am continually the cause of your worries and diminished happiness. And I wish I could be just the opposite. But please tell me how I could contribute at the moment to bringing you closer together? Would you be more comfortable with Pia coming to Berlin immediately … I once wronged you gravely. But I hope that you can now believe again everything I tell you. I also ask you to tell me everything, as in today's letter to Pia.[68]

Bayer's state of mind darkened from day to day, and it appears that his despondency was only surpassed by the disillusionment that Ise Gropius confessed to her husband: "These few days have made me so tired and broken that I only regret not having left immediately after your letter came." For it was by no means the case that "Herbert and I are in a wonderful state while you are in a bad one, but that all three of us are

miserable."[69] As Ise Gropius perceived it, Bayer was "somehow still a kind of half-savage, with the most naive egoism, and talking him into being good makes him sometimes even more stubborn." To her, at any rate, Bayer seemed "as distant as the moon" at the time. The familiarity of their first days on vacation had evaporated; Bayer, who "shied away from the slightest touch … felt misunderstood by me, had expected that I would somehow ask him to come back, and had no clue at all how hurtful and brusque all his actions are for me."[70] Ise Gropius realized that she had "now happily caused a wasteland on all sides," because in her current situation she was not an ideal partner for Walter Gropius either, as she could not offer him the required integrity, undivided loyalty, and exclusivity.[71] Physically, she and Bayer "had been together just once" since the arrival of the fateful letter, "but I noticed right away that it was only out of good will. It's not that Herbert didn't respond, but the grief and listlessness afterward is so painful for me."[72]

In some sort of a last-ditch effort to save the relationship, a final hiking tour in the summer of 1933 led the couple to the Italian Dolomites. Again, the tryst had Walter Gropius's tacit blessing. "With P[ia] it didn't work out very well anymore," Bayer jotted down some time that year. His thoughts were elsewhere, he wrote—"too much with the child and the mountains, and less with love." He continues, with specific reference to the trip to the Dolomites, "that is why the last hours in Bolzano were a sad fiasco. … I consider it impossible to even think about reviving our relationship, even under 'permitted' circumstances."[73]

Thus, in the end, Walter Gropius emerged the winner in the contest of emotions (see Fig. 5.6). Neither he nor Ise Gropius nor Bayer ever explicitly commented on how and why the liaison finally came to its end. In May 1933, on the occasion of Gropius's fiftieth birthday, Bayer presented him with a multi-paneled collage. Its contents already signaled that their creator had achieved some kind of ironic distance from the events of the preceding year, while at the same time testifying to the depth of the relationship that weathered the ordeal. "In this series of epic photomontages, tensions between Bayer and his mentor come clearly—if also playfully—to the surface in seven pictures of Gropius as philanderer, cuckolded lover, sensualist, and dirty old man," writes art historian Elizabeth Otto. "Bayer also shows Gropius as virile, full of life, and even heroic."[74] The work's captions show Gropius as the clear winner in the rivals' struggle for Ise Gropius's affections. The love affair and its outcome also confirmed the old hierarchy in which Bayer, the erstwhile student, remained inferior to his adopted father Gropius, while always paying him the respect that was his due.

In conversations with her daughter, Ise Gropius would later liken her story to Arthurian legend: Lancelot, in pursuing an impossible affair with Queen Guinevere, abused the trust of King Arthur.[75] Unlike the saga, however, there was no great disagreement here between husband and lover, and the tragedy was limited to wounded pride and a life of suppressed passion.

Of all the protagonists, Walter Gropius seems to have emerged from the episode with the greatest restraint and maturity. Considering the wealth of experience he had by then amassed, it is perhaps no surprise that he managed—albeit not without psychological injuries of his own—to lose neither his wife nor his younger friend. Apparently, everything stayed above board from then on. After all, with their departure in October

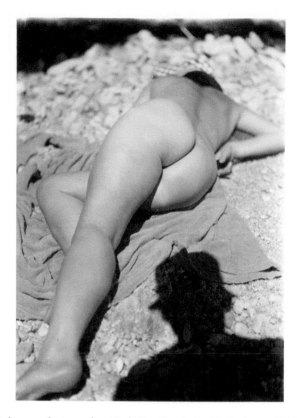

Figure 5.6 Unknown photographer, Nude (Ise Gropius) with shadow, c. 1932. Photograph; Bauhaus-Archiv Berlin, Estate of Walter Gropius.

1934, the Gropiuses decision to move to England removed "Pia" from Bayer's influence for good.[76] In the spring of 1935 Ise Gropius remarked to Marcel Breuer on the state of her love life at the time: "With me, everything is purely legal, despite—or because—my old suffering has by no means been cured."[77] Ise Gropius's deep affection for Herbert Bayer—the attractive, perpetually sun-kissed Austrian—would persist for the rest of her life, even if they never rekindled their affair.[78] As Ati Gropius Johansen reported, shortly before her death in 1983, Ise wrote a passionate and tender letter to her former lover, assuring him one last time that she regretted nothing of what had happened and that there was nothing to forgive or forget.[79]

Part Two

A Commercial Artist in Nazi Germany

Working for Dorland Advertising Agency in Berlin

From January 1933 on, the series of fundamental political upheavals that wracked Germany left drastic, long-lasting marks on each person living there at the time. Adolf Hitler's accession to power as chancellor on January 30, the Reichstag Fire of February 27 and the immediate cover that it offered for the mass round-up of political opponents, the lightning-fast consolidation of Nazi party power following the parliamentary elections of March 5, and the Enabling Act of March 23 granting Hitler full legislative and executive powers—all of these events, and so many more, paved the way for the National Socialists to enforce their policy of social and political *Gleichschaltung*, the coordination of all aspects of public and private life.

The Bauhaus was hated from the beginning in conservative circles for its "leftism," and was an early target as the National Socialists rose to power.[1] After members of the Nazi party were elected into Dessau's local government in May 1932, they withdrew critical local funding from the school; in response, director Ludwig Mies van der Rohe relocated the Bauhaus to Berlin, where it reopened as a private institution that fall. With the overwhelming consolidation of Nazi power nationally during the course of 1933, however—and a particularly aggressive raid on the school on April 11 that resulted in its temporary closure—the institution succumbed to the immense pressure, and the staff shut it down for good that July.

For a time during 1933 it seemed conceivable to Mies and others, including his partner Lilly Reich, Bauhaus master Wassily Kandinsky, and Friedrich Engemann, who taught technical drawing, that the school might survive by adhering to the regime's policy of *Gleichschaltung*—the "coordination" of all aspects of cultural and social life with Nazi ideology. After all, certain aspects of Bauhaus teaching, such as the emphasis on functionalism and effectiveness, did not fundamentally run counter to the goals of the new regime; the former Bauhaus master Oskar Schlemmer even felt that his art accorded perfectly with National Socialist principles.[2] Even after the institution closed, however, Nazi harassment of former Bauhäusler continued apace—and indeed, with unimagined ruthlessness.[3] It is worth emphasizing, however, that the authorities set their sights on the school's most obvious targets: Jewish artists and those closely associated with "international" (i.e., leftist) tendencies. As the former director of Berlin's Bauhaus Archive Peter Hahn has put it, "contrary to a widely held impression, no one seems to have been persecuted *just* for belonging to the Bauhaus."[4] Many a Bauhäusler did in fact escape the charge of "Jewish Bolshevism," either tacitly or explicitly.

Herbert Bayer is a notable example of someone who remained almost entirely unscathed by the political and cultural earthquakes of 1933. Adolf Hitler's rise to power did nothing to interrupt the professional success he was beginning to enjoy as artistic director of Studio Dorland. Nor were the members of his "Berlin network of helpers from the Bauhaus" at the studio adversely affected.[5] Kurt Kranz, the brothers Hannes and Hein Neuner, Max Gebhard, Carl Schlemmer (Oscar's brother), Albrecht Heubner, Xanti Schawinsky, and Hin Bredendieck were among those Bayer cultivated and brought into the studio's orbit. Heinz Loew, Joost Schmidt, and Werner Graeff were also affiliated, somewhat more loosely. Some, like Kranz, had already come to the agency as Bauhaus students on an *Außensemester*, the practical work-study semester required by the curriculum.[6] The studio also served as a meeting place for the circle grouped around Walter and Ise Gropius, Marcel Breuer, László Moholy-Nagy, Marianne Brandt, and Otti Berger during their Berlin days.[7] As Alexander Schug writes, "A widely branching network of former teachers and students had survived the closure of the Bauhaus and was supported by the common Bauhaus experience, lasting collegiality, and often friendship."[8]

Kranz, who had earned his Bauhaus diploma in 1933 during the institution's very last days, served as Bayer's longtime assistant at Studio Dorland. He later recalled his workplace as "an oasis in the commercially minded advertising landscape of Berlin … At Dorland, the approach to graphic work was what it had been at the Bauhaus … But the intellectual jesters on the Kurfürstendamm [where Berlin art circles converged at the time] saw it differently: 'Advertising cuts up all *isms* for sale,' or 'Bayer's little clouds won't do it either.'"[9] While the trade press celebrated the studio for its unique style (see Fig. 6.1),[10] Kranz was also aware of the snootiness of the Ku'damm intelligentsia, who scoffed at advertising as a decidedly secondary art. To them, Bayer's clouds, known throughout the trade as *Bayer-Wölkchen* (see Plate 19), were mere Surrealist borrowings; for Bayer, they served to express moods and psychological states of mind.[11]

Bayer, who ran the studio as an independent contractor, not as a company employee, found himself in a delicate economic situation. On the one hand, he was technically independent of the mother ship—the advertising agency Dorland GmbH Berlin—and remained free to accept his own commissions. On the other, he was contractually bound to the agency, and was financially dependent on receiving regular projects from it. Thus, the more egalitarian, private network of relationships with his former Bauhaus friends and new colleagues at Dorland overlapped with the hierarchical relationships within his studio and between his studio and the agency.[12] Although Bayer always gave the impression that the studio was entirely under his control,[13] it is not clear whether he had the privilege of turning down jobs that Dorland GmbH Berlin had acquired. After the war, however, he never claimed that he had been forced to carry out particular commissions under pressure from the parent agency.

Interestingly, despite being the official head of Studio Dorland, Bayer did not list this position in his response to Gropius's 1935 survey; instead, he merely noted that he had been active since 1930 "as a freelance painter and graphic artist, mainly in the design of all kinds of advertising media."[14] (See pp. 57–8 and 138.) We do not know why he neglected to mention Dorland in this context. Certainly, he was perfectly happy to acknowledge the work in later years.[15] Perhaps at a time of heightened nationalist

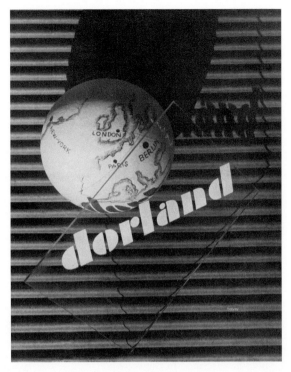

Figure 6.1 Herbert Bayer, Advertisement for Dorland agency, c. 1934. Photograph; Private collection. © Estate of Herbert Bayer/Artists Rights Society (ARS), New York/VG Bild Kunst, Bonn.

zeal, he wished to downplay his connection to an agency that was still very active internationally. Or maybe, as a former Bauhaus teacher, his idea of himself as an independent artist called for discretely suppressing anything that smacked too much of commercial activity. In the complex advertising landscape of the 1930s, however, Bayer's work in the applied arts represented a relatively safe professional haven compared to the often harrowing experiences of other modern artists at the time. Overregulated as the branch was by a confusing set of laws, it was nonetheless difficult for the regime to control it.[16]

In the fall of 1933, Bayer published his brochure "*Dorland 1*" as a vehicle for customer relations combined with a review of commissions so far (see Fig. 6.2). Here, he presented the agency's main fields of activity through examples of his own most striking works. His preface noted that Dorland's advertising agency in Berlin at that time included: (1) a studio for creative design (Bayer's Studio Dorland); (2) photography and photomontage services; (3) a text department; (4) customer service; (5) ad distribution; (6) market research in Germany and abroad; (7) a special department for textile advertising; (8) sales organization in foreign markets; and (9) print commissions and publishing.[17] In other words, it offered everything we would today classify as a full-service agency.[18] In the cover letter he sent at the time to his future collaborator

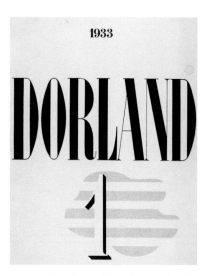

Figure 6.2 Herbert Bayer, magazine *Dorland* no. 1 (only issue), cover, 1933. Letterpress; Private collection. © Estate of Herbert Bayer/Artsts Rights Society (ARS), New York/VG Bild Kunst, Bonn.

Alexander Dorner, Bayer emphasized that his "selection should meet all wishes and directions."[19] The note he inscribed in the copy he gave his wife was less varnished: "A selection / according to *practical* points of view, unfortunately / again this way is necessary / a lot of average work and / sometimes the opportunity to do / something really good."[20] These lines once again make clear that Bayer always considered his commercial design work as a sort of compromise. In 1937 he went so far as to describe it to Gropius as his own personal "advertising purgatory" (*mein reklame-fegefeuer*).[21]

Although Dorland GmbH Berlin maintained international links to its sister agencies in Paris, London, New York, and elsewhere, it was an independent company that had been majority German-owned since 1930. The Nazi advertising council nonetheless initially refused to grant it an official advertising license.[22] According to a 1963 Dorland press release, the antipathy of the Nazi regime had been piqued by the agency's policy of doing business with international clients and employing Jewish staff—not by its association with former Bauhäusler or because of designs that were deemed aesthetically unacceptable.[23] That Nazi ideology did not always categorically oppose a "modern look" has already been noted.[24] Viewers today may nonetheless find themselves astonished by the boldness with which some Nazi-era design picked up on the visual language of the avant-garde, often as if there had been no aesthetic or political break. That an agency like Dorland, despite its international operations, was openly tolerated and granted commissions until well into the war years is one of the many paradoxes of what I have called "diversity within *Gleichschaltung*."[25] Indeed, in order to foster the impression of a range of directions in publishing and commercial art, the regime was prepared to tolerate certain more sophisticated aesthetic directions— provided, of course, that there were no breaches in ideological conformity with the

Nazi state. The careers of Mies van der Rohe and Wilhelm Wagenfeld furnish other notable examples of this phenomenon.[26]

Alexander Schug and his colleagues have already detailed the specific strategies that made Studio Dorland and its high-profile staff the most prominent advertising address in Germany.[27] Bayer's design work succeeded in establishing a global reputation for the agency as the "epitome of modern advertising design," as Schug calls it.[28] In 1933 the contemporary trade press lauded Walter Matthess, chief owner of Dorland GmbH Berlin, and Bayer, creative head of Studio Dorland, as "leading figures in the German advertising world" and credited Bayer in particular with the great merit of uniting German advertising with international trends.[29] "You are simply a pioneer and fifteen years ahead of your time," Bayer's friend Jorge Fulda later acknowledged.[30] The decisive role Bayer's unmistakable design features played can be traced back to three major strategies: (1) the use of photographs, albeit only as raw material for further graphic processing; (2) the clear and logical organization of a visual space to facilitate orientation; and (3) the combination of everyday motifs with improbable or impossible elements, aimed at creating surprise effects in the minds of viewers.[31] Ellen Lupton recently described his approach to materials, "He worked with a fine paintbrush and opaque gouache or with an airbrush, a device that applies a fine spray of paint to a surface, commonly used for retouching photographs. The resulting images are seamless and fluid."[32]

It is worth noting in particular that, while working for Dorland, Bayer had set up a darkroom in his studio and hired a photographer—whose identity is no longer known—to take the shots he needed for his designs. "And it was always photography," he later recalled in an interview. "It was very seldom that I drew illustrations or something. Of course, it was a principle of mine. I believed in anonymity and, let's say, the impersonality of the photographic illustration, versus the personal artistic representation."[33]

Bayer's commercial work of the 1930s falls into four main categories: (1) company advertising, especially for fashion and hygiene products; (2) book and magazine covers; (3) typefaces and type specimens; and (4) publications associated with Nazi propaganda exhibitions.[34] Further information illuminates the complexity of Bayer's work in each of these categories:

(1) Company Advertising

This was certainly Bayer's main area of responsibility at Studio Dorland, especially from 1935 onward. Willy B. Klar, the longtime advertising manager at Dorland GmbH Berlin, was in charge of acquiring commissions from the textile industry. In his colorful memoirs, he eloquently testified to the interrelationships and business practices in this branch, and described how technical innovations in particular were the driving force for advertising: novel snap fasteners and zippers, artificial silk, and water-repellent fabrics first had to be made known to a wider public, opening up a lucrative field of activity for creative advertisers.[35] The Dorland archive contains hundreds of advertising motifs that were used in campaigns by various manufacturers and, since the commissions came through the agency, they generated considerable profits.[36] Even

if the ads bear Bayer's signature, it cannot be assumed that he personally executed all pieces in this very large body of work.[37] This was the bread-and-butter business that his employees handled. Typically, they would adapt an existing basic layout with new pictures, slogans, and explanatory texts, while the general impression remained the same, promoting a recognition effect within a campaign. An internationally recognized graphic designer like Bayer is unlikely to have done the grunt work of designing the individual motifs of a given ad campaign.

An exception emerged with Bayer's drafts for a multi-part Chlorodont ad series, which appeared regularly in high-circulation magazines throughout Germany beginning in January 1937. Each of the first series was numbered to indicate its part within the campaign (e.g. "No. 10 of the Chlorodont series"), a hitherto unknown practice. The full-page black-and-white motifs resemble small posters and were intended to draw attention to the toothpaste company's educational film *Lebende Werkzeuge* (*Living Tools*). Although some use the old German typeface Fraktur, all the features that made Bayer's pictorial language so distinctive are on display in the series: the focus on a core statement, an interlacing of elements on different visual levels, and montages of individual photographs to gesture to a story line (see Fig. 6.3). Classical Greek statues and elements from his paintings and drawings are present here as well. As the historians Thomas Gubig and Sebastian Köpcke write, "With his idiosyncratic black-and-white photo collages, [Bayer] burst the dogmatic rigor of Chlorodont advertising of those years. With his playful montages, he liberated it from its pedantic frostiness and gave it back its vitality and individuality."[38]

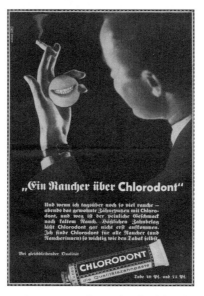

Figure 6.3 Herbert Bayer, Advertisement for Dorland's Chlorodont campaign, 1938. Offset printing; Private collection. © Estate of Herbert Bayer/Artsts Rights Society (ARS), New York/VG Bild Kunst, Bonn.

(2) Book and Magazine Covers

Bayer's list of cover design projects with the Dorland Studio is long, and includes several commissions of the renowned Rowohlt publishing house, for the Büchergilde Gutenberg, and for Scherl publishers.[39] He also created the cover and layout for Carola Giedion-Welcker's book *Moderne Plastik* (*Modern Sculpture*), which came out in Zurich (see Fig. 9.4). For his most prestigious project, his cover designs for *die neue linie*, he was commissioned directly by Beyer Verlag rather than through the Dorland studio.[40] The most progressive lifestyle magazine of its day, *die neue linie* was never state-owned, nor was it an official organ of German propaganda abroad.[41] Bayer continued to design spectacular covers for the magazine well into the 1930s.[42] Several of these are remarkable designs in a Surrealist spirit, such as the October 1934 issue, which features a mystical moonlit seascape with the large doll-like head of a woman hovering above it (see Plate 18).[43] The empty picture frame placed in the lower foreground—as we have seen, a recurring element in his photomontages and paintings—evokes, for example, the frame held aloft by the bridal couple in Bayer's own wedding photograph of nearly a decade earlier (see Fig. 2.3).

The floating head on that cover bears a striking resemblance to one on the cover of an advertising brochure Bayer did for the magazine in 1930.[44] Moreover, the same stylized head was included in perhaps the most spectacular advertising medium Bayer ever designed: a 1932 oversized billboard for *die neue linie* that appeared on the side of a building near Berlin's Anhalter Bahnhof, where it was visible from the railway tracks (see Fig. 6.4).[45] This enormous work combined the woman's

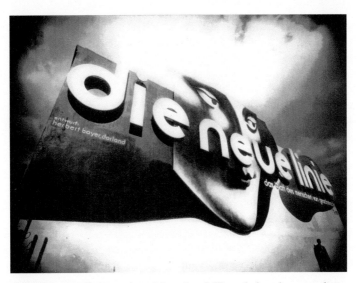

Figure 6.4 Unknown photographer, Magazine billboard for *die neue linie*, c. 1932. Photograph; Private collection.

three-quarter profile with lettering and color surfaces in a three-dimensional composition.[46] Here is clear visual proof that some forms of modern design could be continued without interruption after the official Nazi policy of *Gleichschaltung* was introduced. Intriguingly, although observers had already noticed Bayer's affinity for Surrealism as early as the 1920s, their creator would vehemently rebuff it throughout his life.[47] "I had no direct contact with the surrealists, and did not see any publications which may be said to have had influence on my work."[48] Although he did not deny the importance of the fantastic in his work, he attributed it primarily to his interest in natural forms; any symbolic content was unintentional. Certainly, works such as the above-mentioned "floating" cover for *die neue linie* of 1934 cast doubt on his later insistence.

Despite the dazzling covers that he created for *die neue linie* and other periodicals, Bayer, unlike some of his internationally renowned colleagues, never served as art director of a magazine. That is, after the failed experiment with German *Vogue*, he did not have to work out designs for inside pages and layouts. Only in individual cases did he put together entire issues, such the February 1928 issue of *Bauhaus* magazine or the Dorland brochure of 1933. There was one exception, however; the Berlin photo studio Atelier Binder published an occasional house magazine called *Die Gesellschaft* (begun in 1928), and from around 1932 onward, its A4-sized issues were designed by "herbert bayer, studio dorland." Its focus on technically excellent photography from Atelier Binder, presented to the best advantage in the magazine, probably came very close to Bayer's ideas of a modern layout.[49]

(3) Typefaces and Type Specimens

With the explosion of print media in the early twentieth century, designs for new type forms were essential means of communicating content in what readers perceived as modern or innovative in its form. Already at the Dessau Bauhaus Bayer had designed his Universal, with an aim to create a typeface based on the principles of New Typography, using only geometric forms.[50] He was by no means the only designer of "Constructivist" typefaces, but Universal ultimately succeeded—despite its undoubtedly modernist, Bauhaus-like appearance—because it graced the covers of a mass circulation magazine, *die neue linie,* from 1930 until 1943.

For Berthold A.G., a type foundry in Berlin, Bayer designed, among other things, the so-called Bayer-Type, an industrial typeface in 1935, as a classic serif roman type on a geometric basis (see Plate 9). It was mainly used in the Scandinavian countries and earned him royalties until he left Germany for the United States.[51] At the time of its creation, an extensive portfolio of typeface samples for Bayer-Type—which may or may not have been assembled by Bayer himself—received high praise in the professional world.[52] Undoubtedly from Bayer's drawing table, on the other hand, were two brochures showcasing typefaces that he had *not* created: Berthold's Normande and Signal from 1933. These advertising brochures are among Bayer's best typographic works (see Plate 10). Brilliantly produced in four-color printing with special inserts, folded transparent covers, and a generous layout overall, they carried Bayer's name out into the world of printing.

(4) Publications for National-Socialist Propaganda Exhibitions

Bayer contributed booklets, posters, and other printed matter—from flyers and logos to catalogue cover designs—to a trilogy of major Nazi exhibitions: *Deutsches Volk, deutsche Arbeit* (German people, German work, 1934), *Das Wunder des Lebens* (The Wonder of Life, 1935), and *Deutschland* (Germany, 1936).[53] All three exhibitions served the regime as significant propaganda events to generate a sense of community by events that integrated different media, and they will be discussed in greater detail in Chapter 7. For each of the three exhibitions, Bayer created the key visual for the poster, the catalogue cover (the *Amtlicher Führer*, or "official guide") and publicity materials. Most importantly, for each show he composed the slender companion booklet (*Austellungsprospekt*), a high-circulation, affordable paperback that conveyed each exhibition's basic ideas to a mass audience through visual storytelling. That each show involved a suite of often quite similar looking publications has unfortunately led to misunderstandings and ambiguities in the literature.[54] Both the catalogues and booklets for all three exhibitions were designed in the still unconventional square format (with a side length of twenty-one centimeters, one of the new DIN standards) for high recognition value. This format had, in fact, been popular in modern graphic design circles since Moholy's 1923 catalogue for the first Bauhaus exhibition. Bayer himself had already tried it out in the often overlooked catalogue cover with the striking American flag that he designed in 1933 for the German pavilion at the Chicago World's Fair (see Plate 11). While the interior pages of the three larger 1934–1936 catalogues show conventional book typography (typeset by others), Bayer himself designed the individual booklets: three sets of striking layouts. They show Nazi propaganda statements embedded within complex graphics via Bayer's characteristic montage technique.

Without minimizing this work, it is worth noting that Bayer's participation in the "propaganda trilogy" was restricted to graphic design only. That is, he designed posters and companion booklets, while the actual arrangement of the exhibition was in other hands.[55] Kristie La has speculated that Bayer, who could have been even more successful than he was in the Third Reich, abstained from executing the exhibitions because he recognized the risk of collaborating with the regime. On the other hand, "he also valued his practice too much to abandon it, choosing instead to believe in the possibility of a middle way that would allow him to continue working without having to make too many concessions to those newly in power."[56] This "middle way" resembles the idea of living "the right life in the wrong one"—a possibility Theodor Adorno flatly dismissed in *Minima Moralia*, a work he began writing from his own American exile in 1944.[57] It was, however, an illusion that Herbert Bayer would continue to harbor until deep into the 1930s.

Understandably enough, in the postwar period Bayer played down this work. In the 1967 monograph that he organized for himself, he only included the poster for *Das Wunder des Lebens* and four harmless color graphics on the functioning of the human body with their accompanying texts omitted, along with an illustration of daily nutritional requirements; he presented these merely as examples of his montage technique.[58] Bayer deliberately excluded all other printed material from the propaganda exhibitions.[59]

It is symptomatic that, when photography curator Christopher Phillips asked him about the booklet he designed for the 1936 *Deutschland* exhibition (see Plate 17) Bayer's only comment was singularly anodyne: "This is an interesting book in that it was made exclusively with photography and photomontage, and printed in duotone technique."[60] There may be a variety of reasons why he failed to acknowledge the political–historical background conditions. Nonetheless, his efficient designs for all three propaganda exhibitions certainly contributed to legitimizing the Nazi regime's policies. Three years after the end of the war, Bayer summed up his Dorland years in a private letter. "Although I feel that I did too much and sometimes gave in too easily, I think that we did some pretty progressive work in Berlin."[61]

While most of Bayer's designs in his Dorland period fall into one of these four main categories, there are notable exceptions from branches such as furniture, household appliances, electronic devices, spirits, jewelry, and other consumer goods.[62] This wealth of printed matter proves Bayer and his Studio Dorland as one of the most popular advertising agencies in 1930s Germany, but it has to be emphasized that, unlike many of its competitors, it never produced straight propaganda for the National Socialist party NSDAP, nor for one of its local sections or for any governmental source such as Goebbels' Ministry of Propaganda and Public Enlightenment. The next chapter will look closely at how exactly Bayer pursued his "progressive" ideas under National Socialism, including his work on this propaganda trilogy. It will also examine how his success helped him foster his own impression that he was pursuing a right life in the wrong one.

7

Designs for Propaganda

Considering the type of projects listed in the previous chapter—particularly the propaganda work—one can hardly accept Alexander Dorner's 1947 characterization of Herbert Bayer as a sort of aesthetic resistance fighter, an artist engaged in braving "fascist authorities" and "fighting against a collapsing mountain."[1] The impression was passed down in several accounts of his oeuvre, however, and was indeed the dominant line during Bayer's lifetime. Certainly he consistently pursued a program of modern design without making significant concessions to the regime's preferred idea of much more traditional art. But to interpret this as "resistance" fits neither the perspective of the time nor today's definition of resistance.

Indeed, Bayer demonstrated a rather extraordinary lack of interest in politics and ideology. His wife Irene Bayer-Hecht stated it quite plainly in the text that accompanied his 1936 exhibition at the Künstlerhaus Salzburg: "Herbert Bayer is neither intellectually nor politically active, but purely creative, compulsively projecting from within himself what his deepest urges and longings drive him to create."[2] Under the circumstances, it might have been quite convenient to style oneself as a dreamy artist in order to avoid run-ins with state power. Even so, what Bayer-Hecht described as her husband's "departure from all apparent reality"[3] inevitably brings up the question of the social irresponsibility of Bayer's design achievements during the Nazi era.

Not everyone took a forgiving attitude toward one of the period's most successful commercial artists. In the 1950s the critic and photographer Franz Roh, for example, felt the need to defend Bayer against accusations by art critics that his elegant designs had made him nothing more than a "dandy of form."[4] Bayer's activities in the midst of what Bayer-Hecht euphemistically termed "our present and modern life"[5] exemplify a role that some former members of the Bauhaus managed to play quite successfully, as a "domesticated avant-garde" in the Nazi state.[6] As Bayer's work from the 1930s shows, certain elements of Modernism could in fact be tamed, even shaped into instruments of state propaganda. It should be noted that, like anyone practicing graphic design in Nazi Germany, he was of course a member of the Reich Chamber of Fine Arts, but he never joined the Nazi party.[7]

In an excellent 1994 essay on Bayer's photographic work, Rolf Sachsse explained that Bayer could only bear to remain in Germany by deliberately cultivating a political blindness that allowed him to pursue an everyday pragmatism. "For Herbert Bayer himself, pragmatism meant first and foremost unconditional loyalty to each and every client, because the dependence of his actions on outside impetus implied a fundamental

fear of not receiving another contract after the next one, which would result in losing the basis of his livelihood."[8] As Sachsse put it, the interchangeability of formal elements within Bayer's designs resulted in the use of a supposedly neutral canon, which—Bayer being a "robust pragmatic"—also facilitated his propaganda projects for the Nazi cause. In Sachsse's account, between 1934 and Bayer's departure in August 1938, he "used the modern repertoire as a drawing machine in very concrete ways to impress viewers superficially, that is he pursued by definition an aestheticization of policy, thus acted in a way that had fascism as its underlying cause."[9] Although Sachsse's argument and conclusion (summarized here all too briefly) may still be debated, his examples highlight substantial questions that the artist himself was never ready to face. Thus, Bayer's work from the 1930s calls for a good deal more scrutiny.

As many have noted, Bayer signed not only his own work but also the work of his studio employees with his mark ("– – Y – –") in keeping with the idea of a traditional master workshop (see Fig. 7.1).[10] This was also consistent with a practice Bayer had pursued since his Bauhaus days of identifying the works for which he bore responsibility, a rather unusual choice for commercial art at the time.[11] In the 1930s, however, this system was not entirely Bayer's choice to make. In a letter dated October 1937, the Reich Chamber of Fine Arts (Reichskammer der bildenden Künste)—itself a subsidiary of the Reich Chamber of Culture (Reichskulturkammer)—had decreed that Bayer's name or the "y" sign must appear clearly in all designs or preliminary sketches for Dorland so that the he could be identified as the author of each of his printed products.[12] As the design historian Ute Brüning has pointed out, in some cases the presence of the mark may say little about Bayer's actual involvement.[13] We can assume, however, that the works thus signed received at least his artistic and commercial imprimatur.

Bayer's situation in Adolf Hitler's Germany demands a nuanced presentation, especially as the reasons he gave shortly after the end of the war for his emigration

Figure 7.1 Herbert Bayer, Photographer's stamp with his personal mark "– – Y – –", 1930s. Ink on paper; Private collection. © Estate of Herbert Bayer/Artists Rights Society (ARS), New York/VG Bild Kunst, Bonn.

were themselves so vague: "I really don't know what made me decide to leave Nazi Germany, except that I developed a violent dislike for the whole situation, and I had some uncertain feelings that a major catastrophe was coming on."[14] What then was Bayer's "situation" in the mid-1930s? His "racial" background was certainly no cause for Nazi persecution, and his Austrian citizenship—although it meant the world to him—was hardly considered a blemish at the time. His wife, however, had at least one Jewish parent.[15] Bayer-Hecht's US passport essentially protected her from the increasingly drastic anti-Semitic laws, and for whatever reasons, Bayer-Hecht made no mention of Nazi terror against Germany's Jewish community in her letters.[16] Years later Bayer would state that her status and his concern for their daughter were one of the reasons for his emigration.[17]

A second obvious motive for emigration—political persecution—also seems to have been absent in Bayer's case. Apart from expressing displeasure with the regime in private, the publicity-shy Bayer never appears to have made any political statements that would have made him the target of suppression or reprisal. And while he had undoubtedly made a substantial contribution to the development and dissemination of the New Typography—a visual language widely deemed "left-wing" at the time— the connection did not damage him politically.[18] Bayer never belonged to a political party, never authored a critical piece in the exile press, and never spoke out against the system in public appearances.

It appears, however, that he took a tolerant stance toward the non-conformist politics of his acquaintances. Max Gebhard, who had been his student in the advertising workshop in Dessau, later acknowledged that Bayer was aware of his own political views. Bayer knew Gebhard was a member of the Communist party and the Association of Revolutionary Visual Artists of Germany (ASSO) and that he was involved in illegal activities after 1933; nevertheless, Bayer "behaved correctly and even supported me. Bayer was still the head of the studio in Berlin until 1938 and, like [Albrecht] Heubner, he let me work in his studio during this difficult time and also obtained commissions for us elsewhere."[19] In the 1970s, Gebhard stated in an unpublished interview that he himself did not agree with every commission that was executed by Dorland; before 1933, Bayer, however, had tried with his help to land a contract with the Communist party—in vain: "He might have created a good poster, but he was not convinced of our mission."[20]

There is no doubt that in his private life, Bayer repeatedly and clearly distanced himself from the racial ideology of the Nazis. This was chiefly demonstrated by his intense and lasting friendships with Jewish artists such as Marcel Breuer and Xanti Schawinsky. Willy B. Klar, his colleague at Dorland and close friend—himself classified as a "half Jew" according to the regime's definitions—noted in his memoirs that Bayer nurtured a deep hatred of both Hitler and Joseph Goebbels, and hinted that Bayer even joked about planning their assassinations. Such pranks, had they been reported to the authorities, would have resulted in instant Gestapo harassment.[21] But Bayer's negative view of those in power was only voiced in the private sphere, and, it appears, mostly in connection with professional disadvantages in the awarding of contracts. For example, in a letter to Breuer from December 1933, he wrote: "Today I thought I would get a big contract. But brown gentlemen again prevented this opportunity (but shit—it was crappy)."[22] Even when one concedes that it was risky at the time to commit his political

criticism to writing, it is still notable that the passages in Bayer's letters that are critical of the Nazi regime never refer to political issues but only to his dismay with working conditions: "A lot of work, few brains. In this relationship we have already gotten into a mess," he wrote to Breuer in 1936.[23] It appears that his unhappiness with the "brown gentlemen" related mostly to unfair economic treatment—or, to put it bluntly, a kind of social envy. In political terms, Bayer mainly stayed off the regime's radar, as his comparatively thin personal file with the Reich Chamber of Fine Arts attests.[24]

From a financial point of view, Bayer actually had little reason to be unhappy with his lot. His own brother Theo Bayer chided him gently for being "something of a pampered gentleman [*ein verwöhnter Herr*] when it came to working conditions."[25] Based on his research in the personnel files in the Reich Chamber of Culture, Alexander Schug concluded that Bayer was "one of the best-paid Bauhäusler living in Germany."[26] His income in 1936 was 17,772.33 reichsmarks (see Fig. 7.2).[27] As Schug notes, this was ten times the annual income of someone like Max Gebhard and four times that of Kurt Kranz.[28] Following conversion information from the German Statistical Office,

Figure 7.2 Herbert Bayer, Declaration on the Determination of Fees by the Reich Chamber of Fine Arts for the Financial Year 1937; Denver Public Library, Herbert Bayer Collection.

this corresponds to a 2021 equivalent of about \$85,000.[29] It remains unclear, however, whether this amount actually correlated with his personal income. As already noted, Bayer ran Studio Dorland independently; this made him responsible for all of its expenses; on his 1937 tax return, Bayer stated that, in 1936, he had paid salaries to three employees amounting to about 13,500 reichsmarks. This reduced his taxable self-employment income to around 4,200 reichsmarks that year—not a particularly generous amount considering the material costs to be covered and, as the returns state, without employee income of his own. The extent to which he may have supplemented this income with additional commissions undertaken privately—such as his covers for *die neue linie*—remains nebulous; unfortunately, no further documents on Dorland's accounting practices or on the working conditions in the studio are preserved in his personal files or in official records.

Beyond his commercial activities, Bayer was hardly likely to have made much money as a fine artist during the period, for he was in fact labeled as a "degenerate". At least one of his works was included in the infamous 1937 *Entartete Kunst* (Degenerate Art) exhibition and the subsequent travelling show: *Landschaft im Tessin* (Landscape in Ticino, 1924), from his Bauhaus period, held by the Folkwang Museum in Essen at the time.[30] A total of three of his works were probably confiscated and removed from public museums as part of the regime's campaign against modern art.[31] This was practically inevitable for any former Bauhäusler, and particularly for such a prominent representative of the school as Bayer, as he had been a junior master there.

That Bayer was nevertheless able to work largely unimpeded in Nazi Germany was partially due to the fact that he had left the Bauhaus early and had been working as an independent commercial artist from 1928.[32] Somehow he was not in the censors' sights. As he told interviewer Ruth Bowman in 1981, "They did not see the liaison, so I was unmolested until quite some time."[33] Today we know that practitioners of the applied arts—a category that included Bayer—were simply assigned to a different department of the Reich Chamber of Fine Arts than independent artists, and that this department placed greater emphasis on exploiting design talent to serve the regime.[34] During an initial consolidation phase, the regime attempted to increase the acceptance of its "new order" not only within Germany but also around the world. As Schug put it, "one can assume that an internationally known avant-gardist like Bayer fit in well with the calculations of the Nazi propagandists."[35] His visual language, which often drew on the classical formal vocabulary much touted by the Nazis, seemed to be quite compatible.[36] Bayer's cover designs, booklets, and posters for the three propaganda exhibitions mentioned in the previous chapter serve as prime examples of this constellation.[37]

Building on the large-scale social educational exhibitions of the Weimar era, such as the GeSoLei (Great Exhibition of Health Care, Social Welfare and Physical Exercise, 1926 in Düsseldorf) and the International Hygiene Exhibition (Dresden 1930), the new regime quickly grasped the propaganda value of such shows for reaching a mass audience.[38] A complex institutional network channeled the exhibitions. These included the Institute for German Cultural and Economic Propaganda (IfDKW), founded in April 1933 (later a subordinate of the Advertising Council of the German Economy)

and the national Office for Exhibitions and Trade Fairs, itself a department of the Reichspropagandaleitung (Head office for Reich propaganda), a Nazi party organ that was in fact separate from the Propaganda Ministry—although Goebbels led them both. Together, the institute and the trade-fair office were headed by the Berlin architect Waldemar Steinecker, under Goebbels' leadership. The institute controlled what was officially referred to as "cultural and educational shows with an economic impact."[39] The trade-fair office carried out "political, economic, and cultural tasks" in order "to inform and educate the entire German *Volk*."[40] Clearly the missions of these two organizations were related but separate, with the former oriented particularly to economics and the latter aimed more squarely at education. As "scientific director" for the Berlin Office of Exhibitions and Trade Fairs, the medical scientist Dr. Bruno Gebhard helped plan the entire trilogy; Bayer would later cite him as a professional reference long after both men had launched new careers for themselves in America.[41]

In the run-up to the 1936 Olympics in Berlin, the German Propaganda Studio (Deutsche Propaganda-Atelier, DPA) was founded as a private businesses association that organized, among other things, the events held at the Messehallen am Funkturm, the new Berlin fairgrounds at the base of the radio tower.[42] The head of the DPA was Pay Christian Carstensen, a high-ranking officer in the Propaganda Ministry and likely an acquaintance of Bayer's. A sort of friendship had developed between Bayer and Ingo Kaul, an employee of the news department of Berlin's Trade Fairs Office (Messeamt). This probably dates to 1933 and the first major Nazi exhibition, *Die Kamera*. While *Die Kamera* was aimed at a specific audience—photography professionals and amateurs, members of the camera industry, and producers of technical equipment—in hindsight it is viewed as a precursor to the major propaganda shows that followed. *Die Kamera* defined photography as a "national folk art," and it pioneered propaganda techniques that would soon become familiar through other exhibitions, most notably oversized photo murals intended to overwhelm visitors with National-Socialist ideology.[43]

Kaul had taken over the editorial management of the official catalogue that Bayer designed (see Plate 12). Bayer's cover illustration, a color still-life of darkroom equipment, bore a stylistic resemblance to his February 1928 cover for *Bauhaus* (see Fig. 3.7). As he not only supplied the cover but was also responsible for the layout of the catalogue's entire 122-page editorial section, Bayer and Kaul must have cooperated closely on the book.[44] Bayer received other commissions from the Berlin Trade-Fair Office associated with various exhibitions, including posters for the International Bureau Exhibition (IBA), the annual show for the restaurant, hotel, bakery, and confectionery trades, the open-air flower show at the base of the radio tower, *Sommerblumen am Funkturm*, and the exhibition *Die Straße* (The Street), held in Munich.[45] Kaul's name also appeared as editorial director in each of the catalogues for the major trilogy of exhibitions in 1934, 1935, and 1936 at the Messehallen fairgrounds in Berlin.

While they may have been created though a tangle of overlapping supervisory organizations, the large, state-sponsored propaganda exhibitions pursued one aim: to achieve broad public impact. Their conception and marketing, as executed by the Institut für Deutsche Wirtschaftspropaganda, ensured a steady rise in visitors nationally from 2.1 million in 1935 to 5.3 million in 1938, although the number of exhibitions in

Germany was reduced from 67 to 37.[46] The commercial character of such fairs quickly faded into the background, while the increasingly elaborate productions—conceived by the regime as a stage for cultural and social propaganda—were subject to strict ideological control. The professed goal, apart from "documenting" the development work in the new Germany, was, according to Dr. Immanuel Schäffer from the Propaganda Ministry, "cultural enlightenment" as an "ideological educational task."[47] In other words, indoctrination.

The three mass propaganda shows in which Bayer participated—*Deutsches Volk, deutsche Arbeit* (1934), *Das Wunder des Lebens* (1935), and *Deutschland* (1936), all of them held at Berlin Messehallen—had a prominent role within the Nazi exhibition program. They were pitched as a trilogy by the organizers and understood as such in the contemporary press.[48] The 1934 show presented more of a macroscopic perspective on Germany and an idealized view of its society, while the second, with an emphasis on "health" and "hygiene," homed in on the "nature of the individual." The curator Bruno Gebhard admiringly described *Wunder des Lebens* at the time as the "natural sequel" to the first.[49]

Deutschland, geared as it was toward the international audience visiting Berlin for the 1936 Olympics, synthesized the two previous shows into a glorious presentation of "the Reich" to the outside world.[50] Bayer's coordinated design of the printed communication media for the entire trilogy (posters, official catalogues, companion booklets, and the like) provided it with its visual framework and highlighted the links between the individual shows. According to Ulrich Pohlmann, Bayer's graphic design—and his photomontage work in particular—helped lend Nazi ideology a modern, timely aura and to heroicize the "progress" of the political system. Even if the catalogues and booklets resembled harmless tourism brochures at first glance, there could be no mistake about their political message.[51]

As the leitmotif for 1934's *Deutsches Volk, deutsche Arbeit*, Herbert Bayer designed a laurel wreath symbol that could be placed against different color backgrounds. The motif alluded to the 1933 Nuremberg Rally, the Nazi party's "Congress of Victory" held the previous summer to celebrate the party's rise to power. The wreath appeared on various printed materials for the exhibition, including the cover of the official catalogue. For the cover of the smaller, thirty-six-page booklet, Bayer placed the same motif against a monochrome green background (see Plate 13). Meanwhile, the "typophoto" on the back cover, with its hovering lines of text and dynamic combination of typography and photography, evidenced a far more avant-garde aesthetic, paying visual homage to Moholy-Nagy's famous dust jacket for *Von Material zu Architektur* of 1929.[52] The inner pages of the booklet mainly consist of large-format photographs interleaved with explanatory texts on overleaf pages; these narrower strips only partially cover the pictures for a vivid visual effect (see Fig. 7.3). Predictably enough, the text distills Nazi ideology into pithy slogans—for example, emphasizing the importance of preserving "Germanic blood and cultural heritage" and decrying the Treaty of Versailles as a *Knebelvertrag*, which translates roughly as an "oppressive contract" that the nation had been forced to sign under extreme and unfair pressure; a narrative that many Germans still insisted on.[53] Most of the booklet's visuals relate to everyday life—scenes of farming or of craftsmen, workers, volunteers, and sportsmen engaged in their

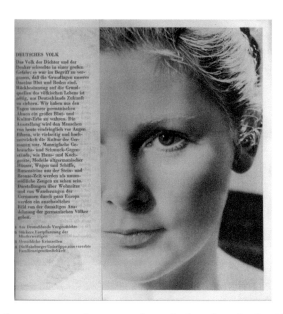

Figure 7.3 Herbert Bayer, Page from *Deutsches Volk, deutsche Arbeit* booklet, 1934. Offset printing; Private collection. © Estate of Herbert Bayer/Artists Rights Society (ARS), New York/VG Bild Kunst, Bonn.

activities. It was intended for wide distribution in hotels, travel agencies in Germany and abroad, trade associations, shipping lines, German railways (Mitropa), and the national airline Lufthansa. The trade press greeted it enthusiastically.[54]

The second show in the trilogy was *Das Wunder des Lebens*, which promoted the regime's racial ideals in the guise of a health exhibition. On view in Berlin between March 23 and May 5, 1935, a version of it later traveled through the Nazi-occupied eastern territories from 1941 on.[55] For the show's publicity and publications, Bayer conceived a highly recognizable emblem that merged the classical Greek sculpture of the Doryphoros or *Spear Bearer*—a version of which was on permanent display in Munich and well-known to Germans as part of their school education—with the exhibition's top popular attraction, the *Gläserner Mensch* (*Transparent Man*), a spectacular anatomical display recently developed at the German Hygiene Museum in Dresden.[56] A feat of plastics technology and lighting, the model's organs and arterial and venal systems could be illuminated in vivid color at the touch of a button; replicas of it soon traveled as far as the 1933 World's Fair in Chicago. Bayer's own iteration of this heroic male nude went a step further, encasing him in a sort of embryonic bubble—a transparent body within a transparent shape.[57] His maquette of the catalogue's cover, preserved in the Wolfsonian-Florida International University (see Plate 14), combines a photomontage of the male figure and a bubble, color airbrush, and black ink into a striking visual that would remain one of Bayer's signature designs throughout his life.[58] Bayer, in fact, borrowed the image's construction principle from the esoteric drawings of Charles Webster Leadbeater, the British theosophist whose 1902 book *Man Visible and Invisible* appeared in German in 1908.[59]

For the accompanying twenty-four-page prospectus in particular, Bayer's montages form an all-too congenial visualization of Nazi-style Social Darwinism, applying a deliberately appealing aesthetic to the vision of a utopia inhabited by "Aryan" Nordic types.[60] As the design historian Jürgen Krause has pointedly put it, the booklet conveys "in an explosive mixture of modernity and martiality ... the biological maxims of the Nazi party dressed in classical garb."[61] Bayer's illustrations—so widely admired in the international trade press—included, among others, an image captioned, "the family as the cell of the *Volk* and guardian of its genetic patrimony" and a visual condensation of the history of creation from the "primeval mist" to the emergence of Aryan man as the "crown of creation."[62]

Tellingly, two entities involved in planning this show were the Nazi party's Race Policy Office (Rassenpolitisches Amt der NSDAP) and the SS Race and Settlement Main Office (SS-Rasse- und Siedlungshauptamt).[63] Bruno Gebhard, the medical doctor who had curated the exhibition, also authored an extensive, academic "companion volume" (*Begleitbuch*) with Bayer's colored montage on its jacket (see Plate 15). As Gebhard noted in his postwar memoirs, the event's propagandistic character was impossible to miss. In the vast halls of the Berliner Messe, viewers could not only wonder at the "Transparent Man," transformed on Bayer's poster into a fine specimen of the *Doryphoros*, but also wrinkle their noses at anti-Semitic photographs "of the Chosen People" and recoil in disgust at a sensational demographic modeling of the adverse effect of allowing "inferiors" to reproduce (see Fig. 7.4).[64] According to Gebhard, a number of prominent Nazis gathered at the *Wunder des Lebens* opening, including one of the party's more notorious racial theorists, Interior Minister Wilhelm Frick, who used the occasion to propound Nazi eugenics policy.[65] It is with these facts

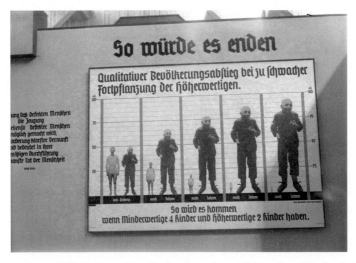

Figure 7.4 Georg Pahl, Demographic display from the exhibition *Das Wunder des Lebens,* 1935; Bundesarchiv Berlin, Image no. 102-16748.

in mind that Sabine Weißler has rhetorically asked: "How clueless or how disengaged could a person like Herbert Bayer be in aestheticizing such slogans?"[66]

It would be going too far, however, to suggest that Bayer deliberately sought to camouflage the regime's message by putting its racial laws into "an aesthetically appealing packaging."[67] Bayer later described his work on the project as being dominated by the design task of communicating "medical information" as effectively as possible to a lay public.[68] As he put it privately in a letter from early January 1935 to Breuer, he had designed the publication as best he could despite his clients' lack of "understanding." Of his avant-gardist application of photomontage in combination with airbrush illustration, he asserted, credibly, "that it was a struggle to push through something like this without punishment."[69]

Years later he wrote to Arthur Cohen that the depictions of Hitler in his illustrations were the result of direct interference from the Propaganda Ministry, meddling to which he claimed to have found a cunning solution:

> The booklet was going to press when the propaganda ministry saw it, or got hold of it, and by my knowledge stopped the presses, and demanded inclusion of adolph [*sic*] hitler … For the page in question, I found the best compromise solution was to show hitler as small as possible and try to relate the pages to the subject of anatomy.[70]

Indeed, in a large photomontage, Hitler appears as a tiny figure at a lectern at the upper right, though arrows and two captions highlight his presence, the inaugurating quote "German workers begin now," which leads up to the podium on a strong diagonal, and a roundel to the left of him with the caption "6.2 mill. unemployed" (see Plate 16). Three dynamic white arrows visibly link the captions to the Führer and, in turn, to the larger photos of men at work, as they build, among other things, major projects like the railroad and the Autobahn. In its design strategy the composition bears a striking resemblance to El Lissitzky's photomontages, such as those he did for the Soviet foreign propaganda magazine *USSR in Construction*.[71]

Before the show opened, Bayer sent twenty copies of his *Wunder des Lebens* booklet to prominent designers all over Germany and abroad. His intent was plainly not to elicit their opinions about its ideological content; rather, he expected they would give feedback—perhaps praise, perhaps criticism—on his avant-garde designs.[72] To sum up the situation in 1935, Bayer still enjoyed the highest reputation among his professional colleagues—a reputation based entirely on his creativity as a designer and certainly not on his political positions. Much to his disappointment, Bayer's informal mailing yielded little feedback. In his notes that February he attributed the low rate of response to "cowardice and lack of conviction on the part of those still living in Germany at the time, and … lack of interest on the part of those *beaux esprits* who have feathered their nests abroad."[73]

This remark, made at a time when many Jewish artists, writers, and designers were fleeing Germany in outright fear for their lives, showed astoundingly little self-awareness and puts his professed apolitical stance in anything but a flattering light. Yet throughout his lifetime, the *Wunder des Lebens* work was frequently reproduced,

becoming something of an emblem of his commercial design, yet with little or no mention of the dubious context for which he crafted it.[74] It is also worth pointing out that even the renowned American trade journal *Industrial Arts* reproduced all of the spreads of the entire twenty-four-page booklet in its winter 1936 issue, alongside full translations of the original texts into English. The article praised the exhibition's content, scientific foundation, and its advertising material while completely ignoring its racist and propagandist background.[75] In subsequent discussions of Bayer, such disregard for the dubious moral nature of the content continued well into the postwar years; Eckhard Neumann, for instance, in his widely read article on Bayer's photographic experiments, presented the cover and four spreads from the booklet as late as 1965 without any commentary or critical assessment.[76]

The 1936 culmination of the trilogy was simply entitled *Deutschland* (see Plate 17). In what can only be interpreted as an expression of pride in his work, Bayer personally inscribed the copy of the booklet he sent to his former mentor Walter Gropius. Later, he again claimed that his role on the project had merely been to convey supposedly neutral information: "This is an informative booklet of German culture, and of the German people at work. As far as I remember any propaganda for the Nazi state would seem to be indirect."[77] The *Deutschland* designs, however, are even less ambiguous than they were for *Das Wunder des Lebens*, emphatically stressing the nationalist goals of the German Reich.[78] One spread is particularly notable, "The Führer speaks and millions listen." It shows three national types—the worker, the farmer, and the soldier—swearing allegiance to Hitler against a background of an endless mass of jubilant followers (see Fig. 7.5a).[79] Again Bayer later claimed—just as with the booklet for *Das Wunder des Lebens*—that the Propaganda Ministry had required to insert the montage.[80] There is no evidence confirming or denying his account.

The cover design developed for *Deutschland* is a section of a globe whose meridians converge on a point within the contours of the German "Reich," precisely at the coordinates of Berlin. Germany, according to the bombastic logic of the exhibition organizers, was to be understood not only as the center of the geographical system but also as the cultural navel of the world. In the summer of 1936, Bayer used his own visual language to stage Germany for the international audience that had arrived for the Olympics. But even he could not keep the regime's demands for kitsch at bay, and the publication is replete with jumping deer, bouncing bunches of grapes, and blooming edelweiss (see Fig. 7.5b).[81] In the words of Jürgen Krause, the booklet "conveyed … an image of the nation that seemed like a paradoxical synthesis of the day before yesterday and the day after tomorrow, of forest solitude and high technology."[82] It was arguably more powerful because of its orientation to an international audience; it included captions in four languages and was printed in the tens of thousands, with the worldwide readership of the trade magazine *Gebrauchsgraphik* receiving a complete copy inserted in the issue of April 1936.[83] Sample pages were also included in the trade journal *Graphische Nachrichten* (*Graphic News*) in its special October 1937 issue devoted to the inaugural *Große Deutsche Kunstausstellung* (Great German Art Exhibition) in Munich. The issue itself strikingly captures Bayer's own paradoxical status in Nazi Germany at the time; just a few pages before the celebratory presentation of his spreads for the *Deutschland* booklet, the issue features the "selected ugliness" of

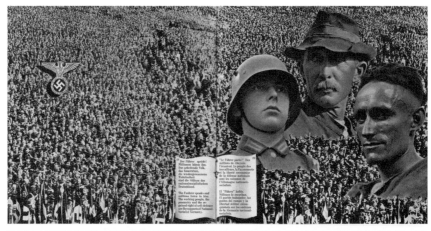

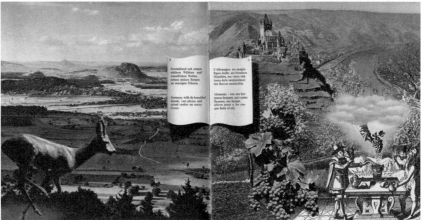

Figure 7.5a/b Herbert Bayer, Spreads from *Deutschland* booklet, 1936. Offset printing; Private collection. © Estate of Herbert Bayer/Artists Rights Society (ARS), New York/VG Bild Kunst, Bonn.

the *Entartete Kunst* exhibition—the very show where at least one of Bayer's works was on display as an example of "degenerate art."[84]

Apart from working up various visuals for *Deutschland,* Bayer's participation in the propaganda for the 1936 Olympics was surprisingly sparse. His February 1936 cover for *die neue linie* took up the theme of the Winter Games in Garmisch-Partenkirchen, combining the Hellenic profile of the head of the Doryphoros with another laurel wreath and a ski jumper in flight (see Plate 19). For the Summer Games, Bayer designed the leaflet for the opening of the outdoor amphitheater at the Olympic park in Berlin, today's Waldbühne but at the time called the Dietrich Eckart Stage in honor of Hitler's early mentor and the spiritual co-founder of Nazism, who had died in 1923. Bayer created a small foldout photographic poster showing an overall view of the spectator terraces and some of his unmistakable "Bayer-clouds" (see Plate 20). Perhaps in this

case, however, the thick cloud cover through which only a small portion of starry sky shows conveyed a sense of looming psychological and physical foreboding.[85] The last of the Olympics-related projects was an English-language booklet on the Hitler Youth, *German Youth in a Changing World*, published in Berlin by the Terramare Office, an organization for propaganda abroad.[86] Considering Bayer's stature and reputation in the Berlin design world at the time, this comparatively meager crop of propaganda projects around the Olympics was perhaps a harbinger of times to come. As the year progressed, commissions became scarce, likely an indication of the increasing disagreement between Bayer and the Nazi authorities.[87]

There is another perhaps more surprising absence in Bayer's design portfolio from this era. According to the extant documents and his own recollections, he was *not* involved in designing any of the actual exhibition displays for the aforementioned propaganda trilogy.[88] Mies van der Rohe, Gropius, Schmidt, Lilly Reich, and other former Bauhäusler, on the other hand, were all active in shaping segments of the first show, *Deutsches Volk, deutsche Arbeit*.[89] Bayer, like these colleagues, attached immense importance to exhibition design, and understood it as a merger of interior design and graphic design, architecture and photography, combined into a dynamic, almost cinematographic *Gesamtkunstwerk*.[90] Bayer later described this understanding, "Exhibition design was discovered to be a new medium of communication, which goes far beyond the use of graphics in two dimensions."[91] He had, moreover, already made a name for himself in this area with his contributions to the *Section Allemande* pavilion in 1930 in Paris, completed on behalf of the Deutscher Werkbund, and the 1931 *Deutsche Bauausstellung Berlin* (German Building Exhibition).[92] Therefore, Bayer's absence from the exhibition design team is particularly surprising. He later mused that the Nazi party may have been unfavorable to him because the commission for the *Deutsche Bauausstellung* had come from the left-wing trade unions; an explanation which cannot be ruled out, but is not substantiated by any of the sources.[93]

Certainly exhibition design had proven to be an ideal area of activity for Bauhäusler, with their universal training and familiarity with different materials and presentation techniques.[94] The core of Bayer's conceptual work in this domain was to control the circulation of viewers through the exhibition space, directing their movements and gazes, and expanding their field of vision.[95] Among the basic achievements in finding a design language for exhibitions, he mentioned first and foremost "the importance of the basic plan with the aim of achieving a suitable flow of traffic."[96]

Despite his expertise and recognition in the field, on Bayer's resumé, his only exhibition design projects listed in the period after 1933 were for a tourism exhibition in Berlin (1935), a traveling show for the Hamburg-based wallpaper industry (1936), a gas and water exhibition in Leipzig (1937), and the exhibition *Die Gemeinschaft* (The Community) in Berlin (1937).[97] A photograph of a model for the German Radio Exhibition organized in Berlin in 1936 has also survived.[98] Little is known about its realization, however, just as the other installations created between 1933 and 1937 have hardly been documented.[99] On the occasion of the 1935 Radio exhibition, Bayer designed a striking six-paneled leaflet that folded out to a large montage with Berlin's iconic Funkturm at the center, flanked by smaller impressions from the exhibition (see Plate 21). As Kristie La describes it: "In an interplay of images, Goebbels speaks

with a voice seemingly broadcast from the [radio] tower to the rest of the world, reaching every home radio that comes off the production line. In this brochure, Bayer dynamically visualizes how Nazi Germany harnessed advanced technology and industrial production to reach the masses."[100]

On an undated postcard addressed to Breuer, which, judging from the content, must have been written in early summer 1936, Bayer mentions that he was putting "the finishing touches on an exhibition in Hamburg."[101] This could have been either the aforementioned commission from the wallpaper industry or work on *Freut Euch des Lebens* (Enjoy Life),[102] an exhibition that ran parallel to the World Congress for Leisure and Recreation organized by the Central Office for Joy and Work (Zentralbüro Freude und Arbeit) under Robert Ley, the notoriously corrupt head of the German Labor Front, or DAF.[103] Much later, Bayer described the show's aim to Cohen as "suggesting how leisure time can be spent constructively and interestingly"[104]—a rather idiosyncratic way of describing the DAF's activities in providing distraction for a submissive population under Nazi dictatorship (see Fig. 7.6).

In fact, Bayer shaped an extensive series of DAF exhibitions with the goal of bringing the fine arts into factories.[105] The shows, which ran from 1934 to 1942, exclusively featured the work of registered members of the Reich Chamber of Fine Arts. They had the stated purpose of "making it easier for the worker to become acquainted with the fine arts, to awaken in him the desire for further aesthetic experiences by means of encountering art in the workplace." As such, they were emphatically intended to "counter the materialism of decades of Marxist working-class education and form a new type of mentally and emotionally open-minded human being."[106] Though others organized the individual exhibitions, Bayer was behind an influential set of "guidelines" for the "execution and typographical design" of the series.[107] He also designed the layout of a separate forty-eight page booklet on "fine arts and the worker" published in 1938 by the Office for After-work Activity (Amt Feierabend) of

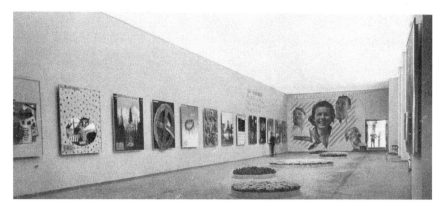

Figure 7.6 Photographer unknown, Installation shot from *Freut Euch des Lebens* exhibition, 1936. Photograph; Private collection, reproduced from Zdenek Rossmann, *Písmo a fotografie*, 1938, pp. 92–93.

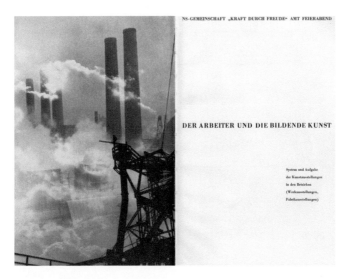

Figure 7.7 Herbert Bayer, Title spread from *Der Arbeiter und die bildende Kunst* booklet, 1936. Offset printing; Private collection. © Estate of Herbert Bayer/Artists Rights Society (ARS), New York/VG Bild Kunst, Bonn.

the DAF's Strength Through Joy program. The booklet on "the system and role of art exhibitions in factories" recycles substantial passages from the guidelines. As a key motif, Bayer chose the same photograph of an industrial zone (see Fig. 7.7) that he had previously used in a montage for his *Deutschland* booklet. Later, on his résumé, Bayer translated *Fabrikausstellungen* as "industrial fairs"[108] rather than "factory exhibitions." This created the false impression that these were trade fairs rather than ideological instruments to re-educate the working-class within the context of the Nazi project Strength Through Joy.

Perhaps most important of all, point nine of the guidelines—also included in the subsequent booklet—quite plainly bears Bayer's stamp in stating that "the first prerequisite for holding an exhibition series is the existence of a transportable exhibition facility," followed by a sketch.[109] A table in the booklet proudly calls attention to the high number of factory exhibitions already held in the program (1,745) and the total number of viewers, over 4 million, from January 1, 1934 to June 1, 1938. Assuming that the booklet was published after June 1 and that the statistics on the table are accurate, this would indicate that the booklet was one of Bayer's last projects before he left Germany in late summer 1938 and that the DAF exhibitions themselves constituted one of Bayer's applied works with the broadest reach altogether. While recognizing the series for what it was—a program that stayed within the strict ideological bounds of the Strength Through Joy movement—it is also worth mentioning that individual shows, depending on the organizers involved, opened up the possibility of bringing workers into contact with a more "modern" approach to art.[110]

Presumably the four impressive photomontages illustrating "The Joy of Work," which Bayer created in cooperation with Kurt Kranz and signed "herbert bayer

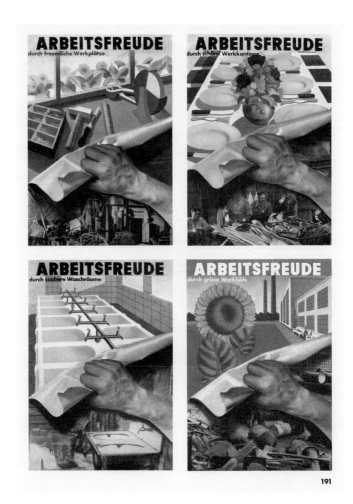

Figure 7.8 Herbert Bayer, Four photomontages for Joy of Work campaign, 1935. Reproductions; Private collection, reproduced from *Die Form* magazine, no. 7, 1935, p. 191. © Estate of Herbert Bayer/Artists Rights Society (ARS), New York/VG Bild Kunst, Bonn.

Kranz," were also part of the same commission. The final number of the Werkbund magazine *Die Form* from early 1935—a special issue entitled *Schönheit der Arbeit*— reproduced them with no reference to the context in which they were designed (see Fig. 7.8).[111] These were subsequently distributed as small posters in A4 format with two significant additions: a caption ("The Beauty of Work–NSG–Strength through Joy") and the Strength through Joy logo—a Nazi Hakenkreuz in a cogwheel (see Plate 22). Bayer offered Cohen a telling assessment of the images when the latter made him aware of the montages in the 1970s. Cohen had remarked "here is a bit of design I am certain you would prefer to forget."[112] Bayer apparently responded by phone, so we can only reconstruct his answer from Cohen's jotted notes: "*non-political*" and "*for improved environment*." Considering it further, Bayer told Cohen that the poster

motif had been designed by his office but not by him personally, probably alluding to Kranz's unexplained participation on this project, and asked whether it was absolutely necessary to include it in the book.[113] Cohen ultimately opted not to reproduce the montages in the chapter on Bayer's graphic design.[114]

Bayer's four DAF photomontages fit seamlessly into the Nazi concept of social propaganda, communicating the purported advantages of National Socialism not only to the German people but also—especially—to audiences in allied nations and other potential collaborators.[115] Another example can be found in the DAF's spectacularly designed magazine *Freude und Arbeit* (*Joy and Work*), a publication launched in 1936 to mark the association's aforementioned world congress, accompanied by Bayer's exhibition, with the participation, among others, of a number of former Bauhäusler from the Dorland network (including Kranz and the Neuner Brothers), though not Bayer himself.[116] Peter Hahn characterizes how this exhibition shows, "that it was perfectly possible to combine Bauhaus modernism with Nazi-tainted subject matter— just so long as the client considered this useful."[117]

An unpublished manuscript fragment by Bayer from 1936 also speaks to this utilitarian view of his time. In it he praises his applied work as a means of educating the people:

> Today's commercial art could to some extent replace earlier public painting as an ethical and aesthetic factor and be used and made useful as a means of educating the people. It must not be inferior to free art. This could be an issue especially for the press as one of the world powers, because its financial basis is formed by advertising. And the thousand means that influence people every day could, without additional effort and with the right mental attitude, fulfill an immensely valuable task in the whole life of mankind.[118]

Bayer's unfinished text left open the question of what he meant exactly by the "right mental attitude" that he wanted to promote. Considering the historical context, however, it is all too easy to surmise that he was referring to the popular mindset that prevailed in Nazi Germany n the mid-1930s.

A good thirty years later, in a speech he gave at a Dorland anniversary event, Bayer admonished his fellow advertising designers to take "moral" responsibility for their work: "The ethical prerequisite for advertising is a good product; that is, a product that is desirable, practical, economical, and attractive. If the product is not good and does not meet these conditions, then there is no moral reason to advertise it."[119] By this logic, only a "good product" would provide "moral reason" for the graphic design work Bayer himself performed in the 1930s. And today it indeed behooves us to subject Bayer himself to his own high demands by asking: how could the various "products" he advertised in his social propaganda—in the major exhibitions geared toward indoctrination and manipulation, in his guidelines for the DAF exhibition series, and related projects—be described as "good"? If the ethical prerequisites are missing—as they so clearly are—does his commercial work from this period not highlight a spectacular failure on Bayer's part to behave in a morally appropriate way?

With this question in mind, one of Studio Dorland's projects from this period demands particular notice: a series of commissions from the Arbeitsgemeinschaft deutsch-arischer Fabrikanten der Bekleidungsindustrie (Working Group of German-Aryan Manufacturers of the Clothing Industry, or ADEFA). This business association was founded as early as May 1933 by fifty high-ranking representatives of the textile industry, mostly members of the Nazi party, with the goal of quashing Jewish influence on or participation in the fashion market. The ADEFA's various successful and unsuccessful efforts to establish a "dress culture appropriate to the German race" (*artgemäße deutsche Kleidkultur*) and eliminate "Jewish taste" have been detailed elsewhere.[120] It is important, however, to note that the association had about 600 members in 1938 (out of some 6,000 firms in the branch), indicating that membership was by no means compulsory for advertisers working with the fashion industry. This in turn strongly suggests that accepting commissions from a distinctly anti-Jewish consortium at the time was a matter of choice rather than (as it so often was) a matter of coercion.[121]

Starting in 1936, the ADEFA ramped up its measures to drive Jewish-owned companies from the market. For this purpose it gave Studio Dorland various commissions for advertising and poster campaigns.[122] While the majority of the designs bear Bayer's "– – Y – –" mark next to the name Dorland, most can be described as routine work by the studio. However, two sets of work stand out in this context: the front and back covers for the 1936 ADEFA annual report (see Plate 23), which Bayer signed with his full name, indicating that he expressly assumed authorship, and five poster designs for the association, also from 1936 and 1937, which he preserved in his estate.[123] Bayer was evidently pleased enough with one work to include it in his own 1967 monograph, but he took the precaution of backdating it to an innocuous year: 1930.[124]

This image (see Plate 24) demands closer attention, and not just for its phony date. In the version that later ran in the monograph, the large-format slogan set in Bayer-Type reads "the mark for water-repellent impregnated clothing." Here it was reproduced as an illustration of his dictum that a poster should be designed with the utmost simplicity. In this particular case, however, Bayer retroactively exaggerated the "simplification" process by conveniently omitting the advertisement's last line, "from Aryan hands," from the image. This would have clearly identified the poster as being part of the ADEFA's anti-Semitic campaign of 1936/1937—an all too unfavorable detail that Bayer simply retouched in the English version of his monograph. For the book's German edition, he even went a step further, blacking out the ADEFA logo in the lower-left corner—and with it the seal's slogan, which also bore the words "Goods from Aryan hands" (see Fig. 7.9). If Bayer reasoned that this pictorial element, set in Gothic type beneath the predictably fierce-looking eagle of the ADEFA logo, might go unnoticed among non-German readers, he took no risks with the German edition.

Although we cannot fully reconstruct the book's production processes from the files, it is hard to believe that in 1967 such a massive intervention could have been undertaken by anyone but Bayer, who was otherwise painstakingly meticulous about how his designs were used. Tellingly, in his substantial donation to the Bauhaus-Archiv Berlin in the 1980s, Bayer included only three (not five) specimen copies of the poster

Plakat, Wasserabstoßende Stoffe 1930

Figure 7.9 Herbert Bayer, Retouched 1936/1937 ADEFA poster, 1967. Reproduction; Private collection, reproduced from *herbert bayer—painter, designer, architect*, p. 49. © Estate of Herbert Bayer/Artists Rights Society (ARS), New York/VG Bild Kunst, Bonn.

series—all with less objectionable motifs and no ADEFA seals. Throughout his life he withheld the original "from Aryan hands" poster; only long after his death did Bayer's second wife, Joella Haweis Bayer, donate the item to the Lentos Kunstmuseum Linz, which presented it to the public in an exhibition in 2009, albeit with Bayer's incorrect backdating and without further comment.[125] Bayer also kept an unretouched version of the poster in his slide archive,[126] and details in its condition and preservation prove without a doubt that all reproductions can be traced back to the same copy of the original poster. Bayer had already retrieved and removed his copy from Dorland's samples archive in the 1930s before his emigration; he was fairly certain that no further copies of this ephemeral work survived.

It is easy to understand why Bayer would have been reluctant to represent himself around 1968 using a poster that so plainly stood for a pro-Nazi business group. Willy B. Klar also later stressed—incorrectly—in his autobiography that the word "Aryan"

had never appeared in any of Dorland's advertisements for ADEFA.[127] In retrospect, it could only have been deeply embarrassing to all involved. Although ADEFA was not an institution of the Nazi government, it was a political lobbying group that openly and unreservedly pursued one of the regime's primary goals: the elimination of Jews from social and economic life.[128] What makes the case exceptionally repugnant is that, rather than concealing an almost unknown poster, Bayer decided to show it proudly as an example of his work but only after he had actively manipulated it in order to rewrite history. Likewise, the backdating to 1930 was no mere "lapse of memory." Just like the retouching, this was deliberate.

A commission such as this one hardly belongs under the innocuous heading of commercial advertising, though Bayer was happy to claim this label for all of his works from the 1930s. "You simply did what was needed by whatever means," he stated.[129] A more plausible notion is that, in accepting this particular commission, Bayer's pragmatism once again gained the upper hand. As the "Aryan" textile manufacturers were amenable to his modern, functionalist approach, he took the job. This is supported by three photographs preserved in the Dorland archive of an ADEFA exhibition held at Berlin's Gersonhaus (January 6–16, 1937). The displays highlight a certain type of progressive design, combining textile presentation with tubular steel furniture in the Bauhaus spirit. Overall the aesthetic was in keeping with what former Bauhäusler preferred in their own commissions for exhibition designs.[130] The extensive collaboration with ADEFA is all the more astonishing given the fact that, as Bayer later professed, "Most of my clients were Jewish clients, if you talk of clients. They stayed with me as long as they could. They appreciated it very much that somebody was still working with them until it became difficult and the persecution started."[131] How Bayer would have justified his own and Dorland's prominent work for ADEFA to his "mostly Jewish" clientele remains a mystery.

A final case study for understanding Bayer's work in the service of Nazi causes is the poster he designed for the Ball of the International Film Congress held in Berlin on April 27, 1935 (see Plate 25), the highpoint of a special week devoted to film initiated by the Association of German Film Theaters and organized by the Reich Film Chamber (Reichsfilmkammer). Closely supervised by Goebbels's Propaganda Ministry, the film congress had vast propaganda value for the regime, both in terms of bringing the domestic film industry into line with Nazi ideology and as a way of touting German film to a prestigious international audience.[132] The festival was slated to attract some 8,000 visitors to the ballrooms at the central hub of Berlin's Zoo Station, including the Reich's entire film elite and Goebbels himself in his role as the congress's official patron. Bayer's posters went up in advance, for example on the delivery vans of the film distributors, where they were pasted alongside advertising for the congress itself.[133] In this case, Bayer signed the poster without the addition of "dorland," indicating that the commission had not come through the agency but was his own personal project. As his central motif he chose a "ball" made up of national flags, including the German national flag with its swastika, surrounded by filmstrips arranged in planetary orbit. Notably, while Bayer has made the flags of England and the United States conspicuously central to composition, neither country had sent a delegation.

Whether Bayer himself attended this glittering social event is not known. He would later stress that he had never visited the *Deutschland* exhibition of 1936, even though he had created so much of its printed matter.[134] Nevertheless, Bayer's contemporaries attested that he showed no particular fear about being in contact with those in power.[135] The Bauhäusler Walter Funkat, who was also active as a graphic and exhibition designer in Berlin at the time, even claimed that Bayer had "a special talent for coming into contact with people from the party."[136] Bayer jotted a handwritten "no" next to Cohen's statement that "you were able to work under the Nazis and obviously did some commissions for official work."[137] A different account comes down to us from Kurt Kranz, who noted that Bayer's friend Ingo Kaul was Bayer's personal if indirect contact in the Propaganda Ministry.[138] Looking back much later, Bayer emphasized on several occasions that he had never worked directly for the Propaganda Ministry but only for the Berlin Messeamt, the entity responsible for organizing such shows. The ministry, he said, "generally during my time did not superimpose itself over work done by the Berliner Messeamt."[139] While this may have been technically correct, it was at the very least deliberately naive to imply that blockbuster shows like *Das Wunder des Lebens* or *Deutschland* could have taken place *without* the ministry's close coordination. Even a glance at the official catalogues confirms this. For example, the official catalogue to *Deutsches Volk, deutsche Arbeit*—one designed completely by Bayer—lists the Berlin Exhibition and Trade Fair Company as the organizer immediately prior to the page touting the name of the exhibition's honorary president: Goebbels. It was Goebbels who wrote the first of its eleven forewords, followed by seven other members of Hitler's cabinet. The Propaganda Ministry had, moreover, appointed a ministry commissioner, Wilhelm Haegert, to head its Division II, which covered mass rallies, public health, youth, and race—a position signaling the propaganda value of such exhibitions.

The ministry's participation in planning *Das Wunder des Lebens* was similar, though on a somewhat less sweeping scale; here it was Wilhelm Frick, not Goebbels, who contributed the preface to the official catalogue, while the Propaganda Ministry was represented on the working committee by Dr. Curt Thomalla, head of the department for public health and welfare. The basic thesis of the exhibition was already determined at the committee's first meeting: that "man is dependent in every respect on his *genetic* make-up" (emphasis added). Thomalla was appointed head of the committee on "Lehre des Lebens" (Teaching of Life).[140] In the 1920s, he had written several scripts with Germany's major movie company UFA for silent films with "medical" themes, among them *Der Fluch der Vererbung* (*The Curse of Heredity*)—a 1927 dramatization subtitled "Those who should not be mothers"—which helped mobilize popular support for the concept of forced sterilization.[141]

As early as 1934, close friends of Bayer's such as Ise Gropius were privately joking about him as the Propaganda Minister's "star."[142] Even he ironically called himself Goebbels's "anonymous favorite."[143] Against this background, we must bring some skepticism to Bayer's later claim that he had never visited the Propaganda Ministry and never uttered the words "Heil Hitler."[144] It was a point he stressed on several occasions: "The Nazis let me work, and I had a great many commissions when I decided to leave for America. But nothing I did was political. I never went to the Propaganda Ministry,

and I never said 'Heil Hitler!'"[145] Even if he perhaps did not actually utter the phrase, he most certainly wrote it. For example, his application for approval of his 1937 London exhibition (see Chapter 11) ends with the words: "In thanking you, I sign / Heil Hitler!"[146]

Despite the circumstances, Bayer appears to have continued to hope that his design work would at least bring a kind of domesticated modernity to the broader public. Thus, after a holiday in Tyrol in early 1935, he jotted in his own notes that "strengthened, I am resuming my 'business.' To give the agency new, free impetus to progress and modern ideas would still be enough of a task [for me] if only the resistance due to stubbornness and cowardice were not insurmountable. So I stick to the quiet, inconspicuous application of possible small 'innovations.'"[147]

Backing up his statements, there are indeed indications of Bayer's popularity in the 1930s. For example, after its extensive article of 1931, the semi-bilingual trade magazine *Gebrauchsgraphik (International Advertising Art)* devoted two more portfolios to him during the Nazi period, making for an unprecedented amount of coverage for a single designer in the history of that periodical. Both pieces, in 1936 and 1938, indicated the strong ties between Bayer and author Eberhard Hölscher, a prolific design writer—and acquaintance of Bayer's—who would take the magazine's editorial helm after the Second World War. Hölscher's April 1936 article was billed as a retrospective of Bayer's work after 1933; it noted that Bayer made artistic styles such as Abstraction and Surrealism appealing to advertisers by emphasizing the force of associations within the viewer's subconscious. This was in itself an extraordinary statement, as the regime had long described such styles as fundamentally incompatible with its goals. The opulently illustrated article had two color supplements bound into it: a brochure by Berthold A.G. advertising its Bayer-Type[148] and the complete twenty-four-page booklet for *Deutschland*—even before it was distributed as part of the exhibition at the Olympic Games.[149]

At the same time, Bayer had also elicited the interest of *Gebrauchsgraphik's* publisher and editor, Hermann Karl Frenzel, in publishing an "encyclopaedia, or picture lexicon." He proposed creating a loose-leaf edition of significant sample drawings for distribution to global illustration agencies in three languages. Despite Frenzel's support, the project never came about, probably because the planned costs (estimated at 30–40,000 reichsmarks) made it difficult to find a publisher.[150] Also in 1936, the Graphic Designer's Section of the Reich Chamber of Fine Arts organized a large-scale exhibition—*German Advertising Art, 1936*—which was shown at Berlin's Haus der Kunst from March 10 to April 13, exactly when Bayer's sumptuous *Gebrauchsgraphik* portfolio ran. Located in the Palais Pourtalès, where the Nazi exhibition direction for Berlin had its offices, the exhibition's aim was to launch an archive of German advertising work supplied by all members, who committed to submitting their three best work examples at the end of any business year. Although the catalogue does not mention Bayer or Studio Dorland, the exhibition itself prominently featured three of Bayer's posters.[151] This, in itself, attests to his status as one of the Third Reich's most important graphic designers.

The third Bayer portfolio to appear in *Gebrauchsgraphik* ran over fifteen pages in the June 1938 issue. By this time Bayer was already deep into planning his emigration

(see Part 3 of this book). In this issue, Hölscher's introductory text describes him as an "uncompromising" artist who had recognized the important cultural–political mission of commercial art and derived from it "the highest sense of responsibility and artistic discipline."[152] Examples included his advertising campaigns for the textile industry (Michels and AGB Stoffe) and and hygiene products (Chlorodont). Remarkably, Bayer himself sketched the construction principles of two of his cover designs for *die neue linie* to bolster the article. A few months later, the analytical approach finally culminated in a key work for understanding Bayer's creative approach: the remarkable cover he designed for the October 1938 issue of *Gebrauchsgraphik* (see Plate 26). It shows a single stylized eye gazing through a window and taking in measurements from nature, while the designer's hand transforms what it sees into a draft; a meandering red line represents the cognitive process linking hand to eye.

For Nazi Germany, the composition was almost unimaginably radical. Its Surrealist style was reminiscent of Max Ernst's famous montage for the cover for Paul Eluard's *Répétitions* (1922).[153] Even more, its author was a commercial artist who by the time of publication had already left for the United States, where he had just prepared a retrospective exhibition of the ostracized and much-maligned Bauhaus. As such, the cover represents a final push on Bayer's part to introduce aesthetic diversity into the overall alignment of Nazi society.[154] Despite the overwhelming ideological conformity demanded of life and culture under Nazism, Bayer continued to pursue the chimera of artistic freedom for a remarkably long time. The looming world war would soon make utterly superfluous such attempts to mask *Gleichschaltung* with liberal garb.

Although, as this cover attests, Bayer's creative impetus during his Berlin period remained unhampered, all in all, it is highly doubtful that he could truly maintain the sort of consistently apolitical attitude—"neither intellectually nor politically active, but purely creative"—that Bayer-Hecht had claimed for him in her brochure text of 1936.[155] There are too many examples of Bayer's commercial graphic design close to the regime's propaganda activities. Certainly, Bayer initially failed to take the Nazi threat seriously, as shown by the flippant irony he sometimes used to close his letters to Breuer: "heil herbert."[156] While up until the 1980s he continued to stress his loyalty to his Jewish customers, especially to those in the textile industry, he admitted that he had noticed their disappearance en masse from the scene.[157] "They gradually disappeared—emigrated or disappeared, we didn't know which. We just did not know what was happening."[158] In another interview in the 1970s, he stated plainly enough: "I didn't think that Adolf Hitler would last long. ... He simply appeared as a crazy man."[159]

Intriguingly, Eberhard Hölscher—whose byline had accompanied the 1936 and 1938 Bayer portfolios in *Gebrauchsgraphik*—captured Bayer's ambivalent attitude toward the era as early as 1934 in an article on Bayer for Kodak's house magazine *Photo-Graphik*. Referring first to his personal contact with Bayer, whom he described as "unceasingly" devoted to pursuing questions of aesthetic design with "thoroughness" and "thoughtfulness," he emphasized Bayer's "higher intellectual and artistic principles." His conclusion was intriguingly clear-sighted: "Bayer is by no means an artist who indulges in utopian dreams. He knows how to accept realities in a matter-of-fact, sober, and skillful way."[160]

Good Life in Berlin

Herbert Bayer's complex professional arrangement with Nazi Germany in the 1930s was embedded in an emotional ambivalence that runs counter to the prevailing image of him as a coolly calculating careerist. From a close reading of his diary entries, Alexander Schug concluded that "Bayer suffered from the conditions that prevailed after 1933" and that he "constantly complained about his state of health, felt abandoned by his emigrating friends, unloved, lonely, and disgusted by the political situation."[1] Complicating the picture is the fact that Bayer's despair corresponded so little with his persona as a debonair man about town.

Amid the national tumults of the year 1933 with the Nazi party rising to power, it seems astonishing that Bayer's personal notes from the period barely mention current affairs. His inward gaze was fixed on the emotional pain caused by the collapse of his marriage, the realization that the time he had spent with his wife had been valuable, and a sense of self-reproach. An undated entry from January 1933 reads:

> Irene is moving into her [new] apartment tomorrow. So now a clear line has been drawn as well. In the next few days I will pull myself together to support her in every way possible. ... Oh my God, she has done so much for me and all in vain; now look at her. At least she has the child. I'm afraid that my complete silence when I'm with her hurts her as much as it hurts me. But I cannot pretend anything to her either. And if I tell her what's going on, we'll never part. I don't think I'm allowed to see her every day anymore. My dear Irene. We were together for almost eight years.[2]

For Irene Bayer-Hecht on the other hand, the early spring of 1933 may well have coincided with some crucial revelations (or at least realizations) about the extent of her husband's longstanding affair with Ise Gropius. By late March, the Bayers had consulted a lawyer, but divorce proceedings were never actually launched while the couple lived in Berlin.[3] Nevertheless, Irene took steps towards her own new life that summer, moving to the spa town of Marienbad in western Bohemia with the goal of making her own living and, ultimately, being able to provide for their daughter, Muci. The child was temporarily left in the care of her father, aided by a nursemaid named Fräulein Klara.[4] As Bayer-Hecht wrote to the man she was now determined to leave, "it is quite impossible for me to continue to tie my life to something as unstable as your vacillating feelings and moods." Their daughter "should have double love from me, so

that she doesn't later reproach me for not having had a father."[5] With Bayer's financial support, she now tried her hand as a freelance beautician, calling herself Mme Angèle, at a salon in Marienbad, but she had little success, noting "a pretty miserable feeling of social decline." She designed advertising leaflets for her services, which touted training at a Parisian beauty clinic and offered individual treatments including "muscle tightening—facial massage—skin care—make-up," as well as her own special products. Despite these efforts, her income did not cover her living expenses.

By July Bayer-Hecht was already complaining of the place, describing its denizens as "greedy for money" and the town as "teeming with Jews, but you have no idea what kind of Jews." Seemingly her own Jewish family background was no hindrance to such remarks. "There are no women on their own, like me. Always just family packs." And, as in Ascona in May 1932, she was apparently still musing aloud to Bayer about finding a new paramour for herself, lamenting that the resort was "a miserable marriage market ... only fat old people" unsuitable for somebody who herself felt "better looking and more beautiful than ever."[6]

Bayer-Hecht's letters also expressed an intense longing for their daughter, coupled with concern for the child's well-being in faraway Berlin. "I cannot be so selfish [and] bring Muci here, since I'm not yet earning anything, because the cost of living here is very high."[7] To console her, Bayer sent seaside film footage of the almost four-year-old Muci frolicking with her handsome father, private footage on Super-8 film that testifies to their evident affection for each other (see Fig. 8.1).[8] The film was made on a brief stay on the Baltic coast in the company of the nanny, Xanti Schawinsky, and Irene von Debschitz, whom Schawinsky later married.[9] Soon after this summer trip, Bayer-Hecht began to mull over the idea of trying her luck in Vienna or Prague, so that Muci

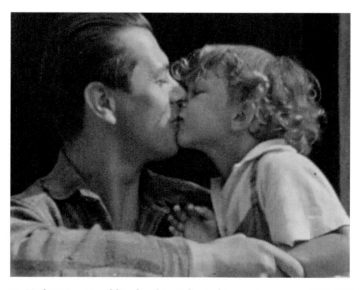

Figure 8.1 Herbert Bayer and his daughter Julia, Baltic coast, summer 1933. Still from a private movie; Denver Public Library, Herbert Bayer Collection.

would later be able to attend a German school. She moved to Prague in the winter of 1933–1934, periodically returning to Berlin to visit her child, but was unable to obtain a beautician's trade license there.[10]

From Bayer-Hecht's letters it appears that, during her time away, Bayer, too, was in something of a rut: "Until two years ago, you succeeded at everything, and when things get difficult now, you suffer too much," she wrote to him, referring to his exhibitions in Paris and Berlin. "It would be the greatest joy for me if at some time I could make it possible for you to relax for a year and just paint your pictures."[11] By autumn 1933, perhaps struck by the prospect of being separated from his beloved daughter, and by the increasing hopelessness of his relationship with Ise Gropius, Bayer apparently suggested that he and his wife continue the relationship after all. Bayer-Hecht, however, sent him an unusually blunt message which alluded to the divorce plans they had explored that spring:

> What else should I see in you? What has been, or is, or could be? Women [for you] have been—for a shorter or longer period of time—experiments in love. Hope and disappointment and eternal repetition. Until the day that one asserts herself and marries you again. And then the unhappiness [will be] back ... Of course your work suffers, I do believe that. It would be a disaster if we moved in together, because your series of affairs is far from over. Maybe [it would stop] at the age of sixty, or if you became ill.[12]

Bayer-Hecht had threatened for years to put more distance between herself and her husband, including separating him from his daughter, so Bayer would have been truly a "lonely metropolitan" for the first time in many years. He had finally lost something he had long relied upon: the devotion of the woman who called herself his "loving idiot" and who, despite all the humiliations she endured, had always stood by him.

It seems that the main reason that Bayer-Hecht did not embrace his idea of resuming their marriage was that she had come to see Herbert's relationship with Walter and Ise Gropius as an insurmountable obstacle.[13] "You love your child. That's understandable ... In any case, your 'friends' will be satisfied with you this way. For years they have declared that marriage isn't a good fit for you. It would be just too awful to have to admit to your family at this point. Long live vanity. Goodbye, Irene."[14] In response to this ironic farewell, Bayer briefly considered taking legal steps to secure custody of Muci.[15] On this occasion his wife once again offered her outspoken assessment of his friends, "You were never malicious, but I believe that the source of the advice [you received] can be correctly guessed as coming from Herr Gropius and Frau Ehrlich and others still, Irene von Debschitz etc. etc., I'm just not up on the latest names."[16] Although the list does not name Ise Gropius literally, she was probably addressed as the mysterious Frau Ehrlich—her maiden name was Frank, which can be used in German as a synoym for "ehrlich" (being honest) and thus could have been an ironic nickname.[17] Bayer-Hecht's quote also singles out Schawinsky's future wife, Irene von Debschitz, who was daughter of the portrait photographer Wanda von Debschitz-Kunowski, Ise's best friend and sole confidante at the time (and as such, fully apprised of the affair's most intimate details).[18]

After her two unsuccessful attempts in Marienbad and Prague, Bayer-Hecht seems to have given up her efforts to achieve financial independence. In the fall of 1934, after she had been completely absent from the capital for a year, she returned permanently to Berlin, following a summer holiday with Bayer and their child. Despite living in separate apartments, the shared goal of the separated couple was to offer Muci at least some semblance of family life. "Irene lives in her old apartment," Bayer wrote to Ise Gropius that November, "I am once again making my way there every day."[19] Later, Bayer-Hecht described to her estranged husband that it was during this period that she "stopped meddling" in his "affairs." She writes, "I no longer asked you about anything, how, where, and with whom you spend your time. If you came, it was voluntary, just as your staying away depended on you."[20] Bayer apparently made it a habit to visit Muci and her mother after work in their small apartment on Knesebeckstraße; he wrote of it as a place, "where I always come and go with a heavy heart. For dinner and to bring the little child to bed. And every day the dire question 'Why don't you sleep at my house, Papi?'"[21] Herbert took his daughter sailing instead, and schoolmates, such as the daughters of Bruno E. Werner, the publisher of *die neue linie*, described her as a bright and cheerful child. The fact that the Bayers saw each other again regularly from this point on is also indicated by the fact that not a single letter between them is preserved from 1934 until Bayer's departure for the United States in the summer of 1938.

The tension between Bayer's inner disillusionment and outward hedonism appears to have reached a peak by the end of 1934, as Bayer was approaching his mid thirties: "I find the inferior mental level, the mental detachment, the general isolation quite depressing," he noted in his sketchbook. "No people, everybody has gone into hiding or has even left the country. My friends are all gone. What's new, women and those I know through work, are superficial connections; nobody tries to understand, to take an interest."[22] That April, on the other hand, Ise Gropius was observing her ex-lover in completely different light: "Herbert is running around town here, tanned, driving the girls crazy," she reported to their close mutual friend Marcel Breuer, "and since he holds the same opinion you do of the female sex, life lies before him without any complications."[23]

Bayer's personal papers shed a good deal of light on his personal network and relationships at this juncture in his creative and professional life.[24] For the period following 1933, research in the Bayer Archive highlights a social constellation that—despite waves of emigration by assorted Bauhäusler—consisted of several tiers (see Fig. 0.3):

1. Those closest to Bayer included Irene Bayer-Hecht, from whom Bayer was now separated; his young daughter Muci, who in her fourth year of life from mid-1933 to mid-1934 lived mostly with her father, with the care of a nanny; and his inner circle from the Bauhaus Dessau period (Breuer, Xanti Schawinsky, and Ise and Walter Gropius), all of whom had left Berlin by October 1934.
2. Bayer also maintained stable but more lighthearted friendships with a number of colleagues from the Dorland environment, first and foremost Willy B. Klar and Arthur "Vips" Wittig, then Jorge Fulda (whom Bayer probably first met in the circle around the Bauhaus band and who now owned a photo studio), and the photographer Hein Gorny.

3. Professionally, he stayed in loose but still important touch with his old teacher László Moholy-Nagy (but not with his ex-wife, the photographer Lucia Moholy), as well as with Alexander Dorner (the Hannover curator who later devoted a study to Bayer after they were both in the United States), Bruno E. Werner (editor of *die neue linie*), and Lady Norton (a.k.a. Peter Norton, who launched the London Gallery in 1936).

4. Finally there was a seemingly infinite—and infinitely interchangeable—Berlin cast of temporary mates, casual lovers, and admiring young females. Despite the tightening grip of totalitarianism and accompanying scourge of phony Nazi morality, this libertine set seemed more interested in continuing the spirit of the roaring twenties than in facing far grimmer realities.

Without some sense of these different social orbits in which Bayer moved, it is impossible to comprehend either his ambivalent attitude in Nazi Germany or his ultimate decision to leave for the United States. Likewise, these curiously overlapping relationships may provide a key to deciphering both his commercial graphic design and his work as an artist.

It is telling that Bayer confided to his diary around this time that he considered "the friendship of men" to be "more important than anything else."[25] Indeed, his pursuits both in and out of the studio were marked intensively by what sociologists would identify as male homosociality. His steady rhythms of work and spending time with his young daughter were regularly punctuated by outbursts of hedonism in the company

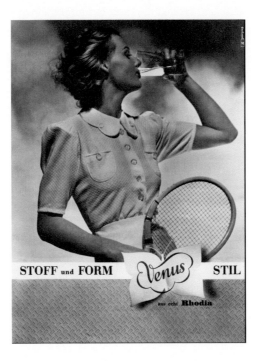

Figure 8.2 Herbert Bayer, advertisement for Venus artificial silk, c. 1937; Private collection. © Estate of Herbert Bayer/Artists Rights Society (ARS), New York/VG Bild Kunst, Bonn.

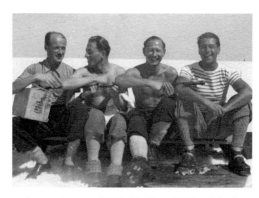

Figure 8.3 Photographer unknown, Willy B. Klar, Walter Matthess, Hans Ritter, and Herbert Bayer in Obergurgl, Tyrol, 1930s. Photograph; Denver Public Library, Herbert Bayer Collection.

of male colleagues and pals: weekends in the nearby mountains, summer vacations at resorts like Ascona, ski trips in the Alps, and spectacular, highly ritualized, evenings of frenetic pleasure-seeking in the company of his "club."

At Studio Dorland, Bayer was universally considered the creative head of the company and its financial anchor. As Dorland Germany's majority owner Walther Matthess noted admiringly, Bayer "often found a new idea for a *Venus* [artificial silk] series in a minute and created the most beautiful montages with the strangest materials" (Fig. 8.2).[26] Not surprisingly, Dorland's prestige in the German advertising scene at the time was due in large part to Bayer's highly recognizable graphic design.[27] The scant film footage of him that survives from the period projects the image of a good-looking, charming man in his prime.[28] So do the many Bayer portraits produced by the photographers Fulda, Yva (on the cover), and Atelier Binder (see Fig. 11.2). His dashing studio was by many accounts highly sought-after in 1930's Berlin.[29] "Herbert Bayer was a silent worker," Klar later wrote. "But I can still hear his bass voice, his sonorous laughter; he liked to laugh, but it was anything but phony."[30]

After the war, Heinz Ritter reminisced about skiing with Bayer and other Dorland colleagues (see Fig. 8.3):

> … how we sat in the [Czechoslovakian] Riesengebirge mountains at the top of the Blaugrund and listened to your yodeling, how we climbed the Rotmoosferner together in Obergurgl [Austria], where the hot sun made us strip off one piece of clothing after another until we climbed in our naked torsos … the [mountain] descent with Schawinsky in the diffuse light over the Gurgl glacier … And, beyond that, our work together at Dorland, which occupied us all so completely … How much shared work and how much shared joy is buried in these memories.[31]

A photographer who captured Bayer several times on their joint ski vacations (see Fig. 8.4) was Hein Gorny, who was four years Bayer's junior. Gorny and his much younger wife, Ruth Lessing Gorny, had moved to Berlin in 1931. (Ruth's father, the distinguished German Jewish philosopher and Zionist Theodor Lessing, had fled

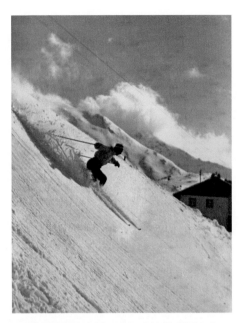

Figure 8.4 Hein Gorny, Herbert Bayer skiing downhill, 1930s. Photograph; Denver Public Library, Herbert Bayer Collection. © Collection Regard/Marc Barbey, Berlin.

Germany for Czechoslovakia in late January 1933 but was murdered that August by Nazi sympathizers in the spa town of Marienbad, where Irene Bayer-Hecht was, in fact, living at the time.) Gorny took over Lotte Jacobi's studio in 1936, and his fashion photos were published in *die neue linie*, among other publications. A few years later, his personal situation showed parallels with Bayer's, though he and his wife experienced considerably more hardship. Gorny's efforts to set up a business in New York in 1938 while his wife dissolved the atelier in Berlin failed when Ruth Gorny was not granted a US residence permit. He had to return to Berlin, and the couple only barely survived the Holocaust under fraught circumstances.[32]

Bayer's greatest friend between 1934 and 1938 was his Dorland colleague Willy B. Klar. The dapper ad man, who loved to sport a carnation in his lapel, served as Dorland's contact with the textile industry, a fact that brought the added benefit of excellent connections to the local fashion scene, not just to designers and photographers but also to models, a world Klar described in detail in his memoirs.[33] In a private letter to his friend Bayer in 1939, Klar recalled how the two men not only "understood and complemented each other incredibly well" but also shared the view that "a woman cannot replace a friend" because a woman lacks "the spirit that characterizes male friendships."[34] Until Bayer's emigration they lunched together almost every day, prowled the cinemas and pubs together, and embarked on many an amorous escapade. Indeed, in matters connected to night crawling, the two friends, "Willybe" and "ba," appear to have been inseparable. Klar would jokingly claim by 1939, the year he was drafted into the army, that their departure from Berlin had caused "eroticism to vanish from the Kurfürstendamm," and that "Hermann Göring's population policy"—the

pro-natalist measures to raise the birth rate among "Aryan" couples—had as a result "suffered a severe setback in Berlin."[35] It is impossible to tell if he was alluding to actual children fathered out of wedlock or, more likely, to a metaphorical state of affairs, but Klar's casual reference to the regime's highly racialized population policy is made more poignant by the fact that Klar's own father was an observant Jew, and that Klar had increasing difficulty living "underground" as the years went on—something Bayer may not have been aware of until after the war.[36]

The two dyed-in-the-wool playboys of West Berlin made frequent outings by automobile—either in Klar's roadster or in Bayer's convertible—preferably in female company. Bayer had acquired his driver's license sometime around July 1931, and driving gave him mobility, independence, and the enviable social status of a motorized flaneur on Berlin's boulevards.[37] In addition to sharing a fondness for skiing and car trips, the two men were often out on the water, either in Klar's sailing yacht *Simsalabim* (*Abracadabra*) or Bayer's own dinghy-sized sailboat named *Bussi-Bussi* (*Smooch*), both vessels traditionally launched by the avid "seadogs" at Pentecost in late spring (see Fig. 8.5).[38] "Remember how you used to rush off the boat at night, a cigar in your muzzle, cap on your head, and in your pajamas," wrote Klar in 1940 of the boats, which he and Bayer sanded and painted, often in the presence of little Muci.[39] Still later, in a long rhymed poem "To Ba" composed in 1947 from a POW camp in the USSR, Klar again evoked those boating trips, memories that sustained him through bleaker times: "*pfingsten – der start war sicher / friedel körner, karin lahl, blond-plaisir / mein gott, was für ein gekicher / gab's unter wasser und hier* (Pentecost—the start date

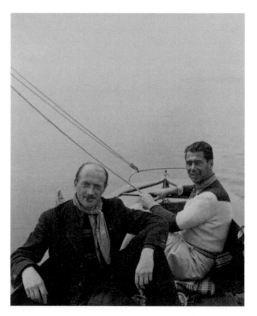

Figure 8.5 Photographer unknown, Willy B. Klar and Herbert Bayer on a sailing trip, c. 1937. Photograph; Denver Public Library, Herbert Bayer Collection.

Figure 8.6 Photographer unknown, Beauty queen Friedl Körner on a vacation trip to Salzkammergut with Herbert Bayer, Austria, 1937. Photograph; Denver Public Library, Herbert Bayer Collection.

was certain / Friedel Körner, Karin Lahl, blonde-pleasure … My god, what a giggle there was under water and here").[40]

That their lady friends included not only the German beauty queen Friedl Körner[41] (see Fig. 8.6) but also the budding model Karin Lahl attests to their status as fashionable men about town. Lahl (known as Karin Stilke after her marriage in 1941) would soon be one of the first German supermodels.[42] In her memoirs she described her life in 1936 around the time that Yva discovered her on Berlin's "Ku'damm," as the fashionable Kürfurstendamm was nicknamed, and introduced her to the city's fashion photographers. Lahl's youthful looks quickly won her entrée into intellectual circles via the author and impresario Karl Vollmoeller, co-writer of the script for *The Blue Angel*, among other influential texts.[43] Lahl may have met Klar and Bayer through Hein Gorny or perhaps at Studio Dorland, which regularly engaged models for its textile advertising campaigns.[44]

Klar's memoirs—self-published in 1981—gleefully recount his bachelor days in salacious detail. In a chapter called "The Wild Thirties," he details the many rituals and antics that he and Bayer undertook in the company of their seven-member "Dublosan" Club. The club took its name from the Dublosan contraceptive ointment, which was highly popular at the time.[45] This group gathered every Monday to pursue the club's stated goal: "to promote socializing with the opposite sex."[46] Vips Wittig, who Klar did not mention, was also a core member (see Fig. 8.7).[47] Fulda later fondly recalled their guiding ditty: "*der alte Brauch wird nicht geknickt, wenn's draussen*

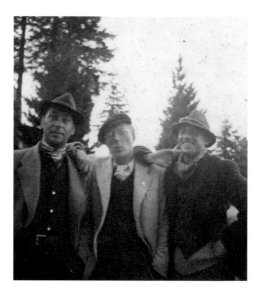

Figure 8.7 Photographer unknown, Herbert Bayer, "Vips" Wittig, and Willy B. Klar hiking in the Giant Mountains, Czechoslovakia, May 1937. Photograph; Denver Public Library, Herbert Bayer Collection.

regnet, wird — [gefickt]" ("our old custom won't be bucked / when it rains, it's time we—[fucked]").[48] Klar's memoirs describe a partiality for the number 69, mentioning that they regularly booked table 69 at their favorite dance haunt, the Delphi Palast. Letters from Fulda also recalled a "69er bumheilclub" (loosely: a hail to the 69 position club, with a passing jab at the Nazi "Sieg Heil" salute) and their proclivities for engaging their changing cast of female partners in such acts as "cold kitchen," "the coffee grinder tour," and sex in public parks.[49] Bayer's talent as a draftsman was put to use in these bacchanals as well. In his role as the club's *Kürmeister* (night master), for example, he would sketch out the evening's prescribed position in advance with white chalk on black cardboard,[50] reportedly advising his friends to pursue a campaign of "once, but long."[51] In Klar's telling, there were also episodes of communal male exhibitionism. In a 1940 letter, Klar nostalgically recalled "our 'orgy' at Stapenhorst's, where you tied a [helium] balloon on your prick and we all sported red carnations in our butts."[52]

Such vivid accounts of private revelry are difficult to reconcile with the image of restrained professionalism that Bayer himself projected—the shy, reserved "Austrian rationalist" who shrank from public attention and avoided public speaking.[53] But perhaps his reticence in making public appearances had less to do with shyness per se than with a certain insecurity about his credentials—as a teacher, as a speaker—that marked him even from his early days at the Bauhaus. In private, he appears to have been less self-conscious.[54] One need only think of Ise Gropius's March 1933 letters to her husband from the mountain retreat she shared with her lover, not only of her description of a man all too happy to regale her with tales of his many

infidelities and conquests but also of her assessment of Bayer "as a kind of half savage with the most naive egoism" (see p. 78).

Bayer's absence of prudery is perhaps the only way to explain his lasting friendship with Jorge Fulda ("Joura"), a rakish *bon vivant* five years his junior, who began moving in Bauhaus circles around 1926 and also consorted with Breuer and Schawinsky. Though himself not a Bauhaus student, the future photographer had been a frequent visitor to the Dessau studio building. The Bauhäusler Helene Nonné-Schmidt and Andor Weininger were also Fulda's friends, as was Umbo (Otto Umbehr), who had been expelled from the Weimar Bauhaus in 1923 but attended—and photographed— many a Bauhaus party in Dessau. Fulda at times even performed with the Bauhaus band, and Schawinsky later described him as an "occasional guest / jura fulda / banjo and solo voice."[55] His status as a kind of honorary Bauhaus member is evident in the fact that a photograph of him playing the banjo was included in the 1938 MoMA exhibition.[56]

Bayer and Fulda had at least one ex-lover in common: Lore Leudesdorff, with whom Bayer had an early liaison in their student days, around the fall of 1922.[57] In February 1928—while Leudesdorff was giving birth to Fulda's son out of wedlock, René Leudesdorff—the two men were skiing across the border in Czechoslovakia.[58] The Fulda–Bayer rapport continued in much the same vein long after Bayer himself became a father in July the following year. Indeed, Fulda spent three Christmas holidays in a row (1933, 1934, and 1935), with Bayer, Irene Bayer-Hecht, and Muci.[59] In 1934 he produced a series of expressive portraits of Bayer in the photo studio he had launched in 1931.[60]

Fulda, seemingly unencumbered by any feeling of fatherly obligation, pursued the bachelor life with gusto, making Bayer a frequent comrade in arms. (Lore Leudesdorff herself was occasionally to be found on the periphery of the Dublosan Club. Fulda never nurtured a close relationship with his son.) The piquant adventures of the two men included an evening on the roof garden of Berlin's chic Hotel Eden. Fulda recalled in a letter how Bayer—"after we had both looked deeply into the eyes and cleavage of various girls and ladies"—accidentally broke the zipper of his trousers on a visit to the men's room and had to flee the restaurant, holding his "hat like a fig leaf in the appropriate place."[61]

Certainly, Fulda's letters convey a vivid picture of Bayer's libido. Like Klar's missives, Fulda's teem with bawdy allusions to his friend, the "wencher" and "old pig."[62] And, like Klar, Fulda was still cracking jokes into the war years and beyond, warning that the beautiful women of midtown Manhattan would not be safe from Bayer unless the police tied "his prick in a knot."[63] Reviewing the Bayer archive from a distance of more than eight decades, one is struck not only by the many love letters, tokens, and poems from girlfriends, but also by the more ribald reminders sent in by his male friends. If Don Giovanni's servant Leporello kept a list of his master's conquests, Bayer was in charge of maintaining his own archive; the fact the ephemera associated with his conquests survived not only the move to America but also any tidying up that Joella Bayer might have undertaken after his death is in itself remarkable, although the dense tangle of hard-to-decode German handwriting may have helped to disguise the nature of the holdings.

Considering the importance of sex and sexuality in Bayer's private life, it seems astonishing that there is so little eroticism in his work as an artist. Bayer later confirmed that he had never been interested in such depictions in his painting—partly because the human body played only a minor role in his rather abstract works.[64] When a female form appears, it is almost inevitably abstract, doll-like, even decorative: a chic silhouette on the cover of *die neue linie*, a stylized Hellenic profile, an abstract face floating bloodlessly above a serene sea, or—as in one of his surrealist photomontages from the period—a nude cropped from a magazine (see Fig. 8.8). While his artwork is largely devoid of female bodies, his personal life seemed to be overflowing with them. In 1937 Bayer trenchantly summed up the latest news in a letter he sent to Breuer in London: "Nothing else is new, except our *jour fix (x=cks)* club [weekly fucking club] and its one requirement: a different girl every Monday. The world keeps turning, even without us being important. Should we drive ourselves so crazy here?"[65] It is precisely the indifferent, naïve undertone to this teasing tenor that once again shows how little thought Bayer gave to politics or current affairs. Instead the sociable Austrian escaped to the rich attractions of his private life.

The seemingly endless flow of hedonistic experiences may help to answer the question of what exactly kept Bayer in Germany until well into the 1930s, even as his work opportunities waned. Bayer had created a cosmos of his own, filled with almost limitless erotic indulgence—as well as his many athletic pursuits, extended vacations, and weekend trips, which he enjoyed together with a circle of all-too-willing

Figure 8.8 Herbert Bayer, *Gute Nacht, Marie (Good night, Mary)*, 1932. Photomontage, gelatin silver print; Denver Art Museum, Herbert Bayer Collection and Archive. © Estate of Herbert Bayer/Artists Rights Society (ARS), New York/VG Bild Kunst, Bonn.

co-conspirators. Many years later, in 1971, he recognized this himself, "One of the reasons for my inertia was probably that I had a good life in Berlin in spite of the political–cultural situation."[66]

A telling example was Bayer's brief but passionate relationship with "Ninette," a French woman who enjoyed his attentions around the turn of the year 1934/1935 (see Fig. 8.9). In flirtatious, somewhat broken German, she wrote to Bayer, "I wish simply that you love me as I love you, because: your love + my love that must be = many love."[67] This was certainly nothing new for an experienced heartbreaker like Bayer, but he is unlikely to have been enthused by her demonstration of possessiveness. A few days later she was apologizing to him, "I ambushed you with my love so great that it was idiotic."[68] In his diary at the same time he was meanwhile writing that "nothing attractive awaits me in Berlin, especially the political events are disturbing. Muzilein [Muci] cries. It's still the old problem."[69] His liaison with Ninette stretched through a skiing holiday and into spring, and although she indicated a readiness to "leave everything for him," like the others, this relationship ended without hope for sharing a future.[70] Bayer saw the affair as nothing more than an amusing interlude. "A French woman has been enchanting me for some time," he confided in his diary, "but my sadness cannot be overcome."[71] A few weeks later in early 1935, he summed up his situation with resignation: "Generally speaking, the whole spring has been filled with

Figure 8.9 Photographer unknown, Ninette, inscribed in French: "To love … is first to make a pact with pain." January 1935. Photograph; Denver Public Library, Herbert Bayer Collection.

bad luck, anger, and misfortune. No love, everything goes wrong, nothing is worth living for, no depth, it must be the big city. Sometimes I'm seized with a terrible longing for my child."[72]

Bayer apparently sought consolation in the company of girls like "Bruny," "Elsy," "Ira," and "Inez"—some of his group's various *bumaiden* (a coinage that might translate roughly to "girlies," or more crudely, "bed-buddies"). For the Hamburg native Inez Heinssen, Bayer was, in Klar's words, "her last great adventure" before she later became a "well-behaved housewife."[73] The two had met in the autumn of 1936, and she fell in love. By December, however, Inez had already undergone what was at the time euphemistically called a "medical treatment" in a location somewhere else in Germany, outside of Berlin. In an unmistakably distraught letter to her "sweet beloved" the young woman wrote: "Everything has become so horribly dark around me, although I know from today that something in me is beginning to live, and this awareness gives me a little bit of strength to bear everything for the time being."[74] Although it is possible that she meant this metaphorically, the phrasing of the letter hints strongly that Heinssen was pregnant by Bayer. The letter bravely wishes him a Merry Christmas with "Muzi," with whom Heinssen had a good rapport, asks that he spare a thought for her, and expresses hope that its author would not "lose heart beforehand and choose another way out."[75]

It is impossible to know whether Heinssen was alluding to an abortion or expressing suicidal feelings, but by January 1937 she received a letter from Bayer (now lost) that made clear to her how lightly he took the matter. "You write in your letter that I'm a stunner who makes sure things don't get boring too quickly," she objected, before emphasizing her desire to have him "alone for once, for 1½–2 days … far away from business and from your Berlin friends."[76] (In a letter the week before she had complained that Willy B. Klar was "bad company."[77]) Her appeal that Bayer stay with her went unheeded, and by the spring of 1937 this relationship, too, had come to an end. Bayer recorded the affair in his diary using the cinematic present tense: "Inez holds my heart in thrall more than any woman ever has …. Unfortunately, it ends very disappointingly. No woman has understood or wanted to understand my work since Irene. So, as usual, I stay alone."[78]

In March 1945, just before the end of the war, Heinssen contacted him from neutral Switzerland, where she was being treated in Davos for health problems that included pulmonary tuberculosis. Her marriage had in the meantime failed. The letter describes Bayer's farewell gift to her, a necklace with a heart, that she wore around her neck "to this day without ever having taken it off" but makes no mention of a child born out of wedlock.[79] Perhaps more striking than the by now familiar scenario of an ex-lover professing continued affection for Bayer is the serious episode of Gestapo harassment that Heinssen mentions:

> Do you remember receiving a letter [from me] years ago in which I emphasized my German nationality? I wrote it under duress. Why? You had sent a letter to [me] at Lietzenburgerstrasse, and when I received it, I was arrested. In the letter you wrote your frank opinion of Germany and the Nazis, and that sealed my fate. The Gestapo questioned me for five days. They wanted to know what had

happened that caused you to write to me like that, and I was unable to give a plausible explanation. I was released when friends intervened—but only after I was forced to write to you.[80]

Unfortunately this incident cannot be dated precisely, but the circumstances suggest that in this case, Bayer penned his anti-Nazi remarks from the safety of the United States; there would have been little reason for him to send a general delivery letter with this content to a girlfriend when he was still living in Berlin. Either way, the event bolsters the idea that Bayer, for all his low opinion of Hitler, had little inkling of Nazi mass surveillance or the dangers that his freely expressed opinions could bring to others.

Bayer-Hecht had in the meantime yet again resigned herself to the hopeless philandering of the man who had fathered her child. "Our misfortune was that you were too handsome, and all the women were after you and wanted to alienate you from me in every way possible. In the end they succeeded."[81] On another occasion, she laconically summed up his fondness for his "cute curly-haired-peroxide-blond beauties."[82] "How can I help it if you have to try out all the Mizis, Lilis, Mimis and Pipis in order to be satisfied?"[83] Fulda for his part seems to have detected at least some twinges of an awakening self-awareness on the part of his old friend. He later described having a "crystal clear" memory of,

> the sentence you uttered in 1934 (?) in the Dorland office, while sitting at your drafting table; after a quiet sigh, it was something like this: "When will I finally become impotent? All this fucking is getting me into such a mess all the time … Only then will I have my peace and quiet and be able to devote myself 100% to my work." It just knocked me over to hear you say that—just when we had both reached the height of our screwing powers.[84]

Irene Bayer-Hecht's role in the whole business seemed pretty obvious to her: "I'm always ready to come to your aid, and tell some blond beast that I'm not getting a divorce."[85] She had, moreover, started to take a self-mocking view of her own unfulfilled love: "They really should write a street ballad about you and your unfortunate bed-warmers. It's hilarious that I want you of all people for a husband. But unfortunately I'm so stupid."[86] In a 1939 letter, however, she framed the matter in different terms; "There's only one really insurmountable obstacle between us: the name Gropius. Nothing else. Everything else could be solved—but not this."[87]

Loyal Bauhaus Circles

Apart from short-lived dalliances and amusements, it was above all the relationships with his old Bauhaus companions that sustained Herbert Bayer in the mid-1930s. Even if his core friends from that circle had left Berlin already by 1934, this is the broader context in which to better understand the possibilities and perils of Bayer's own emigration. At the end of 1934 he lamented their departure, noting in his journal, "My friends are all gone … One lives unimaginatively to survive the present … but only with material intentions."[1] Marcel Breuer and Xanti Schawinsky both departed in 1933—for Switzerland and Italy, respectively—and even the Gropiuses were gone, setting out for England in October 1934. Because the political circumstances prevented the friends from meeting in Germany, vacationing together in Switzerland and Austria gave Bayer periodic but sustaining access to them. An important ritual for Bayer was the annual ski trip in Austria centered on the Hotel Edelweiss & Gurgl, a self-proclaimed "first-rate house" in Obergurgl managed by Angelus Scheiber, for whom Bayer also designed stationery and a leaflet.[2] In 1947 Bayer wrote to his friend Lady Norton that "there was nothing better than our happy days in Tyrol."[3]

At the end of 1934, in a letter to Walter Gropius, Schawinsky described some "carefree celebrations" that he and Bayer had organized together with attractive and accommodating lady friends, both local people and fellow tourists."[4] Later, Schawinsky wistfully remembered leaving Europe in the spring of 1936:

> In Obergurgl in the Austrian Alps, we met Herbert Bayer for skiing … we stayed with the priest, as in the previous years. The cook and the maid whispered compliments about my fiancée [Irene von Debschitz] and congratulated me on my imminent marriage. [Lady] Peter Norton was there, as were the other British people from earlier years, Italians, Yugoslavians, French, and Czechs—but not a single German. The Germans had been prevented from leaving the country by the ten-mark travel restriction. Hans Falkner was teaching the new French technique of parallel skiing … his school was flourishing. He showed us the plans for his hotel [in Obergurgl], which Marcel Breuer had designed and which will be built soon.[5]

Breuer, as a Hungarian Jew, immediately saw the threat posed by the new regime's racial fanaticism and left in the spring of 1933, first returning to Hungary and later moving to Switzerland.[6] While Breuer bounced around continental Europe for about two years in

search of a place to resettle, Bayer represented his closest Bauhaus friend in Germany in various legal matters and looked after his belongings, which he sometimes even stored in the Dorland office.[7] "In any case I stand as your little dumbo (dickköpfchen) in all matters … will you stay in Zurich now?" He even joked that he coveted his friend's rootless life, "I envy you and regret the end of our harmonious marriage." In the fall of 1933 Bayer also took over the advertising for Breuer's new aluminum batten chair construction (see Fig. 3.3). Not only did Bayer develop the product's name and trademark, but he also designed the brochure for the renowned Swiss retailer Wohnbedarf.[8] This of course led to conflicts with owner Rudolf Graber from Zurich who, as Breuer reported, wanted to prevent Bayer's involvement "from becoming officially known in any case, since even here we're seeing the well-known national and local patriotic wave starting to spread, and he wants to spare himself later reproach."[9]

As with so many of his male friends, Bayer's relationship with the dashing Breuer, whose marriage had in the meantime dissolved, was influenced by their mutual delight in chasing pretty girls. A letter of 1937 refers to a special "gentleman's agreement" they had concluded in this regard.[10] Once, while playfully inquiring into how the prowl was going, Bayer made an ironic quip about race: "Have you got a *feminimum* [female] for [me,] your little Aryan?"[11]

In the summer of 1934, the two friends again spent an inspiring vacation traveling together. They boated down the Danube to Budapest in canoes and continued by train via Belgrade to Skopje and on to Greece. Bayer was impressed by the Middle-Eastern influences he encountered in the Balkans and later spent days and weeks on various Greek islands, often living amid the historical ruins (see Fig. 9.1). With his admiration for classicism, he felt very much at home; he later recalled a night on Delos wandering the island beneath a full moon with Breuer.[12] In his travel diary, he recorded how the problems of everyday life in Berlin caught up with him even in Greece's idyllic surroundings, reporting that he had received "a letter from Dorland's

Figure 9.1 Photographer unknown, Marcel Breuer and Herbert Bayer visiting an archeological site in Greece, summer 1934. Photograph; Denver Public Library, Herbert Bayer Collection.

[Walter] Matthess, impudent and deceitful."[13] Once back in Berlin, Bayer described having had "differences with Dorland, due to the eternal tactlessness. But then again a lot of work. Especially for exhibitions that even became interesting for me."[14] The "interesting" show was most likely the mass propaganda exhibition *Deutsches Volk, deutsche Arbeit* for which he designed posters and printed matter. He may also have worked on photomontage leaflets for one of the regime's Strength Through Joy campaigns, *Schönheit der Arbeit* (see Fig. 7.8 and Plate 22).[15]

Walter Gropius had maintained a studio in Berlin but, like Bayer, he was deeply ambivalent about the regime.[16] The Gropiuses soon opted in 1937 to go further afield, much to Bayer's regret, when Gropius received a job offer from Harvard University in Cambridge, Massachusetts.[17] Just a year later Gropius was promoted to head of the Department of Architecture.[18] Harvard's Graduate School of Design (GSD) dean Joseph Hudnut, seeking to strengthen his faculty, took the advice of MoMA's Alfred Barr and traveled to Europe in 1936 to seek out Gropius and Mies van der Rohe, among others.[19] Not wishing to fall foul of the Nazi authorities, Gropius took pains to ensure that all the steps of his Harvard appointment accorded with German law, just as he had when moving to London.[20]

By this time the extramarital affair between Herbert Bayer and Ise Gropius had receded almost completely. As the surviving correspondence shows, however, she maintained a close—presumably platonic—relationship with Marcel Breuer even after she stopped regularly writing to Bayer. Examining the Breuer–Ise Gropius friendship more closely reveals much about how this tightly knit group functioned. Breuer had attracted her attention as early as the spring of 1925, when he was still a newly appointed junior master at the Bauhaus. At that time she noted in her diary:

> Intellectually, Breuer probably surpasses the entire younger generation, despite his twenty-three years. He has the greatest tension in his nature, is often quite unpredictable and changing in mood. He [struggles] to master his great sensitivity and his soft disposition, which surfaces when he is tackled, and to reconcile it with his new position. Physical tenderness may sometimes make his work more difficult, but so far he has proved himself to be quite excellent.[21]

The many trips and vacations all of the members of this group had spent together during their Berlin years also strengthened the friendship. Thus, for example, a desperate Breuer felt perfectly comfortable asking Ise Gropius in the spring of 1935 to "Save my soul!"[22] Four days later, she replied affectionately, invoking his Hungarian nickname, which everyone in their circle used: "Why should I save your soul, Lajko?" and quipped that Breuer and Bayer had already trained their souls to survive on the bare minimum, making any acts of "soul-saving" unnecessary.[23]

Ise Gropius's letters to Breuer show her grappling with political developments, sometimes drawing questionable conclusions. In 1934, early in the Nazi period and before sensing things to come, she wrote, "voices of struggle are stirring here and there in the newspapers, but the other side is also rearming ... The purely Nazi circles are still the most pleasant ones, for that's the only place where one can at least risk a frank word."[24] Perhaps this was her true impression from meetings with the Nazi

elite, perhaps she intended to convey a sharper sense of sarcasm—impossible to decide today. And even a year later, after a stay at a spa in Bad Pyrmont, during which she may have met Bayer again,[25] she showed considerable naïveté in the face of the ongoing Nazi repressions, which were already clearly noticeable by the summer of 1935. Moreover, she seemed to still be undecided about what attitude to take toward those in power: "I have successfully acquainted myself with the SA and the Reichswehr and now know more than before," she wrote Breuer. "The SA is dreaming of the next twenty years and the Reichswehr of the last twenty years. The present seems rather unsatisfactory for both."[26]

Schawinsky, on the other hand, saw early and firsthand how unpleasant Nazis could become. On one particular night in 1933, they were apparently out drinking when a group of SA rowdies burst into the bar. Bayer and Breuer reached safety in time, but Schawinsky and Vips Wittig got caught up in a bloody pub brawl. "What are we supposed to do with our fists when the others have the firearms, handcuffs, and the arrest warrants?"[27] This and other anti-Semitic hostilities induced Schawinsky to leave for Switzerland and then Italy by the fall of 1933. There he worked for the Milan advertising studio of Boggeri, among others, producing graphic design clearly in Bayer's mold—including his well-known ads for Olivetti. What he explained as "functional advertising" that follows technical and psychological progress in a trade magazine article fits well into the apolitical attitude adopted by Bayer, too.[28] In 1934, he thus designed a rather remarkable propaganda poster for the twelfth anniversary of the Italian Fascist revolution, glorifying Benito Mussolini as a leader of the masses. Schawinsky's photomontage grafts a photograph of a large crowd onto a monumental portrait of Mussolini—making his body appear as the people's body in the truest sense of the word, the matrix dots in his enlarged photograph echoing the dots of the heads in the crowd.[29] In the lower third of the poster, enormous letters spelling *Si*— an affirmation of the Italian public's enthusiastic approval of fascism—are filled with text and further photomontage. In fact, Schawinsky was repurposing here some of his earlier, non-political work for the Fascist cause; he had already done something quite similar in his stunning 1931 fold-out prospectus for the river harbor in Magdeburg, writing the word *Hafen* [harbor] in giant letters and filling these in with striking architectural photography.[30]

Schawinsky's Mussolini poster stands as yet another example of how the avant-garde's visual vocabulary could easily be marshaled in the service of right-wing propaganda.[31] According to Kurt Kranz, Bayer's Dorland colleague, Bayer designed a similar portrait of Hitler two years later. Intended as an election poster with the slogan "Ja dem Führer" (Yes to the Führer), this design also used the pattern of dots created by the heads in a dense crowd to form a likeness of the Nazi leader. In Kranz's telling, Goebbels himself rejected the design because, when he showed it to the cleaning staff at the propaganda ministry, they had found it to be "too modern."[32]

Although Bayer and Schawinsky were both active in the field of commercial graphic design, the two did not compete for the same commissions. Schawinsky's position on the design scene was in no way comparable to Bayer's; before he left Germany, he at times used the workshop at Dorland to carry out smaller freelance commissions. After his marriage to Irene von Debschitz in London in early 1936,

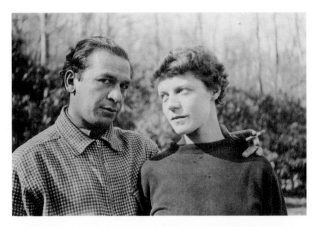

Figure 9.2 Photographer unknown, Xanti Schawinsky and his wife Irene von Debschitz, undated. Photograph; Denver Public Library, Herbert Bayer Collection.

the couple emigrated to the United States that autumn (see Fig. 9.2).[33] Ironically, in 1937/1938 Bayer would again draw inspiration from Schawinsky's Mussolini poster for what turned out to be his most politically demanding work: the cover of the January 1938 number of *die neue linie*. This was a special issue on Italy published with the approval of the Propaganda Ministry and with support from the highest political circles.[34] Bayer, who had already quietly decided to emigrate, and seemingly was eager to continue to comply with the authorities' wishes, responded to the commission with one of his most sophisticated but also morally dubious covers. Once more taking up Schawinsky's idea of the monumental head, he combined a rough-hewn profile of *il Duce* in half tone with the contour of Italy's shoreline, using a classical pillar to mark Rome on the map and superimposing the Italian national colors over the whole composition (see Plate 27). The image of Mussolini as the personification of an Italy both classical and modern was particularly prescient as it was published some fifteen months before Hitler and Mussolini turned their "Berlin–Rome Axis" into the explicitly military "Pact of Steel."

By the time Bayer's Mussolini cover appeared, Schawinsky had long since found his way to North Carolina at the invitation of Josef Albers, where he became a faculty member at the progressive Black Mountain College.[35] Anni and Josef Albers—friends of Bayer's from the Bauhaus days—had been the first former Bauhäusler to gain a foothold in the United States, emigrating in November 1933.[36] Anni Albers taught weaving and textile design at Black Mountain, drawing on her Bauhaus experiences. Her husband, after a short trial period as assistant professor, became head of the art program and stayed in that role until 1949. Their own Black Mountain College offer had come in 1933 through Philip Johnson, the exquisitely well-connected head of MoMA's architecture department, who helped set up the progressive new college from behind the scenes. Johnson was already familiar with Josef Albers' teaching in the Bauhaus *Vorkurs* (preliminary course) from his 1927 visit to Dessau.[37] And in the summer of 1932 a chance meeting in Berlin with both Alberses helped facilitate the

job offer. Once installed in North Carolina, Josef Albers' years of teaching there—and particularly his theoretical and practical development of theater into performance art—would influence a new generation of avant-gardists.[38]

From London, Gropius for his part was intensifying his efforts to rekindle the Bauhaus spirit by the fall of 1935. He was not the only one. Shortly before, the Dutch architect and commercial artist H. Th. Wijdeveld had tried but failed to establish an Académie Européenne Méditerrannée in the South of France, which he had hoped to base on the Bauhaus model, though no former Bauhaus members were involved in its international founding team.[39] Working together with Ise Gropius, ever his collaborator in correspondence related to his work, one of Gropius's first steps was to determine the current whereabouts of former Bauhaus members by sending out a questionnaire. His survey also inquired into which workshops and classes each Bauhäusler had attended and/or in which they had taught, in addition to asking about subsequent activities undertaken in the Bauhaus spirit. Finally, Gropius requested that his respondents send samples of current work, photos, or documents for publication in a forthcoming book.[40] Bayer in his own reply warned his mentor that not all the old Bauhäusler would be keen to associate themselves with such a project: "The behavior of some of the old Bauhäusler here may have made you aware that not everyone will be thrilled by a publication of these works abroad; for it could affect their ability to get ahead here inside the country."[41]

It was perhaps the muted response to his survey that led Gropius that same autumn to pitch another project to "keep the bauhaus flag flying"; together with László Moholy-Nagy, Gropius wished "to continue the series of Bauhaus books" with a volume on "everything we have done in 'advertising design' in recent years."[42] He sent his request for help compiling an up-to-date reference work on exhibition, window, and shop design not only to Bayer but also to the usual suspects—namely Breuer, Schawinsky, Hinnerk Scheper, and Joost Schmidt—but the book never took flight.

Moholy-Nagy, too, was very involved in the idea of carrying forward the Bauhaus legacy and—after exile in Holland and England—in August 1937 turned his attention to the idea of establishing the New Bauhaus in Chicago on behalf of the local Association of Arts and Industries.[43] Originally Gropius was to be entrusted with the school's management but, on accepting the Harvard appointment, suggested Moholy in his place. Although the institution was initially well received and Moholy's vision stood as a model for many interested in reforming design education, it soon fell into financial difficulties with several closures and new foundations.[44] Despite the fact that Bayer had worked closely with Moholy until the latter's departure from Berlin in 1934, there was hardly any direct contact between the two in the immediate period after Moholy's emigration.[45] The teacher who probably influenced Bayer the most in terms of his work would, however involuntarily, three years later become a key figure in his emigration to the United States (see Chapter 13). For his part, Moholy continued to appreciate Bayer not only for his creativity in design and layout but also for his debonair approach to life, later acknowledging an appreciation for his "elegance … combined with tenderness and dignity, the result of a highly developed personal culture."[46] Moholy could hardly have been referring here to the bachelor escapades of

Bayer's "Dublosan" Club, but this just emphasizes how well Bayer managed to keep his professional and leisure activities distinct from one another.

For Bayer, the extended Bauhaus circle also came to include the curator Alexander Dorner who, in time, would be essential for his career. Although a friendship between Bayer and Alexander Dorner only developed when both departed for the US at the same time, there had been various points of professional intersection along the way. As a young curator Dorner had developed perhaps the most progressive museum communication concept of his time when he took up his post at the Hannover Provinzialmuseum in 1919. In 1923, at the age of thirty, he had become the youngest museum director in Europe when appointed head of the museum's painting collection. His visionary installations—including bringing El Lissitzky's *Abstraktes Kabinett* (Abstract Cabinet) to Hannover in 1927[47]—were precursors to the sort of curatorial practice that later flourished at MoMA. Bayer later recalled having met Dorner at the Bauhaus in the 1920s. Despite Dorner's pronounced interest in the avant-garde, the curator also showed an early eagerness to serve the new regime, as historian Ines Katenhusen has pointed out. The fact that the Nazi party denied him membership when he applied in 1933 merely spurred him on, Katenhusen writes, to such further ingratiating gestures as volunteering to remove some Cubist and Constructivist artworks from his galleries, all in the conviction that he was acting with courage and honor.[48]

Whatever the nature of Dorner's complicated relationship with the Nazi regime, he was indeed forced to resign from his post in Hannover in February 1937 on charges of having embezzled funds. Like so many museums across Germany, the Landesmuseum Hannover was also caught up in the controversy surrounding "degenerate art," and Dorner, as a longtime champion of the avant-garde, would have aroused suspicion. After a stint as a travel journalist and screenwriter, he opted in the summer of 1937 to leave via Paris for the United States. That same year Dorner contributed the short introduction to the booklet accompanying Bayer's London show (see Chapter 11), and the August 1937 issue of *die neue linie* contained a story on which Bayer and Dorner collaborated.[49] Although Dorner was not Jewish and thus not persecuted as such by the regime, he later embellished his account of his life in Nazi Germany with a tale of only being able to evade arrest at the last minute. But other rumors circulated as well, for example Sigfried Giedion's false assertion that Dorner had been a member of the Nazi party from an early age, which Bayer did not believe.[50]

Embellishment and rumors aside, there are striking parallels between Dorner's biography and Bayer's. Dorner, too, carefully prepared the groundwork for his emigration, though he claimed it was a spontaneous decision. "I had a mysterious letter from Dorner, Hannover, in which he tells me that he is also learning English," reported Ise Gropius to Breuer in 1935. "Apparently it is also gradually becoming too much for him."[51] Two years later Dorner left Germany with an official German travel permit for the purposes of making a short visit to Gropius. He had, in fact, already been in touch with Alfred Barr and other colleagues and friends abroad for help with his plans to emigrate.[52]

The detailed letters and records of Ise Gropius give a strong sense of how frequently the inner circle of former Bauhäusler, grouped around Walter Gropius, kept in touch

in the first years after 1933.[53] Already since the Bauhaus years, she had undertaken numerous public relations tasks on her husband's behalf and contributed substantially to various institutional events and trips.[54] Now she became a crucial source of informal news across the Bauhäusler network.

A letter dated March 12, 1934, for example—just one of the many Ise Gropius wrote to Breuer—contains a wealth of information about the distinct living conditions, moods, and thoughts of the group at the outset of this decidedly darker era. Of her correspondent she wrote that he had "more Aryan vices than Semitic virtues." Of herself, she lamented that "it is not so easy to be part of the seething soul of the *Volk* [*kochende Volkseele*] without besmirching oneself." Of Bayer and Schawinsky, she took note somewhat mockingly of their apparent insouciance: "Herbert and Xandi write very happily from Gurgl in Tyrol, where they allegedly lead a womanless and therefore untroubled existence." Her husband, she reported, "is studying English every day and has progressed a bit beyond the stage of '*notzing witz plimautz*' [nothing with Plymouth]. But he is still very unhappy."[55] Plans for his move to Massachusetts were already shaping up. "The question is whether I can go with him. Money is scarce, and we mainly live off the car we sold, which won't last forever … Walter is now working on a project for a *Volkshaus* (people's house), a competition announced by the Propaganda Ministry. The request came down verbally from there that he take part. Unpaid, of course."

Her letter goes on to describe the fate of one friend after another, as if giving some kind of status update:

> Moholy really is going to England. He has now been back over there and will emigrate sooner or later. He feels too uncomfortable here and does not want to have to atone for a mess he did not create … [Adolf] Behne is unfortunately deathly ill, lying with TB in a sanatorium, and we don't know whether he'll ever make it back … Axel Dorner … is still sitting at his post and, like everyone else, occasionally has to pass the collection box for [the Nazi charity] winter aid.[56]

This whole letter illustrates very clearly Ise Gropius's important role as a communicator; in later years she remained a central hub in maintaining the network of Bauhäusler who had already gone into exile and those who were still on the fence or trying to get out. She was crucial in facilitating the flow and exchange of information and contacts.

The network that Ise Gropius kept such close tabs on would later also cushion Herbert Bayer's landing in the United States after his emigration. Its larger circle also included international artists and intellectuals who, sympathizing with the Bauhaus spirit, helped prepare routes out for the exiles. One such sympathizer was Noel Evelyn, Lady Norton—known as "Peter" Norton (see Fig. 9.3)—a Bayer champion who has thus far escaped attention among his biographers, perhaps because he himself neglected to mention her in later oral histories. Lady Norton was the wife of British diplomat Sir Clifford Norton. Regular denizens of the Alps, the couple had met Bayer and Breuer one winter while skiing in Tyrol, though it is not known in what year. Bayer later claimed to have first introduced his "good friend" Lady Norton to the world of

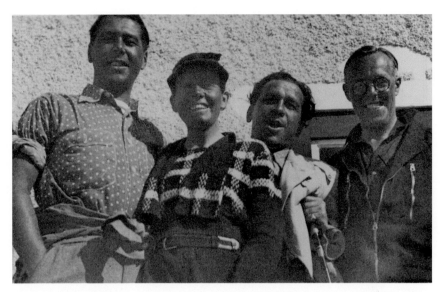

Figure 9.3 Photographer unknown, Herbert Bayer, Lady "Peter" Norton, Xanti Schawinsky, and Sir Clifford Norton, Obergurgl, Tyrol, c. 1937. Photograph; Denver Public Library, Herbert Bayer Collection.

modern art.[57] In 1936 Norton launched the London Gallery on Cork Street in Mayfair. As the 1930s progressed, moreover, Norton was able to travel unimpeded in Europe because of her husband's work as a diplomat, which facilitated her role connecting the continent's avant-garde.[58]

When Walter and Ise Gropius arrived in London, it seemed inevitable that Lady Norton would come into contact with them and their network of former Bauhaus faculty. "Next week we're invited to the Nortons, in formal dress," reported Ise Gropius to Breuer in September 1935.[59] Already by the end of the year Lady Norton had become a fixture of the Bauhaus community in British exile: "We'll all wed Xandi together and then celebrate a tremendous New Year's party at the Nortons," she rejoiced a few months later. "Only Bauhäusler! And of course 1–2 beautiful girls. Moho [Moholy-Nagy] is coming too."[60]

Bayer, who, on a brief visit to London, also attended this celebration, had already mentioned Norton in a letter that summer, asking Breuer on an upcoming trip London to "give my warmest regards to Mistress Norton. ... She is the only girl with an address that I know there, and she has glasses and a huge bosom that will scare you."[61] In August 1936—possibly on the occasion of the Olympic Games—she was in Berlin and met with Bayer to discuss, among other things, a solo show for him at her new gallery in London. Bayer subsequently travelled again to London, after duly notifying the Reich Chamber of Fine Arts of his trip.[62] There he not only saw Lady Norton but also presumably spent some time with Ise Gropius.[63] It is also likely that it was on this trip that he met the art historian Carola Giedion-Welcker, whom, according to his diary, he had always admired.[64] The following year he designed the cover and did the

Figure 9.4 Herbert Bayer, Book cover for H. Girsberger Publishers, Zurich, 1931. Offset printing; Private collection. © Estate of Herbert Bayer/Artists Rights Society (ARS), New York/VG Bild Kunst, Bonn.

typography for her groundbreaking study of contemporary sculpture, *Moderne Plastik* (later published in English as *Contemporary Sculpture*), printed by the Swiss publisher Girsberger (see Fig. 9.4).

It is clear from the surviving letters that Lady Norton's interest in Bayer went beyond a mere business relationship. The New Year's card that she and Bayer sent together to Breuer—"ahoy 1937"—shows that they celebrated the 1936/1937 New Year together in Obergurgl, an occasion that remained unforgettable for her.[65] Norton treasured all her subsequent skiing vacations with Bayer and his friend Hans Falkner.[66] "I think of you so often, Herbert," she wrote to him during a trip to the United States. "You know how much I love you & always will."[67] The affair most certainly did not live up to Lady Norton's expectations, for she too was plagued by jealousy, as Bayer later mentioned

to the Gropiuses when reporting on his London exhibition.[68] Ise Gropius commented this in another letter to Breuer:

> According to Herbert's letter, she seems to have been somewhat disappointed by his stay, since he did not dedicate all his time to her. My god, when I think of all the discussions in which she sought to prove to me that jealousy was entirely beyond her and that she did not understand why I was unable to make a place for her in my life at all.[69]

Certainly something occurred between the two women to strain their future relationship.[70] Bayer held the cosmopolitan patron and gallery owner in high esteem, not least for her many social contacts, which could potentially be helpful for him in the future. When reflecting on his trip to London, his thoughts of leaving Germany intensified, because he once again asked himself "whether I can pitch my tent here. Surprisingly many people know my work," he wrote in his diary, and, he added, he could "live with Lajco, who seems a little out of place. Gropius is in an unfortunate situation, but it's admirable how he adapts … In general, this journey is very impressive."[71] Bayer's Bauhaus-related networks enabled him to imagine a life outside of Germany; they helped him to do so already in 1937, a crucial period in Bayer's life and a year prior to his final departure in 1938. Chapters in the following section will explore Bayer's long path to emigration and highlight the fact that, for him and Breuer alike, the Gropius home was a first point of contact in the United States. Indeed, his old Bauhaus mentor Gropius remained the focal point of Bayer's private and professional network throughout his life; this was already the case in the fateful year of 1937.

Part Three

The Path to Emigration

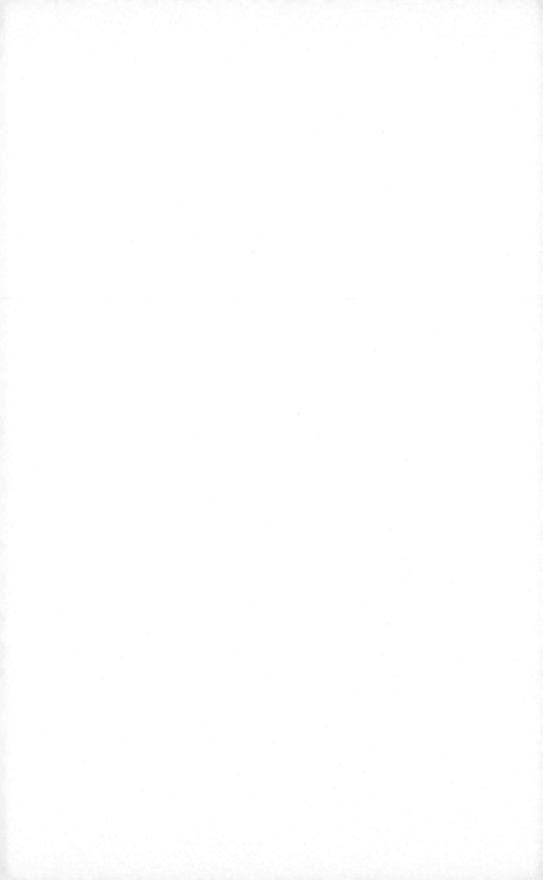

The Last Person Left Behind in Berlin

Although the trips in 1937 to Gropius in the United States and to London for supervising his solo exhibition there were the most decisive steps Bayer took to prepare for emigration, since 1933, he had, in fact, been thinking continually about making a new start, either in a new office or even a new country. The rise of Germany's National-Socialist government did nothing to diminish his natural melancholy, self-doubt, and self-pity. Even in June 1932, when still in the throes of his ultimately unhappy affair with Ise Gropius, he was already picturing various forms of escape, writing: "I have a lot of small-time work to do in the office. Would like to break off everything and start something new."[1] More than six years were to pass, however, before he finally left Germany in the summer of 1938.

In Bayer's account, the last straw was the Nazi annexation of Austria.[2] He had always felt a special longing for his native land and had considered returning to the Alps both in 1936 (perhaps in the context of his show in Salzburg) and again in 1937.[3] Referring to his move to Darmstadt and later to the Bauhaus almost twenty years ago, he even went so far as to state, in a 1937 letter to the Gropiuses, that, "I really believe that the biggest mistake of my life was to leave Austria in a youthful zest for action at that time."[4] Vehemently opposed to the Anschluss, the prospect as a proud Austrian of being forced to become a *Reichsdeutscher* (citizen of the "German Reich") troubled him greatly: "When the Nazis came to steal the country, I decided to go to America and try a new life. Always with the quiet thought of being able to go to Austria soon and then for good," he wrote in his diary in 1938.[5] About his "dubious luck of being taken for a German," he later asserted: "I really have less of a relationship with the German nation than to any other. As an Austrian I feel quite different."[6] After the war, a letter from his Dorland colleague Heinz Ritter recalled Bayer's mood in the spring of 1938, particularly how he had "returned from the mountains, full of bitterness that [he], too, was now to be stamped a Nazi German."[7]

As this book has explored in previous chapters, the Nazi dictatorship drove most of Bayer's inner circle into emigration. Some, like Breuer and Schawinsky, recognizing the wave of racial hatred, left immediately in 1933. Others, like Moholy-Nagy and the Gropiuses, stayed somewhat longer, nurturing the illusion that they could still introduce modern design principles to Germany, albeit under the regime's terms. Moholy, for instance, never felt personally threatened and even applied for membership in the Reich Chamber of Culture; he left before it ever became effective. He maintained his Berlin office, directed by his second wife Sybil, until 1935 while working between

Amsterdam, Budapest, London, and Paris.[8] From the mid-1930s on, as the outward flow of Germany's artists and intellectuals grew more intense, so too did the pressure on those, like Bayer, who remained. Of his close friends, Willy B. Klar tried to make do as best he could in Nazi Germany while Jorge Fulda left for London in 1936 and later moved on to Buenos Aires.

Bayer mused on his isolation in 1934: "So I am what remains of a 'working group.'"[9] And: "I am ... the last person left behind in Berlin alone. ... Perhaps a possible break with Dorland will ultimately be the cause for me [to emigrate]."[10] But an open conflict with Dorland did not come about; on the contrary, he continued to have what, at least from the outside, appeared to be a charmed career in the studio (see Fig. 10.1). One year later Bayer wrote to Ise Gropius, "every now and then there's a clash with the company; at least it brings some movement."[11] By this time, he had indeed firmly established himself in German graphic design, as an overview of his commercial work from the period makes clear.[12] He was well aware of this, writing with both envy and a certain resignation to Breuer in 1935, "With sad eyes I watch all of this movement to London and in London and feel increasingly like an outsider."[13]

The letters Bayer wrote throughout the 1930s make clear that his state of mind wavered between hope and despair. On the one hand, he was confident that conditions would improve for him, which for Bayer always meant he'd receive demanding work that would have to be taken seriously. Life took its regular course and occasionally he even found the time to create works of art. As he later recalled, "in the Thirties, in Berlin ... I worked, I had a studio, and I painted on a Sunday or a Saturday, and when I went on a vacation I painted a little."[14] His optimism was such that, in the mid-1930s, he considered commissioning Breuer to design a house for him.[15] He wrote: "In any case, you would have to show here how ideas of steel and glass can be morally combined with all the hang-ups over *blut und boden* (*blubo*)." After coining that joke

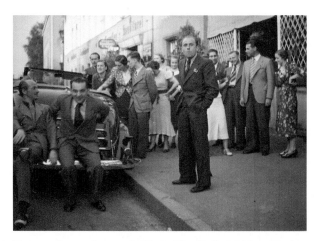

Figure 10.1 Photographer unknown, Willy B. Klar (left), Walther Matthess (front), and Herbert Bayer (right) with the Dorland staff, 1930s. Photograph; Denver Public Library, Herbert Bayer Collection.

abbreviation to scoff at the Nazi notion of blood and soil, he continued: "With me, you'll have nothing to laugh about."[16] Even in 1938, the year he left Germany, Bayer planned to join Willy B. Klar in building a shared bungalow in the Berlin suburb of Groß-Glienicke. The architect was a former Bauhaus student Gustav Hassenpflug, who had been an assistant in Breuer's architectural office for a period of time around 1928.[17] Klar wrote in his memoirs:

> Although Bayer was already plotting his emigration, he agreed to design the two-room bungalow in such a way that one of the two rooms could be used either as a painting studio with a sleeping niche or as our living room … The second room was my bedroom. Small kitchen, no bathroom, only a toilet and shower. Bayer was able to persuade his friend the architect Gustav Hassenpflug, then about twenty-eight years old, to design this little house for us. I was Hassenpflug's first client.[18]

Bayer helped his friend to clear the building site, but he never actually moved in.

On the other hand, Bayer often fell prey to doubt and uncertainty. Starting around 1935, he slowly began to come to the conclusion that, as Adorno put it, there can be no "right life in the wrong one."[19] To Breuer, he wrote: "In the meantime, I've come back here again [to Germany] with reluctance. But you just can't go against the tide."[20] All of his correspondence in the mid-1930s is characterized by uneasiness, sometimes to the point of despair at his own lethargy.[21] In a letter to the Gropiuses, he formulated it strikingly:

> I am sitting with a glass of wine from which I drink to you. In the whores' palace. They and the Jews are now gone. All that remains are the Aryans—and the bad reputation. And my rheumatism, which I picked up here because I've spent years lying in the draft. Should one change all this? Before having seen America?[22]

These remarks from the spring of 1937 show Bayer's awareness of the contradictions that by then marked his continued presence in Germany. But they also show his mistaken impression that most German Jews had already left the country.[23] Presumably this selective perception came from what he observed in his own social circle and professional networks of artists, ad men, publishers, and textile and retail magnates.

Oscillating between self-pity and the need for recognition, between his daily routine and outbursts of hedonism, between pride in his craft and dissatisfaction with his job opportunities, the balance slowly tipped toward emigration. "Outside my inner thoughts about work, life here not only lacks the charm of friendship, of the spiritual atmosphere of progress and modernity," he confided to his diary; "it is even worse than that, because what you get instead it is so vile and stupid and inferior that you must summon all your strength to avoid losing all your inspiration."[24]

To assess Bayer's situation more fully, it is indispensable to consider his emotional background at the time. London, which would have been the most obvious place for him to go, seemed virtually blocked to him. Walter and Ise Gropius had just moved there, a fact that put an end to the troubling love triangle involving Bayer.[25] Bayer could not have possibly justified emigrating to England under the circumstances, for he had

already decided that his friendship with his mentor was more important to him than his passion for his mentor's wife (see pp. 78–9). Yet despite the many attestations of loyalty, Bayer imagined that Gropius might have interpreted any movement toward England on Bayer's part as an attempt to renew the affair with Ise Gropius.[26] Similar concerns were later in play at the time of his 1937 trip to the United States and again in 1938, when he left Berlin for good—for the Gropiuses were by then permanently installed in Massachusetts. At that point, however, the sinister course of world history had made matters more urgent, pushing such considerations into the background.

The graphic-design scholar Ute Brüning has noted a disruption in Bayer's commercial art in the middle of the 1930s; after his steep ascent, his career went almost as steeply downhill.[27] After 1936, apart from advertising work for textiles and personal hygiene products (see Fig. 10.2), he apparently received no substantial contracts for new graphic design work. And this despite the fact that media experts of his day greatly admired his 1937 Chlorodont campaign as both for its educational value and its effectiveness as advertising (see Fig. 6.6).[28] Prestigious, large-scale commissions suddenly dried up, and there were no poster designs worth mentioning. Bayer's creative power declined as well, as most of the 1937 and 1938 covers for *die neue linie* attest, with a notable exception that I will discuss later in this chapter.

Perhaps most noteworthy of all was the fact that Bayer did not participate in the major Nazi propaganda exhibition of 1937, *Gebt mir vier Jahre Zeit* (Give me

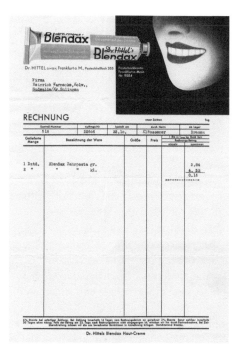

Figure 10.2 Herbert Bayer, Stationery for Dr. Hittel company (Blendax toothpaste), 1933. Letterpress; Private collection. © Estate of Herbert Bayer/Artists Rights Society (ARS), New York/VG Bild Kunst, Bonn.

four years), a veritable culmination of the Führer cult.[29] The traveling show began at the Berlin Messe, like the trilogy of mass exhibitions in the three previous years for which Bayer had designed the printed matter.[30] Considering the praise he had received for those posters, brochures, catalogue covers, and booklets—even in circles close to the Propaganda Ministry—it would have made sense to offer Bayer the commissions for the next show in the lineup. Like the trilogy, it too was organized by his acquaintances from the Berlin Messeamt. But even with Bayer's friend Ingo Kaul serving again as editorial director for the publications, publicity brochure design, and catalogue, these were all executed instead by Ernst Kroll, an employee of the German Propaganda Studio (DPA), a subsidiary of the Propaganda Ministry. It seems plausible that, given the significance of *Gebt mir vier Jahre Zeit*, the Propaganda Ministry was eager to keep all aspects of production as close as possible to the organization itself.[31]

It is highly unlikely that Bayer was given a chance to turn down the job at all, even if he would have objected on political grounds. And if he had refused it, Bayer would most certainly have mentioned his objections after the war, in keeping with his general postwar tendency to emphasize the harmless and apolitical nature of his work during the period of National Socialism. What had happened in the meantime? Was it really, as Kurt Kranz said in 1992, that the Propaganda Ministry no longer had any use for Bayer's advertising style? That Goebbels considered it too modern?[32] Perhaps someone in the Propaganda Ministry had noticed Bayer's Bauhaus past, which could have been particularly alarming in the run-up to the *Degenerate Art* show, in preparation at the same time as *Gebt mir vier Jahre Zeit*. Perhaps the business practices of Studio Dorland had caused a stir, or Bayer had fallen out of favor for other reasons. Perhaps—and most likely—it was just Bayer's naïveté about pursuing his private affairs with the Nazi state.

Already, in late 1934, an overzealous junior employee at Dorland had tattled when Bayer had violated foreign currency laws, probably by sending money to his wife in Czechoslovakia.[33] This bureaucratic run-in was not officially because of Irene Bayer-Hecht's Jewish heritage but rather due specifically to the legal violation. Still, the slap on the wrist must have caused alarm. "Herbert has been very upset about foreign exchange stories," Ise Gropius reported to Marcel Breuer. "He probably sent too much to Irene over time, and a messenger boy at his agency felt obliged to report it."[34] With investigations into this matter looming in early 1935, Bayer expressed anxiousness about how the situation would be resolved. He wrote to Breuer: "I hear that you're still dealing with England ... It would be the land of retreat for me, too, if they threw me out, which is not impossible with my crimes against foreign currencies. I've been denounced and am awaiting punishment."[35]

Although the couple managed to resolve the matter without further trouble, the Bayer family was now on the regime's radar.[36] The next time Bayer "overlooked" a matter of Nazi bureaucracy—when the Bayers failed to hand over the necessary Aryan "pedigree" certificates by the general submission deadline of September 30, 1936—the authorities were decidedly suspicious. He had, in fact, already prepared the information to be filled into the forms for himself, and in July 1937 he received a gruff reminder that he had four weeks to submit the documents or face severe consequences for noncompliance.[37] The draft of his response preserved in his estate notes that he was not able to retrieve the certificates from his native city in Austria[38]; no evidence survives of what the Bayers actually submitted or how the authorities responded.

Amid all this personal tumult, worry, hesitation, and a general decline in his creativity, Bayer did manage to break new ground one more time with the cover he designed for the November 1938 issue of *Gebrauchsgraphik* (see p. 115, Plate 26). It was a parting gift to those he left behind, a trace of the talent that had once brought Bayer to the pinnacle of the European graphic design scene. Other than this one exceptional design, however, his work seems to suffer from the fact that he was merely busy with routine work of securing a living; the advertising campaigns for Dorland's prime clientele in the textile industry posed no significant challenges for him. Nor did they spur him on to do his best work.

It probably also did not help that Bayer, like many, was living in a general climate of increasing fear at the time. The fate of Bayer's friend Bruno E. Werner was certainly not an example that Bayer would have wished for himself. The longtime editor of *die neue linie* was half Jewish and lived under near-permanent Gestapo surveillance. Though Bayer may not have been entirely aware of the degree to which Werner was being observed, this was certainly not a lifestyle that Bayer had in mind, to say nothing of the persecution and a life in hiding that Werner subsequently endured.[39] For Bayer, merely hitting the doldrums of creative mediocrity was punishment enough.

And yet, even in 1937, his determination to leave Germany still wavered. As he confessed to the Gropiuses, "I feel very ill at ease when I picture this change. I think it's laziness. Not just *bodenständigkeit*" (literally, "groundedness," but also perhaps a reference to the regime's emphasis on *Blut und Boden*—blood and soil). "Because I hardly harbor an ardent love of the soil here."[40] In the long-drawn-out decision to emigrate, Bayer initially thought of neutral Switzerland, where a number of writers and artists had already found shelter. It was a serious option for Bayer, which is why, as early as 1934, he asked Breuer, who was based in Zurich at the time, for his assessment: "My inquiry regarding a stay in free *Schwyz* related to me personally. I am actually fed up with the hopeless future that is smiling down on us here. Resignation persists, and in the end it rubs off on tender souls."[41] By January 1935 he had abandoned his plans: "I'm not going back to Switzerland because it's expensive," he put it succinctly.[42]

This was only one of many instances in Bayer's correspondence where the fear of economic hardship—for himself but also for Bayer-Hecht, still his financial dependent even after their divorce, and their daughter—played a pivotal role as he weighed the pros and cons of cutting loose. It seemed unthinkable, at least in the short term, to leave Germany for an uncertain future without any financial security: "For me, the one thing that is always difficult is what I will be able to live on abroad."[43] This led Bayer into the contradictory situation that, while earning good money in Germany, he was constantly on the lookout for sources of foreign currency to fund his emigration. "Herbert seems to be making a good career in Berlin," Ise Gropius reported to Breuer, "and that's important to him, because only money can give him the opportunity to leave the country."[44]

Bayer's emphasis on financial matters—if not his sole motive then at least a major criterion—were a constant in any plan to emigrate: "It makes me want to throw up … nothing to do. London looks like paradise at the moment.—I'm looking around for [ways to get to] America."[45] Despite the lack of creative inspiration, Bayer's professional

position in Germany as chief designer of one of the most important advertising agencies still remained quite enviable (see Fig. 10.3). Studio Dorland, after brief growing pains, had developed an excellent client list, the source of Bayer's rapid rise and "glittering career."[46] "Herbert could hardly take notice of [Walter and me] due to the desperate pileup of work," Ise Gropius wrote to Breuer around the same time Bayer had completed the printed matter for the show *Deutsches Volk, deutsche Arbeit*. "Besides," she noted, "he suffers from the same malady you do: You take the factual things much too seriously and the human things not seriously enough—and they take revenge on that. Herbert is in a miserable state of health … He has had headaches and dizziness for ages, and the doctor diagnosed exhaustion and a poor heart condition."[47] That same day, Bayer confirmed the same to Breuer. "My work is piling up … you could

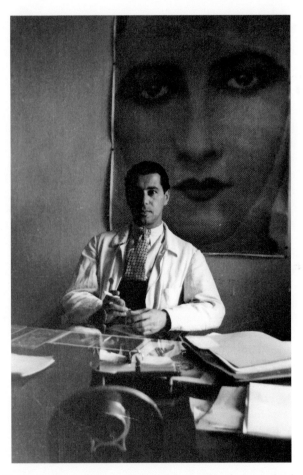

Figure 10.3 Photographer unknown, Herbert Bayer at his desk, Dorland agency, 1933. Photograph; Denver Public Library, Herbert Bayer Collection.

Figure 10.4 Photographer unknown, Herbert Bayer sick in bed, 1938. Photograph; Denver Public Library, Herbert Bayer Collection.

get the persecution mania right away. Things don't look very good with my heart."[48] The art historian Karin Anhold has suggested that Bayer's preoccupation with health-oriented motifs and products in his Dorland work may have also been connected to his personal state (see Fig. 10.4).[49] This is unlikely, given the fact that he had little choice in the commissions he fulfilled for Dorland, but it is certainly possible that his particularly insightful designs were inspired by his own health troubles.

During these years of indecision, Bayer's lack of concrete job opportunities abroad caused his plans to leave the country to fizzle. As early in 1934 he mused aloud to Josef Albers about the studio's favorable order situation while half-heartedly wishing once more that work would dry up so he could thus have "an opportunity to leave."[50] That this did not happen for several more years explains why Bayer's emigration was indeed a long time coming. As his desire to leave increased in 1937, however, he began a phase of careful planning.

Bayer's departure was by no means undertaken in haste. On the one hand, his solo exhibition at the London Gallery in the spring of that year, which is the focus of the next chapter, had allowed him to test the international response to his work as an artist, in addition to permitting the legal export of his artwork out of Germany. On the other hand, a 1937 summer holiday in the United States served as essential preparation for permanently turning his back on Germany. This trip, which is discussed in detail in Chapter 12, was the cornerstone for building a new existence overseas. When his conflict with the Reich Chamber of Culture finally came to a head, it was time to go.

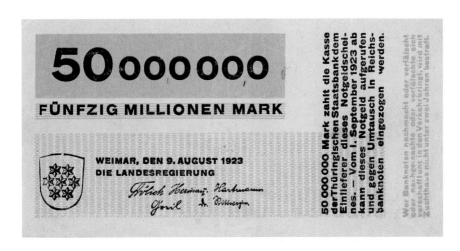

Plate 1 Herbert Bayer, Inflationary money for Thuringia, Weimar 1923. Rotary printing;
Private collection. © Estate of Herbert Bayer/Artists Rights Society (ARS), New York/VG
Bild Kunst, Bonn

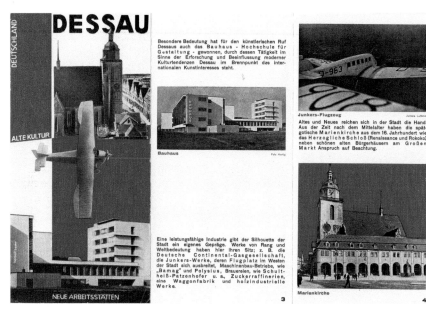

Plate 2 Herbert Bayer, Tourist flyer for the city of Dessau, 1926. Offset printing, folded; Private collection. © Estate of Herbert Bayer/Artists Rights Society (ARS), New York/VG Bild Kunst, Bonn

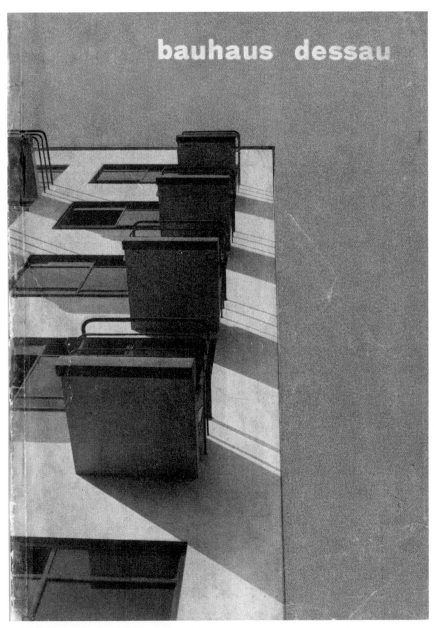

Plate 3 Herbert Bayer, Advertising brochure for the Bauhaus, 1927. Offset printing; Private collection. © Estate of Herbert Bayer/Artists Rights Society (ARS), New York/VG Bild Kunst, Bonn

werbe-entwurf und ausführung

dessau,bauhaus d~~✗~~

herbert-bayer b

berlin-chlbg. 2, hardenbergstr. 24
tel: steinpl. 69 02
bis 1. nov. steinpl. 58 34

immer das wesentliche einer aufgabe muß erforscht und erkannt werden, dann wird die äußere erscheinung einer werbsache das logische mittel sein zum zweck, den die werbsache erfüllen soll. eine arbeit nach dieser auffassung verbürgt überzeugungskraft und qualität. alle darstellungsmittel der typografie, fotografie, malerei, zeichnung wende ich zweckmäßig an bei: warenzeichen, geschäftspapier, inserat, prospekt, plakat, packung, werbebau und anderen werbsachen. meine technischen kenntnisse und erfahrungen sichern eine wirtschaft- liche arbeitsweise.

kdw 80

vdr-kartei der
werbindustrie
februar 1928

Plate 4 Herbert Bayer, Advertising card for his Berlin studio, 1928. Offset printing; Archiv der Moderne Weimar. © Estate of Herbert Bayer/Artists Rights Society (ARS), New York/ VG Bild Kunst, Bonn

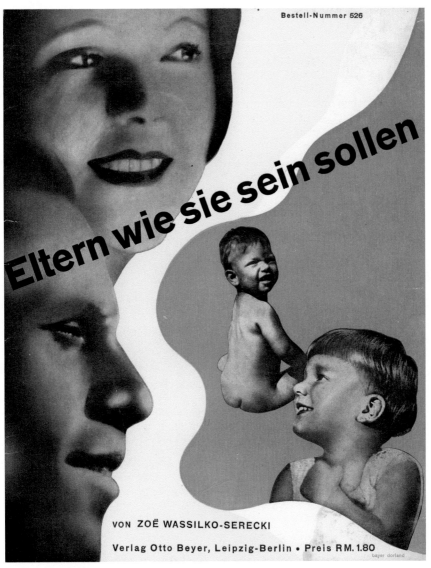

Bestell-Nummer 526

Eltern wie sie sein sollen

VON ZOË WASSILKO-SERECKI

Verlag Otto Beyer, Leipzig-Berlin • Preis RM. 1.80

Plate 5 Herbert Bayer, Book cover for Otto Beyer Publishers, Berlin, 1931. Offset printing; Private collection. © Estate of Herbert Bayer/Artists Rights Society (ARS), New York/VG Bild Kunst, Bonn

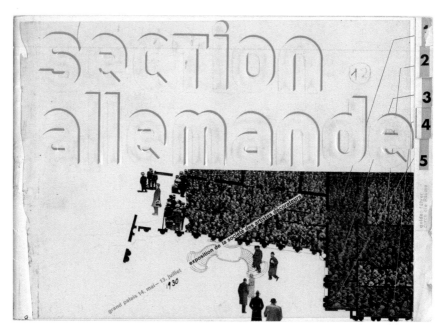

Plate 6 Herbert Bayer, Catalogue for the Section Allemande exhibition, Paris, 1930. Letterpress with embossed plastic cover; Private collection. © Estate of Herbert Bayer/ Artists Rights Society (ARS), New York/VG Bild Kunst, Bonn

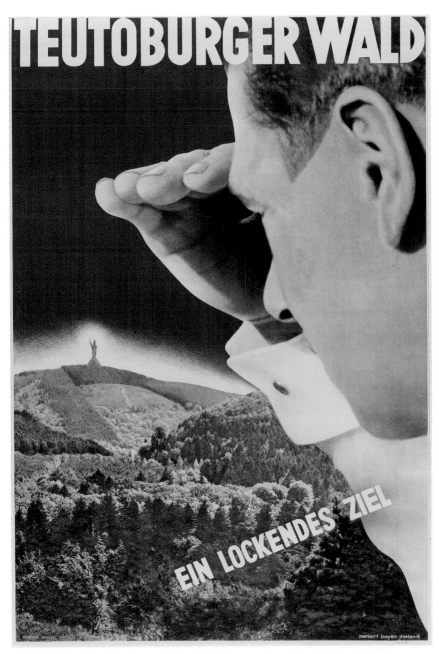

Plate 7 Herbert Bayer, Travel poster for Teutoburger Wald region, 1931. Offset printing;
Lentos Kunstmuseum Linz, Herbert Bayer Collection. © Estate of Herbert Bayer/Artists
Rights Society (ARS), New York/VG Bild Kunst, Bonn

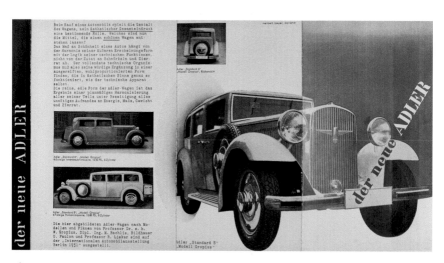

Plate 8 Herbert Bayer, Advertising brochure for Gropius Adler car, 1932. Letterpress, folded; Private collection. © Estate of Herbert Bayer/Artists Rights Society (ARS), New York/VG Bild Kunst, Bonn

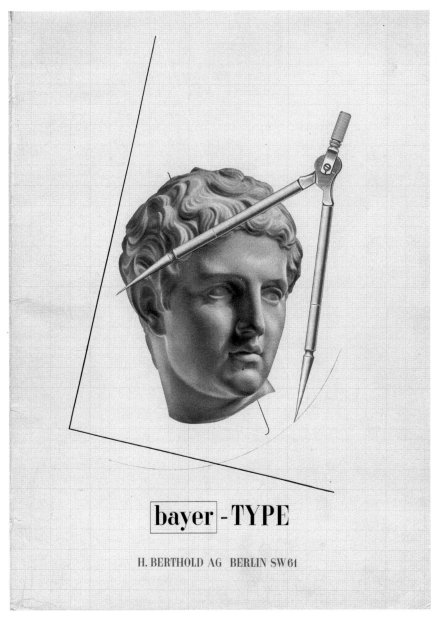

Plate 9 Herbert Bayer, Type specimen for *Bayer-Type*, Cover of folder, c. 1936. Offset printing; Private collection. © Estate of Herbert Bayer/Artists Rights Society (ARS), New York/VG Bild Kunst, Bonn

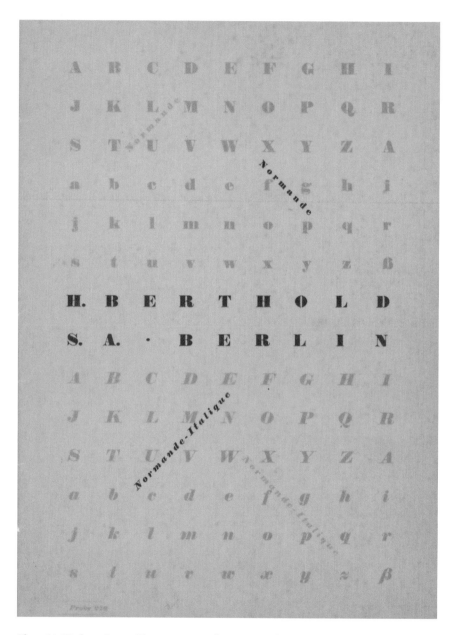

Plate 10 Herbert Bayer, Type specimen for *Normande* typeface, brochure cover, 1933. Offset printing; Private collection. © Estate of Herbert Bayer/Artists Rights Society (ARS), New York/VG Bild Kunst, Bonn

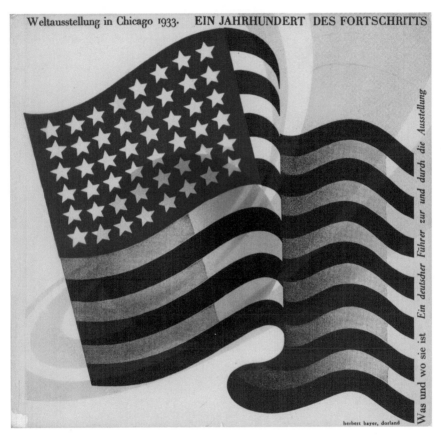

Plate 11 Herbert Bayer, Catalogue for the German pavilion at the Chicago World Fair, cover, 1933. Offset printing on glassine paper; Private collection. © Estate of Herbert Bayer/ Artists Rights Society (ARS), New York/VG Bild Kunst, Bonn

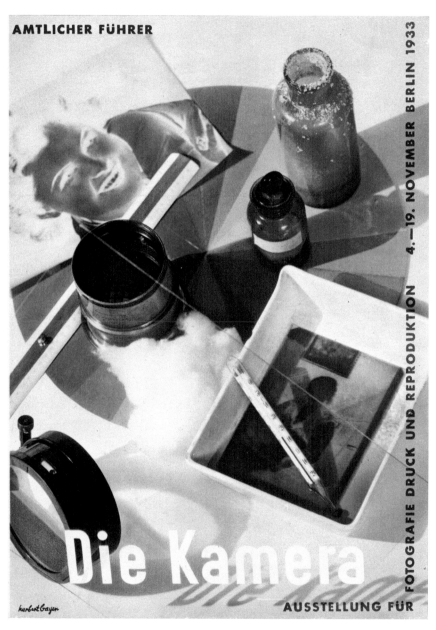

Plate 12 Herbert Bayer, Catalogue for the exhibition *Die Kamera*, cover, 1933. Offset printing; Private collection. © Estate of Herbert Bayer/Artists Rights Society (ARS), New York/VG Bild Kunst, Bonn

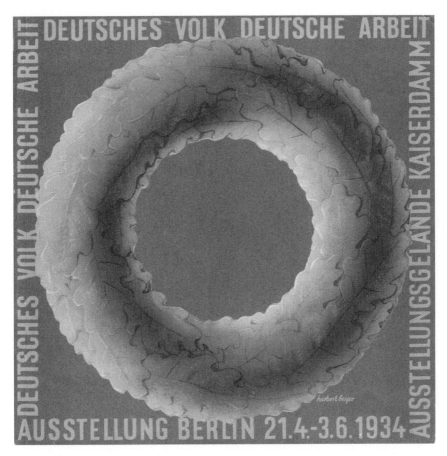

Plate 13 Herbert Bayer, Booklet for the exhibition *Deutsches Volk, deutsche Arbeit,* cover, 1934. Offset printing; Private collection. © Estate of Herbert Bayer/Artists Rights Society (ARS), New York/VG Bild Kunst, Bonn

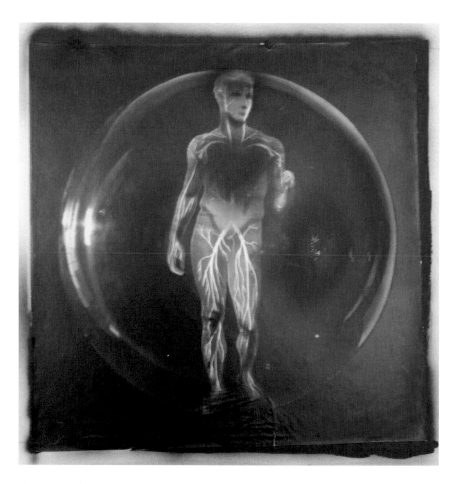

Plate 14 Herbert Bayer, Key visual for the exhibition *Das Wunder des Lebens,* 1935. Collage, photograph, and gouache; The Wolfsonian-FIU, Florida, Herbert Bayer collection. © Estate of Herbert Bayer/Artists Rights Society (ARS), New York/VG Bild Kunst, Bonn

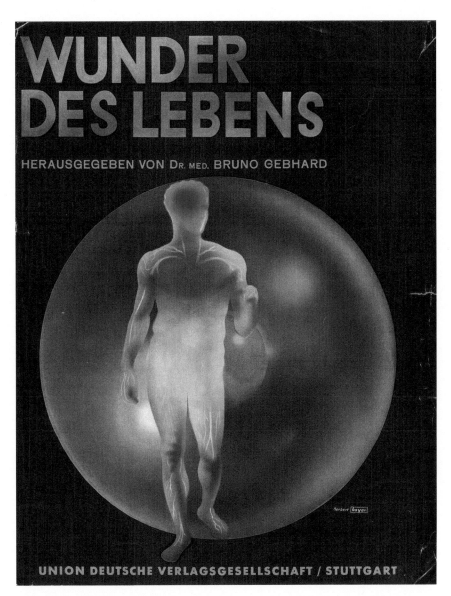

Plate 15 Herbert Bayer, Book cover for Union Deutsche Verlagsgesellschaft, Stuttgart, 1935. Offset printing; Private collection. © Estate of Herbert Bayer/Artists Rights Society (ARS), New York/VG Bild Kunst, Bonn

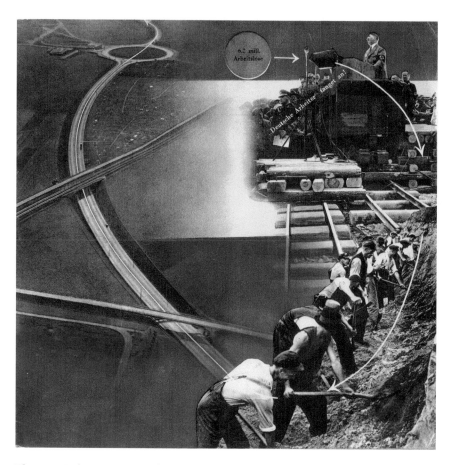

Plate 16 Herbert Bayer, Page from *Das Wunder des Lebens* booklet, 1935. Offset printing; Private collection. © Estate of Herbert Bayer/Artists Rights Society (ARS), New York/VG Bild Kunst, Bonn

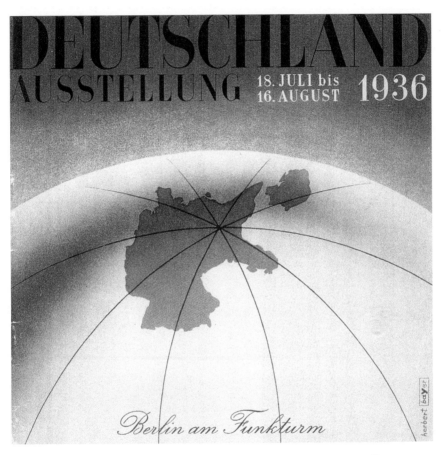

Plate 17 Herbert Bayer, Booklet for *Deutschland* exhibition, cover, 1936. Offset printing; Private collection. © Estate of Herbert Bayer/Artists Rights Society (ARS), New York/VG Bild Kunst, Bonn

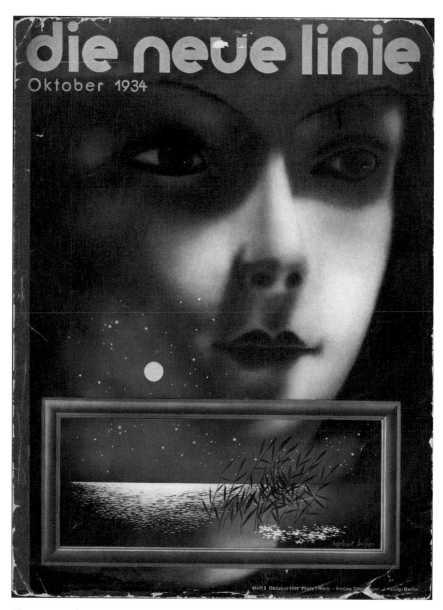

Plate 18 Herbert Bayer, Cover for *die neue linie* magazine, October 1934 issue. Offset printing; Private collection. © Estate of Herbert Bayer/Artists Rights Society (ARS), New York/VG Bild Kunst, Bonn

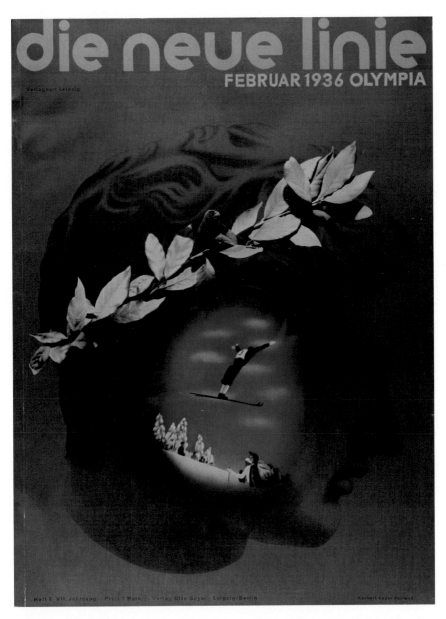

Plate 19 Herbert Bayer, Cover for *die neue linie* magazine, February 1936, winter Olympics issue. Offset printing; Private collection. © Estate of Herbert Bayer/Artists Rights Society (ARS), New York/VG Bild Kunst, Bonn

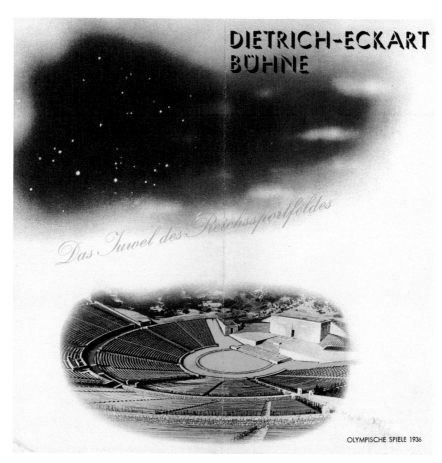

Plate 20 Herbert Bayer, Program flyer for the opening of the Dietrich-Eckart arena, 1936. Offset printing, folded; Private collection. © Estate of Herbert Bayer/Artists Rights Society (ARS), New York/VG Bild Kunst, Bonn

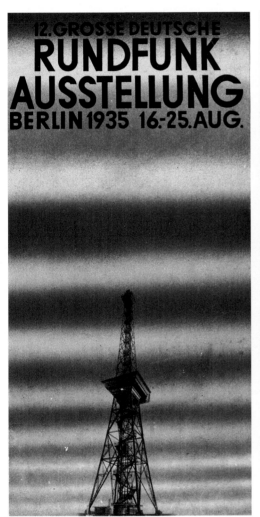
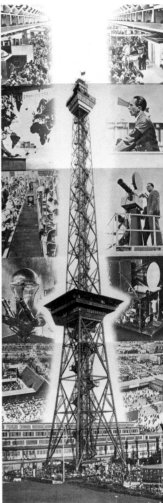

Plate 21 Herbert Bayer, Program flyer for the German radio exhibition, 1936, cover and rear panel with photomontage. Offset printing; Private collection. © Estate of Herbert Bayer/Artists Rights Society (ARS), New York/VG Bild Kunst, Bonn

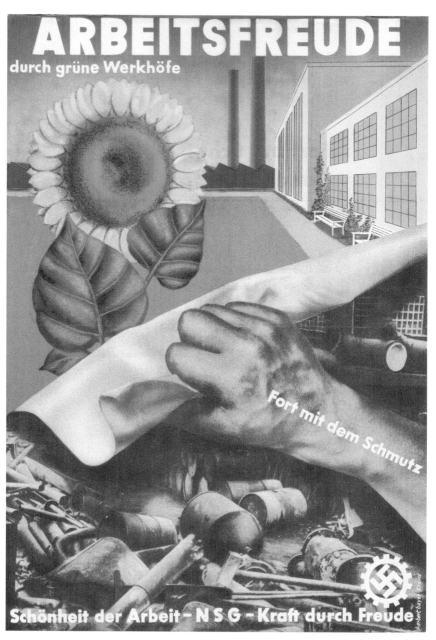

Plate 22 Herbert Bayer, Small poster for clean workspaces, *Joy of Work* campaign, 1935. Offset printing; Private Collection. © Estate of Herbert Bayer/Artists Rights Society (ARS), New York/VG Bild Kunst, Bonn

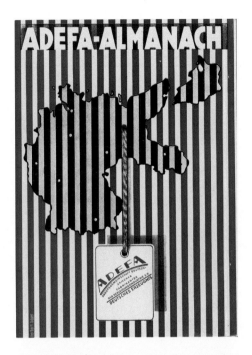

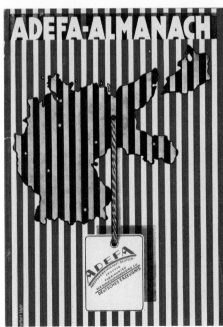

Plate 23 Herbert Bayer, Front and rear cover for ADEFA almanac, 1936. Offset printing; Lentos Kunstmuseum Linz, Herbert Bayer Collection. © Estate of Herbert Bayer/Artists Rights Society (ARS), New York/VG Bild Kunst, Bonn

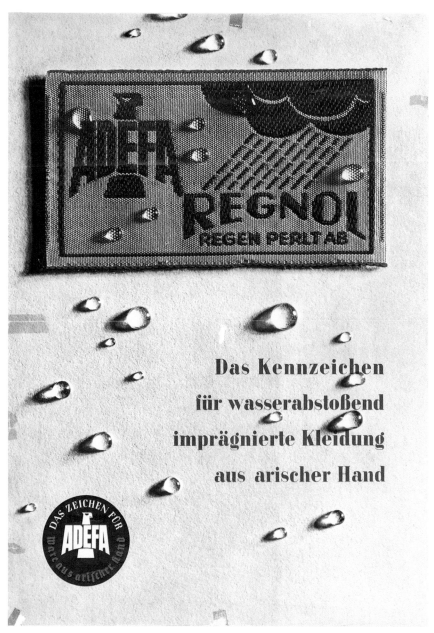

Plate 24 Herbert Bayer, ADEFA poster with Aryan slogan, 1936/37. Letterpress; Lentos Kunstmuseum Linz, Herbert Bayer Collection. © Estate of Herbert Bayer/Artists Rights Society (ARS), New York/VG Bild Kunst, Bonn

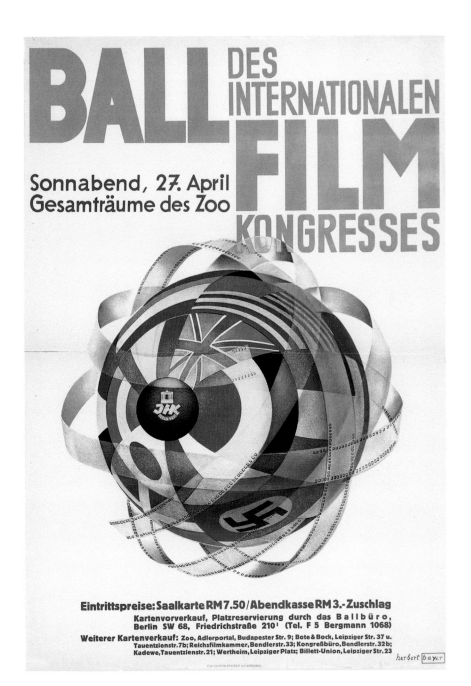

Plate 25 Herbert Bayer, poster for the ball of the International Film Convention, Berlin 1935. Letterpress; Lentos Kunstmuseum Linz, Herbert Bayer Collection. © Estate of Herbert Bayer/Artists Rights Society (ARS), New York/VG Bild Kunst, Bonn

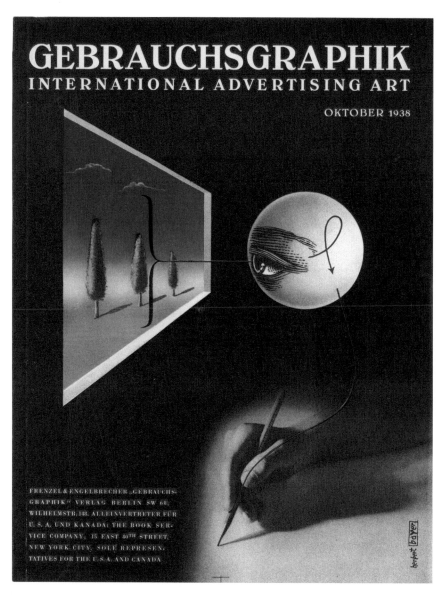

Plate 26 Herbert Bayer, Cover for *Gebrauchsgraphik* magazine, October 1938. Offset printing; Private collection. © Estate of Herbert Bayer/Artists Rights Society (ARS), New York/VG Bild Kunst, Bonn

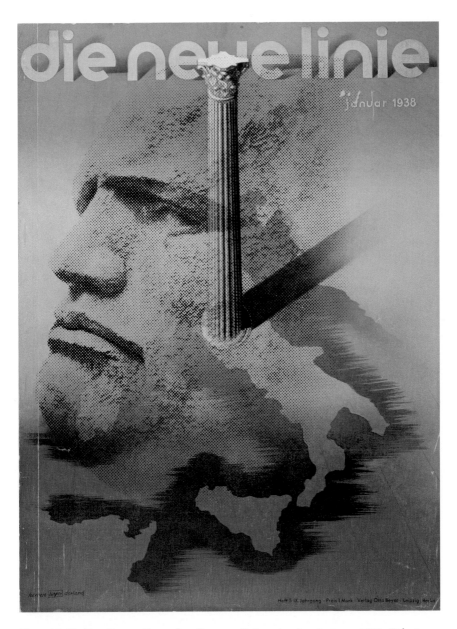

Plate 27 Herbert Bayer, Cover for *die neue linie* magazine, January 1938, Italy issue. Offset printing; Private collection. © Estate of Herbert Bayer/Artists Rights Society (ARS), New York/VG Bild Kunst, Bonn

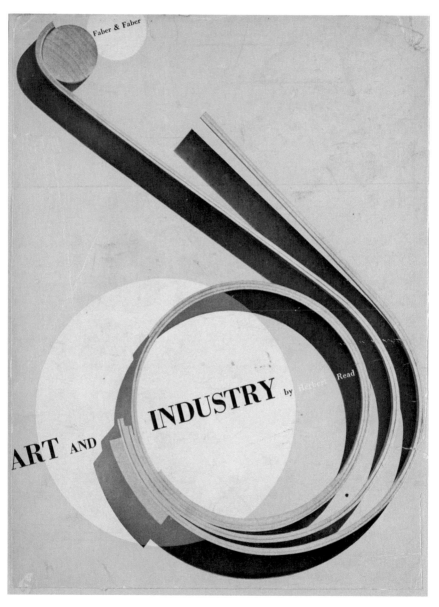

Plate 28 Herbert Bayer, Book cover for Faber & Faber, London, 1934. Offset printing; Private collection. © Estate of Herbert Bayer/Artists Rights Society (ARS), New York/VG Bild Kunst, Bonn

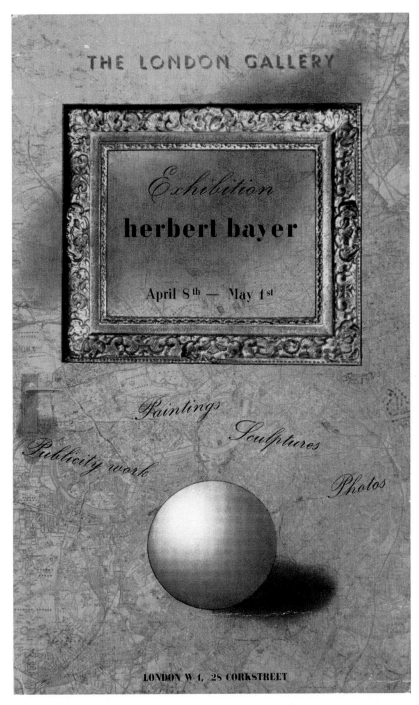

Plate 29 Herbert Bayer, Invitation card for his one-man show at the London Gallery, 1937. Letterpress; Private collection. © Estate of Herbert Bayer/Artists Rights Society (ARS), New York/VG Bild Kunst, Bonn

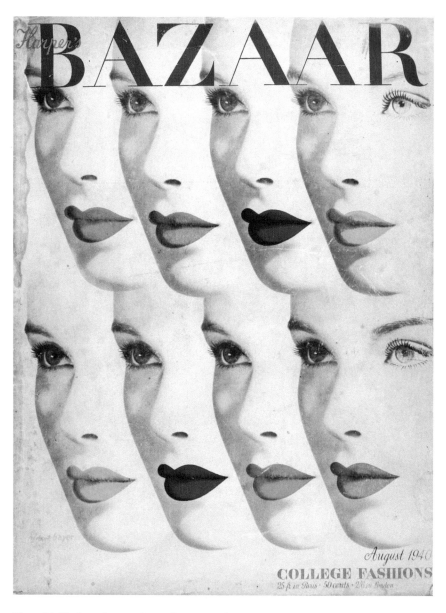

Plate 30 Herbert Bayer, Cover for *Harper's Bazaar* magazine, August 1940, College fashions issue. Offset printing; Private collection. © Estate of Herbert Bayer/Artists Rights Society (ARS), New York/VG Bild Kunst, Bonn

Plate 31 Herbert Bayer, Cover for a General Electric Company brochure, 1942. Offset printing with cellophane wrapper; Private collection. © Estate of Herbert Bayer/Artists Rights Society (ARS), New York/VG Bild Kunst, Bonn

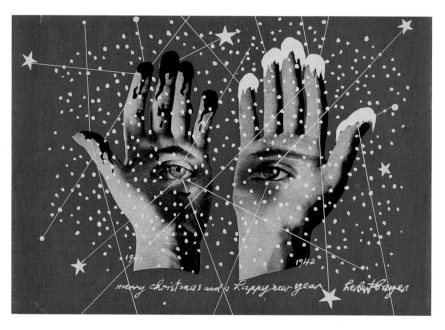

Plate 32 Herbert Bayer, Greeting card for the year 1942, referring to his *Lonely Metropolitan* photomontage. Letterpress; Private collection. © Estate of Herbert Bayer/Artists Rights Society (ARS), New York/VG Bild Kunst, Bonn

Trial Run: The London Gallery Exhibition

Bayer's ideas for organizing an exhibition of his work in London date back to early 1935, when Ise Gropius pitched the idea (presumably to the Nortons) at a reception.[1] Bayer followed up on the contact himself, noting that fall in a letter to Walter Gropius: "I am corresponding with Mrs. Norton [Lady Peter Norton] about an exhibition in London, which I would be very interested in."[2] Perhaps he also wanted to improve his reputation on the English typography scene, which was gaining exposure to Bayer's style; he had, for example, created the jacket design and layout for Herbert Read's 1934 landmark publication on modern design in England, *Art and Industry* (see Plate 28). Read, who appreciated the Bauhaus, explicitly asked Richard de la Mare, the designer at Faber & Faber, to give Bayer the commission, for which the latter received 500 reichsmarks. The surviving correspondence suggests that the publisher's cooperation with Bayer was complicated by his imperfect command of English and lack of experience with Anglo-American printing standards, which led to multiple misunderstandings.[3] When the printer Walter Lewis of Cambridge University Press consulted Stanley Morison, one of the leading figures in the British "reform of printing" movement, about de la Mare's decision, Morison's response was devastating:

> This business of going to a German for typographical intelligence is most unreasonable. ... This Mr. Bayer, not content with being ignorant of the function of italics, deepens his ignorance by willfully shutting his eyes to the utility of capitals. Of course he did not invent. Like most of the modern tricks which the German Jews have elaborated into an intellectual theory tied on to contemporary architectural customs, it was invented in Paris. (By German Jews I really mean Jews in Germany.)[4]

Apart from its anti Semitism and that fact that Morison, for whatever reason, assumed the "maniac, intellectual" Bayer was Jewish, his letter aptly illustrates the strong antipathy to the New Typography coming from the still largely traditional British print and design community. Bayer's final layout for *Art and Industry* was deemed "very weird" by the printers who worked for the publisher, though Read himself seemed satisfied with the result.[5] Interestingly, though it was an internationally significant book, Bayer never included this cover design in subsequent overviews of his own work.[6] His outstanding 1937 cover design for Carola Giedion-Welcker's well-regarded volume *Moderne Plastik* shared the same fate (see Fig. 9.5).

In the summer of 1935, Bayer announced to Breuer in London that, "if I were to put on a small exhibition, I would come over in the autumn."[7] These improvised plans fell through, though Bayer did make a short New Year's visit to attend the celebration held at the Nortons that also marked the Schawinsky wedding (see pp. 136–7). Bayer used the visit to cultivate his personal network.[8] Lady Norton ultimately succeeded in hosting Bayer's long-sought-after solo exhibition in April 1937 at the London Gallery on Cork Street, where it was preceded the previous winter by a show of László Moholy-Nagy's work and followed by Oskar Schlemmer's paintings in June 1937.

When Bayer arrived in London in March 1937 to install the show, he brought practically all his major artworks.[9] A small catalogue with a text by Alexander Dorner (to whom Bayer had already sent a personal copy of his *Dorland no. 1* magazine in 1933) and eleven plates was produced for the opening on April 7, designed by Bayer himself and set in Berthold's Bayer-Type (see Fig. 11.1). The title on the cover—*herbert bayer (Austrian)*—may have raised eyebrows for the parenthetical addition in tiny type, but Bayer had insisted on emphasizing his Austrian nationality in order to distance himself from Nazi Germany. (International discourse tended at the time to overlook the fact that Hitler himself had been born in Austria.) A glamorous portrait by the Berlin photography studio Atelier Binder served as the frontispiece (see Fig. 11.2).

Dorner's short essay, running both in German and English, styled Bayer as a "quiet, confident, reliable, sunburnt 'lad of nature' and lover of sports" living a "double life of the man bound to nature and yet mentally and spiritually a hypersensitive modern town-dweller."[10] Interestingly, the original German text from which the English version was translated—both printed parallel in the catalogue—also described him as an "animalistically beautiful person … with the simplest of basic feelings"—phrasing that the English version did not include.[11] In his essay,

Figure 11.1 Herbert Bayer, Catalogue for his one-man show at the London Gallery, cover, 1937. Letterpress; Private collection. © Estate of Herbert Bayer/Artists Rights Society (ARS), New York/VG Bild Kunst, Bonn.

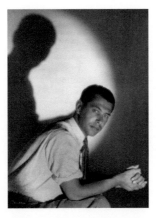

Figure 11.2 Atelier Binder, Herbert Bayer, Studio portrait, c. 1935. Photograph; Denver Public Library, Herbert Bayer Collection.

Dorner significantly claimed that Bayer was a designer of expanded dimensions, and that his commercial design work seemed to bring "art" into "life."[12] Had Dorner had deeper insight into Bayer's well-concealed inner struggles or known of his unbridled sexuality he may not have stressed so unequivocally the artist's talent for harmonizing these opposites as "the fitting complement to his art" and his ability to avoid "the usual, wild restlessness."

The catalogue—which doubled as a sales list—included sixty-two items. Of these, six watercolors were from 1928, representing the earliest works. Apart from these, later oil paintings and drawings dominated the show; there were almost no works from his Bauhaus period on display. Eight photomontages from 1932 were presented as a group. There were also ten original illustrations from a project Bayer valued highly: the booklet he designed to accompany the 1935 Nazi "health" exhibition *Das Wunder des Lebens* (see Chapter 7).[13] Most tellingly, perhaps, the last catalogue entry, no. 63, was simply labeled "Publicity Work" and accompanied by a single plate: a reproduction of the cover of his February 1928 issue of *Bauhaus*, wrongly labelled as "Coverdesign 1937" for unknown reasons. From the catalogue's limited descriptions, it is impossible to gauge the extent to which Bayer's advertising work was present at the London Gallery, but the list of works hints at Bayer's old personal dilemma. On the one hand, he would not have wanted to suppress his expertise as a commercial artist entirely as lucrative commissions were crucial, and he was actively seeking out opportunities abroad. On the other hand, he was clearly reluctant to include extensive examples from his "advertising purgatory"[14]. As an artist, he considered these activities merely a means of securing his livelihood; only in exceptional cases did he attribute a higher value to such work—strikingly, his work for *Das Wunder des Lebens* was one such exception.

Bayer's London exhibition was, after all, his major foreign solo show of his work, in a period of transition when his reputation needed any public attention he could get, and it was also his one-time opportunity to bring major pieces of artwork outside the country that were threatened to be confiscated as "degenerate." When justifying this exhibition to Nazi authorities, Bayer cunningly claimed that the possible art sales could strengthen the German export economy, predicting "if my works are exhibited

in London, I will be able to receive orders and thus provide the German foreign trade with corresponding foreign exchange income."[15] He needed to maintain collegial terms with the Reich Chamber of Fine Arts because—after his fall 1936 trip to London, for which he failed to secure advanced permission and only notified them by mail the day prior to his departure—he had been issued a threat of punishment should he fail to comply a second time with their rules.[16] This scolding, dated November 28, 1936, also included the incorrect claim that his work had already been exhibited in London without permission. Whether Bayer subsequently corrected the error is unclear from his likely incomplete Reich Chamber files; nor do the files contain any official documents about the real exhibition and his second journey to London.

A small, anonymously authored notice headlined "Hitler and Art" in the London newspaper *The Star* on April 10, 1937 prompted an indignant private letter to the publisher from the gallery's "director," leaving open whether the author was Lady or Sir Norton. Read together, article and letter form a noteworthy document of Bayer's precarious position at a politically sensitive juncture. *The Star*'s article, which began with the words "now comes to us Herbert Bayer, Austrian surrealist, one of ablest scholars of [the] famous Bauhaus," went on to place Bayer squarely in the anti-Nazi camp:

> Gropius and his men are themselves rejected as "cultural Bolsheviks." Germany's loss is others' gain … Bayer is here, now holding show at London Art Galleries. Here, too, are other eminent Bauhaus men: Marcell [*sic*] Breuer and Moholy-Nagy—busy with posters, shop window designs … All, with others rejected of Hitler, adding to London's artistic life and some helping British manufacturers and traders make their wares more attractive in competition with those from Teuton tents.[17]

While Bayer may have been irked to be called an "Austrian surrealist," the term "cultural Bolshevik" carried a far more existential risk. For, contrary to the article's assumption that Bayer was a permanent member of the German exile community in London, his return home to Berlin was, in fact, imminent, and the label could have brought real risks of reprisal had it attracted the Gestapo's attention. This certainly explains why the article's assertion that Bayer had been "rejected by Hitler" drew such a vigorous objection: "Mr. Bayer is living and working in Berlin and in no sense of the word has been 'rejected by Hitler.' One of his finest commercial booklets was done for the official exhibition 'Wunder des Lebens' and he himself has no interest in politics."[18] In citing the propaganda exhibition explicitly as proof of Bayer's *proximity* to German authorities, the letter is a rather extraordinary document, but one that must be understood in context. Certainly, it noticeably contradicts Bayer's postwar pains to distance himself from the Nazi regime. For example, he consistently described the *Wunder des Lebens* exhibition project in particular as an initiative on the part of Berlin's office for trade fairs, the Messeamt.[19] However, the Nortons' assertion of Bayer's loyalty to Germany was made with Bayer's obligatory return to Berlin in mind: "I cannot think that these paragraphs are going to make his life at all easy in that capital," stated the unpublished letter to the editor.[20] Bayer appears to have avoided reprisals upon his

immediate return, which suggests that the small news item escaped Gestapo notice; he did not, however, remain under the radar for long.

All in all, Bayer was pleased with the London show: "According to the English—if you can trust those hypocritical Swiss without mountains—it is a big success."[21] Though most of the details about the opening itself are now lost (see Plate 29), it is probable that most of London's small Bauhaus exile community attended, with the exception of Walter and Ise Gropius, who had already left for the United States. Whether Jorge Fulda was also present is not known, but he may well have been, as the two men seem to have maintained contact. Welcoming remarks were delivered by none other than Herbert Read, whose surviving text refers explicitly to the importance of Bayer's commercial art in securing his reputation and emphasizes the close relationship in his work between the fine arts and the applied arts.[22] Moreover, the cocktail party on the second evening must have been something of a sensation: "They say the gallery had never seen so many people before," noted Bayer proudly in a letter to the Gropiuses.[23] The two surviving snapshots from the installation show his paintings hanging rather closely together—an unspectacular presentation that reflected the limited opportunities offered by the small exhibition rooms (see Figs. 11.3 and 11.4).

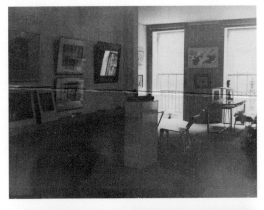

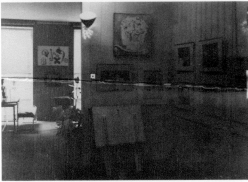

Figures 11.3 and 11.4 Photographer unknown, Views of Bayer's one-man show at the London Gallery, 1937. Photographs; Denver Public Library, Herbert Bayer Collection.

Sales, which Bayer had hoped would launch his new living as a fine artist, were, in fact, equally unspectacular. Ise Gropius, speculating to Breuer about Bayer's possible trip to the United States, noted "he won't be able to afford the trip from the sale of two pictures, and Peter [Lady Norton], who is probably in financial straights herself, won't be able to borrow money to finance a journey to America."[24] When the exhibition closed, however, Bayer left a substantial portion of his work on consignment with Lady Norton, hoping (in vain) that she could support his emigration financially or with opportunities for work.[25] In fact, it would not be long until Lady Norton—when her husband received his new diplomatic posting abroad—sold her portion of the gallery to her friend Roland Penrose, who made it a Mecca for British Surrealists.[26] The Nortons left for Warsaw in January of that year.[27]

Bayer thus returned to Germany in the spring of 1937 unsatisfied and largely disillusioned, as England no longer seemed a destination that would be able to offer him a future.[28] "I've been back for a few days now, trying to adjust again," he wrote to the Gropiuses. "Prospects are dull; even the girls have almost all gone abroad," he wrote, while hinting that he had used the crossing for yet another erotic escapade: "On the ship I handled seven at one blow: the Singing Babies—in all the tones of the scale."[29] At home, he must surely have feared reprisals for going abroad again, after arousing the ire of the authorities for his first unauthorized trip to London, and given the publication of an article that had run in the *Star* that April, which had fortunately gone undetected. Although there is no remaining record in the file that Bayer submitted the documents proving his Aryan ancestry which the Reich Chamber of Culture had insisted upon harshly in July 1937, his first exploratory trip to the United States in the same summer would have been virtually impossible if he had not complied. However he finally finessed his travel permit for the United States, Bayer's efforts paid off. His trip won him two concrete job offers: an organizational role in the upcoming Bauhaus retrospective for the Museum of Modern Art, New York, and a teaching position at Moholy's New Bauhaus in Chicago.

Dress Rehearsal: Summer Excursion to the United States

The United States, that consumer's paradise with its cutting-edge advertising industry, ultimately became a veritable land of opportunity for Herbert Bayer.[1] It offered rich and remunerative fields to commercial graphic designers. More generally, the country continued to have strong appeal for Europeans seeking intellectual, political, religious, and artistic freedom.[2] Various Bauhäusler moreover had long taken note of the fundamental compatibility between functionalism and what was broadly termed the "American way of life," open as it was to progress, effective ways of living and new design.[3] The Bauhaus spirit, for its part, had already found a sympathetic reception in the United States. This began with a handful of transatlantic students that attended the school and continued in 1931 with the first small US Bauhaus exhibition, shown in Cambridge, Massachusetts; New York; and Chicago. The show included typographic works by Bayer.[4] Josef and Anni Albers, the first to arrive in 1933, were soon followed, one by one, by Walter Gropius's inner circle.[5]

Bayer had contemplated moving to the United States even before he joined the teaching staff at the Dessau Bauhaus in 1925; before they married, his American fiancée Irene Hecht had suggested they join her family near Chicago in 1924.[6] By the mid-1930s, he was no stranger to the US graphic-design scene, with his 1928 *Bauhaus* cover garnering first prize in New York's 1931 *Foreign Advertising Photography* exhibition, and his *Gebrauchsgraphik (International Advertising Art)* portfolio of the same year broadly publicizing Bayer's style to the trade. Additionally, Herbert Read's acclaimed *Art and Industry* book, graced by Bayer's jacket design, was widely read in the American art world.

It is thus perhaps no surprise that as early as 1935 Bayer expressed a desire to explore the United States, cajoling Breuer, "Let's go to America now—in the fall—[to] look around a bit; it doesn't cost much now."[7] Next he prepared a voyage for the summer of 1936, making detailed inquiries into setting sail from Southampton on a German ship. He abandoned the plan after that winter's London escapade, fearing the professional disadvantages of being absent from Berlin again. As he told Breuer, "I'm sorry that I can't come with you, but I have to stay in business for a while, having been away for so long."[8] When winter came (see Fig. 12.1), he again nurtured hopes: "My America thoughts won't give me a rest; maybe it's possible in April."[9] The spring of 1937 came and went, and impatience took over: "This year I absolutely must go to America. … This year I definitely have to go. I'm really starting to burn."[10] By then he and his chum

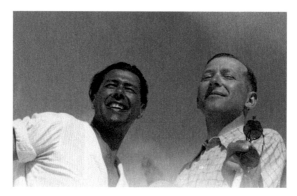

Figure 12.1 Photographer unknown, Herbert Bayer and Marcel Breuer, 1936. Photograph: Denver Public Library, Herbert Bayer Collection.

Willy B. Klar had started taking private English lessons together.[11] Bayer's frustrations with Germany came to a head in the summer of 1937, just as the *Degenerate Art* show opened in Munich. "Am officially called a degenerate painter," he noted in his journal, "but I can do my work unhindered. Always very busy, exhibition work now and then, otherwise booklets, posters, ads, etc. But in the end, everything gets uninteresting and unproblematic. The low standards dictated by Hitler also put pressure on my work."[12]

After Bayer's solo show at the London Gallery closed that April of 1937, he began preparing his trip to the United States in earnest, seeking work in the tried-and-tested manner: through his contacts. For example, he asked Ise and Walter Gropius to help arrange commissions for him.[13] In the spring of 1937, the couple invited Breuer, Bayer, Schawinsky, Alexander Dorner, and Moholy-Nagy to a summer retreat on Planting Island near Cape Cod, Massachusetts, to weigh future possibilities for the group. Breuer and Bayer would both need to cross the Atlantic, as would Moholy. Schawinsky had already joined the Alberses in Black Mountain, North Carolina.

Bayer was eager to make the crossing with Breuer, not least so they could discuss their ideas for a pavilion about the *Man of the Future* (*Mensch der Zukunft*) at the 1939 New York World's Fair. With its opening slogan of "Dawn of a New Day" it had attracted Gropius's attention and his idea to create an exhibit occupied them intensively.[14] Both had already sent Gropius a detailed pitch in April 1937, which they had even had translated into English. Bayer wrote to Breuer with enthusiasm, "We must get the exhibition off the ground. I think we should be *over there together* for our exhibition."[15] The ambitious concept was intended to take stock of what they called the "new art and design concept of the present" and to encompass all areas of modern living—architecture, housing, painting, sculpture, and music, as well as the stage, film, literature, technology, science, philosophy, and education. Bayer's and Breuer's plans to contribute to this mammoth show were eventually shelved.[16] In its place, Gropius and Breuer designed the more modest Pennsylvania Pavilion, according to clear guidelines from the client and with an emphasis on the state's history.[17]

Although both friends tried to be discreet in public about their pending travel plans, they did not remain hidden for long. Bayer warned Breuer in the spring of 1937, "I

suspected that Moho wanted to go ahead of us silently. It's just not right for Pius to make any announcements about our plan. But I think it would in any case be better if the preliminary work were done by the two of us alone without involving too many people."[18] The buzz was a problem, not only for Bayer in Germany but also for Breuer in his English exile, where he was still designing furniture and interiors for the Isokon Corporation. "Rumors are already circulating in London that I'm going to America," he complained, probably with regard to his business prospects, "which makes it a dangerous situation, little by little, for me to stay here."[19] For example, Ise Gropius's younger sister, Ellen Frank (see Fig. 5.1), a well-known German film actress (and former lover of Moholy), inquired about renting Breuer's apartment for six to eight weeks inexpensively during his absence because she had a short engagement in London.[20]

Breuer had long been considering something more than just a vacation in the United States. "If I visit you extensively," he told Ise Gropius, "I think I should actually go all the way out for the summer, and stay right there, show my colors, so to speak." He added: "The *disadvantage* would be that my coming is not sufficiently prepared; you get better contracts sooner and better when you are far away. The *advantage* would be: that I save time, that I feel like I have finally made a decision."[21] Bayer's recommendation to Breuer was in keeping with his own cautious stance: "If I were you, I would first visit a foreign country to get to know the conditions there."[22] In May of 1937, Gropius offered Breuer a job in his studio.[23] Despite this, Bayer continued to urge care, "because even Pius does not know the mentality of the Americans very well. And just as it did not lead to any good success in London, success in the US can take a little longer. In London you have your office."[24]

Breuer, in fact, accepted the Gropiuses' offer with alacrity, euphorically describing to Ise Gropius how the prospect of "American life" had rekindled his "long suppressed, secretive, English deformed, starved breakthrough energies."[25] He already had his sights on Cambridge, where—in addition to the plum job of partner in Gropius's architectural studio—Breuer would also be offered a position as associate professor at Harvard's Graduate School of Design in 1937, again through Gropius's mediation.[26]

Contrary to previous assertions, Bayer and Breuer did not travel on the same ship in 1937.[27] Passenger lists in the archives of US immigration authorities show that Breuer reached New York on August 1, 1937 on the *De Grasse* from Southampton. He had received a short telegram from Lady Norton before his departure that July: "good luck love peter."[28] He named his "friend" Sir Clifford Norton as his contact in the departure country. On the same form, he listed "Professor Walter Gropius" as the "relative" inviting him.[29] Dorner, who, like Breuer, was in Paris for CIAM, set out directly from France for the United States with his wife Lydia on board the *Normandy* on August 2, 1937.[30] He, too, had been officially invited by Gropius, according to the immigration records. Although he would later claim that he had been persecuted by the Third Reich, rumors circulated that the "scoundrel" Dorner, who had long tried to align avant-garde art with National Socialism, had to leave Germany because of some rogueries in Europe regarding the misappropriation of public funds.[31]

According to correspondence, Bayer changed his plans several times, initially hoping to attend CIAM V (the fifth International Congresses of Modern Architecture) that July in Paris and proceeding via Southampton to New York.[32] One of his revised plans involved stopping in Zurich to pick up Lady Norton on his way to Paris.[33] For

unknown reasons, Bayer did not, in the end, attend the congress.[34] But Breuer did, and he used his time in Paris to meet, among others, with art dealer and curator Charlotte Weidler, a key figure in facilitating communications among the international avant-garde in exile.[35] He had got her address from Bayer.[36]

In the meantime, Bayer was at least able to look into possible ship passages from Hamburg (August 7, 12 or 19); as he made his plans, he knew that, by mid-September, he would need to be back in Germany to fulfill his work obligations. Bayer set off from Cherbourg on the *Columbus* on August 15, departing only after Breuer urged that he leave as soon as possible so that he would not miss the opportunity to meet his old friends.[37] Although Bayer later recalled making the transatlantic trip with Dorner and using the journey to discuss the concept of a Museum for the Future (*Museum für die Zukunft*), he must have had another journey in mind.[38] Perhaps he was recalling ideas he developed together with Breuer for the New York World's Fair.

Also, in this case, financial problems stood between Bayer and his ability to leave Germany; he had apparently been unable to obtain foreign currency in Germany that would have paid for his passage on Breuer's ship. At the same time, Bayer had assumed that Breuer would use the funds he still had in Germany to pay for Bayer's passage, but this was not possible.[39] As they made their plans in the spring of 1937, Breuer had to abruptly inform his friend of this bad news; "Since I will not be able to get the blocked money free for a trip to the US under any circumstances, we will probably have to travel separately, which is a shame."[40] Yet, from a contemporaneous letter to Ise Gropius, it seems that Breuer still intended to help Bayer out financially, and he emphasized how important it would be for the two friends to have job opportunities in the New World:

> If Herbert has no money, I will help him out. I'm just afraid that we won't be sailing together, as he will surely come on a German ship, while I'll probably use an English one; some people go round trip for twenty British pounds. Of course, it would be nicer with a contract in your pocket, with paid travel, possibly First Class, to appear as a worthy braggart and future American.[41]

In fact, according to documents from the US immigration authorities, Walter Gropius issued the required official invitation to Bayer.[42] Like Breuer, Gropius also prepared to support his largely impecunious friend.[43]

Once Bayer and Breuer arrived the Gropiuses convened their core circle, including Schawinsky and Moholy, for the anticipated retreat in the town of Marion on the peninsula of Planting Island, just south of the Cape Cod Canal.[44] In the beginning, Bayer reported in letters to friends that he came to the United States "against his will," as he would have preferred a retreat somewhere in the mountains in silence, so that he could listen to the signals of his body tortured by his troublesome life in Berlin.[45] Joining what Peter Hahn has termed the "Bauhaus family"[46] for this gathering, which lasted several days, were Alexander Dorner, MoMA curator John McAndrew, and the interior designer Mary Cook, the future wife of architect Edward Larrabee Barnes who may have drawn Bayer's roving eye—quite possibly what his mentor/rival Gropius had intended when inviting her.[47] Photographs probably taken by Ise Gropius show the group in high spirits on the beach at Planting Island (see Fig. 12.2).[48] Two chief topics

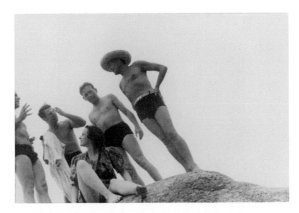

Figure 12.2 Photographer unknown, Summer vacation on Planting Island—Xanti Schawinsky, Herbert Bayer, Marcel Breuer, and Walter Gropius (from left), Mary Cook (front), 1937. Photograph: Denver Public Library, Herbert Bayer Collection.

were under discussion at the meeting: the statutes of the New Bauhaus, recently founded in Chicago, and the options for showing a comprehensive Bauhaus retrospective at MoMA in 1938. The correspondence between Walter Gropius and MoMA's director Alfred Barr indicates that Barr was receptive to the idea of a large-scale Bauhaus show and authorized McAndrew to serve as the museum's delegate at the retreat.[49]

Barr was, of course, already well disposed toward the Bauhaus, having made an exploratory trip to Dessau in 1927—during which time it was Bayer who had given him a tour of the workshop for typography and advertising.[50] The Bauhaus had then, in fact, served as a model for his museum plans. After Gropius and Moholy arrived in the United States, Barr therefore earmarked half of his 1938 annual exhibition budget for a first large Bauhaus retrospective.[51] The show would highlight the contrast between the Modern Movement, for which the Bauhaus stood, and the Beaux-Arts principles that had dominated European art until then.[52]

The group's enthusiasm for the project resulted in the suggestion that John McAndrew serve as exhibition curator, while essentially delegating conception and realization to Bayer—and, notably, not to Moholy, who was setting up the New Bauhaus at the time. Bayer was commissioned to collect objects for the retrospective upon his return to Germany, particularly from the Bauhäusler living in Europe. He would also be in charge of the exhibition and the accompanying catalogue. Gropius reported directly to Barr on the group meeting, including the proposal to employ Bayer full-time to prepare the exhibition.[53] Gropius also announced a visit to MoMA, planned by Moholy for September 4, when Moholy met first with Bayer and Breuer, then with McAndrew.[54] The MoMA guestbook registers Bayer and Breuer for September 15, 1937.[55] This visit must have been successful, because Barr provided Bayer with the appropriate letter of reference at the end of September, officially requesting his support as organizer; a second, more detailed letter from John McAndrew followed.[56] Bayer needed these documents for his dossier, to prove to US immigration authorities that he could make a professional life for himself in America. As Bayer's handwritten estimate of costs suggests, he would

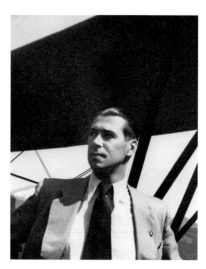

Figure 12.3 Photographer unknown, Herbert Bayer in Northport, Long Island, September 1937. Photograph; Denver Public Library, Herbert Bayer Collection.

ultimately receive a fee of $1,000—a quarter of the total budget.[57] Breuer was not formally involved in planning the exhibition.

The trip to the United States also opened up further prospects for Bayer (see Fig. 12.3). Moholy offered him a teaching position in advertising design at the New Bauhaus in Chicago. The offer seemed vague at first, however, he noted in a letter to Breuer, "moho wrote to me again, but it is not clear whether it was only pro forma for my documents or serious for next fall."[58] Moholy was, in fact, followed to the New Bauhaus in 1937 by his student from his time in Berlin at the end of the 1920s, György Kepes, who had already accompanied him to London.[59] Beyond the MoMA show, Bayer sought other jobs in New York that promised a short-term income. However, his visit to Condé-Nast, publishers of *Vogue*—in whose German offices he had launched his freelance career in 1928—bore no real fruit: "The negotiations with *Vogue* did not lead to any satisfactory results. It will remain a loose collaboration, if I come here. Nothing else tangible has developed."[60] Bayer had a letter for the director of the Carnegie Institute in Pittsburgh, Homer Saint-Gaudens, from Charlotte Weidler, who represented the same institute in Germany.[61] Bayer was unable to keep the appointment, however, due to his departure for Europe and suggested Breuer in his stead.[62]

At the conclusion of this first trip to the United States, Bayer expressed a high degree of ambivalence. A letter from Schawinsky suggests how personally the circle felt Bayer's struggle, "I am deeply saddened that, despite the weeks in New York, no major perspectives have opened up for Herbert."[63] The finances for any future move there were frustratingly up in the air, which is why the letter to Walter Gropius that Bayer sent on the very day he left New York sounded anything but euphoric:

> I'm leaving tonight. Unfortunately, with a very uncertain view of the future ... I'll try to take out a loan so that I can stay here for at least four to six months to start. If I succeed, I'll be here at the beginning of February to do the Bauhaus exhibition.

If I don't succeed, I'll wait in Berlin for my actual appointment to Chicago. Because I will not risk starting here without any money.[64]

This reflects Bayer's typical mindset; he wished to emigrate and considered taking out a loan to get a start, but was adamant that he could not arrive in New York destitute and without any long-term work prospects; he certainly did not want to leave his wife—who was still his financial dependent and a co-parent, even though they had separated—and child behind under Nazi rule. With hindsight, it is clear that he was not aware just how dangerous the political situation in Germany actually was, at the dawn of world war and with increasing reprisals against the regime's numerous enemies.

And yet, with this trip, for the first time Bayer had been offered at least a stepping-stone for his planned departure from Germany; this was not a permanent prospect but, with the salary of $1,000, would provide seed money. In the event that his plans to return to the United States fell through, Bayer had already agreed with Gropius that he would hand over the organization of the MoMA show to Schawinsky. "I asked Xandi to be ready if I was cancelled," he wrote Ise Gropius shortly before Christmas 1937.[65] His traditional greeting card for the year 1938 radiates anything but the spirit of new beginnings; it shows a rather baroque arrangement of an idyllic scene (see Fig. 12.4).[66] It is almost cynical considering that he sent it in the midst of a German political situation that Bayer, too, lamented. By this time, with his allegory of Mussolini for the January 1938 cover of *die neue linie* completed (see Plate 27), he had already produced perhaps the most dubious work of his interwar career: a masterpiece of graphic design but ultimately, and above all, a piece of fascist propaganda.

Figure 12.4 Herbert Bayer, Greeting card for the year 1938, recto and verso. Letterpress; Denver Art Museum, Herbert Bayer Collection and Archive. © Estate of HerbertBayer/Artists Rights Society (ARS), new York/VG Bild Kunst, Bonn.

A Well-Considered Departure

Upon returning from his summer visit to the United States, Bayer's relationship with his future ex-wife and child seems to have stabilized considerably (see Fig. 13.1). The letters Bayer-Hecht sent her husband after his departure in the fall of 1938 are, despite some apparent health problems, written in the voice of a self-confident, strengthened woman far removed from the insecure "loving idiot" she had been in the early 1930s. "It's only now that I realize how capable I am," she wrote of facing the many challenges she had overcome. "And since you're not here to weaken my self-confidence with your contempt, I'm quite up to speed despite my flu and constant fever, and hopefully I won't ever let anyone get me down again. Nobody."[1] She also reflected upon the threesome's relationship with seemingly a greater sense of peace,

> In the last six months, I have seen once again how unimportant your other experiences are for you, and how central Muci and—I think I can safely say—I are in your life. … Believe me, my darling, even if it may often seem a terrible burden to you to be a man and a father and to have such a ball and chain, this lead weight is very useful; it helps you to keep your balance in the oh-so-wild waves of life.[2]

In the spring before his departure, the family apparently spent some relatively harmonious days together on the Baltic Sea.[3] The plan was for Bayer-Hecht and their daughter to follow Bayer to the United States. In one letter, she noted, "I believe that you can make it anywhere on your own. But that's not what matters now; it's that we all have to stick together."[4]

In fact most of Bayer's closest associates were now overseas, and in the year leading up to Bayer's departure, Walter Gropius was making sincere efforts to encourage him as well. He lobbied Moholy-Nagy to speed up Bayer's prospects for employment at the New Bauhaus; he also wrote to Bayer to assure him that his work on the MoMA exhibition would make him better known in the United States and certainly lead to follow-up commissions.[5] Marcel Breuer, after a brief return to London over the holidays, came back to the United States on January 2, 1938; this time, his Harvard affiliation assured him entry.[6] Bayer's dear friend had definitively chosen to live in the United States. "From Pius I heard that your setup is now perfect over there, for which I congratulate you … On the other hand, my situation is still pending, which is a real headache." Bayer also updated Breuer on the uncertainty of the show at MoMA, "The exhibition is also a questionable affair, and I still don't know today how the deadline can be met."[7]

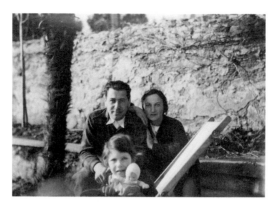

Figure 13.1 Photographer unknown, Herbert Bayer, Irene Bayer-Hecht, and their daughter Julia, 1937. Photograph; Denver Public Library, Herbert Bayer Collection.

When planning his departure, Bayer apparently anticipated receiving some support from the Nortons.[8] But by the end of 1937, he realized that no money would be forthcoming; "Actually, Peter [Lady Norton] abandoned me as well," he lamented to Breuer.[9] All in all, his relationship with his patroness seemed to have cooled considerably in the months since the solo show that spring at the London Gallery: "Peter has behaved rather dubiously up to now," he complained earlier in the fall to Breuer, "So things are up in the air. In the meantime, I've started to reach out [to others] for an affidavit."[10] In the summer of 1938, he finally received this urgently required immigration document from his American father-in-law, Adolf A. Hecht.[11] Hecht presumably wanted to expedite his daughter's departure from Germany, as he would have known that her Jewish heritage increasingly put her and his granddaughter at risk of real danger in Nazi Germany.

Even as Bayer spent the fall of 1937 and the spring of 1938 attempting to secure permission and passage, he returned to his daily routine, in which he still hardly found time for his own art.[12] His focus was almost entirely on advertising designs for Dorland (see Fig. 13.2), which did little to satisfy the demands he set for himself. As he wrote to Ise Gropius at the end of 1937, his time was filled with what he described as,

> always work that, despite all my indifference in completing it, is *not* without its problems. One earns money sometimes, puts something aside to have something to live on afterward. What I do could be worse, but it's too little to count as good. But I don't want to say that too loudly, because at the moment there are prospects of some nice things.[13]

That spring he designed what would be the last of his twenty-six covers for *die neue linie*, a sophisticated montage of a placid Alpine landscape with a photograph taken in 1936 of the soles of his hob-nailed hiking boots (see Fig. 13.3a/b).[14] Removing all elements of the photograph but the hobnails themselves, he superimposed these at

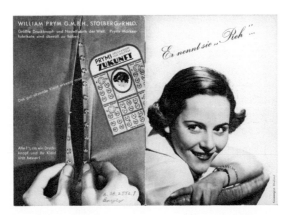

Figure 13.2 Herbert Bayer, Advertising brochure for Prym snap fastener company, 1936. Verso and recto, rotogravure; Private collection. © Estate of Herbert Bayer/Artists Rights Society (ARS), New York/VG Bild Kunst, Bonn.

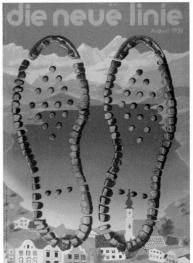

Figure 13.3a/b Herbert Bayer, Soles of hob-nailed hiking boots, 1936. Photograph and montage for *die neue linie* cover, August 1938; Denver Public Library, Herbert Bayer Collection. © Estate of Herbert Bayer/Artists Rights Society (ARS), New York/VG Bild Kunst, Bonn.

nearly full-scale over the color image, to a disturbing effect. During the same period, he also produced four dust jackets for books of the renowned Berlin publisher Ernst Rowohlt.[15] Among these largely innocent travelogues was the German edition of Vincenzo Rossetti's *Städte wachsen aus dem Sumpf* (*Towns Rise from the Marshes*), with a foreword by Benito Mussolini. Rossetti's *Dalle paludi a Littoria* (subtitled "A doctor's memoirs 1926–1936") details travels throughout the Pontine marshes southeast

of Rome during the government's long-term anti-malaria campaigns. The Italian Propaganda Ministry—eager to attach Mussolini's name to the government's success reclaiming land, fighting malaria, and alleviating rural poverty—was keen to see the book published in Germany.[16]

Bayer's broader view of the social circumstances remained remarkably apolitical and self-involved—even in the winter of 1937/1938, when the everyday repressions of the Jewish community and war preparations reigned outright in Hitler's Germany. Bayer seems almost cynical in his resolute focus on himself and his own comparatively small woes. This is also underlined by the presence of a particularly dubious passage in his Christmas letter to Ise Gropius; he closes with a sarcastic quip about Nazi racial fanaticism: "Love = 0.00. Racial purity produces a consistent standard."[17] With this wordplay, Bayer is expressing his dismay at the fact that the regime's anti-Jewish policies had driven many potentially interesting women from his hunting grounds, leaving behind a disappointingly dull selection of "racially pure" women, a shockingly selfish take on the situation. Thus it seems that his private life in prosperous interwar Berlin was still marked by his various erotic conquests (and he had no compunction about discussing them with his former lover), but times had grown dull.

Above all, Bayer was determined not to let the chance to emigrate to the United States escape him. Immediately after his return, he began working earnestly on his MoMA brief[18]: hunting down objects and artworks for the Bauhaus retrospective in New York.[19] He attended to the German Bauhaus members himself, and activated people from his international network to contact those artists who had already left Germany. In Holland, he asked for help from Hajo Rose and Paul Citroën[20]; in Hungary, Farkas Molnár; in Switzerland, Max Bill.[21] The task initially proved more difficult than expected: "the Bauhaus thing doesn't look very encouraging yet," he told Breuer in October 1937.[22] This was clearly the result of something that Bayer had already noted two years earlier, when Walter Gropius sent out his questionnaires—that there would be reluctance on the part of his former colleagues to call attention in Germany to their now unfavorable Bauhaus affiliations (see p. 138).[23]

Bayer's difficulties with the Nazi authorities around the time of his London show in the spring of 1937 were not an isolated affair, but related to a larger campaign; by the late 1930s, Nazi reprisals against modern artists were reaching new heights. Thus it was no surprise that many of the Bauhäusler he sought out reacted with hesitation to the idea of showing their work in a Bauhaus exhibition in the United States, fearing persecution particularly for supporting those Bauhaus members who had already left Germany. As Bayer wrote to Breuer, "The main point with some who don't want to give material is that they don't want to associate with the New Bauhaus. (Perhaps it's just a pretext.) But Moholy's reputation is apparently worse [here] than we all thought."[24] Later, in an undated entry in his diary, probably written from the safety of the United States, Bayer noted: "I still feel a stale aftertaste from my negotiations with former Bauhaus members in the months before my departure. Many of them preferred to deny that they had ever been associated with the Bauhaus. Their lack of principles is really upsetting."[25]

It was at this juncture that Josef Albers now explicitly revealed himself as an opponent of Moholy to Gropius.[26] He even described himself as "chief Moholy hater."[27] This also explains the letter to the editor that Albers submitted anonymously to the

magazine *PM* for printing in the August–September 1938 issue, in which he countered the misconception of an earlier article that he had merely continued Moholy's work at the Bauhaus after the latter left the institution in 1928.[28] The letter stressed that he had offered original courses.[29] With regard to the MoMA project, Schawinsky reported to Gropius that Albers feared that "the exhibition would be completely encrusted by Moholy."[30] Even if no mention of this was made in Bayer's own correspondence, he was doubtless aware of the long-simmering enmity; nevertheless, he still included works of both Moholy and the Alberses in his selection for the MoMA exhibition.

Whatever the extent of the rivalry between Moholy and Albers, Bayer sensed an even more potent competitor to the Gropius group in the person of Ludwig Mies van der Rohe. Not only did Mies boycott the group's plans for the MoMA show, but he was also pursuing the idea of a separate show entirely.[31] Mies held a proprietary stance toward the Bauhaus name, and indeed, his own director's contract of August 5, 1930 had included a clause stating that the "right to use the name Bauhaus" would pass to the school's last director in the event of its dissolution. Mies, however, never pursued this matter in court.[32]

Although Gropius had hoped to include Mies in the MoMA show, the latter quickly rejected any mention being made of his time at the Bauhaus helm. His excuse in 1937 was that he was still living in Germany and would face disadvantages from the association. Even after his emigration in 1938, he still refused to participate, ostensibly in order to protect the students he left behind.[33] Presumably, however, the ongoing rivalry between the two architects was a factor; they had after all competed for the same plum position at Harvard, and Gropius had ultimately secured it.[34] Sibyl Moholy-Nagy, Moholy's second wife, later banned Mies from what she called the "Diaspora of Honorable Emigrants" for what she considered his opportunism in ingratiating himself with the Nazis.[35]

Mies' ambivalence toward Nazi rule is beyond the scope of this book and has been examined elsewhere, as has his extensive participation in Nazi propaganda exhibitions. It is significant to note in this context that his approach was that "modern form could be transferred to any content," as Winfried Nerdinger has put it, "because ultimately he was interested only in a canon of forms. Bluntly put, … he accepted any political compromise but no compromise in terms of the form."[36] For his part, Bayer did not seem to find Mies's attitude that facilitated collaboration particularly objectionable, at least not in 1935 when he expressed some satisfaction that Mies had been assigned a prominent role in the next year's big propaganda exhibition, *Deutschland*.[37]

Bayer had never been close to Mies.[38] Despite this fact, while preparing the Bauhaus retrospective, Bayer nonetheless tried hard to secure Mies's cooperation. After calling on interior designer Lilly Reich, Mies's partner, Bayer reported, referring to Reich by a nickname, "I visited 'Miesmuschel'; they have no archive," he told Gropius. (With this one pun on the word "blue mussel," Bayer could get in several digs at once: that Reich was a "sourpuss," that she served as Mies's "ear," *and* that she was also making her genitalia available to him.) The letter continued:

She had originally agreed to compile a review of the entire Mies period, which
I was to take over as a whole (which would have been fine with me). Later she

cancelled everything because of a letter from him saying that he didn't want to be involved in the exhibition until he was deregistered here. Since he won the tubular steel chair trial, and since he has secured quite a bit of income from it, it seems quite possible that he won't come over at all.[39]

In fact, the issue was beyond Bayer's control. In spring 1938, Walter Peterhans, former head of the photography workshop at Bauhaus Dessau under the directorship of Mies van der Rohe, whose faculty he had just joined in Chicago, declined to participate in the MoMA exhibition:

My own personal work and my teaching activities, in conjunction with that of my colleagues under the direction of Mies van der Rohe, were consistently kept away from the work of the original Bauhaus. I, therefore, believe particularly in consideration of my future activities in the United States, that it would create a false impression if my works were exhibited under a name whose goal can only be identified to a limited degree with my ideas.[40]

The competition between the two former Bauhaus directors illustrates that the networks among artists were not only constituted as intellectual circles or intergenerational chains of teacher–student relationships but were also sometimes based on structural rivalries between contemporaries.[41] Competition between Gropius and Mies would continue long into the future; two of the most exceptional architects of their time, both of whom had been directors of one of the world's most progressive art schools, they later competed within the American sphere for the same commissions, the same contacts, and the same resources. Each was interested in promoting his own interpretation of the merits of the Bauhaus's history.

The MoMA Bauhaus exhibition was initially set to open in spring 1938, but was pushed back, by two seasons, to September or October 1938.[42] Yet in December 1937, facing a slew of administrative difficulties, in his interim report to Gropius, Bayer requested a further postponement of the show. He explained that he still lacked the requisite objects upon which to create the show, that the design of the exhibition had not yet progressed far enough, and that his own travel plans were still uncertain; "my matter is still pending, which is why I will most likely not be able to come at the beginning of February."[43] Extending the date was of existential relevance to him because he would otherwise have lost his crucial start-up capital. "I am afraid, however, that I will not be able to leave here early enough to prepare the exhibition. My papers are not yet ready either, so I cannot keep the deadline, which means that I will lose the honorarium upon which I depend."[44] To leave illegally was out of the question for him because of the risk it would pose to his wife and child. He wrote, "the administrative efforts and the papers must both be worked out; then I'll come to make the exhibition and later start my new life. If not, I'll wait as long as necessary. This uncertainty has worried me a lot for a long time; now I'm looking into the future. I'll sacrifice the Christmas season for the exhibition."[45]

His intense efforts to realize the New York show were finally crowned with success, and by March 1938 he could write confidently to Breuer "Now it's behind me."[46] He

Figure 13.4 Photographer unknown, Xanti Schawinsky and Herbert Bayer, Obergurgl, 1930s. Photograph; Denver Public Library, Herbert Bayer Collection.

permitted himself a last vacation before Easter at his beloved Obergurgl in Austria, accompanied by Lady Norton—with whom he was back on good terms—and Xanti Schawinsky, on one of his trips back to Europe (see Fig. 13.4). "I am taking my leave, so to speak."[47] Schawinsky, for his part, predicted that "a Nazi flag will soon flutter" at the hotel. "It is a pity that such areas are also spoiled. It's good that we're leaving."[48] That summer in Berlin, Bayer also took leave of his old pal, Jorge Fulda, who just a year later would see the wisdom of his friend's departure, "You were right, dear Herbert, to turn your muscular ass on Europe."[49] Fulda supplied more ironic confirmations of the same sort throughout the following year: "you with your Jewish-Marxist-Negroid and alien intelligence have of course perfectly timed the jump of the proverbial rats from the sinking ship to avoid being dragged into Hitler's shit … You lucky one!"[50] Fulda's sarcasm was, of course, not pointing out some deep-seated political or ideological opposition to the Nazis on Bayer's part, commenting rather on Bayer's luck in avoiding having to live in Germany once war broke out on September 1, 1939.

While he was still in Germany during the first part of 1938, Bayer became increasingly confident that he could emigrate on solid financial grounds, especially when in February he received the news that both he and Schawinsky were invited to teach at the New Bauhaus.[51] Schawinsky confirmed Bayer's decision in a March letter to Breuer: "Herbert has chosen Chicago, and so we will work together there."[52] The initial contract terms proved unsatisfactory, however, and Bayer soon insisted on further negotiations, which dragged on until May 1938. He finally agreed to make a binding commitment after Moholy offered him a salary of $5,000 a year.[53]

Meanwhile, Bayer's MoMA preparations did not go unnoticed within the broader network of Bauhaus alumni. In a letter to MoMA's exhibition department, possible lender Max Bill wrote from Switzerland, that, "at the moment it is not well advised to carry on correspondence with Bayer about the exhibition since he is Austrian and since the annexation of Austria has become a *Reichsdeutscher* and thus carefulness is requested."[54] And yet, while some accused him of now being a *Reichsdeutscher*, others—in Berlin at least—were whispering of his plans to emigrate.[55] It was not until

July, however, that he officially informed his colleagues and friends at Studio Dorland that he would be leaving at the end of the month.[56] To protect his copyright, he signed contracts with Dorland (see pp. 180–3). As a parting gift, the studio assembled a small booklet aptly entitled *Bayer-abc*. Its verses, photomontages, and illustrations featured agency artists and managers, some of them Bauhäusler, such as Walter Matthess, Kurt Kranz, Richard Roth, Toni Zepf, and even Xanti Schawinsky. It also mentioned supporting staff from the back office, evidence of Bayer's wide popularity. There are even winking nods to Bayer's luck with the ladies, including photos of various anonymous beauties, first under the letter O with the caption "*Oh weh!*" (ouch!) and again under W ("*oh Weh*").[57] Later, during the war, Matthess conceded in a letter to Bayer that "everything has come about as we foresaw! Only you drew the right conclusions in time. The rest of us stayed. Therefore everything came down on us—worse than bad. The old guard at Dorland that you know is of the same opinion. Our hopes stand and fall with America and England."[58]

During his last year in Germany, until he was safely out of the country, Bayer sought to keep a low profile in his dealings with the regime. When he discovered upon returning from the United States in 1937 that his building's property managers had cleared his attic—and with it many of Breuer's belongings—he did not investigate further or lodge a complaint. "Without coming into conflict with the Gestapo, nothing could be done," he wrote to Breuer.[59] His new passport was issued just in time for his passage after police headquarters received a tax clearance certificate from the Berlin-Wilmersdorf finance office on August 13, 1938 (see Fig. 13.5a/b).[60] There are no reliable sources supporting Rolf Sachsse's conclusion, however, that it was Walter Gropius who ultimately obtained an exemption for Bayer to leave Germany "through his [former] student and friend, the SS chief architect Hanns Dustmann."[61]

Years later Bayer recalled that he had faced few difficulties shipping the objects he had collected for the MoMA show to New York because officially the works were to be returned.[62] The list of materials may have been disappointingly short, but he had secured material to be shipped in a crate ahead of his passage.[63] More problematic were the issues with US Customs, which regulated the import of ceramics, textiles, furniture, and other everyday objects; the situation was complex, as some of the exhibits for the show were intended to remain in the United States.[64] According to Bayer, a considerable proportion of the works on display were eventually sent back to their owners in Germany. He later recalled that some items were sold rather than returned, an opportunity he had already mentioned to the Bauhäusler when rounding up items for the show.[65] However, paintings by Schlemmer—despite their relatively low prices—failed to find American buyers.[66]

As for his own works, which had remained safely in London after his solo show, Bayer had initially planned to take them on board during the *Bremen's* stopover in Southampton. This was thwarted by the complexities of his departure, however. He already had his ticket and had paid the significant required Reich Flight Tax; at the same time, he learned that he was only to receive legal permission for his departure *after* the London material—which had a declared value of 9,000 reichsmarks[67]—had been inspected by German customs in Germany. Time, however, was too short now to get his artwork to Germany before his ship was scheduled to depart. This is why

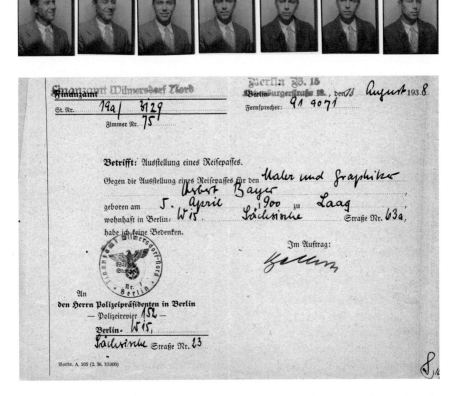

Figure 13.5a/b Photographer unknown, Passport photos for Herbert Bayer, 1937/1938. 7 Photographs and tax clearance certificate to obtain a passport, August 1938; Denver Public Library, Herbert Bayer Collection.

before the trip, and in the presence of a German customs officer (whom he considered to be "anti-Nazi" and sympathetic to him), Bayer apparently had to cable London and instruct them to send the material back to Berlin before he finally received his exit permit to embark on August 15, 1938. In fact, the bulky cargo did not arrive in Berlin from London until just after his own ship had left Bremerhaven. It was inspected by German customs, repacked, and forwarded unhindered. According to Bayer this was the result of the goodwill of an unnamed, elderly German customs officer, to whom he therefore owed not only his departure but also the preservation of all his major paintings.[68]

Upon inspection of other documents, this narrative looks suspiciously like another of Bayer's attempts to embellish the facts; the reality outlined in contemporary sources was more mundane. The starring role in this episode belonged not to the customs officer but once again to Irene Bayer-Hecht. "Your paintings are already at my place," she wrote to him very soon after his departure. "I was at the customs office and took

charge of the two boxes. They got unpacked; contents were compared piece by piece with the list sent from London, were weighed and repacked. Whereupon I received the certificate from customs that they are now back."[69] There were no adverse effects after the appointment at the customs investigation office the next day.[70] She was thus able to send all the artwork on to America in a perfectly straightforward way, together with her own household effects. A year later, for reasons that are unclear today, the Statistical Office claimed it was still looking for proof that correct "repatriation" to Germany of Bayer's artworks (or the equivalent value in funds) had taken place.[71]

In his diary, Bayer described his departure in a mix of tenses, both the past tense and a sort of cinematic present, to reflect impressions that were still very vivid:

> On August 15, I leave Berlin for Bremerhaven with Vips [Wittig] and Irene in *Maxl* [Bayer's car]. At the same time I am leaving my work, my studio, which I have built up over ten years. My child—she was astonishingly reasonable when I left. The situation was not clear to her. … When getting to the ship I was overcome with emotion.[72]

Vips Wittig later recalled the journey in his letters to Bayer; when he died Bayer remembered Wittig's assistance "in a difficult hour."[73] Willy B. Klar, who had been his sidekick in so many bachelor escapades, appears to have been somewhat hurt by the fact that he was not allowed to drive his "much-loved friend" to the ship, despite their agreed-upon plans that he be there.[74] Presumably Irene Bayer-Hecht, who disliked Klar intensely, excluded him from the family send off.

In Bremerhaven, Bayer knew that his passport could potentially cause him difficulties while boarding. For one thing, it not only bore a six-month US visitor's visa but also contained the immigration visa granted to him by the US embassy after he had gone through the tedious procedure of obtaining the affidavit. Further complications could have been caused by the fact that it contained a note that he had been called up for military service. Both factors went unnoticed at the exit checkpoint. Bayer was perhaps exaggerating when he stated later that the discovery of his military obligations could have sent him to a concentration camp.[75] Certainly, however, last-minute complications would have jeopardized his timely departure and with it his ability to launch a new life in the United States. Bayer's Austrian passport itself had moreover become a German document after Hitler's annexation of Austria in March 1938, something that pained Bayer greatly.

By his own account, when Herbert Bayer—profession "painter"—finally arrived in New York on August 22, 1938 (see Fig. 13.6), his guitar strapped on his back, he looked more like a wandering musician than a well-known artist.[76] He was almost turned back by the immigration authorities for having failed an eye test at the US embassy in Berlin. That earlier examination had classified him as "color blind"—sufficient grounds at the time for refusing entry to a would-be immigrant. The notion that a well-known painter could be color blind, however, struck the border officials as absurd; after an improvised test in which he correctly identified the color of the officer's uniform, the seal, and the writing on his entry documents, they allowed Bayer to debark as merely "partially color blind."[77]

Figure 13.6 Photographer unknown, Herbert Bayer on board of the *Bremen* vessel, August 1938. Photograph; Denver Public Library, Herbert Bayer Collection.

Though rich in the opportunities available to him, Bayer was by no means a wealthy man when he landed on American shores. The 1,200 reichsmarks paid to him in cash by the J. Landsberger company in Berlin shortly before his departure, a one-time payment for license claims,[78] had mostly been spent on travel preparations, with the modest balance going to his wife and daughter.[79] Bayer-Hecht's subsequent efforts to set up a special account through which Bayer could continue to support them were stymied by Germany's tight foreign exchange restrictions.[80] "I have done everything to secure [them an] income. But it all seems to have been in vain," Bayer noted ruefully after his arrival. "These days the law does not even allow me to support my relatives with my income. The money belongs to the beloved state."[81] The same probably applied to the fee he earned for the last creative work he had published in Germany: the cover for the October 1938 issue of *Gebrauchsgraphik*, which appeared before the December Bauhaus opening at MoMA (see Plate 26). He later claimed that "all my money was taken from me" at the border control. "This state uses the most excessive robbery and exploitation. Every citizen offers an opportunity for misuse and victimization."[82]

On his previous trips abroad, Bayer, despite being a man of some means, had hardly ever managed to obtain foreign currency in Germany. Breuer and the Gropiuses had therefore repeatedly paid his travel expenses, for which he later reimbursed them with some goods he brought from Germany. The legend that Bayer had arrived in America with "less than twenty dollars in his pocket" is misleading, however.[83] It is based on the series of interviews Bayer gave to Arthur Cohen, during which Bayer initially spoke of landing stateside with "a few dollars."[84] Cohen later suggested the catchier wording, which Bayer subsequently confirmed in a letter.[85] It gives the impression of an almost penniless emigrant arriving in the United States having been robbed of his last few possessions by the Nazis, something that simply was not the case.

Yet, like all other emigrants, Bayer was subjected to the usual highway robbery upon leaving Nazi Germany; all of his funds in reichsmarks were either exhausted by the Reich's Flight Tax or had to remain in a blocked account due to Germany's low exemption limits on foreign exchange.[86] For the seven months from January 1 to July 31, his last fiscal working period in Germany, the profit and loss statement of his

studio reported revenues of 57,516.15 reichsmarks, while production costs, salaries, and other expenses left a profit of circa 21,000 reichsmarks; by law these were governed and kept by the foreign currency authorities.[87] All the same, he was hardly without assets when he set out: his oeuvre was intact (although he was uncertain for a time whether it could be shipped to him); he could look forward to the MoMA honorarium of $1,000 as well as the promise of employment in Chicago, which would bring in several thousand dollars a year. His graphic design expertise, moreover, meant he had excellent prospects of gaining a foothold within a commercially viable field. Finally, he had what was perhaps his most important starting capital of all: the support of his friends upon arrival. Bayer's emigration was indeed the final step in a long and carefully planned exit. With a basic grasp of English from the lessons he had taken in Berlin and all his official paperwork completed on both sides of the ocean, Bayer was in a much better starting position than many other artists and intellectuals fleeing Nazi Germany, some of whom barely escaped with their lives.

Bayer-Hecht's subsequent letters from Berlin to Bayer in the United States make obvious, however, that he had not settled all his affairs before he left. "Unfortunately, it is my chief pleasure to deal with your dear friends, Matthess, Kranz, Klar," she lamented.[88] In fact, although Bayer had entrusted her with protecting his legal and financial interests, he had not armed her with the right documentation or other means of support. "You're a long way away and you've already forgotten everything," she complained. "Tomorrow I have to go to the tax office to ask for the final approval for the move ... I'm afraid we won't be paid anything; the stupid lawyer messed up." In another letter she added: "I learned that this happened because of the lawyer. You were treated as a Jewish business because of him"—she complained.[89] And: "On the studio issues, I consulted with a 'real' lawyer today. He said, even if Matthess closes [Studio Dorland], there's not much we can do because you didn't send the contract to me and you didn't give me properly notarized power of attorney."[90]

By July 1939, Willy B. Klar was loudly bemoaning that Bayer had not delegated any of these tasks to him,

> all matters concerning Dorland would have been in much better hands with me than with anybody else. After all, I know our business inside out. ... I've offered more than once to look after your interests, but you didn't do anything of the sort; you talked to all but your old friend about the estate you left behind; surely you are not so much to blame as your wife, who hates me like a deadly sin and fears that I would probably embezzle incoming funds more for myself and your lady friends.[91]

Bayer had actually intended his wife to play the role of his steward at Studio Dorland, but, "in order to be the boss, I would have to be there all the time and check all the correspondence," she confided to Bayer. "It is impossible to envision what kind of ill feeling this would cause."[92] Instead she described exercising her duties with great deliberation while fibbing about her authorization,

> I'm very reserved, I only go there once a week, just not to offend anyone. I found out from Kranz that Matthess is negotiating with him as head of his studio. I

casually told him ... that I had already received the contract and the power of attorney from you, and my lawyer, who is a [Nazi] party member, will see that we keep our rights, and that we can't be pushed aside just because you're gone.[93]

Bayer-Hecht advanced over 1,300 reichsmarks to pay a tax debt on behalf of the studio for the revenues generated in the first half of 1938 as detailed earlier. She also wrote to Bayer that Klar was dragging his feet about paying the agreed-upon price for Bayer's beloved convertible (see Fig. 13.7), because "he's in debt up to his ears ... can't even pay the interest on his mortgage" and "only leaves by the back door ... because there's always a creditor waiting for him out front ... We have tried to wring each other's necks in the friendliest possible way," she continued, "and are on excellent terms."[94] An interesting subtext is revealed in the passage in which she expresses fear that Bayer would "snarl at her again" for "slandering" his "noble friends."[95] Here, again, latent conflict is evident between Bayer's still-wife and his male chums, on whom Bayer-Hecht blamed much of the family's misery. Klar ended up paying a portion of the amount they asked, after negotiating a discount on the grounds that Bayer "had sold him, your best friend, such a used car."[96] Klar himself wrote Bayer later, that he "had done a damn silly thing" when he bought *Maxl*, because the car had "behaved badly" and had gone "downhill rapidly"

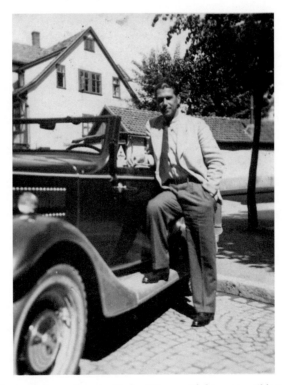

Figure 13.7 Photographer unknown, Herbert Bayer with his convertible in Bad Pyrmont, c. 1933. Photograph; Denver Public Library, Herbert Bayer Collection.

with him. "It's quite clear that I couldn't pay your 'dear' wife the same price, as I had bought the car many months before." He also claimed that an expert engaged by Bayer-Hecht had given only a low estimate.[97]

On top of everything else, there was an argument in the studio about a childish showdown: "Matthess the dear young boy had your name plates unscrewed," recounted Bayer-Hecht. "Kranz called me; what should he do? I said he was your representative, should talk to Matthess. Apparently the two are now deeply at odds." Thanks to her mediation, the conflict with Matthess was deferred, but "he's not happy with you. You've tricked him with the new contract."[98] Here Bayer-Hecht was referring to real trickery on Bayer's part; he only told Matthess that he intended to leave the country after they had signed the contract that would secure Bayer further revenues. With his partner abroad, Matthess no longer wanted to adhere to the contract, and Bayer-Hecht had no legal recourse in the event of an emergency, due to a lack of documents.[99] Klar for his part insisted that "Matthess and Steinbring [Dorland's personnel manager at the time] would never have tried any horse-trading with *me*, or blackmailed me, as you suggest."[100]

Kurt Kranz appears to have remained one of Bayer's few trustworthy allies; the former Bauhaus student who now ran the studio in Bayer's place "does what his duty demands," reported Bayer-Hecht.[101] She had to "come to good terms with him, so that he at least stays faithful," though she also asked herself when the time would come that Kranz, too, would "get the idea that he can steal everything without having to give anything in return."[102] She was also convinced "that the contract with Kranz is our salvation" because Matthess needed him as the new studio manager and therefore required his cooperation. But she doubted "whether Kranz was already working on his own account for those people? He is deeply in debt, as [the bank] did not pay out his mortgage to him because his air-raid shelter is not up to code."[103] Klar meanwhile defended Kranz to Bayer as still inexperienced in such matters and "certainly" trying "to do everything in his power to save as much as possible for you."[104]

Partial as she was, Bayer-Hecht remained unconvinced that Kranz had the creative wherewithal to fill the gap Bayer left at Studio Dorland: "You underestimated your personality. Kranz is meaningless, even if he is a decent guy (hopefully)."[105] And as the years advanced, former Dorland colleagues would reach different verdicts on Kranz. By 1946, Klar was calling him a "Nazi tyrant."[106] "Kranz is back in Berlin, behaving pompously," wrote Matthess to Bayer after the war. He continued, "as a great anti-Semite, he was a propaganda man in Norway during the war, and today he is oriented more toward the east, as business demands. I could well use him, because he is still working in the direction he learned from you. But I don't like that guy."[107]

Bayer-Hecht's impression may not have been too far off the mark that her husband's former colleagues "behave like a pack of wolves, and Matthess and Steinbring concoct a new dirty trick every day."[108] Kranz confirmed Steinbring's tendency to take advantage of others in the interest of the agency—something he did not think Matthess entirely condoned. "Your wife, who has been haunting the place, was no match for Steinbring, of course," Klar reported to Bayer in the United States, "and he certainly took full advantage of this weak situation."[109] Soon Bayer-Hecht's verdict was clear: "I'm convinced that the accounts have been cooked and that Dorland is scamming us,

but I'm helpless."[110] She was denied access to the documents, was put off permanently, and never received the promised payments. Before totally resigning herself, she contemplated playing a little trick on Dorland herself:

> I'm tilting here at two windmill wings: Steinbring and Matthess. With time, I'm getting the impression that they've been cheating you with their bookkeeping for years. I can't get through. It's just impossible for me to get a clear list from them about the Dorland stuff. It is obvious that they are swindling you. In any case, the foreign exchange office is demanding a very precise and clear statement of accounts from me … If [Steinbring and Matthess] don't put their cards on the table, the authorities will set some officer on them who will look into all their pots.[111]

In the end, Bayer-Hecht probably managed little more than getting Dorland to pay the shipping company for the moving expenses.[112]

After his still-wife had entrusted his Berlin furniture, along with his paintings, to a shipping company on September 29, Bayer successfully received them in New York in early 1939.[113] A revealing episode occurred as her own household effects were being packed and loaded. "There's another concern," Bayer-Hecht reported urgently, "our swastika flag was in the same room, too." Implausible as it seems, she could only have been referring to a flag of her own; Bayer and his wife had long lived in separate homes, and his belongings had been delivered only a short while before (by a forwarding agency for temporary storage) to her address, where they remained packed. "I talked to the packer about it, and he said we shouldn't bring it; we can have our own opinions, of course, but it could be unpleasant if an American customs officer came across it. Especially now that there's so much anti-German agitation over there." Yet, after having received this advice, she had to tell Bayer, "I couldn't find the flag anymore, and the container was already gone. I hope it won't cause complications. Anyway, it would be good if you could take Barr, or Ed, or some other American with you to customs."[114]

It is impossible to say whether Bayer-Hecht's possession of what she called "our flag" gives a real indication of her political attitude or was merely part of an overall effort to fit in on festive occasions. While there was no law stipulating that private citizens had to own or fly a flag with the Nazi swastika—which had become the national flag in 1935—the regime had extremely effective ways of securing popular loyalty and consensus indirectly.[115] The private display of personal flags came primarily from social pressure from within the local community and also sometimes through the coercion of block wardens (*Blockwarte*). The latter were known to discipline citizens who had not affixed such decorations to their homes; for example, using so-called house cards to register acts of refusal, as well as distributing pre-printed forms with admonitions.[116] In his memoir, the photo journalist Gerhard Gronefeld, for example, described being denounced by the janitor for showing the flag falsely on Hitler's birthday and had to answer for it to the authorities.[117] For Bayer-Hecht—especially as a foreigner of Jewish descent—flying the Nazi flag as occasion demanded might well have been an opportune way to avoid attracting attention. Local conditions in Bayer-Hecht's well-to-

do Berlin neighborhood of Wilmersdorf are unclear.[118] However, it cannot be entirely ruled out that she may have had other motives for owning a swastika flag.[119]

Understandably enough, Bayer's first letters to Bayer-Hecht made no mention of the exact whereabouts of the extensive archive he left behind, which included records, personal documents, photographs, work records, and printed matter. Under the adverse conditions of his departure, the passenger ship did not offer a favorable option for their transportation. In fact, Bayer-Hecht had arranged for this material to be sent, via the Knauer shipping company, to Bayer's brother Theo in Linz.[120] Just before leaving, on August 11, 1938, Bayer authorized him to serve as trustee for the time after Bayer-Hecht's emigration, also appointing him the family beneficiary. Their contact was cut off by the war, however, and Bayer received no news from the family except for a brief wartime message via the International Red Cross.[121] However, it is clear from the correspondence that Herbert Bayer contributed to the costs of maintaining his parents' grave.[122] After the war, he also supported his relatives in Austria with a substantial amount of everyday consumer goods, to the extent that his financial situation permitted.

Large parts of his archive were already in Linz by the end of 1938.[123] This could have been to facilitate Theo Bayer's efforts to protect Herbert Bayer's copyright (see p. 176). In March 1939, well after Herbert and Bayer-Hecht had left Germany, Theo received another box, this one from Studio Dorland—"full of advertising material, notebooks, and books without an accompanying document."[124] It is not clear why. Perhaps the Dorland agency, having taken over the formerly independent Dorland Studio, simply wanted to get rid of the "legacy" of the former studio manager who had turned his back on Nazi Germany and had, moreover, been branded a "Degenerate Artist" by the regime. Shortly before the beginning of the war, 282 photographs arrived in Austria, sent there by the architect Gustav Hassenpflug.[125] Sadly, these were lost, and nothing is known about them today.

Immediately at the end of the war, Theo Bayer's apartment was ransacked and destroyed by Russian and American troops; so was his attic, in the course of which even the printing blocks or printing plates stored there were broken.[126] He detailed the devastation to his brother in July 1946 and again at the end of November: "It is hard to say what exactly was destroyed or looted and what is left. Certainly there is still a good deal of advertising material, posters, and other things. Photo negatives are also still numerous, but many others have been trampled and otherwise rendered useless".[127] Five months later, Theo Bayer's summation read as follows:

> On the occasion of my last weekend visit to Rohrbach, I also put the things I had stored in the attic halfway in order again. The contents of the boxes you sent me from Berlin at the time of your emigration to the U.S.A. also include the sketches from your trip to Italy. These pictures are probably all there. In the same box there are also many pictures from the time up until about 1920 ... and collections of diaries and letters. In the second box are samples of prospectuses, posters, many photos and negatives. But a lot of these things were only found in tatters and broken with the rest of the wild mess ... A pencil drawing from Nördlingen that I had in my apartment was taken by the Yank."[128]

It is not known when exactly this archive finally made its way to Bayer in the United States; he may have taken it with him after one of his later visits to Austria.

Emigrated safely and with most of his possessions, Bayer had successfully managed the well-considered departure from Germany that had absorbed much of his attention and emotion during the 1930s. But only once he was launched toward the safe haven of New York was Herbert Bayer able to jot down a critical summary of his years in Nazi Berlin. Still, however, he must have perceived the deplorable political situation merely as background noise—an undesirable politicization of private life.

> Now that I have finally left this country, it's clear to me that the last five years have been lost in terms of my work. I have realized that there is no possible way to reconcile German National Socialism with the world in which I must live my life. I've found myself in opposition every step of the way. The depressing gagging of the spirit, the dumbing down, the mendacity. The walling off of all activity beyond Germany. The revolting tone in the press and in public opinion. The violation of all personal initiative. The intermingling of the personal and the political. The bad aspects of the German *Volk* character, which erupted so violently. The shameful racial policy. And above all, the Nazi annexation of my homeland, Austria. That struck me deep in my heart.[129]

Part Four

A New Life: Bayer in the Land of Opportunity

14

Bayer's New Start in the United States:
The Bauhaus at MoMA

On his journey to the United States, Herbert Bayer shared a cabin with his old skiing friend Hans Falkner, part of the Obergurgl set which also included Lady Norton. Falkner planned to open a ski school in the United States and had long nourished hope that Bayer would take part (see Fig. 14.1).[1] Falkner boarded the *Bremen* when it called at Southampton, and for unknown reasons, must have brought parts of Bayer's luggage.[2] On August 22, 1938 bad news awaited Bayer at the New York pier even before he had set foot on American soil: the New Bauhaus had virtually gone bankrupt due to risky speculation on the Chicago Stock Exchange. MoMA's John McAndrew, meeting his ship with Xanti Schawinsky and the New York-based art director Ed Fischer, immediately handed him Moholy-Nagy's letter informing him of the school's abrupt closure and, with it, the cancellation of his job there.[3] Bayer was floored. "Now here I stand with my neck washed," he lamented to Alexander Dorner, drawing on a Yiddish expression for one who has prepared himself in vain.[4] "So I've been dismissed without notice—for the first time in my life," Bayer noted in his diary. "Although this is the reason I came and dissolved everything in Berlin. The first thing I do here will be a lawsuit. I am already facing unforeseen problems. Above all the gangster habits of the millionaires at the Assoc. of Art and Industrie [*sic*] financing the Bauhaus."[5]

When Irene Bayer-Hecht learned of the firing, she urged Bayer not to sue the association. "If you take anybody to court, it should be that pig Moholy. As if he didn't know it before you left! Maybe he wants to get even with you for Rhode Island." Here she was referring to the August 1937 retreat off Cape Cod, during which the Gropius circle had delegated the plum assignment of organizing and the MoMA retrospective not to Moholy but to Bayer. "You've always trusted these people so much, and it has caused only trouble and harm so far," she continued. "Don't believe anything he says, and never do."[6] Bayer-Hecht was, of course, familiar with Bayer's long history of problems with his former teacher, who—as Schawinsky later suggested—liked to borrow ideas.[7] She may also have been referring to Moholy-Nagy's two-year liaison with Ise Gropius's sister, Ellen Frank, which had caused the breakup of his marriage to Lucia Moholy, with whom she had been friendly.[8]

It seems that Moholy had made some kind of last-ditch offer to Bayer and Schawinsky that involved them foregoing their teaching salaries.[9] Bayer did not accept.[10] He inquired to no avail into other teaching opportunities, for instance with Dorner, who had landed a job as director of the Rhode Island School of Design Museum in Providence.[11] In September, not long after his arrival in New York, Bayer traveled

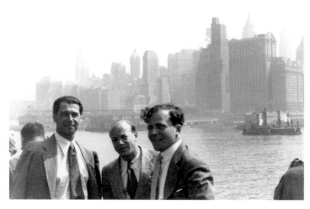

Figure 14.1 Photographer unknown, Herbert Bayer with fellow travelers, New York harbor, August 1938. Photograph; Denver Public Library, Herbert Bayer Collection.

South to Black Mountain College in North Carolina to prepare the exhibition and visit Anni and Josef Albers after a hiatus of four years. Schawinsky had already left the college that summer,[12] and Bayer had spent his first few weeks living with him in New York.[13] Bayer's southern sojourn yielded an almost instantaneous offer—presumably from Josef Albers—to teach there for a year, which he accepted with ambivalence. On the one hand, he longed for a safe haven in his new country, a place quiet enough to be able to turn again to painting; on the other hand, he was plagued by the fear that "this step aside would distract me too much from my previous career, to which I will have to return after all. Because I cannot stay a teacher."[14]

Bayer would, in fact, be offered teaching positions again and again, especially during his early years in the United States, and he accepted a handful of short-term postings which helped secure his livelihood.[15] In 1939 he even considered financing his own school.[16] This would have made him economically independent and thus also autonomous in his work. But he always expressed skepticism about his abilities as a teacher: "Of course I'm not a 'born teacher.' I have to produce, not dogmatize and theorize."[17]

But when Bayer landed in New York, the MoMA show remained his only assignment. As Ellen Lupton put it succinctly in 2020: "In a sense, the Bauhaus came to Bayer's rescue. Promoting the school's legacy proved central to his identity as a European émigré working in the United States."[18] After the various postponements, the Bauhaus retrospective at the Museum of Modern Art finally opened on December 7, 1938 and was on view until January 30, 1939 (see Fig. 14.2).[19] It turned out to be a rather costly undertaking for the museum. When all was said and done, it had consumed more than half of the institution's annual budget for 1938, a good 50 percent more than initially planned. The sumptuous accompanying publication that Herbert Bayer designed was the most expensive catalogue the museum had ever produced.[20] Gropius had even managed to secure a portion of the sales revenues on Bayer's behalf.[21]

According to Bayer, the catalogue was compiled independently of MoMA: "I prepared this book completely, page by page, even layout, page by page, in Europe."[22]

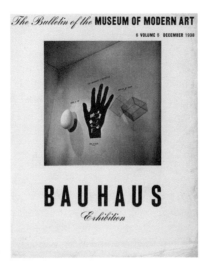

Figure 14.2 Herbert Bayer, *The Bulletin of the Museum of Modern Art*—Bauhaus Exhibition, cover, 1938. Offset printing; Private collection. © Estate of Herbert Bayer/Artists Rights Society (ARS), New York/VG Bild Kunst, Bonn.

After he had sent the material to Gropius, the latter—in Bayer's opinion—mixed everything up so that he had to put the manuscript back in order, together with Ise Gropius.[23] As Bayer later recalled, she helped him and drafted captions based on texts she had received from Alexander Dorner. It is impossible to judge what effect their work together on the exhibition had on the old liaison between the former lovers, or how Walter Gropius, in his roles as both husband and workaholic, responded.

In order to protect the Bauhaus members who remained in Germany, Bayer carefully left a number of the works unattributed, including several by Joost Schmidt.[24] From early on he claimed that he disliked to forage for things from the past.[25] Accordingly, the catalogue also documented works from the New Bauhaus in Chicago as well as Black Mountain College, enabling Bayer to showcase the work of former Bauhaus members from Gropius's network, such as László Moholy-Nagy, Josef and Anni Albers, and Xanti Schawinsky. When gathering the artworks, Bayer had claimed that he did "not so much want to show the school in the exhibition but rather to tell the story of a group of people."[26] To put it in numbers, the exhibition showed works by only twenty-one Bauhaus teachers out of circa 120. As for circa 600 items on view, nearly half of them were by Gropius, Breuer, Moholy-Nagy, Schawinsky, Joost Schmidt, Josef Albers, and Anni Albers.[27]

By Bayer's own account, he set up the exhibition almost single-handedly, repeatedly working late into the night.[28] He also complained to Dorner that the exhibition was "drudgery" (*Sauarbeit*)[29] and was particularly vexed by the lack of commitment from his team: "The work is so enervating because of the laziness and disorganization of my American employees. I am a Prussian in comparison."[30] In addition, he spoke—not very kindly—about the "unpleasant sides of the women's regime" embodied in the

person of Janet M. Henrich, the MoMA staff member responsible for publications, whom he described as "highly uninformed and scheming."[31] Walter Gropius, for his part, hardly found time to support Bayer on site: "I have a terribly regretful feeling about leaving you there to work without any help, but it is absolutely impossible for me to be with you to help to build up [install] the exhibition, as I am so heavily booked up here."[32] Five days later, he suggested that Bayer apply to MoMA for a short-term assistant for the final days.[33] This may have been T. Lux Feininger, son of former Bauhaus master Lyonel Feininger and himself a Bauhäusler, as Bayer later reported having had his help.[34]

At an earlier stage Schawinsky had been hired, but only for a short spell, receiving a sum of $200.[35] According to Bayer's diary of the period, "Xanti was only interested in getting paid for the fourteen days of registration work."[36] It was an altogether stressful time, including "an unjustified confrontation with Breuer"[37]—probably caused by Breuer's sudden, if temporary, insistence on not being included in the show on the basis of his claim that he had learned nothing at the Bauhaus.[38] As for other members of the circle of friends, another telling diary entry at the time describes "uncomfortable confrontations with most of the other Bauhaus members."[39]

In MoMA, the exhibition was given a sequence of small, rather unsuitable, rooms in a unoccupied shop behind a large plate glass display window in Rockefeller Center's lower concourse leading to the subway station.[40] Bayer had to install a total of almost 600 objects and artworks—most of them from Gropius's personal archive. He met these challenges with unconventional presentation techniques that demonstrated Bauhaus methods in action through the show's design.[41] The exhibition is well documented, with a ten-page "installation list" and over fifty installation photographs.[42] Despite the unenthusiastic response of both critics and viewers, the show turned out to be a success for Bayer. Regardless of the cramped space, he had succeeded in presenting his sophisticated communication strategy and thus introduced America to the new European approach to spatial design, already exemplified in Bayer's exhibition designs of 1930 and 1931.[43] According to Arthur Cohen, "the exhibition became a landmark for the American design world and immediately established Bayer's preeminence among American exhibition designers."[44] A contemporaneous photograph, likely made for publicity purposes, shows him posing in front of various exhibits as he lights up a cigarette; the caption identifies Bayer as "Director of the Exhibition of the Bauhaus 1919–1928."[45]

Because the exhibition team had, despite Bayer's and Gropius's sincere attempts, not been able to reach agreements with either of the Bauhaus's other directors, Hannes Meyer and Mies van der Rohe, the widely publicized retrospective was limited to the nine years when Gropius was Bauhaus director, 1919 to 1928. With regard to the Meyer period, it is acknowledged today that the important contributions the Swiss architect made to develop the Bauhaus idea further, namely his collectivist approach to design and building, was overshadowed by his ideological orientation towards Marxism, Communism, and later also Stalinism.[46] It seems as if nobody, including Bayer, ever made an attempt to contact Meyer who had been expelled from the Soviet Union and was living in Geneva around 1937 and 1938.[47] In the MoMA catalogue, Meyer, who was labelled a "communist functionalist" in the English-speaking world, remained almost

invisible; his role was, according to architecture historian Richard Anderson, reduced to that of a mere "dash between Gropius and Mies,"[48] who also received little attention from the editors. Finding this an unsatisfactory situation, Bayer saw his options for representing the Mies era as either using the work of Josef Albers to stand in for it or to omit it altogether; however, neither initially met with Gropius's approval. Instead, Bayer promoted another exhibition concept that illustrated the institution's methods and purpose, as well as its most important achievements and impact.[49] Gropius proposed this more comprehensive concept to Alfred Barr.[50] It was the latter who then advocated ending the exhibition's scope with the year 1928.[51] His justification was also expressed in the catalogue's preface, where he stated that "the fundamental character of the Bauhaus had already been established under Gropius' leadership."[52]

Bayer felt unsettled by a conflict between Gropius and Barr over the scope of the catalogue. Gropius "wanted a book as large as possible, Barr as small as possible."[53] Bayer himself would have liked to use the framework of the catalogue to develop a "new design theory" (see Fig. 14.3).[54] The show's original title was conceived in more universal terms, "The Bauhaus: How it Worked."[55] Ultimately, the exhibition settled on a focus on the Bauhaus's Gropius period. This would considerably shape the later reception of the Bauhaus in the New World.[56]

Figure 14.3 Herbert Bayer, Sketch for the book jacket for the Bauhaus exhibition catalogue, 1938. Photograph; Denver Public Library, Herbert Bayer Collection. © Estate of Herbert Bayer/Artists Rights Society (ARS), New York/VG Bild Kunst, Bonn.

Though the many delays had meant that it was hardly advertised, the show nonetheless set a new record for visitors to a temporary exhibition at MoMA—which had admittedly only been open for two years.[57] According to John McAndrew, the response to MoMA's Bauhaus retrospective was initially positive; the opening for invited guests was so well attended that attendees apparently had little opportunity to gain a real impression of the exhibition. Bayer perceived it as "a huge social event."[58] Architect Ferdinand Kramer, who had enrolled at the Bauhaus for one semester in 1919, had just immigrated to the United States and attended the opening. He later recalled a quirky coincidence:

> Across the street from the museum, [Salvador] Dalí had designed the window displays for the fashionable department store, Bonwit Teller: angels with black raven feather wings in transparent nightgowns. But, dissatisfied with the arrangement, Dalí shattered the store windows and caused a melee, into which police cars and fire engines arrived with great fanfare. This marked the opening of the first representative Bauhaus exhibition in the United States. I didn't know whether I was awake or dreaming.

Visitors may have flocked to Rockefeller Center to see the show, but the critics mostly wrinkled their noses at Bayer's innovative installation (see Fig. 14.4). A handful praised the didactics behind the arrangement of the exhibits, while most described Bayer's design as confusing, enigmatic, or simply awkward.[59] The show as a whole elicited scathing reviews in the US press almost immediately.[60] Just three

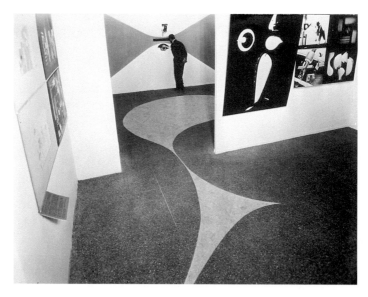

Figure 14.4 Soichi Sunami, View of Bayer's display of Schlemmer's Triadic Ballet at the Bauhaus 1919–1928 exhibition, New York, 1938. Photograph; Denver Public Library, Herbert Bayer Collection.

days after the opening, Barr named four potential sources for the negative responses in a lengthy letter to Gropius:

> (1) Pro-Nazi anti-modern sources; (2) Pro-French anti-German sources; (3) American anti-foreign sources; (4) People who feel that the Bauhaus is too old fashioned to be worth the trouble ... we have already heard reports that the exhibition is considered "Jewish." Many Americans are so ignorant of European names that they conclude that, because the Nazi Government has been against the Bauhaus, the names Gropius, Bayer, Moholy-Nagy, etc., are probably "Jewish-Communist."[61]

In response, Barr proposed publishing a statement declaring that the Bauhaus was fundamentally apolitical along with a clear account of the proportion of Jews who had served on the faculty. Gropius was in favor of stressing the institution's non-political character but refused flat out to address the "Jewish question"; "I think we should not, in any case, defend ourselves against the Jewish question [and] against the foolish point of view of Hitler's."[62] Unequivocal as his position was, however, he immediately watered it down in the next sentence by conceding that it might be useful if MoMA quietly let slip to the press that the Bauhaus teaching staff had only included one Jewish artist on a staff of seventeen and that no Jews had taught in the workshops: "Of course, if you and your staff want to mention this personally to this or that reporter, it may be a good thing to do so; but I do not think we should incorporate any such statement officially into our exhibition captions."[63] This strategic approach to public relations on a difficult matter had its roots in Gropius's experience as director of the Bauhaus.[64]

By the end of 1938, MoMA's American organizers were also starting to worry about potential diplomatic entanglements with Germany.[65] Restraint on the part of Barr, Gropius, and others (or, to be less charitable, a certain desire not to make waves) was what kept the 1938 Bauhaus retrospective in New York a strictly apolitical event. As such, it stands in striking contrast to contemporaneous shows held elsewhere that expressly took a clear stance against Nazi Germany. One such exhibition was *20th Century German Art*, held at London's New Burlington Galleries in July 1938, a direct response to the show of "Degenerate Art" that opened in Munich in mid-1937.[66] The MoMA's Bauhaus exhibition was nonetheless launched on a tour throughout the US, stopping (in two different versions) at fourteen venues and spreading the ideas of the Bauhaus across the country—and, with it, the narrative emphasizing the Gropius years.[67]

In the end, the organizers saw the exhibition as a very mixed bag.[68] Barr himself characterized it as a "disaster" a few weeks after its closing in a letter to Gropius, stating "that in the Bauhaus exhibition a good many works were mediocre or worse, so that the critics were naturally not impressed."[69] Bayer reported that he was satisfied with the number of visitors and the book sales, while situating the negative press squarely within the grand Bauhaus tradition: "I too am disappointed in the kind of criticisms we have gotten," he wrote in one of his first English-language letters to Gropius. "They are just the same as our criticisms in the *Weimar and Dessau Anzeiger*."[70] Even if its success was mixed, however, the exhibition's overall relevance for Bayer's further career in the United States can hardly be overestimated.

Difficult Beginnings:
Bayer's First Eight Years in the United States

In hindsight, the 1938 exhibition proved to be of major significance for the future reception of the Bauhaus in the United States.[1] Bayer's catalogue did its part as well, laying down in detail the central Bauhaus program for the first time in English and for a broad public.[2] In fact, Bayer's work also had implications for how the Bauhaus was remembered in Germany. When the catalogue became available in translation in Germany after the war in its second edition of 1952, the design writer Eberhard Hölscher (one of Bayer's main supporters in the 1930s trade press) reviewed it as a "truly authentic and documentary presentation of the development of the Bauhaus" and noted that the participation of Herbert Bayer and Walter and Ise Gropius had guaranteed its success.[3]

In private terms, the timing of Bayer's emigration was actually an immense stroke of luck; the political situation in Europe came to a head while preparations for the MoMA show were underway. Although Bayer conceded at the time to friends that the decision had been very difficult for him, he assumed that the "exchange for freedom" would pay off.[4] In the late summer and fall of 1938, as the so-called Sudeten Crisis— Nazi Germany's machinations to annex parts of neighboring Czechoslovakia that were home to an ethnic German minority—worsened, and with Bayer's own family still in Germany, he noted in his diary: "The terrible week during which the whole world is in danger of war. ... I am particularly worried about Irene and Muzilein [Muci]. Telegrams back and forth. Everything calms down at the last minute."[5] Bayer was probably referring to the Munich Agreement, concluded on September 30, 1938, in which England, France, and Italy appeased Nazi Germany by consenting to its annexation of the "Sudeten German territory" from Czechoslovakia. In the next letter she wrote her still-husband, Irene Bayer-Hecht included a short paragraph that in retrospect seems difficult to judge politically: "Thank God that everything is now peaceful again. It would have been inconceivable to think of a war. The Führer did a fabulous job. Didn't he?"[6]

One would like to read into this remark the same sort of irony that was evident between the lines of the letters Willy B. Klar sent to Bayer from Berlin.[7] But it is also possible—especially in the light of the episode with the swastika flag when she was packing in Berlin (see p. 182)—that Bayer-Hecht was expressing her actual political opinion here; if so, this would have been heavily shaped by the way the event was covered in Nazi Germany where, we must remember, freedom of the press had been

completely suppressed. Though she herself was half Jewish, she never once mentioned religious or political persecution as a reason for leaving Germany in late 1938; on the contrary, her letters only expressed a desire to maintain for herself the fiction of a family life with Bayer and her daughter in the United States.[8] Having kept the American citizenship she received upon her birth in Chicago, perhaps Bayer-Hecht was able to turn a blind eye to the threat posed by Nazi Germany, and to nurture the illusion that she herself could survive under the increasingly repressive conditions. Writing to Bayer from Berlin on November 9, 1938, Bayer-Hecht seemed oblivious to the tinderbox for prejudice and ethnic violence that Germany had become. In fact, she was writing just hours before the country erupted in a night of spontaneous but state-sanctioned outrage, which was later cynically dubbed "Kristallnacht." This wave of notorious pogroms targeting Jewish communities and businesses could not have gone unnoticed in Berlin on the morning of November 10, although many Berliners averted their eyes. Yet, writing on the eve of this event, Bayer-Hecht's letter calmly stated her readiness to stay on in Germany with Bayer if that was his wish:

> But if you cannot get rid of the feeling that it is not right for you to stay there [in the United States] and you would only be unhappy all the time … let it be; telegraph me and we will stay here when you come back, too. The only thing I want to avoid at all costs is having you over there while we are stuck here alone.[9]

These remarks once again illustrate the extent of the entire Bayer-Hecht family's political myopia; personal concerns dwarfed all else. Even in times of great peril to herself and her daughter, Irene Bayer-Hecht thought only about being close to her still-husband, the man she continued to regard as a soul mate.[10] None of her subsequent letters to Bayer mentioned the horrible events of November 9 and 10. This could well have been a matter of simple prudence; surveillance of foreign mail often meant that any political commentary had serious implications for the sender.[11]

Bayer, too, continued to underestimate the danger his wife and child would have faced had they stayed. His letters show that he did not yet feel ready for their arrival in December 1938—just after the MoMA opening—and one may well wonder whether his close work on the show with Ise Gropius fed his reluctance (see Fig. 15.1). The depth of Bayer-Hecht's sensitivity on this subject can be inferred from her warnings issued to her husband just after he left for the US that August: "Don't let the Gropiuses convince you again that you are only a superficial gigolo, not suited to be a father and husband. First, it's none of their business; second, they're wrong; and third, they've already messed up our lives enough."[12] The topic was still raw in June 1939, more than half a year after her own arrival in the United States: "[T]here's only one really insurmountable obstacle between us: the name Gropius. Nothing else. Everything else could be solved—but not this."[13] Two months later, with words evoking the figure of Greek tragedy Medea, she lambasted Ise Gropius:

> One thing I know for certain, namely that I would no longer be able to cope with such experiences as in the past. If I were again confronted with a human being like Frau Gropius and had to endure the humiliations and insults again, I would

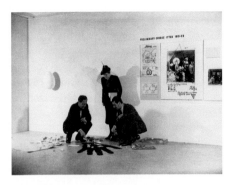

Figure 15.1 Photographer unknown, Herbert Bayer, Walter and Ise Gropius working on the Bauhaus 1919–1928 exhibition at MoMA, New York, 1938. Photograph; Denver Public Library, Herbert Bayer Collection.

kill myself and my child without a second thought. There is a limit to all human suffering. But also to all human endurance.[14]

Anticipating a possible conflict, Bayer had tried before November 1938 to convince his wife to postpone her departure. When her letters indicated that she was finally making concrete plans to leave Germany and come to the United States, he confided to his journal: "Hopefully she can stay a little longer [in Berlin]. It would be too difficult to have her here now. And I had hoped to start with fewer burdens."[15] As it turned out, bureaucracy rendered it impossible to postpone the passage. Bayer-Hecht's passport was about to expire, and she learned from the US consulate that a renewal of her travel documents could mean waiting two years, which made an immediate departure unavoidable.[16]

Fortunately, mother and daughter were able to depart Germany on a ship bound directly for the United States at the end of that very month, probably without making use of the 1,000 Swiss francs Bayer had deposited with Carola Giedion-Welcker in case his family had to leave Germany via Switzerland.[17] Given that the Nazi authorities were all too happy to see any foreigner with a Jewish family background depart voluntarily, her application to leave was swiftly approved. Thus Bayer-Hecht and Julia Bayer traveled from Hamburg aboard the *Washington* on November 30.[18] The ship docked in New York on December 9, 1938.[19] By taking advantage of one of the last opportunities to reach the United States by ship, mother and child escaped the persecution and, often, death that befell even those with partial Jewish ancestry who remained in Germany beyond 1938.[20]

Bayer could not meet them at the pier. He noted in his diary that he had to travel to Philadelphia for an assignment, his first job for the Container Corporation of America, which was to become his most important employer in the United States. This caused "terrible misunderstandings and rantings and ravings" on the part of his wife. It had already been planned that she would stay initially with Xanti and Irene Schawinsky. This brief but intense episode of flight and fights, coming just three days after the MoMA opening, perfectly encapsulates Bayer's eternal struggle to resolve the tension

between his work and his private life: "My heart breaks when I think of those terrible days," he confided to his diary. "I regretted [these fights] from the bottom of my heart. I wanted to be good to both of them, give their lives more security, and be more of a father to Muzi. She was so sweet and pale from the efforts of recent times."[21]

While Bayer's letters to Bayer-Hecht have not survived, it seems that in one he threatened suicide; this at least is what can be surmised from her attempt to hearten him in August 1939: "You must not forget that you are one of the most talented and greatest graphic artists of your day ... I don't want to hear another word about you dying. How are we supposed to live on without you?"[22] In his ongoing correspondence with Bayer, one of Bayer-Hecht's perennial enemies, Willy B. Klar, had no hesitation about offering his own opinion on this sensitive subject: "She has made colossal threats here if you do not submit to her there. She would have you completely in her power. You'd have to live in intimacy with her there. You must never mount nameless girls, etc."[23]

Bayer spent his first eight American years in New York, and the period has been reported on in detail elsewhere.[24] Here it is worth noting that he was extremely willing to integrate into his new social environment and to make the radical linguistic shift to English immediately after leaving Germany, even though his style was (and remained) somewhat awkward.[25] "I made it a rule from the first day on that I would not speak any German," he later recalled, though he continued to write in his diary in a mix of German and English. "There were all those German immigrants here ... and they all wanted to speak German. I always spoke in English."[26] At the same time, he felt lonely and displaced in New York, which he was indeed more than happy to refer to (in German!) as a *Scheiss-Stadt*.[27] Nor did he wish to get used to the crowded streets or to what he considered a certain American public shamelessness. "I am not living. I only drag myself along, unhappy, sad, and unsmiling. There is no joy in anything ... here I feel completely uprooted."[28]

In short, he was initially not at all content with his new life in the United States—"all the promises of this country are so much hot air," reads one of the first English entries in his "Occasional Diaries," concluding that "all goes to pay taxes."[29] According to one outburst in his diary (again in German): "Nobody decides in this country. Nobody takes responsibility ... Even the stupidest person, if he for some reason has a position, money, or the like, speaks out. Are these the advantages of democracy?"[30] He saw great opportunities for himself in the United States, but this would require not "Europeanizing ... but organizing" the Americans.[31] As for womanizing—one of his main pastimes in Berlin—his new surroundings severely hampered his activities. Immediately after landing in New York, Bayer received a multi-page, naughty collage of newspaper clippings in which the "editor", his old friend Vips Wittig, treated Bayer to all sorts of sexual innuendo he had assembled from the domestic press.[32]

In fact, the would-be Don Giovanni faced almost insurmountable cultural differences. Bayer-Hecht had already warned him: "Be careful over there. The ideas of morality are different from what they are here, and the women are unscrupulous."[33] After just three months, Bayer noted in his diary that he had, "a lonely life—without women, even ... Those I met [*was ich kennenlernte*] were stupid and only available

Figure 15.2 Photographer unknown, Joella and Herbert Bayer, USA, 1940s. Photograph; Denver Public Library, Herbert Bayer Collection.

for money or social 'status'. Made-up to the hilt, to the point of insanity. I have the impression that Love is a deeply buried concept. One only goes to bed drunk, a sad state of morality that doesn't permit you to show any awareness of the opposite sex whatsoever."[34] Klar could only dish out his usual scandalous advice: "The business with the girls in U.S.A. is a terrible mess. Can't things be reorganized to suit Berlin standards? *Bum-heil!*"[35] In the same breath Vips Wittig admonished him to "give it to them, but make sure you don't bring shame to the homeland"—a clear reference to Bayer's astonishingly tame social life.[36]

Bayer had, in fact, already met the woman who would become his second wife (see Fig. 15.2). Joella Haweis Levy was still married at the time to the art dealer Julien Levy, but there was an immediate chemistry between them.[37] In February 1939 Bayer was hospitalized for a mental and physical breakdown—the toll of the immensely stressful run-up to the MoMA show, combined with homesickness and a longing for his child, who had in the meantime moved with her mother to family in Chicago. Shortly afterward, he recalled: "God knows how I would have survived these weeks if Joella had not been there. There was a true mixture of our two sufferings, and a great friendship, a person who will surely remain with me for the rest of my life."[38] The final separation of Irene and Herbert Bayer seemed soon to became inevitable. In mid-1939, his still-wife made one more attempt from Chicago to relaunch the marriage in respect and friendship. At the same time, she said she no longer expected anything and declared the situation "hopeless." She had "wanted something from somewhere where nothing was available." Moreover, she expressed gratitude for the material support that Bayer has always provided her and their child. She added:

This country [America] is hard, but also strangely just and generous. Don't we want to be, too? Let all the past be past! To take today and tomorrow as it comes, to become safe and calm for our child, to become safe and calm within ourselves, so that she can find the spiritual basis from which she can go out into life with the feeling that—even if the two people closest to her have not found each again—they are two upright, courageous, pure human beings of whom she can be proud.[39]

Already enamored of Haweis Levy, Bayer was apparently not open to this new beginning, which explains why two of Bayer-Hecht's letters from the summer of 1939 can be read today as breakup notes and farewell messages at the same time. "Do you really believe that there is a woman who would be willing to live with a man who openly tells her that he doesn't love her? Yes, one could be his housekeeper, but not his wife," she asserted. Looking back upon her and Bayer's long relationship, she added:

> I am infinitely grateful to God for the spiritual strength that made me endure all the humiliation and suffering … It is a great injustice that you try to convince me that I am so unpopular. This only applies when you are there, because all women are angry with me when they think that you belong to me. Those poor women, if they only knew … Anyway, unlike before, I can no longer be angry with a woman with whom you have an affair. I would only feel infinitely sorry for her.[40]

She also protested Bayer's ongoing criticism of her and her way of life, which she claimed had destroyed her self-esteem and her impartiality toward people.

A few days later, Bayer-Hecht wrote again and provided what is probably the most clear-eyed account of her life at Bayer's side:

> It was exactly fifteen years ago that I was faced with choice in Paris of going to Weimar to see you or going to America to see my father. Back then I thought there was no decision for me to make—and that you were the first and only person for me. Today it's different. I know that there is a choice … And you see, this is what all our suffering is about. At the very beginning of our marriage I lost my trust in you, and despite the greatest and most devoted love on my part, I could never regain it … Above all, I had something against your friends. Foremost Moholy. But he wasn't actually your friend; in my eyes he was always your enemy … Then there's Frau Gropius. I don't want to say anything more about that. I think after such a long time you've come to the point where you have exactly the same opinion of her as I do. You just have to tell me so I know. Then Herr Klar, and here I insist that he's a phony scoundrel … Then there's the regiment of all your past and present mistresses. I've always spoken ill of these girls because I never wanted to admit to myself that it was your fault, and I wanted to blame them for all your mistakes.[41]

She closed with a sweeping remark that went deep into their shared past: "You have reproached me for deciding on our marriage and our separation. This time, whatever we decide, you will have to bear the same share of the responsibility as a real man."[42]

On July 27, 1944, Bayer was granted US citizenship.[43] He promptly accepted his wife's offer: "If you want to marry someone, just say so, and we will divorce."[44] They formally divorced a month later, on August 22, 1944.[45] On December 2, 1944, Herbert Bayer married Joella Haweis Levy, who at this point had herself been divorced from Julien Levy for more than two years.[46]

Bayer's daughter clearly suffered from the ongoing alienation between her parents. Bayer's relationship with her remained fraught throughout her short life.[47] This was already clear in the spring of 1939, when Muci celebrated her First Communion. Bayer

did not attend. "I didn't bring myself to do it," he noted in his journal, but he visited her that July for her tenth birthday: "We will be very close again very soon ... it was so terribly painful to leave her again. And I swear to myself that I will not see her again for a long time for this reason. It is very difficult. And poor Irene is still suffering so terribly and all over again."[48]

In late September of the same year, Bayer-Hecht wrote her husband about their daughter: "She loves you like an idol. And I believe she is the only person you truly love."[49] Bayer, however, met Bayer-Hecht at the end of September 1939 for a week to clarify that their marriage had no future.[50] This visit left Bayer so deeply shaken that, although he had long since abandoned his Catholic faith, he spontaneously went to a church "to pray for her and for us ... because I see how much suffering I have caused Irene. And she has been the best woman and the most loving person to me."[51]

Another deep existential crisis overcame him in January 1940, a few months before his fortieth birthday; he took out a life insurance policy with his "last funds" to provide for his wife and child in the event of his death. And he set himself the goal of finally solving his family problems.[52] For even in America, his passion for Ise Gropius had not been completely quelled. There was a joint ski trip with her early in 1940 that included Gropius's adopted daughter Ati.[53] Soon afterward, at the beginning of February, Bayer wrote with great clear-sightedness to his ex-lover:

> How can anything of mine be 100 percent when my life has been made up of half measures for so many years? ... Today I know that there is nothing integral until I have become clear with myself. That includes you, Pia. It's the same with you as it is with my pictures, or my everyday work, or whatever I do. And taken together, all of it makes me who I am today: a remainder from various things, without a proper place, without the people I want, consumed by desires and burdened with worries ... I am at my own mercy, and you are protected by marriage. *Such is life!*[54]

This key passage shows once again not only his ongoing emotional turmoil, but how closely Bayer himself experienced the link between his private life and his work as an artist.

In early July 1940, Bayer-Hecht and Muci moved back to New York to be closer to Bayer, but he was disappointed by the encounter with his daughter. Instead of the child of earlier, idealized times, he felt he was meeting a spoiled, untidy, American teen who seemed to have inherited "the nervousness, the excitement of her mother ... I reproach myself most severely for having caused such consequences for the child when I separated from Irene."[55] He considered taking over parental responsibilities from her mother for a while, to remove Muci from the "bad influence" in her environment. In 1943 Bayer again deplored the effects of "American schools, children, and language, movies and radio stories" which added to what he considered an unsatisfactory upbringing.[56] He again lamented his own ignorance in not having anticipated the effects of divorce.[57]

In the 1950s Muci and her father fell out of touch.[58] To Bayer's deep dismay, Julia Bayer suffered an aneurysm in Santa Monica on October 6, 1963, at the age of thirty-four.[59] Bayer was in Munich at the time and only found out about her death through a

call from his second wife. His daughter's early death left him devastated; the year ended with the additional trauma of receiving Muci's ashes. "I am completely broken. ... The year draws to an end with emptiness and a lonely heart for my dead child."[60] He saw himself in a hopeless situation and again thought of suicide in order to follow his daughter, an idea that also came to him in a dream.[61] This hopeless state persisted for the next three years and had a deep effect on his work as an artist.[62] Muci's death brought a letter from her godfather Xanti Schawinsky after long years of silence.[63] (It was Bayer's opinion that their once-close friendship, which he always remembered with great affection, had disintegrated in the United States due to a diffuse sense of envy on Schawinsky's part.[64])

But even before the death of his cherished daughter, Bayer had been plagued by depression and loneliness. Despite years of homesickness, he did not seek extensive contact with the larger German-speaking émigré circles of the 1940s.[65] Indeed, he seems to have regarded his former compatriots more as competitors than as comrades-in-arms. Even in the context of the MoMA retrospective, he noted: "Since the wave of émigrés (artists, art scholars, etc.)—especially from Germany and Austria—has grown enormously, most of the local 'colleagues' would be delighted if this exhibition were a fiasco, for it means competition for them."[66] It is unclear whether this perception was grounded in real experience or simply expressed Bayer's own state of mind at this transitional juncture. The only person he met with frequently in New York was Herbert Matter, a Swiss graphic designer whose photomontage posters he admired.[67]

Still, a number of longer-term friendships helped to sustain him. Bayer later described Vips Wittig as one of the few friends he left behind in Germany with whom he stayed close.[68] Klar was still pursuing vague plans to emigrate in mid-1939,[69] but these fell apart with the onset of war. He was drafted as a motorist into the Wehrmacht, lost an eye to a cataract, and, after years of successfully concealing the fact that he was half Jewish, had his cover blown during his service in the Reichswehr. As a result, he was dragged through Gestapo prisons for high treason, disruption of the military, plotting to desert, and various other crimes. Two years later, at the end of the war, he was liberated from Moabit prison in Berlin by the Red Army, which in turn held him in Soviet prisons for more than seven months on suspicion of being a British spy.[70] Reflecting upon all that he had endured, he wrote to Bayer in 1946, "I am as fed up with the Germans here and have as much hate in my heart as you had in 1938." He continued, "If only I had followed your call and gone there, I told myself ten thousand times ... When I think about it carefully, the main reason was probably my personal connection to my house and my property."[71]

The inner circle of former Bauhäusler, among those whom Bayer could count on in the United States at that time, stood firm for him, even as other relationships in their network underwent tectonic shifts due to the changes caused by the destruction of the German Reich and the beginning of the cold war.[72] Bayer maintained his friendship with Marcel Breuer even after the latter's dramatic split with Walter Gropius, this time definitively, in 1941.[73] Despite the bitterness between his old friend Breuer and his mentor Gropius, Bayer's close relationship with both Walter and Ise remained unchanged over the years. Between 1948 and 1950, for example, Bayer worked through Gropius's firm to design elements for the new Graduate School of Design building at

Harvard.[74] After declining to speak at a Columbia University symposium honoring various architects (on the grounds that he had never been a Gropius student),[75] he offered an olive branch with his much-quoted *Homage to Gropius*, delivered at Harvard's GSD in 1961. His mentor, he declared with an exaggerated flourish, was the founding father of modernity par excellence:

I pay homage to Gropius
for his creative intuition.
for his relentless perseverance in the advancement of life.
for his strength of mind and character
in standing firm against opposition and slander.
for his inspired leadership.
for his deep concern with man and his community.
for his search for a common basis of all understanding
beyond the mastery of material and physical things.
for his belief in personality
as the ultimate decisive value.[76]

The tribute included what only insiders could recognize as a discreet reference to Gropius's grace in handling Bayer's affair with Ise Gropius: "This I learned from him: / to give and take, to live and let live."[77] After Gropius died in 1969, Bayer summed up in his diary one more time the influence that his fatherly friend had exerted on his own life, after he had lost his own father in 1917: "An era dies with him and much of my past. Pius is not dead for me, his spirit is present—I miss him as the warm and longtime friend which he was to me."[78]

Along with Xanti Schawinsky, Alexander Dorner, and Sigfried Giedion, other figures from the Bauhaus era remained important members of Bayer's American network for some time. They were joined by Fernand Léger during his wartime sojourn in America, as well as Friedrich Kiesler and Alexander Calder (see Fig. 15.3).[79] After Bayer's contract in Chicago fell through, his relationship with Moholy-Nagy (who died in 1946 aged just 51) was not without interpersonal bitterness, so things were not easy. During the depths of his personal crisis in the winter of 1940, Bayer wrote to Ise Gropius, suggesting that he was considering a return to Nazi Germany. "Something has to happen. Otherwise I might as well go back home."[80] By "home" Bayer surely meant his native Austria, although he had no illusions about the conditions prevailing there after the Anschluss; this was probably only a rhetorical gesture made to underline the extent of his unhappiness.[81]

Of course Bayer's landing in America was a good deal softer than the conditions that many other European émigrés encountered at the time. While hundreds of thousands of European Jews, including former Bauhaus friends, languished in various cities and ports, waiting for US visas that never materialized, or were refused entry outright, Bayer had arrived in the Land of Opportunity with all his papers in order. Furthermore, his work as a commercial artist provided a good living. Very few émigré artists received an enthusiastic reception as artists but were instead expected to "serve the profit-promising entertainment needs of the 'masses,'" as historian Jost Hermand

Figure 15.3 Fred Hamilton, Alexander Calder and Herbert Bayer in Locust Valley on Long Island, New York, summer 1940. Photograph; Denver Public Library, Herbert Bayer Collection.

put it.[82] Government commissions made it easier for both Bayer and Schawinsky to try their hands in an unfamiliar cultural environment.[83]

And the old networks still proved mutually supportive. Of the design of the Pennsylvania Pavilion at the 1939 World's Fair, Bayer reported that it "shows once again that I can work well with Gropius and Breuer."[84] Unlike such prominent new arrivals to the United States as Nobel-Prize winning author Thomas Mann, Bayer rather followed in the footsteps of Gropius who still scrupulously avoided making political statements. For example, he did not participate in the World's Fair's Freedom Pavilion (which was planned but never materialized) intended to demonstrate the democratic reaction to fascism. It seemed as if Gropius was still concerned that friends, family members, and former Bauhäusler still in Germany would experience reprisals as a result.[85]

At Gropius's urging, Bayer also received the commission to design the cover and typography for Siegfried Giedion's publication *Space, Time and Architecture* in 1940.[86] Giedion, whose Harvard appointment had been supported by Gropius, communicated with Bayer in detail about his ideas, which was easy, as the two lived in the same building in Midtown Manhattan.[87] Both were well pleased with the outcome. While it appeared to be very much of the moment, in fact, Bayer's 1940 montage of a New York highway intersection and a baroque garden is strikingly reminiscent of work that he did in Nazi Germany, specifically his 1935 montage combining a small figure of Hitler with images of the construction of the Autobahn, published in the booklet for the Berlin "health" exhibition *Das Wunder des Lebens*. The similarity underscores Bayer's naïve attachment to that earlier propaganda work, which he would defend on aesthetic grounds throughout his life (see pp. 99–105 and 221–5).[88]

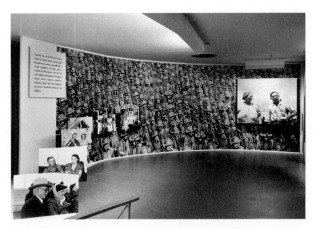

Figure 15.4 Photographer unknown, View of Bayer's displays at the Road to Victory exhibition, MoMA, New York, 1942. Photograph; Denver Public Library, Herbert Bayer Collection.

Gradually, Bayer was also becoming established through his own work in the United States. Following the MoMA retrospective, Bayer received further commissions from the museum. Chief among these was the major exhibition *Road to Victory* of 1942 with what Kristie La has described as its "riveting prose, grandiose narrative, and arresting display."[89] Here Bayer further refined his presentation strategies (see Fig. 15.4) compared to the controversial Bauhaus exhibition of four years earlier.[90] Art historian Benjamin Buchloh, recalling Bayer's involvement in the *Deutschland* exhibition of 1936, argued that Bayer's design also proved how modernist montage aesthetics could be transformed into totalitarian propaganda as well as adapted for the needs of the culture industry of Western capitalism.[91] Referring to its spatial experience of visual communication in a dynamic, multi-perspectival, and multimedia design, French photo historian Olivier Lugon considers *Road to Victory* a masterpiece of propaganda.[92] Bayer, however, later complained that he received almost no feedback for his groundbreaking design.[93]

Despite having new and prestigious projects to work on in New York, Bayer's personal view of his situation was still not positive. Until he was actually able to gain a professional foothold in the mid-1940s, he constantly complained about money problems and indeed even got into debt with Breuer.[94] Even the promises Ed Fischer, an immensely well-connected member of the Art Directors Club of New York and chair of its exhibition committee, to "do something for [Bayer]" had turned out to be nothing more than "chitchat," as Bayer later bitterly put it.[95] In early 1940, Bayer stated in his diary: "I urgently need every *penny* ... No work! All attempts fail."[96] To his dismay, five of the six pieces he submitted for the annual exhibition of the Art Directors Club were rejected. He suspected there were political reasons—some effort to repel the European influence—and that his American colleagues were envious of his having "more experience in all areas of design. More knowledge, more insight. I can see the situation as a whole ... In doing so, I feel the explicit demand to intervene in

solving current problems and practical questions."[97] Although he was always grateful to the country for the opportunity to live and work there, as he later noted with clarity, it took years before he felt recognized and accepted as an artist in America.[98]

During the early years after his emigration, Bayer was entitled to another source of income, funds from the German Reich. However, in times of war, a transfer of foreign currency was out of the question. His brother Theo also tried hard to collect outstanding debts for license fees during this time, for example from Berthold A.G. in Berlin; in this case Herbert Bayer pushed for negotiations as late as March 1940. Theo bargained a one-time commission of 450 reichsmarks, which he still received in January 1941, for the use of Bayer-Type, to which Berthold had the rights until 1946.[99] Other outstanding debts concerned, among others, the Melitta company and the architect and fellow Bauhäusler Gustav Hassenpflug, but by no means did all matters develop in a similarly pleasing manner. On December 6, 1940 Theo Bayer met with the lawyer and auditor Ernst W. Bertenrath, whom Irene Bayer-Hecht had assessed as "trustworthy" and competent.[100] Theo later described him as,

> very well-versed and well-shod, also very friendly, but I had the impression that he is, or was, also "enterprising" with his pockets in mind. He twisted and turned the whole thing around, as if you had to be glad that you didn't have to make payments to him or third parties yourself, and that it was especially the Jewish intermarriage (*Versippung*) that was to blame for the fact that there were no more funds available for you.[101]

On the one hand, the balance sheet submitted to German authorities showed that, between January 1 and July 31, 1938, Bayer had still enjoyed a relatively high income (see pp. 179–80). The liquidation of the commercial property, entrusted to Bertenrath, was carried out through the Foreign Exchange Office at the Chief Finance President; it dragged on until September 1939 and produced the, in retrospect, predictable result that "in the special assets, amounts which could have been transferred to you—of course only with the approval of the chief president of finance—were not available."[102]

No income from Europe was therefore to be expected, a depressing state of affairs that led Bayer to even question his talent in general: "Was I too sure of myself? With all the admiration I had always received as a person?"[103] In this situation, by 1940, Bayer was forced to consider the several standing job offers he had from American advertising agencies.[104] "As much as I hate it, I have to decide these days whether I accept a 'full-time job' in New York or continue as before," he reported. "I'm afraid I'll become completely unproductive if I have to go to the office with hundreds of people at the same time. I know that my 'freedom' is an illusion. But at least it is."[105] Given American society's overall fascination for Surrealism, his visual style and his approach as a self-proclaimed all-round designer was broadly adaptable and commercially interesting.[106] Ultimately he was able to overcome his "European pride" and take a job with the J. Walter Thompson advertising agency as a consultant art director: "I'm expected to represent modern influence in the company. It will mean a lot of careful experimentation …." Interestingly, he added, "there will be no more signed works documenting my compromises."[107]

Crucial to Bayer's reception in the American professional world was a series of articles in *PM*, an influential trade magazine for commercial artists and the advertising industry, which bore the subtitle *An Intimate Journal for Production Managers, Art Directors and their Associates*. Originally conceived of as a special issue titled *The Bauhaus Idea in America* but then published in installments from February 1938 onward, it was up to Walter Gropius to provide the first article for the first issue, with a layout designed by Herbert Matter.[108] The second article, published two issues later in June 1938, was dedicated explicitly to "The Bauhaus Tradition and the New Typography."[109] It appeared just in time for the MoMA exhibition that winter. The thirty-four-page portfolio, designed by Lester Beall, discussed Bayer's work in detail, but Bayer's name was not listed among the US immigrants, as by that summer he had not yet departed from Germany.

Finally, in December 1939, *PM* ran a thirty-two-page cover story on Bayer, who designed the issue's layout as well as its cover.[110] Split into three separate articles he was given the opportunity to present his main fields of activity—commercial art, exhibition design, and typography—with manifesto-like texts, sometimes even supported by transparent inserts with analyses of key motifs. In his "Contribution to Rules of Advertising Design," Bayer highlighted the interplay of consciousness and subconsciousness within consumer psychology, which stood in contrast to the commercialized advertising industry he found in the United States, something the art historian Margarita Tupitsyn has already noted.[111] Percy Seitlin, one of the magazine's editors, nevertheless celebrated Bayer as an advertising artist in the sense of American ideals: "He is an excellent living example of what was expressed by the original and best intention of the Werkbund and Bauhaus: that an artist must have a real, working place in the community; that his work is important not only to himself but to the larger cause of heightening the imaginative life of the people."[112] It is therefore not surprising that Bayer was invited to teach the Advanced Design class at the American Advertising Guild. When published in *PM*'s successor *A-D* and exhibited in the A-D gallery in the following year, the student's works caused quite a public controversy, and again Seitlin had to defend the work samples as "progressive and modern."[113]

In the early 1940s, examples of both Bayer's artwork and graphic design can be found in an array of US periodicals with increasing frequency, for instance his portfolio of photomontages from 1932 (including *Der einsame Großstädter*, see Fig. 0.1) published in January 1940 in the popular magazine *Coronet*, where they were introduced briefly by Julien Levy.[114] Bayer designed the September 1939 and August 1940 covers for the magazine *Fortune*. In December 1941, Walter Gropius personally introduced him to the American media magnate Henry Luce, who, in addition to *Fortune*, also published the hugely influential magazines *Time* and *Life*.[115] More *Fortune* covers were to follow in June 1942 and February 1943,[116] but Bayer's urgent wish to serve as the designer behind the magazine's relaunch was not fulfilled.[117] This was all the more regrettable as it was just at this time that he created another spectacular cover for a different journal: his iconic cover for the August 1940 issue of *Harper's Bazaar* (see Plate 30). German typography expert Eckhard Neumann once called this cover a "design solution that confirms his status as a commercial artist and at the same time anticipates a visual language far ahead of its time." The cover's prescience is evidenced in how its serial sequence of a young woman in half-profile, her lips colored in a range of bold, solid colors, bears a

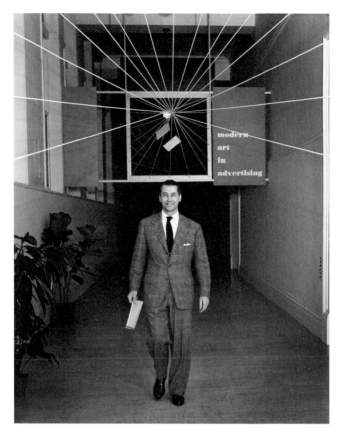

Figure 15.5 Gordon Coster, Herbert Bayer leaving the *Modern Art in Advertising* exhibition, Chicago, 1945. Photograph; Denver Public Library, Herbert Bayer Collection.

striking resemblance to Andy Warhol's later silkscreen experiments with Liz Taylor's lipstick. Certainly, the cover consolidated Bayer's position at the top of American commercial art.[118] In 1942, Bayer created the commissioned booklet "Electronics—a New Science for a New World," which was judged by his contemporaries as the equal of his best German works, this time in the service of public science.[119] An indicator of just how innovative this design was in the eyes of its American audience is the fact that the project's printer, Davis, Delaney and Harrs Inc., distributed it in large numbers to market their own firm. On a transparent additional jacket the company predicted "that this new book will win recognition and acclaim as one of the finest presentations in many years of a scientific subject for the lay mind." (See Plate 31.)

In April 1946, Bayer and his second wife relocated to Aspen in Colorado where he would spend the next 28 years of his life. This move into the mountains was motivated by the fact that he had found a supporter in the major industrialist Walter Paepcke, only four years Bayer's senior, who had established the Aspen Institute there in 1949. The founder of the Container Corporation of America was the son of German

immigrants and a major patron of the New Bauhaus's successor, the Chicago School of Design, and a sponsor of Moholy.[120] Paepcke would faithfully fund Bayer's work until the end of his life in 1960. This close friendship, which according to art historian Bernhard Widder marked a "decisive cut in Bayer's life in New York,"[121] dated back to a first meeting in 1945 at the opening of the exhibition *Modern Art in Advertising* organized by the Container Corporation of America (see Fig. 15.5). In another position obtained through Gropius's influence, Bayer designed this presentation of contemporary advertisements by prominent artists at the Art Institute of Chicago. He also created the exhibition's brochure (see Fig. 15.6); numerous other commissions for the corporation followed.[122]

In particular, Paepcke succeeded in enthusing Bayer for his vision of the mountain town of Aspen as a new Modernist hotspot (see Fig. 15.7). This revived a dream that Bayer thought he had buried already in 1938, when he turned his back on Germany and left the Alps behind.[123] The perpetually melancholic Bayer was plagued by homesickness in the United States and even considered returning to Europe in 1945.[124] His old Bauhaus friend Joost Schmidt recognized his motive for leaving Manhattan for Aspen immediately, writing from Germany that Bayer had obviously "fled New York" for "a beautiful landscape. I can't imagine it, but I think it should be like your beloved Alps. Actually, if you want to be an artist, you shouldn't live in a big city that doesn't let you come to your senses."[125]

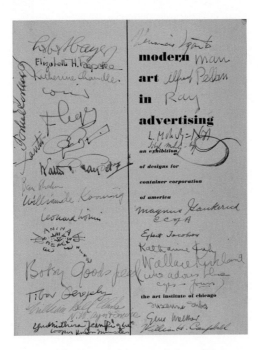

Figure 15.6 Title page of the *Modern Art in Advertising* exhibition catalogue, signed by artists and contributors, Chicago, 1945. Offset printing and ink; Private collection. © Estate of Herbert Bayer/Artists Rights Society (ARS), New York/VG Bild Kunst, Bonn.

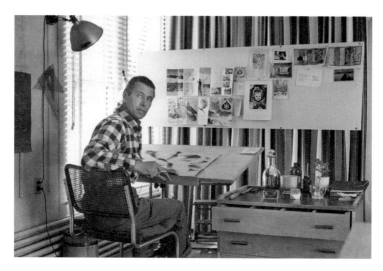

Figure 15.7 Photographer unknown, Herbert Bayer at work in his studio, Aspen, Colorado, c. 1946. Photograph; Denver Public Library, Herbert Bayer Collection.

Later, during a 1958 trip to Austria, he realized that he had lost a sense of a place to call home; "I am now an outsider everywhere, in my home country, among Americans, among non-artists."[126] Despite his notable influence on advertising design, Tupitsyn has hypothesized that that Bayer's retreat to Colorado may not only have been caused by his longing for the mountains but would have also helped him steer clear of the competition from the young American design scene.[127] The connection with Paepcke allowed Bayer to begin to find a sense of being settled in his work and, eventually, his life in the United States. In 1946 Paepcke developed an arrangement that provided him with an annual salary of $8,500 for advising the Container Corporation of America and designing advertising material. This arrangement was explicitly intended to give him the freedom to pursue other activities as well—in Paepcke's words "paint, write books, ski, fully regain his health and all the rest of it, which I estimate to be worth roughly a million dollars a year."[128] Parallel to finding stability in his work through his relationship with Paepcke, Bayer also would have found satisfaction from being involved in initiatives to support former Bauhäusler, such as Gropius's Bauhaus-Fund, which entailed routinely sending CARE packages to family members and Bauhaus affiliates such as Rudi Baschant, Max Gebhard, Carl Schlemmer, and his old friend Willy B. Klar. Numerous thank-you letters testify to Bayer's engagement of this sort.[129] As early as 1947 he heard from his old boss in Berlin, Walter Matthess, who extended an offer to return to Dorland Berlin.[130] But Bayer now categorically ruled out a permanent relocation: "To Germany—I would not like to return."[131]

Not only was Paepcke an enthusiastic and committed patron to designers like Herbert Bayer, Herbert Matter, and other graphic artists of the modern age, but he was also president of the world's largest logistics company of his time.[132] This dual role fitted well with Bayer's straightforward way of approaching arrangements with

commercial clients. A visible expression of their mutual esteem is the special issue of the postwar *Gebrauchsgraphik* magazine on the Container Corporation of America in 1952, to which Bayer contributed not only the cover but also the complete text, which was, essentially, a long eulogy to his sponsor.[133]

In addition to demonstrating his and Paepcke's warm working relationship, this example may illustrate that, even in his new American home, Bayer maintained economic success as the standard by which all things are measured, so that loyalty to his employer was not to be questioned. At the same time, he now condemned those who continued to work in Germany, without seeming to feel particular shame at the fact that he himself had left that totalitarian state much later than many others. This hubris can be traced back as far as a letter to Gropius in 1941 in which he comments on both Hitler's invasion of Greece and the moral stance of his former colleagues in Germany:

> Now it was about time to conquer the heavenly islands of Greece. The ratfink [*Saubazi*, i.e. Hitler] can leave not even those alone. What's going on is simply grotesque. And the prospect of stopping this wave of murders is dwindling. Lately I've received several letters from Germany, but one can't deduce a shred from them. I've also given up answering them. Because one can't help but blame everyone who is still involved there. Even if it's unfair. But personally, their success annoys me the most.[134]

Bayer ultimately found a certain balance in his life, enjoying in his later years a harmonious marriage with his second wife Joella and ample recognition for his creative achievements. A remark he made in 1978, seven years before his death, reveals how deeply his need for validation was rooted in his character. This, too, sheds light on the troubling tightrope walk he undertook in 1930s Germany. Beginning in 1966, Bayer had created a full visual identity for the newly merged Atlantic Richfield Company (ARCO), one of the largest oil corporations of its day. The red diamond of his "ARCO spark" trademark had, by 1978, become a highly visible part of the American landscape. Summing up his work he wrote: "My ideas are now generally understood and appreciated at Arco, by the Board and by the employees. I am considered an equal with the top businessman. This is a position which I have long sought for the designer to attain in order to be useful and effective within the structure of our society."[135]

Herbert Bayer had at last arrived [see Fig. 15.8].

Postscript

Even in her last letter to him, a short note from 1975, an elderly Irene Bayer-Hecht wrote to her ex-husband to offer her friendship and support: "My dear Herbert, just sending you a little love. If I were closer I could help in the work you have."[136]

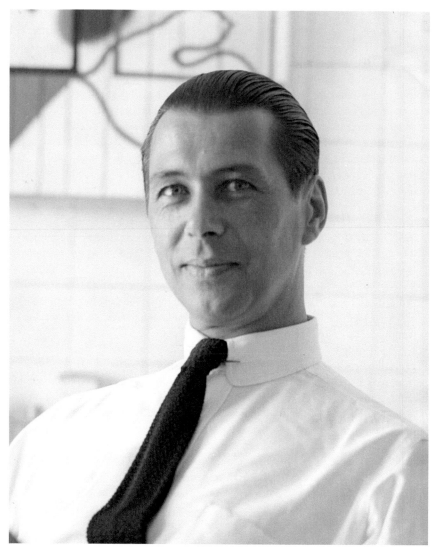

Figure 15.8 Photographer unknown, Herbert Bayer at work in New York, 1942. Photograph; Denver Public Library, Herbert Bayer Collection.

Epilogue: Bayer in Berlin, or: A Life in an Echo Chamber

The political scientist and philosopher Eric Voegelin, who, like Bayer, emigrated to the United States in the summer of 1938, published a treatise that same year on totalitarian states and National Socialism. In his preface to the second edition, printed the following year, he mentioned being confronted by accusations that his analysis had not condemned the Nazi regime strongly enough. Voegelin responded:

> it is precisely in this respect that the politicizing intellectuals fail completely. It is dreadful to hear time and again that National Socialism is a return to barbarism, to the Dark Ages, to times before any new progress toward humanitarianism was made … If my representation gives rise to the impression that it is too "objective" and "advertises" for National Socialism, then that to me seems to be a sign that my representation is good—for the Luciferian aspects are not simply morally negative or atrocious, but are a force and a very attractive force at that. Moreover my representation would not be good if it gave rise to the impression that we are concerned with merely a morally inferior, dumb, barbaric, contemptible matter.[1]

This final chapter considers Herbert Bayer's work from 1933 to 1938 as a case study in this context; and as an epilogue to the course of events described in the previous chapters, it will also discuss how Bayer's Berlin years were portrayed in the literature so far. Looking at Bayer in the 1930s we see a man clinging to his artistic freedom, forging ahead with his personal life, and cultivating an apolitical stance. Although he contributed to Nazi propaganda projects—and received handsome payment in return—Bayer himself never succumbed to the ideological attractions of totalitarianism. Indeed, in private he did not hide his personal distaste for the regime. He was careful, however, to show no signs of his personal aversion to Nazi ideology in public.[2] This later gave some of his American contemporaries—including Alfred Barr—the rather warped impression that he was "pro-Nazi" when working in Berlin.[3] This is a rather surprising misperception given the fact that the American architectural tastemaker Philip Johnson, a close associate of Barr's, was a good deal more enthusiastic about Hitler's "new Germany" at the time than Bayer.[4]

Writing of Josef Albers, who arrived in New York in 1933, Swiss art historian Josef Helfenstein has noted that he showed a "steadfastly apolitical attitude" rather than the political resistance that many attribute as the basis of Albers's prompt departure from

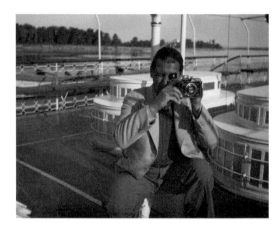

Figure 16.1 Photographer unknown, Herbert Bayer taking pictures on his vacation at the Danube, summer 1934. Photograph; Denver Public Library, Herbert Bayer Collection.

Nazi Germany.[5] Bayer's position was similar. Indeed, political neutrality was something of a Bauhaus creed among many of its members in the interwar period; certainly it was the preferred stance of Bayer's longtime mentor and role model Gropius. Wassily Kandinsky, for example, had countered the charge of being a "dangerous Communist Russian" already in 1924—a year after Bayer enrolled in his mural-painting workshop— by stating in protest, "I have no interest in politics, am totally apolitical, and was never engaged in political activities (don't even read newspapers)."[6] And if Bayer had once been spotted by his friends at the Socialist's Ball before 1933, it was certainly less for political reasons than for personal amusement.[7] Writing at the turn of 1937/1938, Bayer admitted to his journal that his life in Berlin was "regular, almost bourgeois."[8] (see Fig. 16.1) According to extant sources, his deep personal disgust for the Nazi regime never found expression in political opposition, although he did occasionally render it in an aesthetic disdained by the regime (see p. 102).

Bayer must have been aware of the incongruity of identifying as a pure aesthete while creating work that functioned as Nazi propaganda. Judging from the reception he received from his clients and in the trade press, his avant-garde style was not only tolerated but also applauded. For this reason—as Jürgen Krause has pointed out—it is inaccurate to characterize Bayer's works as merely misguided and as only produced during the dictatorship's early phase, when the regime's most abhorrent programs had not yet been put in place. Rather, one could speak here, as Rolf Sachsse has, of "anticipatory obedience" (*vorauseilender Gehorsam*),[9] a familiar term in German scholarship that denotes a willingness to anticipate the wishes of authority before being ordered to take part in it.

In 1972, in the course of reading a work of history on the interwar period, in his diary, Bayer jotted down an insight in his still-awkward English,

> Trying to recall my life during these years I am appalled how blind I lived to the momentous events of these times. Occupied at the Bauhaus with our ideas in which

we were so totally engulfed and with the problems of sustaining an existence in poverty we had no interest in politics. We were clear on this point that art cannot be political but, as I see it today, the artist can and should like any other citizen have political opinions and direction.[10]

In other words, it took him five decades to overcome the Gropius's doctrine of an apolitical Bauhaus. The fact that Bayer's years in Weimar and Dessau coincided with serious political organizing, activity, and resistance in both towns appears to have completely escaped his attention at the time. Looking back from the vantage point of 1972, he admitted that he had only perceived the great upheavals of the times to the extent that they had an impact on his private life.[11]

How credible are Bayer's later meditations on how little he noticed the downsides of Hitler's state? As he put it in his original English:

When the Nazis came to power I was convinced that this could last only a short time. Violence on the political scene was nothing new in those days. But of the real viciousness I had no idea until I witnessed the smashing of Jewish shops by SA troopers. I had kept working largely for Jewish customers until they gradually left. Of concentration camps we did not know.[12]

With his Jewish clients vanishing from his professional field, and with just a slender US passport separating his wife and child from vicious anti-Semitic persecution, did Bayer *really* not ask himself why so many Jews were leaving Nazi Germany at the time or where they were going? How could he *not* have questioned the legitimacy of the discrimination against an entire segment of the country's population? When, at the time, Bayer discussed the regime with his close friends Marcel Breuer and Xanti Schawinsky, was it *only* to mock the buffoonery, the absurdity of the system? Both Bauhäusler were Jews, amply aware of the dangers ahead, and both left Germany in 1933. Could he *really* have traveled abroad regularly—to Switzerland, France, and especially in 1937 to England and the United States—*without* hearing questions from the people he met about the extent of Nazi persecution and of the existence of the concentration camps?

Bayer told himself he "had no idea." While the desire of a seventy-two-year-old man to restore dignity to his life and his past is perhaps understandable, his activities in 1933–1938 involved something more sinister: willingly looking away from the truth, perhaps because it was easier for him. To accept the regime and its ideology as uncritically as he did, and to show as much willingness in his work to adapt to the Zeitgeist, involved nothing short of denial. He managed to maintain this state of denial; when, in 1972, Bayer wrote in his journal, "I never worked for a governmental cause, only for the industry," he was telling himself a lie.[13] Although he never accepted a commission from the Nazi party or from state authorities, he supported an industry that served the ideological aims of the regime.

Next to his own creativity, artistic promise, and craftsmanship, Bayer's overlapping personal networks were his most important asset in his successful years in Berlin. Some of his contacts belonged to his temporary functional networks—for example,

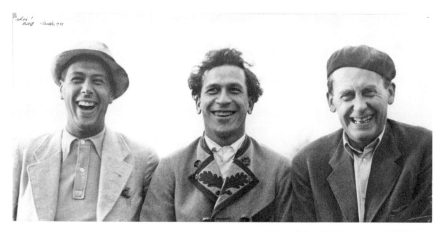

Figure 16.2 Ise Gropius, Group portrait of Xanti Schawinsky, Herbert Bayer and Walter Gropius, Christmas 1933. Photograph; Bauhaus-Archiv Berlin, Estate of Walter Gropius. © Bauhaus-Archiv Berlin.

ex-Bauhäusler who remained in Germany. Others among his contacts, like Ingo Kaul, worked to further the Nazi cause and supported and promoted Bayer as an outstanding German commercial artist of his time (see p. 98). Paramount, of course, was his core circle of old friends and teachers: Walter and Ise Gropius, Marcel Breuer and Xanti Schawinsky, and László Moholy-Nagy (as both his teacher and role model in his field) (see Fig. 16.2). This network of "strong ties" stood by him for decades and finally facilitated his well-planned landing in the United States, preparing the ground for the arrival of one of Germany's leading advertising and commercial artists.[14] But there were so-called "weak ties" as well,[15] which helped him build bridges to other groups of importance; these included Lady Norton (aka Peter Norton) and Alexander Dorner, who later claimed that he and Bayer were "intellectually like-minded."[16]

Bayer found a strong supporter in Dorner who provided a comprehensive review of Bayer's work in 1947, actually the first monograph and for a longer period of time the major source for his biography. Immediately after the war, Dorner succeeded in placing his new book project—*The Way Beyond "Art": The Work of Herbert Bayer*—in a prominent position: a book series affiliated with MoMA, published by the German émigrés George Wittenborn and Heinz Schultz. This high level of attention was rather unusual for a volume addressing the work of a commercial artist, and the book's first edition also served as the companion volume to a touring solo show. Given how tainted and problematic Bayer's time in Nazi Germany was, it is rather shocking that the first major exhibition and catalogue to present Bayer's work to a broader public in the United States specifically characterized him as an anti-Nazi activist. Thus it seems worthwhile to analyze in greater detail the precise circumstances under which both book and exhibition came to life.

In 1938, when Bayer was still preparing MoMA's Bauhaus retrospective, Dorner had been appointed director of the museum at the Rhode Island School of Design

(RISD); the school's directors hoped to develop it into another kind of "New Bauhaus." After minor success and many entanglements—some of them connected to his activities in Nazi Germany—Dorner was fired in 1941; until 1948 he was an adjunct art lecturer at neighboring Brown University, also in the state capital of Providence.[17] It was during this time that he began to write *The Way Beyond "Art,"* an extensive study of modern art in general. To support his ideas with the work of a particular artist, Dorner approached Moholy; this went unrealized, mostly because Moholy, who was diagnosed with leukemia the same year and died soon after, wanted to maintain his artistic independence and remained reluctant to cooperate with another institution.[18] Bayer, however, consented to serve as Dorner's case study and showed great interest in the preparations, although he left all of the work on the catalogue to Dorner from the outset.[19]

The touring retrospective, Bayer's first, opened at Brown University's art gallery on January 20, 1947. It featured examples of his graphic and exhibition design, some documented by photographs, as well as many works of fine art, including six montages, twenty-two paintings and watercolors, gouaches, and drawings.[20] The show was conceptualized by Bayer for easy mounting and transportation and made its way to ten venues, including the Chicago School of Design (the future IIT Institute of Design) in the summer of 1947, half a year after Moholy had succumbed to leukemia.[21] That some of the other galleries on the tour (for example, the Joslyn Memorial Museum in Omaha, Nebraska and the Boise Art Museum in Idaho) were rather more remote from the main centers of the American art world may have contributed to Bayer's doubts that the exhibition would reach the audience it deserved. Even though MoMA consented to publish the book as part of an affiliated series, the museum apparently did not respond to Dorner's proposal to exhibit the show there.[22]

It is possible to reconstruct the genesis and realization of *The Way Beyond "Art"* with the help of Bayer's meticulous filing system for the project, some 400 sheets, as well as the George Wittenborn, Inc. Papers in the MoMA Archives.[23] Planning for the volume began as early as spring 1945; initially meant as a "reputable guidebook" to accompany the exhibition at Brown, it was to be organized in two "layers": one describing "the act of artistic invention" and the other its "impact on practical life."[24]

On April 24, 1945 Dorner sent Bayer the four-page book pitch divided, like the subsequent manuscript, into three main parts, of which the first two were supposed to discuss the genesis of, and tensions in, contemporary art in general, while the third, practical life part would be dedicated to the work of Bayer. Dorner's goals were ambitious: "I want the exhibition and the book to be a step forward not only for both of us, but also for modern life!"[25] Regarding the segment on Bayer, the synopsis stated that he represented a "new type of artist" who strove for more, not contenting himself with mere "self-expression" but pushing for a common language, as displayed in his practical work.[26] Wittenborn and Schultz did not hesitate to accept the project and sent the first contract draft on April 27. The volume was the third in the series "Problems of Contemporary Art." Wittenborn and Schultz initially envisaged working with American graphic designer Paul Rand for the volume's layout, but Bayer himself ultimately designed the typography and book jacket (see Fig. 16.3).

Figure 16.3 Herbert Bayer, Book jacket for Wittenborn and Schultz Publishers, New York, 1946. Offset printing; Private collection. © Estate of Herbert Bayer/Artists Rights Society (ARS), New York/VG Bild Kunst, Bonn.

As 1945 came to an end, Dorner showed the draft of the manuscript to Bayer. In his cover letter accompanying the manuscript, Dorner described the process by which he had arrived at this version as the "difficult birth of a new philosophy of art" with a "revolutionary approach."[27] Indeed, Dorner's philosophical narrative also dominated the exhibition, which, to Bayer's surprise and irritation, included large-scale explanatory texts alongside the pictures.[28] As art historian Rebecca Uchill has concluded, "the primary argument of the exhibition was Dorner's, less an argument about Herbert Bayer's work than one conveying Dorner's interpretation of the evolution of art."[29] This was altogether in keeping with the approach the curator had pursued in his Hamburg days; the Soviet constructivism scholar Maria Gough coined the noun "dornerization" to describe his relationship with El Lissitzky at that time.[30] The same pattern emerged with Bayer after Dorner chose him as a suitable representative for his own mission in arts and politics.[31]

Bayer's response to the draft was ready within three weeks and took the form of a seven-page letter. After congratulating him on the manuscript, Bayer proceeded with an unsparing list of points: a full sixty-one suggested corrections. Some of these related to cosmetic matters such as word choice but others were more substantial, pertaining to factual corrections, queries, and questioning lines of thought.[32] Among other things, Bayer expressed unease that Dorner wished to compare his works to Picasso's *Guernica*.[33] From today's perspective, there is something very striking about Bayer's list—namely that he had no qualms about a particular passage touting him as fighting a "lonely, hopeless fight" against "fascist authorities." The following glorified portrait of the artist-cum-resistance fighter received no comment from Bayer and was printed on page 179 of the book:

> It is amazing how long Bayer managed to brave the fascist authorities in Berlin with his utterly anti-absolutistic, visual speeches. Every poster and picture of his

proclaimed loudly that art does not become "healthy" but degenerates if it relapses into traditional, three-dimensional structures; when it becomes immured in allegedly eternal, general ideas of racial beauty, physical fortitude and God knows what dead Absolutes which force themselves upon life in the guise of brutal, reactionary concepts, it kills life. Bayer fought one of those lonely, hopeless fights against an ever more tyrannical enforcement of obsolete reality by those who were afraid of the life of tomorrow. What finally forced him out was his inner conviction that there was no longer any sense fighting against a collapsing mountain. So he came to this country to continue his revolutionary job.[34]

Considering the meticulous care with which Bayer commented on and corrected the rest of Dorner's manuscript, there is only one conclusion to draw here: that he embraced the passage. The lines make no mention of those works in which Bayer applied his visual language in the service of the regime. Elsewhere, Dorner discusses a handful of these items, for example, the booklets and posters for the propaganda exhibitions, albeit without mentioning their distinctive political contexts.[35] Dorner provides a purely formal interpretation for one work that was granted particular prominence in the show: Bayer's 1935 exhibition poster for *Das Wunder des Lebens* (see Plate 15).[36] To describe the context in which that particular piece was designed, however, would have contradicted his claim that "every poster and picture" of Bayer's loudly proclaimed resistance to such "dead Absolutes" as "ideas of … racial beauty." Instead, the book promotes the idea of a revolutionary David fighting the Nazi Goliath. Bayer apparently was pleased enough with the description not to object.

Written at the end of 1945, the text itself should be viewed within a distinctive historical and moral context. Indeed, Dorner's entire book can be seen as contributing to a kind of informal "denazification" of the artist's reputation in the service of facilitating both their advancement in the United States.[37] Some years later, Bayer would return the favor, serving as a character witness as part of Dorner's request for restitution from the German government in 1953.[38] When corresponding about the cooperation between Dorner and Bayer in 1947, German constructivist Friedrich Vordemberge-Gildewart found harsh words: "Both would fit well together," he wrote to Bauhaus Alumnus Max Bill, with Bayer producing just big *kitsch* and Dorner proving to be a loser in the United States; the book was supposed to turn out, in his opinion, as nothing else than "filth."[39] In his response, Bill claimed that it was also in Bayer's interest that his "swindle" was ennobled by the voices of Nobel laureates in physics.[40] Indeed, Dorner relates Bayer's paintings at some point to the "Uncertainty Principle" by Werner Heisenberg and Erwin Schroedinger's world of immaterial waves.[41] Max Bill rejected an offer to review the book and deplored instead that Wittenborn (whom he held in high esteem) "had fallen among the thieves."[42]

Subsequent correspondence between author and artist about the project lasted for about two years and dealt almost exclusively with questions of artistic intent, illustration material, and cover design. Only once did the topic of content come up again—and tellingly. When Bayer received the final page proofs in late 1946, he asked Dorner to delete the entry on the catalogue for the 1938 Bauhaus exhibition in New York from the biographical overview at the back of the book.[43] Although Walter and Ise Gropius later admitted that the volume was essentially Bayer's work, the credit page

named him only as the book's "co-editor"; apparently—even after eight years—this galled him enough that he preferred to see no mention of it made at all.[44]

Up until the publication of Dorner's study, Bayer was intensively involved in the correspondence between publisher and author.[45] After several production delays, the first copies arrived precisely one day *after* the exhibition closed at Brown.[46] Many details of the book's design, including the selection and arrangement of illustrations, the material and color of the cover, even the typesetting of the title pages, were only decided after consultation with Bayer. In view of this intensive involvement and despite all indications of "dornerization," there remains a good case for describing this publication not only as the first "monograph" *of* Herbert Bayer but also as a book *by* Herbert Bayer.

A second edition, published the following year, offered an opportunity for further revisions. In the summer of 1947, Bayer wrote a letter requesting four fairly harmless changes.[47] Again the heroic paragraph professing Bayer's "anti-absolutistic" tendencies and related passages passed without comment—again suggesting that Bayer must have been quite satisfied with Dorner's account.[48] More than three decades later, when working with writer and editor Arthur A. Cohen to produce a new comprehensive volume, the octogenarian Bayer did admit that he had been "flattered" to receive so much recognition from a distinguished museum director but found the praise for his work to be somewhat exaggerated.[49] As Swiss art historian Stanislaus von Moos rightly pointed out in 1982, however, Dorner seems to have

> repressed some of Bayer's commercial graphic works from his memory when he interpreted Bayer's work as a bold antithesis to the cultural politics of fascism. It speaks for Bayer's artistic instinct that he shuttered himself off from Dorner's "productivist" interpretation of his work, at least with regard to its extreme consequences; the author of *The Way Beyond Art* himself admits that the artist would refuse to compare his can of sardines [that is, Bayer's 1942 jacket design for *Can our Cities Survive?*] with Picasso's *Guernica*.[50]

Shortly after Dorner's death, in 1957, a final revised edition of the book appeared in drastically truncated form. The entire section on Herbert Bayer was omitted, along with the book's subtitle, turning Dorner's contextual essay into the book's primary text. Bayer wrote an indignant letter to the author's widow, Lydia Dorner, who had even authorized a German edition based on the abbreviated version, which was published in 1959.[51]

It was not until 1967 that Bayer himself compiled a comprehensive monograph of his oeuvre, including his commercial art, material that ranged from his 1923 designs for emergency banknotes to the *World Geo-Graphic Atlas* he designed in 1953 (see Fig. 16.4).[52] Appearing in both English and German editions, *Herbert Bayer: Painter Designer Architect* was deftly timed to arrive just before the large-scale exhibition *50 Years of Bauhaus* (*50 Jahre Bauhaus*), which originated in Germany and toured internationally from 1968 on. Bayer was responsible for the show's catalogue, exhibition design, and overall coordination.[53]

herbert **bayer**

visual communication
architecture
painting

Figure 16.4 Herbert Bayer, Book cover for Reinhold Publishers, New York, 1967. Offset printing; Private collection. © Estate of Herbert Bayer/Artists Rights Society (ARS), New York/VG Bild Kunst, Bonn.

If Dorner's *way beyond "art"* recast the artist's last six years in Germany to make them look more intellectually and spiritually defiant than compliant, Bayer's own 211-page monograph simply buries that uncomfortable era beneath a single sentence in the introduction: "The political conditions in Germany in the Thirties impelled me to move to the United States."[54] The book's work list also almost entirely neglects the pieces he did in and for Nazi Germany; the notable exception being—again—his design for the catalogue cover of *Das Wunder des Lebens*, from which he included four pages with his color montages as a plate, while prudently opting to depict these *before* it was combined with text.[55] As for the poster from the German-Aryan Garment Manufacturers' Association (ADEFA) series, by deliberately retouching it and backdating it to 1930, both editions of Bayer's book effectively paper over the political circumstances in which it was created (see pp. 110–12 in detail). The innocuous caption reads simply, "poster, water repellent fabric."

Toward the end of his life, Herbert Bayer chose Arthur A. Cohen as his ultimate biographer. Together with his wife, Elaine Lustig Cohen, widow of Alvin Lustig and herself a graphic designer, he ran the Manhattan-based antiquarian bookstore Ex Libris, which also sold original drawings and advertising ephemera by Bayer.[56] He had had business dealings with Cohen's bookshop since the summer of 1974, when Cohen had first approached Bayer to ask where he planned to place his archive.[57] There Bayer attempted—with mixed success—to sell duplicates of his advertising graphics.

Bearing the confident subtitle *The Complete Work*, Cohen's enormous 426-page book on Bayer appeared in 1984, a year before the artist's death and two years before the author's. Cohen based his extensive study on various interviews he and Ruth Bowman conducted with Bayer in English as part of the California Oral History Project, as well as on a series of letters in which Bayer responded, also in English, to around a dozen detailed questionnaires formulated by Cohen.[58]

These are extremely useful sources of information upon which I too have drawn for this book. However, as first-person narratives of the artist's life and work, they are also problematic. Most tellingly, and yet unsurprisingly, considering the extent to which its author relied on the artist's own narratives, *Herbert Bayer: The Complete Work* oversimplifies the six years Bayer spent living and working in Nazi Germany. Cohen introduces the period with the by now familiar note that Bayer had never followed political events closely and failed to register "the dreadful auguries of political catastrophe in Weimar Germany and the doom of its free institutions."[59] Elsewhere he describes Bayer as a "political ingénue. Like many of the most talented artists in Germany, he was too occupied with his work to be much interested in the political events of the day. He did not believe that National Socialism would thrive."[60]

Cohen does, however, report a noteworthy incident that is documented nowhere else: an episode involving Studio Dorland's misuse, after Bayer left Berlin, of one of his designs—including the Bayer signature—for an advertising graphic to which the slogan "Arbeit macht frei" was added.[61] There are no extant copies of this design, which calls into question its existence. It is possible that the aging Bayer was thinking of the poster series he designed in 1934 for the German Labor Front (DAF) that was changed around 1935 to include new lettering and the Strength through Joy association's Swastika logo (see pp. 107–8 and Plate 21).[62] The adjustments were made well before Bayer left Berlin, however, making it hard to believe that it was done without his approval, or at least his knowledge.

Cohen only mentions the episode in passing in order to suggest that Bayer's mindset corresponded to the attitude of internal emigration,[63] a concept that hardly applies to Bayer, as I outline in the introduction. Cohen concludes his discussion of Bayer's time in Berlin,

> Given that his wife and daughter were Jewish, it was no longer an option to stay put, to "tough" it out as did those who imagined that the madness would pass. After long consideration, accelerated by the Anschluss, which drew Austria into the orbit of the Greater Reich and converted Bayer into a German national, he set his course in emigration. Bayer recognized that his work as a graphic designer was less threatened than his work as a painter.[64]

Elsewhere, the author points out that Bayer was also affected when the German museums were purged of "degenerate art."[65]

In addition to pursuing his interests in fiction and twentieth-century art and design, Cohen was also a theologian who published widely on Jewish thought; the Holocaust was certainly of great interest to him. In keeping with his knowledge of the broader context of Nazi Germany, Cohen was aware of the crucial importance of this

period in Bayer's life and, with the questionnaires and in interviews, had sought—unsuccessfully—to draw him out. When sending a draft of his account on the Berlin period to Bayer for review, he implored his subject: "Please don't ask me to ignore these biographical matters as it is obviously impossible." Bayer's response spoke volumes: "It irritates me to say the least to have to warm up times of my life which I would rather leave resting in piece [*sic*]. In whichever way I will try to answer your questions, it will sound like defense for a crime committed."[66] Bayer ended up authorizing the passage quoted above, and indeed, the published version was very close to Cohen's original draft.

From the broad array of examples of Bayer's commercial graphic design created between 1933 and 1938, Cohen examines only one piece closely: a 1935 ad for a decongestant called Adrianol, a work that is safely removed from any political context. Cohen's justification for the narrowness of his scope—in a book of more than 400 pages!—is rich in unintended irony: "Since it is one of the most thoroughly documented periods in the history of Bayer's oeuvre, it is impossible to do justice in brief compass to this period of Bayer's work as graphic designer."[67] Exactly the opposite was true at the time. The footnote backing up this claim mentions Dorner (describing his book as one of the best surveys of Bayer's prewar work) and Bayer's own 1967 monograph, praised for supplying excellent visual documentation.[68] With hindsight, Cohen evidently did what he could to accommodate his subject's desire to downplay these years. Not only did it spare a much-admired living artist the tinge of Nazi association, it also secured his subject's consent to the publication.

Of Bayer's exhibition designs during the Nazi period, Cohen only states briefly that, despite the influence of National Socialism, they "retained their freshness in technique while their scale and content became progressively narrower and in several cases nationalistically constrained."[69] Nor do his examples include the trilogy of propaganda shows for which Bayer played a prominent role (see Chapters 6 and 7). An illustration from the small 1935 booklet for *Das Wunder des Lebens* is reproduced without comment but with an incorrect date, 1936, in this case an innocent error.[70] Finally, the biographical chronology at the end of the volume makes only general references to the design of exhibition booklets for the years in question. Cohen reiterates Bayer's claim that the propaganda content was inserted only subsequently into Bayer's booklet for the 1936 *Deutschland* exhibition. He bolstered Bayer's statement—made in his diaries from 1938 to 1940 that it was no longer possible to do independent design work in Germany—with the familiar claim that Bayer maintained good relations at Dorland with Jewish clients.[71]

It was around the time of his interviews with Cohen that Bayer bequeathed large parts of his archive and work for transfer during his lifetime to two institutions: the Bauhaus-Archiv Berlin and the Denver Art Museum, near his home in Aspen. He had previously given a number of important pieces to the German curator and typography expert Eckhard Neumann, who contributed an essay to the Bauhaus Archive's 1986 catalogue accompanying the second exhibition of Bayer's donated works.[72] Although printed matter with a decidedly propagandistic character did make their way into both archives at the time, and evidence of their existence also reached Neumann and Cohen, a thorough critical assessment of the material never took place in Bayer's

lifetime, and certainly not as part of the two exhibitions showcasing the gifts. The 1982 Bauhaus Archive catalogue did include some critical remarks in Magdalena Droste's contribution.[73] Gwen Chanzit's studies based on the contents of the Denver archive, however, contain remarkably few political or historical references and therefore no statements about the circumstances leading up to Bayer's emigration.[74] For the period 1933–1938, Chanzit bases her biographical overview on the same stripped-down exhibition list provided by Cohen. And Cohen, in turn, was clearly working off Dorner's highly selective 1947 compilation.[75] Moreover, by erroneously dating *Das Wunder des Lebens* to 1932 and describing it as merely a "large health-oriented exhibition in Berlin,"[76] Chanzit's book inadvertently fosters precisely the same innocuous impression that Bayer himself strove to cultivate. Chanzit was certainly not the only one to hold the line on a depoliticized history of the artist; Karin Anhold, in a 1988 dissertation on Bayer's work through 1938, also missed the show's strong emphasis on racial hygiene, merely characterizing it as "a hygiene exhibition ... that celebrated the human body as a scientific marvel."[77]

As this overview of the literature since Dorner's 1947 book attests, for many years Bayer scholars barely touched on the most troubling years of his biography and work.[78] Certainly the artist himself played an outsized role in encouraging the omission. It was a period during which he felt torn between adaptation and emigration, more confused and disoriented than at probably any other phase of his life. Yet it was clearly more than a sense of awkwardness that led Bayer to make his work in Nazi Germany effectively a taboo topic. As he seemed to note himself late in his life, to some degree he was self-reflective enough to know this work was, by and large, nothing to be proud of.[79]

It is certainly worth stressing that Bayer never actively supported Hitler, his goals, or the Nazi regime, unlike many of the period's "economic mercenaries," the so-called *Konjunkturritter* (economic knights) who joined the Nazi party and pandered to the regime in order to make a quick buck. At the same time, Bayer had no qualms about accepting commissions from the periphery of the state and the party. As long as he could situate the assignments within the vague terms of cultural and commercial advertising, he could view such projects as nothing more than an intellectual and artistic task, a challenge to find the most graphically and aesthetically convincing design solution possible. Postwar attitudes necessitated subsequent touch-ups, revisions, and manipulations. As the design scholar Ute Brüning put it in 1999, "we are dealing with an oeuvre that has been repeatedly tidied-up and streamlined by Bayer himself."[80]

Bayer's "striving for exclusivity and control," in Brüning's words,[81] over his own biography complicate the present study as well. My argument builds on the important work of more critical recent German scholarship, particularly Brüning's 1993 study of the propaganda activities of various Bauhäusler after Hitler's rise to power, which pays substantial attention to Bayer. Rolf Sachsse's sharp 1994 polemic on Bayer's career pursues a similar line, as does the 2000 exhibition catalogue *Die nützliche Moderne* (*Useful Modernism*) prepared by curator Jürgen Krause. Finally, historian Alexander Schug delves deeply into the details of Bayer's development in the 1930s in two publications: his contribution to the 2004 German-language history of Dorland, *Moments of Consistency*—which quotes important sources and outlines the ways in

which Bayer's personality was affected by Nazi rule—and his contribution to the 2009 catalogue *Ahoi Herbert!* accompanying the exhibition in Linz.[82]

These more recent works all stress the same aspect of Bayer's biography: that when he finally decided to emigrate, he had the luxury of planning a soft landing for himself. Not only did he leave Nazi Germany legally and with a coveted US residence visa in his passport, but he was also able to preserve large portions of his oeuvre and personal archive. Additionally, he had already learned English, could tap into a network of influential contacts, and had reasonably good work prospects—including an initial job contract. "What is certain," writes Schug, "is that Bayer's emigration in August 1938 was not a political escape, but was well-considered."[83] Bayer as such is practically the epitome of the Bauhäusler in America, who—in Peter Hahn's 1997 assessment—was able to turn American "exile" into the stuff of legend.[84] Even if Bayer himself continually complained about the unsatisfactory state of his life in America, his close integration into the Bauhaus networks was one of several factors that spared him the harrowing and existential experiences of those *forced* to flee Nazi Germany in fear for their lives.[85]

Unlike many émigrés from Hitler's Germany, Bayer never nurtured ambitions of supporting a revolt against Hitler once he was abroad; nor did he undertake any activities to support refugees. "I know, there is so much going on in the world, that personal messages seem out of place, but what else is it in life than personal relationship(s) that will make the world worthwhile to continue," he wrote to Lady Norton in 1942, a remark that reveals his focus on friends and networks.[86] From the outbreak of the war at the latest, he observed developments with concern, but only occasionally did this result in a true intellectual engagement with current events beyond the usual hand-wringing. It is telling, for example, that after reading a newspaper article on a German-Italian agreement to resettle 200,000 Tyroleans, he noted it as "probably Hitler's greatest betrayal of his countrymen."[87] Of the fall of France he wrote: "The freedom of the individual and the culture of France are now over. Hitler cannot replace it, he never understood it, and that must be why he is now prepared to embark on France's destruction."[88] These are the exceptions, however; for the most part, his preoccupations involved personal problems and earning a living. If his opinion of America was negative at first, this again was largely the result of his uncertain finances.[89]

Today it would be presumptuous—especially for those of us who were spared the existential threat of the Nazi era, either for generational or geographical reasons—to sit in moral judgment on Bayer.[90] This study was by no means undertaken in order to judge the lives of historical actors. Lives lived in contradictory and tumultuous times could hardly have involved anything but multiple contradictions. It would do Bayer a disservice to accuse him of an opportunist attitude when he was a working émigré lucky to get out from under a regime he detested, and luckier still to be able to rejoin a personal network he had built up over many years.

He was, however, judged by his peers in personal correspondence, as documented above by the letters between Vordemberge-Gildewart and Bill who complained about Bayer's outrageous involvement with the regime. Another former Bauhäusler who took issue in private with Bayer's behavior was Jezekiel D. Kirszenbaum, who had emigrated to Paris in 1930 and had produced illustrations and drawings for various Berlin newspapers under the pseudonym Duwdivani.[91] In January 1938, he wrote to his old

Bauhaus friend Paul Citroën, who had returned to the Netherlands, and who, as Jewish, would soon enough be forced into hiding. After calling Moholy a *Gesinnungslump*—a political opportunist, a moral lowlife—Kirszenbaum had some unflattering words left over for Bayer: "A person with ethics wouldn't bring someone like Herbert Bayer to America; he never gave a damn in Germany. Bayer's main thing was to be considered the top Nazi poster artist. No, my dear fellow, a moral pig is still a lowlife."[92]

Despite harsh words from some of his contemporaries, Bayer earned recognition on both sides of the Atlantic by helping, as Hahn writes, to further "the cause of modernism against an artistic tradition that was increasingly perceived as moribund."[93] This legacy remains undisputed. As he grew older, however, his nostalgia for his native Austria became more acute; in a 1970 diary entry, he wrote, "I should never have left *meine geliebte Heimat*."[94] This might have been due at least partly to selective memory—a fundamental problem of history—but it also suggests that emigration had taken a toll. Some of the erroneous information in the Bayer literature can be traced back to the fact that he was quite elderly when Arthur Cohen, Ruth Bowman, Paul Hill, and other interviewers came asking about events that had taken place some fifty years before. Other inaccuracies—particularly the fortuitous backdatings—were, however, deliberate, intended to conceal or trivialize work he had done in the service of Nazism.

Thirty years ago Peter Hahn asked whether Bayer had compromised himself with his Nazi-affiliated works.[95] From today's perspective the only answer can be Yes, considering his backdatings which were aimed at concealing the period during which he created those works. As Rolf Sachsse has pointed out, Bayer's pragmatism bordered on the very *aestheticization of power* that Walter Benjamin warned of in his epilogue to "The Work of Art in the Age of Mechanical Reproduction."[96] The first published version of that seminal text appeared in 1935, the same year that Bayer's handsome poster drew a mass audience to *Das Wunder des Lebens* in Berlin. Particularly when considering Bayer's posters, book covers, Hitler Youth pamphlets, exhibition program planning, and advertisements for ADEFA products, among other things, we must never forget that all served to enhance the appeal of the totalitarian state.

One question remains open, however: whether Bayer actually believed himself when justifying his work for the regime as purely a matter of fulfilling a design brief. Both during and after his Berlin period, was he merely acting strategically—and against his better judgment—to play down his role as one of Nazi Germany's most acclaimed graphic designers? Kirszenbaum may have seen him as "the top Nazi poster artist," but how did he see *himself*? The answers to these questions are buried deep in the character of a person who is no longer available for inquiry—during his lifetime, Bayer's biographers either neglected to ask these questions (or they did not document his answers). Any conclusion from what is presented in this book must remain mere speculation, but evidence suggests that, at least for a certain period of time and in the area of his professional practice, he was able to define a selectively distorted world in which he gave work to old friends even if they were haunted by the regime; in which he continued his business with Jews, even if their numbers were decreasing rapidly; and in which he avoided any preventable direct contact with the Nazi party's officials and institutions. In his own private "echo chamber"[97] he went on chasing girls in the bars of Berlin, earned good money with graphic design for lifestyle products, and

expressed subversive thoughts as if they were part of a parlor game. Politics—especially the regime's atrocities, social and cultural alignment, suppression of free speech—all this seemed to belong to an outside world that Bayer managed to suppress as long as possible.

In one of his later reflections, Bayer confirmed that "typography is not self-expression but is based on and conditioned by the content being expressed"[98]—a remark entirely consistent with the functionalist tradition of Bauhaus teachings. Measured by these standards, only a considerable degree of self-denial can explain Bayer's ability and willingness in the 1930s to give such congenial aesthetic form to such obvious fascist propaganda. In his later life, Bayer sought to maintain the clean image of his commercial oeuvre by dating as many of his designs as possible to the "good ol' days" of the Bauhaus period—or at least close to it, and this practice may have allowed other misattributions to arise.

It was in Weimar and Dessau as an ambitious junior master with a tremendous talent for visual communication that he was not only socialized but also received the labels and titles that marked his entire career: *herbert bayer from the Bauhaus. master practitioner of functional typography. champion of lowercase writing.* For a long time, the Bauhaus was Bayer's calling card. Later it provided him with an entrée into the American advertising industry. Furthermore, he actively kept this connection to a glorious past alive with his designs for the major Bauhaus retrospectives in 1938 and 1968. The exhibitions and the biographies published during his lifetime created another echo chamber in which he deliberately faded out all references to the difficult period in Nazi Germany when he walked the thin line between alignment and opposition. Obviously, by the end of his life, around 1979, it was not a major problem for Bayer to meet the former Bauhaus student Fritz Ertl, later a member of the Waffen-SS and architect at Auschwitz, during one of his family trips to Upper Austria where both were born.[99]

It is only on closer inspection that it becomes clear that, over the course of his long life, Bayer was, in fact, anything but the "model Bauhäusler" he caricatured back in 1923 (Fig. 0.1). His primary fields remained typography and advertising design—fields that were not even taught at the Bauhaus when he first enrolled in Kandinsky's mural workshop. Although he always viewed himself first and foremost as a painter—to which he later added architect and sculptor as well as the typography and graphic design for which he is best known—he never taught, or even attended, the celebrated Bauhaus *Vorkurs*. Indeed, his work in the fine arts never received the acclaim garnered by colleagues such as Moholy-Nagy or Albers.[100] There is something of a paradox to the fact that Bayer, who developed more diverse forms of expression within his concept of Total Design than almost any other Bauhäusler, continued to pursue the ideal of the Gesamtkunstwerk long after his Bauhaus period. Even if he complained of being stuck in "advertising purgatory," at the same time the field offered Bayer, the "assertive pragmatist with a nose for business," as one historian has called him,[101] the opportunity to apply his talent to sought-after and well-paid work. By 1943, when he pitched a show to MoMA's director of exhibitions Monroe Wheeler, Bayer's attitude had already shifted profoundly: "The artist of today," he claimed, "should go out of his own dream world into the reality of life and its problems. It is the fusion of the artist as a creator

and visualizer with the business world and the industrial society which I would like to emphasize in my exhibition."[102]

Bayer had a distinct talent for marketing himself. Even if he continually professed shyness and never enjoyed the role of the teacher, the episodes from his private life point toward an enormous need for recognition paired with a disposition bordering on narcissism. Both qualities were fed by his fine looks, charm, and unapologetic enjoyment of erotic conquest (see Fig. 16.5). His life took place during a dramatic historical period, and he too experienced the intense personal challenges and moral trials of the day. With this study's sometimes rather uncomfortably granular scrutiny of events in his personal life and exploration of his emotional sensitivity I have sought to clarify causes that may have led to certain outcomes while impeding others. A more nuanced understanding of Bayer's fragmented biography is starting to emerge from the rich sources in Bayer's estate. In several ways, as we can see, his biography is representative of many lives lived under National Socialism. A close examination of Bayer's path, marked as it was by personal anguish, hesitation, and complacency, helps illuminate the individual choices made by his entire generation.

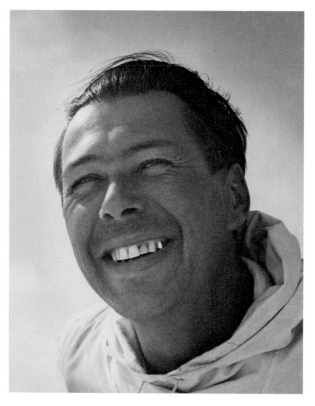

Figure 16.5 Hein Gorny, Herbert Bayer on his skiing vacation, 1935. Photograph; Denver Public Library, Herbert Bayer Collection. © Collection Regard/Marc Barbey, Berlin.

Sources indicate that Bayer's long-lasting ambivalence had its roots in this simultaneity of contradictions, in this juxtaposition of attitudes. It may also have been one cause of the very dissatisfaction and restlessness that triggered his famous self-portrait *The Lonely Metropolitan* (see Fig. 1.1). Tellingly, Bayer's first advertising brochure in the United States, in 1941, took up the same motif of the hands and eyes. But now the "lonely metropolitan" found himself lost not in a Berlin tenement but against a blue starry sky, eyeballs and fingertips linked to the universe. At the turn of 1941/1942, Bayer sent out greeting cards that set the same motif in a snow flurry; now one hand has snow-covered fingertips, the other drips with blood. It is a stark image, embodying anything but optimism for the long years of war ahead (see Plate 32).[103] In hindsight, this illustration could also serve as a visual metaphor for the arguments outlined in this book: Herbert Bayer—one hand covered with white snow, in its purity an incarnation of both his beloved mountain world and his clear conscience of having done nothing wrong in his Berlin years—and one hand dripping with blood from the millions of victims of the Nazi terror he unintentionally supported.

Notes

Introduction

1 "My aim is the total design process." Bayer, "Design," 325. See also Finger, *Gesamtkunstwerk;* Denver Art Museum, *Herbert Bayer* and Paglia, "Herbert Bayer."

2 Reproduced in Farmer and Weiss, *Concepts of the Bauhaus,* 104, no. 118 [online: http://www.harvardartmuseums.org/art/225752; accessed November 15, 2020]

3 Nowak-Thaller, "Herbert Bayers künstlerische Anfänge," 55.

4 See the assessment given by Franz Roh in "Zwischenposition."

5 Hill and Cooper, "Herbert Bayer," 108; see also Cohen, *Herbert Bayer;* Chanzit, *Herbert Bayer.*

6 Bayer, "Dankesrede," 3.

7 See e.g. Rössler and Brodbeck, *Revolutionäre der Typographie.*

8 See Rössler, *Public Relations;* Rössler, *New Typographies.*

9 See e.g. Droste, "Herbert Bayer"; Cohen, *Herbert Bayer;* Nowak-Thaller and Widder, *Ahoi Herbert!*

10 Excellent overviews of the long list of German writers, artists, photographers, and intellectuals who left their German homeland include Barron and Eckmann, *Exiles;* Dogramaci and Wimmer, *Netzwerke des Exils.* See also the publications of relevant institutions, e.g. Asmus and Eckert, "Vermittelte Erinnerung"; Gfrereis and Staack, "Zeitstempel."

11 For more on this topic, see Part 2 of this book and Schug, "Moments of Consistency," 71.

12 See e.g. Theo to Herbert Bayer, July 26, 1946, VL/HB, box 12.

13 For an excellent bibliographic overview, see Philipp, "Auswahlbibliographie Innere Emigration." I address this topic in more depth in Chapters 6 through 9.

14 Hermand, *Kultur,* 177.

15 Ibid., 178.

16 Philipp, "Distanz und Anpassung," 16.

17 Cohen broaches the idea cautiously, almost as if trying to split the difference: "Like many other important German artists of the period, *some of whom* went into what came to be called 'internal emigration,' Bayer knew that the time to leave was fast arriving." (Emphasis added.) See Cohen, *Herbert Bayer,* 41.

18 See the respective entries in Barron and Eckmann, *Exiles,* 211–72.

19 Hahn, "Bauhaus and Exile," 216.

20 Eckmann, "Considering Art and Exile," 30.

21 Dogramaci, "Netzwerke," 14.

22 Eckmann, "Considering Art and Exile," 31.

23 Droste, "Blinde Flecken," 315.

24 HB/ACQ no. 14.

25 The Archives of American Art also contain Ise Gropius's own translations of a selection of the Gropius letters, but I have deliberately chosen to prepare fresh

translations of the relevant letters. For one thing, English was not her native language. For another, as this book will make clear, she had her own reasons for shaping the reception of her relationship with Bayer.

26 "During his lifetime he kept an eye on who wrote about him and what was written about him." Brüning, "Herbert Bayer," 332.

27 Württembergischer Kunstverein, *50 Jahre Bauhaus*; Bauhaus-Archiv, *Herbert Bayer*; Nowak-Thaller and Widder, *Ahoi Herbert!*

28 See Brüning, "Bauhäusler;" Droste, "Herbert Bayer;" Droste, "Herbert Bayers Weg;" Rössler, "Exil mit Kalkül."

29 Schug, "Herbert Bayer;" Schug, "Moments of Consistency." Naturally, there are also more intensive discussions about the background of the activity in advertising and the legal framework under which creative art direction was possible in the Nazi state; see Schug, "Moments of Consistency," 177.

30 See https://history.denverlibrary.org/; DPL, WH2416.

31 Through a congenial division of labor, Chanzit contributed a concise summary of Bayer's career in America, while I wrote about his German period.

32 See Schug, "Herbert Bayer."

33 At the time of this writing, the English language Wikipedia page on Walter Gropius states that Ise Gropius was Jewish, citing only a flimsy secondary source, a book review, to support the claim. A family tree form, filled in the mid-1930s by Ise Gropius herself to satisfy Nazi bureaucracy, clearly discloses her ancestry as either Catholic or Protestant (unpublished document from the family estate). Ise Frank's father, a Prussian civil servant, came from a line of Prussian theologians—the last place one would find a Jewish family background. Her mother's Hamburg family Heckmann was Catholic and has admittedly received less study. But the family business did not undergo "Aryanization" during the Nazi years. If future genealogists do indeed determine some Jewish ancestry for Ise Gropius, we must bear in mind that Ise Gropius Frank herself never found it worth mentioning, either in her extensive diary or in her correspondence with (her many Jewish) friends; nor in the course of her multi-year, extensive cooperation with Gropius's biographer Reginald R. Isaacs.

34 See Rössler, "Exil mit Kalkül."

35 I have referred to this elsewhere as a kind of taming or domestication of the avant-garde. Rössler, *Bauhaus at the Newsstand*, 144.

36 See e.g. Widder, "Emigration," 234.

37 See https://bauhaus.community/.

38 See Blümm et al., *Die bewegten Netze*; Rössler et al., "Von der Institution."

39 The other five networks were the circles (1) around Walter Gropius in the United States, (2) around Hannes Meyer in the Soviet Union, (3) around Gerhard Marcks in Nazi Germany, (4) Ludwig Mies van der Rohe and his architectural classes, and (5) the group of exiles in the Netherlands.

40 In the language used by the Bayer couple, the spelling changes from initially "Muci" to later "Muzi" (from about 1932). For a better understanding, the spelling "Muci" is uniformly used in the following. For more on Bayer's unorthodox understanding of marriage see in particular Chapters 2, 5, and 8.

41 See in particular Chapters 3 and 5.

42 See, for instance, Korac, "Role of Bridging."

43 Rössler, *Berliner Jahre*; Rössler and Chanzit, *Der einsame Großstädter*.

Chapter 1

1 Bayer, *painter, designer, architect*, 9.
2 Theo Bayer to Herbert Bayer, April 2, 1939, Estate of Theo Bayer, Linz. Author's translation.
3 The name Wandervogel has sometimes been translated as "birds of passage" (with a nod to Walt Whitman's description of migratory birds in *Leaves of Grass*, which also influenced the movement). His friends included Fritz Maix, who later became vice president of the Federal Chamber of Commerce in Vienna. HB/OD.
4 Bayer, *painter, designer, architect*, 9.
5 Nowak-Thaller, "Herbert Bayers künstlerische Anfänge," 38–40.
6 Nowak-Thaller, 37–55.
7 Nowak-Thaller, 43–48.
8 HB/OD.
9 Hill and Cooper, "Herbert Bayer," 94.
10 Nowak-Thaller, "Herbert Bayers künstlerische Anfänge," 48.
11 Nowak-Thaller, 52.
12 See Chanzit, *herbert bayer collection*.
13 When Bayer emigrated, he left numerous sketches from that period with his sister Helene. These are now in the estate of Theo Bayer, Linz.
14 See OHP/C, 6.
15 Bayer, *painter, designer, architect*, 9–10; "art decorative" is Bayer's own term for Art Deco.
16 See Ulmer, *Emanuel Josef Margold*.
17 See OHP/B, 5. A large number of designs for packaging and advertising materials from those years are preserved in the Bayer estate in Denver; see Chanzit, *herbert bayer collection*, 35–45 ("pre-bauhaus").
18 PD/HB, *Zeugnis* (letter of reference), February 28, 1922.
19 For Bayer's artistic development see in detail Nowak-Thaller, "Herbert Bayers künstlerische Anfänge," here 53.
20 Bayer, *painter, designer, architect*, 10.
21 Bayer, 10.
22 Droste, "Herbert Bayers Weg," 78–79.
23 OHP/B, 7.
24 See here and in the following at length Droste, "Herbert Bayer," 23–38.
25 HB/OD, 5.
26 For exhaustive biographical sketches see Droste, "Herbert Bayer;" Brüning, "Herbert Bayer."
27 Rudolf Baschant to Bayer, Autumn 1947, VL/HB.
28 For a full transcript see Rössler and Chanzit, *Der einsame Großstädter*, 24–27. The fact that he wrote it in German Sütterlin script—a form of handwriting once widely taught in schools but now extremely difficult for non-initiates to decipher—may explain why it has never been discussed in the literature so far.
29 Bayer, Diary 1922, entry of September 16, 1922, Denver Public Library (DPL), WH2416, Bx 12.
30 Bayer, diary entry of early October 1922.
31 HB/OD, 180.
32 *Freideutsche Jugend* 8, no. 2 (February 1922), n.p.
33 For more information, see for example Rössler, *New Typographies*; Rössler, "Universal Communication"; Brüning, *A und O*.

34 For works of the department see Fleischmann, *bauhaus drucksachen*, 11–13; Lupton, *Herbert Bayer*, 9–14.

35 For a complete list of these students, see Brüning, *A und O*, 60.

36 See Rössler, "Visuelle Identität," 378–79.

37 Cohen, *Herbert Bayer*, 200 is mistaken here when he dates the emergency money order—on the basis of Bayer's fragmentary memories and not his own research— with the end of 1923 after the Bauhaus exhibition was closed. However, the date of issue of the first banknotes, August 20, 1923, can be determined simply by looking at the bills. According to Bayer's own stock lists, his design was changed for the 100 and 500 million marks banknotes.

38 See in detail Heise, "Bauhaus."

39 See Rössler, "Neue Typographie;" Aynsley, *Graphic Design*; Heller, *Merz to Emigre*; Schmalriede, "Typographie und Typofoto."

40 Hemken and Stommer, "'De Stijl'-Kurs."

41 See Hill and Cooper, "Herbert Bayer," 96; OHP/C, 10.

42 One particularly impecunious Bauhaus student was Otto Umbehr (later known as Umbo), who was known to camp in the woods near Weimar. Before he found his calling as a photographer in the mid 1920s, he was frequently homeless; see Jaeger, "Umbo's Circle of Friends," 244. On van Doesberg's students, see Hemken and Stommer, "'De Stijl'-Kurs," especially 177.

43 See the documentation by Wendermann, "Internationale Kongress."

44 HB/ACQ, no. 13.

45 Bayer, "Typography and Design," 100.

46 On Breuer's connection to Moholy, see Hoffmann, "Mondrian," especially 77. Hoffmann's suggestion that Breuer took part in van Doesburg's de Stijl course and was part of the KURI group is not covered in the sources, however. See the KURI manifesto of December 1922, reprinted, among other places, in Bajkay, *Ungarn*, 190–91.

47 See Bakos, "Neue Typografie."

48 OHP/C, 30.

49 See Moholy-Nagy, "Die neue Typographie," 141.

50 See Tschichold, *Die neue Typographie,* and Doede, "Jan Tschichold," 6–7. On the significance of Tschichold's visit to the exhibition, see Le Coultre, Posters, 23–25.

51 See OHP/C, 27.

52 Tschichold, "elementare typographie," 212. Tschichold's afterword even states "this number was originally intended to be a Bauhaus issue."

53 See for example Droste, "Herbert Bayer," 26; also Hintze and Lauerer, "Medienereignisse," 186–91. Even in the interviews that Cohen conducted with Bayer in 1981, Bayer never explicitly said that he was actually present in Weimar for the exhibition, but talks only about the preparations; see OHP/C, 14.

54 Bayer, Travel Diary 1923–24, DPL, WH2416, Bx 70, No. 1.

55 See OHP/C, 24–26.

56 These detailed descriptions from August 13, 1923 on do not include any reference to a visit to the "Bauhaus week" and exhibition. As it can be assumed that Bayer would have recorded his impressions in writing, this also speaks against his participation.

57 Bayer, *painter, designer, architect*, 10–11.

58 See OHP/C, 24.

59 "With my deep and well concealed shyness I try to avoid all speaking in public." HB/OD.
60 Steffen, *Himmel.* For a more detailed biographical account on Leudesdorff see Otto and Rössler, *Bauhaus Women,* 46–51.
61 Steffen, *Himmel,* 82 and 92.
62 See OHP/C, 90–91.
63 "When I walked through Italy this was all sketching, drawing whatever I saw." OHP/C, 73.
64 Nowak-Thaller, "Herbert Bayers künstlerische Anfänge," 54.
65 In a 1937 curriculum vitae included in the catalogue to the 1937 London Gallery exhibition Bayer noted: "1924 painting studio in Berchtesgaden." See the catalogue to the 1937 London Gallery exhibition.
66 Theo Bayer to Herbert Bayer, March 11, 1924, Theo Bayer Estate, Linz.
67 HB/OD.
68 Bayer, Travel Diary 1923–24, 6 volumes, DPL, WH2416, Bx 70, No. 6.
69 XS/Ms, folder 2, 92.
70 "Gesellenprüfungs-Zeugnis der Handwerkskammer zu Weimar für Herbert Bayer," February 3, 1925, PD/HB. Although Bayer successfully completed his journeyman's exam in Weimar, his teaching activities took place exclusively in Dessau.
71 Siebenbrodt and Schöbe, *Bauhaus 1919–1933,* 24. Some members of the faculty, namely those who were not dependent on workshop facilities for their teaching (such as Klee and Kandinsky), had already resumed teaching during the summer months. See for example, Klee, *Briefe,* vol. 2, 1000.
72 The Weimar Bauhaus continued to exist formally with workshops and production sites for one more year (the "double Bauhaus" period) until architect Otto Bartning transformed the institution into the Staatliche Hochschule für Handwerk und Baukunst. See in detail Wahl, *Das Weimarer Bauhaus,* 281–92.
73 Brüning, "Druckerei;" Schöbe and Thöner, "Druck- und Reklamewerkstatt;" Brüning, "Druck- und Reklamewerkstatt."
74 See Rössler, "Das 'rechte Licht.'"
75 Rössler and Brodbeck, *Revolutionäre der Typographie.*
76 See Breuer, "Vom Maler," 92, 100–05.
77 Rössler, *New Typographies,* 34.

Chapter 2

1 For more on the relationship between Herbert Bayer and Irene Bayer-Hecht, see Rössler and Chanzit, *Der einsame Großstädter* and Otto and Rössler, *Bauhaus Women,* 72–77.
2 Irene Bayer-Hecht's account of the relationship is reflected in the more than 100 personal letters she wrote to Bayer from 1923 onward, letters he kept with him until the end of his life. Most of these are housed in the Bayer papers at the Denver Public Library (DPL), Box 12. (Unless otherwise noted, all of her letters cited here are from this collection.) Because Bayer's letters to Bayer-Hecht have not survived, the one-sided correspondence inevitably presents just one of the two perspectives. Moreover, the collection is incomplete in that it is limited to those periods in which the pair lived apart. It therefore sheds less light on those stretches of everyday life in which they saw each other daily.

3 Irene Bayer-Hecht, note to Theo Bayer, n.d., estate of Theo Bayer, Linz.

4 Certainly, Irene Bayer-Hecht qualifies as a member of the "Bauhaus periphery." See the recent statistical analysis of the Bauhaus community, Rössler and Blümm, *Soft Skills,* 5–7.

5 See Sachsse, "Frau an seiner Seite," 68–71. Unfortunately, previous accounts of the life and work of Irene Bayer-Hecht contain substantial inaccuracies; see the biographical sketches by Ute Eskildsen and Jan-Christopher Horak in *Film und Foto,* ed. Eskildsen and Horak, pp. 217–18; Honnef and Weyers, *Deutschland,* 54; Stiftung Bauhaus Dessau, *Bauhaus Objekte*; Düchting, *Seemanns Bauhaus-Lexikon,* 59; and in particular Inga Kleinknecht's chapter on Irene Bayer-Hecht in *Bauhaus: Beziehungen Oberösterreich.* For more on the gross inaccuracies perpetrated by the recent portrayal of Irene Bayer-Hecht in Jana Revedin's *Jeder hier nennt mich Frau Bauhaus,* see the introduction to this book.

6 IB/HB, August 4, 1938.

7 Xanti Schawinsky to Herbert Bayer, July 23, 1939, VL/HB, box 12.

8 Marriage certificate, PD/HB.

9 IB/HB, April 15 and 23, 1925; OHP/B, 15.

10 Irene Hecht, Curriculum Vitae, April 23, 1923, Hauptstaatsarchiv Weimar, Staatliches Bauhaus Weimar, file no. 161, sheet 95.

11 See e.g. Honnef and Weyers, *Deutschland,* 54.

12 Ute Eskildsen, interview with Irene Bayer-Hecht, Santa Monica, CA, October 1977, min. 3:50.

13 "Schwach, will Email arbeiten, kommt für uns nicht in Betracht." Irene Hecht's application of April 24, 1923—"Gesuch um probeweise Aunahme zur Vorlehre in das Staatliche Bauhaus"—is located in the Hauptstaatsarchiv Weimar, Staatliches Bauhaus Weimar, file no. 161, sheet 94.

14 Staatliches Bauhaus Weimar to Irene Hecht, May 8, 1923, Hauptstaatsarchiv Weimar, Staatliches Bauhaus Weimar, file no. 161, sheet 93.

15 IB/HB, January 19, 1924.

16 Steffen, *Himmel,* 95.

17 See the correspondence IB/HB, 1923.

18 IB/HB, October 9, 1923.

19 "Couldn't stand the kiss of the other who wasn't you—So I kissed a third / And thought of you." IB/HB, Ibid.

20 Ibid.

21 IB/HB, November 21, 1923.

22 IB/HB, December 13, 1923.

23 IB/HB, January 19,1924.

24 Ibid.

25 IB/HB, January 15,1924.

26 Ibid.

27 See Stiftung Bauhaus Dessau, *Bauhaus Objekte.*

28 Honnef and Weyers, *Deutschland,* 54.

29 Düchting, *Seemanns Bauhaus-Lexikon,* 59.

30 Sachsse, "Frau an seiner Seite," 69–70.

31 Ute Eskildsen, Interview with Irene Bayer-Hecht, Santa Monica, October 1977, min. 6:40.

32 IB/HB, July 18 and August 20, 1924

33 IB/HB, July 18, 1924.

34 See Rössler, *"Es kommt ..."*

35 IB/HB, December 9, 1924.

36 IB/HB, August 20, 1924.

37 IB/HB, November 28 and 29, 1924.

38 IB/HB, March 9, 1926.

39 Marriage certificate, PD/HM. Bayer also later designed letterhead and business cards for his wife's brother, Andreas Hecht. See the list "Graphic Design and Typography," PD/HB.

40 OHP/C, 15.

41 IB/HB, April 23 and April 29, 1925.

42 IB/HB, February 16, 1926.

43 For a detailed account of Bayer's salary, based on extensive quotes from the correspondence, see Rössler and Chanzit, *Der einsame Großstädter*, 33–69.

44 Contract dated and signed by Bayer on April 22, 1925, private collection. See https://oeffentlicher-dienst.info/beamte/bund/a/1927/. The equivalent of group IX, level 7 in the *Reichsbesoldungsordnung* (Reich's Remuneration System).

45 See https://www.bundesbank.de/resource/blob/615162/3334800ed9b5dcc976da0e650 34c4666/mL/kaufkraftaequivalente-historischer-betraege-in-deutschen-waehrungen- data.pdf

46 "Nor will I ever ask you for money, of course. It is bad enough for me if I live next door to you, accept it, and earn nothing myself." IB/HB, March 11, 1926.

47 Hubert Hoffmann, "Begegnungen mit Herbert Bayer," unpublished manuscript, dated Nov. 25, 1985. Bauhaus-Archiv Berlin, document collection, Immeke Schwollmann-Mitscherlich, folder 2, p. 1. My gratitude goes to Anke Blümm for directing my attention to this source.

48 IB/HB, February 9, 1926.

49 IB/HB, February 11, 1926.

50 IB/HB, February 13, 1926. For a longer excerpt from this letter in German, see Rössler and Chanzit, *Der einsame Großstädter*, 46–47.

51 IB/HB, February 13, 1926.

52 Hubert Hoffmann, "Begegnungen mit Herbert Bayer," unpublished manuscript, dated Nov. 25, 1985. Bauhaus-Archiv Berlin, document collection, Immeke Schwollmann-Mitscherlich, folder 2, p. 1.

53 HB/OD, 137.

54 IB/HB, February 16, 1926.

55 Ibid.

56 See, for instance, Kállai, "Zehn Jahre Bauhaus."

57 IB/HB, February 13, 1926.

58 IB/HB, March 28, 1926.

59 For an overview, see National Collaborating Centre for Mental Health, *Induced Abortion*.

60 IB/HB, March 5, 1926.

61 Ibid.

62 Ibid.

63 IB/HB, February 16, 1926.

64 IB/HB, March 9, 1926.

65 IB/HB, February 26, 1926.

66 IB/HB, March 3 and 4, 1926.

67 "[D]ie verdammte arbeit dieser beamtenkleinkram was du machst soll explodieren, das kann irgendein fatzke auch machen." IB/HB, n.d. [fall of 1926].

68 Irene to Herbert Bayer, July 13, 1926, private collection.

69 IB/HB, September 7, 1926.

70 Sachsse, "Frau an seiner Seite," 70.

71 IB/HB, n.d. [probably autumn 1926].

72 IB/HB, November 11, 1926.

73 Wingler, *The Bauhaus*, 622.

74 Eskildsen and Horak, *Film und Foto*, 217; Müller, *Bauhaus Women*, 127. See the erroneous account in Düchting, *Seemanns Bauhaus-Lexikon*, 59.

75 Sachsse, "Frau an seiner Seite," 70.

76 IB/HB, n.d. [probably late 1926].

77 IB/HB, October 5, 1926.

78 IB/HB, October 5, 1926.

79 "I went to a first-class doctor yesterday and he immediately terminated it in a very clever and relatively painless way. He said that because of last year's catastrophe, I am still so weakened in body and nerves that it would mean life-threatening danger for the child and me. It must not happen for at least another year." IB/HB, November 23, 1926.

80 Rössler, "Eine vergessene Pionierin."

81 On December 25, 1927, Hecht wrote to Bayer, "If it seems to you that things are getting better every day, you are absolutely right. The main reason for this is probably that I have realized how much my view of life was a romantic one … A clarification has already taken place insofar as I disclose my feelings less and less. A training in objectivity."

82 Lindsey and Evans, *Kameradschaftsehe*, 40–54.

83 Irene to Herbert Bayer, December 22, 1927, private collection.

84 Irene to Herbert Bayer, August 4, 1928, private collection.

Chapter 3

1 See Rössler, *Public Relations*.

2 HB/ACQ, no. 1.

3 Especially in comparison to the importance of Klee and Kandinsky for the school, see HB/OD.

4 See in detail the comprehensive biography by Isaacs, *Walter Gropius*.

5 Thöner, "Mr. Bauhaus"; Rössler et al., "Von der Institution."

6 See Etzold, "Walter Gropius."

7 OHP/C, 11.

8 See Droste, "Herbert Bayers Weg."

9 OHP/C, 22.

10 Sachsse, "Von Österreich aus," 3.

11 See e.g. Droste, "Bauhaus Object," 208–15.

12 Siebenbrodt and Schöbe, *Bauhaus 1919–1933*, 250. Prior to this time, of the former students, only Josef Albers had advanced to the circle of masters.

13 OHP/C, 21.

14 OHP/C, 22.

15 See Chapter 5 in particular.

16 OHP/C, 22.

17 On Marcel Breuer see at length Droste and Ludewig, *Marcel Breuer Design*; Vegesack and Remmele, *Marcel Breuer*.

18 See Wolsdorff, "Der Afrikanische Stuhl."

19 "Für die liebe bin ja ich da, was besseres findest du sowieso nicht." Herbert Bayer to Marcel Breuer, February 7, 1935, MB/HB, reel 5709, frame 651.

20 Droste, "Bauhaus Object," 208–15. Among other things they shared an ambition to be credited for their authorship of Bauhaus products.

21 See Droste, "Herbert Bayers Weg," 78. Droste argues that the attitude of Breuer and Bayer was a kind of shift in habitus, a term she uses in the sociological sense of a set of socially ingrained habits, skills, and dispositions shared and passed on by people with similar backgrounds; see Bourdieu, *Theory of Practice*, 86.

22 OHP/C, 34.

23 Droste, "Herbert Bayers Weg," 88.

24 Jorge Fulda to Herbert Bayer, August 11, 1938, JF/HB, box 70.

25 XS/Ms, folder 3, 130.

26 Hahn and Paul, *Schawinsky*, 9.

27 See Rössler and Chanzit, *Der einsame Großstädter*, 42–43.

28 Stiftung Bauhaus Dessau, *Xanti Schawinsky*.

29 See Schawinsky's 1969 statement, first published and commented on by Ute Brüning, in Rössler, *bauhauskommunikation*, 233–38, here 237.

30 Müller, *Typofoto*, 56–57 with additional references.

31 Brüning, "Typofoto," 209.

32 Both the volume with his *complete work* and the catalogue on occasion of his retrospective in 1982 feature this image to illustrate his work as a graphic designer at the Bauhaus and beyond; see Cohen, *Herbert Bayer*, 373 and Bauhaus-Archiv, *Herbert Bayer*, 10.

33 For more on Bayer and the VdR see p. 43 and 52. Particularly in Berlin, where he exercised significant influence, Weidenmüller was known by the moniker he chose for himself—"Werbwart"—a sort of "supervisor" to the booming advertising branch. As such he promoted clear-cut approaches to the industry and developed a preliminary terminology for the "science" of advertising that, however, never gained widespread acceptance.

34 Müller, *Typofoto*, 57.

35 Quoted in Brüning, "Druckerei," 491.

36 See Bayer, "Typografie und Werbesachengestaltung," 10; and Droste, "Herbert Bayer," 61.

37 Herbert Bayer, "beitrag zur grafischen zweckgestaltung," undated manuscript, DPL, WH2416, Manuscripts.

38 Bothe, "Frankfurter Kunstschule," 159.

39 Hill and Cooper, "Herbert Bayer," 100.

40 See Moholy-Nagy, "Bauhaus und Typographie."

41 Herbert Bayer to Walter Porstmann, June 26, 1925, reproduced as an illustration in Kries and Kugler, *#allisdesign*, 355.

42 Bauhaus stationery, 1925; reproduced e.g. in Droste, "Herbert Bayer," 40–42; Brüning, *A und O*, 95. A shorter version ran on the letterhead-diploma: "to save time, we write everything with small letters, and besides: why use two alphabets if we can do the same with one? why write with capitals if one cannot speak with

capitals?" Translation in Isaacs, *Gropius: An Illustrated Biography,* 71. The authorship of these assertions is not documented in the Bauhaus records, but they may have well originated from Bayer himself.

43 Rössler, "Universal Communication," 163.

44 See Kinross, "Large and Small Letters" for a summary of the discussion on all-lowercase use in Germany.

45 Rössler, "Universal Communication," 163.

46 HB/ACQ no. 6.

47 Bayer, "Dankesrede," 5.

48 HB/ACQ no. 1.

49 See Brüning, "Joost Schmidt," 257–64.

50 Nonne-Schmidt, "Typografie," 19–22.

51 For comprehensive overviews see Fleischmann, *bauhaus drucksachen;* Brüning, *A und O*; Rössler, *bauhaus typography*; Lupton, *Herbert Bayer;* Letterform Archive, *Bauhaus Typography*.

52 See in detail Jaeggi, *Fagus,* 98–102; the designs were apparently sent back to the Bauhaus by Benscheidt as "unusable;" see Ise Gropius, diary, June 3, 1928, BHA Berlin 1998/55, folder 12.

53 Sketches and invoice by Herbert Bayer, January 1928, Landesmuseum Oldenburg, archive. On occasion of this exhibition Gropius gave a talk on "The Roots of New Architecture" (January 29, 1928). See Köpnick and Stamm, *Zwischen Utopie und Anpassung.*

54 Brüning, "Druck- und Reklamewerkstatt," 154; Rössler, *Public Relations*; Fleischmann, *bauhaus drucksachen.*

55 See the list "graphic design and typography," PD/HB.

56 "I thought photography is the medium for the new typography." OHP/C, 93. The cover is reproduced prominently, among other sources, in Droste, *Bauhaus 1919–1933,* 137.

57 Bayer, "Dankesrede," 5.

58 Hill and Cooper, "Herbert Bayer," 97–98.

59 For a reproduction, see Weber, *Happy Birthday!,* 139; see also Guttenberger, "Fotografische Selbstporträts."

60 HB/ACQ, no. 6. See also Hartmann, "Eye," 65–68.

61 Herbert Bayer to Walter Gropius, January 12, 1928, BHA Berlin, Walter Gropius archive, folder 29.

62 "Ich schreib Dir vertraulich, daß Breuer und Bayer formell gekündigt haben." Oskar Schlemmer to Tut Schlemmer, January 14, 1928, cited in Hüneke, *Oskar Schlemmer,* 187. Modern scholars have also sometimes interpreted the letter as a notice of resignation; see, for example, Oswalt, "Bauhaus-Krisen," 252–53.

63 See Isaacs, *Gropius: An Illustrated Biography,* 140–41; according to a letter of Gropius to Mayor Hesse from Dessau on January 1, 1928, a major reason for resigning was the internecine politics in which he was finding himself as a scapegoat.

64 Ise Gropius, diary, January 17, 1928, BHA Berlin 1998/55, folder 11.

65 OHP/B, 13.

66 Ibid. Accordingly Hill and Cooper, "Herbert Bayer," 100.

67 The new A4 paper size had been introduced by Germany's nascent organ for standardization, the Deutsches Institut für Normung (DIN). While most of the printing businesses of the day still declined to standardize their products, commitment to the DIN logic signaled a modern approach to graphic design.

68 Here and further on, see Rössler, *Public Relations*, chapter 7.

69 Bayer, "Dankesrede," 7.

70 See the exhibition brochure *Foreign Advertising Photography* (New York 1931), 3. The show ran from March 2 to 16, 1931.

71 See Bayer, Gropius and Gropius, *Bauhaus 1919–1928*, 157; Dorner, *The Way Beyond "Art,"* 138.

72 *Modern Photography: The Special Autumn Number of "The Studio,"* London and New York, 1931, 67. The issue was probably inspired by the *Foreign Advertising Photography* show on display in New York that March.

73 Reproduced in Fleischmann, *bauhaus drucksachen*, 186. Bayer himself submitted this version for inclusion in the plates sections he compiled for his 1967 and 1984 monographs; see Bayer, *painter, designer, architect*, 27 and Cohen, *Herbert Bayer*, 211.

74 Rössler and Brodbeck, *Revolutionäre der Typographie*, 53.

75 Bayer, "Werbephoto." Surprisingly the text is not printed exclusively in lowercase letters.

76 He had previously been involved in the design of the Wörlitz booth at Berlin's 1927 exhibition *Das Wochenende* (The weekend) together with fellow Bauhäusler Heinz Loew and Erich Mende. There is no evidence whether and in what form he took part in redesigning the Museum of Natural History and Prehistory, but that year he did design its printed guide; see Bauhaus-Archiv, *Herbert Bayer*, 159, cat. no. 117 (wrongly dated to approx. 1925). In 1926, he helped preparing the Bauhaus section of the exhibition "New Advertising" (*Neue Reklame*) in Zwickau, but today it is unclear whether he just collected the materials at the Bauhaus or was actually on site putting the exhibits on the wall. See Herbert Bayer to Hildebrand Gurlitt, August 30, 1926, Museumsarchiv, Ausstellung Neue Reklame 1927, Kunstsammlungen Zwickau.

77 OHP/C, 18–19; Bayer later referred to this work as the starting point for his own thoughts on exhibition design.

78 HB/ACQ, no. 4 and no. 13.

79 For a photograph of the exhibition stand at the Zentrale Wohnungsfürsorgegesellschaft Berlin, see Haanen, "Bauhausreklame," 14.

80 Moholy-Nagy, "Elementare Buchtechnik," 60–64.

81 XS/Ms, folder 4, 173.

Chapter 4

1 "Reklame wird 3/5 von Herrn Bayer geleitet." Bauhaus log 1927/28, transcript by Hans M. Wingler (1957), Bauhaus-Archiv Berlin, Hans Maria Wingler files, part 1, folder 29.

2 Hahn and Paul, *Schawinsky*, 14–17. Xanti Schawinsky has preserved photos and other memorabilia from his trip in his visual diary, including maps that allow for reconstructing the itinerary; see Blume, *Xanti Schawinsky. The Album*. See also XS/Ms, folder 3, 145–50 and Fiedler and Feierabend, *Bauhaus*, 115.

3 Blume, *Xanti Schawinsky. The Album*, 15.

4 XS/Ms, folder 3, 130. The last, enigmatic phrase he had put down in his still rough English. For the purpose of authenticity I kept this excerpt in the all-lowercase style that nearly the entire circle embraced—and that Schawinsky and Bayer used well into the 1970s.

5 HB/ACQ, no. 7.

6 Bayer, "Schwebefähre."

7 Bayer, "Aus dem optischen Notizbuch."

8 I am grateful to Magdalena Droste for pointing this important item out to me. See Droste, "Herbert Bayers Weg," 89, which includes a juxtaposition of the motifs.

9 *Berliner Adressbuch*, 1930 edition, 142, https://digital.zlb.de/viewer/image/34115495_1930/166/.

10 Here and in what follows, see Rössler, *Bauhaus at the Newsstand*, 15, which includes additional references.

11 Kammergericht zu Berlin, "Notarielle Feststellung der Auflagenhöhe der in Berlin erscheinenden Zeitschrift *Vogue*," August 29, 1928; copy at BHA Berlin, Herbert Bayer files.

12 Spondé, "Dr. Agha," 17–21; Schug, "Moments of Consistency," 34. Although the Russian-Turkish designer and polymath had first been associated with Dorland's Paris office, his job in Berlin marked his first official association with *Vogue*.

13 Anonymous, "Agha's American Decade."

14 See also Schug, "Moments of Consistency," 40, 43. In the interviews he gave in the early 1980s, Bayer dated his own involvement with *Deutsche Vogue* to his arrival in the German capital. In fact, Bayer's work for the magazine actually came somewhat later.

15 OHP/C, 22.

16 For greater detail on the changes Bayer introduced see Rössler, *Bauhaus at the Newsstand*, 16–17.

17 OHP/B, 13.

18 Nast himself was never eager to reveal the extent of the company's losses. "I suppose it has been a kind of false pride in me which, during the past ten years, has prevented my remembering the exact amount of money which was lost on the German edition of *Vogue*." Anonymous, "Agha's American Decade," unpag.

19 Herbert Bayer to Walter Gropius, September 16, 1935, BHA Berlin, Walter Gropius archive, folder 123. For more on the Gropius survey, both generally and for its importance to Bayer, see pp. 57 and 138.

20 Koetzle, "Zufall," 14.

21 Agha, "Magazine," 13–17.

22 Schug, "Moments of Consistency," 40.

23 Studio Dorland rendered its own name with various capitalizations and hyphenations, ranging from Studio Dorland to Dorland Studio and from Studio-Dorland to studio-dorland. To minimize confusion, I draw on Studio Dorland, the formulation Bayer used in his English-language interviews with Arthur Cohen.

24 Schug, "Moments of Consistency," 46, 50.

25 OHP/C, 23; see in detail Brüning, "– – Y – –" 75 with the different signatures of Bayer.

26 Entry on Herbert Bayer, "Biographical Notes" section; in Bayer, Gropius and Gropius, *Bauhaus 1919–1928*, 220.

27 Ise Gropius, diary, March 18, 1927, BHA Berlin 1998/55, folder 14.

28 On the magazine's history see the extensive account given in Rössler, *Bauhaus at the Newsstand*, particularly 10–14.

29 See Rössler, "Eine vergessene Pionierin."

30 Wessely, "László Moholy-Nagy."

31 Rössler, "Das 'rechte Licht.'" Later on, another former Bauhäusler, Franz Ehrlich, also claimed to be responsible for printed matter at Beyer-Verlag: "In the Beyerverlag,

too, I was not named with resounding fanfares; rather, over a period of two years I successfully designed the occasional printed matter in due modesty." Franz Ehrlich to Grete Reichart, December 5, 1978, Stiftung Bauhaus Dessau, correspondence, H-345.

32 See Rössler, *Viewing our Life*; Rössler, *Illustrated Magazine*.

33 For more on Bayer and his wife's connection to Dr. Friedrich Popitz, see Chapter 2. Bayer-Hecht had an abortion in 1926 in Leipzig, presumably at Popitz's medical practice.

34 See Rössler, *Bruno E. Werner*.

35 Herbert Bayer to Eckhard Neumann, June 7, 1979, private collection.

36 Max Gebhard to Herbert Bayer, December 15, 1947, VL/HB, box 12.

37 It is possible that this nickname was chosen in reference to Gropius's daughter Manon, called "Mutzi"; sadly, both children would later share the fate of an early death.

38 Jorge Fulda described Bayer as a "loving father." Fulda to Herbert Bayer, April 19, 1940, JF/HB.

39 Xanti Schawinsky to Herbert Bayer, November 9, 1963, VL/HB, box 12; see also the photos in Blume, *Xanti Schawinsky. The Album*. It is surprising that Schawinsky describes Bayer in his memoirs as a close friend but there is no mention of him serving as best man at the Bayer wedding or of being godfather to Julia "Muci" Bayer; see XS/Ms.

40 IB/HB, May 21, 1932.

41 "I was living alone at the time, separated." OHP/C, 26. Apparently he rented a furnished room and had his mail sent to the Dorland office at Kurfürstendamm 32; IB/HB, May 21, 1932.

42 For a picture of the Povolozky bookshop and gallery in Paris see Museum Wiesbaden, *Vordemberge-Gildewart*, 249.

43 The Povolozkys had nurtured associations with artists like Amedeo Modigliani, Pablo Picasso, and Chaim Soutine since the 1910s and maintained a lively interest in modern art. Immediately after Bayer's exhibition, for instance, the gallery showed the first solo exhibition of Friedrich Vordemberge-Gildewart, a Constructivist painter and typographer and advertising designer from Hannover, who had also visited the Bauhaus in 1923 for the Constructivist Congress. See Rattemeyer and Helms, *Vordemberge-Gildewart*, 25 and 336.

44 "Herbert Bayer est cubiste ou constructiviste ou surréaliste, selon certains critères. Oui, tout cela et bien d'autres choses encore: c'est un jeune peintre d'aujourd'hui." Paul Dermée, essay for the exhibition brochure, Galerie Povolozky, Paris 1929.

45 IB/HB, January 27, 1929.

46 IB/HB, January 23, 1929.

47 IB/HB, January 27, 1929. No poster from this exhibition has been preserved.

48 IB/HB, February 10, 1929.

49 IB/HB, January 23. "Es wurde übelgenommen als ich erwähnte, dass ich Kritiker kaufen möchte. Sie sagten, dies kann man machen. Doch es weiss ein jeder, und hier gilt es als nichts, auch bei den Kunsthändlern." (It was resented when I mentioned that I wanted to buy critics. They said, this can be done. But everybody knows it. Here it is considered nothing, even by art dealers.)

50 Zervos, "Herbert Bayer," 56.

51 Moholy-Nagy, "La photographie."

52 IB/HB, February 10, 1929.

53 Circular of the Oberösterreichischer Künstlerbund März (*Upper Austrian Artist's Association März*), November 1, 1928, MAERZ-Archiv, Linz. I would like to thank Gerhard Brandl for his research.

54 See Rössler, *Berliner Jahre*, D.03.

55 Herbert Bayer and Xanti Schawinsky to Ise Gropius, November 4, 1929, BHA Berlin, Walter Gropius archive, correspondence Ise Gropius.

56 *Film und Foto: Internationale Ausstellung des deutschen Werkbunds* (Stuttgart 1929), 77.

57 Moholy's Room No. 1 was recently reconstructed as a virtual reality environment; see Gertz, Schaden, and Scholz, *Bauhaus and Photography*.

58 *Film und Foto. Internationale Ausstellung des deutschen Werkbunds, Stuttgart 1929*, 53–54 (nos. 73–98).

59 Westheim, "Herbert Bayer," 151.

60 Haanen, "Bauhausreklame," 11.

61 See in detail Rössler, "Das 'rechte Licht.'"

62 HB/ACQ, nos. 13 and 4.

63 Lottner, *Überblick*, 15.

64 Ring announcement (July 7, 1928); in detail see Broos, "Leben des Rings," 9.

65 Kurt Schwitters, Ring announcement no. 19 (July 1928), cited in ibid., 115. In October 29, 1928, Schwitters writes, "Bayer has applied for admission." Kurt Schwitters: Ring announcement no. 22 (October 24, 1928); cited in Rattemeyer and Helms, *Ring "neue werbegestalter,"* 119.

66 This contrasts with other voting procedures; see, for example, Kurt Schwitters, Ring announcement no. 22 (October 24, 1928), cited in Rattemeyer and Helms, *Ring "neue werbegestalter,"* 124. It is possible that Bayer's application for membership was previously rejected. In 1931 Schwitters writes, somewhat ambiguously, "I would also like to ask the members to again give me the names of colleagues who have become members. I believe, for example, that people like Teige, Kassak, Molzahn, Moholy, Lissitzky, Doesburg, and Bayer should be members of our organization. We chose not to admit the others, and I would like to put these gentlemen to the vote again." Kurt Schwitters: Ring announcement no. IIa (January 19, 1931), cited in Rattemeyer and Helms, *Ring "neue werbegestalter,"* 126.

67 Eisele, Naegele, and Lailach, *Moholy-Nagy*, plates 28, 36, 41, 49, 54, 64.

68 See Rasch and Rasch, *Gefesselter Blick*.

69 See Jaeggi, *werkbund-ausstellung*.

70 Hemken, *Deutscher Werkbund*, 117.

71 See, for example, the article on Bayer in *Vendre* (July 1930), 48.

72 Herbert Bayer, "beitrag zur grafischen zweckgestaltung," undated manuscript, DPL, WH2416, Manuscripts.

73 Herbert Bayer, "Analyse (werkbund exhibition Paris 1930)," undated manuscript, DPL, WH2416, Exhibitions.

74 Siegfried Giedion, "Der Deutsche Werkbund in Paris" (*Neue Zürcher Zeitung*, June 17, 1930) and *Walter Gropius* (New York, 1954), 49, both cited in Miller, "Points of View," 2. See also Jaeggi, *werkbund-ausstellung*, unpag.

75 Miller, "Points of View," 2.

76 For the concept of the "eyeball hominid" representing an exhibition visitor, see Lupton, *Herbert Bayer*, 82. As Kristie La has noted, Bayer's expanded vision, despite giving a modernist impression, was "conservative at heart," because it produced "a passive spectator under the guise of an active one." La, "Herbert Bayer," 68.

77 See Krause, "Westfalen-Lippe."

78 For a reconstruction of the hall in virtual reality, see https://www.fh-erfurt.de/projekte/detailansicht/bauhaus-trifft-vr. See also Rössler, "Ausstellung als begehbares Informationsdesign."

79 Arthur Cohen, for example, writes "… all of them had joined together to celebrate a German trade union, itself anathema to the Nazis." Cohen, *Herbert Bayer*, 295.

80 Bayer, *painter, designer, architect*, 35–37; Cohen, *Herbert Bayer*, 295–97.

81 Frenzel, "Herbert Bayer;" see also Brüning, "Herbert Bayer," 344.

82 See the transcript of the log reprinted in Hahn, *Bauhaus Berlin*, 57.

Chapter 5

1 The Dessau show was wrongly listed as having occurred in 1931 by Alexander Dorner, misinformation that has subsequently been repeated. See Dorner, *The Way Beyond "Art,"* 235; also Bayer, *Painter, Designer, Architect*, 205; Cohen, *Herbert Bayer*, 395.

2 IB/HB, April 4, 1932.

3 "I read her your letter, and the result was two hours of terrible crying, I could not comfort her at all, daddy should come and give her a kiss right away." IB/HB, May 3, 1932.

4 IB/HB, April 8, 1932.

5 "You know, whatever you decide, my happiness does not depend on such things." IB/HB, April 14, 1932.

6 IB/HB, May 3 and June 4, 1932.

7 A woman of many names, Meta Erna Niemeyer had studied at the Bauhaus Weimar in its early years, receiving the nickname Ré from Kurt Schwitters around 1925 before she married the Dada experimentalist Hans Richter in 1926. Though their marriage had already deteriorated by 1927, the official divorce took place in 1931. In 1937 she married the Surrealist pioneer Philippe Soupault. See Otto and Rössler, *Bauhaus Women*, 52–55.

8 IB/HB, May 21 and July 9, 1932.

9 "Thank you very much, dear, hopefully you have enough to live on." IB/HB, May 5 and May 22, 1932.

10 IB/HB May 3, 5, and 22, 1932.

11 Walter Gropius's biographer Reginald Isaacs kept Bayer's identity scrupulously anonymous, indicating his name in the sources with *** and noting only that "the other man" was a confidant from Gropius's inner circle. See the German edition of Isaacs, *Walter Gropius, Der Mensch*, vol. 2, 602–11 (an abbreviated edition in English was published posthumously in 1991 as *Gropius: An Illustrated Biography* and devotes a short section to "Ise Gropius's Search for Identity," 164–173). More recent publications have since confirmed that Ise's lover was Herbert Bayer; see e.g. Weber, "Kunst, Kitsch und Kalauer," 19; Otto, "Designing Men," 196; Widder, "Emigration," 237.

12 Isaacs, *Walter Gropius*, vol. 1, 309–10. (See the briefer account in the English version, *Gropius*, 105.)

13 IB/HB, March 28, 1926.

14 Ise Gropius, diary, June 23, 1925, BHA Berlin 1998/55, folder 12.

15 Ise Gropius, diary, July 1925, BHA Berlin 1998/55, folder 12.

16 In 2013, Ati Gropius Johansen (1926–2014) mentioned in conversation with the author a family rumor that attributed the cause of her adopted mother's infertility to complications from an abortion in the summer of 1923 (during the couple's rush "pre-honeymoon" in Italy). The rumor remains unconfirmed, along with the open question of whether Ise Gropius's hypothetical pregnancy would have been by Walter Gropius or by Hermann Frank, to whom she was betrothed until that summer. Ati Gropius Johansen in conversation with Patrick Rössler, Erfurt, September 10, 2013.

17 Ise Gropius, editorial comment to Reginald Isaacs, August 1974, quoted in Isaacs, *Gropius, 124* (German edition, vol. 1, 369).

18 XS/Ms, folder 4, 173.

19 Isaacs, *Gropius*, 167 (see also German edition, vol. 2, 590–91).

20 Danilowitz, "Portrait photographs," 24. See also Meister, *One and One*, 53–55.

21 Isaacs, *Gropius*, 168 (see also German edition, vol. 2, 591).

22 Gropius Johansen in conversation with the author, Erfurt, September 10, 2013 (see note 16).

23 OHP/B, 3. He told Cohen: "She was uneducated. But she was a person who had great instinct and great understanding for what I was doing and what I wanted to do, while my father did not have." OHP/C, 5.

24 Walter Gropius to Ise Gropius, n.d. (believed to be late summer 1931), quoted in Isaacs, *Gropius*, 168 (see also German edition vol. 2, 596).

25 HB/IG, January 1932.

26 Ibid.

27 Isaacs, *Gropius*, 169 (see also German edition, vol. 2, 602).

28 Ibid. (see also German edition, vol. 2, 603). Isaacs does not supply a source for the remark.

29 IB/HB, June 4, 1932.

30 IB/HB, May 22, 1932.

31 IB/HB, June 13, 1932.

32 IWG/HB, June 3, 1932.

33 See Walter Gropius's letters to Ise Gropius from early July 1932. Extracts cited in Isaacs, *Gropius*, esp. 172–73 (German edition, vol. 2, 604–06).

34 Bayer to Ise Gropius, June 1932, IWG/HB.

35 Bayer to Ise Gropius, June 8, 1932, IWG/HB.

36 Ibid., IWG/HB.

37 Bayer to Ise Gropius, June 9, 1932, IWG/HB.

38 Walter to Ise Gropius, July 4, 1932: "Maybe we shall arrive at a point where we can give our friendship an even higher value than the one of spontaneous sympathy. Anyway he seems happy that I can deal with him without constraint and heaviness; this surprises even myself." Isaacs, *Walter Gropius*, 170 (German edition, vol. 2, 604–05).

39 IG/WG, June 1932.

40 See IG/WG, July 22, 1932; for a translated excerpt in English, see Isaacs, *Walter Gropius*, 170–71 (German edition, vol. 2, 606).

41 Ibid. Isaacs, *Gropius*, 171 (German edition, vol. 2, 605).

42 This passage was not included in Isaacs's account. See IG/WG, July 22, 1932.

43 IG/WG, July 25, 1932.

44 HB/IG, July 25, 1932.

45 Ibid.

46 IG/WG, July 1932.

47 Isaacs, *Gropius*, 171 (German edition, vol. 2, 606).
48 IB/HB, July 12, 1932.
49 IB/HB, undated [May or June 1932].
50 IB/HB, July 12, 1932.
51 An exception is Anhold, who interpreted the work in relation to Bayer's separation from his wife. Yet without the context of Bayer's passionate affair with Ise Gropius, he misinterprets the situation fundamentally. Anhold, "Imagery," 177–79 and 187.
52 Dorner, *The Way Beyond "Art,"* 147–48.
53 See Hartmann, "Eye," 66.
54 Cf. Baum, *Herbert Bayer*, 8.
55 Anhold, "Imagery," 228.
56 HB/AS&S, October 13, 1932. For this and subsequent quotations, see Rössler and Chanzit, *Der einsame Großstädter*, 114.
57 HB/AS&S, October 14, 1932.
58 HB/AS&S, October 27, 1932.
59 Isaacs, *Gropius*, 171 (German edition, vol. 2, 606–07).
60 HB/AS&S, 1933.
61 For a more detailed description, see Rössler and Chanzit, *Der einsame Großstädter*, 116–23.
62 Isaacs, *Gropius*, 172–73 (German edition, vol. 2, 610–11).
63 IG/WG, March 1933, first letter.
64 IG/WG, March 1933, third letter.
65 IG/WG, March 9, 1933.
66 IG/WG, March 13, 1933.
67 IG/WG, March 16, 1933.
68 Bayer to Walter Gropius, March 9, 1933, IWG/HB
69 IG/WG, March 13, 1933.
70 IG/WG, March 15, 1933.
71 IG/WG, March 9, 1933.
72 IG/WG, March 16, 1933.
73 HB/AS&S, 1933.
74 Otto, *Haunted Bauhaus*, 83–86.
75 Gropius Johansen, *Ise Gropius,* 23.
76 Assessment by Ati Gropius Johansen, interview with author, September 10, 2013.
77 Ise Gropius to Marcel Breuer, undated fragment [March or April 1935], MB/HB, reel 5709, frame 652.
78 See the narrative presented in Isaacs, *Gropius*, 173 (German edition, vol. 2, 610–11).
79 Gropius Johansen, *Ise Gropius*, 23.

Chapter 6

1 See, for example, the accounts in Hahn, *Bauhaus Berlin* as well as in Hahn "Bauhaus and Exile."
2 Schlemmer quoted Joseph Goebbels in a private letter to his former colleague Gunta Stözl: "Right now everything is being checked—one's origins, one's party, [whether or not one is] Jewish, Marx[ist], Bauhaus," he wrote. "I consider myself pure, and my art strong, in keeping with nat. soc. principles—namely 'heroic,

steely-romantic, unsentimental, hard, sharp, clear, creative of new types,' etc." Oskar Schlemmer to Gunta Stözl, June 16, 1933, Bauhaus-Archiv Berlin; cited in Nerdinger, "Modernisierung," 19; partial English translation in Koss, "Bauhaus Theater," 727.

3 See Droste, "Der politische Alltag," 209, and the correspondence reprinted on the following pages.

4 Hahn, "Bauhaus and Exile," 214 (emphasis added).

5 Brüning, "Herbert Bayers neue Linie," 224.

6 Kranz, "Bauhaus Pedagogy," 206.

7 "They came mostly privately, rarely on business." Klar, *Chuzpe*, 78. See also Brüning, "Bauhäusler," 26; Schug, "Herbert Bayer," 177 with additional references. Most of this circle left Germany by 1935. The exceptions were Otti Berger—murdered at Auschwitz after her efforts to emigrate fell through—and Marianne Brandt, who stayed on under apparently restrained circumstances, finally joining the Reich Chamber of Culture in 1939. See Otto, "Marianne Brandt's Experimental Landscapes."

8 Schug, "Moments of Consistency," 63.

9 Kranz, "Bauhaus Pedagogy," 207. "Scoffer" might have been a better translation for "Spötter" than *jesters*.

10 See for example the report in *Annoncen-Expedition*, May 31, 1933.

11 See in detail Anhold, "Imagery," 113–14 and 226, which traces Bayer's cloud motifs in painting and graphic design back to his landscape oils from 1924.

12 See Blümm et al., *Die bewegten Netze*.

13 Brüning described his attitude as, "Das Studio? Das bin ich." Brüning, "– – Y – –," 77.

14 Herbert Bayer to Walter Gropius, September 16, 1935, BHA Berlin, Walter Gropius archive, folder 123.

15 See for example HB/ACQ, no. 5.

16 Berghoff, "Times Change," 2003.

17 Bayer, *Dorland 1*, III.

18 See Schug, "Moments of Consistency."

19 Herbert Bayer to Alexander Dorner, November 17, 1933, private collection.

20 Dedication copy to Irene Bayer, today preserved at BHA Berlin, 2006/17.

21 Herbert Bayer to Walter Gropius, IWG/HB, January 25, 1937. This quote also used by Schug, "Herbert Bayer," 183.

22 "I had a telephone conversation with Dorland, they got it in the neck when they fought for the right to run the advertising business." Herbert Bayer to Ise Gropius, IWG/HB, June 15, 1934.

23 Dorland Berlin, press release, October 4, 1963, 3; cited in Schug, "Herbert Bayer," 177. This occurred even though Dorland always played down international references in its external presentation and put its German customers in the foreground; see the report on Dorland in *Annoncen-Expedition*, May 31, 1933.

24 See, among others, Krause, *Die nützliche Moderne*; Rössler, *Bauhaus at the Newsstand*.

25 On the broader phenomenon of efforts undertaken by various artists and designers at the time to uphold "diversity" within the Nazi policy of *Gleichschaltung*—including a certain tolerance on the part of the regime toward fostering (for the benefit of an international audience) an impression of variety within, among other things, magazine publishing—see my detailed accounts in Rössler, *Bauhaus at the Newsstand*, 69–79 and Rössler, "Vielfalt in der Gleichschaltung." See also Sösemann, "Propaganda und Öffentlichkeit," 127–39.

26 See the articles in Nerdinger, *Bauhaus-Moderne*.

27 On Dorland's history under National Socialism, see Schug, "Moments of Consistency," 64–73.

28 Schug, "Herbert Bayer," 176.

29 See the report on Dorland in *Annoncen-Expedition*, May 31, 1933.

30 Jorge Fulda to Herbert Bayer, April 19, 1940, JF/HB.

31 Brüning, "Herbert Bayers neue Linie," 221.

32 Lupton, *Herbert Bayer*, 35.

33 OHP/C, 28.

34 In 2013, these and his other advertising designs of the time were documented in detail in a preliminary catalogue of his graphic design work from 1928 to 1938; see Rössler, *Berliner Jahre*, 166–284.

35 Klar, *Chuzpe*, 53–129.

36 See Schug, "Moments of Consistency."

37 See Brüning, "– – Y – –."

38 Gubig and Köpcke, *Chlorodont*, 72–73.

39 For an overview see Rössler, *Berliner Jahre*, section C.

40 HB/ACQ, no. 5.

41 See the incorrect assertion by Sachsse, "Von Österreich aus," 6–7, who also wrongly assigns the journal to the Ullstein-Verlag.

42 See Rössler, *Bauhaus at the Newsstand*. For reproductions of these covers see, for example, Schug, "Herbert Bayer," 224, 225.

43 For a more detailed interpretation see Paul, *Bilder einer Diktatur*, 68–70.

44 Rössler, *Berliner Jahre*, C.06.

45 Rössler, *Bauhaus at the Newsstand*, 2nd edn, 52.

46 Cohen, *Herbert Bayer*, 299.

47 For example, Anhold uses this terminology when referring to the Bauhaus dance poster (Fig. 3.1) and the *bauhaus* magazine cover design (Fig. 4.1). Anhold, "Imagery," 33 and 49.

48 HB/ACQ, no. 1.

49 For reproductions of sample covers see Rössler, *Berliner Jahre*, C.14a–c.

50 See examples in Brüning, "Herbert Bayer," 332–39.

51 HB/ACQ, no. 5.

52 Wetzig, "Schriftschaffen," 215–17; here Bayer is also called a "bold innovator." Though usually attributed to Bayer, his authorship of the portfolio is highly dubious—at least in terms of the quality of the work samples it included (collected to encourage printing press owners to purchase a set of types).

53 For an extensive treatment of this material, see Rössler, "Herbert Bayers Bildsprache."

54 For an unclear reference to catalogue and booklet see, for example, Schug, "Herbert Bayer," 179.

55 For example, see Schmidmair, "Ausstellungsgestaltung," 17. For the popular misconception according to which Bayer was also involved in designing the exhibitions himself, see, for example, Anhold, "Imagery," 148.

56 La, "Herbert Bayer," 75.

57 "Es gibt kein richtiges Leben im Falschen." (There is no right life in the wrong one.) See Adorno, *Minima Moralia*.

58 Bayer, *painter, designer, architect*, 44–45.

59 See Chapters 7 and 16 for an in-depth discussion of these works and how Bayer presented them in his legacy. The material has, until now, largely been sidelined

within Bayer's oeuvre. Gwen Chanzit's authoritative biography, *Herbert Bayer*, addresses in detail the important works made before 1933 as well as those Bayer created in the United States from 1938 onward. Chanzit subsumes Bayer's activity for Nazi propaganda exhibitions in a succinct sentence drawing on Dorner's brief biographical sketch of Bayer from 1949 (Dorner, *The Way Beyond "Art,"* 120, 240). Cohen's 1984 monumental Bayer monograph, *The Complete Work* (like Bayer's own monograph) mentions only the cover of the brochure *Das Wunder des Lebens* because of its classical motif; see below.

60 Herbert Bayer to Christopher Phillips, n.d. (c. 1980); cited in Buchloh, "Faktura," 118.
61 Herbert Bayer to Walter Matthess, January 6, 1948, VL/HB, box 12.
62 For an overview see Rössler, *Berliner Jahre*, parts F–H.

Chapter 7

1 Dorner, *The Way Beyond "Art,"* 179. For a detailed discussion of Bayer's postwar reception see Chapter 16 of the present volume.
2 i.b. [Irene Bayer-Hecht], flyer for the annual exhibition of the Kunstverein Salzburg, 1936. Brüning, "Bauhäusler," 342 dated this text wrongly as from 1931.
3 i.b. [Irene Bayer-Hecht], flyer for the annual exhibition of the Kunstverein Salzburg, 1936.
4 "Dandy der Form." Franz Roh, "Zwischenposition," 191. See also p. 228.
5 i.b. [Irene Bayer-Hecht], flyer for the annual exhibition of the Kunstverein Salzburg, 1936.
6 See Rössler, "Vielfalt in der Gleichschaltung." The term was originally coined in an exhibition called "Cold War Modern: The Domesticated Avant-Garde" held at Wellesley College's Davis Museum and Cultural Center in 2000. Art historian Anna Wessely transferred this term into German in a lecture she gave in June 2006 in Berlin; see Wessely, "László Moholy-Nagy," 124.
7 He was listed as member # G 1615 with his address at Kurfürstendamm 32 in Berlin; see Fachgruppe Gebrauchsgraphiker, *Deutsche Werbegraphik*, 42.
8 Sachsse, "Von Österreich aus," 4.
9 Sachsse, 8.
10 See for example, Brüning, "– – Y – –"; Schug, "Herbert Bayer," 176.
11 See at length Droste, "Bauhaus Object," here 212–15.
12 Personal file of Herbert Bayer, Reich Chamber of Fine Arts, Landesarchiv Berlin, A Rep. 243-04 no. 447, reel 8, 435.
13 See Brüning, "– – Y – –."
14 Bayer to Walter Matthess, January 6, 1948, VL/HB, box 12.
15 OHP/B, 15.
16 See pp. 170 and 198.
17 "I was separated, but my first wife and our child were still living in Berlin ... I thought I should flee first and see whether I could—where I could go, and decide on that, so then later on they came to America." OHP/B, 15.
18 See Rössler, "Neue Typographie;" Rössler, "Frankfurt, Leipzig, and Dessau."
19 Gebhard, "Kommunistische Ideen," 11–12.
20 Interview with Max Gebhard, 1976, TU Munich, Architekturmuseum, Estate of Richard Paulick, pauli-160-1. I wish to thank Anke Blümm for pointing me to this source.

21 "But if he occasionally wanted to borrow our little sailboat *Bussi-Bussi* for a day out alone, I was pretty sure that there was no girl involved but that he had concocted some plan to kill Hitler and/or Goebbels, whom he hated deeply." Klar, *Chuzpe*, 79.

22 "Heute habe ich geglaubt, einen großen auftrag zu bekommen. aber braune herren haben diese aussicht wieder zugemacht (doch scheise es war kacke)." Bayer to Breuer, December 12, 1933, MB/HB, reel 5709, frame 349. Breuer's professional constellation was similar to Bayer's, but his Jewish background led him to leave Germany in 1933; see Chapter 9.

23 Bayer to Breuer, December 3, 1936, MB/HB, reel 5709, frame 349.

24 Personal file of Herbert Bayer, Reich Chamber of Fine Arts, Landesarchiv Berlin, A Rep. 243-04 no. 447, reel 8, 435.

25 Theo Bayer to Herbert Bayer, November 26, 1938, Estate of Theo Bayer, Linz.

26 Schug, "Herbert Bayer," 182.

27 "Declaration on the Determination of Fees by the Reich Chamber of Fine Arts for the Financial Year 1937," April 22, 1937. See the personal file of Herbert Bayer, Reich Chamber of Fine Arts, Landesarchiv Berlin, A Rep. 243-04 no. 447, reel 8, 435.

28 Schug, "Herbert Bayer," 185, note 51.

29 https://www.bundesbank.de/resource/blob/615162/3334800ed9b5dcc976da0e6503 4c4666/mL/ kaufkraftaequivalente-historischer-betraege-in-deutschen-waehrungen-data.pdf

30 Schug, "Herbert Bayer," 180; Bayer is neither mentioned nor represented with illustrations in the mass-produced booklet accompanying the exhibition, which contributed significantly to the dissemination of the dictum of "degenerate art"; Kaiser, *Entartete Kunst*.

31 Cohen, *Herbert Bayer*, 404–405, note 56. According to Roh, *Entartete Kunst*, in 1962, it was the drawing *Woman from Behind* (*Frau von rückwärts*, 1928; Landesgalerie Hannover) in addition to the aforementioned oil painting. According to Bayer's recollections, the 1928 gouache *Blaue Stunde* (*Blue Hour*) was also destroyed without him knowing about the circumstances in detail. See also OHP/B, 14.

32 Droste, "Herbert Bayer," 62–79.

33 OHP/B, 14.

34 See e.g. Anonymous, "Sechste Anordnung" (130) on the compatibility of Bauhaus product design with Nazi aesthetics; see in greater detail Eisele, "Adolf H."

35 Schug, "Herbert Bayer," 181.

36 Meißner, "Quand l'art moderne," 41ff.

37 For a more in-depth analysis of Bayer's contributions to the propaganda exhibitions see Rössler, "Herbert Bayers Bildsprache."

38 See Thamer, "Geschichte und Propaganda," 351–52, 360 and note 31.

39 Anonymous. "Ausstellungsbilanz 1938," 1356.

40 Schäffer, *Wesenswandel*, 21.

41 HB/ACQ, no. 7.

42 For a summary see Weißler, "Bauhaus-Gestaltung," 48ff.; Keppler, "Moderne unterm Hakenkreuz," 12.

43 See Pohlmann, "Nicht beziehungslose Kunst;" Schug, "Herbert Bayer," 177.

44 Gemeinnützige Berliner Ausstellungs- und Messe-Ges. m. b. H., *Die Kamera*, 2. Bayer's *Die Kamera* catalogue was not used for the second installation of the show in Stuttgart (March–April 1934); rather, its almost unaltered contents were arranged anew by local designer Robert Niethammer, including the use of a Fraktur typeface.

45 See Rössler, *Berliner Jahre*, D. 15-22.

46 Zuschlag, *Entartete Kunst*, 226ff.

47 Schäffer, *Wesenswandel*, 30ff.

48 Wischek, "Zur Deutschland-Ausstellung," 27; Wischek, "Berliner Großausstellungen."

49 Bruno Gebhard, statement in a meeting directed by Ministerialdirektor Arthur Gütt of the SS racial office, January 17, 1935, Bundesarchiv Potsdam/Berlin, file R41/1008; cited from Thamer, "Geschichte und Propaganda," 366.

50 Wischek, "Zur Deutschland-Ausstellung," 27.

51 Pohlmann, "El Lissitzkys Ausstellungsgestaltungen," 60–63.

52 László Moholy-Nagy, *Von Material zu Architektur*, Bauhaus Book 14, 1929. Moholy's dust jacket for his book is reproduced in Brüning, *A und O*, 139.

53 See Gebhard and Maiwald, "Ein Rundgang."

54 Schug, "Herbert Bayer," 179.

55 See Jockheck, "Deutsche Leistung." I thank Isabel Röskau-Rydel (Krakow) for this information. There is no indication that Herbert Bayer's catalogue illustrations were reused in the course of the traveling exhibition.

56 Anhold, "Imagery," 152–53.

57 Over the years, Bayer had developed a strong interest in Hellenic sculpture and had already published an article in a popular magazine in which he painted over photographs to put Greek statues in contemporary clothing; Herbert Bayer, "Zieh Dich aus und Du bist Grieche" (Undress and you are a Greek), *Uhu* 6, No. 12 (September 1930), 28–32.

58 The Wolfsonian at FIU, Herbert Bayer Collection, object # TD1994.36. See Chapter 16 with more information on the significance of this motive for Bayer's oeuvre.

59 Leadbeater, *Der sichtbare und unsichtbare Mensch*, 1908.

60 Schug, "Herbert Bayer," 180. This brochure is reprinted in Beier and Roth, *Der gläserne Mensch*, 78–83.

61 Krause, *Die nützliche Moderne*, 50.

62 For their press reception, see e.g. Anonymous, "Modern Art," 160–61.

63 See the copy of the minutes of the meeting in preparation for the exhibition *Das Wunder des Lebens*, January 21, 1935, BArch R 3901/21008, vol. 4, 101–10.

64 See the news photos from the exhibition *Das Wunder des Lebens* (1935): Library of Congress #640487263/Corbis Historical IH157264 and Bundesarchiv Berlin, Image no. 102-16748 (photo: Georg Pahl).

65 Bruno Gebhard Papers, Dittrick Medical History Center and Museum, Case Western Reserve University, Cleveland, Ohio. See also Gebhard, *Strom und Gegenstrom*, the second part of his autobiography. Gebhard served as a curator at the German Hygiene Museum in Dresden—the original site of the "transparent man" display—from 1927 until 1932, when he went on leave to devote himself to Berlin's exhibition program. After planning on *The Wonder of Life* and other propaganda shows, Gebhard, a former Social Democrat, then managed to present versions of his health exhibitions in the United States which in 1937 gave him the opportunity to emigrate. He planned and designed the health exhibit at the New York World's Fair of 1939–1940 and later founded the Cleveland Health Museum in Cleveland, Ohio. As with Bayer himself, the experience of having worked on Nazi mass propaganda projects did not hinder his subsequent career in the United States.

66 Weißler, "Bauhaus-Gestaltung," 60.

67 Keppler, "Moderne unterm Hakenkreuz," 80.

68 "The problem for me was how to produce medical information without becoming too medically anatomical for popular taste and for general interest." HB/ACQ, no. 7.

69 "in anbetracht dessen, dass es ein kampf war, sowas überhaupt ohne strafe durchzusetzen." Bayer to Breuer, January 10, 1935, MB/HB, reel 5709, frame 641.

70 HB/ACQ, no. 7.

71 Wolf, "SSSR na Stroike."

72 HB/AS&S, February 4, 1935.

73 Ibid., 1935.

74 "Una de las páginas más extraordinarias de su carrera." Rodrigues Prampolini, "Herbert Bayer," 53; see also Brüning, "Herbert Bayer," 344. As one of two illustrations in the publication for his 1936 solo exhibition in Salzburg, he chose a motif from the *Wunder des Lebens* booklet. For further discussion, see Chapter 16 of the current book.

75 See Anonymous, "A Berlin Exhibition." It is beyond the purview of this book to examine the history of American interest in eugenics or its links to the Nazi promotion of such policies in the 1930s, but one interesting point of intersection with Bayer's own orbit was the 1934 export exhibition *Eugenics in New Germany*, also curated by Bruno Gebhard. It began its US tour in Pasadena, CA in September 1934 and, as with *Wunder des Lebens,* included many materials derived from displays at the German Hygiene Museum in Dresden, where Gebhard had been active. See Dittrick Medical History Center and Museum, "Eugenics exhibition travels to the United States, 1934," https://www.flickr.com/photos/dittrick/2614008804/in/photostream/ (accessed January 29, 2021).

76 Neumann, "Herbert Bayer's photographic experiments," 42–43.

77 HB/ACQ, no. 7.

78 Sachsse, "Von Österreich aus," 7–8.

79 See Otto, *Haunted Bauhaus*, 196–98.

80 Cohen, *Herbert Bayer*, 41.

81 For a reproduction of eight spreads from this brochure see Nowak-Thaller and Widder, *Ahoi Herbert!*, 227–31.

82 Krause, *Die nützliche Moderne*, 50.

83 See Hölscher, "Herbert Bayer," (1936).

84 See *Graphische Nachrichten* 16, no. 10 (October 1937), 471 and 487.

85 See this interpretation in Anhold, "Imagery," 227.

86 For a reproduction see Rössler, *Berliner Jahre*, 214, D.28. Terramare was itself a forerunner to West Germany's cultural organization Inter Nationes, which ultimately merged with the Goethe Institute.

87 See Chapter 11 for more details.

88 HB/ACQ, no. 7 and no. 13.

89 See Tymkiw, *Nazi Exhibition Design*. On the activities of the two former Bauhaus directors Mies and Gropius on behalf of the Nazi regime, see Nerdinger, "Bauhaus-Architekten" and Weißler, "Bauhaus-Gestaltung." The designer and East German functionary Walter Funkat later played down their activities with the naive statement that "all this had nothing to do with politics, but simply with industry" (Dolgner and Semrau, "Im Gespräch," 119). On Lilly Reich's involvement, see Gemeinnützige Berliner Ausstellungs- und Messe-Ges. m.b.H., *Deutsches Volk, deutsche Arbeit*, 226–29. On the participation of other Bauhäusler in this and other exhibitions in the trilogy, see Faber, "Ganz modern."

90 See Lugon, "La photographie."

91 Bayer, *Painter, Designer, Architect*, 11.

92 See pp. 63–5; Chanzit, *Herbert Bayer*, 112–15; and Rössler, "Ausstellung als begehbares Informationsdesign."

93 HB/ACQ, no. 7. See also Cohen, *Herbert Bayer*, 41.

94 Herbert Bayer, "Grundlagen der Ausstellungsgestaltung," undated manuscript, DPL, WH2416, Bx 7.

95 Lugon, "Dynamic Paths," 131–33; also Pohlmann, "El Lissitzkys Ausstellungsgestaltungen," 60ff.

96 Bayer, Preface to *Exhibitions and Displays*, 15.

97 Droste, "Herbert Bayer," 111 referring to Bayer, *painter, designer, architect*, 205. See also HB/ACQ, no. 13.

98 Cohen, *Herbert Bayer*, 298.

99 Droste, "Herbert Bayer," 110.

100 La, "Herbert Bayer," 72.

101 Bayer to Breuer, undated, MB/HB, reel 5708, frame 724.

102 Rossmann, *Písmo a fotografie*, 92–93. The exhibition installation, however, refers to the "Amt Feierabend" of KdF which was founded around 1937, which is why an unambigous assigment of this design is difficult.

103 My thanks go to Ute Brüning for this research.

104 HB/ACQ, no. 13.

105 For an in-depth analysis of the factory exhibitions see Tymkiw, *Nazi Exhibition Design*, 72–115.

106 Amt Feierabend, *Der Arbeiter*, 12.

107 Herbert Bayer, "Richtlinien für die Durchführung und typographische Gestaltung," n.d., detailed in Droste, "Herbert Bayer," 12.

108 Cohen, *Herbert Bayer*, 378: "Develops style and direction for the implementation and typographic organization of the Fabrikausstellungen (industrial fairs)."

109 Anonymous, *Der Arbeiter*, 12–13.

110 Bavaj, *Ambivalenz der Moderne*, 155; Tymkiw, *Nazi Exhibition Design*, 98.

111 Compare to the four montages without the Strength through Joy logo reproduced in *Die Form* 10, no. 7 (1934–35), 191; as small posters, two of these drafts have thus far been ascertained in the original print with the logo; see Rössler, *Berliner Jahre*, D.15a-d.

112 HB/ACQ, no. 3.

113 Ibid.

114 Cohen, *Herbert Bayer*, Chapter II.1, 191–239. See Chapter 16 for a longer discussion of Cohen's authorized monograph of 1984.

115 Linne, "Sozialpropaganda," 237–54.

116 Willy B. Klar, writing to Bayer about Hannes Neuner's work on behalf of the regime: "With Neuner it has become very bad." Klar to Bayer, n.d. [June 1940], WBK/HB. See also Brüning, *A und O*; Rössler, "'Wir zerstreuten uns zu Tode.'"

117 Hahn, "Bauhaus and Exile," 217.

118 Two-page manuscript (apparently incomplete), dated June 26, 1936; copy at the BHA Berlin, estate of Herbert Bayer. Partially reprinted in Droste, "Herbert Bayer," 73.

119 Herbert Bayer, "Gestaltung und Industrie," speech on occasion of a Dorland anniversary event, Berlin, October 4, 1963, DPL, WH2416, Manuscripts.

120 See Guenther, *Nazi Chic?*; Sultano, *Wie geistiges Kokain*; Guenther, "Destruction of a Culture".

121 Schnaus, *Kleidung*, 114–15.

122 See the overview of works in Rössler, *Berliner Jahre*, H.07 bis H.14. On the
 relationship between Dorland and the ADEFA see Klar, *Chuzpe*, 113ff.
123 For reproductions see Rössler, *Berliner Jahre*, H.07 a-e.
124 In *Painter, Designer, Architect*, Bayer gives the incorrect date of 1930 instead of
 1936–1937. Bayer, *Painter, Designer, Architect*, 49.
125 Nowak-Thaller and Widder, *Ahoi Herbert!*, 220.
126 Mounted slide, DPL, WH2416, Bx 38, Posters, 19.
127 Klar, *Chuzpe*, 115.
128 See in detail Guenther, *Nazi Chic?*, 155–65.
129 Hill and Cooper, "Herbert Bayer," 103. Bayer made this remark specifically about the
 relationship between photography and manipulation when he reflected in 1977 the
 beginnings of his career as a photographer and discussions with Moholy-Nagy.
130 See e.g. Jaeggi, *Werkbund-Ausstellung*.
131 OHP/B, 14.
132 See in detail Choy, "Inszenierungen," 120, 148–49.
133 "Film-Lieferwagen werben für Kongreß," *Film-Kurier*, April 6, 1935.
134 HB/ACQ, no. 7.
135 Schug, "Herbert Bayer," 181.
136 Interviews with Walter Funkat, February and April 1996; quoted in Brüning,
 "Fotografie," 56.
137 HB/ACQ, no. 3.
138 Brüning, "Bauhäusler," 26.
139 HB/ACQ, no. 7.
140 See the copy of the minutes of the meeting in preparation for the exhibition *Das
 Wunder des Lebens*, January 21, 1935, BArch R 3901/21008, vol. 4, 101–10.
141 See Grossmann, *Reforming Sex*, 136–65.
142 Ise Gropius to Breuer, February 19, 1934, MB/HB, reel 5709, frame 426.
143 Bayer to Josef Albers, January 31, 1934, The Josef and Anni Albers Foundation,
 Connecticut; reproduced in Schug, "Herbert Bayer," 182.
144 "I never had to go to the propaganda ministry, I never had to say, or never said,
 'Heil Hitler.'" OHP/B, 14. Later again, in written form: "I have never been at the
 propaganda ministry. I have never said heil hitler (nor belonged to the party)." HB/
 ACQ, no. 7. Before, 1972, in his diary notes: "I never said heil hitler." HB/OD, 204.
145 Hill and Cooper, "Herbert Bayer," 103.
146 A copy was kept in his Reich Chamber of Culture file. Bayer to Reich Chamber of
 Fine Arts, August 31, 1936, personal file of Herbert Bayer, Reich Chamber of Fine
 Arts, Landesarchiv Berlin, A Rep. 243-04 no. 447, reel 8, 435. I discuss the 1937
 London exhibition in Chapter 11 of this volume.
147 HB/AS&S, spring 1935.
148 This is a further developed version of the 1933 brochure known in the literature; see
 Bayer, *painter, designer, architect*, 42.
149 See Hölscher, "Herbert Bayer," (1936).
150 Herbert Bayer, "Enzyklopädie oder Bild-Lexicon," information sheet, June 24, 1933,
 DPL, WH2416, Bx 5.
151 See Fachgruppe Gebrauchsgraphiker in der Reichskammer der Bildenden Künste,
 Deutsche Werbegraphik; Stolze, "Kunst." See also Pfund, "Exhibition," 35–37; the
 photograph on page 36 documenting Bayer's contributions.
152 Hölscher, "Herbert Bayer," (1938), 7–8.
153 Anhold, "Imagery," 159.

154 To describe this phenomenon, I coined the phrase "diversity in *Gleichschaltung*" in a 2007 essay, building on work by Bernd Sösemann and Hainer Michalske. See Chapter 6 of this volume; Rössler, "Vielfalt in der Gleichschaltung"; and Jaeger, "Künstlerisch Gutes," 302.

155 i.b. [Irene Bayer-Hecht], flyer for the annual exhibition of the Kunstverein Salzburg, 1936.

156 Bayer to Breuer, March 1936, MB/HB, reel 5709, frame 836.

157 HB/ACQ, no. 7; Klar, *Chuzpe*, 109–18.

158 Hill and Cooper, "Herbert Bayer," 103.

159 Interview with Herbert Bayer in Barnard, *Herbert Bayer*, c. min. 20:30; similar remark from 1977 in Hill and Cooper, "Herbert Bayer," 103: "I did not think that the mad political regime could last. But I was wrong."

160 "Im übrigen aber ist Bayer durchaus kein Künstler, der utopischen Wunschträumen nachhängt. Er weiß sich sachlich, nüchtern und geschickt mit der Praxis abzufinden." Hölscher, "Herbert Bayer," 1934, 15. As the postwar editor of *Gebrauchsgraphik*, Hölscher would subsequently be an important part of Bayer's network after the war as well. In 1952, for example, he edited a special issue of *Gebrauksgraphik* (no. 9) on the Container Corporation of America, which was written and compiled by Bayer.

Chapter 8

1 Schug, "Herbert Bayer," 182–84 with numerous quotes from Bayer's diaries that need not be reprinted here.

2 HB/AS&S, January 1933.

3 Dr. Fritz Mann to Irene and Herbert Bayer, September 9, 1933, VL/HB, box 12. The couple finally divorced in 1944 when both partners had moved to the United States.

4 IB/HB, August 1, 1933.

5 IB/HB, August 22, 1933.

6 IB/HB, July 2, 8, and 15, and August 1, 1933.

7 IB/HB, July 8, 1933.

8 Black-and-white film recordings without soundtrack, three reels [undated, probably 1933], DPL, WH2416, special collection; mentioned in HB/AS&S 1934.

9 HB/AS&S 1933.

10 See e.g. IB/HB, October 4 and 10, 1933.

11 IB/HB, August 7, 1933.

12 IB/HB, September 18, 1933.

13 IB/HB, October 21, 1933.

14 IB/HB, November 16, 1933.

15 IB/HB, December 12, 1933.

16 It is impossible to tell from the Bayer archives whether, even as late as Christmas 1933, Irene Bayer-Hecht knew anything concrete about Ise Gropius's role in her husband's life. IB/HB, December 12, 1933.

17 "Frau Ehrlich", however, might have also been one of Bayer's many lovers.

18 Assessment by Ati Gropius Johansen, personal interview, September 10, 2013.

19 Herbert Bayer to Ise Gropius, November 3, 1935, IWG/HB.

20 IB/HB, July 15, 1939.

21 HB/AS&S, 1934.

22 HB/AS&S, late 1934.

23 Ise Gropius to Breuer, April 18, 1934, MB/HB, reel 5709, frame 492.

24 See Rössler, "Exil mit Kalkül," 61.

25 HB/38–40, 6.

26 Walter Matthess to Bayer, VL/HB, box 12.

27 Klar, *Chuzpe*, 78.

28 Black-and-white film (without soundtrack), three reels, n.d. [probably 1933], DPL, WH2416, special collection.

29 Klar, *Chuzpe*, 78.

30 Ibid., 79.

31 Heinz Ritter to Bayer, December 8, 1947, VL/HB, box 12.

32 See among others Koetzle, *Lexikon der Fotografen*, 174; Schube, "Umbo," 238.

33 Klar, *Chuzpe*, 46–99.

34 Klar to Bayer, August 10, 1939, WBK/HB. Klar also describes here the futile attempt to establish a similar friendship with Hein Gorny as a "Bayer replacement."

35 Klar to Bayer, July 29, 1939, WBK/HB.

36 Klar to Bayer, May 27, 1946, WBK/HB. In his memoirs, Klar reported that his father, a former member of the Social Democrats, concealed his Friday evening visits to the synagogue and the whole family managed for years to disguise their Jewish family background, until way into the 1940s. Klar claimed that he himself had already entered the paramilitary National-Socialist Motorist Corps (whose bylaws normally required a proof of Aryan ancestry) in 1933 for camouflage and was drafted to the Reichswehr in 1939. See Klar, *Chuzpe*, 131.

37 PD/HB. For the picture in his driver's license, he used a detail from a photograph taken by his wife four years earlier as part of the series showing him at the drafting table while working on the Dessau brochure (Fig. 3.5).

38 Klar to Bayer, Bayer, August 10, 1939, WBK/HB.

39 Klar to Bayer, Bayer, February 15, 1940 and undated [November 1946], WBK/HB.

40 Poem by Klar, "An Ba" (dedicated to Bayer), written at Christmas 1947 from a Soviet POW camp, December 25, 1947, WBK/HB.

41 Klar, *Chuzpe*, 96.

42 Moderegger, "Modefotografie," 70–71. I am grateful to Johannes Ch. Moderegger for his kind information and for providing transcripts of his October 1996 interview with Karin Stilke.

43 An immensely wealthy *bon vivant*, Vollmoeller was well-known for his longstanding penchant for extremely young women, but he spent little time in Germany after 1933, preferring Basel, Venice, Paris, and Hollywood. On Vollmoeller and his nude photographs of the 1920s, see Bürger, *Schattenreich*.

44 See Stilke, "Ich bin ein Sonntagskind." She also mentions several "Jewish" acquaintances and married couples who managed to flee abroad before November 1938, possibly a reference to Herbert and Irene Bayer.

45 In one instance, Klar calls the group "dublosan-club 69." Klar to Bayer, October 24, 1940, WBK/HB. For further information on the Dublosan brand, see Museum of Contraception and Abortion, Vienna (website), Condoms/Dublosan, https://muvs. org/de/verhuetung/kondome/dublosan-id2505/.

46 Klar, *Chuzpe*, 94.

47 A letter from Klar to Bayer lists those who took part in the club's erotic escapades as Ernst Baier (an Olympic figure skater); two brothers named Stapenhorst (probably Fritz and Klaus, the sons of film producer Gustav Stapenhorst, though

Klar's memoirs refer to "Gustav" Stapenhorst); a certain Bob Bauer; and somebody named Jimmy Günther. Klar to Bayer, February 15, 1940, WBK/HB. On Wittig's participation, see HB/OD. Jorge Fulda, if he was not himself a member of the Dublosan club, had many similar adventures with Bayer, as his numerous letters from 1941–1945 (and later) in JF/HB attest.

48 Jorge Fulda to Bayer, October 8, 1941, JF/HB.

49 The phrase "*kalte Küche*" refers to anal sex, while "*Kaffeemühlen-Tour*" was their shorthand for cunnilingus. Fulda to Bayer, April 19, 1940, JF/HB; Fulda to Bayer, April 30, 1943, JF/HB.

50 Klar, *Chuzpe*, 95.

51 Fulda to Bayer, November 11, 1945, JF/HB.

52 Klar to Bayer, February 15, 1940, WBK/HB. Klar mentions all five of the men, not just Bayer, putting on a parade for their female partners—but only after undertaking extensive preparations in a separate room—certainly a more extensive account of all-male horseplay than is to be found elsewhere in the Bayer literature. Klar, *Chuzpe,* 94–5.

53 Hubert Hoffmann, "Begegnungen mit Herbert Bayer," unpublished manuscript, dated November 25, 1985. Bauhaus-Archiv Berlin, document collection, Immeke Schwollmann-Mitscherlich, folder 2, p. 1–2.

54 See HB/OD.

55 Schawinsky, "Metamorphose Bauhaus," 84.

56 Bayer, Walter Gropius, and Ise Gropius, *Bauhaus 1919–1928*, 175. Fulda recognized himself in the picture; see Fulda to Bayer, September 27, 1970, JF/HB.

57 See pp. 24 and 28.

58 Fulda to Bayer, August 22,1973, JF/HB.

59 Fulda to Bayer, April 30,1943, JF/HB.

60 Fulda to Bayer, January 6, 1956 and August 18, 1971, JF/HB. For a reproduction of a portrait photo from 1934 see Rössler, *Berliner Jahre*, 64, 3.1.

61 Fulda to Bayer, April 21, 1953 and August 18, 1971, JF/HB.

62 Fulda to Bayer, August 11, 1939 and April 19, 1940, JF/HB.

63 Fulda to Bayer, April 19, 1940, JF/HB.

64 See OHP/C, 63.

65 Bayer to Breuer, October 26, 1937, MB/HB, reel 5709, frame 1048. Emphasis added. The word play in Bayer's use of the French term "*jour fix (x=cks)*" refers to both the regularity of the meetings (literally, a fixed day) and the German slang term for sex (*ficks*, from *ficken*).

66 HB/OD, 204.

67 "Ninette" to Bayer, December 30, 1934, VL/HB, box 70.

68 "Ninette" to Bayer, January 2, 1935, VL/HB, box 70.

69 HB/AS&S, late 1934. The "old problem" refers to his separation from his wife Irene and his notorious infidelity.

70 "Ninette" to Bayer, February 25, 1935, VL/HB, box 70.

71 HB/AS&S, late 1934.

72 HB/AS&S, spring 1935.

73 Klar to Bayer, August 10, 1939, WBK/HB.

74 Inez Heinssen-Schacht to Bayer, undated [December 1936], VL/HB, box 12.

75 Heinssen-Schacht to Bayer, undated [December 1936] and March 25, 1945, VL/HB, box 12.

76 Heinssen-Schacht to Bayer, January 20, 1937, VL/HB, box 12.

77 Heinssen-Schacht to Bayer, January 14, 1937, VL/HB, box 12.
78 HB/AS&S, summer 1937. This insight into Irene's interest in his art must relate to the text she wrote introducing Bayer's work for the flyer to his 1936 exhibition in Salzburg.
79 Heinssen-Schacht to Bayer, March 25, 1945, VL/HB, box 12.
80 Ibid., 12.
81 IB/HB, June 8, 1939.
82 IB/HB, September 4, 1938.
83 IB/HB, August 19, 1938.
84 Fulda to Bayer, August 18, 1971, JF/HB.
85 IB/HB, August 19, 1938.
86 IB/HB, September 4, 1938.
87 Handwritten addendum, IB/HB, June 8, 1939.

Chapter 9

1 HB/AS&S, late 1934.
2 For reproductions see Rössler, *Berliner Jahre*, 224–25, E.06–08.
3 Bayer to Lady Norton, October 29, 1947, VL/HB.
4 Isaacs, *Walter Gropius*, vol. 2, 724. [not in the English edition].
5 XS/Ms, folder 5, 238.
6 Breuer's Jewish background does not seem to have been widely known among his Bauhaus friends, as is suggested by a jesting letter Ise Gropius wrote to Breuer after his departure: "You deceived me about your family tree. You let me to believe that your intelligence was of pure Aryan origin and in doing so drove me mad about my deepest thinking on race! For teach me to know the Aryans!" (March 12, 1934, MB/HB, reel 5709, frame 456).
7 Bayer to Breuer, October, 6 1933, MB/HB, reel 5708, frame 728/729.
8 See Vegesack and Remmele, *Marcel Breuer*, 106–09; also Rössler, *Berliner Jahre*, F. 03, 05, 05a.
9 Breuer to Bayer, February 11, 1934, MB/HB, reel 5709, frame 420.
10 Bayer to Ise and Walter Gropius, April 17, 1937, IWG/HB. The particular nature of this agreement is unknown.
11 Bayer to Breuer, May 4, 1934, MB/HB, reel 5709, frame 510.
12 See OHP/C, 60–61.
13 Bayer, Travel Diary 1934, June 9, DPL, WH2416, Bx 70. In their correspondence, both Bayer and Bayer-Hecht occasionally spell the name Matthess incorrectly; these incidences have been silently corrected here.
14 HB/AS&S, 1934.
15 See esp. pp. 107–9.
16 Nerdinger, "Bauhaus-Architekten," 154–58.
17 "I received the news of your departure from this wormy continent with real sadness … Your previous 'closeness' was also an illusion. But at least it was that." Bayer to Gropius, January 25, 1937, IWG/HB. Schug also includes this quote in "Herbert Bayer," 183.
18 On Gropius's journey to Harvard and his relevance to the university, see James, "Changing the Agenda," 242–47.

19 For greater detail, see Grawe, *Call for Action*, 59–97; Schulze, "Bauhaus Architects."

20 Nerdinger, "Bauhaus-Architekten," 157–58.

21 Ise Gropius, diary, May 21, 1925, BHA Berlin 1998/55, folder 11.

22 Breuer to Ise Gropius, April 6, 1935, BHA Berlin, Walter Gropius archive, folder 64.

23 The entire passage reads: "Why should I save your soul, Lajko? First of all, it's hardly worth it, for it is certainly quite an undernourished creature; and second of all—now that it has been elevated to a general commodity—an aristocrat can get along well enough without it. You and Herbert have been slimming down [your souls] for so long that I thought it would no longer be a problem. Well, I think … the salvation of souls would be superfluous." Ise Gropius to Breuer, April 10, 1935, MB/HB, reel 5709, frame 657. In a fragment of a letter from the same period, Ise Gropius closes with, "hurry soon into the arms of your loving Pia." MB/HB, reel 5709, frame 653.

24 Ise Gropius to Breuer, March 12, 1934, MB/HB, reel 5709, frame 458 and 459.

25 Assessment by Ati Gropius Johansen, personal interview, September 10, 2013.

26 Ise Gropius to Breuer, September 15, 1935, MB/HB, reel 5709, frame 723. (The SA, or Sturmabteilung, was the original paramilitary wing of the Nazi party; the German army was called the Reichswehr until 1935, when its name was changed to the Wehrmacht.)

27 XS/Ms, folder 4, 209.

28 Hahn and Paul, *Schawinsky*, 203.

29 For a reproduction of this poster see de Jong, *The Poster*, 170.

30 Fleischmann, *bauhaus drucksachen*, 306–09.

31 For more on this topic in relation to Bayer, see Chapters 6 and 7. Neumann, *Xanti Schawinsky*, 14.

32 See the description by Brüning, "Bauhäusler," 47, note 19, based on an interview conducted in 1992 with Kurt Kranz.

33 Hahn and Paul, *Schawinsky*, 17.

34 See the brochure announcing the special issue to advertisers, distributed by Beyer publishers in 1937. For more background on this issue see Rössler, *Bauhaus at the Newsstand*, 88–89, 115–17.

35 Danilowitz, "Perspektiven und Grenzen," 95–104; see also in detail Grawe, *Call for Action*.

36 In the summer of 1930, Josef Albers photographed the Bayers with their one-year-old daughter in Ascona—joyful family photos that showed no traces of the secret extramarital affair that was then just beginning between Bayer and Ise Gropius (see p. pp. 69–70. and Fig. 5.3). Although Bayer and Albers worked together at the Bauhaus and shared an affiliation with the inner Gropius circle, their friendship faded over the years. In a melancholic letter shortly before Albers passed away, Bayer confirmed the "great warmth, friendship, and admiration" he had always felt for him. Bayer to Josef and Anni Albers, November 1975, cited in Danilowitz, "Herbert Bayer und Josef Albers," 274.

37 Helfenstein and Mentha, *Josef und Anni Albers*, 13. For the Reception of Albers in the United States see also Saletnik, "Pedagogic Objects."

38 Tupitsyn, "Ablehnung und Akzeptanz," 16–17. Albers' shaping the school's adventurous spirit of experimentation had a lasting impact not only on subsequent Black Mountain students like Robert Rauschenberg, who enrolled at Black Mountain College in 1948, and Kenneth Noland but also on the many faculty who taught there well into the 1950s, including John Cage, Merce Cunningham, Robert Motherwell, Franz Kline, and other major figures of postwar American art.

39 See Heinze-Greenberg, "Artistic European Utopia." Ironically, Wijdeveld summarized in a 1948 letter that now—apart from himself—all living former comrades-in-arms (Ozenfant, Mendelsohn, Hindemith, Bonifaz, Chermayeff) were now working in the United States. See also Barnstone, "Real Utopian."

40 See pp. 58 and 84.

41 Bayer to Gropius, September 16, 1935, BHA Berlin, Walter Gropius archive, folder 123.

42 Gropius to Bayer and others, November 16, 1935, VL/HB.

43 See the correspondence of Moholy-Nagy on this matter, as quoted in Bernstein, "Purism and Pragmatism," 262–69.

44 See Margolin, "László Moholy-Nagys Odyssee."

45 In reference to Droste's diagnosis for the 1920s, one could speak here of "competitors at a distance," see Droste, "Herbert Bayers Weg," 80.

46 László Moholy-Nagy: Notes on the work of Herbert Bayer #7, collected on occasion of the exhibition at North Texas State Teachers College, April 1943. American Archives of Art/Smithsonian Institution, Samuel Benton Cantey Papers, Artist File: Herbert Bayer, reel no. 1688.

47 See e.g. Moreau, "Raum, Zeit, Betrachter," 93.

48 See Katenhusen, "Biografie des Scheiterns?" particularly 268–69, with numerous examples.

49 For this general interest magazine piece, Bayer provided two montage panels with Greek statues dressed in bathing suits, accompanied by Dorner's essay advocating physical fitness as a human need that extends beyond the requirements of labor. It is not known whether they met in the course of this collaboration. "Antike am Wannseestrand," *die neue linie* 8, no. 12 (August 1937), 20–21, 53.

50 HB/ACQ, no. 7.

51 Ise Gropius to Breuer, April 10, 1935, MB/HB, reel 5709, frame 657.

52 See the exhaustive depiction of Katenhusen, "Biografie des Scheiterns?" 270–72.

53 MB/HB, reel 5709, Correspondence. See also Ise Gropius, diary, BHA Berlin 1998/55.

54 Etzold, "Walter Gropius," 69–71. Gropius wrote to his wife as early as 1924, "one must win the press, as you have also correctly recognized. You obviously have a great talent for diplomatic actions." IG/WG, folder 27/28.

55 All passages from Ise Gropius to Breuer, March 12, 1934, MB/HB, reel 5709, frame 456–59. It is not clear whether Gropius would have wanted to say something—or "nothing"—about the popular tourist spot of Plymouth. Rather, this must have been a phrase from a language textbook he was working with.

56 Ibid., frames 456–59.

57 HB/ACQ, no. 7.

58 See Holz, "Recasting Exile," 285–86. I thank Lucy Wasensteiner, London, for further information on the Norton family. See also the short biography presented in Hadley, "Female Gallerists." Noel "Peter" Norton was also instrumental in bringing a show of "degenerate" artists to London in 1938; see Wasensteiner, *Exhibition.*

59 Ise Gropius to Breuer, September 15, 1935, MB/HB, reel 5709, frame 724.

60 Ise Gropius to Breuer, December 1935, MB/HB, reel 5709, frame 761.

61 Bayer to Breuer, June 23, 1935, MB/HB, reel 5709, frame 689.

62 Bayer to Reich Chamber of Fine Arts, August 31, 1936, personal file of Herbert Bayer, Reichskulturkammer, Landesarchiv Berlin, A Rep. 243-04 no. 447, reel 8, 435. In his letter he disclosed that he would already travel the following day; apparently he sent his message at short notice on purpose so that any response would arrive too late to prevent his journey.

63 Assessment by Ati Gropius Johansen, personal interview, September 10, 2013.

64 HB/OD, 137; also HB/ACQ, no. 7. On Giedion-Welcker, see Bruderer Oswald, *Das neue Sehen.*

65 Lady Norton and Herbert Bayer to Breuer, December 31, 1936, MB/HB, reel 5709, frame 923.

66 Lady Norton to Bayer, December 15, 1939, VL/HB.

67 Lady Norton to Bayer, May 22, 1939, VL/HB.

68 Bayer to Ise and Walter Gropius, IWG/HB, April 17, 1937.

69 Ise Gropius to Breuer, May 19, 1937, MB/HB, reel 5709, frame 978.

70 "I often think, too, of Pius, never of Pia."—"I still feel I would not wish to see her." Lady Norton to Bayer, November 15, 1940 and January 26, 1947, VL/HB.

71 HB/AS&S, late 1936.

Chapter 10

1 Herbert Bayer to Ise Gropius, June 9, 1932, IWG/HB.

2 See Eckhard Neumann's interview with Walter Matthess, at that time owner of the Dorland advertising agency and a personal friend of Herbert Bayer: "When the slogan 'Heim ins Reich' (Home to the Reich) was created in Germany and Austria was occupied, it was no longer possible for Herbert Bayer to stay in Germany." Bauhaus-Archiv, *Herbert Bayer*, 108.

3 In the summer of 1936 he noted in his diary: "An irrepressible homesickness has made me suffer, especially in recent years. I want to go back to where I come from." HB/AS&S. For similar sentiments expressed in 1937, see the heretofore unpublished correspondence in Schug, "Herbert Bayer," 183–84.

4 Herbert Bayer to Ise and Walter Gropius, IWG/HB, April 17, 1937.

5 HB/AS&S.

6 HB/38–40, 40.

7 Heinz Ritter to Herbert Bayer, December 8, 1947, VL/HB, box 12.

8 See the assessment offered in Passuth, *Moholy-Nagy*, 76. See also Brüning's detailed account of the complicated situation surrounding Moholy's studio; Brüning, "Ateliers des Moholy-Nagy."

9 HB/AS&S, 1934. What Bayer calls his "working group here."

10 Bayer, Travel Diary 1934, June 9, DPL, WH2416, Bx 70.

11 Bayer to Ise Gropius, November 3, 1935, IWG/HB.

12 Rössler, *Berliner Jahre*, Part II.

13 Bayer to Breuer, June 23, 1935, MB/HB, reel 5709, frame 689.

14 OHP/C, 73.

15 Ise Gropius to Breuer, September 15, 1935, MB/HB, reel 5709, frame 724.

16 Bayer to Breuer, September 6, 1935, MB/HB, reel 5709, frames 713 and 714.

17 Grohn, *Gustav Hassenpflug*, 43.

18 Klar, *Chuzpe*, 98–99.

19 See Adorno, *Minima Moralia* (also Chapter 6).

20 Bayer to Breuer, September 6, 1935, MB/HB, reel 5709, frame 714.

21 "Today back to the usual witches' caldron." Bayer to Breuer, January 7, 1937, MB/HB, reel 5709, frame 930. After spending the holiday season skiing, Bayer probably referred to life in Germany and in the metropolis of Berlin in general and to his day work at Dorland in particular.

22 Bayer to Ise and Walter Gropius, IWG/HB, April 17, 1937. Cited in Schug, "Herbert Bayer," 183.
23 In fact, the annual emigration figures of German Jews after the first wave of emigration in 1933 (37,000 people) remained stable, with about 23,000 emigrants per year between 1934 and 1937, compared to about 384,000 German Jews after the 1935 census. See Wetzel, "Auswanderung aus Deutschland," Statistisches Reichsamt, *Statistisches Jahrbuch*, 18.
24 HB/AS&S, 1934.
25 Assessment by Ati Gropius Johansen, interview with author, September 10, 2013.
26 There is no evidence, however, of Walter Gropius actually expressing such concerns to anybody.
27 See Brüning, "Herbert Bayer," 344, who describes the reasons for this descent as "vague."
28 See Wehlau, *Lichtbild in der Werbung*, 142.
29 On this exhibition and its relationship to *Die Kamera* see Tymkiw, *Nazi Exhibition Design*, 134–143.
30 See Chapters 6 and 7.
31 Although the DPA was a private firm, it was established under the direction of NS propaganda officer Carstensen in 1936 and thus had very close ties to Goebbels' ministry; see p. 98.
32 Interview with Kurt Kranz, fall 1992; cited in Brüning, "Bauhäusler," 30.
33 Chapter 8 details Irene Bayer-Hecht's attempts to set up her own business, first in Marienbad and then in Prague.
34 Ise Gropius to Breuer, January 19, 1935, MB/HB, reel 5709, frame 647.
35 Bayer to Breuer, January 10, 1935, MB/HB, reel 5709, frame 642.
36 Bayer's foreign currency legal problems were apparently settled without a lawsuit or court appearance, as there are no documents either in Bayer's Reich Chamber of Fine Arts dossier, the Berlin registry office, or in his personal archive. Certainly he would have mentioned any persecution by the Nazi state to bolster his reputation after the war. There were, moreover, subsequent occasions when he managed to obtain foreign currency, for instance for his travels to London in 1936 and 1937 (see Chapter 11).
37 Reich Chamber of Fine Arts, order of the State Director, July 29, 1937, personal file of Herbert Bayer, Reich Chamber of Fine Arts, Landesarchiv Berlin, A Rep. 243-04 no. 447, reel 8, 435.
38 See the undated typescript in the Bayer estate; PD/HB.
39 See Rössler, *Bruno E. Werner*.
40 Bayer to Ise and Walter Gropius, April 17, 1937, IWG/HB, folder 30; this quote also used by Schug, "Herbert Bayer," 183.
41 Bayer to Breuer, May 4, 1934, MB/HB, reel 5709, frame 509.
42 In this case, Bayer was referring not to the canton of Schwyz but idiomatically to Switzerland as a whole. Bayer to Breuer, January 10, 1935, MB/HB, reel 5709, frame 641.
43 Bayer to Breuer, September 6, 1935, MB/HB, reel 5709, frame 713.
44 Ise Gropius to Breuer, April 10, 1935, MB/HB, reel 5709, frame 656.
45 Bayer to Breuer, March 29, 1936, MB/HB, reel 5709, frame 819.
46 Krause, "Westfalen-Lippe," 50.
47 Ise Gropius to Breuer, September 21, 1934, MB/HB, reel 5709, frame 578.
48 Bayer to Breuer, September 21, 1934, MB/HB, reel 5709, frame 583.

49 Anhold, "Imagery," 89 and 134–147 (chapter IV).

50 Bayer to Albers, January 31, 1934, The Josef and Anni Albers Foundation, Connecticut; reproduced in Schug, "Herbert Bayer," 182.

Chapter 11

1 "I arranged an exhibition of Herbert's works with one of the attendees." Ise Gropius to Breuer, January 19, 1935, MB/HB, reel 5709, frame 646.

2 Bayer to Gropius, September 16, 1935, BHA Berlin, Walter Gropius archive, folder 123.

3 Kinross, "Herbert Read's *Art and Industry*," 41–42.

4 Stanley Morison to Walter Lewis, July 25, 1934, cited in Barker, *Morison*, 337. I am grateful to Gerd Fleischmann for pointing out this episode to me.

5 Walter Lewis to Stanley Morison, July 31, 1934; Herbert Read to Richard de la Mare, October 29, 1934; both cited in Kinross, "Herbert Read's *Art and Industry*," 43.

6 Bayer, *Painter, Designer, Architect*; Bauhaus-Archiv, *Herbert Bayer*; Cohen, *Herbert Bayer*.

7 Bayer to Breuer, September 6, 1935, MB/HB, reel 5709, frame 714.

8 Afterward, Bayer wanted to "remind some people of himself," wrote Bayer to Breuer, January 14, 1936, MB/HB, reel 5709, frame 781.

9 We can date his arrival through a note to Breuer, "on April 1st I want to be in London for my exhibition." Bayer to Breuer, February 7, 1937, MB/HB, reel 5709, frame 942. See also Widder, "Emigration," 234.

10 Dorner, "Herbert Bayer," 3.

11 "... des naturverbundenen, animalistisch-schönen Menschen ... mit einfachsten Grundgefühlen." Dorner, "Herbert Bayer," 7, 11.

12 Dorner, *The Way Beyond "Art*," 215–16. See also Uchill, "Re-viewing," 118, for an analysis of this text in greater depth.

13 Schug, "Moments of Consistency," 69. For more on this exhibition, see Chapters 6 and 7.

14 Bayer to Gropius, January 25, 1937, IWG/HB; see also Chapter 6 which contextualizes this remark, esp. p. 86.

15 Bayer to Reich Chamber of Fine Arts, August 31, 1936, personal file of Herbert Bayer, Reich Chamber of Fine Arts, Landesarchiv Berlin, A Rep. 243-04 no. 447, reel 8, 435.

16 Reich Chamber of Fine Arts, State Director to Bayer, December 4, 1936, personal file of Herbert Bayer, Reich Chamber of Fine Arts, Landesarchiv Berlin, A Rep. 243-04 no. 447, reel 8, 435. In the same file see order of the Chamber's President, November 28, 1936.

17 "Hitler and Art," *The Star*, April 10, 1937.

18 London Gallery to Arthur Lawson, April 12, 1937, DPL, WH2416, Bx 9, folder 84.

19 See e.g. HB/ACQ, no. 7.

20 London Gallery to Arthur Lawson, April 12, 1937, DPL, WH2416, Bx 9, folder 84.

21 Bayer to Ise and Walter Gropius, April 17, 1937, IWG/HB.

22 Speech by Herbert Read at the opening of Herbert Bayer's exhibition, London Gallery, DPL, WH2416, Bx 5.

23 Bayer to Ise and Walter Gropius, April 17, 1937, IWG/HB.

24 Ise Gropius to Breuer, May 19, 1937, MB/HB, reel 5709, frame 978.

25 "If I could rely on Peter [Lady Norton] for the money she surely told you about, I would come to London for a few days in December." Bayer to Breuer, December 1, 1937, MB/HB, reel 5709, frame 1064.

26 Levy, *Scandalous Eye*, 104.

27 Holz, "Recasting Exile," 287.

28 Bayer to Carola Giedion-Welcker, August 21, 1937, gta Archiv/ETH Zürich, estate of Sigfried Giedion.

29 Bayer to Ise and Walter Gropius, IWG/HB, April 17, 1937.

Chapter 12

1 Throughout this chapter I draw on Grawe's outstanding *Call for Action* for background information on Bauhäusler in the United States.

2 Chanzit, *Herbert Bayer Collection*, 209.

3 See Grawe's extensive overview in "Von der Hochschule," 123–36.

4 Langfeld, *German Art*, 68–69.

5 See Wingler, *Bauhaus in America*.

6 OHP/C, 26; see also p. 29.

7 Bayer to Breuer, June 5, 1935, MB/HB, reel 5709, frame 682.

8 Bayer to Breuer, April 23, 1936, MB/HB, reel 5709, frame 828.

9 Bayer to Breuer, December 3, 1936, MB/HB, reel 5709, frame 920.

10 Bayer to Breuer, February 7, 1937, MB/HB, reel 5709, frame 941.

11 Klar, *Chuzpe*, 79; also Bayer in OHP/C, 105: "I learned a little English in Germany. I took some lessons."

12 HB/AS&S, summer 1937.

13 "Can't you bring me an order in America, to be there for a few months?" Bayer to Ise and Walter Gropius, IWG/HB, April 17, 1937.

14 Bergdoll, "Encountering America," 260–62.

15 Bayer to Breuer, July 1937, MB/HB, reel 5709, frames 997 and 1011 (emphasis in the German original).

16 "It is sad that our exhibition plans went up in smoke." Bayer to Breuer, October 26, 1937, MB/HB, reel 5709, frame 1049.

17 For more on these plans, see the extensive account in Bergdoll, "Encountering America," 260–63.

18 Bayer to Breuer, spring 1937, MB/HB, reel 5708, frame 721.

19 Breuer to Ise Gropius, May 28, 1937, MB/HB, reel 5709, frame 984.

20 Ellen Frank to Breuer, July 5, 1937, MB/HB, reel 5709, frames 1011 and 1012.

21 Breuer to Ise Gropius, May 28 1937, MB/HB, reel 5709, frame 984, emphasis original.

22 Bayer to Breuer, June 5, 1937, MB/HB, reel 5709, frame 990.

23 Breuer to Bayer, May 31, 1937, MB/HB, reel 5709, frame 988.

24 Bayer to Breuer, June 5, 1937, MB/HB, reel 5709, frame 990.

25 Breuer to Ise Gropius, June 21, 1937, BHA Berlin, Walter Gropius archive, folder 64.

26 Koehler, "Walter Gropius," 76; James, "Changing the Agenda," 248–52.

27 Chanzit, *Herbert Bayer Collection*, 111: "Marcel Breuer traveled on the same boat as Bayer in 1937."

28 Noel, Lady Norton to Breuer, July 23, 1937, MB/HB, reel 5709, frame 1024.

29 See NA-PCL, roll T715_6017, line 9.

30 See NA-PCL, roll T715_6018, line 27.

31 "Halunke," "… viele Schweinereien …," Friedrich Vordemberge-Gildewart to Max Bill, June 22, 1947 and March 11, 1952. Museum Wiesbaden, Estate of Friedrich Vordemberge-Gildewart, correspondence. See also Katenhusen, "Biografie des Scheiterns?", 269–70 with a more detailed account of the allegations. This directly contradicts Dorner's 1942 statement in a letter to Gropius, that he committed many actions against the Nazi rulers, including sending information to exiled Jews. Alexander Dorner to Ise and Walter Gropius, March 21, 1942. Houghton Library, Walter Gropius Papers, bMS Ger 208 (654). I wish to thank Ines Katenhusen for her cooperation and access to materials concerning Alexander Dorner.

32 Mumford, *CIAM Discourse*, 110–16.

33 Bayer to Breuer, June 5, 1937, MB/HB, reel 5709, frame 990.

34 "I can't go to the congress now"; Bayer to Breuer, July 1937, MB/HB, reel 5709, frame 998.

35 See Rotermund-Reynard, "Geheime Netzwerke."

36 See Bayer and Breuer's correspondence, May 28–31 1937, MB/HB, reel 5709, frames 986 and 988.

37 See NA-PCL, roll T715_6025, line 2; also Ise Gropius to Marcel Breuer, June 1, 1937, MB/HB, reel 5709, frame 989.

38 The trip together with Dorner could not have been Bayer's 1938 passage either; according to the official passenger lists Dorner and his wife made that trip on board the *Britannic,* arriving in New York on September 25, a good month after Bayer's arrival on the *Bremen*; see NA-PCL, roll T715_6223, line 2. (Widder, "Emigration," 234, is incorrect.) Bayer would later indirectly imply that Dorner stole his ideas and sketches; see OHP/C, 50; later confirmed in HB/ACQ, no. 7.

39 Bayer to Breuer, May 28, 1937, MB/HB, reel 5709, frame 986.

40 Breuer to Bayer, May 31, 1937, MB/HB, reel 5709, frame 988.

41 Breuer to Ise Gropius, May 28,1937, MB/HB, reel 5709, frame 985.

42 See NA-PCL, roll T715_6025, line 2.

43 "Herbert, who will probably arrive penniless." Ise Gropius to Breuer, July 3, 1937, MB/HB, reel 5709, frame 1008.

44 They met on the Shaw Estate on Planting Island (Marion, MA). Ise Gropius to Breuer, July 3, 1937, MB/HB, reel 5709, frame 1008.

45 Bayer to Carola Giedion-Welcker, August 21, 1937, gta Archiv/ETH Zürich, estate of Sigfried Giedion.

46 "Die ganze alte Freundschaft ist tatsächlich mit heute Abend in seinem Hause versammelt," ibid. See the account in Hahn, "Bauhaus and Exile," 219, including the author's use of the term "Bauhaus family."

47 Years later, Bayer recalled with characteristic off-handed sexism that Mary Cook "was invited for her presence as an attractive American female." HB/ACQ, no. 7.

48 Isaacs, *Walter Gropius* (German edition), vol. 2, 855.

49 See the correspondence between Alfred Barr and Walter Gropius, August 10 to 24, 1937, BHA Berlin, Walter Gropius archive, folder 249.

50 See Alfred Barr, "Notes on the Work of Herbert Bayer, #2, on Occasion of the Exhibition at North Texas State Teachers College," April 1943. Archives of American Art/Smithsonian Institution, Samuel Benton Cantey Papers, Artist File: Herbert Bayer, reel no. 1688.

51　For Barr, McAndrew and the reasons behind the MoMA's decision to host this exhibition see in greater detail Bergdoll, "'Momento Mori,'" 119–23; and Danilowitz, "Perspektiven und Grenzen," 102.

52　Hahn, "Bauhaus and Exile," 219.

53　Gropius to Barr, September 1, 1937, BHA Berlin, Walter Gropius archive, folder 249.

54　Moholy-Nagy to Bayer and Breuer, September, 4 1937, MB/HB, reel 5709, frames 1025 and 1026.

55　See Bergdoll, "'Momento Mori,'" 120 with a reproduction of this guestbook entry.

56　Alfred Barr and John McAndrew, letter of reference for Herbert Bayer, September 28, 1937, undated, BHA, Herbert Bayer files, folder 2.

57　See the note in BHA Berlin, Walter Gropius archive, folder 247. Transportation and insurance are estimated at $840, leaving $2,160 to set up the exhibition.

58　Bayer to Breuer, December 14, 1937, MB/HB, reel 5709, frame 1066.

59　See Jones, "Un art publicitaire?"

60　Bayer to Gropius, October 28, 1937, BHA Berlin, Walter Gropius archive, folder 247.

61　Rotermund-Reynard, "Geheime Netzwerke," 267.

62　See the correspondence between Homer Saint-Gaudens and Herbert Bayer, September 17 to 22, 1937, BHA Berlin, Herbert Bayer files, folder 2.

63　Xanti Schawinsky to Walter and Ise Gropius, October 23, 1937, BHA Berlin, Walter Gropius archive, folder 641.

64　Bayer to Gropius, October 28, 1937, BHA Berlin, Walter Gropius archive, folder 247.

65　Bayer to Ise Gropius, December 20, 1937, BHA Berlin, Walter Gropius archive, folder 30. It seems that Bayer may not have informed Schawinsky of this plan, for the latter expressed surprise when informed about this arrangement; see Xanti Schawinsky to Walter and Ise Gropius, October 23, 1937, BHA Berlin, Walter Gropius archive, folder 641: "[Herbert Bayer's] puzzling words: 'if it does not work out with me, you have to take over the exhibition.'"

66　Rössler, *Berliner Jahre*, A.07.

Chapter 13

1　IB/HB, August 15, 1938.

2　IB/HB, August 19, 1938.

3　IB/HB, June 8, 1939.

4　IB/HB, August 15, 1938.

5　Gropius to Bayer, November 14, 1937, BHA Berlin, Walter Gropius archive, folder 247.

6　See NA-PCL, roll T715_6096, line 1.

7　Bayer to Breuer, December 1, 1937, MB/HB, reel 5709, frame 1065.

8　"I should be able to rely on Peter in the money matter." Bayer to Breuer, December 1, 1937, MB/HB, reel 5709, frame 1064.

9　Bayer to Breuer, December 14, 1937, MB/HB, reel 5709, frame 1066.

10　Bayer to Breuer, October 26, 1937, MB/HB, reel 5709, frame 1049. Then, as now, the affidavit of support is a contract signed by a US citizen agreeing to assume financial responsibility for a candidate for immigration.

11　OHP/C, 101.

12　"My painting lies completely still, it would be the only real thing for my parched soul." Bayer to Ise Gropius, December 20, 1937, BHA Berlin, Walter Gropius archive, folder 30.

13 Bayer to Ise Gropius, December 20, 1937, BHA Berlin, Walter Gropius archive, folder 30, emphasis original.

14 The cover ran in August 1938. The original photograph of the boots is reproduced in Atlantic Richfield Company, *Herbert Bayer*, 64 and Baum, *Herbert Bayer*, 81.

15 Rössler, *Berliner Jahre*, C.26–C.29.

16 Oels, *Rowohlts Rotationsroutine*, 92, quoting the correspondence between publisher Ernst Rowohlt and the Italian embassy.

17 "liebe = 0,oo. die rassenreinheit erzeugt einen durchgehenden standard." Bayer to Ise Gropius, December 20, 1937, BHA Berlin, Walter Gropius archive, folder 30. Schug also cites this passage but doesn't comment on the explosiveness of Bayer's word choice. See Schug, "Herbert Bayer," 184.

18 For a comprehensive account of the exhibition preparations see Bergdoll, "'Momento Mori.'"

19 "Bayer is in Germany right now hunting up material," John McAndew to Charles Ross, October 13, 1937, The Museum of Modern Art, Registrar Exhibition Files, Exh. 82.

20 Bayer to Paul Citroen, November 1 and 20, and December 14, 1937, BHA Berlin, Paul Citroen files, folder 9.

21 Bayer to Gropius, December 3, 1937, BHA Berlin, Walter Gropius archive, folder 247.

22 Bayer to Breuer, October 26, 1937, MB/HB, reel 5709, frame 1049.

23 Bayer to Gropius, September 16, 1935, BHA Berlin, Walter Gropius archive, folder 123.

24 Bayer to Breuer, November 13, 1937, MB/HB, reel 5709, frame 1054. Bayer's assertion that the rejection of the New Bauhaus might be just a pretext presumably refers to the ongoing fear of persecution by Nazi authorities.

25 HB/38–40, 8.

26 Josef Albers to Gropius, undated, BHA Berlin, Walter Gropius archive, folder 10.

27 Josef Albers, Interview with Robert Jay Wolff, New Preston, CT, March 30, 1977; cited in Allen, *Romance*, 56.

28 See Sandusky, "The Bauhaus Tradition," 31.

29 Albers, "To the Editors: Albers and the Bauhaus," 49.

30 Xanti Schawinsky to Walter Gropius, October 28, 1937, BHA Berlin, Walter Gropius archive, folder 641.

31 Bayer to Breuer, November 13, 1937, MB/HB, reel 5709, frame 1054.

32 Current legal assessments assume that protection of the name expired when the school was dissolved; see Neurauter, "Bauhaus," 496–499.

33 Like Bayer, Mies made his first trip to America in 1937 to sound out his future career options; his permanent move to Chicago followed in 1938. On Mies van der Rohe's Chicago period see James, "Changing the Agenda," 236–41. See also Lambert, *Mies in America*.

34 For the conflict between Ludwig Mies van der Rohe and Walter Gropius, see Grawe, "Von der Hochschule," 120–23; Grawe, *Call for Action*; Hahn, "Bauhaus and Exile," 219; and Allen, *Romance*, 55–56, which details the rivalry between Mies and Moholy.

35 "His deadly fascist designs … proved the old German proverb that he who lies down with dogs gets up with fleas." Moholy, "The Diaspora," 24–26.

36 Nerdinger, "Bauhaus-Architekten," 163.

37 "Mies is to be given the overall direction of the *Deutschland* exhibition during the Olympics. At least." Bayer to Ise Gropius, IWG/HB, November 3, 1935. Bayer's cryptic postscript "at least" may refer to the fact that he was not contributing to the exhibition itself; or that any modern designer was involved at all.

38　This was also the case with other prominent members of the later Bauhaus; for instance, he did not keep in touch with Ludwig Hilberseimer or Walter Peterhans, two former Bauhaus masters who followed the last director of the Bauhaus to the United States.

39　Bayer to Gropius, November 3, 1937, BHA Berlin, Walter Gropius archive, folder 247.

40　Walter Peterhans to Janet Heinrich, March 2, 1938, MoMA New York, Records of the Registrar Department, Exh. #82; also quoted in Bergdoll, "'Momento Mori,'" 126.

41　For this typology see Collins, *Sociology of Philosophies*.

42　Alfred Barr agreed to a postponement in January 1938, for which Gropius thanked him; see the correspondence between Barr and Gropius, January 4 and 6, 1938, BHA Berlin, Walter Gropius archive, folder 249.

43　Bayer to Gropius, December 3, 1937, BHA Berlin, Walter Gropius archive, folder 247.

44　Bayer to Breuer, December 14, 1937, MB/HB, reel 5709, frame 1066.

45　Bayer to Ise Gropius, December 20, 1937, BHA Berlin, Walter Gropius archive, folder 30.

46　Bayer to Breuer, March 28, 1938, MB/HB, reel 5709, frame 1098.

47　Ibid.

48　Xanti Schawinsky to Breuer, March 11, 1938, MB/HB, reel 5709, frame 1097.

49　Jorge Fulda to Bayer, April 20, 1939, JF/HB.

50　Fulda to Bayer, November 25, 1939, JF/HB. Similarly, in a letter of December 21, 1938: "You have perfectly timed shaking Hitler's dust from your precious feet."

51　Gropius to Bayer, February 11, 1938, BHA Berlin, Walter Gropius archive, folder 31.

52　Schawinsky to Breuer, March 11, 1938, MB/HB, reel 5709, frame 1097.

53　See the correspondence between Moholy-Nagy and Bayer, May 21 to 31, 1938, BHA Berlin, Walter Gropius archive, folder 459.

54　Max Bill to MoMA, March 21, 1938, The Museum of Modern Art, Registrar Exhibition Files, Exh. 82.

55　This according to Charlotte Weidler, who worked from Berlin for the Carnegie Institute; see Rotermund-Reynard, "Geheime Netzwerke." Bayer wrote, "In the meantime, the wildest rumors about my absence have circulated here." Bayer to Breuer, October 26, 1937, MB/HB, reel 5709, frame 1048.

56　HB/ACQ, no. 7.

57　Rudolf Seidel et al. *bayer a b c*. Hand-pasted brochure, 1938, Dorland Berlin, VL/HB. Reproduced in full in Rössler, *Berliner Jahre*, 121.

58　Walter Matthess to Bayer, undated [probably 1942/43 from Switzerland], VL/HB, box 12.

59　Bayer to Breuer, November 13, 1937, MB/HB, reel 5709, frame 1053.

60　Notification of the tax and revenue office Wilmersdorf-Nord to the Chief of Police Berlin, August 13, 1938, DPL, WH2416.

61　Sachsse, "Von Österreich aus," 10.

62　OHP/C, 101.

63　See Bayer's list, September 1, 1938, BHA Berlin, Walter Gropius archive, folder 31. The shipment was listed as including: 3 Bauhaus-Portfolios (*Europäische Grafik*, Master's Portfolio, Kandinsky's "Kleine Welten"), 1 photomontage *Blick ins Leben* (H. Bayer; original), 4 small montages (K. Bott [Both]), 2 watercolors (M. Breuer, L. Feininger; original), 3 woodcuts (G. Marcks), 2 lithographs (G. Muche, L. Moholy-Nagy), 8 photos (Schawinsky and other), 3 anniversary portfolios (e.g. "9 Jahre Bauhaus" and Gropius's 50th birthday present) plus additional works from the *Vorkurs* (preliminary course), letters, documents, plans and photos of Bauhaus daily life. It can be ruled out that Bayer also carried other items on loan with him on his transatlantic passage; see also HB/ACQ, no. 14.

64 Janet M. Henrich, MoMA New York, to Walter Gropius, April 14, 27 and 28, 1938, BHA Berlin, Walter Gropius archive, folder 248. In these negotiations the opening of the exhibition was also set for November 8, 1938.

65 See, for instance, Herbert Bayer to Erich Consemüller, October 20, 1937, The Museum of Modern Art Archives, NY, Coll. MoMA Exhibitions, series 82, folder 3.

66 OHP/C, 102. Beyond Bayer's recollections, no documents have survived to shed a light on how the sales were organized and how the revenues were distributed. See also Blümm, "'this may become …'."

67 IB/HB, September 4, 1938.

68 Cohen, *Herbert Bayer*, 42; based on Bayer's recollections, as documented in OHP/C, 101 and HB/ACQ, no. 7.

69 IB/HB, August 19, 1938.

70 IB/HB, August 26, 1938.

71 Theo Bayer to Herbert Bayer, December 1, 1939, Estate of Theo Bayer, Linz.

72 HB/38–40, 4.

73 HB/OD.

74 Willy B. Klar to Bayer, July 29, 1939, WBK/HB.

75 "Only by a hazardous trick I escaped the authorities and prison." HB/38–40; see also OHP/C, 101 for Bayer's detailed description of the incident.

76 Interview with Herbert Bayer in Barnard, *Herbert Bayer*, 22:20.

77 Ibid., 22:50; OHP/C, 105; see also Chanzit, *Herbert Bayer*, 111. Bayer later claimed to Arthur Cohen that he was quite tired and overworked the day of his test at the embassy and had not been able to recognize a particular figure. There are no indications anywhere in the archive or elsewhere that he had eye problems.

78 Theo Bayer to Herbert Bayer, July 10, 1946, VL/HB, box 12.

79 "I left money for Irene and Julia to take care of travel expenses." HB/ACQ, no. 14.

80 IB/HB, October 9, 1938.

81 HB/38–40, 13.

82 Ibid., 3–4.

83 Cohen specifies this; *Herbert Bayer*, 42.

84 "You said you came with twenty-five dollars."—"And nothing[…]" OHP/C, 101.

85 HB/ACQ, no. 7.

86 See in greater detail Mußgnug, *Reichsfluchtsteuer*. In a sample calculation, e.g. 100,000 reichsmarks were deposited in a blocked account, reduced by the 25 percent flight tax, and "the emigrant would be allowed to take with him only a few hundred reichsmarks," which would be converted to the currency required for immigration. The money in the blocked account could then be sold to a foreign buyer wanting to purchase reichsmarks for a low bid in foreign currency if one found an interested buyer at all; see Black, *Transfer Agreement*, 126.

87 Theo Bayer to Herbert Bayer, July 26, 1946, VL/HB, box 12.

88 IB/HB, August 15, 1938.

89 IB/HB, September 4, 1938.

90 IB/HB, August 15, 1938.

91 Klar to Bayer, July 29, 1939, WBK/HB.

92 IB/HB, October 16, 1938.

93 IB/HB, August 15, 1938.

94 IB/HB, September 26, 1938.

95 IB/HB, October 16, 1938.

96 IB/HB, September 9, 1938.

97 Klar to Bayer, July 29, 1939, WBK/HB.

98 IB/HB, September 4, 1938.

99 IB/HB, September 9, 1938.

100 Klar to Bayer, July 29, 1939, WBK/HB (emphasis original).

101 IB/HB, September 4, 1938.

102 IB/HB, September 9, 1938.

103 IB/HB, October 16, 1938.

104 Willy B. Klar to Herbert Bayer, July 29, 1939, WBK/HB.

105 IB/HB, October 24, 1938.

106 Klar to Bayer, n.d. [November 1946], WBK/HB.

107 Walter Matthess to Bayer, November 22, 1947, VL/HB, box 12.

108 IB/HB, September 9, 1938.

109 Klar to Bayer, July 29, 1939, WBK/HB.

110 IB/HB, October 16, 1938.

111 IB/HB, October 24, 1938.

112 IB/HB, September 26, 1938.

113 HB/38–40, 26.

114 IB/HB, October 16, 1938.

115 See e.g. Berghoff, "Times Change," 139.

116 I would like to thank my colleagues Hans-Ulrich Thamer and Jürgen Reulecke for their assessments on this issue.

117 Ranke, *Deutsche Geschichte*, 25. Apparently, Gronefeld did not use a stick to hang it into the streets, but rather attached it to one of his flower boxes which was not deemed correct by the block warden.

118 For her last weeks in Germany and after her personal belongings were packed for shipping, Bayer-Hecht moved in with her Hungarian friend Elisabeth Gergely who had an apartment in Wilmersdorf as well; Muci spent some of this time in a boarding house for children. See IB/HB, September 9 and October 9, 1938.

119 Bayer-Hecht, for instance, had praised Hitler's role in negotiating the Munich Agreement of September 30, 1938 (see p. 197); IB/HB, October 9, 1938.

120 IB/HB, August 15, 1938.

121 See the diary entry from December 1939 in which Bayer writes: "I don't know what has happened to my siblings since the war began." HB/38–40, 41. See also the message from the International Red Cross, processed from November 20, 1942 to July 22, 1943, Estate of Theo Bayer, Linz.

122 Theo Bayer to Irene Bayer-Hecht, September 7, 1938, Estate of Theo Bayer, Linz.

123 "All your archives … are packed in boxes in my custody." Theo Bayer to Herbert Bayer, November 26, 1938, Estate of Theo Bayer, Linz.

124 Theo Bayer to Herbert Bayer, March 26, 1939, Estate of Theo Bayer, Linz.

125 Theo Bayer to Herbert Bayer, August 21, 1939, Estate of Theo Bayer, Linz. Another shipment from Berlin that Bayer apparently announced for the turn of the year 1939/1940 may not have arrived in Linz, if it was sent at all; see Theo Bayer to Herbert Bayer, December 1, 1939, Estate of Theo Bayer, Linz.

126 Theo Bayer to Herbert Bayer, March 12, 1946, VL/HB, box 12.

127 Theo Bayer to Herbert Bayer, July 10, 1946, VL/HB, box 12.

128 Theo Bayer to Herbert Bayer, November 6, 1946, VL/HB, box 12.

129 HB/38-40, 1–3. This key passage, though undated, was either written immediately after Bayer's arrival in New York or possibly while he was still on board the *Bremen*. It begins: "jetzt, wo ich dieses land verlassen habe, ist mir klar, dass die letzten 5 jahre

in bezug auf meine arbeit beinahe verlorene jahre sind." La has noted in this passage a "discomforting level of self-stylization in this text, especially at the beginning and end; I do not doubt, however, that there is also a level of sincerity, palpable in the bitter reckoning, built-up frustration, and simmering anger that fuel the fragments that grow longer and more acrid as they go on." La, "Herbert Bayer," 74. La's translation of the passage, however, implies, incorrectly, that Bayer made this entry before leaving Germany.

Chapter 14

1 Hans Falkner to Bayer, November 1941; Herbert Bayer Collection, box 70: "Herbert, couldn't you join us? You've always been interested in building a ski lodge with me."
2 HB/38–40, 4, 39.
3 OHP/C, 32.
4 Bayer to Dorner, September 7, 1938, cited from Katenhusen, *"Mann mit Mission,"* final chapter.
5 HB/38–40, 5–6; some excerpts quoted by Neumann, "Kunst als universelle Verantwortung," 9.
6 IB/HB, September 1, 1938.
7 Xanti Schawinsky to Sibyl Moholy-Nagy, August 25, 1948, reprinted in Passuth, *Moholy-Nagy*, 425.
8 Passuth, *Moholy-Nagy*, 66.
9 Grawe, "Von der Hochschule," 129.
10 Moholy-Nagy to Bayer and Schawinsky, September 26, 1938, BHA Berlin, Walter Gropius archive, folder 31. With the support of Walter Paepcke, the institution was reestablished in 1939, but without the participation of Bayer.
11 Katenhusen, *"Mann mit Mission,"* final chapter.
12 Hahn and Paul, *Schawinsky*, 21.
13 HB/38–40, 7: "The daily private life with friends makes the first days more pleasant."
14 HB/38–40, 11.
15 "The only successes I have had which nobody envies are with lectures and teaching courses. [...] It's sad and shameful, and I only do it because I desperately need every penny of money." HB/38–40, 77–78.
16 "the idea of an own school often occupies me. [...] 40 Wochen with 10$ each / 400 x 10 = 4.000"; HB/38–40, 109.
17 HB/38–40, 109.
18 Lupton, *Herbert Bayer*, 71.
19 See p. 179. In December 1937, facing a slew of administrative difficulties, Bayer in his interim report to Gropius requested a second postponement of the show. From the original timeframe of spring 1938, it had already been pushed back by two seasons to September or October 1938. A further postponement of the opening to November 22, 1938 was necessary due to catalogue delays; Bayer to Gropius, September 26, 1938, BHA Berlin, Walter Gropius archive, folder 31. For the actual opening, see the undated MoMA press release, BHA Berlin, Walter Gropius archive, folder 248.
20 Staniszewski, *Power of Display*, 143.

21 See Gropius–Barr correspondence, September 8 and 15, 1938, BHA Berlin, Walter Gropius archive, folder 249. Bayer recalled that he later shared the small revenues with Ise Gropius; OHP/C, 34. A contract was only signed for the second edition, produced in 1951 by the publishing house of Charles T. Branford, Boston, which guaranteed the three editors together a total of 20 cents per book sold; see DPL, WH2416, Bx 37.

22 OHP/C, 33.

23 "He messed it all up and mixed it all up, and I had so much work to straighten it out again." OHP/C, 33.

24 HB/ACQ, no. 14.

25 Bayer to Carola Giedion-Welcker, August 21, 1937, gta Archiv/ETH Zürich, estate of Sigfried Giedion.

26 Herbert Bayer to Ferenc Molnar, November 3, 1937, Museum of Modern Art, Bauhaus exhibition files, REG 82.

27 Official records list at least 573 items on display; see Museum of Modern Art Archives, Exhibition no. 82, Bauhaus 1919–1928. For more details on the exhibition see Bergdoll, "'Momento Mori,'" Sajic, "The Bauhaus 1919–1928," and Blümm, "'This May Become …'".

28 OHP/C, 34; see also HB/38–40, 19: "The exhibition itself was a huge task for me alone."

29 Bayer to Dorner, September 7, 1938, cited in Katenhusen, *"Mann mit Mission,"* final chapter.

30 HB/38–40, 14.

31 HB/38–40, 14–15. See Janet M. Henrich's correspondence with Walter Gropius, BHA Berlin, Walter Gropius archive, folder 248.

32 Gropius to Bayer, October 22, 1938, BHA Berlin, Walter Gropius archive, folder 31.

33 Gropius to Bayer, October 27, 1938, BHA Berlin, Walter Gropius archive, folder 31.

34 HB/38–40, 17.

35 See Gropius's request from September 8, 1938 and Barr's September 15, 1938 response, BHA Berlin, Walter Gropius archive, folder 249.

36 HB/38–40, 20.

37 HB/38–40, 20.

38 HB/ACQ, no. 14.

39 HB/38–40, 20.

40 Bergdoll, "'Momento Mori,'" 128.

41 Neumann, "Kunst als universelle Verantwortung," 9; Blümm, "'this may become …'".

42 "The Bauhaus: How it worked." Installation List, Museum of Modern Art Archives, CUR 82.

43 These exhibitions are discussed on pp. 63–5 of this book. For more on the structure of the exhibition see Staniszewski, *Power of Display*, 144–45.

44 Cohen, *Herbert Bayer*, 300.

45 Photo documentation, Museum of Modern Art Archives, Exhibition no. 82, Bauhaus 1919–1928, image S 2336.

46 See Oswalt, "Bauhaus-Krisen," 264.

47 Bergdoll, "'Momento Mori,'" 125–26; see also in greater detail Koehler, "The Bauhaus."

48 Anderson, "Der kommunistische Funktionalist," 412.

49 Bayer to Gropius, November 3, 1937, BHA Berlin, Walter Gropius archive, folder 247.

50 Gropius to Bayer, November 14, 1937, BHA Berlin, Walter Gropius archive, folder 247.

51 Barr to Gropius, September 15, 1938, BHA Berlin, Walter Gropius archive, folder 249.

52 Bayer, Gropius and Gropius, *Bauhaus 1919–1928*, 8–9.

53 HB/38–40, 21.

54 "It is a shame not to be able to seriously compile this into a new theory of design." HB/38–40, 9.

55 See "The Bauhaus: How it Worked." Installation List, Museum of Modern Art Archives, CUR 82.

56 Grawe, "Von der Hochschule," 119. The catalogue, which was later translated into German, also contributed significantly to the interpretation of the Bauhaus in the Federal Republic of Germany.

57 McAndrew, "'Modernistic' and 'streamlined,'" 2–3.

58 HB/38–40, 18.

59 See at length Staniszewski, *Power of Display*, 143–52; also Langfeld, *German Art*, 111–17.

60 For a documentation of media coverage see Staniszewski, *Power of Display*, 145, 151. Staniszewski, however, does not deal with the controversy between Barr and Gropius, nor with the unfavorable light in which the correspondence puts MoMA.

61 Barr to Gropius, December 10, 1938, BHA Berlin, Walter Gropius archive, folder 249.

62 Gropius to Barr, December 15, 1938, BHA Berlin, Walter Gropius archive, folder 249.

63 Gropius to Barr, December 15, 1938, BHA Berlin, Walter Gropius archive, folder 249. Unfortunately, this inglorious chapter of the American Bauhaus reception has not been dealt with either in the specialist literature or at the 2009 MoMA retrospective; see James-Chakraborty, "From Isolationism to Internationalism."

64 See Etzold, "Walter Gropius."

65 For an overview of the controversies around the exhibition see also Langfeld, *German Art*, 112–17.

66 Holz, "Recasting Exile," 285.

67 See in greater detail Blümm, "'This May Become …'" The more comprehensive version of the travel exhibition was shown at four venues: the George Walter Vincent Smith Gallery of Art, Springfield, Massachusetts (March 1 to 29, 1939); the Milwaukee Art Institute (November 1 to December 6, 1939), the Cleveland Museum of Art (January 17 to February 24, 1940), and the Cincinnati Art Museum (March 8 to April 5, 1940). The smaller version was on display mainly at University galleries, for instance in Cambridge (Harvard), Minneapolis, Seattle, and Oakland.

68 See the undated report of Barr on the reviews of the Bauhaus exhibition, December 15, 1938, BHA Berlin, Walter Gropius archive, folder 249.

69 Barr to Gropius, March 3, 1939, MoMA New York, Records of the Registrar Department, Exh. #82.

70 Bayer to Gropius, December 28, 1938, BHA Berlin, Walter Gropius archive, folder 31. The *Weimar and Dessau Anzeiger* is not the name of an actual newspaper but rather a joking generalized title for the right-wing papers that attacked the Bauhaus in its Weimar and Dessau locations.

Chapter 15

1 Hahn, "Bauhaus and Exile," 219. Also, the 2009 retrospective organized at MoMA to mark the ninety years since the institution's founding stressed the extent to which

that early MoMA show of 1938 had disseminated Bauhaus principles and products in the United States; see Bergdoll and Dickerman, *Bauhaus 1919–1933*, 12.

2 Schulze, "Bauhaus Architects," 229.

3 Hölscher's review appeared in the September 1952 edition of *Gebrauchsgraphik*, a special issue on Herbert Bayer and his work for the Container Corporation of America. See Hölscher, "Bauhaus 1919–1928," 63. The German edition of *Bauhaus 1919–1928* was published in 1955 by the Stuttgart-based publisher Hatje.

4 "Aber der Tausch in die Freiheit wird es sicher wert sein." Bayer to Carola Giedion-Welcker, undated [August 1938], gta Archiv/ETH Zürich, estarte of Sigfried Giedion.

5 HB/38–40, 12–13.

6 IB/HB, October 9, 1938.

7 Klar, who was also half-Jewish, deliberately masked his discontent in a language of over-affirmation, writing in 1940, a time of wartime letter censorship: "Adolf Hitler is the only right man for the German people. This is the man and the constitution that Germany deserves. The small oposition group is supposed to emigrate; it is they who do not fit in here. I hope you understand me correctly, my old comrade." That final remark signalled clearly enough that Klar saw himself more as one who sympathized with the exiles than as one of the Germans kept down by Hitler. Klar to Bayer, February 15, 1940, WBK/HB.

8 See, for instance, IB/HB, October 16, 1938.

9 IB/HB, November 9, 1938.

10 This is evident in many of her letters. For example, on August 19, 1938, she wrote, "Look, darling, why should a new life together for the two of us be such a big experiment? If you marry a stranger, it is also an experiment. We know each other so well. We know so well that we can rely on each other. There is a deep tenderness in us, and in erotic terms we always understood each other brilliantly in the past. Don't be afraid that I want to take away your freedom. I have received a long bitter lesson and will hardly be able to forget it. Let us try to build a new life … I will do everything to make you find a reflection of your homeland there [in the United States] and to make you feel comfortable and warm. I also want to remain young and beautiful and elegant, and only ask for the respect that I can claim as your wife and mother in and outside the house." IB/HB.

11 See also p. 130.

12 IB/HB, August 26, 1938.

13 IB/HB, June 8, 1939.

14 IB/HB, August 4, 1939.

15 HB/38–40, 12–13.

16 IB/HB, August 15, 1938.

17 Bayer to Carola Giedion-Welcker, undated [August 1938], gta Archiv/ETH Zürich, estate of Sigfried Giedion.

18 IB/HB, September 1, 1938.

19 See NA-PCL, roll T715_6258, lines 12 and 13. Bayer recalled incorrectly that they arrived on board the *President Roosevelt* on December 13, 1938; HB/ACQ, no. 14.

20 On the deteriorating living conditions of Jews still in Germany after 1938, see Evans, *Third Reich at War*, 67–72, esp. 70, which discusses the situation of "mixed-race" Jews who were deemed one-half or one-quarter Jewish.

21 HB/38–40, 23–24.

22 IB/HB August 5, 1939.

23 Willy B. Klar to Bayer, July 29, 1939, WBK/HB.

24 Chanzit, *Herbert Bayer*, 83–85; Cohen, *Herbert Bayer*, 229–239; Droste, "Commerce and Culture."

25 See e.g. Bayer's articles contributing to his special issue of *PM* magazine; Bayer, "Herbert Bayer," 1–32.

26 OHP/C, 105.

27 "A shitty city;" Bayer to Breuer, November 13, 1940, MB/HB, reel 5709, frame 1300.

28 Bayer, Sketchbook 1943, Denver Public Library, Herbert Bayer Archive (DPL, WH2416), Box 12; translated in Chanzit, *Herbert Bayer*, 84.

29 HB/OD.

30 HB/38–40, 71–72.

31 HB/38–40, 74.

32 Reproduced in Rössler and Chanzit, *Der einsame Großstädter*, 148–54.

33 IB/HB, August 19, 1938.

34 HB/38–40, 15.

35 *Bum-heil* (Hail to fucking) is, as I discussed in Chapter 8, an obvious pun on the Nazi salute *Sieg heil* and a running gag between the two men. Willy B. Klar to Bayer, August 10, 1939, WBK/HB.

36 Vips Wittig to Bayer, May 19, 1939, VL/HB, box 70.

37 See e.g. Widder, "Emigration," 237.

38 HB/38–40, 25.

39 IB/HB, June 8, 1939.

40 IB/HB, July 15, 1939.

41 IB/HB, August 4 and 5, 1939.

42 Ibid.

43 Certificate of Naturalization #5962861, U.S. Department of Justice, PD/HB.

44 IB/HB, June 8, 1939.

45 Decree of Divorce No. 84523, Judicial District Court of the State of Nevada, PD/HB. The divorce agreement specified that Bayer-Hecht received the furnishings of her New York apartment and a monthly alimony of $250, and that she would be the beneficiary of a $3,000 life-insurance policy. She also retained custody of their child, Julia, but generous visitation arrangements were jointly agreed. Otherwise, both spouses indemnified each other from claims, and thus Bayer-Hecht from possible copyright issues with regard to the work of Bayer.

46 See the exhaustive collection of materials in the Denver Public Library, Herbert Bayer Collection, DPL, WH2416; also Neumann, "Kunst als universelle Verantwortung," 10.

47 Chanzit, *Herbert Bayer*, 84.

48 HB/38–40, 28–29.

49 IB/HB September 30, 1939.

50 "Unfortunately she had to see that there is no more love, but that, with my affection and friendship, I want the best for her" HB/38–40, 37.

51 Ibid., 38.

52 Ibid., 69–70.

53 Ati Gropius Johansen, personal interview, September 10, 2013.

54 Herbert Bayer to Ise Gropius, IWG/HB, February 2, 1940. While the letter is in German, the last phrase is in English.

55 HB/38–40, 95–97.

56 Herbert Bayer: Sketchbook 2—1940 Journal, DPL, WH2416, Bx 12.

57 HB/OD, 203.

58 HB/OD. Their estrangement had some interruptions, however. Ati Gropius later recalled that the two of them had occasionally been guests of the Gropius family. Ati Gropius Johansen, personal interview, September 10, 2013.

59 California Death Index 1940–1997. Sacramento, CA, State of California Department of Health Services, Center for Health Statistics, Rec. #103228678. See also Cohen, *Herbert Bayer*, 388.

60 HB/OD.

61 "I saw myself hanged in the studio." HB/OD, 164.

62 "My child's death had caused me to be in a somber mood in the last years and my palette became monochrome and grey, triste and hopeless." HB/OD.

63 Schawinsky to Bayer, November 9, 1963, VL/HB, box 12.

64 HB/OD.

65 Widder, "Emigration," 238.

66 HB/38–40, 19–20.

67 "I still think that he is one of the most important graphic designers of our time." HB/ACQ, no. 6. For more on the relationship between Bayer and Matter see Roessler, "Bauhaus-Typografie und Schweizer Grafik."

68 HB/OD.

69 "For my part, I'm still considering such a step a hundred times over"; Klar to Bayer, August 10, 1939, WBK/HB.

70 Klar to Bayer, May 27, 1946 and August 5, 1947, WBK/HB.

71 Klar to Bayer, May 27, 1946 and undated [November 1946], WBK/HB.

72 See Rössler et al., "Von der Institution;" Blümm et al., *Die bewegten Netze*.

73 Koehler, "Walter Gropius," 80 with additional references. The prestige of Breuer's association with Gropius and the latter's connection to Harvard University nevertheless remained essential for Bayer's subsequent success in America.

74 James, "Changing the Agenda," 246.

75 HB/OD, 5–6.

76 Bayer, "Homage to Gropius," 32.

77 Ibid., 31.

78 HB/OD.

79 HB/ACQ, no. 14.

80 Herbert Bayer to Ise Gropius, February 2, 1940, IWG/HB.

81 See his diary entry dating from December 1939: "Whom I commiserate most today are my countrymen who have to go to an unwanted war for this criminal, or perhaps experience for a second time terrible years of hunger." HB/38–40, 41.

82 Hermand, *Kultur*, 239.

83 Tupitsyn, "Ablehnung und Akzeptanz," 21.

84 HB/38–40, 27. It is not clear whether this is the same commission, because Tupitsyn, "Ablehnung und Akzeptanz," 21, does not cite any further evidence of the design of the "American" pavilion.

85 Hahn, "Bauhaus and Exile," 218.

86 HB/38–40, 68.

87 Herbert Bayer to Lady Norton, November 15, 1942, VL/HB, box 70.

88 See Harbusch, "Space, Time and Architecture," 250–51.

89 La, "Herbert Bayer," 80. See also Uchill, "Re-viewing," 114–20.

90 Staniszewski, *Power of Display*, 210–24.

91 Buchloh, "From Faktura." 118–19.

92 Lugon, "La photographie," paragraphs 25–27.

93 Interview with Herbert Bayer, November 1977; see Hill and Cooper, "Herbert Bayer," 105.

94 Herbert Bayer to Marcel Breuer, November 13, 1940, MB/HB, reel 5709, frame 1299. See also HB/38–40, 73: "Lajco loans me $1,000 for one year. I'm afraid even that won't be enough considering how things stand."

95 HB/38–40, 17. On Ed Fischer's position, see also the *24th Annual of Advertising Art*, edited by the Art Directors Club of New York in 1945, unpag.

96 HB/38–40, 72, 84, 90. "It makes a big difference in life whether you can count on a bank account or have to work out the monetary basis for every step of your life. And that spoils my life and eats up my creativity."

97 HB/38–40, 75–76, 80.

98 HB/OD.

99 Theo Bayer to Herbert Bayer, November 26, 1938, Estate of Theo Bayer, Linz, and June 30, 1946, VL/HB, box 12.

100 IB/HB, October 9, 1938.

101 Theo to Herbert Bayer, July 26, 1946, VL/HB, box 12; see already a previous letter from December 9, 1940; Estate of Theo Bayer, Linz.

102 Theo to Herbert Bayer, July 26, 1946, VL/HB.

103 HB/38–40, 86.

104 See the overview of Bayer's exhibition work in Droste, "Commerce and Culture," 121–23; Chanzit, *Herbert Bayer*, 85.

105 Bayer to Ise and Walter Gropius, December 30, 1943, IWG/HB.

106 Grawe, "Von der Hochschule," 135.

107 Bayer to Ise and Walter Gropius, February 8, 1944, IWG/HB. This quote was used as well by Droste, "Commerce and Culture," 120.

108 See Gropius, "Essentials"; see also the preface of the editors.

109 See Sandusky, "The Bauhaus Tradition."

110 Bayer, "Herbert Bayer." For a full reproduction of the *PM* portfolio see Lupton, *Herbert Bayer*, 84–106.

111 Compare with the detailed interpretations of this source in Tupitsyn, "Herbert Bayer," 85–86.

112 Comment by Percy Seitlin in Bayer, "Herbert Bayer," 32.

113 Anonymous, "Herbert Bayer's Design Class," 18–30; Seitlin, "What is Taught," 32.

114 See Levy, "From a Portfolio." That Levy, Bayer's second wife's husband, from whom she had separated, performed this task evidences the ongoing friendship in Bayer's network.

115 Walter Gropius, letter of recommendation for Herbert Bayer, directed to Henry Luce, dated December 1, 1941, BHA Berlin, Walter Gropius archive, folder 32.

116 Time Inc., *Fortune*. The series of Bauhäusler working for the magazine was later to be continued by Peter Piening, art director at *Fortune* between 1942 and 1946, who claimed to have attended the Bauhaus, although no records of the school ever mention him. Piening was followed by Walter H. Allner, who had studied advertising graphics and typography at the Bauhaus between 1927 and 1930. Allner emigrated first to Paris and then worked for *Fortune* from 1951 eventually becoming its art director; see Bauhaus Archiv, *Bauhäusler in Amerika*.

117 "Of course *Fortune* would be *the* place for me." Bayer to Gropius, November 28, 1941, BHA Berlin, Walter Gropius archive, folder 32.

118 Bauhaus-Archiv, *Herbert Bayer: Kunst und Design in Amerika 1938–1985*, 26.

119 Ibid., 22–23.

120 Bernstein, "Purism and Pragmatism," 265. On his support of Moholy-Nagy see the impressive episode when Paepcke entrusted his savings to him in order to rescue the institution, as recounted by Allen, *Romance*, 62.

121 Here, and in the following, see Widder, "Raumvisionen," 320.

122 Droste, "Commerce and Culture," 121–22.

123 "My old longing to have a small farm in the mountains at home has also been put on hold." HB/38–40, 3.

124 See Widder, "Emigration," 238. In December 1938, Bayer wrote: "What is life without the place to which one belongs?" Pasted-in entry from December 1938; HB/38–40, 22. For the idea of returning to Europe in 1945, see Allen, *Romance*, 128.

125 Letter from Joost Schmidt to Herbert Bayer, November 7, 1946; VL/HB, box 12.

126 HB/OD.

127 Tupitsyn, "Herbert Bayer," 86.

128 Walter Paepcke to Joella and Herbert Bayer, February 1, 1946; quoted from Allen, *Romance*, 139.

129 See the correspondence collected in VL/HB.

130 The invitation reads, in part, "What used to make us often malicious and caused a discord in our cooperation is no longer the case." Walter Matthess to Bayer, November 22, 1947, VL/HB, box 12.

131 Bayer to Hannes Meyer, March 31, 1947, VL/HB, box 12.

132 See Jones, "L'avant-garde européenne."

133 In Bayer's own words: "The Container Corporation deserves praise, not only for its sharp eye and courage to go its own way, but also for its consistency in following this line." Bayer, "Künstlerische Gestaltung," 44. For a detailed account of the mutual esteem between Paepke and Bayer, see Allen, *Romance*.

134 Bayer to Ise Gropius, 2 May [1940], IWG/HB.

135 Herbert Bayer to John McCormick, August 1, 1978; quoted in Chanzit, *Herbert Bayer*, 204. In his death certificate Bayer is described as an "artist architect," PD/HB.

136 IB/HB, July 22, 1975.

Epilogue

1 Voegelin, *Political Religions*, 24–5.

2 Hahn, "Bauhaus and Exile," 222.

3 Alfred Barr referred to Bayer's "pro-Nazi years in Berlin" in an unpublished set of "Notes on the work of Herbert Bayer" #2. These were collected on the occasion of the exhibition at North Texas State Teachers College, April 1943. Archives of American Art, Smithsonian Institution, Samuel Benton Cantey Papers, Artist File: Herbert Bayer, reel no. 1688.

4 See Lamster, *The Man*; Schulze, *Philip Johnson*, 102–59.

5 Helfenstein, "Josef und Anni Albers," 67.

6 Wassily Kandinsky to Will Grohmann, August 11, 1924, cited in Kandinsky, *Will Grohmann*, 55; see also von Beyme, *Avantgarden*, 48.

7 IB/HB January 27, 1929.

8 HB/AS&S, late 1937.

9 Sachsse, "Von Österreich aus;" see also Krause, *Die nützliche Moderne*, 13.

10 HB/OD, 203.

11 "I noticed only the effects they had on my immediate life." HB/OD, 204.

12 HB/OD, 204. It is impossible to identify the event involving the SA to which Bayer is referring.

13 HB/OD, 204.

14 Droste, "Herbert Bayer," 77.

15 Granovetter, "Strength of Weak Ties."

16 "Gleichgesinnter im Geiste," personal note by Alexander Dorner, n.d., Harvard Art Museums Archives, Papers of Alexander Dorner, BRM 1, Folder 276.

17 See at length Katenhusen, "Biografie des Scheiterns?" 271–79.

18 Moholy-Nagy to Bayer, May 21, 1945, DPL, WH2416, Correspondence File #127.

19 "The size of the catalog which you plan is, of course, entirely up to you as you will be the author, I hope." Bayer to Dorner, March 6, 1945, DPL, WH2416, Correspondence File #127.

20 Exhibition packing list, Bayer to Dorner, October 26, 1946. Niedersächsisches Landesarchiv/Hauptstaatsarchiv Hannover, VVP 21, no. 74.

21 For a list of venues see Bayer, *painter, designer, architect*, 206. See also Uchill, "Re-viewing," 125.

22 Dorner to Bayer, March 31, 1947. Niedersächsisches Landesarchiv/ Hauptstaatsarchiv Hannover, VVP 21, no. 74.

23 See here and in the following DPL, WH2416, Correspondence File #127; The Museum of Modern Art Archives, New York, George Wittenborn, Inc. Papers, Series I, Folder I.B.9–18.

24 Dorner to Bayer, February 23, 1945, DPL, WH2416, Correspondence File #127.

25 Dorner to Bayer, April 16, 1945, DPL, WH2416, Correspondence File #127. (This text was subsequently retitled "The Way Beyond Art/Herbert Bayer".)

26 Dorner to Bayer, April 24, 1945, DPL, WH2416, Correspondence File #127. The transformed paragraph in the book later read as follows: "He never escapes into the sacred field of 'art,' he never dodges what is very often a banal subject matter. It is admirable how often he succeeds brilliantly in integrating the banal product of practice and the vision of energetic life." Dorner, *The Way Beyond "Art,"* 170.

27 Dorner to Bayer, December 31, 1945, DPL, WH2416, Correspondence File #127.

28 See, for example, Bayer to Dorner, August 3, 1947; Niedersächsisches Landesarchiv/ Hauptstaatsarchiv Hannover, VVP 21, no. 74. The responses of the visitors were mostly negative as well; see Katenhusen, *"Mann mit Mission,"* final chapter.

29 Uchill, "Re-viewing," 129.

30 Gough, "Constructivism Disoriented," 78. My thanks go to Ines Katenhusen for pointing me in the direction of this concept.

31 Katenhusen, "Kollaborationen und Kollisionen."

32 Bayer to Dorner, January 22, 1946, DPL, WH2416, Correspondence File #127.

33 The author ignored the request that he take a different tack and included the analogy into the printed edition; see Dorner, *The Way Beyond "Art,"* 187–90.

34 Dorner, *The Way Beyond "Art,"* 179.

35 Ibid., 171–77.

36 Uchill, "Re-viewing," 135.

37 On the formal process of "Denazification" that a few years later would begin to take place throughout West Germany see Boehling, "Transnational Justice?"

38 Max Hirschberg (Dorner's lawyer) to the German consulate general in New York, December 18, 1953, Niedersächsisches Landesarchiv/Hauptstaatsarchiv Hannover, file 401, acc. 2000/155, no. 32; cited from Katenhusen, *"Mann mit Mission,"* final chapter.

39 Friedrich Vordemberge-Gildewart to Max Bill, June 22, 1947. Museum Wiesbaden, Estate of Friedrich Vordemberge-Gildewart, correspondence.

40 Max Bill to Friedrich Vordemberge-Gildewart, June 24, 1947. Museum Wiesbaden, Estate of Friedrich Vordemberge-Gildewart, correspondence.

41 Dorner, *The Way Beyond "Art,"* 160–64.

42 Max Bill to Friedrich Vordemberge-Gildewart, June 30, 1947. Museum Wiesbaden, Estate of Friedrich Vordemberge-Gildewart, correspondence.

43 Bayer to Dorner, December 6, 1946, DPL, WH2416, Correspondence File #127.

44 The printed version elegantly covered this fact by listing the volume just as a "published book" on occasion of the exhibition, without naming any of the editors. See Dorner, *The Way Beyond "Art,"* 235.

45 Bayer to Wittenborn & Co., March 5, 1947, DPL, WH2416, Correspondence File #127.

46 Dorner to Bayer, March 2, 1947, DPL, WH2416, Correspondence File #127. For a detailed depiction of the production process see Katenhusen, *"Mann mit Mission,"* final chapter.

47 Bayer to Dorner, June 2, 1947, DPL, WH2416, Walter Gropius archive, folder 33.

48 "Of course I will be identified with the ideas in that book." Bayer to Gropius, January 8, 1947, BHA Berlin, Walter Gropius archive, folder 33. Gropius, on the other hand, complained to Dorner that the responsibility for the exhibitions of 1930 (Paris), 1931 (Berlin), and 1939 (New York) lay with him and not with Bayer, as Dorner's text suggests; Walter Gropius to Alexander Dorner, July 17, 1947, reprinted in the sales catalogue no. 7, Christian Hesse Auctions Hamburg, May 2013, 332.

49 HB/ACQ, no. 7.

50 Von Moos, "Modern Art," 101–02.

51 Uchill, "Re-viewing," 138–39. Lydia Dorner claimed that her late husband had always wanted to publish the book without the text on Bayer; see Lydia Dorner to Robert L. Leslie, May 7, 1959, New York Public Library, The Typophile Inc. records, box 47, folder 7. The German version appeared as *Überwindung der "Kunst"* from the Hannover publisher Fackelträger in 1959.

52 See Bayer, *Painter, Designer, Architect.*

53 Württembergischer Kunstverein, *50 Jahre Bauhaus.*

54 Bayer, *painter, designer, architect,* 11.

55 Ibid., 44. In the "Listing of Works," under the category "graphic design; exhibition design" (p. 205) the year of 1935 includes only the innocuous "traveling exhibits, berlin | municipal exhibit, berlin." It makes no mention of Bayer's participation in the trilogy of propaganda exhibitions described in Chapter 7 of this book.

56 See, for example, the catalogue *Herbert Bayer/Piet Zwart: Masters of Design,* New York: Ex Libris, n.d. (ca. 1988).

57 Bayer to Cohen, July 3, 1974 and November 28, 1975; Museum of Modern Art, New York, Architecture and Design department, Object nos. 1150.2015.1–2. www.moma.org/collection/works/198501 and /200173.

58 All materials filed in OHP/B, OHP/C, and HB/ACQ. For more documents on the development of this monograph, see the Arthur A. Cohen Papers, Beinecke Rare Books and Manuscript Library, Archives at Yale, Box 10.

59 See Cohen, *Herbert Bayer,* 32.

60 Ibid., 404–5, note 55. Here Cohen is clearly drawing on Bayer's own account of his work for the 1931 Building Worker's Union exhibition, where he explains: "I think I was naive not to think of these connections, and only concentrated on my artistic work." HB/ACQ, no. 7.

61 Ibid., 404, note 55.

62 Rössler, *Berliner Jahre*, D.15.

63 "Like many other important German artists of the period, some of whom went into what came to be called 'internal emigration,' Bayer knew that the time to leave was fast arriving." Cohen, *Herbert Bayer*, 41.

64 Ibid.

65 Ibid., 405, note 56.

66 HB/ACQ, no. 7.

67 Cohen, *Herbert Bayer*, 220; for the deficits see also Anhold, "Imagery," 3.

68 Ibid., 409, note 26.

69 Ibid., 295.

70 Ibid., and also the image on 229.

71 Ibid. For example, on 379, Cohen notes that, in 1936, Bayer "Designs catalogue for summer exhibition, *Deutschland Ausstellung*, in which insertion of propaganda material confirms Bayer's conviction that free design is no longer possible in Germany."

72 Neumann, "Kunst als universelle Verantwortung." These items were never returned to Bayer.

73 See Droste, "Herbert Bayer."

74 Chanzit, *Herbert Bayer Collection*; Chanzit, *Herbert Bayer*.

75 Ibid., 31, 120 and 233, note 14.

76 Ibid., 20; the book mentions the poster on pp. 59 and 61. Published originally in 1987, a second edition of the book from 2005 is revised to include additional visual material but reproduces this passage unchanged, without taking more recent research into account, such as correcting the date of the exhibition (it was 1935, not 1932), or adding anything about Bayer's Berlin period.

77 Anhold, "Imagery," 66.

78 A similar phenomenon could be observed in the retrospective of Xanti Schawinsky's work from 1981, which also tuned out his work in the service of the Italian fascists; see Holz, *Xanti Schawinsky*, 43-45.

79 See above, note 10 quoting a diary entry from 1972.

80 Brüning, "Herbert Bayer," 332.

81 Ibid.

82 See Krause, *Die nützliche Moderne*, 12–14, 50–1, 76–8; Schug, "Herbert Bayer," 177–84; Schug, "Moments of Consistency," 60–73.

83 Schug, "Herbert Bayer," 184.

84 Hahn, "Bauhaus and Exile," 222. "The leaders of the Bauhaus are regarded today almost as legends."

85 "The step across the Atlantic, which was so difficult for many emigrants, went almost smoothly for Bayer." Schug, "Moments of Consistency," 73.

86 Herbert Bayer to Lady Norton, November 15, 1942, VL/HB, box 70.

87 HB/38–40, 108.

88 Ibid., 98.

89 HB/OD.

90 This is not the stance of all scholars. German curators Iris Dressler and Hans Christ, for instance, asserted in 2020 that Bayer was "until 1937 ... one of the most prominent suppliers to National Socialist propaganda activities" and "helped to lend a modern face to the inhuman, racist, and anti-Semitic ideologies of the National Socialists." Blume, "50 Years," 59, 60.

91 See Dillmann, *Jecheskiel David Kirszenbaum.*

92 "Ein Mensch mit Gesinnung holt Herbert Bayer nicht nach Amerika, wo es dem in Deutschland alles Piepe war. Die Hauptsache, als erster Nazi-Plakatzeichner zu gelten. Nein, mein Lieber, Gesinnungsschwein bleibt Lump." Jezekiel Kirszenbaum to Paul Citroën, January 4, 1938, BHA Berlin 8034/190. I thank Klaus Weber for the reference to this document.

93 Hahn, "Bauhaus and Exile," 222.

94 The entry is in English, but Bayer wrote the reference to his "beloved homeland" in German. HB/OD, 163.

95 Hahn, "Wege der Bauhäusler," 210–11.

96 See Sachsse, "Von Österreich aus," with additional references.

97 Stegmann et al., "Echo Chambers."

98 Bayer, "Über Typographie," 76.

99 Hubert Hoffmann, "Begegnungen mit Herbert Bayer," unpublished manuscript, dated November 25, 1985. Bauhaus-Archiv Berlin, document collection, Immeke Schwollmann-Mitscherlich, folder 2, p. 7.

100 Hoffmann, p. 1.

101 Steinhausen, "Herbert Bayer," 81.

102 Herbert Bayer to Monroe Wheeler, November 23, 1943; copy attached to a letter to Alexander Dorner, March 6, 1945; Niedersächsisches Landesarchiv/ Hauptstaatsarchiv Hannover, VVP 21, no. 76.

103 This motif was later reused by the avant-garde electronic pop band The Chemical Brothers for their record *We Are The Night* (2007). I am indebted to Volker Gehrau for calling my attention to this album cover.

Bibliography

Frequently cited archival sources are abbreviated as follows:

OHP/B: California Oral History Project, Interview with Herbert Bayer, Montecito, California; October 3, 1981 (Interviewer: Ruth Bowman); transcript: Archives of American Art, Smithsonian Institution.

OHP/C: California Oral History Project; Interviews with Herbert Bayer, Montecito, California; November 3 and 7, 1981 and March 8–10, 1982 (Interviewer: Arthur A. Cohen); transcript: Archives of American Art, Smithsonian Institution.

HB/ACQ: Herbert Bayer, Answers to Arthur Cohen's Questionnaires, 14 letters, March 23, 1982 to March 7, 1983; Denver Public Library, Herbert Bayer Archive (DPL, WH2416), Box 9, Folder 98.

PD/HB: Personal Documents of Herbert Bayer; Denver Public Library, Herbert Bayer Archive (DPL, WH2416), Box 28.

HB/AS&S: Herbert Bayer, Diary 1932–1938 ("Archaic Signs and Symbols"); Denver Public Library, Herbert Bayer Archive (DPL, WH2416), Box 12.

HB/38-40: Herbert Bayer, Diary 1938–1940 [untitled]; Denver Public Library, Herbert Bayer Archive (DPL, WH2416), Box 12.

HB/OD: Herbert Bayer, Diary 1958–1972 ("Occasional Diaries"); Denver Public Library, Herbert Bayer Archive (DPL, WH2416), Box 12.

IB/HB: Letters from Irene Bayer-Hecht to Herbert Bayer; Denver Public Library, Herbert Bayer Archive (DPL, WH2416), Box 12.

JF/HB: Correspondence between Jorge Fulda and Herbert Bayer; Denver Public Library, Herbert Bayer Archive (DPL, WH2416), Box 70.

WBK/HB: Correspondence between Willy B. Klar and Herbert Bayer; Denver Public Library, Herbert Bayer Archive (DPL, WH2416), Box 70

VL/HB: Letters of various people to Herbert Bayer; Denver Public Library, Herbert Bayer Archive (DPL, WH2416), Boxes 12 and 70.

MB/HB: Correspondence between Marcel Breuer and Herbert Bayer and others; Archives of American Art, Smithsonian Institution, Marcel Breuer Papers, Reel 5708/5709.

IWG/HB: Correspondence between Ise and Walter Gropius and Herbert Bayer; Archives of American Art, Smithsonian Institution, Letters from Herbert Bayer to Walter and Isc Gropius, Reel 2287A. (Selected portions of this archive translated into English by Ise Gropius.)

HB/IG: Correspondence between Herbert Bayer and Ise Gropius, Bauhaus-Archiv Berlin, Gropius estate.

IG/WG: Correspondence between Walter and Ise Gropius, Bauhaus-Archiv Berlin, Gropius estate, correspondence Ise Gropius. (Portions of this archive translated into English by Ise Gropius available in the Archives of American Art, Smithsonian Institution, Letters from Herbert Bayer to Walter and Ise Gropius, Reel 2393.)

XS/Ms: Xanti Schawinsky, fragment of an autobiography (n.d., 1970s); manuscript, Bauhaus-Archiv Berlin, Schawinsky collection, Folders 1 to 5.

Adorno, Theodor. *Minima Moralia: Reflections on a Damaged Life* (1951), trans. Edmund F. N. Jephcott. London: Verso, 2005.

Agha, Mehemed F. "What Makes a Magazine 'Modern'?" *Advertising Arts* 1, no. 10 (October 1930), 13–17.

Albers, Josef. "To the Editors: Albers and the Bauhaus." *PM* 4, no. 8 (August–September 1938), 49.

Allen, James Sloan. *The Romance of Commerce and Culture: Capitalism, Modernism, and the Chicago–Aspen Crusade for Cultural Reform.* Chicago: University of Chicago Press, 1983.

Amt Feierabend, ed. *Der Arbeiter und die Bildende Kunst. System und Aufgabe der Kunstausstellungen in den Betrieben.* [Berlin:] NS-Gemeinschaft "Kraft durch Freude", Amt Feierabend, [1938].

Anderson, Richard. "Der kommunistische Funktionalist. Zur Rezeption in der englischsprachigen Welt." In *Hannes Meyer und das Bauhaus. Im Streit der Deutungen,* edited by Thomas Flierl and Philipp Oswalt, 411–20. Leipzig: Spector Books, 2018.

Anhold, Grit-Karin. "The imagery of Herbert Bayer's European years, 1920-1938." PhD diss., Rutgers The State University of New Jersey, New Brunswick, 1988.

Anonymous. "A Berlin Exhibition—The Wonders of Life." *Industrial Arts* 25 (Winter 1936), 313–18.

Anonymous. "Agha's American Decade." *PM* 5, no. 2 (August–September 1939).

Anonymous. "Ausstellungsbilanz 1938." *Die deutsche Volkswirtschaft* 36 (1938), 1356.

Anonymous. "Herbert Bayer's Design Class." *A-D* 7, no. 5 (June–July 1941), 18–30.

Anonymous. "Modern Art Gets Down to Business." *Commercial Art and Industry* 18, no. 106 (April 1935), 156–61.

Anonymous. "Sechste Anordnung über den Schutz des Berufes und die Berufsausübung der Gebrauchsgraphiker (Gebührenordnung). Vom 16.10.1935." *Der Werbungsmittler, Zeitschrift des Reichsverbandes der deutschen Werbungsmittler* 22, no. 7 (July 1936), 130.

Asmus, Sylvia, and Brita Eckert. "Vermittelte Erinnerung. Zur Geschichte des Deutschen Exilarchivs und seiner Ausstellungen." In *Gedächtnis des Exils. Formen der Erinnerung,* edited by Claus-Dieter Crohn and Lutz Winkler, 35–46. München: edition text+kritik, 2010.

Atlantic Richfield Company, ed. *Herbert Bayer: Photographic Works.* Los Angeles: ARCO Center for Visual Arts, 1977.

Aynsley, Jeremy. *Graphic Design in Germany 1890-1945.* London: Thames & Hudson, 2000.

Bajkay, Eva, ed. *"Von Kunst zu Leben." Die Ungarn am Bauhaus.* Pécs: Janus Pannonius Múzeum, 2010.

Bakos, Katalin. "Neue Typografie—neue Werbung." In Bajkay, *Die Ungarn am Bauhaus,* 246–65.

Barker, Nicolas. *Stanley Morrison.* London: Macmillan, 1972.

Barnard, John C., dir. *Herbert Bayer—the man and his work.* N.d. (c. 1975); Aspen: The Aspen Institute; Denver Public Library, WH2416, special collections. www.youtube.com/watch?v=grYA7c2haU8.

Barnstone, Deborah A. "Real Utopian or Utopian Realist? Erich Mendelsohn's Multiple Passages of Exile and the Academic Europeenne Mediterranee." In *Passagen des Exils/Passages of Exile,* edited by Burcu Dogramaci and Elizabeth Otto, 109–25. München: edition text + kritik, 2017.

Barron, Stephanie, and Sabine Eckmann, eds. *Exiles + Emigrés: The Flight of European Artists from Hitler*. New York: Abrams, 1997.

Bauhaus-Archiv, ed. *Bauhäusler in Amerika*. Darmstadt: Bauhaus-Archiv, 1969.

Bauhaus-Archiv, ed. *Herbert Bayer. Das künstlerische Werk 1918–1938*. Berlin: Gebr. Mann, 1982.

Baum, Peter, ed. *Herbert Bayer 1900–1985*. Linz: Neue Galerie, 2000.

Bavaj, Ricardo. *Die Ambivalenz der Moderne im Nationalsozialismus. Eine Bilanz der Forschung*. München: Oldenbourg, 2003.

Bayer, Herbert. "Aus dem optischen Notizbuch." *Das illustrierte Blatt* 17, no. 5 (February 2, 1929), 116–17.

Bayer, Herbert. "Dankesrede zur Verleihung des Kulturpreises der Deutschen Gesellschaft für Photographie (DGPh), Cologne 1969." DPL, WH2416, Manuscripts.

Bayer, Herbert. "Design, designer, and industry." *Magazine of Art* 44, no. 8 (December 1951), 324–25.

Bayer, Herbert. "Die Schwebefähre von Marseille." *Das illustrierte Blatt* 16, no. 49 (December 8, 1928), 1394–96.

Bayer, Herbert. *Dorland 1*. Berlin: Dorland advertising agency, 1933.

Bayer, Herbert. *herbert bayer—painter, designer, architect*. New York: Reinhold 1967.

Bayer, Herbert. "Herbert Bayer." Special issue, *PM* 6, no. 2 (December 1939), 1–32.

Bayer, Herbert. "Homage to Gropius." In Droste and Friedewald, *Our Bauhaus*, 30–32. Munich: Prestel, 2019. First published in German as "Ehrung an Gropius." In *Bauhaus. Idee—Form—Zweck—Zeit*, edited by Eckhard Neumann, 99–103. Frankfurt: Göppinger Galerie, 1964.

Bayer, Herbert. "Künstlerische Gestaltung—ein Ausdrucksmittel der Industrie." *Gebrauchsgraphik* 23, no. 9 (September 1952), 2–60.

Bayer, Herbert. Preface to *Exhibitions and Displays*, by Erberto Carboni, 12–16. Milano: "Silvana" ed. d'Arte, 1957.

Bayer, Herbert. "Typografie und Werbesachengestaltung." *bauhaus* 2, no. 1 (March 1928), 10.

Bayer, Herbert. "Typography and Design." In *Concepts of the Bauhaus: The Busch-Reisinger Museum Collection*, edited by John D. Farmer and Geraldine Weiss, 99–101. Cambridge, MA: Harvard University, 1971.

Bayer, Herbert. "Über Typographie," *form+zweck* 11, no. 3 (March 1979), 75–77.

Bayer, Herbert. "Werbephoto." *Wirtschaftlichkeit* 2, no. 32 (February 20, 1928), unpag.

Bayer, Herbert, Walter and Ise Gropius, eds. *Bauhaus 1919–1928*. New York: Museum of Modern Art, 1938. (German edition: Stuttgart: Hatje 1955.)

Bayer-Hecht, Irene [i.b.]. Untitled essay, flyer for the annual exhibition. Salzburg: Kunstverein, 1936.

Beier, Rosmarie, and Martin Roth, eds., *Der gläserne Mensch—eine Sensation. Zur Kulturgeschichte eines Ausstellungsobjekts*. Stuttgart: Hatje, 1990.

Bergdoll, Barry. "Encountering America: Marcel Breuer and the Discourses of the Vernacular from Budapest to Boston." In *Marcel Breuer. Design und Architektur*, edited by Alexander von Vegesack and Mathias Remmele, 258–307. Weil am Rhein: Vitra Design Museum, 2003.

Bergdoll, Barry. "'Momento Mori' or New Beginning. Notes on 'Bauhaus 1919–1928' at The Museum of Modern Art, New York, 1938." *Architectura* 48, nos. 1+2 (2018), 118–33.

Bergdoll, Barry, and Leah Dickerman, eds. *Bauhaus 1919–1933 - Workshops for Modernity*. New York: Museum of Modern Art, 2009.

Berghoff, Hartmut. "'Times change and we change with them.' The German Advertising Industry in the 'Third Reich'—Between Professional Self-Interest and Political Repression." *Business History* 45, no. 1 (January 2003), 128–47.

Bernstein, Sheri. "Purism and Pragmatism: Josef Albers, Laszlo Moholy-Nagy." In Barron and Eckmann, *Exiles + Emigrés*, 253–69.

Beyme, Klaus von. "Die Stellung der künstlerischen Avantgarden zur Weimarer Republik." In *Politik, Kommunikation und Kultur in der Weimarer Republik*, edited by Hans-Peter Becht, Carsten Kretschmann and Wolfram Pyta, 31–49. Heidelberg: Verlag Regionalkultur, 2009.

Black, Edwin. *The Transfer Agreement. The Dramatic Story of the Pact Between the Third Reich and Jewish Palestine*. New York: Carroll & Graf, 2001.

Blümm, Anke. "'this may become the most important document of the Bauhaus'—Die Bauhaus-Ausstellung im MoMA 1938 als Produkt des engen Netzwerks um Gropius." In Blümm et al., *Die bewegten Netze*.

Blümm, Anke, Magdalena Droste, Patrick Rössler, Jens Weber, and Andreas Wolter. *Die bewegten Netze des Bauhauses. Von der Institution zur Community: Bauhaus-Angehörige nach 1933*. Göttingen: Wallstein, forthcoming.

Blume, Torsten, ed. *Xanti Schawinsky. The Album*. Zurich: Ringier, 2015.

Blume, Torsten. "50 Years after *50 Years Bauhaus* in 1968: Hans Christ and Iris Dressler in Conversation with Torsten Blume." In *Ludwig Grote and the Bauhaus Idea*, edited by Peter Bernhard and Torsten Blume, 155–64. Leipzig: Spector Books, 2021.

Boehling, Rebecca. "Transitional Justice? Denazification in the US Zone of Occupied Germany." In *Transforming Occupation in the Western Zones of Germany: Politics, Everyday Life and Social Interactions, 1945–55*, edited by Camilo Erlichman, 63–80. London: Bloomsbury Academic, 2018.

Bothe, Rolf. "Die Frankfurter Kunstschule 1923–1933." In Kunstschulreform 1900–1933, edited by Hans M. Wingler, S. 144–83. Berlin: Gebr. Mann, 1977.

Bourdieu, Pierre. *Outline of a Theory of Practice*. Cambridge: Cambridge University Press, 1977.

Breuer, Gerda. "Vom Maler zum Werbefachmann. Max Burchartz und die Typografie seiner Zeit." In *Max Burchartz 1887–1961. Künstler Typograf Pädagoge*, edited by Gerda Breuer, 85–137. Berlin: Jovis, 2010.

Broos, Kees. "Das kurze, aber heftige Leben des Rings 'neue werbegestalter.'" In Rattemeyer and Helms, *Ring "neue werbegestalter"*, 7–10.

Bruderer Oswald, Iris. *Das neue Sehen. Carola Giedion-Welcker und die Sprache der Moderne*. Bern: Benteli, 2007.

Brüning, Ute. "Bauhäusler zwischen Propaganda und Wirtschaftswerbung." In Nerdinger, *Bauhaus-Moderne*, 24–47.

Brüning, Ute, ed. *Das A und O des Bauhauses*. Leipzig: Edition Leipzig, 1995.

Brüning, Ute. "Die Ateliers des Moholy-Nagy—ein Netzwerk?" In Blümm et al., *Die bewegten Netze*.

Brüning, Ute. "Die Druck- und Reklamewerkstatt: Von Typographie zur Werbung." In *Experiment Bauhaus*, edited by Bauhaus-Archiv, 154–55. Berlin: Kupfergraben, 1988.

Brüning, Ute. "Druckerei, Reklame, Werbewerkstatt." In: Fiedler and Feierabend, *Bauhaus*, 488–97.

Brüning, Ute. "'Fotografie war nicht mein Ziel.' Ausbildung und Werbepraxis in den Jahren 1924–1940." In *Walter Funkat. Vom Bauhaus zur Burg Giebichenstein*, edited by Ute Brüning and Angela Dolgner, 13–61. Dessau: Anhaltische Verlagsges, 1996.

Brüning, Ute. "Herbert Bayer." In Fiedler and Feierabend, *Bauhaus*, 332–45.

Brüning, Ute. "Herbert Bayers neue Linie: Standardisierte Gebrauchsgrafik aus dem Hause Dorland." In *Moments of Consistency. Eine Geschichte der Werbung*, edited by Stefan Hansen, 221–26. Bielefeld: Transcript, 2004.

Brüning, Ute. "Joost Schmidt: ein Curriculum für Werbegrafiker." In Rössler, *bauhauskommunikation*, 257–64 and plates VII–XII.

Brüning, Ute. "Typofoto." In *Photography at the Bauhaus*, edited by Janine Fiedler, 205–19. Berlin: Dirk Nishen, 1990.

Brüning, Ute. "– – Y – – = Herbert Bayer? Als der Urheber aus der Gebrauchsgrafik verschwand." In Rössler, *Herbert Bayer*, 64–80.

Buchloh, Benjamin H. D. "From Faktura to Factography." *October* 30 (Autumn, 1984), 82–119.

Bürger, Jan. *Im Schattenreich der wilden Zwanziger. Fotografien von Karl Vollmoeller aus dem Nachlass von Ruth Landshoff-Yorck*. Marbach: Dt. Schillergesellschaft, 2017 (Marbacher Magazin No. 160).

Chanzit, Gwen F. *From Bauhaus to Aspen. Herbert Bayer and Modernist Design in America*. Ann Arbor: UMI Research Press, 1987; revised ed., Boulder: Johnson, 2005.

Chanzit, Gwen, ed. *herbert bayer collection and archive at the denver art museum*. Denver: Denver Art Museum, 1988.

Choy, Yong Chan. "Inszenierungen der völkischen Filmkultur im Nationalsozialismus: Der Internationale Filmkongress Berlin 1935." PhD diss., Technische Universität Berlin, 2006. https://depositonce.tu-berlin.de/handle/11303/1587.

Cohen, Arthur A. *Herbert Bayer. The Complete Work*. Cambridge, MA: MIT Press, 1984.

Collins, Randall. *The Sociology of Philosophies: A Global Theory of Intellectual Change*. Cambridge MA: Belknap Press of Harvard University, 1998.

Danilowitz, Brenda. "Herbert Bayer und Josef Albers. Privates und öffentliches Leben." In Nowak-Thaller and Widder, *Ahoi Herbert!*, 269–74.

Danilowitz, Brenda. "Josef Albers und die Rezeption der abstrakten Kunst in Neuengland (1933–1950)." In Helfenstein and Mentha, *Josef und Anni Albers*, 187–96. Cologne: DuMont, 1998.

Danilowitz, Brenda. "Perspektiven und Grenzen eines amerikanischen Bauhauses: Das Black Mountain College." In *Bauhaus Global*, 95–104. Berlin: Gebr. Mann, 2010.

Danilowitz, Brenda. "Portrait photographs." In *Josef Albers Photographs 1928–1955*, edited by Marianne Stockebrand, 20–29. Munich: Schirmer/Mosel, 1992.

Denver Art Museum, ed. *Herbert Bayer: A Total Concept*. Denver: Denver Art Museum, 1973.

Dillmann, Ulrich, ed. *Jecheskiel David Kirszenbaum. Karikaturen eines Bauhäuslers zur Weimarer Republik*. Weimar: Volkshochschule, 2021.

Doede, Werner. "Jan Tschichold." In: Beiheft zu *Die neue Typographie. Ein Handbuch für zeitgemäss Schaffende* by Jan Tschichold, supplement to the reprint, 6–7. Berlin: Brinkmann & Bose, 1981.

Dogramaci, Burcu. "Netzwerke des künstlerischen Exils als Forschungsgegenstand—zur Einführung." In Dogramaci and Wimmer, *Netzwerke des Exils*, 13–28.

Dogramaci, Burcu and Karin Wimmer, eds. *Netzwerke des Exils. Künstlerische Verflechtungen, Austausch und Patronage nach 1933*. Berlin: Gebr. Mann, 2011.

Dolgner, Angela, and Jens Semrau. "Im Gespräch mit Walter Funkat." In *Walter Funkat. Vom Bauhaus zur Burg Giebichenstein*, edited by Ute Brüning and Angela Dolgner, 119–27. Dessau: Anhaltische Verlags-Gesellschaft, 1996.

Dorner, Alexander. "Herbert Bayer (Austrian)/(Österreich)." In *Herbert Bayer*, 7–11. London: London Gallery, 1936.

Dorner, Alexander. *The Way Beyond "Art": The Work of Herbert Bayer*. New York: Wittenborn and Schultz, 1947.

Droste, Magdalena. *Bauhaus 1919–1933*. Cologne: Taschen, 2006.

Droste, Magdalena. "Blinde Flecken. Künstlerinnen des Bauhauses während der NS-Zeit —Verfolgung und Exil. Zum Stand der Forschung." In *Entfernt. Frauen des Bauhauses während der NS-Zeit—Verfolgung und Exil*, edited by Inge Hansen Schaberg, Wolfgang Thöner, and Adriane Feustel, 312–33. München: edition text+kritik, 2012.

Droste, Magdalena. "Der politische Alltag. Bauhäusler berichten—Briefe aus der Zeit des Dritten Reiches." In Hahn, *Bauhaus Berlin*, 209–34.

Droste, Magdalena. "Herbert Bayers künstlerische Entwicklung 1918–1938." In Bauhaus-Archiv, *Herbert Bayer*, 18–79.

Droste, Magdalena. "Herbert Bayers Weg vom Bauhaus in die Werbung." In Nowak-Thaller and Widder, *Ahoi Herbert!*, 77–91.

Droste, Magdalena. "The Bauhaus Object between Authorship and Anonymity." In Saletnik and Schuldenfrei, *Bauhaus Construct*, 205–25.

Droste, Magdalena. "Vom Bauhaus zu 'Commerce and Culture.' Herbert Bayer als Partner der Industrie in Amerika." In *Herbert Bayer: Kunst und Design in Amerika 1938–1985*, edited by Bauhaus-Archiv, 119–24. Berlin: Gebr. Mann, 1986.

Droste, Magdalena, and Boris Friedewald, eds. *Our Bauhaus. Memories of Bauhaus People*. Munich: Prestel, 2019.

Droste, Magdalena, and Manfred Ludewig. *Marcel Breuer Design*. Cologne: Taschen, 1992.

Düchting, Hajo, ed. *Seemanns Bauhaus-Lexikon*. Leipzig: Seemann, 2009.

Eisele, Petra. "Adolf H. beim Zeitungslesen unter dem Adventsbaum. Zur Rezeption der Gestaltungsprinzipien des Bauhauses im Nationalsozialismus." In *Bauhaus-Ideen 1919–1994. Bibliografie und Beiträge zur Rezeption des Bauhausgedankens*, edited by Andreas Haus, 30–41. Berlin: Reimer, 1994.

Eisele, Petra, Isabel Naegele, and Michael Lailach, eds. *Moholy-Nagy und die Neue Typografie A–Z*. Bönen: Verlag Kettler, 2019.

Eskildsen, Ute, and Jan-Christopher Horak, eds. *Film und Foto der zwanziger Jahre*. Stuttgart: Württembergischer Kunstverein, 1979.

Etzold, Marc. "Walter Gropius als Kommunikator. Netzwerke und Initiativen." In Rössler, *bauhauskommunikation*, 55–76.

Evans, Richard J. *The Third Reich at War*. New York: Penguin, 2008.

Faber, Monika. "Ganz modern und kühn. Die Avantgarde und die Propagandaausstellungen in den dreißiger Jahren." In *Kunst und Diktatur*, edited by Jan Tabor, 72–79. Baden: Grasl, 1994.

Fachgruppe Gebrauchsgraphiker in der Reichskammer der Bildenden Künste, ed. *Ausstellung Deutsche Werbegraphik 1936*. Berlin: Limpert, 1936.

Farmer, John D., and Geraldine Weiss, eds. *Concepts of the Bauhaus: The Busch-Reisinger Museum Collection*. Cambridge MA: Harvard University, 1971.

Fiedler, Jeannine, and Peter Feierabend, eds. *Bauhaus* [English edition]. Rheinbreitbach: h. f. ullmann Publishing, 2019. First published in German as *Bauhaus*, Cologne: Könemann, 1999.

Finger, Anke. *Das Gesamtkunstwerk der Moderne*. Göttingen: Vandenhoeck & Ruprecht, 2006.

Fleischmann, Gerd, ed. *bauhaus drucksachen typografie reklame*. Düsseldorf: Marzona, 1984.

Frenzel, H. K. "Herbert Bayer." *Gebrauchsgraphik* 8, no. 5 (May 1931), 2–19.

Gebhard, Bruno. *Im Strom und Gegenstrom, 1919–1937*. Wiesbaden: Steiner, 1976.

Gebhard, Bruno, and Ernst W. Maiwald. "Ein Rundgang durch die Ausstellung." In Gemeinnützige Berliner Ausstellungs- und Messe-Ges. m.b.H., *Ausstellung Deutsches Volk, deutsche Arbeit*, 183–221.

Gebhard, Max. "Kommunistische Ideen im Bauhaus." *bauhaus 3*, edited by Galerie am Sachsenplatz, 10–13. Leipzig: Galerie am Sachsenplatz, 1978.

Gemeinnützige Berliner Ausstellungs- und Messe-Ges. m.b.H., ed. *Amtlicher Führer durch die Ausstellung Deutsches Volk, deutsche Arbeit*. Berlin: Ala, 1934.

Gemeinnützige Berliner Ausstellungs- und Messe-Ges. m.b.H., ed. *Die Kamera. Ausstellung für Fotografie, Druck und Reproduktion*. Berlin: Union Deutsche Verlagsgesellschaft, 1933.

Gertz, Corina, Christoph Schaden, and Kris Scholz, eds. *Bauhaus and Photography. New Vision in Contemporary Art*. Bielefeld: Kerber, 2018.

Gfrereis, Heike, and Verena Staack. "Zeitstempel und Körperspur. 'Exil' als Thema im Marbacher Literaturmuseum der Moderne." In *Gedächtnis des Exils. Formen der Erinnerung*, edited by Claus-Dieter Crohn and Lutz Winkler, 47–66. München: edition text+kritik, 2010.

Gough, Maria. "Constructivism Disoriented: El Lissitzky's Dresden and Hannover 'Demonstrationsräume'." In *Situating El Lissitzky: Vitebsk, Berlin, Moscow*, edited by Nancy Perloff and Brian Reed, 77–125. Los Angeles: Getty, 2003.

Granovetter, Mark S. "The Strength of Weak Ties." *The American Journal of Sociology* 78, no. 6 (May 1973) 1360–80.

Grawe, Gabriele Diana. *Call for Action. Mitglieder des Bauhauses in Nordamerika*. Weimar: VDG, 2002.

Grawe, Gabriele Diana. "Von der Hochschule für Gestaltung zur Schule des Stils. Facetten der Bauhausrezeption in den USA." In *Bauhaus-Ideen 1919–1994. Bibliografie und Beiträge zur Rezeption des Bauhausgedankens*, edited by Andreas Haus, 116–42. Berlin: Reimer, 1994.

Grohn, Christian. *Gustav Hassenpflug. Architektur, Design, Lehre 1907–1977*. Düsseldorf: Marzona, 1985.

Gropius, Walter. "Essentials for Architectural Education." *PM* 4, no. 5 [42] (February– March 1938), 3–16.

Gropius Johansen, Ati. *Ise Gropius*. Boston: Historic New England, 2013.

Grossmann, Atina. *Reforming Sex: the German Movement for Birth Control and Abortion Reform, 1920–1950*. New York: Oxford University Press, 1995.

Gubig, Thomas, and Sebastian Köpcke. *Chlorodont. Biographie eines deutschen Markenproduktes*. Dresden: Werkarchiv der Dental-Kosmetik, 1997.

Guenther, Irene. *Nazi Chic? Fashioning Women in the Third Reich*. Oxford: Berg, 2004.

Guenther, Irene. "The Destruction of a Culture and an Industry." In *Broken Threads: The Destruction of the Jewish Fashion Industry in Germany and Austria*, edited by Roberta S. Kremer, 76–97. Oxford: Berg, 2007.

Gutbrod, Karl, ed. *"Lieber Freund." Künstler schreiben an Will Grohmann. Eine Sammlung von Briefen aus fünf Jahrzehnten*. Cologne: DuMont, 1968.

Guttenberger, Anja. "Fotografische Selbstporträts der Bauhäusler zwischen 1919 und 1933." PhD diss., Freie Universität Berlin, 2011. https://refubium.fu-berlin.de/handle/fub188/8338.

Haanen, Karl Theodor. "Bauhausreklame." *Die Reklame* 22, no. 1 (January 1929), 11–14.

Hadley, Gill. "Three Female Gallerists who Changed the Course of British Art." *Royal Academy Magazine* (September 2016), royalacademy.org.

Hahn, Peter. "Bauhaus and Exile: Bauhaus Architects and Designers between the Old World and the New." In Barron and Eckmann, *Exiles + Emigrés*, 211–23.

Hahn, Peter. "Wege der Bauhäusler in Reich und Exil." In Nerdinger, *Bauhaus-Moderne*, 202–13.

Hahn, Peter, ed. *Bauhaus Berlin. Auflösung Dessau 1932, Schließung Berlin 1933, Bauhäusler und Drittes Reich.* Weingarten: Kunstverlag, 1985.

Hahn, Peter, and Barbara Paul, eds. *Xanti Schawinsky. Malerei, Bühne, Grafikdesign, Fotografie.* Berlin: Nicolai, 1986.

Harbusch, Gregor. "Space, Time and Architecture, 1941." In *Sigfried Giedion und die Fotografie. Bildinszenierungen der Moderne*, edited by Werner Oechslin and Gregor Harbusch, 250–51. Zürich: gta, 2010.

Hartmann, Udo. "The Eye of Herbert Bayer." In *Photography at the Bauhaus*, edited by Janine Fiedler, 65–68. Berlin: Dirk Nishen, 1990.

Heinze-Greenberg, Ita. "An Artistic European Utopia at the Abyss of Time: The Mediterranean Academy Project, 1931–1934." *Architectural History* 45 (2002), 441–82. https://doi.org/10.2307/1568792.

Heise, Nele. "Das Bauhaus in allen Taschen." In Rössler, *bauhauskommunikation*, 265–80.

Helfenstein, Josef. "Josef und Anni Albers—Europa und Amerika." In *Josef und Anni Albers—Europa und Amerika*, edited by Josef Helfenstein and Henriette Mentha, 65–81. Cologne: DuMont, 1998.

Helfenstein, Josef, and Henriette Mentha, eds. *Josef und Anni Albers—Europa und Amerika. Künstlerpaare—Künstlerfreunde.* Cologne: DuMont, 1998.

Heller, Steven. *Merz to Emigre and Beyond: Avant-Garde Magazine Design of the Twentieth Century.* London: Phaidon, 2003.

Hemken, Kai Uwe. "The Deutscher Werkbund section at the 1930 'Exposition de la Société des Artistes Décorateurs' in Paris." In *New Exhibition Design 1900–2000*, edited by Anna Müller and Frauke Möhlmann, 114–20. Stuttgart: avedition, 2014.

Hemken, Kai Uwe, and Rainer Stommer. "Der 'De Stijl'-Kurs von Theo van Doesburg in Weimar (1922)." In *Konstruktivistische Internationale Schöpferische Arbeitsgemeinschaft 1922–1927. Utopien für eine europäische Kultur*, edited by Bernd Finkeldey, 169–77. Stuttgart: Hatje 1992.

Hermand, Jost. *Kultur in finsteren Zeiten. Nazifaschismus, innere Emigration, Exil.* Cologne: Böhlau, 2010.

Hill, Paul and Thomas Joshua Cooper. "Herbert Bayer, Interview, November 1977," in *Dialogue with Photography*, edited by Paul Hill and Thomas Joshua Cooper, 93–108. Stockport: Lewis, 2005.

Hintze, Josefine, and Corinna Lauerer. "Medienereignisse am Bauhaus." In Rössler, *bauhauskommunikation*, 185–204.

Hoffmann, Tobias. "'Mondrian: er ist ja recht eigentlich der Gott des Bauhauses und Doesburg ist sein Prophet.' Konstruktivismus am Bauhaus." In *Bauhausstil oder Konstruktivismus? Aufbruch der Moderne in den Zentren Berlin—Bauhaus—Hannover—Stuttgart—Frankfurt*, edited by Tobias Hoffmann, 61–80. Cologne: Wienand, 2008.

Hölscher, Eberhard. "Bauhaus 1919–1928." *Gebrauchsgraphik* 23, no. 9 (September 1952), 63.

Hölscher, Eberhard. "Herbert Bayer." *Gebrauchsgraphik* 13, no. 4 (April 1936), 18–25.

Hölscher, Eberhard. "Herbert Bayer." *Gebrauchsgraphik* 15, no. 6 (June 1938), 2–16.

Hölscher, Eberhard. "Herbert Bayer." *Photo-Graphik* 1, no. 3 (May 1934), 13–15.

Holz, Hans Heinz. *Xanti Schawinsky. Bewegung im Raum—Bewegung des Raums*. Zürich: ABC, 1981.

Holz, Keith. "Recasting Exile Artist's Groups as Transnational Diasporic Communities." In Dogramaci and Wimmer, *Netzwerke des Exils*, 279–95.

Honnef, Klaus and Frank Weyers, ed. *Und sie haben Deutschland verlassen ... müssen. Fotografen und ihre Bilder 1928–1997*. Bonn: Rheinisches Landesmuseum, 1997.

Hüneke, Andras, ed. *Oskar Schlemmer. Idealist der Form. Briefe—Tagebücher—Schriften*. Leipzig: Reclam, 1990.

Isaacs, Reginald R. *Walter Gropius. Der Mensch und sein Werk*. 2 vols. Berlin: Gebr. Mann, 1983–84.

Isaacs, Reginald R. *Gropius. An illustrated biography of the creator of the Bauhaus*. Boston: Bulfinch Press of Little, Brown, and Company, 1991.

Jaeger, Roland. "'Künstlerisch Gutes in werbegerechter Form': Die internationale Zeitschrift 'Gebrauchsgraphik.'" In *Blickfang. Bucheinbände und Schutzumschläge Berliner Verlage 1919–1933*, edited by Jürgen Holstein, 291–307. Berlin: Holstein, 2005.

Jaeger, Stella. "Umbo's Circle of Friends." In *Umbo: Photographer*, edited by Inka Schube, 245–50. Cologne: Snoek, 2019.

Jaeggi, Annemarie. *Fagus. Industriekultur zwischen Werkbund und Bauhaus*. Berlin: Jovis, 1998.

Jaeggi, Annemarie, ed. *werkbund-ausstellung paris 1930. leben im hochhaus*. Berlin: Bauhaus-Archiv, 2007.

James, Kathleen. "Changing the Agenda: From German Bauhaus Modernism to U.S. Internationalism: Ludwig Mies van der Rohe, Walter Gropius, Marcel Breuer." In Barron and Eckmann, *Exiles + Emigrés*, 235–52.

James-Chakraborty, Kathleen. "From Isolationism to Internationalism. American Acceptance of the Bauhaus." *Bauhaus Culture. From Weimar to the Cold War*, edited by Kathleen James-Chakraborty, 153–70. Minneapolis: Univ. of Minnesota Press, 2006.

Jockheck, Lars. "'Deutsche Leistung im Weichselraum'. NS-Ausstellungen im 'Generalgouvernement' 1940–1944." In *Geschichtsbilder und ihre museale Präsentation*, edited by Stefan Dyroff and Markus Krzoska, 121–42. München: Meidenbauer, 2008.

Jones, Julie. "L'avant-garde européenne au service du capitalism. Walter P. Paepcke et le couple art/commerce aux États-Unis (1930–1950)." *Études photographiques*, no. 24 (November 2009), 42–71. http://journals.openedition.org/etudesphotographiques/2821.

Jones, Julie. "Un art publicitaire? György Kepes au New Bauhaus 1937–1943." *Études photographiques*, no. 19 (December 2006), 46–67. http://journals.openedition.org/etudesphotographiques/1262

Jong, Cees de. *The Poster. 1,000 Posters from Toulouse-Lautrec to Sagmeister*. New York: Abrams, 2010.

Kaiser, Fritz, ed. *Entartete Kunst. Ausstellungsführer*. Berlin: Verlag für Kultur-und Wirtschaftswerbung, 1937.

Kállai, Ernst. "Zehn Jahre Bauhaus." *Die Weltbühne* 26, no. 4 (January 21, 1930), 135–39.

Kandinsky, Wassily. *Briefe an Will Grohmann 1923–1943*. Edited by Barbara Wörwag. Munich: Hirmer, 2015.

Katenhusen, Ines. "Biografie des Scheiterns? Alexander Dorner, ein deutscher Museumsdirektor in den USA." In *Bücher, Verlage, Medien*, edited by Claus-Dieter Krohn, Erwin Rotermund, Lutz Winckler and Wulf Koepke, 260–84. München: edition text+kritik, 2004.

Katenhusen, Ines. "Dorner, Lissitzky, Moholy-Nagy, Bayer. Kollaborationen und Kollisionen." In *Lissitzky und der bioskopische Raum*, edited by Kai-Uwe Hemken. Kassel: Kassel University Press, forthcoming

Katenhusen, Ines. "*Mann mit Mission*". *Der Museumsreformer Alexander Dorner in seiner Zeit (1893–1957)*. Berlin: DeGruyter, forthcoming.

Keppler, Stefanie. "Moderne unterm Hakenkreuz. Fotografie und Ausstellungsgestaltung in den Propagandaausstellungen 1933 bis 1937 in Berlin." Master's thesis, University of Tübingen, 2000.

Kinross, Robin. "Herbert Read's *Art and Industry*: A History." *Journal of Design History* 1, no. 1 (1988), 35–50.

Kinross, Robin. "Large and Small Letters: Authority and Democracy." *Octavo* 3, no. 5 (1988), 2–5.

Klar, Willy B. *… ein bißchen Chuzpe und ein Haufen Glück. Mein Leben mit Texten und Textilien*. Oberaudorf a. I.: Verlag Willy B. Klar, 1981.

Klee, Felix, ed. *Paul Klee. Briefe an die Familie 1893–1940*. 2 vols. Cologne: DuMont, 1979.

Kleinknecht, Inga. "Irene Bayer-Hecht. Bauhaus-Fotografin und 'Meistergattin'." In *Bauhaus-Beziehungen Oberösterreich*, edited by Inga Kleinknecht, 66–83. Weitra: Verlag Bibliothek der Provinz, 2017.

Koehler, Karen. "The Bauhaus, 1919–1928: Gropius in Exile and the Museum of Modern Art, N.Y., 1938." In *Art, Culture, and Media under the Third Reich*, edited by Richard A. Eitlin, 287–315. Chicago: University of Chicago Press, 2002.

Koehler, Karen. "Walter Gropius und Marcel Breuer. Von Dessau nach Harvard." In Költzsch and Tupitsyn, *Bauhaus Dessau*, 70–81.

Köpnick, Gloria, and Rainer Stamm, eds. *Zwischen Utopie und Anpassung. Das Bauhaus in Oldenburg*. Petersberg: Michael Imhof, 2019.

Koetzle, Hans-Michael. "'Mich hat der Zufall interessiert'. Interview mit Alexander Liberman." *Leica World* 1, no. 1 (1996), 12–17.

Koetzle, Hans-Michael. *Das Lexikon der Fotografen 1900 bis heute*. München: Knaur, 2002.

Költzsch, Georg-W., and Margarita Tupitsyn, eds. *Bauhaus Dessau > Chicago > New York*. Cologne: DuMont, 2000.

Korac, Maja. "The Role of Bridging Social Networks in Refugee Settlements: The Case of Exile Communities from the former Yugoslavia in Italy and the Netherlands." In *Homeland Wanted: Interdisciplinary Perspectives on Refugee Resettlement in the West*, edited by Peter Waxman and Val Colic-Peisker, 87–107. New York: Nova Science, 2005.

Koss, Juliet. "Bauhaus Theater of Human Dolls." *Art Bulletin* 85, no. 4 (December 2003), 724–45.

Kranz, Kurt. "Bauhaus Pedagogy and Thereafter." In Droste and Friedewald, *Our Bauhaus*, 198–214.

Krause, Jürgen. "Westfalen-Lippe im Bauhaus-Format: Herbert Bayer wirbt für den Fremdenverkehr." In *basis bauhaus … westfalen*, edited by Ulrich Herrmanns, 49–54. Münster: Westfälisches Museumsamt, 1995.

Krause, Jürgen, ed. *Die nützliche Moderne. Graphik- & Produkt-Design in Deutschland 1935–1955*. Münster: Westfälisches Landesmuseum für Kunst und Kunstgeschichte, 2000.

Kries, Mateo, and Jolanthe Kugler, eds. *The Bauhaus #itsalldesign*. Weil am Rhein: Vitra Design Museum, 2015.

La, Kristie. "'Enlightenment, Advertising, Education, Etc.': Herbert Bayer and the Museum of Modern Art's *Road to Victory*." *October*, no. 150 (Fall 2014), 63–86.

Lambert, Phyllis, ed. *Mies in America*. New York: Abrams, 2003.

Lamster, Mark. *The Man in the Glass House. Philip Johnson, Architect of the Modern Century*. New York: Little, Brown and Company, 2018.

Langfeld, Gregor. *German Art in New York. The Canonization of Modern Art, 1904-1957*. Amsterdam: Amsterdam University Press, 2015.

Le Coultre, Martijn F. "Posters of the Avantgarde." In *Jan Tschichold. Posters of the Avantgarde*, edited by Martijn F. Le Coultre and Alston W. Purvis, 16–77. Basel: Birkhäuser, 2007.

Leadbeater, Charles Webster. *Der sichtbare und der unsichtbare Mensch*. Leipzig: Theosophisches Verlagshaus, n.d. [1908].

Letterform Archive, ed. *Bauhaus Typography at 100*. Exhibition catalogue, San Francisco: Letterform Archive, 2021.

Levy, Julien. "From a Portfolio of Photomontages by Herbert Bayer." *Coronet* 7, no. 3 (January 1940), 30–37.

Levy, Silvano. *The Scandalous Eye: the Surrealism of Conroy Maddox*. Liverpool: Liverpool University Press, 2003.

Lindsey, Ben. B., and Wainwright Evans. *The Companionate Marriage*. New York: Boni & Liveright, 1927. German edition: *Die Kameradschaftsehe*. Stuttgart: DVA 1928.

Linne, Karsten. "Sozialpropaganda—Die Auslandspublizistik der Deutschen Arbeitsfront 1936-1944." *Zeitschrift für Geschichtswissenschaft* 57, no. 3 (March 2009), 237–54.

Lottner, Perdita, ed. *'Typographie kann unter Umständen Kunst sein'. Ring 'neue werbegestalter' 1928-1933. Ein Überblick*. Hannover: Sprengel Museum, 1990.

Lugon, Olivier. "Dynamic Paths of Thought. Exhibition Design, Photography and Circulation in the Work of Herbert Bayer." In *Cinema Beyond Film. Media Epistemology in the Modern Era*, edited by François Albera and Maria Tortajada, 117–44. Amsterdam: Amsterdam University Press, 2010.

Lugon, Olivier. "La photographie mise en espace. Les expositions didactiques en Allemagne (1920-1930)." *Études photographiques*, no. 5 (November 1998). http://journals.openedition.org/etudesphotographiques/168.

Lupton, Ellen. *Herbert Bayer: Inspiration and Process in Design*. New York: Princeton Architectural Press/Moleskine Books, 2020.

Margolin, Victor. "László Moholy-Nagys Odyssee. Von Ungarn nach Chicago." In Költzsch and Tupitsyn, *Bauhaus Dessau*, 198–207.

McAndrew, John M. "'Modernistic' and 'Streamlined'." *The Bulletin of the Museum of Modern Art* 5, no. 6 (December 1938).

Meißner, Jörg. "Quand l'art moderne devient commercial. Propagande et publicité dans l'œuvre de Herbert Bayer." *Vingtième Siècle. Revue d'histoire*, no. 101 (2009), 27–48. https://doi.org/10.3917/ving.101.0027.

Meister, Sarah Hermanson. *One and One is Four: The Bauhaus Photocollages of Josef Albers*. New York: The Museum of Modern Art, 2016.

Michalske, Hainer. "Öffentliche Stimme der 'Inneren Emigration'? Über die Funktion der 'Frankfurter Zeitung' im System nationalsozialistischer Propaganda." In *Jahrbuch für Kommunikationsgeschichte*, edited by Holger Böning, Arnulf Kutsch and Rudolf Stöber, 170–93. Stuttgart: Franz Steiner, 2001.

Miller, Wallis. "Points of View: Herbert Bayer's Exhibition Catalogue for the 1930 *Section Allemande*." *Architectural Histories* 5, no. 1 (January 2017), 1–22. http://doi.org/10.5334/ah.221.

Moderegger, Johannes Christoph. *Modefotografie in Deutschland 1929-1955*. Norderstedt: Libri BoD, 2000.

Moholy, Sibyl. "The Diaspora." *Journal of the Society of Architectural Historians* 24, no. 1 (March 1965), 24–26.

Moholy-Nagy, László. "Bauhaus und Typographie." *Anhaltische Rundschau*, September 14, 1925. Reprinted in *Das Bauhaus 1919–1933. Weimar, Dessau, Berlin und die Nachfolge in Chicago seit 1937*, edited by Hans M. Wingler. 6th ed. Cologne: Dumont, 2009.

Moholy-Nagy, László. "Die neue Typographie." In *Staatliches Bauhaus Weimar 1919–1923*, edited by Bauhaus Weimar, 141. Munich: Bauhausverlag, 1923.

Moholy-Nagy, László. "Elementare Buchtechnik." In *Europäische Buchkunst der Gegenwart*, edited by Verein Deutsche Buchkünstler, 60–64. Leipzig: Schick, 1928.

Moholy-Nagy, László. "Fotografie ist Lichtgestaltung." *bauhaus* 2, no. 1 (March 1928), 2–9.

Moholy-Nagy, László. "La photographie ce qu'elle était, ce qu'elle devra être," *Cahiers d'Art* 4, no. 1 (1929), 28–33.

Moos, Stanislaus von. "'Modern Art gets down to Business'. Anmerkungen zu Alexander Dorner und Herbert Bayer." In Bauhaus-Archiv, *Herbert Bayer*, 93–104.

Moreau, Dominique. "Raum, Zeit, Betrachter. Proun oder der Geist der Utopie im unendlichen Raum." In *El Lissitzky: Konstrukteur, Denker, Pfeifenraucher, Kommunist*, edited by Victor Malsy, 86–95. Mainz: Hermann Schmidt, 1990.

Müller, Claudia. *Typofoto. Wege der Typografie zur Foto-Text-Montage bei László Moholy-Nagy*. Berlin: Gebr. Mann, 1994.

Müller, Ulrike. *Bauhaus Women. Art, Handicraft, Design*. London: Thames & Hudson, 2009.

Mumford, Eric. *The CIAM Discourse on Urbanism, 1928–1960*. Cambridge MA: MIT Press, 2000.

Museum Wiesbaden, and Stiftung Vordemberge-Gildewart, eds. *Friedrich Vordemberge-Gildewart. Briefwechsel*. Nuremberg: Verlag für Moderne Kunst, 1997.

Mußgnug, Dorothee. *Die Reichsfluchtsteuer 1931–1953*. Berlin: Duncker & Humblot, 1993.

National Collaborating Centre for Mental Health. *Induced abortion and mental health. A systematic review of the mental health outcomes of induced abortion, including their prevalence and associated factors*. London: Academy of Medical Royal Colleges, December 2011. www.aomrc.org.uk/wp-content/uploads/2016/05/Induced_Abortion_Mental_Health_1211.pdf

Nerdinger, Winfried. "Bauhaus-Architekten im 'Dritten Reich'." In Nerdinger, *Bauhaus-Moderne*, 153–78.

Nerdinger, Winfried, ed. *Bauhaus-Moderne im Nationalsozialismus. Zwischen Anbiederung und Verfolgung*. München: Prestel, 1993.

Nerdinger, Winfried. "Modernisierung, Bauhaus, Nationalsozialismus." In Nerdinger, *Bauhaus-Moderne*, 9–23.

Neumann, Eckhard. "Herbert Bayer's Photographic Experiments." *Typographica (New Series)* 6, no. 11 (June 1965), 34–44.

Neumann, Eckhard. "Kunst als universelle Verantwortung. Der Weg Herbert Bayers in Amerika." In *Herbert Bayer: Kunst und Design in Amerika 1938–1985*, edited by Bauhaus-Archiv, 8–13. Berlin: Gebr. Mann, 1986.

Neumann, Eckhard, ed. *Xanti Schawinsky Foto*. Bern: Benteli, 1989.

Neurauter, Sebastian. *Das Bauhaus und die Verwertungsrechte. Eine Untersuchung zur Praxis der Rechteverwertung am Bauhaus 1919–1933*. Tübingen: Mohr Siebeck, 2013.

Nonne-Schmidt, Helene. "Typografie 1923 bis 1932." In *Joost Schmidt, Lehre und Arbeit am Bauhaus 1919–32*, edited by Egidio Marzona, 19–22. Düsseldorf: Marzona, 1984.

Nowak-Thaller, Elisabeth. "Herbert Bayers künstlerische Anfänge in Linz (1919–1920) und Darmstadt (1921)." In Nowak-Thaller and Widder, *Ahoi Herbert!*, 37–55.

Nowak-Thaller, Elisabeth, and Bernhard Widder, eds. *Ahoi Herbert! Bayer und die Moderne*. Weitra: Verlag Bibliothek der Provinz, 2009.

Oels, David. *Rowohlts Rotationsroutine. Markterfolge und Modernisierung eines Buchverlags vom Ende der Weimarer Republik bis in die fünfziger Jahre*. Essen: Klartext, 2013.

Oswalt, Philipp. "Die verschwiegenen Bauhaus-Krisen." In *Hannes Meyer und das Bauhaus. Im Streit der Deutungen*, edited by Thomas Flierl and Philipp Oswalt, 247–65. Leipzig: Spector Books, 2018.

Otto, Elizabeth. "Designing Men. New Visions of Masculinity in the Photomontages of Herbert Bayer, Marcel Breuer, and László Moholy-Nagy." In Saletnik and Schuldenfrei, *Bauhaus Construct*, 183–204.

Otto, Elizabeth. *Haunted Bauhaus. Occult Spirituality, Gender Fluidity, Queer Identities, and Racial Politics*. Cambridge MA: The MIT Press, 2019.

Otto, Elizabeth. "Marianne Brandt's Experimental Landscapes in Painting and Photography during the National Socialist Period." History of Photography 37, no. 2 (May 2013), 167–81.

Otto, Elizabeth and Patrick Rössler. *Bauhaus Women. A Global Perspective*. London: Herbert Press, 2019.

Paglia, Michael. "Herbert Bayer: Beyond the Bauhaus." *Modernism* 8, no. 2 (summer 2005).

Passuth, Krisztina. *Moholy-Nagy*. Weingarten: Kunstverlag, 1986.

Paul, Gerhard. *Bilder einer Diktatur. Zur Visual History des "Dritten Reiches"*. Göttingen: Wallstein, 2020.

Pfund, Paul. "An Exhibition as the Basis of Artist's Archives." *Gebrauchsgraphik* 13, no. 5 (May 1936): 35–37.

Philipp, Michael. "Auswahlbibliographie Innere Emigration." In *Aspekte der künstlerischen inneren Emigration 1933–1945*, edited by Claus-Dieter Krohn, Erwin Rotermund, Lutz Winckler and Wulf Koepke, 200–16. München: edition text+kritik, 1994.

Philipp, Michael. "Distanz und Anpassung. Sozialgeschichtliche Aspekte der Inneren Emigration." In *Aspekte der künstlerischen inneren Emigration 1933–1945*, edited by Claus-Dieter Krohn, Erwin Rotermund, Lutz Winckler and Wulf Koepke, 11–30. München: edition text+kritik, 1994.

Pohlmann, Ulrich. "El Lissitzkys Ausstellungsgestaltungen in Deutschland und ihr Einfluß auf die faschistischen Propagandaschauen 1932–1937." In: *El Lissitzky: jenseits der Abstraktion*, edited by Margerita Tupitsyn, 52–64. München: Schirmer & Mosel, 1999.

Pohlmann, Ulrich. "'Nicht beziehungslose Kunst, sondern politische Waffe': Fotoausstellungen als Mittel der Ästhetisierung von Politik und Ökonomie im Nationalsozialismus." *Fotogeschichte* 8, no. 28 (1988), 17–31.

Prampolini, Ida Rodrigues. *Herbert Bayer. Un concepto total*. Mexico: Universidad Nacional Autónoma de México, 1975.

Ranke, Winfried. *Deutsche Geschichte kurz belichtet. Photoreportagen von Gerhard Gronefeld, 1937–1965*. Berlin: Nicolai, 1991.

Rasch, Heinz and Bodo, eds. *Gefesselter Blick. 25 kurze Monografien und Beiträge über neue Werbegestaltung*. Stuttgart, Wissenschaftlicher Verlag Dr. Zaugg, 1930.

Rattemeyer, Volker, and Dietrich Helms, '*Typographie kann unter Umständen Kunst sein*'. Vordemberge-Gildewart. Typographie und Werbegestaltung. Wiesbaden: Landesmuseum Wiesbaden, 1990.

Rattemeyer, Volker, and Dietrich Helms, '*Typographie kann unter Umständen Kunst sein*'. *Ring 'neue werbegestalter*'. *Die Amsterdamer Ausstellung 1931*. Wiesbaden: Landesmuseum Wiesbaden, 1990.

Rattemeyer, Volker, and Dietrich Helms, '*Typographie kann unter Umständen Kunst sein*'. *Vordemberge-Gildewart. Typographie und Werbegestaltung*. Wiesbaden: Landesmuseum Wiesbaden, 1990.

Roh, Franz. "Die Zwischenposition von Herbert Bayer." *Die Kunst und das schöne Heim* 54, no. 8 (Mai 1956), 290–93.

Roh, Franz. *Entartete Kunst. Kunstbarbarei im dritten Reich*. Hannover: Fackelträger, 1962.

Rössler, Patrick. "Bauhaus-Typografie und Schweizer Grafik. Brüder im Geiste: Herbert Bayer und Herbert Matter." In *Die Schweizer Avantgarde und das Bauhaus. Rezeption, Wechselwirkungen, Transferprozesse*, edited by Gregory Grämiger, Ita Heinze Greenberg, and Lothar Schmitt, 75–90. Zurich: gta, 2019.

Rössler, Patrick. *bauhaus.typography/bauhaus.typografie*. Berlin: bauhaus-archiv gmbh, 2017.

Rössler, Patrick. *Bauhausmädels. A Tribute to Pioneering Women Artists*. Cologne: Taschen, 2019.

Rössler, Patrick. "Das 'rechte Licht' in der Öffentlichkeit. Bauhaus-Schwerpunkte in zeitgenössischen Periodika." *Aus dem Antiquariat, N. F. 7*, no. 3 (September 2009), 163–74.

Rössler, Patrick. "Die 'Neue Typographie' und das Buch. Fachdiskurse und Umschlagentwürfe zwischen den Kriegen." In *Wissen im Druck. Zur Epistemologie der modernen Buchgestaltung*, edited by Christof Windgätter, 68–98. Wiesbaden: Harrassowitz, 2010.

Rössler, Patrick. "Die Ausstellung als begehbares Informationsdesign. Das Bauhaus und die Präsentation der Baugewerkschaften auf der 'Deutschen Bauausstellung' 1931." In *Entwürfe der Moderne. Bauhaus-Ausstellungen 1923–2019*, edited by Hellmuth Th. Seemann and Thorsten Valk, 173–95. Göttingen: Wallstein, 2019.

Rössler, Patrick. "Die visuelle Identität des Weimarer Bauhauses. Strategien und Maßnahmen im Corporate Design." In *Klassik und Avantgarde. Das Bauhaus in Weimar 1919–1925*, edited by Helmuth Th. Seemann and Thorsten Valk, 367–84. Göttingen: Wallstein, 2009.

Rössler, Patrick. "Eine vergessene Pionierin—Irmgard Sörensen-Popitz, Art Directorin im Beyer Verlag." In *Women in Graphic Design 1890–2012*, edited by Gerda Breuer and Julia Meer, 120–31. Berlin: Jovis, 2012.

Rössler, Patrick. "*Es kommt … die neue Frau! 'Visualisierung von Weiblichkeit in deutschen Printmedien des 20. Jahrhunderts.*' Erfurt: University of Erfurt, 2019.

Rössler, Patrick. "Exil mit Kalkül. Strategische Netzwerke als Starthilfe: Herbert Bayers 'Neubeginn' in den USA (1938)." In Dogramaci and Wimmer, *Netzwerke des Exils*, 51–70.

Rössler, Patrick. "Frankfurt, Leipzig, and Dessau: 'Neue Typographie'—the New Face of a New World." In *The Oxford Critical and Cultural History of Modernist Magazines, Vol. III (Europe 1880–1940)*, edited by Peter Brooker, Sascha Bru, Andrew Thacker, and Christian Weikop, 969–91. Oxford: Oxford University Press, 2013.

Rössler, Patrick. *Herbert Bayer: Die Berliner Jahre—Werbegrafik 1928–1938*. Berlin: Vergangenheitsverlag, 2013.

Rössler, Patrick. "Herbert Bayers Bildsprache für die Propagandaausstellungen des Reiches. Zur Mediatisierung von Alltag im NS-Deutschland." In *Die Mediatisierung der Alltagswelt*, edited by Maren Hartmann and Andreas Hepp, 211–30. Wiesbaden: VS, 2010.

Rössler, Patrick. *Illustrated Magazine of the Times. A Lost Bauhaus Book by László Moholy-Nagy and Joost Schmidt—an Attempt at Construction.* Berlin: Gebr. Mann, 2019.

Rössler, Patrick. *New Typographies—Bauhaus & Beyond. 100 Years of Functional Graphic Design in Germany.* Göttingen: Wallstein, 2019.

Rössler, Patrick. *Public Relations and the Bauhaus. Communication in a Permanent State of Crisis.* New York: Routledge, 2014.

Rössler, Patrick. *The Bauhaus at the Newsstand. die neue linie 1929–1943.* Bielefeld: Kerber, 2007; 2nd revised ed. 2009.

Rössler, Patrick. "Universal Communication. Conceived Globally, Made Locally: On the Diffusion of New, Functional Typography." In *Big Plans! Modern Figures, Visionaries, and Inventors*, edited by Claudia Perren, Torsten Blume, and Alexia Pooth, 142–67. Bielefeld: Kerber, 2016.

Rössler, Patrick. "Vielfalt in der Gleichschaltung—die 'domestizierte Moderne' am Kiosk. Eine Lifestyle-Illustrierte zwischen Bauhaus-Avantgarde und NS-Propaganda." In *Jahrbuch für Kommunikationsgeschichte*, edited by Holger Böning, Arnulf Kutsch and Rudolf Stöber, 150–95. Stuttgart: Franz Steiner, 2007.

Rössler, Patrick. *Viewing our Life and Times. A Cross-Cultural Perspective on Media Globalization.* Erfurt: University of Erfurt, 2006.

Rössler, Patrick: "'Wir zerstreuten uns zu Tode'. Formen und Funktionen der Medialisierung des Politischen in illustrierten Zeitschriften der NS-Zeit." In *Von der Politisierung der Medien zur Medialisierung des Politischen? Zum Verhältnis von Medien, Öffentlichkeiten und Politik im 20. Jahrhundert*, edited by Klaus Arnold, Christoph Classen, Susanne Kinnebrock, Edgar Lerch, and Hans-Ulrich Wagner, 183–239. Leipzig: Leipziger Universitäts-Verlag, 2010.

Rössler, Patrick, ed. *bauhauskommunikation. Innovative Strategien im Umgang mit Medien, interner und externer Öffentlichkeit.* Berlin: Gebr. Mann, 2009.

Rössler, Patrick, ed. *Bruno E. Werner. Ein Mann mit Eigenschaften.* Stuttgart: Edition 451, 2010.

Rössler, Patrick, and Anke Blümm. "Soft Skills and Hard Facts: A Systematic Assessment of the Inclusion of Women at the Bauhaus." In *Bauhaus Bodies. Gender, Sexuality, and Body Culture in Modernism's Legendary Art School*, edited by Elizabeth Otto and Patrick Rössler, 3–24. New York: Bloomsbury, 2019.

Rössler, Patrick and Mirjam Brodbeck. *Der Revolutionäre der Typographie. Gesammelte Werbegrafik der 1920er und 1930er Jahre aus dem Netzwerk des Buch- und Schriftgestalters Jan Tschichold.* Göttingen: Wallstein, 2022.

Rössler, Patrick and Gwen Chanzit. *Der einsame Großstädter. Herbert Bayer: Eine Kurzbiografie.* Berlin: Vergangenheitsverlag, 2014.

Rössler, Patrick, Magdalena Droste, Jens Weber, and Andreas Wolter. "Von der Institution zur Community: Das Bauhaus als kommunikatives Netzwerk." In *Medien-Journal* 35, no. 2 (April 2011), 16–32.

Rossmann, Zdenek. *Písmo a fotografie v reklamě.* Olomouc: Index, 1938.

Rotermund-Reynard, Ines. "Geheime Netzwerke—Charlotte Weidlers Briefe an den Kunstkritiker Paul Westheim (1933–1940)." In Dogramaci and Wimmer, *Netzwerke des Exils*, 261–76.

Sabine Eckmann. "Considering (and Reconsidering) Art and Exile." In Barron and Eckmann, *Exiles + Emigrés*, 30–39.

Sachsse, Rolf. "Die Frau an seiner Seite. Irene Bayer und Lucia Moholy als Fotografinnen." In *Fotografieren hieß teilnehmen: Fotografinnen der Weimarer Republik*, edited by Ute Eskildsen, 67–75. Düsseldorf: Richter, 1994.

Sachsse, Rolf. "Von Österreich aus: Herbert Bayer." *Camera Austria* 16, No. 46 (1994), 3–11.

Sajic, Adrijana. "The Bauhaus 1919–1928 at the Museum of Modern Art, N.Y., 1938; the Bauhaus as an Educational Model in the United States." PhD diss., City University of New York (CUNY), 2013. https://academicworks.cuny.edu/cc_etds_theses/183.

Saletnik, Jeffrey. "Pedagogic Objects. Josef Albers, Greenbergian Modernism, and the Bauhaus in America." In Saletnik and Schuldenfrei, *Bauhaus Construct*, 83–102.

Saletnik, Jeffrey, and Robin Schuldenfrei, eds *Bauhaus Construct. Fashioning Identity, Discourse and Modernism*. London: Routledge, 2009.

Sandusky, L. "The Bauhaus Tradition and the New Typography." *PM* 4, no. 7 (June–July 1938), 1–34.

Schäffer, Immanuel. *Wesenswandel der Ausstellung. Ein Überblick über das deutsche Ausstellungswesen und die Ausstellungsarbeit*. Berlin: Daenell, 1938.

Schawinsky, Xanti. "Metamorphose Bauhaus." In *Bauhaus. Idee—Form—Zweck—Zeit*, edited by Eckhard Neumann, 82–93. Frankfurt: Göppinger Galerie, 1964.

Schmalriede, Manfred. "Zur Entwicklung von Typographie und Typofoto innerhalb der Neuen Gestaltung. Kunsttheoretische Aspekte." In Eskildsen and Horak, *Film und Foto*, 26–37.

Schmidmair, Friedrich. "Ausstellungsgestaltung als intensivierte und neue Sprache." In Nowak-Thaller and Widder, *Ahoi Herbert!*, 15–20.

Schnaus, Claudia. *Kleidung zieht jeden an. Die deutsche Bekleidungsindustrie 1918 bis 1973*. Berlin: de Gruyter, 2017.

Schöbe, Lutz, and Wolfgang Thöner. "Druck- und Reklamewerkstatt." In *Die Sammlung*, edited by Stiftung Bauhaus Dessau, 92–99. Ostfildern: Hatje, 1995.

Schube, Inka. "Umbo. Photographer. The Chronicler under the Circus Dome." In *Umbo. Photographer*, edited by Inka Schube, 235–44. Cologne: Snoek, 2019.

Schug, Alexander. "Herbert Bayer—ein Konzeptkünstler in der Werbung der Zwischenkriegszeit." In Nowak-Thaller and Widder, *Ahoi Herbert!*, 173–85.

Schug, Alexander. "Moments of Consistency. Eine Geschichte der Werbung." In *Moments of Consistency. Eine Geschichte der Werbung*, edited by Stefan Hansen, 10–209. Bielefeld: Transcript, 2004.

Schulze, Franz. *Philip Johnson. Life and Work*. Chicago: University of Chicago Press, 1996.

Schulze, Franz. "The Bauhaus Architects and the Rise of Modernism in the United States." In Barron and Eckmann, *Exiles + Emigrés*, 225–34.

Seeger, Adina. "Fritz Ertl—Bauhausschüler und Baumeister im KZ Auschwitz-Birkenau." In *Hannes Meyers neue Bauhauslehre—Von Dessau nach Mexiko*, edited by Philipp Oswalt, 497–506. Basel: Birkhäuser, 2019.

Seitlin, Percy. "What is taught and why. A footnote on the recent Bayer classwork exhibit at the A-D Gallery." *A-D* 7, no. 5 (June–July 1941), 31–2.

Siebenbrodt, Michael, and Lutz Schöbe. *Bauhaus 1919–1933. Weimar—Dessau—Berlin*. New York: Parkstone Press International, 2009.

Sösemann, Bernd. "Propaganda und Öffentlichkeit in der 'Volksgemeinschaft.'" In *Der Nationalsozialismus und die deutsche Gesellschaft. Einführung und Überblick*, edited by Bernd Sösemann, 114–154. Stuttgart: Deutsche Verlagsanstalt, 2002.

Spondé, Michael. "Dr. Agha and the New French Advertisement." *Gebrauchsgraphik* 5, no. 4 (April 1928), 17–21.

Staniszewski, Mary Anne. *The Power of Display. A History of Exhibition Installations at the Museum of Modern Art*. Cambridge, MA: MIT Press, 1998.

Statistisches Reichsamt: *Statistisches Jahrbuch für das Deutsche Reich, 1937.* Berlin: Verl. für Sozialpolitik, Wirtschaft u. Statistik, 1937.

Steffen, Kai [Lore Leudesdorff]. *Unter dem weiten Himmel.* Düsseldorf: F. M. Bourg, n.d. [1970].

Stegmann, Daniel, Birgit Stark, and Melanie Magin: "Echo Chambers." In *Encyclopedia of Technology and Politics*, edited by Andrea Ceron. Cheltenham: Edward Elgar Publishing, 2022.

Steinhausen, Ansgar. "Herbert Bayer. Tapeten, Typo, Tafelbilder." *Häuser*, March 2019, 76–81.

Stiftung Bauhaus Dessau, ed. *Bauhaus Objekte. Eine Auswahl aus der Sammlung der Stiftung Bauhaus Dessau auf CD.* Berlin: Jovis, 2004.

Stiftung Bauhaus Dessau, ed. *Xanti Schawinsky, Magdeburg 1929–31/Fotografien.* Leipzig: Messedruck, 1993.

Stilke, Karin. "Ich bin ein Sonntagskind. Erinnerungen eines Fotomodells." In *Karin Stilke Fotomodell*, edited by Wilhelm Hornbostel, 13–83. Hamburg: Museum für Kunst und Gewerbe, 2007.

Stolze, Gustav. "Kunst mitten im Leben." *Die Kunstkammer* 2, no. 4 (April 1936), 12–14.

Sultano, Gloria. *Wie geistiges Kokain … Mode unterm Hakenkreuz.* Wien: Verlag für Gesellschaftskritik, 2004.

Thamer, Hans-Ulrich. "Geschichte und Propaganda. Kulturhistorische Ausstellungen in der NS-Zeit." *Geschichte und Gesellschaft* 24, no. 3 (July 1998), 349–81.

Thöner, Wolfgang. "Der talentierte Mr. Bauhaus." *Spiegel Geschichte*, May 18, 2008. https://www.spiegel.de/geschichte/architekt-walter-gropius-a-946994.html.

Time Inc., ed. *Fortune. The Art of Covering Business.* Layton: Gibbs Smith, 1999.

Tschichold, Ivan [Jan], ed. "elementare typographie." Special issue, *Typographische Mitteilungen* 22, no. 10 (October 1925).

Tschichold, Jan. *Die neue Typographie. Ein Handbuch für zeitgemäss Schaffende.* Berlin: Bildungsverband der Deutschen Buchdrucker, 1928.

Tupitsyn, Margarita. "Ablehnung und Akzeptanz des Bauhaus-Gedankens in Amerika." In Költzsch and Tupitsyn, *Bauhaus Dessau*, 14–25.

Tupitsyn, Victor. "Herbert Bayer. Von der erweiterten Sicht zum erweiterten Feld." In Költzsch and Tupitsyn, *Bauhaus Dessau*, 82–89.

Tymkiw, Michael. *Nazi Exhibition Design and Modernism.* Minneapolis: University of Minnesota Press, 2018.

Uchill, Rebecca. "Re-viewing The Way Beyond 'Art': Herbert Bayer, Alexander Dorner, and Practices of Viewership." *Architectural Theory Review* 23, no. 1 (August 2019): 114–45. https://doi.org/10.1080/13264826.2019.1616867.

Ulmer, Renate. *Emanuel Josef Margold.* Stuttgart: Arnoldsche, 2003.

Vegesack, Alexander von, and Mathias Remmele, ed. *Marcel Breuer. Design und Architektur.* Weil am Rhein: Vitra Design Stitung, 2003.

Voegelin, Eric: *The Political Religions.* The Collected Works of Eric Voegelin, vol. 5, *Modernity Without Restraint*, 19–73. Columbia: University of Missouri Press, 2000. First published in German as *Die politischen Religionen.* 2nd ed., Wien: Bermann Fischer, 1939.

Wahl, Volker. *Das Weimarer Bauhaus. Ein Studienbuch zu seiner Geschichte 1919–1926.* Jena: Vopelius, 2019.

Wasensteiner, Lucy. *The Twentieth Century German Art Exhibition: Answering Degenerate Art in 1930s London.* New York: Routledge, 2019.

Weber, Klaus. "Kunst, Kitsch und Kalauer. Die erstaunliche Welt der Bauhaus-Geschenke." In *Happy Birthday! Bauhaus-Geschenke*, edited by Klaus Weber, 6–27. Berlin: Bauhaus-Archiv, 2004.

Weber, Klaus, ed. *Happy Birthday! Bauhaus-Geschenke*. Berlin: Bauhaus-Archiv, 2004.

Wehlau, Kurt. *Das Lichtbild in der Werbung für Politik, Kultur und Wirtschaft. Seine geschichtliche Entwicklung und gegenwärtige Bedeutung*, Würzburg: Triltsch, 1938.

Weißler, Sabine. "Bauhaus-Gestaltung in NS-Propaganda-Ausstellungen." In Nerdinger, *Bauhaus-Moderne*, 48–63.

Wendermann, Gerda. "Der Internationale Kongress der Konstruktivisten und Dadaisten in Weimar im September 1922. Versuch einer Chronologie der Ereignisse." In *Europa in Weimar. Visionen eines Kontinents*, edited by Hellmut Th. Seemann, 375–98. Göttingen: Wallstein, 2008.

Wessely, Anna. "László Moholy-Nagy und 'die neue linie." *Acta historiae artium* 48, no. 1 (October 2007), 191–202.

Westheim, Paul. "Herbert Bayer, Photograph und Maler." *Kunstblatt* 13, no. 5 (May 1929), 151–53.

Wetzel, Julia. "Auswanderung aus Deutschland." In *Die Juden in Deutschland 1933–1945. Leben unter nationalsozialistischer Herrschaft*, edited by Wolfgang Benz, 412–98. Munich: Beck, 1989.

Wetzig, Emil. "Das Schriftschaffen der deutschen Schriftgießereien." *Archiv für Buchgewerbe und Gebrauchsgraphik* 74, no. 5 (May 1935), 215–17.

Widder, Bernhard. "Emigration: New Yorker Jahre." In Nowak-Thaller and Widder, *Ahoi Herbert!*, 233–39.

Widder, Bernhard. "Raumvisionen im amerikanischen Westen." In Nowak-Thaller and Widder, *Ahoi Herbert!*, 319–27.

Wingler, Hans M. *The Bauhaus. Weimar, Dessau, Berlin, Chicago*. 3rd printing, Cambridge, MA: The MIT Press, 1979.

Wingler, Hans M. *Bauhaus in America. Resonanz und Weiterentwicklung*. Berlin: Bauhaus-Archiv, 1972.

Wischek, Albert. "Berliner Großausstellungen im Dritten Reich. Sechs Jahre Nationalsozialistischen Ausstellungswesens." In *Jahrbuch der Reichshauptstadt*, edited by Georg Birk and Gerd Daenell, 143–45. Berlin: Verlag für Kultur- und Wirtschaftswerbung, 1939.

Wischek, Albert. "Zur Deutschland-Ausstellung." In *Amtlicher Führer durch die Ausstellung 'Deutschland'*, edited by Gemeinnützige Berliner Ausstellungs-, Messe und Fremdenverkehrsgesellschaft, 25–27. Berlin: Ala, 1936.

Wolf, Erika. "SSSR na Stroike. From Constructivist Visions to Construction Sites." In *USSR in Construction*, edited by Petter Österlund, [14–21]. Sundsvall: Fotomuseet, 2006.

Wolsdorff, Christian. "Der Afrikanische Stuhl. Ein Schlüsselwerk des frühen Bauhauses." *Museumsjournal* 18, no. 3 (July–September 2004), 40–41.

Württembergischer Kunstverein, ed. *50 Jahre Bauhaus*. Stuttgart: Württembergischer Kunstverein, 1968.

Zervos, Christian. "Herbert Bayer (Galerie Povolozky)." *Cahiers d'Art* 4, no. 1 (1929), 56.

Zuschlag, Christoph. *"Entartete Kunst". Ausstellungsstrategien im Nazi-Deutschland*. Worms: Werner, 1995.

Index

Italic numbers are used for illustrations, pl. indicates plates. Italic text is also used for titles of journals and some German terms. Herbert Bayer is abbreviated as HB, Irene Bayer-Hecht as IB-H.

ADEFA 110–12, *111*, 223, *pls.* 23–4
advertising
 Bauhaus workshop for 43, 45, 46–7,
 62, *pl.* 3
 brochure for Gropius Adler car (1932)
 41, *pl.* 8
 brochure for Prym snap fasteners 170,
 171
 campaign for Chlorodont 88, *88*
 role of commercial art 109
 tourist campaign for Teutoburger Wald
 region (1931) 65, *pl.* 7
 tourist flyer for the city of Dessau
 (1926) 43, *44*, *pl.* 2
 in the USA 208, 209
 see also posters; Studio Dorland
Agha, Mehemed F. 56, 57
Albers, Anni 137
Albers, Josef 70, *71*, 137–8, 172–3, 215–16,
 261 n.36
American Advertising Guild 209
Anderson, Richard 193
Anhold, Karin 154, 226
Anschluss 147, 185
anticipatory obedience 216
archives of HB 184, 225–6
Art Directors Club of New York 207
Ascona, Switzerland 53, 67, 69, 70, 71, 75
Aspen, Colorado 210, 212, *212*
Atelier Binder 90
Atlantic Richfield Company (ARCO)
 213
Austria 15, 147, 156, 185
 see also Linz; Obergurgl

Bahlsen factory 18
banknotes 22, *pl.* 1

Barr, Alfred 165, 193, 195
Baschant, Rudolf (Rudi) 20
Bauhaus
 advertising workshop 43, 45, 46–7, 62,
 pl. 3
 Berlin, move to 83
 closure of 83
 corporate design of 46, *46*, 47
 Dessau, move to 25, 31, 35
 emigration of members 133, 147
 exhibitions 23, 66
 HB's circle of friends 39–43, 84, 133–5,
 138–9
 HB's departure from 48–51, 54
 HB as junior master 25, 31, 32, 33, 35
 HB as student 19–23
 IB-H and 28, 36, 37
 Nazi harassment of 83
 New Typography and 22, 23, 25,
 45–6
 resignations from 48
 stationery designs 45, 240–1 n.42
 USA, links with 161
Bauhaus magazine 48–50, *49*, 62
Bayer, Herbert
 archives 184, 225–6
 Bauhäusler, support for 212
 in Berlin 1928–1938 3–5, 8
 biography by Cohen 223–6
 censorship by 110–11, *111*, *pl.* 24
 color-blindness 178
 creative development 16–17
 divorce of 202
 early work 18, 21, *21*
 English, speaking of 200
 evaluation of 229–31
 family background 1, 15–16, *16*

finances 32–3, 96–7, 151, 207–8 *see also* emigration of HB, finances
friendships 84, 133–5, 138–9 *see also* networks of
friendships in USA 204–5
graphic designer, identity as 43, *44*, *pl. 2*
health of 36, 153–4, *154*
Herbert Bayer: Painter Designer Architect 222–3, *223*
hiking and camping 16
homesickness 211
as ideal *Bauhäusler* 2, 229
infidelity of 34 *see also* relationships, other extra-marital
literature, recent 226–7
marriages *see* Bayer-Hecht, Irene (IB-H, 1st wife); Bayer, Joella Haweis Levy (2nd wife)
mental health 148–9, 200, 201, 203, 204
military service 17
moral position of 109
mother, relationship with 71
musical talent 16, *17*
networks of 7–9, *9*, 39–43, 120–1, 206, 217–18 *see also* friendships
political stance, biographers' views of 93–4, 222–9
political stance, evidence for 93–6, 111–15, 206
political stance, HB's views of 113–14, 215–17, 220–1
publications 219–23 *see also* book covers; booklets; catalogues
relationship with Ise Gropius 68, 69–80, 203
relationships, other extra-marital 20–1, 24, 33, 53, 77–8, 129–31, 142–3, 172
religious faith 203
on role of commercial art 109
sexual appetite 125–8, 131
signing of work 94, *94*
social life 120–4, *122–4*
survey of Bauhäusler, reply 138
Total Design 2, 65
USA, unhappiness in 200, 205
womanizing, lack of in USA 200–1

works, customs inspection of 176–8
works, sale of 157–8, 160
see also emigration of HB
Bayer, Herbert (art works)
Der einsame Großstädter (The Lonely Metropolitan) (1932) 1, *2*, 47, 75–6, 231
Der Muster-Bauhäusler (Model Bauhaus Man) (1923) *2*, 3
Landschaft im Tessin (Landscape in Ticino) (1924) 97
Menschen unmöglich [Selbst-Porträt] (Humanly Impossible [Self-Portrait]) (1932) 76, *76*
Stadt (The City) (1922) 21, *21*
Bayer, Joella Haweis Levy (2nd wife)
friendship with HB 201
marriage to HB 202
Bayer, Julia "Muci"
death of 203–4
early years 59–60, *60*, 67, 72, 117–20, *170*
emigration to USA 199
and HB in USA 202–3
Bayer, Maximilian (HB father) 15, *16*, 17
Bayer, Rosa 15, *16*, 71
Bayer, Theo 15, *16*, 96, 184, 208
Bayer-Hecht, Irene (IB-H, 1st wife) 8, 27–38
abortions 31–2, 35, 38
advises HB on Moholy-Nagy 189
appearance of 28, *28*
Bauhaus and 27, 28, 37
as beautician 118
Berlin, plans move to 38
dependence on HB 67
divorce of 202
divorce, plans for 117, 119
emigration, considers 67–8, 169
emigration to USA 199–200
family background 27–8
finances 30, 32–3, 68, 151, 179
on HB and politics 93
and Ise Gropius 68–9, 198–9
and Ise Gropius and HB's affair 72, 73, 74–5, 119, 131
Jewish descent of 27, 95
love letters to HB 29, 30
marriage 31, *32*, 33–4, 36, 38

marriage, failure of in USA 201–2
marriage, reflects on 202
meetings with HB 28–9, 31
mental health 35
on other affairs of HB 131
in Paris 30
photographs of *28, 32–3, 60*
photography of 36–7, *44*, 47, 62
political views of 182–3, 197–8
product design 36, *37*
separation from HB 38, 59–60, 117–20
Studio Dorland, involvement with
 180–2
support for Paris exhibition (1929)
 60–1
swastika flag of 183–4
tour of Italy and France (1928) 53
Walter Gropius, attitude towards 74
Willy B. Klar and 181
works of HB, customs inspection of
 177–8
Bayer-Type 90, 208, *pl. 9*
Berchtesgaden, Germany 23, 24–5, 30, *30*
Berlin, Germany
 ADEFA fashion industry project
 110–12, *111*, 223, *pls. 23–4*
 Bauhaus move to 83
 Das Wochenende exhibition (1927)
 242 n.76
 Deutsche Bauausstellung Berlin
 (German Building Exhibition,
 1931) 65, *65*
 exhibitions and trade fairs 98 *see also*
 Nazi exhibitions
 film congress ball 112–13, *pl. 25*
 Film und Foto exhibition (1929) 54, 62
 HB impressions of 20
 HB move to 38
 Neue Typografie exhibition (1929) 63
Bertenrath, Ernst W. 208
Berthold A.G. 90, 208
Beyer, Otto and Arndt 58–9
Bill, Max 175, 221
billboards 89–90, *89*
Black Mountain College, USA 137–8, 190,
 261 n.38
book covers
 Art and Industry 155, *pl. 28*
 books of Italian propaganda 171–2

*Eltern wie sie sein sollen (How parents
 should be)* book cover 60, *pl. 5*
*Herbert Bayer: Painter Designer
 Architect* 222–3, *223*
Moderne Plastik (Modern Sculpture)
 89, *142*
Space, Time and Architecture 206
*The Way Beyond "Art": The Work of
 Herbert Bayer* 219, *220*
book design 50–1, *51*, 221
booklets
 Das Wunder des Lebens (1935) 101,
 102, *pl. 16*
 Deutsches Volk, deutsche Arbeit (1934)
 99–100, *100*
 Deutschland (1936) 103, *104*, 114
 Electronics—a New Science for a New
 World 210, *pl. 31*
 factory exhibitions 106–7, *107*
 Nazi exhibitions 91, 92, 225
 Olympic Games (1936) 105
Bowman, Ruth 71, 97
Breuer, Marcel
 emigration of 133–4, 169
 friendship with Ise Gropius 135
 HB and 40, 41, 134, *134*, 204
 HB, cooperation with 42, *42*
 Italy and France, bicycle tour (1928)
 53–4, *54*
 Jewish background 133, 260 n.6
 photographs of *54, 134, 162, 165*
 USA trip 162–3
 work of 22–3, 41–2
Brown University retrospective (1947) 219
Brüning, Ute 94, 150, 226
Buchloh, Benjamin 207
Burchartz, Max 25
business cards 54–5, *pl. 4*

Cahiers d'Art 61
Calder, Alexander 205, *206*
catalogues
 Bauhaus designs 23, 42, *42*, 46, *46*
 Chicago World Fair German pavilion
 91, *pl. 11*
 Deutsches Volk, deutsche Arbeit (1934)
 99, 113, *pl. 13*
 Deutschland (1936) 103, *104*, *pl. 17*
 Die Kamera exhibition (1933) 98, *pl. 12*

HB's London exhibition 156-7, *156-7*
Nazi exhibitions 91
Section Allemande exhibition (1930)
 64, *pl. 6*
 see also booklets; Nazi exhibitions
Chanzit, Gwen 226
Chicago, USA *see* New Bauhaus, Chicago
clothing industry *see* fashion industry
Cohen, Arthur A. 5, 108–9, 179, 192, 221,
 223–6
companionate marriage 38
Condé-Nast 55–7
Constructivism 22–3
Container Corporation of America 210–11,
 213
Cook, Mary 164, *165*
copyright, protection of 176, 184

DAF *see* German Labor Front (DAF)
Danilowitz, Brenda 70
Darmstadt, Germany 18
Debschitz, Irene von 119, 136–7, *137*
Degenerate Art 97, 103–4, 139, 162
Dermée, Paul 60
Dessau, Germany
 Bauhaus moves from 83
 Bauhaus moves to 25, 31, 35
 HB exhibition (1932) 66, *66*
 HB leaves 48, 53
 HB marriage 31
 HB's life in 39, 42
 IB-H attends lectures in 37
 tourist flyer (1926) 43, *44, pl. 2*
Deutsche Propaganda-Atelier (DPA,
 German Propaganda Studio) 98,
 151
Deutsche Vogue 55–7, *57*, 62
die neue linie (The New Line)
 billboard 89–90, *89*
 issue on Italy (1938) 137, *pl. 27*
 Olympic Games (1936) 104, *pl. 19*
 other HB designs 58–9, 139, 170–1,
 171, pl. 18
DIN standards 49, 241 n.67
Doesburg, Theo van 22
Dorland GmbH Berlin 56, *57*–8, *58*, 84, 86
 see also Studio Dorland
Dorner, Alexander 93, 139, 163, 189,
 218–19

catalogue for HB's London exhibition
 156–7, *156*
*The Way Beyond "Art": The Work of
 Herbert Bayer* 218, 219–22
Droste, Magdalena 41

emigration 5
emigration of HB
 archive sent to Linz 184
 arrival in New York 178
 departure from Germany 178
 finances 152, 164, 166–7, 174, 175,
 179–80
 introduction 4, 5, 9
 options for 152, 154
 passport *177*, 178
 plans for 170, 175–6
 reasons for 94–5, 147, 185
 see also MoMA Bauhaus retrospective
 (1938)
eugenics 101, *101*, 103, 254 n.75
exhibition designs
 DAF factory exhibitions 106–9, *107–8*
 Das Wochenende (1927) 242 n.76
 Deutsche Bauausstellung Berlin
 (German Building Exhibition,
 1931) 65, *65*
 Freut Euch des Lebens (Enjoy Life)
 (1936) 106, *106*
 Modern Art in Advertising (1945)
 211, *210, 211*
 Nazi period 105–6, *106 see also* Nazi
 exhibitions
 Pressa (1928) 50–1, *51*, 59
 Road to Victory (MoMA, 1942) 207,
 207
 Section Allemande (1930) 63–4, *64*,
 pl. 6
 see also MoMA Bauhaus retrospective
 (1938)
exhibitions of HB's work
 Bauhaus, Dessau (1932) 66, *66*
 Bauhaus, Wiemar (1923) 23
 Brown University retrospective (1947)
 219
 Film und Foto (1929) 54, 62
 Foreign Advertising Photography (1931)
 49, 57, 161
 German Advertising Art (1936) 114

Linz (1929) 61–2
London (1937) 155–60, *156–7*, *159*,
 pl. 29
Neue Typografie (1929) 63
Paris (1929) 60–1
exile 5
eyeball hominid 64, *64*, 245 n.76

factory exhibitions 106–9, *107–8*
Falkner, Hans 189
Fascist propaganda 136
fashion industry 110–12, *111*, *pls. 23–4*
female body 128
fictional representations 7
film congress ball 112–13, *pl. 25*
Fischer, Ed 189, 207
flags 183–4
Fortune 209
France 53–4, *54–5*
 see also Paris
Frauen-Mode 59
Frenzel, Hermann Karl 66, 114
Freude und Arbeit (Joy and Work) 109
Fulda, Jorge 87, 125–6, 127, 131, 148, 159,
 175
Funkat, Walter 113

Gebhard, Bruno 98, 99, 101, 253 n.65
Gebhard, Max 95
Gebrauchsgraphik (International
 Advertising Art) 65–6, 114–15, 152,
 161, 179, 213, *pl. 26*
German-Aryan Garment Manufacturers'
 Association *see* ADEFA
German Labor Front (DAF) 106–9, *107–8*,
 pl. 22
German Union of Building Trades 65, *65*
Giedion, Siegfried 64
 Space, Time and Architecture 206
Giedion-Welcker, Carola 141
 Moderne Plastik (Modern Sculpture)
 89, 141–2, *142*, 155
Gläserner Mensch (Transparent man) 100,
 pl. 14
Gleichschaltung 83, 86, 249 n.25
Goebbels, Joseph 95, 98, 112, 113
Gorny, Hein 122–3
graphic designer, HB as 43, *44*, *pl. 2*
Great War 17

Greece 134, *134*
greetings cards 167, *167*, 231, *pl. 32*
Gropius, Ise
 family background 223 n.33
 fictional representations 7
 friendship with Marcel Breuer 135
 HB, relationship with 40, 68, 69–80,
 203
 on HB's bureaucracy problems 151
 on HB's character 126–7
 on HB's health 153
 as hub of the Bauhaus network 139–40
 and IB-H 68–9, 119
 infertility of 69, 247 n.16
 and Lady "Peter" Norton 141, 143
 marriage to Walter Gropius 68
 and the MoMA catalogue 191
 on Nazis 135–6
 photographs of *69–70*, *80*, *199*
 on *Pressa* exhibition (1928) 59
 on sale of HB's work 160
Gropius, Walter
 affair between Ise Gropius and HB 71,
 72–3, 73–4, 75, 77, 78, 79–80
 Bauhaus, promotion of 138
 Bauhaus, resignation from 48
 Bauhäusler, invites to USA 162, 163,
 164–5, *165*
 Bauhäusler, support for 212
 biography by MacCarthy 7
 emigration, plans for 140
 at Harvard University 135
 HB and 20, 40–1, *40*, 143, 149–50, 169,
 204–5
 on IB-H 28, 74
 MoMA Bauhaus retrospective (1938)
 165, 173, 192–3, 195
 offers job to Breuer 163
 survey (1935) 57, 84, 138, 172
Gropius Johansen, Ati 12, 70, 80
Gubig, Thomas 88

Haanen, Karl Theodor 62
Hahn, Peter 5, 83, 109, 227, 228
Hartwig, Josef, on IB-H 28
Hassenpflug, Gustav 149
Hecht, Andreas (Bondi) 31, *32*
Hecht, Irene *see* Bayer-Hecht, Irene (IB-H,
 1st wife)

Heinssen, Inez 130–1
Hermand, Jost 4, 206
Hitler, Adolf 102, 115, 136, *pl.* 16
Hölscher, Eberhard 114, 115, 197
Hudnut, Joseph 135
human body 128

Illustrierte Blatt, Das 54, *55*
Industrial Arts 103
inner emigration 4, 224
Institute for German Cultural and
 Economic Propaganda (IfDKW)
 97–8
Isaacs, Reginald 69, 70, 77
Italy
 bicycle tour (1928) 53
 die neue linie (The New Line) special
 issue on 137, *pl.* 27
 HB and Ise Gropius skiing (1932) 72,
 72
 Schawinsky emigrates to 136
 walking tour (1923) 23–4

J. Walter Thompson advertising agency
 208
Jewish clients 112, 115, 217
Johnson, Philip 137

Kandinsky, Wassily 19–20, 22
Katenhusen, Ines 139
Kaul, Ingo 98, 113, 151
Kirszenbaum, Jezekiel D. 227–8
Klar, Willy B.
 advises HB on women in the USA 201
 buys HB's car 181, *183*
 on Dorland GmbH 87
 on emigration of IB-H 200
 excluded from HB's departure 178
 friendship with HB *122*, 123–4, *126*
 on HB anti-Nazism 95
 HB designs bungalow for 149
 on HB personality 122
 on Kurt Kranz 182
 remained in Germany 148, *148*
 sexual adventures 125, *126*
 Studio Dorland and IB-H 180
 war, experiences during 204
 on work for ADEFA 111–12
Klee, Paul, on IB-H 28

Köpcke, Sebastian 88
Körner, Friedl 125, *125*
Kramer, Ferdinand 194
Kranz, Kurt 84, 107–8, *108*, 109, 113, 136,
 182
Krause, Jürgen 101, 103, 216, 226
Kristallnacht (1938) 198
Kroll, Ernst 151
Kunstblatt 62

La, Kristie 91, 105–6, *207*
Lahl, Karin 125
language barrier 7
laurel wreath symbol 99
leaflets, German Radio Exhibition (1935)
 105, *pl.* 21
Leipzig, Germany, IB-H in 29, 31, 36–7
leisure activities 122–5, *122–4*
Leudesdorff, Lore 24, 28–9, 127
Levy, Joella Haweis *see* Bayer, Joella
 Haweis Levy
Linz, Austria 18, 184
 HB exhibition (1929) 61–2
Lissitzky, El 22
London, England
 HB blocked from going to 149
 HB exhibition (1937) 155–60
 Lady "Peter" Norton, links to 141
lowercase lettering 45–6
Lugon, Olivier 207
Lupton, Ellen 87, 190

MacCarthy, Fiona 7
magazines 55–9
 Gebrauchsgraphik 65–6, 114–15, 152,
 161, 179, 213, *pl.* 26
 Harper's Bazaar 209–10, *pl.* 30
 Vogue, German edition 55–7, *57*, 62
 other American 103, 166, 209
 other German 54, *55*, 61, 62, 90, 109
 see also die neue linie (The New Line)
Maltan, Josef (Sepp) 20, 23, 24–5, *30*
Margold, Emanuel Josef 18, 19
Marienbad, Germany 117, 118
Matthess, Walter 57–8, 87, *122*, *148*, 182,
 212
May, Matthias 18
McAndrew, John 165, 189, 194
Meyer, Hannes 192–3

Mies van der Rohe, Ludwig 83, 173–4
military service 17
Miller, Wallis 64
Modern Photography 50
Moholy-Nagy, László
 Albers and 172–3
 Film und Foto exhibition (1929) 62
 Germany, remains in 147–8
 HB and 20, 40, 138, 166, 205
 IB-H, distrusted by 36
 IB-H on 27
 lowercase lettering and 45
 magazine design 59
 Neue Typografie exhibition (1929) 63
 New Bauhaus, Chicago 138, 189
 on photography 50
 typography and 22, 23, 25
Molnár, Farkas 28
MoMA Bauhaus retrospective (1938)
 catalogue 190–1, 193
 effect of 197
 Gropius and the Jewish question 195
 HB role 165–6, 175, *199*
 import of items to the US 176
 installation 192, 194, *194*
 lack of support for HB 191–2
 response to 194–5
 Schawinsky and 167
 scope 172–4, 192–3
MoMA *Road to Victory* (1942) 207, *207*
money *see* banknotes
Moos, Stanislaus von 221
Morison, Stanley 155
Munich Agreement (1938) 197
Mussolini, Benito 136, 137, 171–2, *pl. 27*

Nazi-era design 86–7
Nazi exhibitions 91–2, 97–105, 113, 225
 Das Wunder des Lebens (1935) 100–3,
 101, 113, 157, 158, 221, 223, 225,
 226, *pls. 14–16*
 Deutsches Volk, deutsche Arbeit (1934)
 99–100, *100*, 105, 113, *pl. 13*
 Deutschland (1936) 99, 103–5, *104*,
 114, *pl. 17*
 Die Kamera (1933) 98, *pl. 12*
 Gebt mir vier Jahre Zeit (1937) 150–1
Nazi flags 183–4
Nazism

biographers' views of HB's political
 stance 93–4, 222–9
bureaucracy, HB's problems with 151,
 158–9
evidence for HB's political stance 93–6,
 111–15, 206
exploitation of designers 97
harassment of Bauhaus 83
Ise Gropius on 135–6
political stance, HB on his 113–14,
 215–17, 220–1
Nerdinger, Winfried 173
Neumann, Eckhard 103, 209, 225
New Bauhaus, Chicago 138, 166, 175,
 189
New Typography
 banknotes 22, *pl. 1*
 Bauhaus and 22, 23, 25, 45–6
 British antipathy towards 155
 HB and 3, 20, 21–2, 63
 lowercase lettering 45–6
 in the USA 57
New York World's Fair (1939) 162, 206
Ninette (French woman) 129, *129*
Nonné-Schmidt, Helene 31, *32*
Norton, Noel Evelyn "Peter," Lady 140–2,
 141, 156, 158, 160, 170, 175
Nowak-Thaller, Elisabeth 17, 24
Nuremberg Rally 99

Obergurgl, Austria 133, 141, 175
Office for Exhibitions and Trade Fairs
 97–8
Olympic Games (1936) 104–5, *pls. 19–20*
Otto, Elizabeth 79

Paepcke, Walter 210, 211, 212
paper sizes 49, 241 n.67
Paris, France
 Breuer in 163–4
 HB exhibition (1929) 60–1
 IB-H considers move to 67–8
 IB-H in 30
 Section Allemande exhibition (1930)
 63–4, *64*
Penrose, Roland 160
Peterhans, Walter 174
Philipp, Michael 4
Phillips, Christopher 92

photographs of HB
 with Alexander Calder *206*
 as child *16–17*
 designing the *Dessau* prospectus *44*
 with Dorland staff *148*
 in Germany *216*
 with Hans Ritter *122*
 with IB-H *32–3*, *170*
 with Ise Gropius *70*, *199*
 with Joella Bayer *201*
 with Julia Bayer *71*, *118*, *170*
 with Lady "Peter" Norton *141*
 with Marcel Breuer *54*, *134*, *162*, *165*
 with Mary Cook *165*
 at MoMa exhibition *199*
 passport photographs *177*
 with Sepp Maltan *30*
 sick in bed *154*
 skiing *123*, *230*
 as a student *19*
 at Studio Dorland *58*, *153*
 studio portrait *156*
 in USA *165–6*, *190*, *212*, *214*
 with Vips Wittig *126*
 with Walter Gropius *40*, *165*, *199*, *218*
 with Walter Matthess *122*, *148*
 wedding *32*
 with Willy B. Klar *122*, *123*, *126*, *148*
 with Xanti Schawinsky *40*, *54*, *70*, *141*,
 165, *175*, *218*
photography
 Atelier Binder house magazine 90
 Die Kamera exhibition (1933) 98, *pl.* 12
 Film und Foto exhibition (1929) 54, 62
 HB and 47, 50, 87
 HB article on (1928) 50
 HB published 54, *55*, 61
 of IB-H 36–7, *44*, 47
photomontages
 Das Wunder des Lebens (1935) 102,
 pl. 16
 *Der einsame Großstädter (The Lonely
 Metropolitan)* (1932) 1, *2*, 47, 75–6
 *Eltern wie sie sein sollen (How parents
 should be)* book cover 60, *pl.* 5
 Gute Nacht, Marie (Good night, Mary)
 (1932) 128, *128*
 Joy of Work campaign (1935) 107–9,
 108

Menschen unmöglich [Selbst-Porträt]
 (Humanly Impossible [Self-Portrait])
 (1932) 76, *76*
 by Moholy-Nagy 59
 for Walter Gropius 79
 picture-within-picture 31, 89, *pl.* 18
*PM: An Intimate Journal for Production
 Managers ...* 209
Pohlmann, Ulrich 99
Popitz, Friedrich 38
Porstmann, Walter 45
posters
 ADEFA fashion industry project
 110–11, *111*, *pl.* 24
 Bauhaus events (1923) 23, *40*
 International Film Congress ball
 (1935) 112–13, *pl.* 25
 Joy of Work campaign (1935) 108–9,
 108, *pl.* 22
 Nazi exhibitions 91, 101
 Olympic Games (1936) 104–5, *pl.* 20
 propaganda 136, 137
 Section Allemande exhibition (1930) 64
 travel poster for Teutoburger Wald
 region (1931) 65, *pl.* 7
Povolozky, Jacques and Elena 60, 244 n.43
prizes 49, *49*
profile of HB
 building of 62, 64–5
 peak of 66, 87, 102, 114, 122, 152–3
 decline of 150
propaganda events *see* Nazi exhibitions
Propaganda Ministry 102, 103, 112,
 113–14, 151
propaganda posters 136, 137

racial theories 101, *101*
Read, Herbert 159
 Art and Industry 155, 161, *pl.* 28
Reich Chamber of Fine Arts 93, 94, 96, 97,
 106, 114, 158
Reich, Lilly 173
reputation of HB *see* profile of HB
resistance 93
Richter, Ré 67–8
Ring neuer Werbegestalter (Ring of new
 advertising designers) 63
Ritter, Heinz 122, *122*, 147
Roh, Franz 93

Rossetti, Vincenzo
 Dalle paludi a Littoria 171–2
 Städte wachsen aus dem Sumpf (Towns
 rise from the marshes) 171

Sachsse, Rolf 40–1, 93, 94, 176, 216, 226,
 228
Schäffer, Immanuel 99
Schawinsky, Alexander (Xanti, Xandi)
 at the Bauhaus 42–3
 on the Bauhaus circle 69–70, 127
 career 43
 emigration of 137
 HB and 31, *32*, 40, *40*, 43, 51
 on HB's US visit 166
 IB-H and 27
 Italy and France, bicycle tour (1928)
 53–4, *54*
 on life at Bauhaus Prellerhaus 42
 MoMA Bauhaus retrospective (1938)
 167, 192
 Mussolini propaganda poster 136, 137
 New Bauhaus, closure of 189
 on Obergurgl ski trip 133, 175, *175*
 photographs of *32*, *40*, *54*, *70*, *141*, *165*,
 174, *215*
 on wall painting 25
Schlemmer, Oskar 83
Schmidhammer, Georg 18
Schmidt, Joost "Schmidtchen" 31, *32*, 47,
 211
Schug, Alexander 58, 84, 87, 97, 117,
 226–7
Schultz., Heinz 218, 219
Schwitters, Kurt 63
Seitlin, Percy 209
signing of work 94, *94*
skiing 122, *122–3*, 133, 142
social propaganda 109
Société des Artistes Décorateurs 63–4, *64*
Sörensen-Popitz, Irmgard "Söre" 38, 59
Soupault, Ré 67–8
standards 49, 241 n.67
stationery designs 9, 150, *150*
 see also business cards
Stilke, Karin (née Lahl) 125
Studio Dorland 84–92, *85*
 ADEFA fashion industry project
 110–12, *111*, *pls.* 23–4

after HB's emigration 180–2
 Bayer-abc booklet 176
 books and magazines 58–9, 89–90, *89*,
 pl. 18
 brochure 85–6, *86*
 company advertising 87–8, *88*
 HB joins 57–8, *58*
 HB remains with 148, *148*
 HB's differences with 135
 Nazi-era design 86–7
 Nazi exhibitions *see* Nazi exhibitions
 strategies of HB 87
 success of 122
 typefaces and type specimens 90, *pls.*
 9–10
 see also Dorland GmbH Berlin
Sudeten Crisis (1938) 197
Surrealism 90, 115
swastika flags 183–4
Switzerland 33, 77, 152
 see also Ascona

teaching positions
 Bauhaus junior master 25, 31, 32, 33,
 35
 in the USA 189, 190, 209
Thomalla, Curt 113
transparent man 100, *pl.* 14
Tschichold, Jan 23
Tupitsyn, Margarita 209
Tupitsyn, Victor 212
typefaces 90, 208, *pls.* 9–10
typography *see* New Typography

Uchill, Rebecca 220
United States of America
 Bauhäusler in 161, 163, 164–5
 HB emigrates to *see* emigration of HB
 HB's first trip to 161–7
 HB's friendships 204–5
 HB's job offers and prospects 166, 189,
 190
 HB's networks 206
 HB's work 207–13
 IB-H emigrates to 199–200
 New York World's Fair (1939) 162, 206
 see also MoMA Bauhaus retrospective
 (1938)
Universal typeface 90

Verband deutscher Reklamefachleute
 (VdR) 43, 54, 62
Voegelin, Eric 215
Vogue, German edition 55–7, *57*, 62
Vogue, US edition 166
Vordemberge-Gildewart, Friedrich 221
Vu 61

wall painting 25
Wallbrecht, Irene 33
Wandervogel 16
Weidenmüller, Johannes "Werbwart" 38,
 43, 50, 54–5, 240 n.33
Weidler, Charlotte 164
Weißler, Sabine 102

Werner, Bruno E. 59, 152
Westheim, Paul 62
Widder, Bernhard 211
Wiesbaden, Germany 77
Wijdeveld, H. Th. 138
Wirtschaftlichkeit (Economic efficiency) 50
Wittenborn, George 218, 219
Wittig, Vips 125, *126*, 178, 200, 201, 204
Working Group of German-Aryan
 Manufacturers in the Garment
 Industry *see* ADEFA

Zervos, Christian 61
Zwickau, Germany, *Neue Reklame*
 exhibition (1926) 242 n.76